The Thames and Hudson Encyclopaedia of
BRITISH ART

The Thames and Hudson Encyclopaedia of

BRITISH ART

General Editor

David Bindman

Editor for Medieval Art Nigel Morgan

316 illustrations

THAMES AND HUDSON

© 1985 Thames and Hudson Ltd, London

First published in Great Britain in 1985
by Thames and Hudson Ltd, London

First published in the USA in 1985 by
Thames and Hudson Inc., New York

Library of Congress Catalog Card Number 84-51499

Printed and bound in Hungary

Contents

Foreword

The surge of interest in British art has been a striking phenomenon of recent years. Exhibitions, books, articles and theses all testify to an international esteem that would have been unthinkable a few years ago. But until now there has been no handbook or guide written by specialists which can provide readily accessible information over the whole field. This encyclopaedia aims to fill that gap, not just as a reference book but as a companion to excite curiosity and encourage exploration.

The period covered is from the Anglo-Saxon era to the present day in painting, sculpture, and printmaking. Medieval art forms such as goldsmiths' work and embroidery are also included, because it is not possible to make a distinction between 'fine' and 'decorative' art before the 16c., and the story of stained glass is continued up to the present, as an extension of painting. Entries will be found for the more important artists, and also for such topics as schools, concepts, techniques, institutions, patrons and writers on art. Artists from abroad who settled for long or short periods in Britain are included, such as Rubens and Mondrian, whose time in England was brief but of great importance; artists who, though British by birth, made their careers elsewhere are excluded.

The entries reflect modern ways of looking at British art. Stubbs and Wright of Derby, for example, feature very much more largely than they would have done thirty years ago. Subject painting now has a major place alongside portraiture and landscape, and the long entries on Fuseli, Blake and John Martin represent a growing appreciation of the imaginative achievements of British artists. British sculpture – so often underrated – is given the attention it deserves, as is printmaking, especially caricature. The variety of 20c. British art and the controversies surrounding it are reflected in the differing viewpoints of the contributors.

Throughout the book, indeed, there has been no attempt to enforce uniformity of approach.

The illustrations have been chosen to illuminate the range of entries, using works both famous and unfamiliar, and to illustrate artistic life and the interrelationships between artists, patrons, institutions and media.

Bibliographical references are given at the end of the individual entries, and a full bibliography of reference books and works on British art follows the last entry.

At the end of the book is an international gazetteer of collections of British art. Arranged according to country and place, this gives a unique overview, which is invaluable not only when travelling – in fact or in imagination – but as an extension of the encyclopaedia itself, further documenting areas of patronage and art collecting.

My warmest thanks must go to my fellow contributors (listed on pp.11–12) who have often had to boil down the knowledge of decades into a very small compass, and especially to Nigel Morgan who was entirely responsible for the selection of the medieval entries. I must also record my gratitude to the staff of the Yale Center for British Art in New Haven and the Paul Mellon Centre for Studies in British Art in London (especially Brian Allen), and to Diana Dethloff, Caroline Elam, Richard Godfrey, John Hale, Joyce Jayes and Christopher Wilson. It has been a particular delight to work once again with the same editor at Thames and Hudson and I can only record my regret that her name may not be mentioned.

DAVID BINDMAN
Westfield College
University of London

How to use this book

Topics other than artists' biographies are set out in a **subject index** overleaf.

Within the entries, **cross-references**, printed in SMALL CAPITALS, allow one to move through the book from artist to artist, from the general to the specific, or from the specific to the general. In the entry on landscape painting, for instance, the subject is outlined century by century; the reader may then follow up the major artists mentioned, and further round out the picture by looking up the other artists listed at the end of each century division. Moving from an individual to a general essay can show how he or she fits into the history of a genre.

Illustrations are usually on the same page or double-page as the entries they illustrate. Where they appear under a different heading, the cross-reference is preceded by a star: thus, in the Cotman entry, '*NORWICH SCHOOL'. With the exception of manuscript illuminations and miniatures (which are in gouache or water-colour), unless otherwise stated the medium for paintings is oil, and for sculptures stone or marble.

The **bibliographical references** at the end of the entries are often in abbreviated form (e.g. 'Whinney (1964)'). Full details will be found in the **bibliography** at the end of the book, where titles are grouped thematically and chronologically. The reader is advised to look first among the books on the particular period or theme of the entry (such as 'Medieval' or 'Techniques'), and then under the more general headings. 'Exh.' after a title denotes an exhibition catalogue.

Locations of works of art are given in various abbreviated forms. Most are self-evident. Where a place-name only is given, reference is to the chief museum or gallery in that place (e.g. Cardiff = National Museum of Wales). Major national collections in London are given without the place-name, abbreviated as follows:

BL	British Library
BM	British Museum
NG	National Gallery
NPG	National Portrait Gallery
Tate	Tate Gallery
V&A	Victoria and Albert Museum

Other abbreviations are:

AG	Art Gallery
ARA	Associate Member of the Royal Academy
BN	Bibliothèque Nationale
exh.	exhibited/exhibition
MFA	Museum of Fine Arts
MoMA	Museum of Modern Art (New York)
NG	National Gallery
NGA	National Gallery of Art
NGS	National Gallery of Scotland
PRA	President of the Royal Academy
RA	Royal Academy/Royal Academician
Yale BAC	Yale Center for British Art, New Haven

Acknowledgments for illustrations will be found on the last page of this book.

7

Subject Index

STYLES, SCHOOLS AND GROUPS

Aesthetic Movement
amateur artists (18c.)
Anglo-Saxon art
Art and Language
Bloomsbury
Bristol School
Camden Town Group
Canterbury School
Conceptual art
Constructivism
Cranbrook Colony
Decorated style
drawing masters
East Anglian illumination
Etching Revival
Euston Road School
Glasgow School
Gothic
Group X

Industrial Revolution
International Gothic
London School of glass-
 painting
Neoclassicism
Neo-Romanticism
New English Art Club
New Generation Sculpture
Newlyn School
New Sculpture
Norwich School
Norwich School of glass-
 painting
Omega Workshops
Performance art
Pictish art
Picturesque
Pop art
Pre-Raphaelite Brotherhood

Rococo
Romanesque
Ruralists, Brotherhood of
St Albans School
St Ives School
Scottish Colourists
Scottish medieval art
Scottish painting
Shoreham
Situation
Sublime
Surrealism
Unit One
virtuosi
Vorticism
Welsh medieval art
Winchester School
York School of glass-
 painting

TYPES OF ARTISTIC PRODUCTION

alabasters
altarpieces
Apocalypse illustration
anecdotal painting
Bestiaries
Biblical illustration in
 manuscripts
Books of Hours
brasses
bronze
caricature
chantries
Coade stone
conversation piece
crosses
decorative painting
Doom paintings
drawing (medieval)
Easter sepulchres

enamels
fancy pictures
figurative painting (20c.)
fonts (medieval)
goldsmiths' work (medieval)
Gospel books
grisaille
grotesques
history painting
ivory carving
illuminated manuscripts
landscape painting
lead
marble
marine painting
miniature painting
misericords
opus anglicanum
outdoor painting

panel painting
plaster casts
popular art
portrait painting
printmaking
Psalter illustration
reliquaries
roof bosses
screens
sculpture
sporting painting
stained glass
terracotta
theatrical painting
tombs (medieval)
vestments
wall-painting
watercolour
wood-engraving

INDIVIDUAL WORKS AND GROUPS OF WORKS

Albert Memorial
Bayeux Tapestry
Benedictional of St Ethelwold
Bury Bible
Douce Apocalypse
Eleanor Crosses
Elgin Marbles
Foundling Hospital

Lambeth Bible
Lindisfarne Gospels
Norwich Retable
Pepysian Sketchbook
Queen Mary Psalter
St Albans Psalter
St Paul's Cathedral
 (monuments)

Sherborne Missal
Sutton Hoo
Vauxhall Gardens
Westminster, Palace of
 (19c. decoration)
Westminster Retable
Wilton Diptych
Winchester Bible

TECHNIQUES

acrylic
alabasters
aquatint
Baxter print
bronze
canvas
chromolithograph
Claude glass
Coade stone
drawing (medieval)
enamels
engraving

etching
fresco
gouache
lead
lithography
lithotint
marble
mezzotint
oil painting
outdoor painting
painting: supports, grounds
 and pigments

panel
pastel
plaster casts
polyautograph
printmaking
screenprinting
stipple engraving
tempera
terracotta
Venetian Secret
watercolour
wood-engraving

GALLERIES, EXHIBITING SOCIETIES, ART SCHOOLS AND PERIODICALS

Axis
British Institution for
 Promoting the Fine Arts
 in the United Kingdom
Camden Town Group
Circle
Foundling Hospital
Graphic

Grosvenor Gallery
Group X
ICA
London Gallery
New English Art Club
Omega Workshops
Royal Academy of Arts
Royal College of Art

St Martin's Lane Academy
7 and 5 Society
sketching clubs
Slade School of Art
Society of Artists
Society of Arts
Unit One

PATRONAGE AND WRITING ON ART

Ackermann, Rudolph
Albert, Prince
Alloway, Laurence
Arundel, Earl of
Beaumont, Sir George
Bell, Clive
Bohun family
Burke, Edmund
Charles I
Committee of Taste
Cromwell, Oliver
Egremont, Lord
Elizabeth I
Evelyn, John
Farington, Joseph

Frederick, Prince of Wales
Fry, Roger
Gambart, Ernest
George III
Gilpin, William
Grand Tour
Graves, Henry
Hazlitt, William
Henry III
Henry VII
Henry VIII
Knight, Richard Payne
Leathart, James
Lumley Inventory
Monro, Dr Thomas

Price, Uvedale
printselling (19c.)
Read, Sir Herbert
Richard II
Richardson, Jonathan
Ruskin, John
Select Committee on Arts
and Manufactures
Shaftesbury, Earl of
Sheepshanks, John
Stokes, Adrian
Vertue, George
Wykeham, William of

MEDIEVAL ART

Abell, William
alabasters
altarpieces
Anglo-Saxon art
Apocalypse illustration
Baker, William
Bayeux Tapestry
Benedictional of St
Ethelwold
Bestiaries
Biblical illustration in
manuscripts
Bohun family patronage
Books of Hours
Brailes, William de
brasses
Bury Bible
Canterbury School
chantries
crosses
Decorated style
Doom paintings
Douce Apocalypse
drawing
East Anglian illumination
Easter sepulchres
Eleanor Crosses
enamels
Flower, Barnard
fonts

goldsmiths' work
Gospel books
Gothic
grisaille
grotesques
Henry III
Henry VII
Hone, Galyon
illuminated manuscripts
International Gothic
ivory carving
Lambeth Bible
Lindisfarne Gospels
London School of glass-
painting
Massingham, John
misericords
Norwich Retable
Norwich School of glass-
painting
opus anglicanum
panel painting
Paris, Matthew
Pepysian Sketchbook
Pictish art
Power, Robert
Prudde, John
Psalter illustration
Queen Mary Psalter
reliquaries

Richard II
Romanesque
roof bosses
St Albans Psalter
St Albans School
Sarum Illuminator
Scheerre, Herman
Scottish medieval art
screens
sculpture
Sherborne Missal
Siferwas, John
stained glass
Sutton Hoo
Thomas of Oxford
Thornton, John
tombs
Torel, William
Twygge, Richard
vestments
wall-painting
Welsh medieval art
Westminster Retable
Wilton Diptych
Winchester Bible
Winchester School
Wykeham, William of
York School of glass-
painting

List of Contributors

DA Dawn Ades, Lecturer in History of Art, University of Essex

BA Brian Allen, Assistant Director, Paul Mellon Centre for Studies in British Art, London

MB Malcolm Baker, Assistant Keeper, Department of Sculpture, Victoria and Albert Museum, London

JB Jane Beckett, Lecturer in History of Art, University of East Anglia

DB David Bindman, Reader in History of Art, Westfield College, University of London

DBr David Brown, Assistant Keeper, Modern Collection, Tate Gallery, London

MRFB Martin Butlin, Keeper of the Historic British Collection, Tate Gallery, London

MCa Marian Campbell, Assistant Keeper, Department of Metalwork, Victoria and Albert Museum, London

MC Michael Compton, Keeper of Museum Services, Tate Gallery, London

LC Lynne Cooke, Lecturer in History of Art, University College London

DC David Cordingly, Deputy Head, Department of Pictures, National Maritime Museum, Greenwich

PC Peter Cormack, Deputy Keeper, William Morris Gallery, London

ND Nicholas Dawton, Assistant Curator of the College Collection and Slide Librarian, Department of History of Art, University College London

DD Diana Dethloff, research student in History of Art, Westfield College, University of London

SD Stephen Deuchar, research student in History of Art, Westfield College, University of London

JE Judy Egerton, Assistant Keeper, British Collection, Tate Gallery, London

EE Elizabeth Einberg, Assistant Keeper, British Collection, Tate Gallery, London

SF Susan Foister, Curator and Head of Archive and Library, National Portrait Gallery, London

CF Celina Fox, Keeper of Paintings, Prints and Drawings, Museum of London

DF David Freedberg, Professor of History of Art, Columbia University, New York

WF William Furlong, Head of the Foundation Department, Wimbledon School of Art, London

JG John Gage, Lecturer in History of Art, Cambridge University

RG Richard Godfrey, Head of the Old Master Prints Department, Sotheby's, London

FG Francis Greenacre, Keeper of Painting, City of Bristol Museum and Art Gallery

TG Thomas Gretton, Lecturer in the Department of History of Art, University College London

AG Alastair Grieve, Senior Lecturer, School of Fine Arts, University of East Anglia

RH Robin Hamlyn, Assistant Keeper, British Collection, Tate Gallery, London

CH Catherine Hassall, painting restorer

AH Andrew Hemingway, Senior Lecturer in History of Art, Ealing College of Higher Education, London

JH John Higgitt, Lecturer, Department of Fine Art, University of Edinburgh

TH Tim Hyman, painter, writer and teacher

CMK C. M. Kauffmann, Keeper of Prints and Drawings, Victoria and Albert Museum, London

MK Michael Kitson, Deputy Director, Courtauld Institute of Art, University of London

BL Bruce Laughton, Professor of Art History, Queen's University, Kingston, Canada

ML Sir Michael Levey, Director, National Gallery, London

JDM J. D. Macmillan, Senior Lecturer and Curator of the Talbot Rice Art Centre, Department of Fine Art, University of Edinburgh

RM Richard Marks, Keeper of the Burrell Collection and Assistant Director, Glasgow Museums and Art Galleries

MM M. A. Michael, Lecturer in Art History, University of St Andrews

NM Nigel Morgan, Director, Index of Christian Art, Princeton University

PN Patrick Noon, Curator of Prints and Drawings, Yale Center for British Art, New Haven

DP David Park, Leverhulme Research Fellow, Courtauld Institute of Art, University of London

NP Nicholas Penny, Keeper of Western Art, Ashmolean Museum, Oxford

TP Tom Phillips, painter, writer and composer

AR Anthony Radcliffe, Keeper of Sculpture, Victoria and Albert Museum, London

BR Benedict Read, Deputy Witt Librarian, Courtauld Institute of Art, University of London

DR Duncan Robinson, Director, Yale Center for British Art, New Haven

NR Nicholas Rogers, research assistant on the Index of Christian Art, Princeton University, and research worker for the Medieval Institute, Western Michigan University

RS Richard Shone, Associate Editor, *The Burlington Magazine*

KS Kim Sloan, research student in History of Art, Westfield College, University of London

MS Michael Quinton Smith, Senior Lecturer in History of Art, University of Bristol

JS John Sunderland, Witt Librarian, Courtauld Institute of Art, University of London

ET Evelyn Thomas, teacher of Art History, Malvern Girls' College

RT Rosemary Treble, London-based historian of Victorian painting

WV William Vaughan, Reader in History of Art, University College London

JW Jeffrey West, research student, Courtauld Institute of Art, University of London

CW Christopher White, Director, Paul Mellon Centre for Studies in British Art, London

PW Paul Williamson, Assistant Keeper, Department of Sculpture, Victoria and Albert Museum, London

AW Andrew Wilton, Curator of the Clore Gallery for the Turner Collection, Tate Gallery, London

AY Alison Yarrington, Lecturer in History of Art, University of Leicester

A

Abbott, John White *see* TOWNE

Abell, William (fl. 1446–70), a limner and citizen of London, was paid £1 6s 8d in 1447–8 for illuminating the Consolidation Charter of Eton College. Also attributable to him are the virtually identical Founder's Charter of King's College, Cambridge, a Missal written in 1461 for Abbot Ashenden of Abingdon (Oxford, Bodleian and Trinity College), and several other, mostly secular, works. His style, with its strong contrasting colours, linear draperies, and conventionalized landscape motifs, was particularly suited to heraldic decoration. NR
□ J. Alexander in *Kunsthist. Forschungen Otto Pächt* (1972), 166–72

Ackermann, Rudolph (1764–1834) was the most important publisher of fine illustrated books in the early 19c. He came to England from Saxony to work as a coach-builder, but by the mid 1790s he had established a successful drawing academy and print shop in the Strand, 'The Repository of Arts'. He provided regular employment for artists, including A. C. Pugin and ROWLANDSON, and promoted numerous inventions, notably gas-lighting. It is for his magnificent books illustrated in aquatint and later in lithography, issued in monthly parts, that he is best remembered. They cover topography, travel, architecture, decoration, design, gardening and science, as well as caricature. CF
□ J. Ford, *Rudolph Ackermann* (1983)

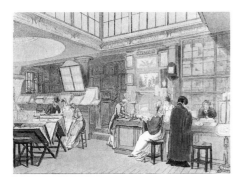

Ackermann's Repository of Arts: detail of an aquatint after A. C. Pugin and Rowlandson published by Ackermann, 1809.

acrylic A range of resins emulsified in water that can bind pigment and dry rapidly. The water's evaporation gives this medium the matt appearance that distinguishes it from oil. It came into general use in the 1960s, often for large abstract paintings that required dense, even fields of colour. MC
□ G. P. A. Turner, *Introduction to paint chemistry and principles of paint technology* (1980)

Adams, Robert *see* CONSTRUCTIVISM; HILL

Aesthetic Movement A term commonly used by c.1880 to describe the doctrine of and taste for 'art for art's sake' which flourished from the late 1860s to the early 1890s. It embraced not only painting but literature, architecture and the decorative arts, and represented the culmination of a trend, dating back to the 1830s, toward a greater concern with taste combined with a reaction against the notion that art has a specifically moral function. An emphasis on beauty and the supremacy of an individual artist's sensibility are central to the movement. They are foreshadowed in the visionary intensity of ROSSETTI's work, and linked, through Swinburne, to the idea current in France after c.1830 that a pure elevation of the soul is more important in art than realism or an appeal to the heart or intellect.

In this spirit, LEIGHTON had, as early as 1860, consciously explored the purely decorative and sensuous potential of a subject in *Lieder ohne Worte* (exh. RA 1861; Tate). In its air of abstraction and musical title this 'subjectless' picture anticipates both the work of the 2 central painters of the movement, WHISTLER and Albert MOORE, and the statement made in 1873 by Aestheticism's 'apostle', the critic Walter Pater, that 'all art constantly aspires towards the condition of music'.

The gallery most closely associated with the movement was the GROSVENOR GALLERY in London, whose artists included BURNE-JONES, CRANE, Leighton, Moore and WATTS. A picture by Whistler exhibited there in the opening year, 1877, sparked off the libel case between the artist and RUSKIN, in which the issue of 'art for art's sake' as against moral content finally emerged into open conflict.

While today many of the best remembered features of the Aesthetic Movement are the fashionable posturings of its leaders, Whistler and Oscar Wilde, it was instrumental in

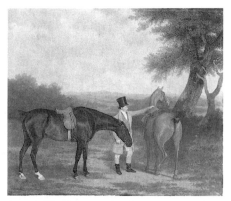

Agasse, *Two Hunters with a Groom*, c.1805 (Tate).

changing critical attitudes to art and the function of artists. RH
□ R. Spencer, *The Aesthetic Movement* (1972)

Agar, Eileen *see* SURREALISM

Agar, Jacques d' *see* AMATEUR ARTISTS

Agasse, Jacques Laurent (1767–1849) worked in England after 1800 as a sporting, animal, and genre painter. Born in Geneva, he moved to Paris where he studied painting (under David) and veterinary science before being invited to England by Lord Rivers. Though Rivers became his only steady source of patronage he also accepted important commissions for paintings of wild animals from the Royal College of Surgeons in 1821 and from George IV in 1827. His work may be compared to that of his predecessor Stubbs in its range of subject-matter, skilful observation of animal anatomy, and careful draughtsmanship; but partly because of a change in taste he died poor and little known. *See* SPORTING PAINTING. SD
□ D. Baud-Bovy, *Peintres genevois* (1904)

Aikman, William *see* SCOTTISH PAINTING

alabasters represent the main, though not the most important, English contribution to late medieval sculpture. Alabaster, a white, slightly translucent, massive form of gypsum, had been quarried in the midlands since the 12c., but it was not until the first half of the 14c. that sculptors realized the ease with which it could be carved and coloured. Its first major use was in the 1330s, for the TOMBS of Edward II at Gloucester, John of Eltham at Westminster Abbey, and Bishop Hotham at Ely. Thereafter it was widely employed for tombs, where it is seen at its best. But alabaster was used above all in late medieval England for altarpieces, statues and devotional panels (*see* SCULPTURE: GOTHIC, STONE).

The materials for a history of alabasters are fragmentary, most of those which were not exported having been ground up to make plaster of Paris at the Reformation. A prime difficulty in their evaluation is the paucity of datable material. Two figures in S. Croce, Rome, have been identified as those exported in 1382 by Cosmato Gentilis. At Santiago de Compostela is a retable donated in 1456 by an English pilgrim. Comparisons can be made with a few other dated works, such as the

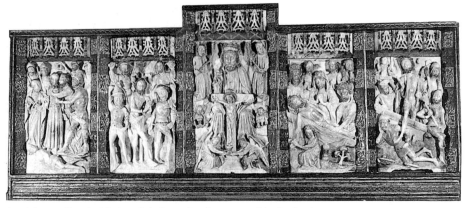

An **alabaster** altarpiece in its original wooden frame, 15c. (Nottingham).

Greene monument of 1419 at Lowick (Northants) and the Gylbert tablet of *c*.1492 at Youlgreave (Derbys.). Iconography can sometimes suggest the date of a piece: e.g. images of St Armel and Henry VI are to be placed after 1485. Costume evidence must be treated with caution, because of the alabasterers' reliance on patterns.

The earliest alabaster panels were carved in relatively low relief. Soon a standard format of a vertical rectangle usually about 45 cm. high was developed. By *c*.1390 an embattled canopy, derived from contemporary manuscripts or stained glass, had been introduced, and this device remained popular well into the 15c. That century saw the elaboration of details and compositions, figures being more deeply cut. Popular subjects such as the Passion rarely stimulated the sculptors' imagination, and the stereotyped images of the head of St John the Baptist well illustrate their artistic poverty. Despite the routine nature of much of their work the alabasterers enjoyed an international reputation. They were called upon in 1408 to execute the tomb of John IV of Brittany, formerly at Nantes, and their products were sent as far afield as Iceland and Dalmatia.

Nottingham appears to have been the chief centre, but alabasterers are also recorded in York, Lincoln, Burton-on-Trent and London. Though the names of several sculptors are known, one of the earliest being Peter the Mason of Nottingham (fl. 1360–80) who supplied a reredos for St George's Chapel, Windsor, only a few tombs can be assigned to named individuals. Nor has any convincing identification of local schools been made as yet. *See also* SCULPTURE: 17C. NR
□ *Ill. cat. of the exhibition of English medieval alabaster work* (London, Soc. of Antiquaries, 1913); F. W. Cheetham, *Medieval English alabaster carvings in the Castle Museum, Nottingham* (1962); Stone (1972), 179–80, 189–92, 197–8, 202–4, 216–8

Albert, Prince of Saxe-Coburg (1819–61) married Queen Victoria in 1840, and as her Consort had much influence on the artistic world. His main concern was not to promote individual artists but to improve the didactic role of state patronage. As Chairman of the Royal Commission on the Fine Arts from 1842 he had a decisive influence on the Palace of WESTMINSTER scheme which he hoped to organize on rational lines with German

methods. As a collector he dutifully bought English paintings, avoiding anything too controversial like the Pre-Raphaelites. DB
□ W. Ames, *Prince Albert and Victorian taste* (1967); Vaughan (1979)

Albert Memorial, London The climax of Victorian public commemorative sculpture, created in 1862–76 to the design of Sir G. G. Scott with contributions by many of the major sculptors of the age. Around a Gothic shrine enclosing FOLEY's statue of the Prince, radiating sculptures symbolize the arts and sciences that Albert encouraged, with reliefs of artists, poets and composers (by H. H. Armstead and J. B. Philip, under Scott's close supervision), 4 groups representing more practical concerns (*Commerce* by T. THORNYCROFT, *Engineering* by J. Lawlor, *Agriculture* by W. C. Marshall and *Manufactures* by H. Weekes), and the 4 major continents over which those interests extended (*Asia* by Foley, *Europe* by P. MacDowell, *Africa* by W. Theed and *America* by J. Bell). All but the reliefs seem incongruous with the architect's Gothic design. (*See* *SCULPTURE: VICTORIAN.*) BR
□ Read (1982)

Alexander, Cosmo (1724–73) was a minor Scottish portrait painter of Jacobite background. He enters history chiefly for his encouragement, during a brief sojourn in America, of the young Scots American Gilbert Stuart (1755–1828), whom he brought with him back to Britain to complete his training. DM
□ Caw (1908); Irwin (1975)

Alken, Henry Thomas (1785–1851), painter and etcher of SPORTING subjects, was the best known of a family of 4 generations of minor artists. His anecdotal and often humorous representations of sporting episodes enjoyed wide popularity. SD
□ W. Shaw Sparrow, *Henry Alken* (1927)

Allan, David (1744–96) trained in Glasgow at the Foulis Academy and in Rome where he was closely associated with Gavin HAMILTON. Though he aspired to be a HISTORY painter and was successful as a portraitist, he is chiefly remembered as the founder of Scottish genre and the inspiration of WILKIE. His best-known work is the illustrated edition of Allan Ramsay's *Gentle Shepherd* (1788). He also

produced a wide variety of Italian subjects. *See also* SCOTTISH PAINTING. DM
□ Caw (1908); T. C. Gordon, *David Allan, the Scottish Hogarth* (1951); *The indefatigable Mr Allan* (exh., Scottish Arts Council, 1973); Irwin (1975)

Allan, Sir William *see* SCOTTISH PAINTING

Alloway, Lawrence (b. 1926) was a leading London critic, and one of the few who affected the development of art. His interest in the mass media contributed to POP ART, a term which he may have invented (*c.*1956) to describe not the art itself but the products of the mass media. He became increasingly a protagonist of American art, and moved to New York in 1962. MC

Alma-Tadema, Sir Lawrence (1836–1912), whose paintings of Roman life now epitomize Victorian academic classicism, was himself a foreigner, Dutch-born, and trained in Belgium under Dyckmans and Leys. GAMBART brought his Roman paintings to London in 1865, and Alma-Tadema settled there in 1870, married an Englishwoman, and in 1873 took British citizenship. He painted the intimate or telling moments behind great events of classical history in astonishingly vivid reconstructions whose potential banality and occasional titillation are generally offset by his bold composition, daring perspectives and exceptional sensibility as a colourist. His hyper-real marble settings were as accurate as Alma-Tadema, a dedicated amateur archaeologist, could make them, using his own site drawings, the latest research and a huge photograph collection of archaeological remains. RT
□ V. G. Swanson, *Sir Lawrence Alma-Tadema* (1977); Treble (1978)

altarpieces formed an important part of the furnishing of all churches in the later Middle Ages. They consisted of ★PANEL paintings, or compositions of figure sculpture in stone, ★ALABASTER or wood, and were usually set in elaborate frames standing above and behind the altar. Almost all English altarpieces were destroyed at the Reformation or by Puritan iconoclasm in the later 16c. and 17c. Those panel paintings that survive were saved through being protected by Catholic families (e.g. the Thornham Parva Retable) or through their use as parts of tables, chests or cupboards (e.g. the NORWICH and WESTMINSTER RETABLES and that in the church at Newport, Essex). In Norfolk some altarpiece panels survived because they had already been re-used in the later Middle Ages to decorate rood SCREENS,

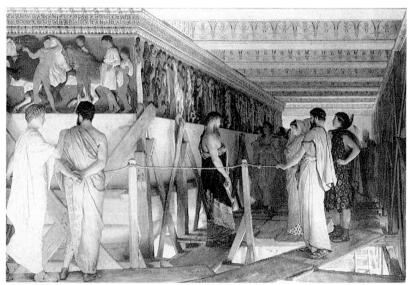

Alma-Tadema, *Pheidias and the Frieze of the Parthenon, Athens,* 1868–9 (Birmingham).

which seem to have been allowed to retain their painted decoration at the Reformation (e.g. the 2 sets of panels from St Michael-at-Plea, Norwich, now in the Cathedral).

With the exception of the Westminster Retable, which has a complex programme, these painted altarpieces have the Crucifixion as their central subject, flanked by standing saints or scenes of the Passion, Resurrection and Ascension of Christ. Small devotional panels such as the WILTON DIPTYCH may have served as altarpieces in churches, though they may also have been used in private oratories.

Sculptured altarpieces consisted of narrative episodes from the Life of Christ or figures of saints in niches. Even where the frames survive, most have lost all their figures, but fragments can be seen at Christchurch Priory (Hants), St Davids (Pembs.) and on the reverse of the reredos at Westminster Abbey. The empty niches of the reredos of All Souls College Chapel, Oxford, formed the splendid setting for now lost figures by John MASSINGHAM.

Alabaster altarpieces were made up of individual panels, of which many exist separated from their containing frame. Some complete examples survive because they were exported to the Continent (e.g. at Compiègne (Mus. Vivenel), Santiago de Compostela, and, via Germany, in the V&A). The range of subjects of the isolated panels (found in churches and museums in Britain and abroad) is wide, taken from the Lives of Christ, the Virgin and the saints. NM

□ W. L. Hildburgh in *Antiquaries Journal*, VI (1926); P. Lasko and N. Morgan, eds., *Medieval art in East Anglia* (exh., Norwich, Castle Mus., 1973), nos. 51, 52, 56

amateur artists of the 18c. were the inheritors of liberal reforms in education brought about in the previous century by men such as Henry Peacham and John Locke. They and the founders of private academies for gentlemen were responsible for introducing drawing and the appreciation of painting into courses of studies considered appropriate for young men embarking upon a GRAND TOUR, a military, naval, or business career, or life on a country estate.

In 1673 Samuel Pepys, who along with his wife received private drawing lessons, was instrumental in ensuring that drawing was taught to navigational students in the Royal Mathematical School at Christ's Hospital. In

1681 Jacques D'Agar advertised in the *London Gazette* that he had established an academy for drawing, limning (miniature painting), and painting. This was probably the first such academy in London and was followed in 1697 by a similar one run by Bernard LENS II and John Sturt.

Precedents were thus set for the methods by which amateurs could receive an education in drawing in the next century. By 1750 drawing lessons were also available, along with lessons in the other polite accomplishments of fencing, dancing, and music, to students at Eton, Westminster, and the universities.

The writings of RICHARDSON, SHAFTESBURY and Chesterfield confirmed the benefits of drawing lessons, and the letters of the sons and daughters of gentry throughout the 18c. are full of references to their attempts at heads in crayons and landscapes in watercolour, and requests for suitable prints to copy. The innumerable drawing manuals produced in the century illustrate the accepted method of progression: from copying parts of the face and body, to drawing after antique statues and prints of landscape. After attaining proficiency in these basic steps, the pupil was encouraged to compose his own historical or figurative pieces, draw portraits of members of his family or pets, or to venture out-of-doors with a CLAUDE GLASS or camera obscura to depict the local scenery in a classical or picturesque style. Pupils who were talented enough to reach these last stages were encouraged to exhibit or etch their performances.

George Simon, 2nd Lord Harcourt, and his sister Elizabeth, later Lady Lee, were avid amateurs who had lessons from several artists: Jacob Bonneau and George Knapton for the rudiments of drawing, Richard Dalton for heads in crayons, Joshua Kirby for perspective, Alexander COZENS for wash landscapes, and Paul SANDBY for watercolours and etching.

The most accomplished amateurs, like Lady Diana Beauclerk, Lady Amelia Farnborough, Sir George BEAUMONT and Lord AYLESFORD, tended to be members of the aristocracy, but by the end of the century drawing was taught to all levels of society, from children in charity schools to members of the royal family. *See also* CLERK OF ELDIN; DRAWING MASTERS. KS
□ I. Fleming-Williams in Hardie, III (1968), 245–67; S. MacDonald, *History and philosophy of art education* (1970); M. Clarke, *Tempting prospect* (1981), 103–22

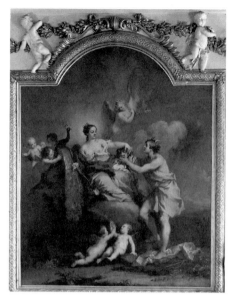

Amigoni, *Mercury presenting the Head of Argus to Juno*, Moor Park, early 1730s.

Amigoni, Jacopo (1682?–1752), a Venetian DECORATIVE painter, was the last major Italian artist to work extensively in England in the 18c., arriving in 1729 and leaving for Madrid in 1739. Little of his English work survives but what does is full of Venetian wit and vitality, especially the *Jupiter and Io* cycle at Moor Park (Herts.). He was resented by HOGARTH, who took from him a commission for decorative paintings in St Bartholomew's Hospital, London, in 1736. DB

□ Croft-Murray, II (1970)

Anderson, William *see* MARINE PAINTING

Andrews, Michael (b. 1928) was little known to the general public until his retrospective in 1981; his infrequent shows, often in obscure places, had however always been followed avidly by fellow professionals and aficionados who admired his exquisite handling of paint and his urbane portrayal of a specifically English *angst*. A SLADE pupil in the early 1950s, he produced relatively little until the late 1970s, since when (admittedly with some loss of tension) a new fluency has been displayed. He has achieved a rare mastery of that most difficult of genres, the complex group portrait. TP

□ *Michael Andrews* (exh., Arts Council, 1981)

anecdotal painting signifies a type of art current during most of the 19c. which is concerned with incidents from domestic or rural life, or from a popular literary source. The pictures, usually small in scale, were executed in an unpretentiously naturalistic style. At the time it was seen as the opposite of HISTORY painting. Frequently, however, the distinction became blurred.

Anecdotal painting was extremely popular, and its rise has been associated with the growing power of the middle classes and industrialists (e.g. SHEEPSHANKS) – people with little artistic or classical education who appreciated skilled but straightforward narratives about familiar topics. But it must be remembered that it was also enthusiastically supported by members of the aristocracy and by the monarchy.

The narrative techniques of HOGARTH and the genre scenes of 18c. painters like ZOFFANY and MORLAND largely provided the basis for anecdotal painting. It was WILKIE who first gave it its distinctive character, softening Hogarth's devices, sentimentalizing his subjects and displaying a consummate and detailed technique based upon Netherlandish paintings of the 17c. (*see* *SCOTTISH PAINTING). Wilkie's earliest successes had been with rural scenes from his native Scotland like *The Village Politicians* (1806; Earl of Mansfield). With the growth of urbanization the appeal of the rural idyll remained a popular topic. It was much exploited by W. COLLINS and MULREADY and, later, by painters of the CRANBROOK COLONY.

Anecdotal painting owed part of its success to its adaptation of the approaches of popular literature. Some artists, notably C. R. LESLIE, made a speciality of using subjects from the better-known light classics. On the whole contemporary literature was not used – perhaps because artists did not feel confident enough about the extent of its appeal.

In the 1840s some anecdotal painters (in particular COPE and REDGRAVE) attempted themes concerning social problems. These were always treated within the limits of a strict decorum. In the 1850s, partly under the influence of the PRE-RAPHAELITES, painters became more probing in their portrayal of modern life. After 1870 anecdotal painting began to fall out of fashion, largely under the impact of French realist art. WV

□ Reynolds (1953); Boase (1959)

Angillis, Peter *see* CONVERSATION PIECE

Anglo-Saxon art falls naturally into 2 broad and stylistically distinct periods: an early phase, which scarcely outlasted the Viking raids and invasions of the 9c., and a later phase, which began with an artistic revival in the late 9c.–10c. in the south of England.

Early (7–9c.) At the start of the 7c. England was divided into a number of small kingdoms dominated by the pagan and culturally Germanic Anglo-Saxons, who had first come to Britain about 2 centuries earlier. Their art, known to us primarily through metalwork, is closely related to Continental Germanic art. The Polychrome Style (*cloisonné* settings of garnets, other stones, or glass) and the Germanic 'Style II' (rhythmic interlacing patterns formed of stylized animals) were used in the decoration of jewellery and weapons and, with brilliant virtuosity, in the early 7c. work found at SUTTON HOO.

Detail of a shoulder clasp from Sutton Hoo, early 7c. (BM).

The conversion of the Anglo-Saxons to Christianity brought a new patron – the church – and new influences. A mission from Rome under Augustine had arrived in Kent in 597 and opened up contacts with Italy and Gaul. Shortly afterwards missionaries from the isolated Irish church started work in England, their most famous foundation being the Northumbrian monastery of Lindisfarne. Differences between the Roman and Irish churches led to administrative difficulties and very diverse artistic influences, which interacted most creatively in Northumbria.

In Lindisfarne and other Northumbrian centres books were written and decorated in the Irish manner, with an emphasis on enlarged and ornamented initials. In the second half of the 7c. important manuscripts such as GOSPEL BOOKS attracted skilful decoration, which borrowed much from metalwork, especially the zoomorphic 'Style II' of the Anglo-Saxons and the spiral and trumpet patterns of the Celts. The Book of Durrow (Dublin, Trinity College), written perhaps *c.*680 in Northumbria or somewhere in contact with Northumbria like Iona, has pages of ornament that might have been designed by a metalworker. Very soon these quite distinct but compatible Celtic and Anglo-Saxon traditions of abstract ornament were combined with other ingredients, especially interlaces and key patterns, to form a new style called, slightly misleadingly,

'Hiberno-Saxon' (literally, 'Irish-Saxon'). This style was used widely in Anglo-Saxon, Irish, PICTISH and British Celtic (mainly WELSH) art, and even on the Continent in areas open to Insular influence. Its various ingredients already interact in the certainly Northumbrian ★LINDISFARNE GOSPELS of *c.*700. This book, which is clearly in the tradition of the Book of Durrow, juxtaposes rich barbarian ornament and representational art in the form of simplified copies of Italian Evangelist portraits, drawn from the alien classical tradition of Mediterranean art.

Another stream in Northumbrian art is associated with the pro-Roman Wilfrid and Benedict Biscop, founder of the monasteries of Jarrow and Monkwearmouth, who seem to have wished to transplant as far as was possible the art of contemporary Rome. The *Codex Amiatinus* (Florence, Bib. Laurenziana), the great Bible which was written *c.*700 at Jarrow or Wearmouth, is so Italianate in script and decoration that it was long thought to be Italian. The Northumbrian origin is certain, but scholars are not yet agreed on the nationality of the artist or artists.

Anglo-Saxon sculpture probably originated in Northumbria, in the architectural sculpture of churches such as Hexham, Jarrow and Wearmouth, which was executed in the first place by foreign craftsmen. The great series of

stone *CROSSES probably began shortly after. In their figures and plant-scrolls classical influences are dominant: Hiberno-Saxon ornament is generally much less important, Celtic spirals being notably absent.

Mediterranean models were widely available – chiefly in books, but also in other media, including panel paintings, e.g. a set known to have been brought back from Rome by Benedict Biscop. Such models are reflected in crude copies incised into the wood of St Cuthbert's Coffin (*c*.698; Durham Cathedral), and in the sophisticated iconography of the Ruthwell Cross. A fascinating mingling of cultural influences can be seen in the 8c. Franks Casket (BM), of whalebone, where crowded scenes illustrate Roman and Northern myth, the sack of Jerusalem and the Adoration of the Magi.

The formative phase of Anglo-Saxon Christian art is most clearly seen in Northumbria. Overall, however, our picture of early Anglo-Saxon art is very incomplete, because of immense losses, and ill-defined, because of problems of dating and, in the case of portable works, of origin. It is uncertain, because of the international nature of the Hiberno-Saxon style, whether some objects should be regarded as Anglo-Saxon or not. For example, the magnificent Ardagh Chalice (Dublin, Nat.

Mus. of Ireland) is very close in style and presumably in date to the Northumbrian Lindisfarne Gospels, although it was found in Ireland. Several important manuscripts cannot with certainty be attached to a particular centre, and several important centres are not apparently represented in surviving works. Other areas of England do, however, emerge as artistically important during the 8c.

Kent was the first English kingdom to accept Christianity, but little is known of the art, as opposed to the architecture, of the Kentish church before the 8c., when the Vespasian Psalter (BL) and the *Codex Aureus* (Stockholm, Royal Lib.) were decorated at Canterbury. Their painting follows imported models closely in a slightly simplified and decorative manner, retaining some sense of the third dimension. They make much use of the rich colours and gold of Mediterranean books; at the same time they adopt the ornamental repertoire of the Hiberno-Saxon books of northern Britain, although it is handled in a rather less metallic way. Loosely designed and somewhat comical beasts, usually with profile heads, are characteristic of the decoration of southern books. In sculpture, Kent has only one known monument to compare with the stone crosses of Northumbria: the cross which formerly stood in the 7c. church at Reculver.

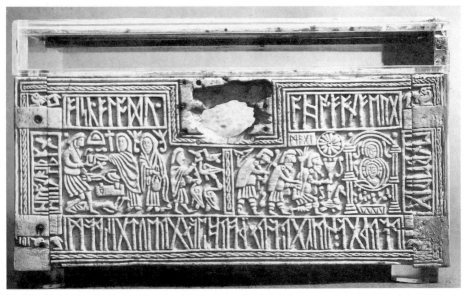

The front of the Franks Casket, showing Wayland the Smith and the Adoration of the Magi, 8c. (BM).

The classicizing style of its surviving fragments (Canterbury Cathedral) seems to fit better with later 8c. southern English manuscripts and with Mercian sculpture of *c*.800 than with the traditional 7c. date suggested by inconclusive archaeological evidence.

Some books in southern English styles, e.g. the Book of Cerne (Cambridge Univ. Lib.), probably came from the midland kingdom of Mercia. Mercia also preserves some remarkable sculpture of *c*.800, in particular the architectural sculpture at Breedon-on-the-Hill, with its classicizing figure style and its ornamental friezes of human, animal, bird, plant and geometric motifs reminiscent of southern English manuscripts.

Developments in the 9c. are less easy to define. There are fewer artistic landmarks. The Viking raids, which began at the end of the 8c., led, by the second half of the 9c., to large-scale invasion and settlement. The only Anglo-Saxon dynasty to survive was that of Wessex, and regular monasticism had probably disappeared by the end of the century. Very little manuscript decoration survives. Sculpture of some distinction continued to be made in Northumbria, Mercia and Wessex, though it is difficult to date. There is, however, some fine and roughly datable southern English metalwork of around the mid 9c.: the gold rings of King Ethelwulf and Queen Ethelswith and the silver hoard found at Trewhiddle (all BM), and, closely related, the magnificent Fuller Brooch (BM), which is of silver inlaid with niello and bears allegorical figures apparently symbolizing the 5 senses. Both sculpture and metalwork show animal and foliage ornament, although it is generally less subordinated to a fluent overall geometric design than in the Hiberno-Saxon phase. There is a greater emphasis on individual animals, which tend to be of fantastic but indeterminate species. Carolingian art may have been responsible for classicizing influences *c*.800 (e.g. in Mercian sculpture) and probably continued to exercise some influence later in the century in Wessex.

With much of England under Scandinavian control by the end of the 9c., Alfred (reigned 871–99) directed the military and ecclesiastical recovery of Wessex. Little remains of the art of Alfred's Wessex. The initials in a copy of Gregory's *Pastoral Care* (Oxford, Bodleian), written at Alfred's command, are conservative in style, but works like the Alfred Jewel (Oxford, Ashmolean) and a probably con-

temporary wall-painting fragment in Winchester (City Mus.) look forward to the artistic renaissance of the 10c.

Late (10–11c.) The only Anglo-Saxon kingdom to survive the Viking raids and invasions of the 9c. was Wessex; and during the first half of the 10c. the kings of Wessex gained control over the rest of England. From this time until the Norman Conquest, and beyond, the south was dominant politically, ecclesiastically and artistically.

The revival of Wessex initiated under Alfred before his death in 899 seems to have stimulated an artistic renaissance based largely on Carolingian models. The stole and maniple of Bishop Frithestan found with St Cuthbert's relics (Durham Cathedral) were made between 909 and 916, very probably at Winchester. They bear figures and acanthus foliage in a competent

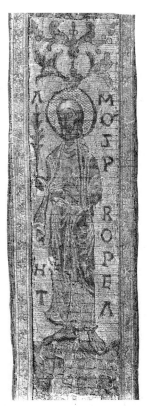

Detail of 'St Cuthbert's Stole', embroidered between 909 and 916 (Durham Cathedral).

classicizing style owing much to Carolingian and possibly to Byzantine art. (These are, apart from fragments, the only examples known to survive of Anglo-Saxon embroidery, an art for which England was then famous.) The miniatures in books of the second quarter of the 10c. such as the Life of St Cuthbert (Cambridge, Corpus Christi College) or the Athelstan Psalter (BL) look like simplified and provincial reflections of Carolingian manuscript painting. The use of acanthus in decoration is also Carolingian in origin and, except for some minor decorative details and a taste for zoomorphic initials, the rich tradition of pre-Viking illumination was lost or ignored.

The reintroduction of Benedictine monasticism from the mid 10c. under the leadership of SS. Dunstan and Ethelwold led to the production of many fine books in southern English monasteries over the next century. The monastic reform originated on the Continent, which must have lent imported Continental books and works of art a new prestige as models. Carolingian styles were selectively adapted with a new confidence to English decorative taste.

An influential new type of illumination, that of the so-called ★WINCHESTER SCHOOL, was used to decorate service books like the BENEDICTIONAL OF ST ETHELWOLD, GOSPEL BOOKS, and similarly important texts, in Winchester, and perhaps elsewhere, by the 970s. This opulent manner with its gold, rich colours and prominent acanthus borders co-existed with the extensive and unusual use of high quality line DRAWING, to be seen as early as c.950 at Glastonbury in 'St Dunstan's Classbook' (Oxford, Bodleian).

A lively sense of line, both expressive and decorative, fluttering folds and hems, and energetic figures are characteristic of both painting and drawing in the century before the Conquest. There are developments within this general stylistic framework, from the relatively staid figures of the second half of the 10c., through the frenetic broken line of manuscripts influenced c.1000 by the Carolingian Reims School of illumination, to more mannered and, in the mid 11c., hardened styles. Anglo-Saxon artists extended the technique of line drawing: they used inks of several colours, as in a copy (BL, MS Harl.603) of the monochrome line drawings of the Carolingian Utrecht Psalter (an influential model in England from c.1000: *see* ★CANTERBURY SCHOOL and DRAWING), and they also emphasized lines with strokes of wash that can suggest modelling.

It appears that these styles were used widely in the south of England, but it is not always possible to say where a particular manuscript was written. Winchester was an important centre of book production throughout the late Anglo-Saxon period, Glastonbury probably was so in the second half of the 10c., and Canterbury certainly so in the 11c. The evidence is less good for other centres, but some may have been equally important.

Miniatures and drawings are preserved in several different types of text – PSALTERS and Gospel books especially, but also other sorts of service book, monastic texts, classical and Early Christian authors (e.g. Prudentius' *Psychomachia*), and 'scientific' texts like the *Aratea* with its illustrations of the constellations. The 'Caedmon Genesis' (Oxford, Bodleian) and the Aelfric Hexateuch (BL) contain important cycles of Old Testament illustrations (*see* ★BIBLICAL ILLUSTRATION).

Late Anglo-Saxon book decoration is highly

The opening page of 'St Dunstan's Classbook', showing Dunstan prostrate before Christ, c.950 (Oxford, Bodleian).

original and distinctive in spite of its great debt to Carolingian models. The artists responded to and heightened the decorative potential of Carolingian art; their illustrations tend to be much more expressive than their models, and in some cases incorporate startling iconographic innovations.

The fluttering draperies and lively acanthus seen in manuscripts were used in other media, although in these the losses have been even greater. A rather linear wall-painting with a very limited palette at Nether Wallop (Hants) has recently been shown to date from *c*.1000. A number of fine *IVORIES and a few pieces of ecclesiastical metalwork in similar styles, which seem to have been made in Anglo-Saxon workshops, give a slight idea of the lost but sometimes documented riches of Anglo-Saxon church furnishings.

Several pieces of architectural figure sculpture remain in the south of England, including parts of monumental reliefs of the Crucifixion (e.g. at Romsey and Breamore, Hants). The treatment of some pieces, like the angels at Bradford-on-Avon or the Harrowing of Hell at Bristol, recalls manuscript styles. In the north sculpture is mainly represented in the continuing tradition of stone CROSSES. These are generally rough in comparison with pre-Viking crosses, but some motifs survive from earlier Northumbrian sculpture. The strong Scandinavian influence in northern England from the later 9c. is reflected in the choice of ornament and even in pagan subject-matter: the 10c. cross at Gosforth juxtaposes scenes of the Crucifixion and the Twilight of the Gods.

The successive styles of Viking decoration, which preserve the Dark Age Germanic taste for zoomorphic ornament seen also in early Anglo-Saxon art, appear in sculpture in northern England from the 10c. and in the south especially in the 11c. The reign of the Danish King Cnut (1016–35) was a period of renewed Scandinavian influence, which can be seen in a Ringerike style animal on a tomb from St Paul's churchyard in London (Mus. of London) or in details in a few manuscripts. In the south generally, however, the impact of Scandinavian styles was only slight.

Late Anglo-Saxon art was much admired across the Channel, and its influence is obvious in many 11c. manuscripts from northern France.

The Norman Conquest led to the displacement of almost the entire Anglo-Saxon ruling

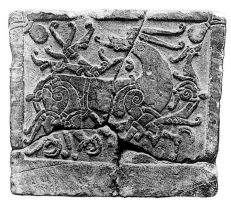

Tombstone from St Paul's churchyard, early 11c. (Mus. of London).

class and ecclesiastical hierarchy and also to radical changes in art and architecture with the introduction of ROMANESQUE forms from the Continent, but local artistic traditions were not immediately or totally submerged. Such a notable work as the BAYEUX TAPESTRY is still Anglo-Saxon in character, and the late Anglo-Saxon style and Norman work under Anglo-Saxon influence are essential ingredients of the mature English Romanesque of the 12c. JH
□ T. D. Kendrick, *Anglo-Saxon art to AD 900* (1938); id., *Late Saxon and Viking art* (1949); Stone (1972); Temple (1976); C. Nordenfalk, *Celtic and Anglo-Saxon painting* (1977); Alexander (1978); D. Wilson, *The Anglo-Saxons* (3rd ed. 1981); C. R. Dodwell, *Anglo-Saxon art: a new perspective* (1982); D. Wilson, *Anglo-Saxon art* (1984)

Apocalypse illustration In the 13c. and 14c. the Book of Revelation (the Apocalypse) was frequently drawn on as a source of illustration – usually in the form of manuscript picture-books, but also occasionally on a monumental scale in wall-painting and stained glass.

The Apocalypse was interpreted in the Middle Ages as an allegory of past and present events, and a prophecy of the future. St John's visions of strange beasts and persons who cause catastrophes and persecutions were the basis of predictions of the signs which would precede the end of the world. In addition to this prophetic aspect, the Apocalypse doubtless appealed at a lighter level as a Biblical equivalent of the fantasies found in secular romances.

Illuminated Apocalypses tend to contain 60–100 illustrations, and fall into various groups according to the choice of particular series of images. Some expand the range by adding episodes of the legend of Antichrist.

The fashion for Apocalypse illustration in England began *c*.1240, and the first phase of interest lasted until *c*.1280 (*see* ★DOUCE APOC-ALYPSE; EAST ANGLIAN ILLUMINATION; ST ALBANS SCHOOL). Interest revived during the first third of the 14c., and a final phase, in the closing years of that century, produced notable examples in WALL-PAINTING (Westminster Abbey Chapter House) and ★STAINED GLASS (York Minster east window).

Some 400 years after the Apocalypse had been of such interest to medieval artists it again became of great importance in the work of BLAKE. NM

□ M. R. James, *The Apocalypse in art* (1931); R. K. Emmerson, *Antichrist in the Middle Ages* (1981); Marks and Morgan (1981)

aquatint is a mean of producing areas of tone in ETCHING by 'biting' the spaces between minute grains of resin, and is ideally suited to imitating wash drawings and watercolours. It became very popular in England, where it was introduced in 1771. Its early practitioners included BARRY, Thomas and William ★DAN-IELL, GAINSBOROUGH and especially Paul ★SANDBY. RG

□ Griffiths (1980)

Armitage, Kenneth (b.1916) first gained international acclaim at the Venice Biennale of 1952. His figurative, modelled sculpture, often of genre subjects like *People in a Wind* (1950; Tate), stood somewhat apart from the prevailing climate of *angst*-ridden expressionism. His work in the 1960s and 1970s continued to be figurative, though he explored new materials, such as resin and aluminium. His recent works, mostly of trees, have been characterized by modesty of scale and statement. LC

□ N. Lynton, *Kenneth Armitage* (1962)

Armstead, H. H. *see* ALBERT MEMORIAL

Arnatt, K. *see* CONCEPTUAL ART

Arnold, Graham *see* RURALISTS

Art and Language is an international group that was formed in 1968. The dominant figures in Britain have been Michael Baldwin (b.1945), David Bainbridge (b. 1941), Harold Hurrell (b.1940), Terry Atkinson (b.1939), and later an art historian, Charles Harrison (b.1942), although the composition of the group has varied. Their work comprises a journal of the same name, lengthy texts and indexes, and posters, diagrams, flags and paintings. The intention seems to be to dissolve the habitual conceptual and word patterns that act as a conservative restraint in art and society, so that eventually a new, Socialist ideology may emerge. Without this, they believe, no radical change will take place. *See also* CONCEPTUAL ART. MC

□ *Art and Language* (exh., Eindhoven, 1980)

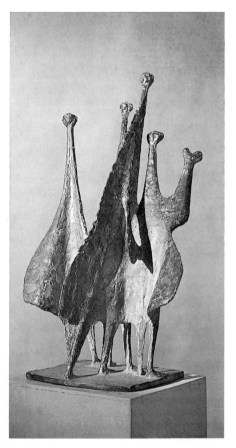

Armitage, *People in a Wind*, bronze, 1950 (Tate).

Art Union of London An association founded in 1836, imitating Continental and provincial unions, which held annual art lotteries. Winners chose a work of art from approved exhibitions – generally at the ROYAL ACADEMY. The lottery created publicity and excitement, and the Union broadened the public for art further by annual subscriptions for engravings and bronze or parian china models of exhibited works. RT
□ E. Aslin in *Apollo*, LXXXV, no. 59 (1967), 12–16

Arundel, Thomas Howard, 2nd Earl of (1585–1646), was one of the leading members of CHARLES I's 'Whitehall' group of connoisseurs and collectors. He 'discovered' HOLLAR in Cologne, patronized MYTENS, and was instrumental in bringing RUBENS and VAN DYCK to the English court. His collection of paintings contained works by them, together with family portraits and 16c. Flemish and German paintings. The famous Arundel Marbles (Oxford, Ashmolean) are the surviving part of a superb collection of antique and contemporary sculpture (*see also* GUELFI). Like Charles I he employed agents in Madrid, The Hague (Sir Dudley Carleton) and Brussels (Balthasar Gerbier), as well as the diarist EVELYN, the miniaturist Norgate and the musician Nicholas Lanier. He travelled to Italy with Inigo Jones 1613–15 and to Central Europe during the 1630s. In 1641 he commissioned his tomb from FANELLI (unexecuted). He died in exile in Italy and his collection was dispersed. DD
□ M. F. S. Hervey, *Life of Thomas, Earl of Arundel* (1921); *The age of Charles I* (1972)

Atkinson, Conrad (b.1940) has set himself the task of creating a Socialist art. He uses various techniques to document the sites of political agitation and oppression, siding with – among others – trade unionists, strikers, women, low-paid workers, and Catholics in Northern Ireland. His work is generally narrative, making use of statements and documents, often in a symbolic context. *See also* CONCEPTUAL ART. MC
□ C. Atkinson, *Work about the North* (exh., Carlisle, 1980)

Atkinson, Lawrence (1873–1931) after painting in a Fauvist manner met Wyndham Lewis and joined the Rebel Art Centre in 1914 (*see* VORTICISM). From then on he produced geometric abstract paintings characterized by an asymmetric structure and strong diagonals. He also produced sculpture and wrote poetry. JB
□ H. Shipp, *The New Art* (1922)

Atkinson, Terry *see* ART AND LANGUAGE

Auerbach, Frank (b. Berlin 1931) is the most gifted and eloquent of the followers of BOMBERG, under whom he studied at the Borough Polytechnic. From his first one-man show at the Beaux Arts Gallery in 1956 shortly after leaving the ROYAL COLLEGE, the prodigious thickness of his paint, more especially a feature of earlier works, was misconstrued by critics as an attempt to produce quasi-sculptural textures and marked him out as an oddity. The tenacity with which he subsequently pursued his vision, in the single-room Camden Town studio

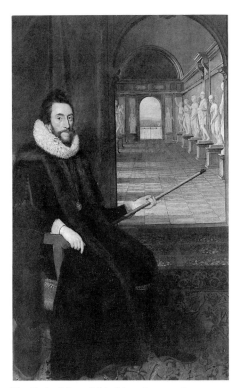

The Earl of **Arundel** in his sculpture gallery, painted by Mytens *c.*1618 (NPG, at Arundel Castle).

where he has lived and worked for over a quarter of a century, has revealed a painter whose search for the structure and particularities beyond first appearances necessitates a constant rehearsal on the picture surface, revision literally heaped on revision. The 1978 retrospective at the Hayward confirmed the consistency of this development, an early compositional rigidity giving way to an agonized bravura and, more recently, to a new confident and colourful lyricism.

His range of subject-matter has varied little since the 1950s – urban landscapes (notably a series of building sites and many studies of Primrose Hill), nudes, versions of old master paintings (including an ambitious sequence after Titian), and *PORTRAITS: like Lucian FREUD he tends to paint repeatedly the people he knows well.

Auerbach is steeped in the history of painting and as his work becomes more familiar echoes of Rembrandt, Hals and the eccentric Magnasco emerge; the kinship with SICKERT is a constant feature. A study of his many large-scale portrait drawings provides perhaps the best clue to the unifying elements in his work as a whole. Apart from the odd burst of direct etching, printmaking has provided little stimulus. He is widely read in German and English literature, has had a brief career as an actor, and has been an influential teacher. TP
□ *Auerbach* (exh., Arts Council, 1978)

Austin, William *see* DRAWING MASTERS

Axis A quarterly review of contemporary abstract art (inspired by the Parisian *Cahiers Abstraction-Création*), under the editorship of Myfanwy Evans; 8 numbers appeared 1935–7. *See* CONSTRUCTIVISM. AG

Aylesford, Heneage Finch, 4th Earl of (1751–1812) was probably the most talented of John Malchair's amateur pupils at Oxford (*see* DRAWING MASTERS). His skill as an architectural draughtsman, watercolourist and etcher is indisputably evident in albums containing work by him and other members of his family (formerly at Packington; dispersed in 1973). KS
□ I. Fleming-Williams in *Country Life*, CL (1971), 170–74, 229–32; A. P. Oppé in *Print Collector's Quarterly*, XI (1924), 262–92

Ayrton, Michael *see* NEO-ROMANTICISM

B

Bacon, Francis (b. 1909) has achieved wider international recognition than any other British painter this century. Brought up in Ireland, he had no formal training. He spent a brief period in Berlin in 1928 and worked throughout the 1930s as an interior designer. Only in 1944, after completing *Three Studies for a Crucifixion* (Tate), did he commit himself exclusively to painting, destroying almost all his earlier work.

From the early 1950s, Bacon's sources show an un-English appetite for strong meat. Velázquez's *Pope Innocent X* was fitted out with the gaping wounded face of the nurse from Eisenstein's film *The Battleship Potemkin*; Muybridge's photographs yielded not only wrestlers (made to represent violent homosexual lovers) but also a paralytic child. The sensationalism and shock-combinations might recall Surrealism; but his 1953 series based on Van Gogh's *Self-Portrait on the Road to Tarascon* suggested his identification with Expressionism, and the symbolic colour-shapes of *Three Studies for a Crucifixion* (1962; New York, Guggenheim) were a direct inheritance from Gauguin and Munch. Novel to post-war painting was the illusionistic emphasis: qualities of glitter and speed, familiar in photography, were appropriated once again for painting. He wanted, he said, 'to bring the figurative thing up on to the nervous system more violently and more poignantly', sometimes starting out from random splashes and traces.

Bacon's images have been widely interpreted as existential prophecy; their religious overtones have led Christian apologists to view them as 'negatives' of faith. But the flavour of his best work, with its powerful colour and intense physicality, is robust. Bacon himself speaks of 'exhilarated despair': 'one's basic nature is totally without hope, and yet the nervous system is made out of optimistic stuff'.

At 50, Bacon seemed poised for towering achievement, but the promise has remained largely unfulfilled. In his portrait triptychs, monuments to the shifting personality, the formula of distorted figure against flat colour-ground, identical in scale and format, wears thin. Yet Bacon has embodied for his contemporaries both a vision of horror and the romance of the artist as subversive, living

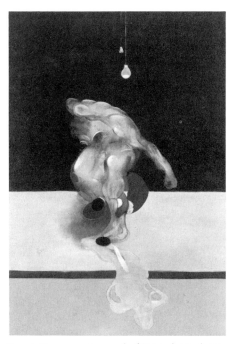

Francis **Bacon**, centre panel of *Triptych March 1974* (priv. coll.).

beyond good and evil: the sensational milieu – homosexuality, drink, gambling – has become part and parcel of the work. Memorable portraits of him by FREUD, Bill Brandt and KITAJ reflect his identity as culture-hero, while Bacon's own images, standing as signposts in the opening shots of Bertolucci's *Last Tango in Paris*, or at the centre of Pasolini's *Teorema*, confirm his resonance beyond England, and beyond painting. TH
☐ J. Russell, *Francis Bacon* (1971); D. Sylvester, *Interviews with Francis Bacon* (1975); M. Leiris, *Francis Bacon* (1983)

Bacon, John, the Elder (1740–99), began his career as a sculptor modelling for a ceramic factory and worked for Wedgwood and the COADE factory. In hundreds of marble chimneypieces and church monuments of all sizes which his studio produced in the last 2 decades of the 18c. he displayed great taste in devising ornament in low relief and unprecedented precision in reproducing it. He also created for his larger works a numerous family of ornamental females, ostensibly personifi-

cations, in elegant drapery with tiny folds. His *Lord Chatham* (London, Westminster Abbey) is brilliant but his other public commissions reveal his limitations in the heroic mode.

His son, **John Bacon the Younger** (1777–1859), took over the efficient production line and inherited a little of his father's artistic ability. NP
☐ Gunnis (1953); Whinney (1964); N. Penny, *Church monuments in Romantic England* (1977)

Bacon, Sir Nathaniel (1585–1627), often considered the only talented English painter of the early 17c., was an amateur who painted mainly friends, family and self-portraits. His interest in detail and cool colours suggest Dutch influence. DD
☐ Waterhouse (1978)

Baily, Edward Hodges (1788–1867) was an influential figure in early 19c. sculpture. A pupil of FLAXMAN, his European reputation was as a sculptor of allegorical subjects; he also produced many portrait busts. His most famous work is his *Nelson* for the Column in Trafalgar Square, London (1839–43). *See also* SCULPTURE: EARLY 19C. AY
☐ Gunnis (1953); Read (1982)

Bainbridge, David *see* ART AND LANGUAGE

Baker, William, painter, is mentioned in Eton College records for 1486–7. He and one Gilbert, mentioned in 1485–6, have been reasonably identified as the artists of the important series of *grisaille* ★WALL-PAINTINGS of miracles of the Virgin in the chapel, probably commissioned by Bishop Wayneflete of Winchester. Their indebtedness to Netherlandish artists, notably Bouts, is such that they were probably Flemish. NR
☐ M. R. James and E. W. Tristram in *Walpole Soc.*, XVII (1928–9), 1–43; Rickert (1965)

Baldwin, Michael *see* ART AND LANGUAGE

Banks, Thomas (1735–1805), sculptor, was generally acknowledged as superior in genius to his more successful near contemporary, John BACON. He had no interest in the ornamental, and little ability at running a studio, but was devoted to the elevated ideals promoted by academic theory. His career began well, if

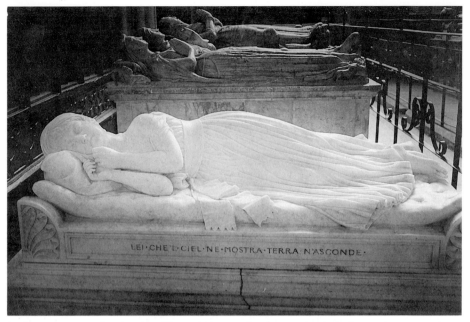

Banks, monument to Penelope Boothby in Ashbourne church, 1793. (In the background are 15c. and 16c. alabaster effigies.)

slowly, with a visit to Italy in 1772 as travelling scholar of the ROYAL ACADEMY and by 1779 when he returned he had executed a series of heroic and lyrical reliefs of great expressive power related in style to the drawings of FUSELI. In 1781 he went to St Petersburg, but he found life there uncongenial and soon returned to London. He modelled some powerful bust portraits and created the highly popular and influential effigy of the sleeping Penelope Boothby (1793; Ashbourne, Derbys.). At the end of his life he obtained 2 major public commissions for ST PAUL's (Captains Burgess and Westcott), and having devised beautiful reliefs for their pedestals created ludicrous figures on top from which no reputation could easily recover.

See also COADE; WOOLLETT. NP
□ C. F. Bell, *Annals of Thomas Banks* (1938 and corr. of 1942); Whinney (1964)

Barker, Thomas, 'of Bath' (1769–1847) was the son of a horse painter. The Barkers, a Welsh family, settled at Bath *c*.1782. Thomas's reputation is based mainly on his imitations of GAINSBOROUGH's 'fancy pictures' of peasant genre, e.g. *Woodman at his Cottage Door* (1819;

Bath, Victoria AG). Under the sponsorship of his patron, the collector Charles Spackman, Barker made a trip to Italy in 1790–93, and his work in the later 1790s shows some influence from Roman and Neapolitan art. He occasionally exhibited in London but his fame was largely confined to Bath. BA
□ *Barker of Bath* (exh., Bath, Victoria AG, 1962)

Barlow, Francis (1626?–1704), described by John EVELYN as 'the famous painter of Fowle, Beasts and Birds', may have served an apprenticeship with the portrait painter William Sheppard (fl.1641–*c*.1660) before establishing himself in London in 1652/3 as a painter of animals, birds and SPORTING scenes. He was the only English member of the group of artists employed by the Duke of Lauderdale to decorate Ham House, and his overdoor paintings there show careful observation of nature, a rather dry execution, and an emphasis on outline. His 3 large-scale sporting scenes of 'fowle and huntings' of the mid 1660s for the hall at Pyrford (Surrey) foreshadow the decorative sporting schemes of WOOTTON. A prolific draughtsman and etcher, he is best known today for his illustrations to *Aesop's*

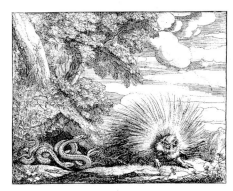

Barlow, The Porcupine and the Adders, etching from *Aesop's Fables*, 1665.

Fables and other books. He had influential patrons, such as General Monck (whose half-length is one of Barlow's rare portraits) and the 3rd Earl of Devon, but he died in poverty. DD
□ Whinney and Millar (1957); Croft-Murray (1960)

Barret, George (1728/32?–84), one of the most prolific and successful landscape painters in oil and watercolours of the 1770s, came to London from Dublin in 1763. He specialized in picturesque renderings of British scenery and country house views, and was seen as a rival to WILSON. Several of his children carried on his

style into the 19c., especially the watercolourist **George Barret Jun.** (d.1842). EE
□ Hardie, 1 (1966); Herrmann (1973)

Barry, James (1741–1806), an Irish painter of HISTORY, made the most passionate and strenuous attempt to carry out its lofty principles, but died a martyr to its cause. After study in Rome 1766–70 he achieved an immediate success in London, eventually becoming Professor of Painting at the ROYAL ACADEMY. He was a pioneer of AQUATINT, but his main aim was to create vast wall-paintings on the scale of Raphael's *Stanze*, and he was able to carry out one major scheme – largely at his own expense: *The Progress of Human Culture* (1777–84), for the SOCIETY OF ARTS.

He had real gifts as a draughtsman and colourist but he was so convinced of the hostility of the art establishment that he became wholly consumed by paranoia, ending his life in lonely misery. To younger artists like BLAKE and HAYDON he was a victim of British philistinism; others saw him as an artist of absurd pretensions. Yet Dr Johnson was undoubtedly right in seeing an unusual 'grasp of mind' in his work, and his many self-portraits are among the most moving of all British works of art. *See also* NEOCLASSICISM; POLYAUTOGRAPH. DB
□ W. L. Pressly, *The life and art of James Barry* (1981); id., *James Barry* (exh., Tate, 1983)

Barry, detail of *The Crowning of the Victors at Olympia*, in the Royal Society of Arts, London, 1777–84. The seated figure at the left is a self-portrait.

Bartolozzi, Francesco (1727–1815) trained in Venice as a line engraver, but on his arrival in England in 1764 soon adapted to the new STIPPLE technique, with which his name is always associated. His vast output includes many prints after his compatriot Cipriani, Angelica KAUFFMANN, REYNOLDS, and the drawings of old masters such as HOLBEIN and Guercino. He was particularly associated with works of a soft and decorative character, although he did not eschew the practice of more serious line engraving. He had many pupils who executed numerous plates that bear his name. He was a foundation member of the ROYAL ACADEMY, his election infuriating other engravers who had been excluded. RG
□ A. Calabi and A. De Vesme, *Francesco Bartolozzi* (1928)

Batoni, Pompeo (1708–87) was an Italian painter patronized by British ★GRAND TOURISTS in Rome in the mid 18c. He specialized in flamboyant and colourful portraits in classical settings – e.g. Colonel William Gordon, in swaggering Highland dress, set against the Colosseum (1766; Fyvie Castle). The young REYNOLDS was probably influenced by the variety of his poses. Batoni also painted altarpieces and historical and mythological subjects. BA
□ E. Bowron, *Pompeo Batoni and his British patrons* (exh., London, Kenwood, 1982)

Bawden, Edward *see* 7 AND 5 SOCIETY

Baxter print In 1835 George Baxter patented a method of making colour prints through the overprinting of an intaglio key-plate by numerous wood or metal blocks inked with oil-colours. There were many licensees after 1849, but the technique had a short life. RG
□ Griffiths (1980)

Bayes, Walter *see* CAMDEN TOWN GROUP

Bayeux Tapestry A hanging that presents a continuous narrative of the events leading up to and including the Battle of Hasting in 1066. It is a unique historical document, for while similar hangings are known to have existed, no comparable examples have survived. Although called a tapestry, it is in fact an embroidery, worked in coloured wools on a linen ground, and is about 79 m. long and 0.5 m. wide.

The main action is largely confined to the central frieze, which is framed above and below by a decorative border, enriched by foliage, birds and animals, illustrations of fables and genre scenes. In some cases the borders provide additional information to the narrative, such as the portentous appearance of Halley's Comet. Short inscriptions identify the scenes. On one level the tapestry describes historical events, while on another it gives a subtle but unequivocal account of God's punishment of Harold for his disloyalty and the breaking of his oath made at Bayeux.

The prominence given to Odo, Bishop of Bayeux 1049/50–97, suggests that it was he who

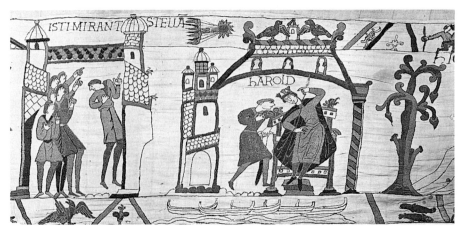

Appearance of Halley's Comet, an evil omen for King Harold, in the **Bayeux Tapestry**, *c.*1066–82 (Bayeux, Mus. de la Tapisserie).

commissioned the hanging, probably for his cathedral where it was listed in an inventory of 1476. However, iconographic and stylistic comparisons of the images with contemporary English illuminated manuscripts, and epigraphic study of the inscriptions, suggest that it was produced in England. This view has been strengthened by recent research, which has proposed persuasive arguments in favour of St Augustine's at CANTERBURY. JW

□ F. Stenton *et al.*, *The Bayeux Tapestry* (1965); N. P. Brook and H. E. Walker in *Proc. Battle Conference on Anglo Norman Studies*, I (1978), 2ff

Beale, Mary (1632/3–99) was a portrait painter greatly influenced by LELY, whose life and work are exceptionally well documented through the notebooks kept by her husband. She was at her best portraying children and close friends, and she occasionally painted miniatures. DD

□ *The excellent Mary Beale* (exh., London, Geffrye Mus., 1975)

Beardsley, Aubrey (1872–98) in a short life more remarkable for industry than event developed a mastery of black-and-white line drawing unequalled in its balance of eloquent space and telling detail. Almost all his major work is cheaply accessible in its originally intended form, the commercial line-block reproduction. The original artwork for this process, painfully scraped, worked and re-worked, shows how well his art concealed its labour. Though encouraged by (among others) BURNE-JONES and Puvis de Chavannes, he was largely self-taught. By his twentieth year he was a professional artist commencing what was to be one of the masterpieces of the art of the book, Malory's *Morte d'Arthur* (1894), which finally incorporated (including initial letters) 470 designs. While scandalous rumours inevitably attached themselves to his secretive private life it is probable that the eroticism that pervades his art and writing was based more on fantasy than experience. Our image of English *fin-de-siècle* decadence derives as much from Beardsley's vision as from the writings of Oscar Wilde. As in the case of Wilde, firm artistry and wit save the work from voluptuous self-indulgence. Dogged by tuberculosis, he was prodigiously hard-working to the end. His output as a painter was negligible, yet, as with Daumier, it would be false to think of him simply as an illustrator. TP

□ M. Benkovitz, *Aubrey Beardsley* (1981)

Beale, *Self-portrait, c.1665* (NPG).

Beardsley, ink drawing of J. M. Whistler (Washington, NGA, Rosenwald Coll.).

Beare, *Portrait of an Elderly Lady and a Young Girl*, 1747 (Yale BAC).

Beare, George (fl. 1744–9) probably trained in London but appears to have based his practice as a portraitist in Salisbury. All his known portraits date from the 1740s and have affinities with HOGARTH's realism. BA
□ C. H. Collins Baker in *Country Life*, CXXIX (1958), 572–3

Beauclerk, Lady Diana *see* AMATEUR ARTISTS

Beaumont, Sir George (1753–1827) was an accomplished AMATEUR landscape painter and one of the most important patrons and collectors of his generation. His work in oils reveals his admiration for Claude and WILSON, and he was a great supporter of CONSTABLE. In 1826 he gave a major group of pictures to the NG, including Rubens's *Château de Steen*. *See also* DRAWING MASTERS. BA
□ M. Greaves, *Regency patron: Sir George Beaumont* (1966); *Sir George Beaumont* (exh., Leicester, 1975)

Beechey, Sir William (1753–1839) was with Hoppner the dominant portraitist between Reynolds and Lawrence. He was taught by ZOFFANY and became Queen Charlotte's portrait painter in 1793. BA
□ W. Roberts, *Sir William Beechey* (1907)

Beerbohm, Max (1872–1956) was a writer and caricaturist whose urbane wit embodies the stylishness of the 1890s and the Edwardian period. His watercolours of such figures as Oscar Wilde, Frank Harris and Edward VII are usually conceived in a spirit of amused affection, mocking, but rarely malicious. *See also* CARICATURE; *NICHOLSON, W. RG
□ R. Hart-Davis, *Cat. of the caricatures of Max Beerbohm* (1972)

Beggarstaff Brothers *see* NICHOLSON, W.

Bell, Clive (1881–1964) was a writer on art associated with BLOOMSBURY. His interest was furthered by Roger FRY and the Post-Impressionist exhibitions. His book *Art* (1914) was an influential salvo against English philistinism which developed the theory of 'significant form'. This stressed the relative unimportance of subject-matter, and claimed a high place for Cézanne and the Post-Impressionists within the European tradition. He later did much to promote the London Group and the EUSTON ROAD SCHOOL. RS
□ C. Bell, *Since Cézanne* (1922); id., *Old friends* (1956)

Bell, Graham (1910–43), painter, came to England from South Africa in 1931, met

Graham **Bell**, *The Café*, c.1937 (Manchester).

COLDSTREAM in 1932, and worked closely with him *c*.1937–9. Bell was particularly responsible for the political awareness of the EUSTON ROAD SCHOOL. In painting his talent was lyrical but controlled, as became a passionate admirer of Cézanne. He was killed flying with the RAF. BL

□ K. Clark, *Graham Bell* (1947); B. Laughton, *The Euston Road School* (1985)

Bell, John (1812–95) *see* ALBERT MEMORIAL

Bell, Vanessa (1879–1961) was a painter and decorative designer and a central figure, with her sister Virginia Woolf, in BLOOMSBURY. After study at the ROYAL ACADEMY Schools, in 1907 she married the critic Clive BELL. She was influenced by Cézanne and Matisse from 1911 and at the OMEGA WORKSHOPS was closely associated with Duncan *GRANT, with whom she painted mural schemes; she also designed textiles, theatre sets, and book jackets for the Hogarth Press. Brilliant colour and simplification of design are hallmarks of her pre-1920 painting, which included abstract works (*c*.1915) and portraits. Thereafter she was a poetic realist in landscapes, figures in interiors, and still-lifes. RS

□ R. Morphet, *Vanessa Bell* (exh., London, Anthony d'Offay Gall., 1973) F. Spalding, *Vanessa Bell* (1983); *and see* BLOOMSBURY

Benedictional of St Ethelwold (BL) A book of blessings to be said by a bishop, opulently decorated in the 970s for Ethelwold, Bishop of Winchester 963–84, a leading figure in the revival of monasticism in England. Full-page miniatures of saints precede the text, which is interspersed with further miniatures and 2 historiated initials illustrating the principal feasts of the year. The iconography, although often original, owes much to Carolingian art and especially to the School of Metz. The illumination is the most important example of the later Anglo-Saxon *WINCHESTER SCHOOL. The imposing yet decorative style with its heavy but animated drapery and massive foliate borders assimilates Carolingian models to English taste. *See also* BIBLICAL ILLUSTRATION. JH

□ F. Wormald, *The Benedictional of St Ethelwold* (1959); Temple (1976)

Bentham, Martin *see* STAINED GLASS: 16–18C.

Bestiaries are illustrated books of animal lore which were very popular from the mid 12c. and particularly in the 13c. The habits of animals, birds, fish and insects, both real and fantastic, are described and given a moral meaning. The Pelican, e.g., piercing her breast to feed her young with her own blood, was a symbol of sacrifice and of Christ. Motifs from the Bestiaries were used in Romanesque sculpture, Gothic misericords, bench ends, corbels, roof bosses and wall-paintings, and as GROTESQUES in illuminated manuscripts.

Early illustrated Bestiaries have simple drawings set in the text. Late in the 12c. a luxury type appeared with fully illuminated framed pictures, and this fashion was followed in the 13c. Wall-paintings, such as those that existed in the Painted Chamber of Henry III's Palace of Westminster in London, seem to have expanded the subject-matter by introducing landscape and genre settings for the beasts and birds, and such compositions influenced manuscript illumination.

The fashion for illustrated Bestiaries declined in the 14c. and examples are rare after *c*.1325. The subjects survived in other forms of art, above all in woodcarving. After the medieval period a few Bestiary images continued to be

The Whale, from the Ashmole **Bestiary**, late 12c. (Oxford, Bodleian).

used, notably the Pelican, a symbol of piety and parental sacrifice on 18c. funerary monuments. NM

□ M. R. James, *The Bestiary* (1928); T. H. White, *The book of beasts* (1954); B. Yapp, *Birds in medieval manuscripts* (1981); Morgan (1982)

Bettes, John (d. before 1576) was paid for painting royal miniatures in 1546/7, but his only certain surviving work is a portrait of an unidentified man dated 1544 (Tate). It shows a study of HOLBEIN's manner of defining the features. SF

□ Auerbach (1954)

Bevan, Robert (1865–1925), painter, studied at Westminster School of Art in London under Fred Brown, and at the Académie Julian in Paris. In 1890–91 and 1893–4 he stayed at Pont Aven in Brittany, on the second occasion meeting Gauguin, whose influence may appear in paintings such as *Early Morning on Exmoor* (1897; coll. R. A. Bevan) with long drawn-out brushstrokes and deep reddish colours. When Bevan's work was spotted at the Allied Artists' Association in 1908 he was invited to join the Fitzroy Street Group. Subsequently he became a founder member of the CAMDEN TOWN GROUP, the London Group (1913) and the Cumberland Market Group (1914). He was always interested in horses, and his best known 'Camden Town' pictures are the *Cab Yard* series of c.1910, executed from drawings with the tones divided in a Neo-Impressionist manner, and the *Horse Mart* paintings of c.1912 and after. The latter comprise some imaginative compositions which are also documents of their time, though rather stiffly executed. BL

□ R. A. Bevan, *Robert Bevan* (1965); Baron (1979)

Bewick, Thomas (1753–1828) was the first artist to exploit fully the possibilities of WOOD-ENGRAVING as an expressive medium and he was able to create with it on a tiny scale some of the most memorable images in British art. He worked for almost all his life in Newcastle, outside the orbit of London, though his influence was felt there in the work of his pupils. He was born near Ovingham and was apprenticed 1767–74 in Newcastle to Ralph Beilby, a general engraver who executed all kinds of work from banknotes and trade cards to silver engraving. Bewick took over the wood-engraving side. After a trip to Scotland

in 1776, followed by a brief period working unhappily in London, he returned to Newcastle the next year and became Beilby's partner. The partnership lasted until 1797. Afterwards Bewick continued to run a general workshop in which metal-engraving predominated, wood-engraving being only occasionally used. The designs which made Bewick's fame were essentially the products of his spare time.

This fame rests essentially on 2 books, *A General History of Quadrupeds* (begun 1785, published 1790) and the *History of British Birds* (begun 1791, vol. I published 1797 and vol. II 1804). He was entirely responsible for the text and the collection of information in both cases. As scientific documentation the wood-engraved illustrations are a landmark; their artistic claims rest on their exquisite technique and on their wider vision of nature. The studies of animals and birds often contain minutely drawn landscape backgrounds, and his greatest artistic contribution is to be found in the little vignettes which end the account of each animal or bird. He called these punningly '*Tale-pieces*', for they were 'seldom without an endeavour to illustrate some truth or point some moral'. These tiny scenes of rural life express an unsentimental attitude which derives from a mordant perception of human folly and the bleakness of life. Though they reveal a strong awareness of contemporary literature they are quite without pastoral sentiment; the countryside is one in which beggars and vagrants wander and cruelty and misfortune abound. Bewick's stern morality shows men themselves often behaving like animals. Wisdom is the hard-won realization of the vanity of all earthly things. This bleak philosophy is, however, balanced against an exquisite sensitivity to nature and a stark and sometimes scatological humour. In 'saving the toll', a tiny vignette in *British Birds*, a man, despite

Bewick, 'Saving the Toll', wood-engraving from *British Birds*.

warnings, takes his cow through the water to save the toll and loses his hat in the process, a comic incident which is set within a fully realized landscape of the utmost delicacy. Bewick was a master of the animating touch and minute observation.

Much of the wood-engraving work in *British Birds* was done by apprentices, many of whom were to have distinguished careers. They included his brother **John Bewick** (1760–95) and son **Robert Elliot Bewick** (1788–1849), and also Robert Johnson (1770–96), a talented draughtsman and water-colourist, and perhaps most gifted of all, Luke Clennell (1781–1840). Bewick himself continued adding vignettes to *British Birds* for the rest of his life, and there is a vivid account by Audubon, the American bird artist, of him working on one in 1827. In 1822 he began writing his *Memoir*, a work fully expressive of his gritty character and powers of observation, which remained unspoiled by his growing fame as an artist and naturalist.　　DB

☐ I. Bain, *Thomas Bewick* (exh., Newcastle, Laing, 1979); id., *A memoir of Thomas Bewick* (1979)

Biblical illustration in manuscripts took a number of different forms in the course of the Middle Ages, in GOSPEL BOOKS, picture cycles related to the New Testament or particular books of the Old Testament, PSALTERS, Bibles and APOCALYPSES.

It may be said that it was the Bible which brought the human figure back into British art after the departure of the Romans and the Anglo-Saxon invasion. From the establishment of the see of Canterbury by Roman missionaries in 597, the church needed painting and sculpture to illustrate the Bible and Lives of saints, and illuminated manuscripts were brought over from Italy to be copied. The earliest illuminated Gospels embody the marriage between Insular abstraction and the representation of the human figure imported from the Mediterranean. In even the most splendid of these manuscripts, such as the LINDISFARNE GOSPELS, the illustrations are limited to Evangelist portraits.

The Viking invasions put an end to this early flowering of Anglo-Saxon art and it was not until the return of stability and the monastic reforms of the 10c. that there was a revival, based on renewed contact with the Continent. The earliest New Testament cycle occurs in the

Building the Tower of Babel, from Aelfric's paraphrase of the Pentateuch, *c*.1025–50 (BL).

970s in the BENEDICTIONAL OF ST ETHELWOLD (*see* ★WINCHESTER SCHOOL). Two Old Testament cycles illustrate Anglo-Saxon texts: the 'Caedmon' manuscript of Genesis and Exodus (Oxford, Bodleian), of *c*.1000, contains 48 illustrations from the Creation to Abraham; and Aelfric's paraphrase of the Pentateuch and Joshua (BL), of *c*.1025–50, has over 400 illustrations, all different from those in the 'Caedmon' manuscript. The use of extensive picture cycles to illustrate Old Testament subjects, in manuscripts comprising one or several books only, rather than the complete Bible, was standard on the Continent as well since the Early Christian period; but both the 'Caedmon' and Aelfric cycles are more extensive than anything produced on the Continent in the early 11c. During the same period, the Psalter emerged as the main repository of New Testament illustrations (e.g. BL, MS Cotton Tib.C.VI, of *c*.1050).

After another hiatus, apparently caused by the Norman Conquest, from the 1120s there is a profusion of Biblical images, not only in manuscripts but also in wall-paintings and sculpture. New Testament illustration is dominated by 3 related picture cycles of

1120–40, all probably produced for Psalters. The earliest is the ST ALBANS PSALTER (*see* *ILLUMINATED MANUSCRIPTS: ROMANESQUE), the second the introductory leaves added to the Bury New Testament (Cambridge, Pembroke College), and the third 4 separate leaves in London (BL, MS Add. 37472; V&A, MS 661) and New York (Pierpont Morgan Lib., MSS M.724 and M.521). Although they differ considerably in layout, these picture cycles are closely related in choice of subject and in the composition of individual scenes, and it is likely that they derived from a common prototype, perhaps Ottonian.

For Old Testament illustrations in the 12c. it is manuscripts of the complete Bible that provide the widest selection. They are typically very large and beautifully written volumes (e.g. the *BURY, LAMBETH and WINCHESTER BIBLES), with one historiated initial, or occasionally a miniature, as frontispiece for each book of the Bible. The practice of selecting individual scenes of particular relevance, detaching them from their position in larger cycles, and placing them on their own at the opening of each book of a complete Bible – a striking departure from the traditional system of picture cycles – had arisen in France and Flanders in the 11c. Once it was established, the selected scenes soon became fairly standard, though never uniform.

The growth in literacy and the emergence of a class of wealthy lay patrons in the 13c. led increasingly to the production of picture books for private devotion. Outstanding among these were sumptuous manuscripts of the Apocalypse, produced in great numbers in England and France from *c.*1250. Pictorial Bibles are extremely rare but of exceptional interest: they include the Holkham Bible Picture Book (BL), of *c.*1327–35, with 200 scenes, many incorporating Biblical legend and commentary.

Typological cycles, in which New Testament scenes are paralleled with events of the Old Testament, are common in wall-painting, sculpture and metalwork, but rare in English book illumination, with the exception of one mid 13c. manuscript possibly from Worcester (Eton College, MS 177). Elsewhere, single scenes such as the Ascension of Elijah, a type of the Ascension of Christ, were chosen. The most complex typological and allegorical image to find its way into illustrated Bibles is the Tree of Jesse, based on Isaiah's messianic prophecy and

The Tree of Jesse, from the Lambeth Bible, *c.*1150 (Lambeth Palace Lib.).

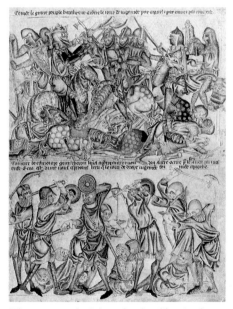

'The great people fight each other, likewise the common people', from the Holkham Bible Picture Book, *c.*1327–35 (BL).

showing the ancestors of Christ, of which the Lambeth Bible contains the most splendid example. CMK

□ Kauffmann (1975); Temple (1976); C. M. Kauffmann, *The Bible in British art* (exh., V&A 1977); Morgan (1982)

Bird, Edward *see* BRISTOL SCHOOL

Bird, Francis (1667–1731) was a sculptor whom VERTUE ranked with SCHEEMAKERS and RYSBRACK, although the unevenness of his work belies this assessment. After training in Flanders, and then in Rome with the Bernini follower Le Gros, he returned to work with GIBBONS and CIBBER, with a further visit to Rome in 1711. On Cibber's death Wren employed him to complete the sculpture for St Paul's in London (1706–21), resulting in his most ambitious work in the Roman Baroque manner, *The Conversion of St Paul* for the west pediment (1706). Bird's oeuvre includes several tomb sculptures, some of which, like the influential monument to the Duke of Newcastle (1723; London, Westminster Abbey), were designed with James Gibbs, although the full extent of their collaboration is not known. His earlier Priestman monument (1712; Westminster Abbey) had introduced a new format which NOLLEKENS later perfected, with portrait profiles *all'antica* in medallions hung from ribbons against a pyramid. His appointment as a director of KNELLER's Academy and his flourishing workshop are evidence of his high contemporary reputation. He executed few works in the decade preceding his death, concentrating on his marble export business.

AY

□ Gunnis (1953); Whinney (1964)

Blake, Peter (b.1932) is one of those artists who, like Stanley SPENCER, seem to set the standard for what is most specifically British in British art. Like Spencer, he has belonged both to the ROYAL ACADEMY and to the avant-garde.

Blake's early pictures are of boys and girls showing off their comics, badges and other symbols. From this he developed to pictures featuring pop and film stars, and thus became a POP artist before the term was coined. He next turned to the more local world of wrestlers and strippers and then to genuinely fictional characters, while living in the country as a member of the Brotherhood of RURALISTS.

His pictures derive in a complicated way

Peter **Blake**, *Self-portrait with Badges*, 1961 (coll. the artist).

from photographs, but are worked up, usually over a long period, until their fantasy becomes compellingly real. MC

□ M. G. Compton, *Peter Blake* (exh., Tate, 1983)

Blake, William (1757–1827) was one of the most gifted and certainly the most singular of all British artists. He is unique in being at least as important a figure in literature as in art, and it is as a poet that he is still best known. He was, however, trained as an engraver, apprenticed 1772–9 to James Basire and attending the ROYAL ACADEMY Schools briefly in 1779–80, before setting up as a reproductive engraver, the source of his livelihood. His artistic reputation rests upon the visionary quality of his 'Illuminated' books and watercolours, and upon his experimental printmaking which occupied the time left over from daily business. His originality springs from his religious attitudes, in his conception of the true artist as a prophet in the Old Testament tradition, granted the divine insight to see the vanity of the world in its eternal perspective and the obligation to show mankind the way to redemption. He insisted at all times on the

William **Blake**, frontispiece to *America*, relief
etching, 1793 (BL).

LINNELL bought from him extensively (*see also*
EGREMONT). Though his 'Great Task' was a
lonely one, his art before 1800 is sometimes
close in style, if not in deeper meaning, to that
of many leading figures at the RA, especially
BARRY, WEST and FUSELI, though he was bitterly
hostile to REYNOLDS. His art after 1800 often
parallels in its sacramental nature the work of
some of his German contemporaries like
Philipp Otto Runge and the Nazarenes.

Blake's career after 1779 was at first
unremarkable except for the appearance of his
only conventionally printed poems, *Poetical
Sketches* (1783). With the encouragement of
admirers like ROMNEY and Flaxman he exhi-
bited historical and Biblical watercolours at the
RA. In 1787 he underwent a severe emotional
and religious crisis precipitated by the death of
his younger brother Robert. Out of this
unhappy period came the first Illuminated
books, and from 1793 to *c*.1796 he worked on a
series of prophecies, the 'Lambeth' books,
beginning with *America a Prophecy*. These
complex and densely written books make up a
kind of personal Bible; they attempt to
incorporate the experience of revolution into
the spiritual and mythological history of
mankind. They are adorned with visual images
of great power but these rarely illustrate the
text directly. By the end of the 1790s he had also
evolved a colour-printing technique, used in 6
of the 7 copies of *The Book of Urizen* (1794), and
in the 12 Large Colour Prints (1795; 11 in the
Tate), a series of exhibition works of extraor-
dinary energy and urgency, in which mys-
terious forms enact sublime dramas in a
seemingly limitless space.

In 1796 he worked on a series of 537
watercolour illustrations to Young's *Night
Thoughts* (BM), followed in 1799 by a
commission from Butts for about 50 small
paintings in 'fresco' (Blake's word for his
tempera painting; *see also* WATERCOLOUR)
making up a Biblical cycle. They are notable
for an eclecticism derived largely from the
study of old master paintings in the Orléans
Collection on display in London, and they
initiate a change towards a more devotional and
Gothic style which can be seen in many of the
Biblical watercolours also commissioned by
Butts in subsequent years. These show a
widening of Blake's range of expression,
reaching a kind of culmination in the designs
for the Book of Revelation (Washington,
NGA; etc.).

primacy of spiritual vision over material
observation, seeking a form of discourse which
might appeal to and yet transcend all the senses.

Such ideas lie behind his search for a method
of integrating text and design by a printing
process which would allow him to publish
works of prophecy himself. The method,
finally achieved *c*.1788, was a novel form of
relief printing or relief etching, in which the
text and design were applied to the copper plate
by stopping out the parts to be printed and
etching away the rest of the surface. The first
successful book in what Blake called 'Illumi-
nated' printing was the most famous, *Songs of
Innocence* (1789), and he continued until old age
to produce prophecies in this new medium,
continually expanding the range of effects,
usually adding colour by hand and sometimes
by colour printing.

Blake aimed to reach a wide public for his
prophecies, but his arcane language and
mysterious apocalyptic imagery did not have a
wide appeal. The few copies of the Illuminated
books he was able to print were largely bought
by friends; FLAXMAN and Fuseli gave him some
encouragement, and later Thomas Butts and

Around 1800 he returned to prophecy. After working 1800–1803 in Felpham (Sussex) for the poet William Hayley he began to reformulate his mythological history of man in 2 final books: *Milton a Poem* (begun 1804), and his masterpiece in Illuminated printing, *Jerusalem* (also begun 1804, but not completed until the 1820s). The former gives Milton a decisive role in Blake's prophetic endeavour, while the latter spans the history of the human spirit through 'Albion the Ancient Man' who is both a human and a national archetype.

The purposeful development of Blake's creative work after 1800 was belied by the reality of daily life, in which continual setbacks to his hopes of finding a public culminated in an unsuccessful retrospective exhibition in 1809 for which he wrote a brilliant but erratic apologia for his art, *A Descriptive Catalogue*. The exhibition's failure and his own bitterness inaugurated a long period of isolation and poverty, from which he found refuge in a luminous series of watercolour illustrations to Milton's poems (San Marino, Huntington; New York, Pierpont Morgan Lib.; Manchester, Whitworth; Boston; Cambridge, Fitzwilliam), containing an intricate commentary on the poet's attitudes, executed with an exquisite and, given Blake's hostility to materialism, unexpected sensitivity to nature.

Blake was rescued from obscurity in 1818 by Linnell who, with the SHOREHAM painters, commissioned work from him and found patrons. Linnell persuaded him to make an engraved edition of the watercolours he had made c.1805 for the Book of Job (New York, Pierpont Morgan Lib.), which was published in 1825, and a series of 100 watercolour illustrations to Dante (Tate, etc.) which remained, with 7 engravings, unfinished on his death. Though Blake had reservations about Dante's theology the watercolour technique is freer and more atmospheric than ever before, revealing his continuing imaginative vitality and ability to learn from others, in this case the landscape watercolour school.

In his last years he had achieved a modest celebrity and the friends of those years kept his memory alive until his rediscovery c.1850, mainly by ROSSETTI and Blake's first biographer, Alexander Gilchrist. For his Victorian admirers he was in varying degrees an exemplar of spiritual heroism, poetic lyricism, artistic dedication and inspired craftsmanship. It has remained for the 20c. to elucidate the meaning

William **Blake**, *The Dance of Albion*, engraving, after 1800 (Washington, NGA, Rosenwald Coll.).

of his prophecies and to come to terms with his visual imagination, though much remains to be done in placing his religious ideas within the English Dissenting tradition. DB

☐ G. L. Keynes, *Blake: complete writings* (1957); D. Bindman, *Blake as an artist* (1977); id., *William Blake: his art and times* (1982)

Blast *see* LEWIS, P. W.; VORTICISM

Bloomsbury The Bloomsbury Group has usually been seen in terms of its literary contribution, but now Bloomsbury painting can take its place as an identifiable approach and style, particularly in the work of Duncan *GRANT, Vanessa BELL and Roger FRY. Grant's influence was at its strongest in the 1920s and can be detected in the painting of Edward Wolfe (1897–1982) and the London Group. The 3 chief painters were profoundly influenced by Fauvism and to a lesser extent Cubism; their work was dominated by a celebration of the sensuous beauty of daily surroundings, the visual results of friendship and love and an attitude of pacific reflection. Although their painting and decorative work of c.1912–20, which embraced extreme formal

abstraction and figurative fantasy, commands interest today, their work from 1920 onwards contains their most mature productions. Subject-matter almost never includes conscious symbolism, violent events or narrative elements. Rich colour, a loose handling of paint and simplicity of composition characterize Grant and Bell; Fry's later work is more subdued and has a consistently linear quality in landscape and portrait. Dora Carrington (1893–1932), Henry Lamb (1883–1960) and ETCHELLS were at various times associated with the group. *See also* BELL, C.; GERTLER. RS □ Q. Bell, *Bloomsbury* (1968); R. Shone, *Bloomsbury portraits* (1976); I. Anscombe, *Omega and after* (1981)

bodycolour *see* GOUACHE; WATERCOLOUR

Bohun family patronage was responsible for some of the most important English manuscripts in the second half of the 14c. Heraldic and textual evidence indicates that some 10 books, mostly PSALTERS, ranging from one in Vienna begun before 1361 (Österr. Nationalbib., Cod. 1826*) to one in Edinburgh of

Psalm 52, from a **Bohun** Psalter, *c.*1370 (Oxford, Exeter College, MS 47).

*c.*1389–97 (Nat. Lib., Adv. MS 18.6.5), were executed for Humphrey de Bohun, 6th Earl of Hereford (d.1361), his nephew Humphrey, 7th Earl (1342–73), and the latter's daughters Mary (d.1394) and Eleanor (d.1399). The precise provenance of these manuscripts is undecided, although some may have been produced by London illuminators.

The lively figure style which they developed also appears in manuscripts made for other patrons, e.g. the Lytlington Missal (London, Westminster Abbey) and the Carmelite Missal (BL). NR □ M. R. James and E. G. Millar, *The Bohun manuscripts* (1936); Rickert (1965); Marks and Morgan (1981), 22–3, 84–5

Bomberg, David (1890–1957) was a passionate and questing artist of complete integrity whose many exhibitions were, apart from some early attention as an associate of the VORTICISTS, shunned by critics. A tightly schematic style gave way to a forceful expressionistic naturalism which he developed especially in the 1920s and 1930s in his travels to Palestine and during later stays in Spain. His influence as a teacher, notably at the Borough Polytechnic, was considerable; traces of his approach can still be seen in art schools, transmitted via pupils such as AUERBACH and KOSSOFF. Though his reputation has soared since his death, his eloquent portraits and landscapes continue to be neglected in favour of the earlier mechanistic works. *See also* SLADE. TP □ M. Lipke, *David Bomberg* (1967)

Bonington, Richard Parkes (1802–28) was one of the most influential painters of his generation. His development was mercurial and acquisitive, drawing inspiration from a wide range of masters, including GIRTIN, CONSTABLE, TURNER, 17c. Netherlandish painters, Veronese and Ingres. His dazzling virtuoso style in turn attracted a host of French and English imitators, notably Isabey, BOYS, and William Callow (1812–1908). COX, STANFIELD and David ROBERTS were all captivated by his work, and his relationships with Delacroix and Huet were of central importance to French painting.

Bonington was born near Nottingham, and studied with FRANCIA in Calais and with Baron Gros in Paris. He exhibited watercolours at the 1822 Salon from his first Normandy tour of the previous year. His reputation as a watercol-

Bonington, *On the Coast of Picardy*, 1826 (London, Wallace Coll.).

ourist established, he began to paint in oils and to design lithographic views of medieval architecture. In the 1824 Salon he received a gold medal for his landscape paintings. He made the first of several trips to London in 1825 with Delacroix, with whom he later shared a studio and who influenced his first historical subjects. In 1826 he toured northern Italy briefly, and in his final hectic years produced mostly Venetian views and a group of literary and historical exhibition oils (London, Wallace Coll.). He died of consumption in London.

See also MARINE PAINTING. PN
□ Boase (1959); M. Spencer, *Bonington* (1967); J. Ingamells, *Bonington* (1980)

Bonneau, Jacob *see* AMATEUR ARTISTS

Books of Hours are a form of prayer book used mainly but not exclusively by the laity, which first appeared in illustrated form in the mid 13c. (*see* William de BRAILES), and by the 15c. was the most popular of all illustrated books.

The Hours are the 8-fold division of the day into times of prayer according to the system of the Breviary, and by extension the term is used for the liturgical offices themselves. The laity in using such texts were in effect reading part of the daily prayers of the priest. Books of Hours contain as their main text the Hours of the Virgin, comprising Psalms, scriptural readings and prayers with an emphasis on devotion to Mary. Other Hours (e.g. of the Holy Trinity), prayers to the saints, devotional sequences of Psalms, and the Office of the Dead are also included.

Typically, the main decoration consists of full-page miniatures illustrating the Lives of Christ, the Virgin and the saints, and historiated initials. Special images of Christ and the Virgin, such as the Man of Sorrows or the Madonna of Humility, were popular for their devotional value. Often the owner of the book is shown kneeling before Christ, the Virgin or a saint, and frequently heraldic bearings identify the family.

In the 15c. English production of these books declined as a result of competition from imported Hours for the English market made in Flanders and Rouen. *See also* ★ILLUMINATED MANUSCRIPTS: GOTHIC; SCHEERRE. NM
□ J. Harthan, *Books of Hours* (1977); Marks and Morgan (1981)

bosses *see* ROOF BOSSES

Bourdillon, F. W. *see* NEWLYN SCHOOL

Bourne, John Cooke (1841–96) depicted the making of the London to Birmingham Railway and the achievement of the Great Western Railway in 2 volumes of coloured

The Grey-Fitzpayn **Book of Hours**, *c.*1300–1308 (Cambridge, Fitzwilliam). The initial beginning the Hours of the Trinity shows Christ blessing the book's owner.

lithographs published in 1838–9 and 1846, for which he worked on all the stones himself. The preparatory drawings and watercolours (Ironbridge Gorge Museum; British Rail) stand as his highest achievement. Most of the pictures show how well a new subject-matter could be fitted to pre-existing canons of landscape; but in some of them Bourne in addition conveys the purposefulness of the gigantic task, and the absorbed gratification brought by watching men at work. *See also* ★INDUSTRIAL REVOLUTION. TG

□ Klingender (1968)

Bower, Edward *see* PORTRAIT PAINTING: 17C.

Bowler, Henry Alexander (1824–1902), a genre painter strongly influenced by the PRE-RAPHAELITES, is known almost entirely through his remarkable *The Doubt – Can these Dry Bones Live?* (1855; Tate), which is rich in allegory and shows a fine handling of light effects. WV

□ Ironside and Gere (1948)

Boydell, John (1719–1804) was one of the most influential printsellers of the 18c. He commissioned engravings after famous paintings (*see* WOOLLETT), and in 1786 initiated the Boydell Gallery, an ambitious scheme to commission large paintings and engravings of Shakespearean subjects. The intention was to promote the British school of HISTORY painting and encourage the choice of serious subjects from British authors. The scheme was actively supported by FUSELI, ROMNEY, Paul SANDBY and WEST; other artists who participated included W. HAMILTON, NORTHCOTE, OPIE, PETERS, WHEATLEY, and WRIGHT OF DERBY. The paintings on the whole were disappointing and the engravings poorly received (the enterprise was savagely caricatured by GILLRAY), with the result that Boydell was rapidly forced to sell the paintings by a lottery. *See also* GRAVES. DB

□ Godfrey (1978)

Boyle, Mark (b.1934), born in Glasgow, has worked consistently with Joan Hills since the late 1960s, recording samples from all over the surface of the earth. They make near perfect reconstructions, incorporating loose elements from the surface and recording the effects of human and natural forces. MC

□ M. Boyle, *Journey to the Surface of the Earth* (1970); J. L. Locher, *Mark Boyle's Journey . . .* (1978)

Boys, Thomas Shotter (1803–74), watercolourist, was apprenticed to the engraver George Cooke before moving to Paris in the mid 1820s. He became a close friend of BONINGTON, whose influence is apparent in his most important work, a series of watercolour views of Paris executed 1830–35. He returned to London in 1837 following the publication of his set of chromolithographs, *Picturesque Architecture in Paris, Ghent, Antwerp, Rouen, etc.* A set of tinted lithographs of London sites (1841) capped the most creative decade of his career. In London he continued to exhibit topographical watercolours until his death, but these, although technically proficient, rarely displayed the assurance and excellence of his early works. PN

□ Boase (1959); J. Roundell, *T. S. Boys* (1974)

Boxall, Sir William *see* WHISTEER

Brailes, William de is the best documented lay artist in English 13c. art, his name occurring in various civic records in Oxford from *c.*1230 until shortly after 1250. He and his workshop illuminated Bibles, Psalters and a famous early BOOK OF HOURS (BL, MS Add. 49999). His particular interests are extended narrative illustration and the relationship of ornamental illumination of initials and line endings to the text and total appearance of the page.

Some painting attributed to him is in fact by collaborators; they form the first clear example of a workshop of lay artists producing illuminated books. NM

□ S. C. Cockerell, *The work of W. de Brailes* (1930); Morgan (1982)

Boys, *The Pont des Arts, Paris*, watercolour, 1831 (priv. coll.).

William de **Brailes** saved at the Last Judgment: self-portrait detail from a Bible leaf, c.1230–50 (Cambridge, Fitzwilliam, MS 330).

Bramley, Frank (1857–1915) made his reputation with *A Hopeless Dawn* (1888; Tate), the most successful of the NEWLYN SCHOOL interior scenes in which carefully observed effects of light, usually from 2 or 3 sources, were combined with powerful but detached and understated human dramas. FG
□ See NEWLYN SCHOOL

Brangwyn, Frank (1867–1943), painter and etcher in a heroic-realist manner derived from Continental academic painting, was born and trained in Belgium. His exceptional facility and boldness of handling made him extremely successful as a mural painter in Britain and abroad. Among his most notable works are the British Empire Panels (1924–33; Swansea, Guildhall). DB
□ Farr (1978)

Branwhite, N. C. see BRISTOL SCHOOL

brasses – funerary monuments in the form of engraved sheet latten – were first produced in the Low Countries and northern France in the mid 13c., but it was in England that they achieved their greatest popularity. It has been estimated that there are some 7,500 pre-1700 brasses in English churches. Whereas large quadrangular plates were favoured on the Continent, English monuments usually consisted of separate elements of brass inlaid in stone. Their relative cheapness encouraged their widespread adoption; the artistic interest of the many small stock figures and simple incriptions is negligible, but even poorly designed brasses, if dated correctly, can provide valuable costume evidence.

Brasses generally imitate contemporary types of sculptured TOMBS, and were often executed in the same workshops. Brasses in the form of a cross or an image on a bracket, the most common types in the 14c. (although few survive intact), can be related to earlier incised and low-relief coffin-lids. There are 3-dimensional parallels for motifs such as the holding of a heart or a spouse's hand, the cadaver, and the figure kneeling at a prayer-desk. Canopies over effigies were translated into brass in forms which, unrestrained by structural considerations, are similar to those seen in stained glass. The weepers around tombs were transformed into figures of saints or mourners down the sides of canopies, or of children at their parents' feet. The medium was particularly well suited to elaborate pictorial compositions such as the brass of Bishop Wyvil (d.1375) at Salisbury, but many of the more unusual iconographic forms are only known from indents, the shapes they left in the stone matrix.

Most brasses were manufactured in London, but there were also important centres of production at York, Norwich, Bury St Edmunds, Cambridge, and possibly, in the late 13c.–early 14c., Lincoln. In recent years several of the workshops have been characterized and tentatively connected with documented individuals. Provincial ateliers mostly copied metropolitan models, but sometimes, as at Bury St Edmunds in the late 15c., they drew on the talents of local artists.

Some of the most sumptuous 14c. brasses in England, such as those of Adam Walsokne and Robert Braunche at King's Lynn, are imports from the Low Countries, and it was from this source that all pre-Reformation Scottish brasses appear to have come, although only fragments remain.

The first English brasses of which any portions survive are those of Margaret and John de Valence (d.1276 and 1277) at Westminster Abbey in London, and St Thomas de Cantilupe (made in 1287) at Hereford Cathedral. The figural poses and treatment of architectural details in late 13c.–mid 14c. brasses reflect the

Brass of Sir Robert de Setvans, c.1310 (Chartham church).

development of the DECORATED style. The Setvans brass at Chartham (Kent), of c.1310, recalls a miniature in the De Lisle Psalter (BL). An even more outstanding manifestation of Court Style is the brass of Sir Hugh Hastings (d.1347) at Elsing (Norf.), which in its interest in movement and perspective looks forward to the WALL-PAINTINGS in St Stephen's Chapel, Westminster.

From c.1375 to c.1450 brasses were distinguished by economy of line and clarity of design, and standard patterns were often used for details or even whole figures. Particularly fine examples of this period are those of Eleanor de Bohun (d.1399) at Westminster Abbey, Margaret Cheyne (d.1419) at Hever (Kent) and Prior Nelond (d.1433) at Cowfold (Sussex).

In the later 15c. and early 16c. the greater use of shading and the adoption of three-quarter poses stimulated a greater variety of compositions, not always successful. The increasing treatment of the brass as a subordinate part of a wall-monument also contributed to the development of new types.

In the Reformation period the scrap-metal value of brasses encouraged their destruction as graven images. Another consequence of the Reformation was the engraving of new brasses on the reverses of ones ransacked from churches both in England and abroad. There is a definite improvement in the quality of brasses at the very end of the 16c. and early 17c., with well-known sculptors such as Gerard Johnson, Epiphanius EVESHAM and Edward Marshall producing examples. Thereafter they sank into provincial obscurity until the 19c. revival, to which A. W. N. Pugin made an important contribution. NR

□ M. Stephenson, *List of monumental brasses in the British Isles* (1926, repr. with appendix 1964); M. Norris, *Monumental brasses: The craft*, and *Monumental brasses: The memorials* (1978)

Brett, John (1831–1902), painter, knew the PRE-RAPHAELITES by 1856; in 1858 he won RUSKIN's praise for *The Stonebreaker* (Liverpool), then struggled under the critic's manipulative attention until their friendship ended in 1864. He was a distinguished amateur astronomer, and almost all his subsequent paintings were precisely observed panoramas of the British coast in high colour of crystalline clarity. *See also* ★LANDSCAPE PAINTING: 19C.

RT

□ Staley (1973)

Bright, Henry *see* NORWICH SCHOOL

Brisley, Stuart (b.1933) began to work as a ★PERFORMANCE artist in the mid 1960s, as a development from environmental construction. In the 1970s his work was characterized by the use of the human body as a participant in a ritual, and as a metaphor or index for examining political or psychological relationships involving power and authority and their relationship to the individual. Brisley's most recent works include *The Georgiana Collection* (presented at the Lewis Johnson Gall., London, in 1983), which involves discarded human debris retrieved from areas near his home in north London. WF

□ A. Mackintosh, *Contemporary artists* (1978); *Stuart Brisley* (exh., ICA, 1981); W. Furlong in *Audio Arts* (1981)

Bristol School A group of professionals and amateurs who made an original contribution to British art in the 1820s, largely through the influence of Francis DANBY. The first to prove that national success could come to an artist

resident in Bristol was Edward Bird (1772–1819). In 1820 a retrospective exhibition of his work, an entirely novel tribute, was organized by a group of amateurs who had, through evening meetings and sketching expeditions to the environs of Bristol, brought together the city's artists, initially including Bird, Danby, E. V. Rippingille (1798–1859) and N. C. Branwhite (1775–1857). The most important of the amateurs were George Cumberland (1754–1848), a writer on art and friend of BLAKE, and the Rev. John Eagles (1783–1855), whose criticisms of TURNER were to spark off RUSKIN. Cumberland's simple landscape sketches have a directness of vision and lack of picturesque composition reminiscent of his friend LINNELL. Eagles on the other hand argued that the view before the sketcher should inspire him to visions of poetry and enchantment. Their support for Bird, and their contrasted naturalism and fantasy, are reflected in the great variety of the Bristol School.

Rippingille, Samuel COLMAN, Rolinda Sharples (1793–1838) and William West (1801–61) all produced, in the 1820s, narrative paintings which were brighter in colour and more contemporary in their references than Bird's. Samuel Jackson (1794–1869) and James Johnson (1803–34) followed Danby closely in brilliant paintings of wooded valleys and contemplative twilight scenes as well as in 'poetic landscapes', the ambitious exhibition paintings that developed from the evening sketching meetings. West, Colman and Paul Falconer Poole (1807–79) were inspired by both Danby's and John MARTIN's apocalyptic scenes.

Most of Bristol's artists were patronized by G. W. Braikenridge, whose vast collection of topographical watercolours, made largely in the 1820s, is of unrivalled quality (Bristol, City AG). The principal artists involved were Hugh O'Neill (1784–1824), T. L. S. Rowbotham (1783–1853), Jackson, Johnson, and the mysterious Edward Cashin (fl. 1823–6). Despite Braikenridge's antiquarian purpose, many of the painters allowed mood and effects of light to dominate the scene.

With Danby's departure in 1824 the cohesion of the school diminished, but the evening sketching parties continued and the subject-matter, especially in the work of West, became more fantastic and exotic. Two younger artists, James Baker Pyne (1800–1875) and William James Muller (1812–45), were

Bristol School: Danby, *Clifton Rocks from Rownham Fields*, c.1822 (Bristol).

much affected by their early years in Bristol; Muller's scenes in the Middle East, more imaginative than those of David ROBERTS who visited Egypt at the same time, recall the poetic landscapes and sepia sketches of the 1820s. FG
□ Greenacre (1973)

British Institution for Promoting the Fine Arts in the United Kingdom An association founded in London in 1805 which offered prizes and bought modern works, and held 2 annual exhibitions, one of contemporary British painting and one of old masters. It was in a sense the last of the ROYAL ACADEMY's 18c. rivals, and also an early example of the growth of different ways of selling contemporary painting before the emergence of the commercial gallery system. It gave rise to similar associations in major provincial cities. TG
□ Boase (1959); R. Altick, *The shows of London* (1978)

Bronckhorst, Arnold *see* SCOTTISH PAINTING

bronze is an alloy of tin and copper. Until the introduction of sand moulds in the 19c. it was usually cast by the 'lost wax' method. A clay core was covered by a layer of wax in which the details of the figure were modelled. This was covered by an outer clay 'investment' through which wax branches projected. When the wax was melted out, molten bronze was poured in so all that was formerly wax became bronze. The clay investment was then removed, the branches sawn off, and the bronze chiselled and polished. This process was often carried out in a foundry that cast bells and cannon.

Cost meant that bronze was usually chosen only for the most prestigious commissions, such as the 13c. royal effigies by William TOREL and TORRIGIANO's tomb of Henry VII. Although used by FANELLI and LE SUEUR in the 17c., bronze was comparatively rare in England until the 19c., when it became common for large-scale public statuary (*see* CHANTREY and WESTMACOTT), and was favoured in the NEW SCULPTURE. MB

□ A. Radcliffe, *European bronze statuettes* (1966), 16–19

Brooking, Charles (1723–59) was the most gifted of all English marine artists. He was brought up in Deptford and suffered illness and poverty for much of his short life. A breezy atmosphere, acutely observed seas, and ships delineated with extraordinary skill are characteristics of his finest paintings. DC

□ C. Sorensen, *Charles Brooking* (1966)

Brown, Ford Madox (1821–93) was a historical and genre painter closely associated with the PRE-RAPHAELITE BROTHERHOOD.

Born in Calais, the son of a ship's purser, he trained under Baron Wappers in Antwerp and in Paris. In 1844 he came to England, where he took part unsuccessfully in 2 of the competitions for the decoration of the Palace of WESTMINSTER. In 1845 he went to Rome, where his contact with the German Nazarenes strengthened his interest in medievalism.

Back in England in 1846, he was approached by the young ROSSETTI who had been attracted by his work. Rossetti became Brown's student briefly, and they remained close friends. It is likely that Brown would have become a member of the Pre-Raphaelite Brotherhood had not Holman HUNT objected to his 'germanic' style. From *c.*1850 Brown showed an increasing interest in realism. If anything he slightly preceded the Pre-Raphaelites in treating modern subjects. In 1852 he began his 2 realist masterpieces – *The Last of England* (1852–6; Birmingham), which was concerned with the problem of emigration, and *Work* (1852–65; Manchester), an allegorical celebration of the manual labourer (*see also* INDUSTRIAL REVOLUTION). During the same period his interest in detailed, direct study led him to produce a remarkable series of *plein-air* landscapes which are uncompromising in their rejection of picturesque effect and close observation of colour (*see also* OUTDOOR PAINTING).

In 1861, though his association with Rossetti, Brown was brought in to William MORRIS's newly founded firm of designers. Under the influence of the 'second generation' Pre-Raphaelites, he (like the mature Rossetti and Burne-Jones) developed an interest in decorative effect in his work. This can be seen in his cycle of pictures on the history of the city which he painted in Manchester Town Hall 1878–93.

A stubborn and prickly character, Brown was often his own worst enemy. He fiercely

Ford Madox **Brown**, *Work*, 1852–65 (Manchester).

opposed the artistic establishment (he ceased to exhibit at the ROYAL ACADEMY after 1853) and pioneered the setting up of one-man shows. He was also something of an outsider in Pre-Raphaelite circles, and never achieved the fame of the principal members of that group. It is only in recent decades that his significance has begun to be fully assessed. *See also* *LEATHART.

<div style="text-align: right">WV</div>

□ F. M. Hueffer, *Ford Madox Brown* (1896); M. Bennett, *Ford Madox Brown* (exh., Liverpool, 1964)

Brown, Fred *see* NEW ENGLISH ART CLUB; SLADE

Brown, John (1749–87), a Scottish painter, was in Florence and Rome 1769–81 and there, under the influence of FUSELI, the Renaissance and classical antiquity, he developed a distinctive Romantic SUBLIME style in his figure drawings. On his return to Scotland and later in London he worked mainly as a miniaturist. JS

□ Pressly (1979)

Burgin, Victor (b.1941) is a CONCEPTUAL artist who in the late 1960s worked with short texts, distributed round a gallery like pictures. More recently, under the influence of Marxist and structuralist analysis, he has used photographs and texts to reveal directly or ironically what he sees as the contradictions of bourgeois ideology. MC

□ V. Burgin, *Work and commentary* (1973)

Burke, Edmund (1729–97), writer and Whig politician, came from Dublin to London in 1750. His *Philosophical Enquiry into the Origin of our Ideas of the Sublime and Beautiful* (1757) had a profound effect on aesthetics and theories of landscape art for at least 75 years. *See* SUBLIME.

<div style="text-align: right">JS</div>

□ J. T. Boulton, ed., *Burke's Enquiry* (1958)

Burn, Rodney *see* SLADE

Burne-Jones, Sir Edward Coley, Bt (1833–98) developed the mystical and symbolic tendencies of the PRE-RAPHAELITE BROTHERHOOD, endowing them with a unique wistfulness and sense of design.

He turned to art while an undergraduate at Oxford, like his friend William MORRIS, under the spell of ROSSETTI. He abandoned his studies, and in 1856 joined Rossetti, Morris and others in decorating the Oxford Union building with

Burne-Jones, *The Beguiling of Merlin*, 1874 (Port Sunlight).

murals on the legends of King Arthur. In 1861 he became a founder member of Morris's decorative arts firm. His gift for 2-dimensional design led him to produce models for STAINED GLASS, tapestries and other objects for the rest of his life. Meanwhile a trip to Italy (1862) with RUSKIN revealed to him the qualities of Botticelli and Mantegna. His handling of figures became more assured, he began to paint on a larger scale, and influenced by the AESTHETIC MOVEMENT he paid more attention to formal patterning. Some pictures – notably *The Golden Stairs* (1880; Tate) – abandon subject-matter altogether. More characteristically, he illustrated medieval and classical legends charged with symbolic overtones. In 1878 he showed works at the International Exhibition in Paris, and from then on he had a high reputation on the Continent, influencing European Symbolism.

A quiet and retiring man, Burne-Jones exuded an air of otherworldliness, though he could be shrewd and calculating. Similarly his pictures, despite their ethereal subjects, have an underlying firmness of design and execution.

<div style="text-align: right">WV</div>

□ M. Harrison and B. Waters, *Burne-Jones* (1973); *Burne-Jones* (exh., Arts Council, 1975)

Burra, *Dancing Skeletons*, gouache, 1934 (Tate).

Burra, Edward (1905–76) exhibited with the Surrealists in the 1930s but remained an individualist whose work showed little influence from Surrealism. He was born and lived in Rye (Sussex), though his chosen themes were drawn from more exotic locations. In 1929 he went to France with Jean Cocteau and in 1930 with Paul NASH, when he was drawn to the low-life of Mediterranean ports. His work of the early 1930s recalls the Berlin Dadaist George Grosz in its satirical-allegorical force. In 1933–4 he was in Mexico, where he responded to the vivid popular culture, and New York, where he painted the night life of Harlem. Though he later concentrated more on landscape and everyday objects his sharp, slightly exaggerated FIGURATIVE style changed little. *See also* WATERCOLOUR. DA
□ Farr (1978)

Bury Bible (Cambridge, Corpus Christi College) One of the masterpieces of English ROMANESQUE art, produced at the abbey of Bury St Edmunds *c*.1135. It is described in the Bury Sacrists' Chronicle as having been commissioned by Sacrist Hervey and beautifully illuminated by Master Hugo. Master Hugo is also recorded in Bury as casting a great bell and the bronze west doors of the abbey church, and carving a cross in the choir and statues of the Virgin and St John. The surviving part of the Bible (Genesis-Job) contains 6 miniatures and 42 initials. Master Hugo's style is characterized by strong, rich colours, and monumental figures of which the faces are modelled on the Byzantine pattern by dark shading in ochre and grey with greenish tints and white highlights. The disposition of the draperies, with sinuous, double-line folds articulating the body beneath, is the hallmark of the Bury Bible figure style and, indeed, of English ILLUMINATION in general in the period *c*.1140–70. *See also* BIBLICAL ILLUSTRATION.
 CMK
□ Kauffmann (1975); R. M. Thomson in *Viator*, 6 (1975), 51–8

Bushnell, John *see* SCULPTURE: 17C.

Butler, Elizabeth Thompson, Lady *see* ROYAL ACADEMY: 19C.

Butler, Reg (1913–81) began his mature career as a sculptor in the post-war years welding figures in a surrealistic spirit. In 1953 he won the international competition for *The Unknown Political Prisoner* (unrealized). He then turned to naturalistically modelled sculptures of girls, which, apart from some totemic works

Detail from the **Bury Bible**, *c*.1135: Jeremiah and the Siege of Jerusalem (Cambridge, Corpus Christi College).

(the *Cheekles*), dominated his work thereafter. The poses became more overtly erotic, and in the 1970s he painted the bronze surfaces in a mimetic fashion. LC
□ R. Butler, *Creative development* (1962); *Reg Butler* (exh., Tate, 1983)

Butler, Richard *see* STAINED GLASS: 16–18C.

C

Cadell, F. C. B. *see* SCOTTISH COLOURISTS

Callcott, Sir Augustus Wall (1779–1844) studied painting briefly with HOPPNER and at the ROYAL ACADEMY Schools, and later held influential positions in the London art establishment. The placid picturesqueness of his landscape and marine oils was primarily Dutch-inspired, although he was frequently compared to TURNER, whom he greatly admired. PN
□ D. Brown, *Augustus Wall Callcott* (exh., Tate, 1981)

Callow, William *see* BONINGTON

Calvert, Edward (1799–1883), a member of the SHOREHAM group, owes his reputation to a series of tiny engravings of country scenes made in 1827–31 and only published long after his death. Their intensity reveals the heady influence of BLAKE and PALMER, but they have a pagan sensuality all their own. DB
□ R. Lister, *Edward Calvert* (1962)

Camden Town Group was the name invented by SICKERT for an exhibiting society formed in 1911. Its origins lay in an artists' cooperative called the Fitzroy Street Group, also Sickert-inspired, formed in 1907, of which the most prominent first members were GORE, GILMAN and Lucien PISSARRO. Wendy Baron has described their paint handling then as 'a late flowering of English Impressionism'. The subject-matter of Gore and Gilman became influenced by Sickert's 'vocabulary' of nudes sitting in cramped, shabby rooms, still-lifes on cluttered mantelpieces, and street scenes in working-class Camden Town and Cumberland Market. The Fitzroy Street Group

expanded in 1908–10 to include Walter Bayes (1869–1956), BEVAN and GINNER, all of whom were aware of Post-Impressionism.

The decision to form a society to rival the NEW ENGLISH ART CLUB, which was hostile to Post-Impressionism, was taken by Sickert, Gore, Gilman, Bevan and Ginner. They formed the core of the Camden Town Group, with Gore as President. Three exhibitions were held in 1911 and 1912. The 16 members in 1911 did not show much unity in style. Malcolm Drummond (1880–1945) and William Ratcliffe (1870–1955) were talented protégés of the 'core', but Pissarro and his protégé J. B. Manson (1879–1945) were closer to Neo-Impressionism than e.g. to the near *cloisonniste* technique of Ginner. Augustus JOHN, J. D. Innes (1887–1914) and Henry Lamb (1883–1960) were more romantic. Duncan GRANT was a temporary recruit from Bloomsbury. Wyndham LEWIS, invited to join only after some dissension, was an independent proto-Cubist outsider. Only Sickert exhibited typically 'Camden Town' genre paintings, of 2 figures in a bedroom, one clothed and one nude, which he shamelessly entitled *Camden Town Murder Series No. 1 and No. 2*.

In October 1913 9 Camden Town painters took part, as 'the *Intimistes* of England', in an exhibition of 'Post-Impressionist and Futurist Art' at the Doré Galleries which also included Lewis and his friends. A month later a new society was formed, the London Group: Gilman replaced Gore as President; Sickert and Pissarro resigned in 1914. A new era of anti-establishment exhibitions had been born.
See also LANDSCAPE: 20C. BL
□ Baron (1979); *The Camden Town Group* (exh., Yale BAC, 1980)

Cameron, D. Y. (1865–1945) was a younger member of the GLASGOW SCHOOL and a distinguished landscape painter. He is best known for his etchings, influenced by the work of Charles Méryon, which are characterized by sharp angular drawing and deeply bitten lines. They made an important contribution to the 20C. ETCHING REVIVAL. DM
□ Caw (1908); Hardie (1976)

Camp, Jeffery *see* GREEN; ROYAL ACADEMY: 20C.

Canaletto, properly called Giovanni Antonio Canale (1697–1768), was the most brilliant

Canaletto, *The Thames and the City of London from the Terrace of Somerset House, c.* 1746–50, bought by George III (Royal Coll.).

Venetian view painter of his age, much patronized by British Grand Tourists and bought by GEORGE III. When the war of the Austrian Succession restricted tourism, he followed his market, setting out in May 1746 for England, where he remained, with few interruptions, until his final return to Venice in 1755. He painted a series of superb views of London and the Thames as well as country houses for patrons including the Dukes of Richmond, Beaufort and Northumberland. His style was widely imitated and greatly influenced Samuel SCOTT (*see also* LANDSCAPE: 18C.). EE

□ W. G. Constable, *Canaletto* (1962, 2nd ed. rev. J. G. Links 1976)

Canterbury School of illumination Both monasteries at Canterbury, the cathedral priory of Christ Church and the abbey of St Augustine, were among the half-dozen richest houses recorded in Domesday Book in 1086; both have a distinguished place in the history of English ROMANESQUE book illumination and a dominant one 1070–1120.

In the ANGLO-SAXON period important illuminated books were produced at Canterbury, notably the 8c. *Codex Aureus* (Stockholm, Royal Lib.) and a copy of the Carolingian Utrecht Psalter, made *c.* 1000 (BL, MS Harley 603). (The first of several copies: see below, and *see* PSALTER ILLUSTRATION and DRAWING.) The earliest post-Conquest manuscripts contain initials decorated in a Norman style, characterized by clambering figures and

dragons in foliage scrolls (BL, MS Arundel 91). At St Augustine's especially, Anglo-Saxon calligraphic technique, with its nervous, zig-zag outlines, survived to mingle with the decorative features imported from Normandy (e.g. Cambridge, Trinity College, MS 0.2.51). Some of these early manuscripts include historiated as well as decorated initials, and occasionally full-page pictures (St Augustine's *City of God, c.* 1120; Florence, Bib. Laurenziana, MS Plut.XII.17), but they do not contain extensive cycles of narrative illustrations. However, Canterbury retained its central importance for the development of decorative forms, which reached a peak of inventiveness by *c.* 1130 (Cambridge Univ. Lib., MS Dd.1.4: *see* ★ILLUMINATED MANUSCRIPTS: ROMANESQUE).

It was only from the mid 12c. that Canterbury manuscripts were once again as fully illustrated as they had been in the Anglo-Saxon period. The Dover Bible (Cambridge, Corpus Christi College), with its 38 historiated initials, is one of the great Romanesque Bibles, and the Eadwine Psalter of *c.* 1160 (Cambridge, Trinity College), derived like its Anglo-Saxon forerunner from the Utrecht Psalter, contains 126 framed drawings illustrating the Psalms, as well as a famous full-page miniature of the scribe Eadwine. The LAMBETH BIBLE is less certainly of Canterbury origin, and although there are a few fine manuscripts at the end of the 12c., Canterbury no longer played an important part in English illumination.

See also BAYEUX TAPESTRY. CMK

□ C. R. Dodwell, *The Canterbury School* (1954);

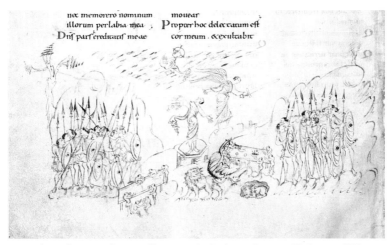

nec memorero nominum mouear
illorum per labia mea ; Propter hoc delectatum est
Dñs parf eredirarif meæ cor meum . & exultabir

Canterbury drawing of *c*.1000: illustration for Psalm 17 from MS Harley 603 (BL).

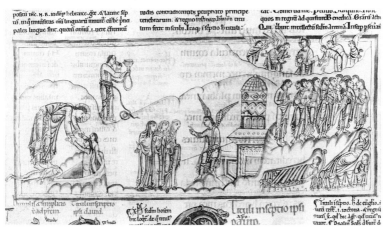

Canterbury illumination of *c*. 1160: illustration for Psalm 16 from the Eadwine Psalter (Cambridge, Trinity College).

Kauffmann (1975); Temple (1976); A. Lawrence in *Medieval art and architecture at Canterbury* (British Archaeol. Assoc. conference trans., 1982), 101–11

canvas began to replace panel as a support for oil paint in England in the mid 16c., though the effects of its texture were not fully exploited until the late 17c. (*see* PAINTING: GROUNDS). Pictures on canvas can be very large while remaining light and transportable; its use contributed to the increasing popularity of life-size portraits in the 17c. and 18c.　CH
□ Gettens and Stout (1966)

caricature is the pictorial exaggeration of a person's distinguishing features so as to excite ridicule and amusement. First practised in Italy by Annibale Carracci, it was given wide currency by the drawings P. L. Ghezzi (1674–1755) made in Rome of celebrities and tourists. Some of these were etched and published in 1736–42 by Arthur Pond, and introduced the art to England. Its popularity was further established by the group caricatures in oil of Englishmen in Italy by Thomas Patch (1725–82) and, surprisingly, REYNOLDS, who painted a witty parody of the *School of Athens* (1751; Dublin, NG Ireland).

Caricature added a new element to the existing tradition of satirical prints, in which figures were shown correctly proportioned but in bizarre or allegorical situations. This approach had relied heavily on Dutch examples, but the many prints inspired by the South Sea

Gillray, *Wierd-Sisters* (a caricature of Dundas, Pitt and Thurlow), etching and aquatint, 1791.

Grant, *Quite Unbearable* (a caricature of Russia's suppression of Poland's independence), lithograph, 1832.

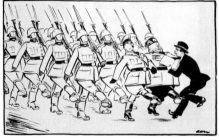

Low, *The Autograph Collector* (a caricature of Anthony Eden's initial hope for agreement with Hitler and Mussolini), line block, 1933.

Bubble (1720) launched a strong native tradition. Over the next few decades, particularly in the 1740s, increasing numbers of anti-Government and personal satires were published. Often crammed with figures, they were usually issued uncoloured and in quite small numbers.

An amateur, George Townshend (1724–1807), first applied the new 'Italian' art of caricature to political subjects. His erratic but expressive drawing caused a minor sensation (deplored by Hogarth, who despised caricature) and signalled the continuing importance of the amateur as designer and suggester of caricatures and ideas.

From the 1760s social caricatures became increasingly popular, especially those mocking the absurd fashions of the 'Macaroni'. Often brightly coloured, and fantastically exaggerated, they herald the golden age of the English caricature, which lasted from c.1780 to 1830. An early practitioner was James SAYERS. ★GILLRAY, ★ROWLANDSON and CRUIKSHANK are the major figures, but many other artists contributed to the torrent of prints issued from various publishers. Often crude and rapidly executed, they bespeak an impressive energy of vituperative invention. Usually produced as single prints, garishly hand-coloured, they could be bought individually, hired out for the evening, or stared at in the printshop windows.

By 1830 the tradition of the single etched print was played out, and numerous artists, such as the radical C. J. Grant (fl. 1829–46), began their careers by etching, but in the early 1830s changed to lithography or the design of woodcuts and wood-engravings. Increasingly the caricature (soon to acquire the new name of 'cartoon') was harnessed to magazines or newspapers where it could reach a mass audience, although becoming subject to technical and editorial restraints. Moreover, the exuberant tastelessness of an earlier generation was viewed with disfavour by the Victorians, whose taste was established by the harmless political humour of John Doyle ('HB', 1797–1868). *Punch* magazine (founded in 1841) embodies the propriety of Victorian humour and satire, the political designs of John Leech (1817–64) and Sir John Tenniel (1820–1914), although brilliantly inventive, having the character of editorial sermons or rebukes. Equally unlikely to wound were the lithographed caricature portraits published in *Vanity Fair* from 1869, the work of 'Ape' and 'Spy'

(Carlo Pellegrini and Leslie Ward). Max BEERBOHM admired 'Ape' and drew for *Vanity Fair*, where his work stands as a welcome relief from its spry but rather institutionalized wit.

Through the popular press and wide syndication the 20c. cartoonist has been able to reach an audience of millions. The most important figure of this century was David LOW, whose broad style of brushwork was perfectly developed to stand out from a mass of newsprint. Cartoonists have absorbed ideas from the various movements of 20c. art, but the conventions and language of the genre still have their roots in the old traditions, of which some of the best comic artists, such as Ronald Searle, are keen students. Personal satire was held within certain limits until the foundation of *Private Eye* in 1961 provided an outlet for work unpublishable elsewhere. The savage assaults of SCARFE, Ralph Steadman and others were geared to an audience increasingly disrespectful of institutions and establishment figures. RG
□ F. G. Stephens and M. D. George, *Cat. of political and personal satires in the BM* (1870ff)

Carmichael, J. W. *see* MARINE PAINTING

Caro, Anthony (b.1924) is perhaps the key figure in post-war British sculpture. In 1960, in *Twenty-Four Hours* (Tate), he changed from a modelled quasi-expressionist figurative style to a mode of abstract welded steel sculpture, whose neutral mood and anonymous handling reflected a new desire to return to the first principles of sculpture and to re-establish its basic and essential constituents. For Caro these were formal qualities, and his subsequent work may be seen as an attempt to explore something of the variety and range of possibilities available within this definition of sculpture. This change was occasioned largely by a visit to America in 1959 when he came into contact with the modernist theories of Clement Greenberg and with the works of certain artists, including Kenneth Noland and David Smith.

In the 1960s his work became very spare, as in *Early One Morning* (1962; Tate), where the forms have been reduced to scarlet lines and planes moving through the spectator's space in a manner which seems totally free from such traditional sculptural properties as weight, gravity, and mass. Welding enabled Caro to cantilever light-weight industrial forms out into space from a horizontal spine so that the sculpture as a whole seemed to float above the

Caro, *Early One Morning*, painted steel, 1962 (Tate).

ground, touching it lightly only at several points, an effect enhanced by the vibrant painted surfaces which concealed the textures and thus the connotations of steel.

In the 1970s Caro reversed the appearance of his work by incorporating huge chunks of raw steel. Though more expressive on account of their textured surfaces and massive, often cumbersome components, they are still structured in a mode derived from Cubism. In those of his most recent works which are cast in bronze, he has reverted not only to a traditional material and technique but to a more explicit engagement with Cubism, as if still trying to wrench a monumental public art from it, something that the sculptors at the beginning of the century working in this idiom, like Lipchitz and Laurens, significantly failed to do. *See also* SCULPTURE: 20C. LC
□ W. Rubin, *Anthony Caro* (1975); D. Waldman, *Anthony Caro* (1982)

Carrington, Dora *see* BLOOMSBURY; GERTLER

Carse, Alexander *see* SCOTTISH PAINTING

Carter, B. A. R. *see* EUSTON ROAD SCHOOL

Carter, Thomas I (d.1756) and **Benjamin** (d.1766) were brothers who ran a flourishing sculptors' yard in London, producing monuments and chimneypieces. ROUBILIAC may have been among their assistants during the 1730s. Their monuments (e.g. Col. Thomas Moore at Great Bookham, Surrey, 1735) mainly followed patterns established by immigrant Flemish sculptors and by James Gibbs, though their chimneypieces sometimes have more Rococo features (*see* SCULPTURE: ROCOCO).

Following Thomas's death his son, **Thomas II** (d.1795), worked with Benjamin and then took over the business. The best of his monuments – notably that to Chaloner Chute (erected 1775; The Vyne, Basingstoke) – are in an idiosyncratic, light style. MB

□ Whinney (1964); R. Gunnis in *Architectural Rev.*, CXXIII (1958), 334

Cashin, Edward *see* BRISTOL SCHOOL

casts *see* PLASTER

Caulfield, Patrick (b.1936) was of the POP generation and has always made use of styles and imagery outside the High Art repertoire, but from interior decoration and small furnishings rather than from the mass media. He quickly developed a style characterized by strong, black outlines and flat areas of colour, all carefully controlled as in an abstract painting. Later he inserted passages in styles imitated from print. MC

□ M. Livingstone, *Patrick Caulfield* (exh., Tate, 1981)

Chadwick, Lynn (b.1914) was trained as an architectural draughtsman, which possibly influenced his first works, metal mobiles. From the early 1950s he has made totemic or ritualistic figurative and animal hybrids, in an innovative technique, welding and modelling iron, plaster and gypsum compounds. His most recent works are cast in bronze. LC

□ J. P. Hodin, *Lynn Chadwick* (1961); A. Bowness, *Lynn Chadwick* (1962)

Chalmers, G. P. *see* SCOTTISH PAINTING

Chalon, Alfred Edward (1780–1860) and **John James** (1778–1854) were devoted bachelor brothers and co-founders of the revived Sketching Society in 1808 (*see* SKETCHING CLUBS). Alfred was a prolific and fashionable watercolour portraitist, and became Portrait Painter in Watercolours to Queen Victoria. John had a wider range, painting landscape, history, animal and genre scenes. RT

□ Hardie, II (1967); Wood (1978)

Chambers, George *see* MARINE PAINTING

Chantrey, Sir Francis Legatt (1781–1841) was the most original and technically accomplished early 19c. sculptor, renowned for his

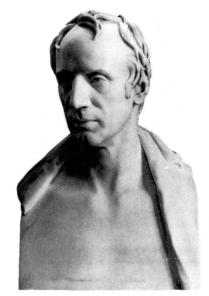

Chantrey, *Wordsworth*, 1820 (Indiana University).

portrait busts. Born near Sheffield, he began his career in 1797 as an apprentice woodcarver, and then turned to portrait painting. Apart from intermittent studies at the ROYAL ACADEMY Schools following his move to London in 1802, he had little formal training as a sculptor. It was only after his style had matured that he visited Paris and the Continent in 1814 and 1815, and Italy in 1819.

Chantrey's financially advantageous marriage *c.*1808 enabled him to establish a studio which became the centre of his large practice. Testimony to his lifelong interest in techniques was the setting up of his own BRONZE foundry *c.*1830. The resulting major public statues in bronze, the first being the equestrian statue of George IV for Marble Arch in London (1828–30; now in Trafalgar Square) technically outshone contemporary productions.

His reputation was established by the exhibition of the bust of Horne Tooke (Cambridge, Fitzwilliam) at the RA in 1811. The informal pose and sensitive rendering of the flesh became hallmarks of the many busts which followed and reveal his admiration for ROUBILIAC. He was also popular for his church monuments, especially the Robinson children (1817; Lichfield Cathedral).

The deceptive simplicity of Chantrey's

works, with their emphasis upon large, unbroken forms and strong chiaroscuro, stemmed from his belief in the primacy of the study of nature over the antique, which placed him outside contemporary Neoclassical aesthetics (*see* SCULPTURE: NEOCLASSICAL, EARLY 19C.).

He was created RA in 1818 and knighted in 1832. The material evidence of his success was the large fortune which he left to the Academy at his death, creating the Chantrey Bequest. *See also* ST PAUL'S. AY

☐ Gunnis (1953); Whinney (1964); *Sir Francis Chantrey* (exh., NPG, 1981); A. Potts in *Oxford Art Journal* (1981), 4, (2), 17

chantries were essentially endowments provided by donors for priests to chant masses for the souls of the dead at a particular altar or tomb in a church with the intention to help in their release from purgatory. From the 13c. until the Reformation the foundation of chantries was an important aspect of lay patronage of the church.

The richest patrons built small architectural structures enclosing an altar and usually incorporating a family tomb or group of tombs. Such chapels often contain elaborate painted and sculpted decoration – e.g. the Despenser chantries in Tewkesbury Abbey, and the chantry of Prince Arthur (son of Henry VII) in Worcester Cathedral. Most of these schemes of decoration were destroyed at the Reformation, but in the chantry of Prince Arthur, and in that of Henry V in Westminster Abbey, London (*see* MASSINGHAM), much of the figure sculpture survives. In parish churches one of the finest examples is the Kirkham chantry at Paignton (Devon). NM

☐ G. H. Cook, *Medieval chantries and chantry chapels* (1947)

Charles I, King 1625–49 (b.1600) Even before his accession, Charles had begun to assemble what was to become the most spectacular of all British collections. He was inspired by the example of his brother Henry (d.1612) and of a number of other collectors associated with the court, especially the Duke of Buckingham, the Earl of ARUNDEL, and ambassadors like Sir Dudley Carleton. In Spain in 1623 he acquired several Titians, a Correggio, and, above all, the Raphael Cartoons (V&A). Once he assumed the throne, his ambassadors and agents scoured Europe for further works of art, and he

constantly received gifts from relatives, friends, and associates. The largest acquisition was that of the bulk of the Gonzaga Collection in Mantua; like earlier and later purchases, it aroused considerable resentment at home and abroad. The pictures included Mantegna's *Triumphs of Caesar* (still at Hampton Court), 4 Correggios, more Titians, Raphael's *La Perla*, and paintings by Dosso, Giulio Romano, and Andrea del Sarto, as well as by contemporary masters like the Carracci, Guido Reni and Caravaggio (*Death of the Virgin*). Leonardo's *St John the Baptist* was acquired from Louis XIII in exchange for Holbein's *Erasmus*. Northern works were not neglected: they included the WILTON DIPTYCH, notable portraits by Cranach, Holbein, Dürer (the *Self-Portrait* now in the Prado) and Rembrandt, as well as Bruegel's *Three Soldiers*, the Van Eyck triptych now in Dresden, and Mabuse's *Adam and Eve*.

The extent of Charles's patronage of contemporary art was just as unprecedented. The collection of MINIATURES was expanded. From *VAN DYCK he commissioned a great series of portraits of himself and his family, and a number of historical and mythological pictures. Large-scale works were ordered from Honthorst and GENTILESCHI. It must have been Charles who commissioned RUBENS to paint the ceiling of the Whitehall Banqueting House, and further decorations were ordered – from Jordaens and Gentileschi – for the Queen's House in Greenwich. In 1642 Charles fled from London; Inigo JONES and painters like William DOBSON remained in his entourage as long as possible.

In 1625 Abraham van der Doort had been appointed the first Surveyor of the King's Pictures, and his inventory of 1639–40 gives the fullest impression of the vast holdings. Within 2 years of Charles's execution in 1649, much of the collection had been sold, to the advantage of private connoisseurs and dealers, but also to adorn the royal galleries abroad which were to become the most splendid of the European national collections, in Madrid, Munich, Paris and Vienna.

For Charles's patronage of sculpture, *see* FANELLI; LE SUEUR; *SCULPTURE: 17C. DF

☐ *The age of Charles I* (1972); O. Millar, *The Queen's pictures* (1977)

Cheere, Sir Henry (1703–81) was apprenticed to the mason-sculptor Robert Hartshorne. By 1728 he was in partnership with Peter

Cheere, detail of the Sausmarez monument in Westminster Abbey, *c*.1750.

Scheemakers' brother Henry (d.1748), with whom he executed the monument to the 1st Duke of Ancaster at Edenham. This and other early works signed by Cheere alone are in the broad late Baroque manner associated with the Flemish sculptors working in England. In the early 1730s he adopted a lighter drapery style, apparent in his statue of Christopher Codrington (commissioned 1732; Oxford, All Souls College). To this essentially Rococo figure style Cheere in the 1740s added an exuberant Rococo ornamental vocabulary of scrolls and shellwork (*see* SCULPTURE: ROCOCO). Such decoration is most impressively employed on the Sausmarez monument (*c*.1750; London, Westminster Abbey). It occurs also on his chimneypieces and the many smaller wall monuments of 1740–50, which, with their differently coloured marbles, delicate floral swags, and groups of cherubs' heads are readily recognizable. At its best, Cheere's work is distinguished and inventive, but with his increasing involvement in public affairs his later monuments were probably executed largely by assistants. ROUBILIAC may have been among them in the 1730s.

Cheere's brother **John** (d.1787) was also a sculptor, specializing in lead figures and plaster busts. MB
□ Whinney (1964); M. Webb in *Burl. Mag.*, c (1958), 232, 274; *Rococo* (1984)

Chéron, Louis (1660–1725) was a DECORATIVE painter who came to England from France *c*.1695, having studied previously in Rome. His essentially Italian style can be seen at Boughton House. He was important as a drawing teacher at the first academies in London (*see* ST MARTIN'S LANE ACADEMY). DB
□ Croft-Murray, 1 (1962)

chromolithograph A LITHOGRAPH printed in colours. The term refers particularly to Victorian productions, the over-elaboration of certain garish examples leading to the derogatory abbreviation 'chromo'. RG
□ J. Friedman, *Color printing in England* (1978)

Cibber, Caius Gabriel (1630–1700) was a Danish-born sculptor trained in Italy and the Netherlands who came to England shortly before the Restoration, working with John Stone (1620–67) until 1667. His first major commission was the relief for the Monument to the Great Fire of London (1673–5), executed in the Italian Baroque style. Garden and decorative sculpture predominate in the 1690s with work at Chatsworth (1688–91), Hampton Court (1691–6) and St Paul's (1698–1700; *see*

Cibber, *Raving Madness*, 1675 (Beckenham, Bethlem Royal Hospital).

Clerk of Eldin, *The Hill of Arthur's Seat and the Town of Edinburgh*, etching, 1774 (Edinburgh, NGS).

★SCULPTURE: 17C.). Unusual for this competent but uninspired sculptor are the powerful figures of *Raving* and *Melancholy Madness* for Bethlem Hospital, London (1675; Beckenham (Kent), Bethlem Royal Hosp.). *See also* BIRD.　　AY
□ H. Faber, *C. G. Cibber* (1926); Gunnis (1953); Whinney (1964)

Circle, subtitled *An International Survey of Constructive Art*, was edited by the architect J. L. Martin, the painter Ben NICHOLSON, and the sculptor Naum GABO, and published in 1937. It included essays and photographs of works by leading abstract artists (e.g. MONDRIAN) and International Style architects. *See* CON-STRUCTIVISM.　　AG
□ *Circle: Constructive art in Britain 1934–40* (exh., Cambridge, Kettle's Yard, 1982)

Claude glass A portable black convex mirror whose weak reflection reduces a panorama to miniature proportions and eliminates much detail and colour, thus enabling its suitability as a composition to be judged. Said to have been developed by Claude Lorrain, it became an important aid to landscape sketching from the 17c. (*see also* AMATEUR ARTISTS).　　EE

Clausen, Sir George (1852–1944), painter, was a founder member of the NEW ENGLISH ART CLUB, but never really broke with the ROYAL ACADEMY and can be classified as a 'progressive Academician'. In the 1880s he was an admirer of Bastien Lepage, but by *c*.1900 his rural genre paintings were closer to Impressionism.　　BL
□ G. Clausen, *Lectures on painting* (1904)

Clennell, Luke *see* BEWICK

Clerk, John, of Eldin (1728–1812) was a gifted amateur etcher from Penicuik near Edinburgh. His wife was a sister of Robert and James Adam, and he was also a friend of Paul SANDBY, who may have taught him ETCHING. His views of Scotland after his own drawings reveal an admiration for Claude and Rembrandt. Technically they are often over-worked, reflecting the amateur's disbelief that the lines will actually bite.　　KS
□ E. S. Lumsden and M. Hardie in *Print Collector's Quarterly*, XII (1925), 15–39, XIII (1926), 97, and XX (1933), 362–4; Godfrey (1978)

Cleveley, John, the Elder *see* MARINE PAINTING

Cleyn, Francis *see* DOBSON, W.

Clint, George *see* THEATRICAL PAINTING

Clipstone Street Artists' Society *see* SKETCH-ING CLUBS

The Clique was a group of painters who sought without deep conviction to dissociate themselves from the stuffiness of the ROYAL ACADEMY *c*.1838. They were never regarded as a serious threat (unlike the PRE-RAPHAELITES), and the more notable members, FRITH, EGG, and John PHILLIP, went on to become popular successes. Richard DADD was also a member.　　DB

□ Treble (1978)

Closterman, John (1660–1711), portrait painter, was born in Osnabrück, and after 2 years in Paris arrived in London in 1681 where

he worked as John RILEY's drapery painter. At first he painted middle-class sitters in a relatively modest style, but by 1690 he had adopted a more elegant manner based on French models and VAN DYCK.　　　DD
□ Waterhouse (1978); *John Closterman* (exh., NPG, 1981)

Coade stone was the most successful of various late 18c. attempts to develop a cheap method of reproducing sculptural decoration in an artificial stone. A fired clay akin to stoneware, it was marketed by Eleanor Coade, whose workshop in Lambeth, London, produced between 1769 and 1821 a wide range of garden sculpture, architectural ornament and coats-of-arms, details of which are given in a series of published catalogues. The method of manufacture enabled work modelled by many leading English sculptors – among them FLAXMAN, BACON and BANKS – to be reproduced very inexpensively. Coade stone ornaments are found on numerous English country houses, but the most extensive scheme was probably the decoration of Greenwich Palace Chapel.
　　　MB
□ J. E. Ruch in *Architectural History*, II (1968): A. Kelly in *National Trust Studies* (1979)

Cohen, Bernard (b.1933) is an abstract painter whose style has always manifested a consistent interest in process and in the medium itself. His pictures are generally the result of a sequence of actions, lately the placing of a selection of devices in different sectors of the canvas while varying systematically their scale, colour, etc. *See also* SITUATION.　　　MC
□ R. Morphet, *Bernard Cohen* (exh., Arts Council, 1972)

Cohen, Harold (b.1928), brother of the above, has consistently sought to enrich his art by intellectual means. He was, from an early date, interested in concepts such as mapping, and in California in the 1970s and 1980s he has been developing computer drawing devices whose programmes allow them to create configurations analogous to those he might make freely. *See also* SITUATION.　　　MC
□ *Harold Cohen* (exh., Tate, 1983)

Coldstream, Sir William (b.1908), painter and teacher, studied at the SLADE 1926–9, travelled in Italy and France, and established a reputation in London by 1933. The national

Coldstream, *Sir Humphrey Milford*, 1938 (priv. coll.).

slump forced him to take a job in the GPO Documentary Film Unit 1934–6. W. H. Auden, with whom he had worked on the film *Coalface*, persuaded him to turn to portrait painting, and in 1937 he painted Auden, Christopher Isherwood and Stephen Spender among others. In the same year he was a co-founder of the EUSTON ROAD SCHOOL. The probity of his work at this time, which depended upon a system of verification of proportional measurements, affected the School's teaching. During World War II, the portraits he painted of Indian soldiers in Egypt, and landscapes during the Italian campaign, reached a new level of maturity. He taught at Camberwell 1945–8, and was Slade Professor of Fine Art 1949–75. Since doing numerous commissioned portraits in the 1960s he has painted an increasing number of nudes, still-lifes and urban landscapes. Perhaps without intending it, he has become the *doyen* of the revival of serious FIGURATIVE PAINTING in Britain.　　　BL
□ *William Coldstream* (exh., Arts Council, 1962); *Eight figurative painters* (exh., Yale BAC, 1981); B. Laughton, *The Euston Road School* (1985)

Collier, Evert or **Edward** (d.*c*.1702) was born in Holland and produced still-life paintings in the manner of Roestraeten, incorporating his own personal speciality of *trompe-l'oeil* effects, much admired by Pepys. It seems he was in London 1695–8. Examples of his work survive at Newbattle Abbey.　　　DD
□ Waterhouse (1978)

Collins, Cecil *see* JONES, D.

Collins, Charles Allston (1828–73) was the son of William COLLINS and a close friend of MILLAIS. His meticulous but rather stiffly painted works were commonly associated with the PRE-RAPHAELITES. WV
□ Boase (1959)

Collins, William (1788–1847), a painter of rural idylls and coastal scenes, was trained by MORLAND and was also influenced by his friend WILKIE. His pictures, such as *Rustic Civility* (V&A), dwell upon the simple pleasures of peasant life. He was father of C. A. COLLINS and of the novelist Wilkie Collins. WV
□ W. W. Collins, *Memoirs of the life of William Collins* (1848)

Collinson, James (1825–81) was a member of the PRE-RAPHAELITE BROTHERHOOD, but resigned in 1850 after converting to Catholicism. In later years he occasionally exhibited lightly moralizing scenes of domestic life. WV
□ Treble (1978)

Colman, Samuel (1780–1845), a Bristol artist who has emerged very recently from obscurity, produced large apocalyptic paintings which compare well with those of John MARTIN. He was a Nonconformist, and the naïvety of his work emphasizes his commitment to religion and to the politics of Dissent. He had moved from Yeovil to Bristol by 1816, and was much influenced by the younger artists of the BRISTOL SCHOOL. See also POPULAR ART. FG
□ M. Whidden, *Samuel Colman – Belshazzar's Feast, a painting in its context* (1981)

Colquhoun, Robert (1914–62) was one of the most individual painters of the 1940s, representing a more cosmopolitan spirit than his NEO-ROMANTIC contemporaries like Minton and Sutherland. His figure compositions reveal the influence not only of the British landscape tradition but of Continental late Cubism, especially Picasso. He was born in Glasgow, and settled in London in 1941 with his inseparable companion, the painter Robert MacBryde (1913–66). DB
□ Rothenstein (1952–74), III

Colt, Maximilian (fl.1600–1645) came to London from Arras *c* 1595 He was appointed Master Sculptor to James I, but his conservative style failed to sustain royal patronage. His major works are the tomb of Elizabeth I (1605; London, Westminster Abbey) and the more unusual monument to his patron, the 1st Earl of Salisbury (d.1612; Hatfield), who is represented on a black marble slab supported by 4 life-size kneeling allegorical figures in white marble (*see* ★SCULPTURE: 17C.) AY
□ Whinney (1964)

Committee of Taste A group of gentlemen connoisseurs appointed by the Treasury in 1802 to control monuments erected by the government to national heroes, in particular those in ST PAUL'S. AY
□ Whinney (1964)

Conceptual art is a name given to a wide range of art forms and practices which came into general use *c.*1968. At its most basic it means art which is derived from a concept so formulated that the construction of the work requires no further decision to be taken. In this sense it applied to the forms and procedures of the Minimal artists in the USA, such as Robert Morris, Donald Judd and Sol LeWitt. However, as soon as the creative act was deemed to be located in the prior concept, rather than in the physical realization, artists could content themselves with formulating that concept and leaving the realization to others, or to natural forces. The formulation could be in words only or in other conventional signs. The activity prescribed by the concept could be a thought process as well as a physical procedure, and might or might not result in an object, however loosely defined. If there was no final resulting object, or only an ephemeral one, the activities would often be photographed or otherwise documented.

Precursors in the field were the Frenchman Yves Klein and the Italian Piero Manzoni (who both died young), and the Dutchman Stanley Brouwn. In about 1968, artists in Britain, continental Europe and America found when they met or heard of each other's activities that they were doing 'Conceptual art', and exhibitions were quickly organized, of which the most important for Britain was Harald Szeeman's 'When Attitudes Become Form' (Berne/ICA, 1969). British artists at the ICA included K. Arnatt (b.1930), BURGIN, FLANAGAN, R. LONG, R. Louw (b.1936) and MCLEAN.

It was held that the new art did not produce marketable commodities. What was produced

could be too large, too dirty, too ephemeral, derisory or too firmly embedded in the environment to be sold, or it might even not exist as an object. Since artists were using words, numbers, photography, film, video recordings, etc., they could deal much more directly with abstract ideas, including the social or political, and in particular with the structures and definitions of the art world.

On the whole, as the 1970s progressed, 'Conceptual' attitudes diffused into art generally. It was seen that they formed no more than an extreme case of what has been quite common in modern art. Most of the artists did produce saleable objects and were, on the whole, quickly absorbed into the art market. Some have, however, maintained the mode as a means of political consciousness-raising: Conrad ATKINSON, ART AND LANGUAGE, and WILLATS. MC
□ *When attitudes become form* (exh., Berne/ICA, 1969)

Conder, Charles *see* NEW ENGLISH ART CLUB

Constable, John (1776–1837) has generally been regarded as the paradigm of the English landscape artist. Even in his own lifetime, and in spite of his general lack of recognition, he gave his name to that small tract of the Stour Valley in Suffolk, between East Bergholt and Dedham, which provided the subjects for so much of his painting. The son of a wealthy miller in Bergholt, he was a slow developer, and always suffered from his family's disapproval of his vocation as artist. Although he joined the ROYAL ACADEMY Schools as a student in 1799, he at first owed little to that institution except a belief in the supreme virtues of nature, as expounded by REYNOLDS (a painter he always profoundly admired), and a love of the art of the past, especially GAINSBOROUGH, Claude, Ruisdael and Rembrandt.

From 1802 until *c.*1820 his art was based on an obsessive involvement with the scenery of his native place, translated into pictures chiefly through the procedures of sketching in oils, which had been in vogue among young English landscapists since before 1800, but

Constable, *Hadleigh Castle*, *c.*1828–9 (Yale BAC).

which were developed by him into a tool of unsurpassed range and refinement. Not only sketches, but also a number of exhibited works of the 1810s seem to have been the products of OUTDOOR PAINTING (*see* *LANDSCAPE PAINTING: 19C.*). The crowning achievement of this Suffolk-based phase of Constable's work is his most famous picture, *The Hay-Wain* (NG), which he showed at the RA in 1821 under the characteristic title of *Landscape: Noon.*

This 6-foot canvas was, however, painted in the studio, the third of a series of large Stour scenes designed essentially for exhibition, and specifically related to Constable's tardy recognition by the RA, of which he was elected an Associate only in 1819. From then onwards he based himself in London and Hampstead, and although he continued to paint many subjects from Stour Valley sketches, his interests broadened to include many other parts of England, as well as much more purely aesthetic and even scientific problems related to landscape art. The 6-foot canvases of the 1820s came to be worked out with the help of full-size compositional sketches (that for *The Hay-Wain* is now the V&A); and work on this scale concentrated Constable's attention as never before on purely painterly considerations. By the mid 1820s topography and even verisimilitude had ceased to play a determining role. He became increasingly reluctant to sell his work (his private income ensured him a living), and he seems, like TURNER, to have planned a museum to house his collection. In the event, the bulk of his studio, including an incomparable series of oil sketches, was presented in the 1880s to the RA and the V&A by his daughter.

In 1829 Constable was made a full Academician, and the last years of his life were largely spent in consolidating his reputation, by the publication of a series of MEZZOTINT engravings by David Lucas (1802–81) after his work, *English Landscape Scenery*, somewhat on the model of Turner's *Liber Studiorum*, but with ample commentaries by the artist himself. He also took to lecturing on the subject of the history and practice of landscape.

Although Constable was never a popular painter until after his death, and was rarely commissioned to paint anything but portraits and even religious works, his posthumous biography by C. R. LESLIE (1843, 2nd ed. 1845), one of the classics of 19c. biography, assured his fame, and led to a good deal of interest in his work in the following decades. There was,

however, little emulation (except on the part of his numerous family, whose skilful pastiches of the early sketches have muddied the water of Constable connoisseurship in recent years), until Wilson STEER and the NEW ENGLISH ART CLUB took him up at the time of Isobel Constable's bequest. It is an irony that a painter who prided himself on never travelling abroad, and who despised modern art on the Continent, should have had an important following in France, from the early 1820s, and even in Germany from about 10 years later. Leslie's picture of a benign and dedicated 'natural painter' shaped the reception of Constable until very recent research (notably the full publication of the correspondence) revealed a much more aggressively ambitious personality. Renewed attention to the late work has served to emphasize the importance of academic thinking in Constable; and studies like Ernst Gombrich's *Art and Illusion* (1960) have, indeed, undermined the very notion of 'natural' painting. *See* *MACLISE*. JG

□ R. B. Beckett, ed., *John Constable's correspondence* (1962–8); id., *John Constable's discourses* (1970); G. Reynolds, *Cat. of the Constable coll.* (V&A, 2nd ed. 1973); L. Parris, I. Fleming-Williams and C. Shields, eds., *John Constable: further documents and correspondence* (1975); id., *Constable: paintings, drawings and watercolours* (exh., Tate, 1976); Parris, *Tate Gallery Constable coll.* (1981); Reynolds, *Later paintings and drawings of John Constable* (1984)

Constructivism began with the open-work assembled structures, evolved from Picasso's Cubist sculptures, which Russian artists such as Tatlin, Rodchenko and GABO created just after the Russian Revolution. At that time there was a split between the Productivist followers of Tatlin, who believed that artists should design useful objects, and Gabo, who believed the artist had an important part to play in society by making pure art works which were analogous to, but separate from, the discoveries of scientists. Gabo used plastic in his constructions to suggest real space and kinetic rhythms. He came to London in 1936 and was a co-editor of CIRCLE, to which he contributed an important essay, 'The Constructive Idea in Art'. By then 'Constructive Art' embraced all those artists who practised geometric abstract art and stood opposed to contemporary trends of realism and Surrealism. Few actually made constructions; exceptions include the open,

Constructivism: above, Gabo, model for *Spheric Theme*, plastic, *c*.1937 (Tate); right, Kenneth Martin, *Small Screw Mobile*, brass and steel, 1953 (Tate).

white, wooden structures of Eileen Holding, and Peter LANYON's slightly later reliefs and freestanding assemblages.

The ideas of the *Circle* group did not survive the Second World War, but in 1951 a new group of artists making constructed abstract art gathered around Victor PASMORE. In this new group were Kenneth MARTIN and his wife Mary (1907–69), Anthony HILL, Adrian Heath (b.1920), Robert Adams (1917–84) and, from 1954, John Ernest (b.1922) and Stephen Gilbert (b.1910). In the face of considerable opposition they organized exhibitions of their work and published their writings in several ephemeral publications. Although they were encouraged by Ben NICHOLSON, their art was different. They looked to the Swiss artists Paul Klee and Max Bill, to the writings of the American relief-artist Charles Biederman, and to books on harmonious proportion by M. Ghyka, J. Hambidge, J. W. Power and Le Corbusier. In their art they used the Golden Section, root rectangles and Fibonacci's system of addition. To make their art more real several members moved from painting into relief constructions – Pasmore and Mary Martin in 1951, Hill and Ernest in 1955. Kenneth Martin developed systematically constructed mobiles from 1951. They used materials which were machine-made, such as plastic and metal, and often left them undisguised by paint. Architects collaborated with them on their exhibitions and in architectural projects such as Peterlee New Town (Pasmore), Musgrave Park Hospital, Belfast (Mary Martin), and the freestanding *Oscillation* at the Engineering Laboratory,

Cambridge (Kenneth Martin).

By *c*.1960 artists in the group were exhibiting abroad and, no longer needing to hold together, they drifted apart.

Through their teaching they have influenced many younger artists such as Peter Lowe (b.1938) and Gillian Wise-Ciobotaru (b.1936). In 1969 another group was formed, called Systems, which included Jeffrey Steele (b.1931), Michael Kidner (b.1917), and Malcolm Hughes (b.1920). They were influenced to some extent by Kenneth and Mary Martin, but primarily by Max Bill and Richard Lohse. AG

□ Farr (1978); *Sculpture 20c.* (1981)

conversation piece Usually a small-scale group portrait of family or friends engaged in some favourite occupation in private surroundings, an important manifestation of the informality which characterizes British painting in the 1720s. It was given considerable impetus by expatriate Flemings like Egbert van Heemskerck (*c*.1700–1744) and Peter Angillis (1685–1734); and MERCIER, by anglicizing the pastorals of WATTEAU, paved the way for HOGARTH, *DEVIS, WHEATLEY and ZOFFANY. Other painters of conversation pieces include DANDRIDGE, Gawen *HAMILTON, HAYMAN, HIGHMORE, MORTIMER, NASMYTH, VAN AKEN, WALTON, WOOTTON and WRIGHT OF DERBY.

BA

□ *The conversation piece* (exh., London, Kenwood, 1965); E. D'Oench, *The conversation piece: Arthur Devis and his contemporaries* (exh., Yale BAC, 1980)

Cooke, Edward William (1811–80) was the most accomplished of the many marine artists working in England in the 1860s and 1870s. He was noted for the brilliant realism of his seas and the meticulous accuracy of his ships and fishing boats. DC

□ J. Howsego, *E. W. Cooke* (1970)

Cooper, Abraham *see* MARSHALL

Cooper, Samuel (*c.*1608–72), miniaturist, was one of the most accomplished artists of the 17c. A skilled linguist, courtier, musician and painter, he associated with the élite of his day, and successfully weathered the Civil War.

Born in London, Cooper eventually resided with his uncle, the limner John Hoskins (*c.*1590–1664/5; *see* MINIATURE PAINTING). He undoubtedly assisted with Hoskins's many miniature copies after VAN DYCK, although no work can be ascribed with certainty to him before the portrait of Van Dyck's mistress, *Margaret Lemon* (*c.*1637; The Hague, Maurits-huis). Already in his earliest works Cooper employed a broad, vigorous handling, distinct from the traditional stippling technique of his uncle's circle and analogous to an oil painter's method. His approach to his subject, however, changed with the shifting pretensions of his clientèle. Thus the severe, sober naturalism of his Commonwealth portraiture, e.g. *Oliver Cromwell* (Buccleuch Coll.; *see* ★MINIATURE PAINTING), was followed after the Restoration by an enlarged format, richer colouring, and more vivacious characterization.

Cooper's miniatures, especially his sketches from the life, were valued highly for their authenticity and for the authority of their execution. During his lifetime, only LELY could compete with his primacy as a portraitist.

Alexander Cooper (*c.*1609–60), his brother, achieved considerable success as a miniaturist to the Protestant courts of northern Europe. PN

□ D. Foskett, *Samuel Cooper* (1974)

Cope, Charles West (1811–90), a HISTORY and ANECDOTAL painter, executed spirited murals of English history in the Palace of WESTMINSTER, and also, more congenially, scenes of rural life. *See* ★ROYAL ACADEMY: 19C. WV

□ C. H. Cope, *Reminiscences of C. W. Cope* (1891); Boase (1959)

Copley, John Singleton (1738–1815) was an American painter whose remarkable natural talent can be seen in portraits executed in New England before his departure for Europe in

Copley, *The Death of Major Peirson*, 1783 (Tate).

1774. After a time in Rome studying antique art and Raphael he settled permanently in London in 1775. There he was highly successful as a portrait painter, and his ambitions as a HISTORY painter came to fruition in the early 1780s with several large depictions of contemporary subjects following the example of his countryman WEST, the most successful of which were *The Death of Chatham* (NPG) and *The Death of Major Peirson* (Tate). BA

□ J. Prown, *Copley* (1966)

Cosway, Richard (1742–1821) was the most acclaimed *MINIATURE painter of the 18c. Trained at Shipley's School (*see* SOCIETY OF ARTS) and the ROYAL ACADEMY, he was practising professionally by 1760. In 1771 he was elected RA and from the mid 1780s was principal painter and artistic factotum to the Prince of Wales. He painted some excellent portraits in oils, but it was as a miniaturist that he excelled. A facile, confident touch and subtle characterization are traits of his best mature style. Although his public mien was foppish, he appears to have been an intensely spiritual man with a pronounced cabalistic bent.

His wife, **Maria Cosway** (1759–1838), was also a painter. PN

□ Murdoch, Murrell, Noon and Strong (1981)

Cotes, Frances (1726–70) was one of the most accomplished PASTEL portraitists of the 18c. He began to paint oils in the later 1750s with an emphasis on fashion rather than character. His later work is similar to REYNOLDS's, and he became a serious rival both to him and to GAINSBOROUGH, being patronized by GEORGE III. BA

□ E. M. Johnson, *Francis Cotes* (1976)

Cox, *Rhyl Sands*, watercolour (V&A).

Cotman, John Sell (1782–1842) was the leading watercolourist of the *NORWICH SCHOOL and one of the most original artists of his generation. His artistic education remains a mystery, but he moved from Norwich to London *c*.1798, entered Dr MONRO's circle, and later joined the Sketching Society (*see* SKETCHING CLUBS). He made tours in Wales and Yorkshire before returning to Norwich in 1806. Between 1810 and 1821 he concentrated on etching, producing a series of publications, notably the *Miscellaneous Etchings*, *Antiquities of Norfolk*, and *Antiquities of Normandy*, which earned him the title of 'the English Piranesi'. He moved to Yarmouth in 1812 to teach drawing to the Dawson Turner family, and relied heavily on teaching in his second Norwich period, 1823–33. In 1833 he returned to London to teach drawing at King's College. His reputation rests primarily on drawings made in 1805–6 in the region of the Greta River in Yorkshire, and on the watercolours of his first Norwich period, which combine naturalism with a distinctive sense of flat pattern, and were sympathetic to the formalist criticism of the early 20c. In the 1820s he developed a brightly coloured virtuoso watercolour style partly inspired by BONINGTON, and painted many Continental subjects based on his own sketches and on those of other artists. His most important oil paintings also belong to this period. Cotman's later output is patchy, but much of it is still undervalued. Some of his late drawings in watercolour mixed with flour paste are outstanding. *See also* MARINE PAINTING; VARLEY, C.

Cotman's sons **Miles Edmund** and **John Joseph** were also painters: *see* NORWICH SCHOOL. AH

□ M. Rajnai, ed., *John Sell Cotman* (1982)

Cowie, James *see* SCOTTISH PAINTING

Cox, David (1783–1859) epitomizes in his work the use of WATERCOLOUR to express a spontaneous response to the open air that has since become peculiarly associated with the medium. His style is at the opposite pole to the tight finish typical of the Old Water-Colour Society, though he was a regular exhibitor himself from 1812. Born in Birmingham, he trained as a scene painter and, in London, was taught by John VARLEY whose style he adapted. Like Varley he published a *Treatise on Landscape Painting* (1814) and other manuals, and was a

teacher of drawing for much of his life. He lived in Hereford 1815–27, and visited the Low Countries and northern France in 1826–7, 1829 and 1832. He absorbed some of the lessons of BONINGTON, and his later style became impressionistically free, with loose chalk underdrawing and wet, rapidly applied colour. In the last decade of his life he visited north Wales frequently, and repeatedly painted its rainy scenery. He produced a few oil paintings, having taken lessons from W. J. Muller c.1840.

His son, also **David** (1809–85), was a capable pupil and follower. AW

□ N. W. Solly, *A memoir of . . . David Cox* (1873); W. Hall, *Biography of David Cox* (1881); Hardie, II (1967); S. Wildman *et al.*, *David Cox* (exh., Birmingham, 1983)

Cozens, Alexander (1717?–86), born in Russia, is now known to have been educated and trained as an artist in London. A view of Eton College was engraved after his design in 1742, but topography was to be rare in his large output. In 1746 he studied in Rome, experimenting with etching and evolving a series of alternative methods of picture-making which he codified in a sketchbook (Yale BAC). Such systems occupied him throughout his life. They were developed partly as an aid in teaching: he was DRAWING MASTER at Christ's Hospital and later at Eton, and a popular tutor among the aristocracy and gentry (*see* AMATEUR ARTISTS), forming a close relationship with William Beckford. But he was clearly a systematizer by temperament, and published or planned schemes for the categorization of human heads, trees, skies, complete landscapes and much else. His best-known work is the *New Method of assisting the Invention in Drawing Original Compositions of Landscape* (1786), in which he proposed the use of random 'blots' as an 'instantaneous method of bringing forth the conception of an ideal subject'. The majority of his own landscapes, in monochrome wash (occasionally in oil), are essays in this type of abstraction and often attain an otherworldly poetry which must have influenced his son, J. R. COZENS. AW

□ A. P. Oppé, *Alexander and John Robert Cozens* (1952); Williams (1952); Hardie, I (1966); A. Wilton, *The art of Alexander and John Robert Cozens* (exh., Yale BAC, 1980)

Cozens, John Robert (1752–97) achieved the decisive transition from topographical view-making to romantic watercolour painting, and

J. R. **Cozens**, *Italian Vineyard in the Euganean Hills: View from Mirabella, the Villa of Count Algarotti*, watercolour, 1782–3 (V&A).

exercised a vital influence on GIRTIN and TURNER. His early exhibits at the SOCIETY OF ARTISTS were landscapes probably in the manner of his father, Alexander COZENS. In 1776 he showed at the ROYAL ACADEMY an oil *Landscape, with Hannibal . . . showing to his army the fertile plains of Italy* (lost), which indicates that he was alive to the concept of 'historical landscape' promulgated by WILSON, though he was not to pursue this path. Later that year he accompanied Payne KNIGHT to Switzerland and Italy, making monochrome drawings of Alpine subjects which he used, on commission, as bases for watercolours. In these conventional technique was replaced by contrasting systems of washing and hatching, achieving great richness within a narrow range of blues, greens and greys, and an altogether novel evocation of vast scale often combined with a mood of gentle melancholy. Another series of intensely felt works was executed for William Beckford, with whom he made his second journey to Italy in 1782. Of his sketchbooks from this trip 6 survive (Manchester, Whitworth). He spent much time at Naples, playing the cello with Sir William Hamilton, and returned to England in 1783. A small group of soft-ground etchings, of which few are now known, was one result of this journey. A set of *Delineations of the general character . . . of forest trees*, also in soft-ground, and conceived in the spirit of his father, was issued in 1789. His later watercolours are often repetitions, usually less intense, of earlier subjects; a few are of English scenes. His lifelong tendency to depression developed into severe mental illness and by 1794 he was in the care of Dr MONRO. AW
□ A. P. Oppé, *Alexander and John Robert Cozens* (1952); F. Hawcroft, *Watercolours by John Robert Cozens* (exh., Manchester, Whitworth, 1971); A. Wilton, *The art of Alexander and John Robert Cozens* (exh., Yale BAC, 1980)

Cragg, Tony (b. 1949) is the most notable of a group of young British sculptors working in the early 1980s with materials of low status, like plastics and wooden fragments found in urban settings. These are arranged to form simple images like a leaf, a boat or a bottle. The unassuming appearance of these works belies the philosophical issues at stake, which arise from the interaction of image, material and title. *See also* FLANAGAN; *SCULPTURE: 20C. LC
□ *Tony Cragg* (exh., British Council, 1982)

Craig-Martin, Michael (b.1941) is an artist whose inventiveness creates works of very diverse appearance. Frequently they are elaborated by processes which can be deciphered by analysis. They are presented in such a way that the viewer is made conscious of his efforts to do this as well as of his physical relationship to the work. They include boxes which will not close, paradoxical word forms and mirrors. MC

Cranbrook Colony A group of genre painters, led by WEBSTER and including HORSLEY, G. B. O'Neil (1828–1917) and A. E. Mulready (d.1886), who settled in the village of Cranbrook (Kent) in the mid 19c. and devoted themselves to painting rural scenes. They harked back to the narrative humour of WILKIE, W. COLLINS and W. MULREADY, but their technique showed the influence of the PRE-RAPHAELITES. WV
□ Maas (1969), 232–4

Crane, Walter (1845–1915), engraver, designer, illustrator, painter and art educator, was notable for his illustrated 'Toy Books' published in the 1860s–70s. They are distinguished by inventive compositions, boldly outlined and tinted with flat colours made possible by new developments in colour printing (furthered by Crane's printer, the pioneering Edmund Evans). His art and his friendships connect him

Crane, illustration from *Beauty and the Beast*, coloured wood-engraving by Edmund Evans, 1875.

with the AESTHETIC MOVEMENT (*see also* GROSVENOR GALLERY), but his lasting concern was to disseminate good design amongst a wider public, particularly through his notable commercial designs for wallpapers, fabrics and ceramics. In 1885 he became a Socialist, and his lectures and illustrations all reflect his interest in the relationship between art, industry, and the consumer. As a painter he was less successful; his subject pictures are close in spirit to those of his friend BURNE-JONES. RH
□ I. Spencer, *Walter Crane* (1975)

Crawhall, Joseph *see* GLASGOW SCHOOL; SPORTING PAINTING

Craxton, John *see* NEO-ROMANTICISM

Cristall, Joshua (1768–1847) was trained as a painter on china, but quickly gravitated towards more academic modes, studying at the ROYAL ACADEMY Schools and with Dr MONRO. He exhibited frequently with the Old Water-Colour Society from 1805, and became its President in 1820. His classically inspired landscapes, often with large-scale figures, contributed substantially to the early OWCS style. He was a prominent member of the Sketching Society (*see* SKETCHING CLUBS). AW
□ B. Taylor, *Joshua Cristall* (exh., V&A, 1975)

Critz, John de, the Elder *see* DOBSON, W.; PORTRAIT PAINTING: 17C.

Crome, John (1768–1821) was a leading artist of the *NORWICH SCHOOL. Trained as a coach-and sign-painter, he had some instruction from BEECHEY, OPIE, and a Norwich amateur, Thomas Harvey. Crome spent his life in Norwich, working mainly as a drawing master, and playing a key role in the Norwich Society of Artists. He visited France in 1814 and occasionally exhibited in London. He was basically a Sunday painter, and his oeuvre is small. Although he began painting *c*.1790, few works can be dated before 1804–5. He absorbed influences from Dutch painting, WILSON, and GAINSBOROUGH, but responded equally strongly to contemporary art. From the dramatic painterly style of *Carrow Abbey* (Norwich, Castle Mus.) he developed through Dutch-inspired works like *The Beaters* (Edinburgh, NGS) to an open naturalism exemplified by *Scene on the River at Norwich* (Yale BAC). Some fine watercolours by him survive, and his

achievements as an etcher anticipate the ETCHING REVIVAL. His work generally is distinguished by uncluttered design and economy of means. Problems of dating and attribution still hinder understanding of Crome, and neither of the recent catalogues is satisfactory. AH
□ D. and T. Clifford, *John Crome* (1968); N. L. Goldberg, *John Crome* (1978)

Crome, John Berney *see* NORWICH SCHOOL

Cromwell, Oliver (1599–1658), whose 'ruffness, pimples and warts' are recorded with varying degrees of directness in COOPER's miniatures and the paintings of LELY and Robert Walker (d.1658), was not the arch-philistine of legend. He kept the Raphael Cartoons in England, decorated his rooms at Whitehall with rare tapestries, retained – to Puritanical disgust – the garden statuary at Hampton Court, and made it possible for Lely to suggest a decorative scheme for Parliamentary White-hall. See *MINIATURE PAINTING. DD
□ D. Piper in *Walpole Soc.*, XXXIV (1958); *The age of Charles I* (1972)

crosses of stone were erected in Britain throughout the Middle Ages, but the most interesting and most impressive, with heights of *c*.5 m. apparently not unusual, are those of the early centuries, when the freestanding stone cross was, it seems, unique to Britain and Ireland. The early crosses were raised for a variety of commemorative, memorial and votive functions and sometimes, apparently, to mark a place of worship. Stone crosses appear to derive from wooden prototypes, probably originating in Ireland. Early British memorial stones with incised crosses and possibly certain types of Middle Eastern freestanding monuments may also have played a part.

The stone cross with relief sculpture seems to be a development of the 8c. (The technique of relief sculpture had perhaps been re-introduced into Britain by foreign masons who were brought in to build churches in Northumbria in the later 7c.) The numerous early stone crosses were generally rectangular in section and the surfaces were usually divided into panels used as fields for decoration or figures. There are considerable geographical variations, and the relative chronology remains contentious.

The great cross at Ruthwell, which may date from the mid 8c., is amongst the earliest of the

Detail of the Ruthwell **cross**, mid 8c.? (Ruthwell church).

Northumbrian crosses. Mediterranean influence is obvious in its skilful sub-classical vine-scrolls and prominent figure carving. There are approximately contemporary crosses at Bewcastle and Hexham. A slightly later phase can be exemplified by the Rothbury Cross. The Iona crosses (*c*.800) make less use of figures and their rich decoration has links with both Irish and PICTISH sculpture. The characteristic ring circling the head of these crosses originated in Iona or in Ireland and is absent from pre-Viking English crosses. The Irish series seems also to go back to the 8c. The rich 'Hiberno-Saxon' ornament of the Ahenny crosses was probably carved no later than 800, but the principal Irish 'high crosses' with their numerous crowded religious scenes date from the 9c. and 10c.

Few crosses remain in the south of England, but fragments with figures in a highly

classicizing style survive from a remarkable round-shafted cross formerly at Reculver in Kent (now in Canterbury Cathedral), perhaps of *c*.800.

Stone crosses of the later Anglo-Saxon period, most of which are in northern England, were usually crude but could be vigorously barbaric and often combined earlier motifs with Scandinavian influences. There are also early medieval decorated crosses in Wales and Cornwall and on the Isle of Man. JH
□ J. R. Allen and J. Anderson, *The Early Christian monuments of Scotland* (1903); G. B. Brown, *The arts in early England*, V (1921) and VI ii (1937); R. N. Bailey, *Viking age sculpture in northern England* (1980)

Cruikshank, George (1792–1878) was the son of a caricaturist, Isaac, and began his career when very young. CARICATURES of Napoleon's retreat from Russia were succeeded by satires of Regency follies with something of the spirit of GILLRAY, and in 1820 he was paid £100 'not to caricature His Majesty in any immoral situation'. His tastes changed with the century, however, and he eventually became a fanatical Temperance propagandist. He etched thou-

The Railway Dragon

Cruikshank, *The Railway Dragon*, etching, 1845 (V&A).

sands of lively illustrations (including Dickens's *Oliver Twist*, 1837), often quirky and teeming with innumerable tiny figures. RG

□ G. W. Reid, *Descriptive cat. of . . . George Cruikshank* (1837)

Cumberland, George *see* BRISTOL SCHOOL

Cumberland Market Group *see* BEVAN; GINNER

D

Dadd, Richard (1817–86), a painter of literary and 'fairy' subjects and founder member of the CLIQUE, first exhibited signs of madness on a journey to Greece and the Middle East in 1842–3, and shortly after his return murdered his father. He was confined in Bethlem Hospital from 1844 and Broadmoor from 1864 until his death. Encouraged by sympathetic doctors he

Dadd, *The Fairy Feller's Master-Stroke, c.*1855–64 (Tate).

continued to paint, producing a large number of works of haunting intensity and detail, referring often to the experiences of his previous life. His major surviving works are *Oberon and Titania* (1854–8; priv. coll.) and *The Fairy Feller's Master-Stroke* (*c.*1855–64; Tate). DB

□ P. Allderidge, *The late Richard Dadd* (exh., Tate, 1974)

Dahl, Michael *see* ★HAMILTON, GAWEN; PORTRAIT PAINTING: 18C.

Dalton, Richard *see* AMATEUR ARTISTS

Danby, Francis (1793–1861), a major Romantic painter, was Irish-born, and settled in Bristol 1813–24 where he became the outstanding artist of the ★BRISTOL SCHOOL. From picturesque watercolours of the spectacular local scenery he progressed to more intimate and personal landscapes, which often include children playing with innocent concentration, or adults (perhaps the artist's friends). His palette became much brighter, and his oils have a hard enamel surface without parallel in England. Despite their careful observation and detail they are primarily landscapes of mood depicting man's sensations before nature.

Danby's more ambitious exhibition pieces were initially either large Biblical scenes, which led to rivalry with John MARTIN, or what he called 'poetic landscapes', chiefly scenes of fantasy without literary references. He moved to London in 1824 and in 1829 fled to the Continent to escape marital and financial problems. He eventually returned to London in 1838 and settled in Exmouth in 1847. FG

□ E. Adams, *Francis Danby* (1973); Greenacre (1973)

Danckerts, Hendrik *see* LANDSCAPE PAINTING: 17C.

Dandridge, Bartholomew (1691–*c.*1755) studied at the KNELLER Academy with HIGHMORE and HOGARTH. His lively touch, seen in CONVERSATION PIECES like *The Price Family* (New York, Met.), is as close as any English painter gets to the lightness of the school of WATTEAU. BA

□ C. H. Collins Baker in *Apollo*, LXXVI (1938), 132–7

Daniell, E. T. *see* NORWICH SCHOOL

Thomas **Daniell**, 'Hindoo Temples at Agouree', 1796, aquatint from *Oriental Scenery*.

Daniell, Thomas (1749–1840) and his nephew **William** (1769–1837) were topographical artists whose oil paintings and AQUATINTS (especially *Oriental Scenery*, 1795–1808), made during a stay in India 1786–94 or based later on drawings, created a vogue for Oriental views and architecture. Thomas initially specialized in country house views (e.g. a series still at West Wycombe Park). William later turned to British topography, publishing an extensive *Picturesque Tour round Great Britain*. EE
□ T. Sutton, *The Daniells* (1954); M. Archer, *Early views of India* (1980); M. Shellim, *India and the Daniells* (1980)

Dassier, Jacques Antoine (1715–59) worked as a medallist in England 1740–57 and was probably associated with the circle of the ST MARTIN'S LANE ACADEMY. His medals celebrating 'famous men living in England', praised by VERTUE, are early examples of a fully Rococo style (*see* SCULPTURE: ROCOCO). MB
□ *Rococo* (1984)

Dauphin, Louis *see* STAINED GLASS: 16–18C.

Davie, Alan (b. 1920) was the first and remains one of the most persistent British exponents of Abstract Expressionism. He is also a musician and has been affected by Zen Buddhism. His paintings almost always contain devices and signs of types that are universal in man's earliest art, and may arise from the deepest levels of consciousness. MC
□ A. Bowness, ed. *Alan Davie* (1967)

Davies, John *see* SCULPTURE: 20C.

Dayes, Edward (1763–1804) was a painter of MINIATURES and HISTORY subjects as well as a topographer, but is known for his work as a watercolourist of antiquities and landscape views, occasionally of considerable grandeur. He taught GIRTIN, and his lively scenes in London squares and parks influenced TURNER (see also MONRO). He committed suicide. AW
□ Hardie, I (1966)

Deare, John (1759–98) began his career carving pictorial tablets for Thomas CARTER's chimneypieces and ended it in Rome (where he went with a ROYAL ACADEMY scholarship in

Deare, *The Judgment of Jupiter*, 1786 (Los Angeles County Mus. of Art, purchased with funds donated by Anna Bing Arnold).

1785) with a high reputation fully justified by his few known works. His reliefs of Venus riding the surf (Parham Park) and Queen Eleanor sucking poison out of her husband's wounds (1789–95; priv. coll.; Liverpool; etc.) display great elegance of design and exquisite handling. His relief of the assembled gods from Northwick Park (Los Angeles County Mus. of Art) is the most impressive heroic composition attempted by a British sculptor in the late 18c. NP

□ Gunnis (1953)

Decorated style A term first applied to architecture, and loosely used to describe the art of the period *c*. 1290–1350. Within that period, however, very different artistic approaches existed, and the word 'Decorated' is best restricted to one particular stylistic mode. This ornate and playful manner is characterized by an elaboration of decorative motifs and the development of complex rhythmic systems of figure composition. In sculpture, rich foliage is combined with crowded groupings of figures, best seen (in association with the distinctive ogee or S-curve arches) in the Lady Chapel of Ely Cathedral (1321–49; *see* *SCULPTURE: GOTHIC, STONE), and in some *EASTER SEPULCHRES. In manuscript illumination a profusion of ornamental border motifs and GROTESQUES are favoured by many artists, e.g. those of the Gorleston and Ormesby Psalters (*see* *EAST ANGLIAN ILLUMINATION).

During the same period some architecture, sculpture and painting shows an alternative restrained manner (e.g. the QUEEN MARY PSALTER), strongly dependent on French models, which has been associated with the Westminster court. There were mutual influences between these artists and those working in the Decorated style, but their formal approaches remain distinct. NM

□ Rickert (1965), 122–45; Stone (1972), 129–76; J. Bony, *The English Decorated style* (1979)

decorative painting is the name given to the work of painters, usually of foreign origin and training, who made large-scale mural paintings in great houses in England from the 1670s to the 1730s. They represent the ascendancy in England of the late Baroque from France and Italy, though by the end of its period of fashion English artists had often taken the best commissions. Invariable features of the 17c. phase were the quasi-architectural painting of

Decorative painting by Verrio on the King's Staircase at Hampton Court, *c*.1699–1705.

cornices, mouldings and surrounds, a high degree of illusionism which began eventually to seem unsophisticated, and a pompous repertoire of subjects from allegory and mythology. At its worst decorative painting can appear soulless and even absurd, but transformed by the Venetian painters like PELLEGRINI, the RICCI and *AMIGONI who made brief visits to England after 1700 it brought a vivacity and sophistication redolent of 18c. court life on the Continent. For these artists England was merely a lucrative stopover in an international network stretching from Düsseldorf and Munich to Venice and Madrid.

Late Baroque decorative painting first came to England under the auspices of the Duke of Montagu who brought VERRIO from France *c*.1671. *Faute de mieux* he became the main royal decorative painter. He was joined in 1683/4 by LAGUERRE, who was a more serious artist, though working in essentially the same French manner. Other French painters also came over before the end of the century, including CHÉRON, but though they continued to gain great commissions into the early years of the 18c. they were rapidly overtaken in quality and reputation by the Venetians and (perhaps less

justly) by the English artist *THORNHILL. The Venetians nonetheless did not get the most important royal and national commissions, and their surviving English works are to be found in grand but not the grandest houses: Verrio, Laguerre and Thornhill worked at Hampton Court and Chatsworth, and the Venetians at Kimbolton, Narford and Moor Park.

The Venetians usually worked not directly on the walls as Verrio had done but on very large canvases; this is indicative not only of their predilection for easel painting but also of the growing tendency for patrons and architects to prefer decorative settings in which paintings were firmly subordinated to architectural or stucco decoration. Spectacular scenic efforts like Verrio's Heaven Room at Burghley or Thornhill's Painted Hall at Greenwich ceased to be fashionable by the end of the 1720s, and the last eminent artist to enter the genre of decorative painting was HOGARTH, who as the son-in-law of Thornhill had hopes of inheriting his practice. When large-scale mythological and religious painting was revived in England in the 1760s it did so under the banner of HISTORY painting, and owed little to earlier

decorative painting. *See also* KENT, STREETER.

DB

□ Croft-Murray (1962 and 1970); Waterhouse (1978), 125–34

Delvaux, Laurent (1696–1778) was with SCHEEMAKERS and RYSBRACK one of the talented Flemish sculptors who came to England *c*.1720. He is recorded as working for PLUMIER along with Scheemakers, with whom he formed a partnership after Plumier's death. Delvaux left for Italy in 1728 and did not work again in England, but he had already begun work on the notable monument to Dr Hugo Chamberlin (London, Westminster Abbey) which Scheemakers completed by 1731. A number of garden sculptures have been attributed to him and they show considerable talent. DB

□ Whinney (1964)

Denny, Robyn (b.1930) creates large, abstract paintings, generally in strong flat colours, rectilinearly divided, which correspond to the scale and reach of the human viewer. Most are symmetrical or in resolvable asymmetries based on a vertical axis. The impetus for them is

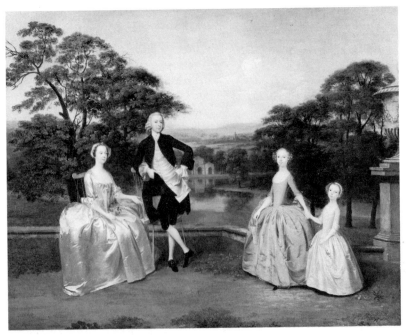

Devis, *The James Family*, 1751 (Tate).

moral – a sense of the duty to engage in a severe discipline, with a restricted means of expression. See also SITUATION. MC
□ R. Kudielka, *Robyn Denny* (exh., Tate, 1973)

Deverell, Walter Howell (1827–54) was a close associate of the PRE-RAPHAELITES, and is famous for *Twelfth Night* (1850; *Forbes Magazine* Coll.). He died of consumption before revealing his full potential. WV
□ Ironside and Gere (1948); *Pre-Raphaelites* (exh., Tate, 1984)

Devis, Arthur (*c*.1711–87), a topographer by training, specialized in small-scale, informal CONVERSATION PIECES. He worked from the late 1730s for predominantly middle-class clients in his native Lancashire as well as in London. His neat style and the naïve doll-like physiognomy of his figures betray his use of small lay figures, but his observation of posture and property makes his work a fascinating and charming record of mid 18c. manners. BA
□ E. D'Oench, *The conversation piece: Arthur Devis and his contemporaries* (exh., Yale BAC, 1980); *Polite society by Arthur Devis* (exh., Preston/NPG, 1983–4)

De Wint, Peter (1784–1849) is with David COX the most influential exponent of WATER-COLOUR as the natural medium for expressing the freshness of the English countryside. He derived his bold, simple compositions and palette of warm russets and greens from GIRTIN, though applying his colour more fluidly. His architectural subjects and earthy still-lifes testify to a refined sense of structure and able

De Wint, *Lincoln Cathedral from Drury Lane*, watercolour (priv. coll.).

draughtsmanship. He showed elaborate finished watercolours at the Old Water-Colour Society, and also worked in oil. He is particularly associated with the neighbourhood of Lincoln. See also MONRO. AW
□ Hardie, II (1967); D. Scrase, *Peter de Wint*, (exh., Cambridge, Fitzwilliam, 1979)

Dismorr, Jessica see GROUP X

Dixon, Robert see NORWICH SCHOOL

Dobson, Frank (1886–1963) was initially hailed for his carved female figures by Roger FRY, who championed plastic qualities and 'significant form', and he was a member of the avant-garde GROUP X. His later sculptures, often modelled in TERRACOTTA, have an idealizing, classicizing spirit that recalls Maillol. LC
□ R. Mortimer, *Frank Dobson* (1926); T. W. Earp, *Frank Dobson, sculptor* (1946)

Dobson, William (*c*.1610/11–46), Aubrey's 'most excellent painter England hath bred', studied with Francis Cleyn (1582–1658), who gave him an interest in Italian High Renaissance and Venetian painting and the opportunity to study the royal collection (see CHARLES I). Virtually nothing is known of his work before 1642, when he embarked on the brief career at the exiled court in Oxford that lasted until his death. Although the deaths of VAN DYCK and John de Critz the Elder (d.1642) had removed serious opposition, he was apparently not officially appointed the King's Principal Painter. Of about 50 known paintings his most characteristic are half-length portraits with hands, often containing classical allusions to the sitter's learning or bravery. He is a much coarser artist than Van Dyck, and his Royalist sitters exude a rudeness of health and vigorous confidence not found in the latter's more delicate courtiers. Some of his paintings were engraved by FAITHORNE. See *PORTRAIT PAINTING: 17C. DD
□ *The age of Charles I* (1972); Waterhouse (1978); M. Rogers, *William Dobson* (exh., NPG, 1983)

Dodgson, John see EUSTON ROAD SCHOOL

Doom paintings, representations of the Last Judgment, are among the commonest as well as the largest and most impressive survivals of medieval WALL-PAINTING. The Doom was

73

usually sited prominently above the chancel arch, facing the congregation. The subject is based on the account of the Second Coming in Matthew 24–5, and the basic elements – Christ enthroned in Judgment, angels sounding the Last Trump, the Resurrection of the Dead, and the reception of the Blessed in Heaven and of the Damned in Hell – recur in Dooms throughout the Middle Ages. Christ is typically shown displaying his wounds and accompanied by angels holding the Instruments of the Passion (as in the early Doom, of *c.*1100, at Clayton (Sussex)). These features, and the painting's frequent juxtaposition with the carved rood at the chancel arch, emphasized the link between the First and Second Comings.

During the course of the Middle Ages new elements were added, which tended to diminish the awesomeness of the subject. Thus from *c.*1200 the Virgin is often represented interceding for mankind, sometimes with bared breast as in the recently discovered 14c. Doom at Ickleton (Cambs.). In the later Dooms, features such as the buildings of Heaven and Hell are often depicted with considerable attention to detail; and, probably partly as a result of influence from contemporary drama and sermons, a greater range of types appears among the Damned. A particularly splendid, though unfortunately repainted, late Doom is that in St Thomas's Church, Salisbury (*c.*1500). A small number of Dooms from the end of the medieval period are painted not on a wall but on a wooden tympanum that would have occupied the space above the rood SCREEN.

DP

□ E. W. Tristram, *English medieval wall painting* (1944, 1950, 1955); A. Caiger-Smith, *English medieval mural paintings* (1963)

Douce Apocalypse (Oxford, Bodleian) One of the finest of the illustrated APOCALYPSES that had a great vogue in 13c. England. The manuscript was made before 1272 for Edward I and Eleanor of Castile, and there is every indication that it was produced at the Westminster court. The figure style is characterized by the use of pear-shaped heads and mannered hand gestures which reveal some of the most precocious foreshortening to be seen in any 13c. painting (cp. WESTMINSTER RETABLE; *and see* GOTHIC). The drapery shows a confident

Doom painting over the chancel arch in St Thomas's, Salisbury, *c.*1500.

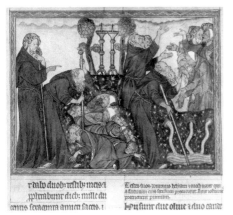

Douce Apocalypse, before 1272: the two Witnesses, shown as friars (Oxford, Bodleian).

grasp of the new French 'broad fold' style, and figures are placed in landscapes with remarkably early depictions of naturalistic foliage. MM

□ A. G. and W. O. Hassall, *The Douce Apocalypse* (1961); P. Klein, *Endzeiterwartung und Ritterideologie: die englischen Apokalypsen der Frühgothik und MS Douce 180* (1983)

Dow, T. Millie *see* GLASGOW SCHOOL

Doyle, John *see* CARICATURE

drawing (medieval) A special characteristic of English art of the later *ANGLO-SAXON period (10–11c.) is the emphasis on drawing rather than painting as a means of book illustration. Throughout English medieval art this tradition persisted, and was particularly popular in certain periods, most notably the 13c.

Sketches were first done in lead or silverpoint, and then worked up in ink. This was normally brown, but the Anglo-Saxons also used red, blue and green inks. Drawings of the 10c. have light colour washes – giving rise to the term 'tinted drawing' – which allow modelling, a technique favoured in later periods as well.

A famous Carolingian manuscript illustrated by drawings, the Utrecht Psalter, came into the possession of Canterbury Cathedral Priory in the later 10c. and had a great influence on the style of Anglo-Saxon drawing (*see* *CANTERBURY SCHOOL). At Canterbury the tradition of tinted drawing remained important in manu-

scripts of the ROMANESQUE period. Other monastic centres such as Bury St Edmunds and Winchester showed a similar interest during the 12c.

Texts most commonly found decorated with drawings in the 12c. and 13c. are BESTIARIES, Lives of saints, and astrological and medical treatises. In the 13c. Matthew *PARIS used tinted drawings for marginal illustrations in his chronicles. In the 14c. the artists of the *QUEEN MARY PSALTER workshop used tinted drawing combined with full painting. In the 15c. drawings served mainly to illustrate didactic texts of medicine and astrology but also occur in popular devotional works such as prayer rolls. In the mid 15c. under Flemish influence some high quality examples were produced, notably the copy of the works of Thomas Chaundler made for Thomas Bekynton, Bishop of Bath and Wells (Cambridge, Trinity College, MS R.14.5). *See also* *PEPYSIAN SKETCH-BOOK. NM

□ F. Wormald, *English drawings of the 10c. and 11c.* (1952); Rickert (1965); M. W. Evans, *Medieval drawings* (1969); Kauffmann (1975); Temple (1976); Morgan (1982)

drawing masters in the 17c. often were also writing masters, mathematicians, or engravers and the drawing manuals they produced were not merely useful compilations of technical information, but a form of self-advertisement. Some of these manuals also contained plates depicting parts of the body, drawings after antique statues, copies of old masters, and, very rarely, landscapes.

In the 18c., drawing became a required accomplishment for the man of taste and more artists were able to supplement their incomes by teaching (e.g LAMBERT); some specialized, but most were willing to turn their hands to any style or medium. It was not unusual for the trade to be passed from father to son or brother, as for instance in the Bickham, LENS and COZENS families.

Alexander Cozens found a large market for his drawings and publications amongst former pupils at Eton, and Paul SANDBY also gained many commissions through his private pupils and his students at the Woolwich Military Academy. At Oxford, however, John Malchair (1729–1812) made little attempt to sell his own work even though he had a large number of very talented pupils, including Sir George BEAUMONT and Lord AYLESFORD. William

Austin (1721–1820), an engraver who boasted at least 400 pupils, acquired a small fortune through his teaching. *See also* AMATEUR ARTISTS; COTMAN; COX; CROME; FRANCIA; NORWICH SCHOOL; TOWNE. KS

□ I. Fleming-Williams in Hardie, III (1968), 212–44; M. Clarke, *Tempting prospect* (1981), 90–102; J. Friedman in *Apollo*, CV (1977), 262–7

Drummond, James *see* SCOTTISH PAINTING

Drummond, Malcolm *see* CAMDEN TOWN GROUP

Duncan, Thomas *see* SCOTTISH PAINTING

Dyce, William (1806–64) was a religious and historical painter who prefigured the PRE-RAPHAELITES in his desire to revive the values of Italian Quattrocento art. To some extent he was a follower of the German Nazarenes, but he was more naturalistic in his concerns.

He obtained an MA at Marischal College in his native Aberdeen before coming to London to study art. Two visits to Rome (1825, 1827–30) inspired him with an admiration for early Italian art and brought him into contact with the Nazarenes. In 1830 he settled in Edinburgh, where he worked principally as a portrait painter. In 1836 he was brought to London – at EASTLAKE's suggestion – to become director of the new Government Schools of Design. His work in the new Palace of WESTMINSTER, which continued up to his death, kept him from his preferred career as a religious painter.

Dyce was an early supporter of the Pre-Raphaelites and in the 1850s his pictures showed the influence of their detailed naturalism, notably his masterpiece, the evocative *Pegwell Bay* (1859–60; Tate).

Dyce's art often seems to suffer from an excess of erudition, but he is certainly the most distinguished and interesting 'high' artist in the generation preceding the Pre-Raphaelites.

 WV

□ Boase (1959); M. Pointon, *William Dyce* (1979)

Dyce, *Pegwell Bay, Kent – a Recollection of October 5th 1858*, 1859–60 (Tate).

E

Eardley, Joan *see* SCOTTISH PAINTING

East Anglian illumination comprises manuscripts, mostly PSALTERS, made for use in the dioceses of Norwich, Ely and the Fenlands part of Lincoln in the early 14c., many of which are typical of the DECORATED style. The first manuscript to show many of the elements which were to become characteristic is the Brussels Peterborough Psalter (Bib. Roy., MS 9961–2), which was probably made *c*.1290–1300. Border decoration frames the main liturgical divisions of the text in meandering foliage, inhabited by GROTESQUES, birds, animals and leaves, often naturalistic, and sometimes arranged into anecdotal scenes unrelated to the text. The figure style shows the flowing S-curves and subtle modelling of drapery found in the work of the Parisian illuminator Honoré in the later 13c. The heads, however, are drawn with high eyebrows which give them a distinctive sense of expression, often surprise. These expressions appear again in the Howard Psalter (BL), the earlier parts of another Psalter from Peterborough (Cambridge, Corpus Christi College, MS 53), and the Croyland APOCALYPSE (Cambridge, Magdalene College), which all date from *c*.1310–20.

Yet another Psalter from Peterborough (Oxford, Bodleian, MS Barlow 22), of *c*.1320, shows a different trend. Its artist is more conservative in his border decoration, and his surviving work only includes grotesques where they have some connection with the text. His figures have broad chins and their drapery displays curiously 'troughed' folds. In these last features he seems to have inspired a prolific but neglected artist active *c*.1330, who is known chiefly from his work on a Psalter now in Schloss Herdringen (MS 8). The 2 artists collaborated with others on the Tiptoft Missal (New York, Pierpont Morgan Lib.).

The influence of these artists can be felt in the 2 major monuments of East Anglian illumination, the Ormesby Psalter (Oxford, Bodleian) and the Gorleston Psalter (BL). Both reveal several distinct periods of painting – 2 in the case of the Gorleston Psalter, and 3 in the case of the Ormesby Psalter. The second phase of work on the Ormesby Psalter, *c*.1310–20,

produced some of the most ambitious and successful borders in English illumination, with wide inhabited extensions to historiated initials used at all the liturgical divisions; the accompanying monumental figure style, with square-jawed unsmiling faces, may be due to Italian (Florentine?) sources. Both the Ormesby and the Gorleston Psalters were added to, perhaps as late as *c*.1330, by a group of artists who illuminated a Psalter made for use in East Anglia which is now in Douai (Bib. Mun., MS 171, ruined by damp in 1914–18). It seems that these artists were called in by the monk Robert of Ormesby to finish the Ormesby Psalter and add portraits of the Bishop of Norwich and himself to the opening Beatus page. This group of artists is particularly important, as they used both stylistic and iconographical features from Italian painting (perhaps Sienese) which may have been learned at first hand, including careful attention to the modelling and texture of skin and a new heaviness in the figures, best seen in the Crucifixion added to the Gorleston Psalter (*see* ★ILLUMINATED MANUSCRIPTS: GOTHIC).

East Anglian illumination: Psalm 109 from the Ormesby Psalter, a product of the second phase of work, *c*.1310–20 (Oxford, Bodleian).

In the 1330s some of the Italian weightiness was lost, though illuminators retained their interest in modelling and 3-dimensional space (e.g. in the St Omer Psalter (BL), made in the 1330s for the St Omer family of Norfolk).

In the 1340s East Anglian artists combined Italianate influences with others from the Low Countries. The Psalter of Simon de Montacute, Bishop of Ely (Cambridge, St John's College) shows the new trend towards severe, dark modelling on the faces and agitated figures with slightly disjointed limbs. These features also appear in the famous Luttrell Psalter (BL), started c.1340, but probably finished later, which maintains the East Anglian interest in anecdotal scenes in its borders despite having less naturalistic ornament.

A group of manuscripts stemming from the Psalter of Simon de Montacute can be associated with the diocese of Ely in the 1340s and 1350s. It includes the Zouche Hours (Oxford, Bodleian) and the Botiler Hours (Baltimore, Walters AG). These manuscripts have a new type of border with symmetrical sprays of conventionalized kidney-shaped

leaves, but they continue earlier experiments in modelling and figure style, and show an understanding of space, tonality, and psychological expression that herald developments in English painting as a whole. MM
□ P. Lasko and N. J. Morgan, eds., *Medieval art in East Anglia* (exh., Norwich, Castle Mus., 1973); L. F. Sandler, *The Peterborough Psalter in Brussels and other Fenland manuscripts* (1974)

Easter sepulchres Structures of a temporary or permanent nature in a medieval church (almost always on the north side of the chancel) which served to represent the Holy Sepulchre in Jerusalem in the ritual re-enactment of the Easter story: a cross and/or host was placed within the sepulchre on Good Friday and removed on Easter Sunday.

The most elaborate permanent examples, in Lincolnshire, Nottinghamshire and South Humberside, are in the DECORATED style, richly ornamented with figure sculpture. Many of this group, such as that at Hawton (Notts.), were erected next to the tomb of the donor who paid for them. In a later practice, the donor's own tomb was specifically intended to be used as an Easter sepulchre. The iconographic schemes vary in detail but generally share an emphasis on Christ Risen or on the moment of Resurrection, suiting the association with a tomb. ND
□ Stone (1972), 168–9, 171, 231; P. Sheingorn in *Studies in iconography*, 4 (1978), 37–60

Eastlake, Sir Charles Lock (1793–1865) was a historical and genre painter whose learning and judiciousness led him to become the *éminence grise* of the early Victorian art world. He was in Italy 1815–30, where he came into contact with the Nazarenes and developed his scholarship. In 1840 he became secretary to the Royal Commission for the decoration of the Palace of WESTMINSTER and was largely responsible for the employment of DYCE and MACLISE. As Keeper (1843–7) and later Director (1855–65) of the NG he pursued an adventurous policy acquiring important Italian Primitives. He was an influential President of the ROYAL ACADEMY 1850–65. WV
□ D. Robertson, *Sir Charles Eastlake and the Victorian world* (1978)

Edwards, Edward *see* ROYAL ACADEMY: 19C.

Easter sepulchre at Hawton, early 14c.

Edwards, Lionel *see* SPORTING PAINTING

Egg, *Past and Present*, No.3, 1858 (Tate).

Egg, Augustus Leopold (1816–63) began as a painter of historical genre scenes. A friend of FRITH and DADD, with them *c.*1838 he established the CLIQUE. Later he was influenced by the PRE-RAPHAELITES and produced finely staged scenes of modern life, notably *Past and Present* (1858; Tate). WV
□ Treble (1978)

Egley, William Maw (1826–1916) was a HISTORY and genre painter. The son of a miniaturist, he painted small, highly worked scenes from Shakespeare and Molière. He is best known today for his detailed pictures of modern life, particularly *Omnibus Life in London* (1859; Tate). WV
□ Maas (1969)

Egremont, Sir George O'Brien Wyndham, 3rd Earl of (1751–1837) was one of the few aristocratic collectors to buy contemporary British paintings and sculpture on a large scale in the early 19c. He was a particular friend and patron of *TURNER (who had a studio at Petworth, Egremont's country house), and he also bought works by FLAXMAN, FUSELI, and – most unusually – BLAKE. The collection is largely intact and can still be seen at Petworth. DB
□ *Apollo*, Petworth no. (May 1977)

'Eidophusikon' *see* LOUTHERBOURG

Eleanor Crosses A set of monumental crosses commissioned by Edward I after the death in 1290 of his queen, Eleanor of Castile, to mark the resting places of her bier on its journey from Harby (Notts.) to Westminster. In this he was emulating the lavish funeral arrangements of the French king Louis IX, who had died in 1270. Of the original 12 crosses, each incorporating statues of the Queen, only 3 are still standing: at Waltham, Hardingstone and Geddington.

The accounts, which survive for 1291–4, show that the figures on the Waltham Cross were (like those on the Charing Cross, the most expensive) by Alexander of Abingdon, and that those on the Hardingstone Cross were carved by William of Ireland and transported from London in 1292. The swaying poses and gracefully arranged drapery of the Waltham and Hardingstone Eleanors bear witness to a new development in English sculpture, analogous to that seen in the WESTMINSTER RETABLE. The figures on the Geddington Cross, which is not mentioned in the existing records and probably dates from 1294–7, show a greater sense of verticality in their drapery treatment,

Statue of Eleanor of Castile on the **Eleanor Cross** at Hardingstone, by William of Ireland, 1291–2.

anticipating the style of later sculpture in the midlands.

The Eleanor Crosses are also important for their repertoire of ornamental motifs, such as the ogee arch which appears on the Harding-stone Cross and became a prominent feature in DECORATED architecture. ND

□ Stone (1972), 142–7; J. Bony, *The English Decorated style* (1979), 20–22

Elgin Marbles (BM) The marble reliefs from the Parthenon acquired by Lord Elgin in 1801–3 and purchased by the state in 1816 formed the first English collection of original Greek sculpture. They clarified understanding of the Greek classical style, previously based upon Roman/Late Hellenistic copies. Although admired by sculptors, particularly CHANTREY and WESTMACOTT, as examples of 'nature in the grand style', they evoked a limited stylistic response despite their central role in the aesthetic-critical debate 1806–16. An early example of their influence is *Hercules taming the Thracian Horses* (1816; London, Royal Mews) by W. Theed the Elder (1764–1817). The Marbles also influenced artists other than sculptors, e.g. Albert MOORE and Frederick WALKER. *See also* ★ALMA-TADEMA. AY

□ J. Rothenberg, *'Decensus ad terram'* (1977)

Elizabeth I, Queen 1558–1603 (b.1533) Portraits of the Queen were produced in quantity and eagerly collected by her subjects from the time of her accession. Such was the demand and, apparently, the low quality of the images early in the reign that in 1563 a proclamation was drafted decreeing that only portraits of a type personally approved by her were to be produced. The later portraits, with their elaborate symbolism, were at a greater remove from the physical appearance of the monarch.

Images of Elizabeth reflect the praises lavished on her by the courtly *literati* and contemporary pageantry, in which the cult of the Virgin Mary was replaced by that of the Virgin Queen, who was adored as Diana, Astraea, the rose or the phoenix. The *Sieve Portrait* (c.1580; Siena) represents her as a Roman Vestal Virgin, celebrated for her chastity of which the sieve was a symbol; while in the *Rainbow Portrait* (Hatfield) a complex web of symbols is woven around the conceit that the Queen is the sun without which the rainbow of peace cannot appear. In this late portrait Elizabeth appears with an un-shadowed, unwrinkled face and loosened hair, as she does in some ★MINIATURES by Nicholas HILLIARD, who records an important con-versation in which the Queen expressed her preference for being portrayed without any shadowing in the face.

The portraitist George Gower (d.1596) attempted unsuccessfully in 1584 to gain a monopoly of large-scale portraiture of the Queen, but differing types continued to appear, one of the most striking being the intensely hieratic *Ditchley Portrait* (NPG). In this image, attributed to GHEERAERTS, the sun appears to dispel a storm while the Queen stands on a map of England, her feet by the site of Ditchley, where an entertainment had been given in her honour in 1592 (*see* ★PORTRAIT PAINTING: 16C.) SF

□ R. Strong, *Portraits of Queen Elizabeth I* (1963)

embroidery (medieval) *see* OPUS ANGLICANUM

enamels, in which colours are fused by heat onto a metal surface, were a specialized aspect of the medieval metalworker's craft. Colours in powdered form (made by heating together and then grinding glass–flint or sand, red lead, and soda or potash, with a metallic oxide as a colouring agent) are placed separately on a prepared metal base and fired. When cool the surface is polished. The difference in techniques lies chiefly in the way the metal base is prepared.

During the Romanesque period the favoured technique was *champlevé* ('raised field'), on copper or bronze, in which the design is gouged out leaving thin ridges which separate the enamel colours. Notable survivals in this

Pediment figures from the **Elgin Marbles**, drawn by Benjamin Robert Haydon in 1806 (BM).

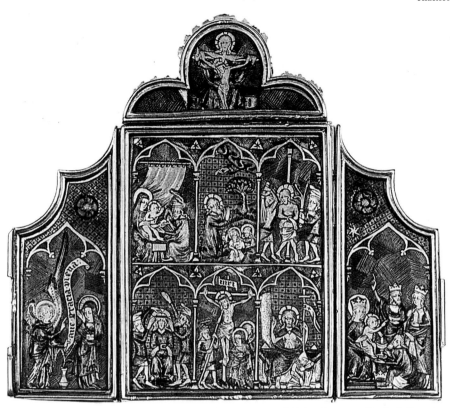

Gothic *basse-taille* enamel miniature altarpiece, the Campion Hall Triptych, *c.*1350 (Oxford, Campion Hall, on loan to V&A).

technique are 7 plaques of the 12c. showing the lives of SS. Peter and Paul, probably from a series decorating a reliquary (Dijon; Lyon; V&A; New York, Met.; Nuremberg), and 3 ciboria (V&A; New York, Pierpont Morgan Lib.). All are indebted to work from the Meuse Valley in Belgium, a major centre of enamel production, but their iconography is distinctively English, and compares with contemporary illuminated manuscripts, sculpture and wall-painting.

In the Gothic period, *basse-taille* enamelling on silver or gold became fashionable. In this more sophisticated technique a design is engraved on the metal in varying degrees of depth and remains visible through a layer of translucent enamel.

A late Gothic technique is *émail en ronde bosse*, or encrusted enamel, in which opaque and translucent colours are enamelled onto objects in the round or in high relief, usually of gold (*see* ★GOLDSMITHS' WORK).

See also RELIQUARIES. MCa

□ M. Chamot, *English medieval enamels* (1930); P. Lasko, *Ars sacra* (1972); M. Campbell, *Medieval enamels* (1983)

Romanesque *champlevé* enamel plaque of St Paul, *c.*1170–80 (V&A).

engraving is the art of incising lines into a copper or steel plate by the use of a burin. Unlike ETCHING acid is not required, though in the 18c. in England etching was often used as the preliminary stage of an engraving. The skills required of an engraver needed a long apprenticeship, during which practitioners developed a formalized system of cross-hatching, flicks and parallel lines which could allow the printing of thousands of impressions. The process was largely used for reproduction rather than the production of original works.

Not until the 18c. did British engravers match the skill of their Continental counter-parts (*see* WOOLLETT). VERTUE was the first of many engravers to complain of the technique's difficulties while vaunting its superiority compared with easier modes such as MEZZO-TINT. *See also* EVELYN; FAITHORNE. RG
□ Griffiths (1980)

Epstein, Jacob (1880–1959) is a major figure in British sculpture this century, at least from a historical standpoint, for almost single-handedly he established modernist principles as the common currency in public as well as domestic sculpture. Not surprisingly, his career was marked by a series of public scandals, beginning with the unveiling of his tomb of

Epstein, torso from *The Rock Drill*, bronze, 1913–14 (Tate).

Oscar Wilde in Paris in 1911. Influenced by the fascination with primitive art then sweeping Parisian studios, Epstein abandoned the delicate style of his early modelled works, as seen in the Rodinesque *Baby Awake* (1902–4; Shinman Coll.), for the crudely 'primitive' manner of carving epitomized by the *Figure in Flenite* (1913; Tate). Themes of sexuality and pro-creation dominate these years, though in the *Rock Drill* (c.1914; destroyed) Epstein elevated the archetypal 'modern man', the industrial labourer. Cubism and its offshoots never really engaged him, and after this tentative foray he reverted to a simplified stylization for the monumental carvings on mythic or religious subjects that he was to execute intermittently throughout his later life.

By contrast, his modelled busts were in great demand from the 1920s on, and works like the *Vaughan Williams* (Arts Council), in which his love of rhetoric and baroque exuberance are kept at bay, are amongst his finest sculptures. He was not interested primarily in psychology but in physiognomy and emotion, and in this respect (as in others) Epstein belongs as much to the 19c. as to the 20c. Through his great sensitivity as a modeller Epstein imparts a vivacity and immediacy to these portraits seldom equalled in modern times. In carving he never attained a comparable skill, and even in his best works, like *Elemental* (1932; Shinman Coll.), he tends to bluff his way through. *See also* LEWIS, W.; *SCULPTURE: 20C.; VORTICISM.
 LC
□ J. Epstein, *An autobiography* (1955); R. Buckle, *Jacob Epstein, sculptor* (1963)

Ernest, John *see* CONSTRUCTIVISM

Etchells, Frederick (1886–1973) was initially part of the BLOOMSBURY circle, and by 1913 he had begun to adopt the broad open planes of Cubist painting. He joined the VORTICISTS in 1914 and his pictures, often of urban subjects, became increasingly abstracted in form. He was a member of GROUP X, then gave up painting in the 1920s and became an architect. JB
□ Cork (1975–6)

etching differs from ENGRAVING in that the lines are not laboriously incised with a burin but drawn through a protective layer of wax and then 'bitten' by corrosive acid. The method is fairly easy to learn and more akin in its freedom to drawing, and thus has always been

popular with painters and with AMATEURS (*see* e.g. John *CLERK OF ELDIN).

Etching was established in England by *HOLLAR in 1636, and widely practised in the 18c., when its range was enlarged by the invention of AQUATINT. In the later 19c. some artists elevated it to the status of a cult (*see* *ETCHING REVIVAL). RG

□ Griffiths (1980)

Etching Revival is a loose term of description for the change which took place in England during the 1860s from the precise, linear etchings used principally to illustrate literary subjects to a more open, French-inspired approach, based on direct observation of nature. WHISTLER settled in England in 1859 and, influenced particularly by the Barbizon School, produced work which combined free-flowing lines with detailed description, the deeper tones conveyed by touches of drypoint and the open plate area used to suggest light. LEGROS followed Whistler to England in 1863 and together with Whistler's brother-in-law Seymour HADEN, they revived interest in the medium, culminating in the formation of the Royal Society of Painter-Etchers and Engravers in 1880. Through lectures, a multitude of publications and technical demonstrations, the status of printmaking was enhanced as never before. The ritual of editions, signing, mounting and framing was encouraged by dealers and followed by small collectors, anxious to make a safe investment. As SICKERT pointed out in his 1912 article, 'The Old Ladies of Etching-Needle Street', much uninspired, amateurish work was produced, and the reputation of most British painter-etchers did

Etching Revival: Seymour Haden, self-portrait at work, 1862.

not survive the crash of the art market in 1929–31. *See also* CAMERON; HAYTER. CF

□ W. R. Sickert, 'The Old Ladies of Etching-Needle Street', in *English Review* (Jan. 1912), repr. in O. Sitwell, ed., *A free house* (1947); E. S. Lumsden, *The art of etching* (1925)

Etty, William (1787–1849) aimed to produce grand style HISTORY paintings as advocated by Reynolds. Strongly influenced by Rubens and the Venetians, his pictures tend to a voluptuous and decorative display of bodies and colours, as in *Youth on the Prow and Pleasure at the Helm* (1832; Tate), though he sought to create works that were morally uplifting and even classical in form. He was a life-long attender at the ROYAL ACADEMY life-classes, and is the most celebrated painter of the nude in British art. JS

□ D. Farr, *William Etty* (1958)

Euston Road School was the name given by Clive BELL to a group of painters and students at the School of Drawing and Painting in London, which existed from October 1937 to the summer of 1939, and it became a generic description of a certain style for a decade or so thereafter. The School opened at 12 Fitzroy Street, and moved to 314/316 Euston Road in February 1938. ROGERS, COLDSTREAM and PASMORE were the founding teachers, with Graham BELL 'very close to the Prospectus'. They proposed an objective approach to realist painting inspired by Cézanne and Degas, as opposed to 'the pseudo-realism of the Royal Academy and kindred societies'. 'Euston Road' realism became associated with social consciousness prior to World War II. The School and its circle were dispersed by the war, but the single-minded researches of Coldstream and Pasmore during the war years produced a new dialectic about objectivity in painting, which was pursued when they reconvened at the Camberwell School of Art in 1945, and were joined by Rogers, GOWING, John Dodgson (1890–1969) and B. A. R. Carter (b.1909). Here a second generation of students learned their open-minded spirit of enquiry. *See also* LANYON; STOKES. BL

□ B. Laughton, *The Euston Road School* (1985)

Evans, Myfanwy see AXIS; PIPER

Evelyn, John (1620–1706) is, like Pepys, best remembered for his Diary. It provides a fascinating description of collections he visited

abroad during the Civil War, post-Restoration meetings with other men of letters, and personal observations on artists such as BARLOW, FANELLI, GIBBONS, HOLLAR and LELY. A great admirer of contemporary French engravers and owner of an impressive collection of prints, in his indigestible *Sculptura* (1662) he emphasized the importance of engraving as a reproductive medium and introduced his readers to the new technique of MEZZOTINT. *See also* ARUNDEL.

DD

□ Hind (1923); Whinney and Millar (1957)

Evesham, Epiphanius (1570–*c*.1633) was the first English-born sculptor of any character, introducing elements of emotional intensity into the standard repertoire of English tomb sculpture. A recusant, working mainly for Catholic patrons, he trained in Richard Stevens's Southwark workshop. Contact with French Mannerist art when working in Paris 1601–*c*. 1614 is evident in the monument to Sir Thomas Hawkins (1618) at Boughton-under-Blean (Kent), which includes an unusual relief of Hawkins's daughters graphically mourning his death, a theme developed in greater depth in the monument to Lord Teynham (1632) at Lynsted (Kent). *See also* BRASSES. AY

□ Esdaile (1946); Whinney (1964)

Evesham, detail of the monument to Sir Thomas Hawkins in Boughton-under-Blean church, 1618.

Eworth, Hans (1520–?74), of Antwerp, is first recorded in England in 1549, though variant spellings of his name make documentation uncertain. He is now credited with a coherent group of pictures bearing the monogram 'HE' formerly associated with Lucas de Heere. Notable is the portrait of Sir John Luttrell as a sea god, alluding to peace with France (1550; London, Courtauld). More typical of Eworth's combination of pale but strongly characterized

Eworth, *'Frances Brandon Duchess of Suffolk and Adrian Stokes'*, 1559 (priv. coll.).

faces with sumptuous costume and jewellery is the half-length double portrait called *Frances Brandon Duchess of Suffolk and Adrian Stokes* (1559; priv. coll.). SF
□ Strong (1969)

F

Faed, Thomas (1826–1900), the younger brother of **John Faed** (1820–1902), trained in Edinburgh, then spent most of his life in London, where he was one of the most successful painters of his time. He worked in a vein of sentimental genre ultimately derived from WILKIE. His first success was *The Mitherless Bairn* (1855; Melbourne), which provided the model for many of his later compositions. DM
□ Caw (1908); Irwin (1975); M. McKerrow, *The Faeds* (1982)

Faithorne, William (*c*.1616–91) was the most accomplished English portrait ENGRAVER of the 17c. His early plates, notably those after DOBSON, are very broadly executed, but his style became more refined following a period in Paris at the end of the 1640s. His engravings are based on his own drawings (e.g. *John Milton*, 1670), or on paintings by such artists as LELY and VAN DYCK, which he usually adapted to the format of a bust in an oval. He also engraved many portrait frontispieces, and made a number of independent portrait drawings, most notably *John Aubrey* (1666; Oxford, Ashmolean). RG
□ L. Fagan, *Descriptive cat. of the engraved works of William Faithorne* (1888); Godfrey (1978)

fancy pictures were a type of painting, popular in the late 18c., combining portraiture and genre, in which idealized peasants are engaged in rural pursuits. The term was used by REYNOLDS to describe ★GAINSBOROUGH's rustic scenes inspired by Murillo. BA
□ Waterhouse in *Burl. Mag.*, LXXXVIII (1946), 134–40

Fanelli, Francesco (fl.1609–62/75), sculptor, was born in Florence at an unknown date and is first documented working in Genoa in 1609/10, and again in 1620 and 1627. Later, probably in 1631, he came to England, and is recorded in the service of CHARLES I by 1635. In about 1640

small BRONZES by Fanelli were inventoried in the King's collection (Royal Coll.). In 1640 he made for William Cavendish, Earl (later Duke) of Newcastle a bronze bust of Charles, Prince of Wales, and probably at about the same time a set of 11 small bronzes, all with equine or equestrian subjects. (The bust and 2 of the bronzes survive at Welbeck.) At some time after 1641 he left England and appears to have settled in Paris, where his book of fountain designs, *Varie Architetture*, was published in 1661. He was still living in 1662, but dead by 1675.

Best known for his statuettes, produced in great quantities, he was also responsible for some sets of bronze reliefs designed for mounting in cabinets. The ascription to him by John EVELYN of the 'Diana' fountain, formerly at Hampton Court and now in Bushey Park, has been shown to be erroneous. Fanelli's activity as a maker of monuments is problematic, the one documentary reference to such activity being in the will of 1641 of Thomas, Earl of ARUNDEL, who specified that Fanelli should make his tomb. Because of the war, this was not executed. Among the many undocumented monuments in England popularly ascribed to Fanelli, only those of Sir Robert Ayton in Westminster Abbey, London (1637/8), and Lord Treasurer Weston (d.1636) in Winchester Cathedral would actually appear to be his work. AFR
□ J. Pope-Hennessy, *Essays on Italian sculpture* (1968); A. Radcliffe and P. Thornton in *Connoisseur*, CXCVII (1978), 254–62

Farington, Joseph (1747–1821) was a pupil of Richard WILSON and the ROYAL ACADEMY Schools. Although he painted landscapes in oil, his reputation rests on topographical pen, ink and wash drawings, the result of many sketching tours, the best of which have something of the calligraphic touch of CANALETTO. He settled in London in 1781 and soon after began to play an important role in the politics of the ROYAL ACADEMY (he became RA in 1785). His extensive *Diary* is the best source of gossip and information about the London art world between 1793 and 1821 (*see* e.g. LAWRENCE). BA
□ W. Ruddick, *Joseph Farington* (exh., Bolton, 1977); Farington, *Diary* (1978–)

Farnborough, Lady Amelia *see* AMATEUR ARTISTS

Ferguson, William Gouw (*c*.1633–*c*.1690) was born in Scotland and may have trained there, though he was established in The Hague while still young. Best known as a painter of still-lifes, he also painted capricci in the Dutch Italian manner (e.g. at Ham House). DM
□ Brydall (1899); Caw (1908); Apted and Hannabus (1978)

Fergusson, J. D. *see* SCOTTISH COLOURISTS

Ferneley, John *see* MARSHALL

Fielding, Anthony Vandyke Copley (1787–1855), one of a large family of WATERCOLOUR painters, was a prolific exhibitor at the Old Water-Colour Society, of which he became President in 1831. His early work is in John VARLEY's manner, but he later absorbed TURNER's influence, especially noticeable in his MARINES. He taught RUSKIN watercolour. He also practised in oil. AW
□ Hardie, II (1967)

figurative painting has provoked much fierce polemic in Britain in recent years. From the 1960s the prevailing wind, blowing from America, persuaded many that abstraction was the only art which mattered. The reaction, when it came in the late 1970s, was sharp, and young figurative artists who had felt stigmatized as backward children joined hands with elderly surviving social realists, Marxist and populist critics, and life-room diehards, as well as 2 painters often associated with POP ART, HOCKNEY and KITAJ. In his influential exhibition 'The Human Clay' at the Hayward Gallery in London (1976), Kitaj seemed to espouse a revival of traditional drawing disciplines; other exhibitions emphasized function ('Art for Whom'; Arts Council, 1978) or subject-matter ('Narrative Painting'; Bristol, Arnolfini/etc., 1979). Meanwhile many previously marginal reputations – such as Beckmann and Balthus in Europe, or SPENCER and BURRA in England – were incorporated within a newly legitimized figurative tradition.

By 1980 it was widely recognized that the various kinds of art that had been jammed into the spare room marked 'figuration' had begun to separate out, from the imagery of fantasy and dream exemplified in Ken KIFF to the re-creation of the single figure in the huge magisterial watercolours of Leonard McComb (b.1930). A series of brilliant interviews by

Peter Fuller (collected in *Beyond the Crisis in Modern Art*, 1980) and the professorship of Peter de Francia (b.1921) at the ROYAL COLLEGE OF ART were other factors in creating a new climate, hostile to avant-gardist strategies. But all have been outflanked by the success of so-called 'New Image' painting, where figurative and expressionist elements have been appropriated within a new international avant-garde style. *See also* COLDSTREAM. TH

Fildes, Luke (1843–1927) learned engraving and painting at a mechanics' institute, the South Kensington Schools and the ROYAL ACADEMY. In 1866 he began to draw for WOOD-ENGRAVING, first as a corrector of unengraveable drawings, then as a contributor to literary periodicals. His *Houseless and Hungry* contributed considerably to the success of the first issue of the GRAPHIC in 1869. He turned it into an exhibition painting in 1874. Primarily on the strength of his short association with *The Graphic*, he has been thought of as a social realist. His later subject paintings, however, are predominantly rural, and include many Venetian genre scenes. He was one of a number of prosperous artists who had houses purpose-built by leading architects in Melbury Road, Kensington (others were Marcus Stone, WATTS, and Holman HUNT). From the mid 1880s he was a successful society portrait painter, and he became RA in 1887. TG
□ Farr (1978)

Finlay, Ian Hamilton (b.1925) is a Scottish poet who has since 1962 created a highly individual form of concrete poetry which relies usually on single words or word-clusters within different visual settings. At his Wild Hawthorn Press since 1961 he has produced innumerable pamphlets and cards in which words and image play an equal part. His most dramatic work has been the cultivation of an emblematic garden at his house, Stonypath, now Little Sparta (Dunsyre, Lanarkshire). Here inscribed stone objects are intended to provoke reflection upon the relationship between the modern and the classical worlds, often by the placing of modern symbols, such as aircraft carriers, in antique context. His stance towards the world has been strongly combative. DB
□ *Ian Hamilton Finlay* (exh., Arts Council, 1977)

Fisher, Mark *see* NEW ENGLISH ART CLUB

Fildes, *Houseless and Hungry*, wood-engraving from *The Graphic*, 1869.

Fitzroy Street Group *see* BEVAN; CAMDEN
TOWN GROUP; GINNER; PISSARRO

Flanagan, Barry (b.1941) is amongst the most
imaginative and enquiring sculptors of his
generation. There is no family likeness between
his works – abstract and figurative, modelled,
carved or constructed, in a wide variety of
materials – yet unity is given by certain
consistent attitudes. They are characterized by a
vigorous questioning of dogmas and by
statements at once witty and profound, as in his
series of anthropomorphic hares which have a
tragic quality without heroics or self-
consciousness. In *a nose in repose* (1977–9; Tate)
the orifice appears to be reclining on its side on a
neat pile of blocks; its form is a found one, the
carving being restricted to the etching of a line,
whose shape seems little related to the object or
to the surface. Although his ideas initially had
greater affinity with European developments,
as seen in an exhibition like 'When Attitudes
Become Form' (Berne/ICA, 1969), Flanagan's
insouciant fertility has proved inspiring to
many British artists, including POPE, GILBERT
AND GEORGE, and CRAGG. *See also* CONCEPTUAL
ART. LC
□ *Barry Flanagan* (exh, Venice Biennale/
London, Whitechapel, 1982)

Flanagan, *a nose in repose*, stone and wood, 1977–9
(Tate).

Flaxman, John (1755–1826), sculptor, was the son of a cast-maker and was first employed by Wedgwood, for whom he still worked in Italy 1787–94. By 1800 he had a reputation on the Continent greater than had been enjoyed by any earlier British artist, on account of the engravings by Tommaso Piroli of his drawings illustrating Dante, Homer and Aeschylus, with their drastic but eloquent simplifications of form, denial of space and purity of line. His relief style possesses similar qualities and was highly influential for its rejection of pictorial effects (*see* ★SCULPTURE: NEOCLASSICAL).

By 1810, when he was appointed Professor of Sculpture at the ROYAL ACADEMY, it was clear that, like BANKS, he would not fulfil his early promise, and obvious that he would not enjoy the commercial success of his elders BACON and NOLLEKENS. He lacked both commercial flair and physical strength, failed to keep his best students, or to engage good assistants, permitted his models to be badly executed, and often did not conceive them on a large enough scale: his more heroic ideas are successful in inverse proportion to their size. He also had little interest in portraiture. Much of his late work is dull, and some disgraceful; but at his best, as in the simplest of his designs for silverware adorned with Greek pastorals, or in his marble reliefs of floating pagan nymphs or Christian souls, or in his tender domestic groups and devotional figures, he was without equal in Europe. The 'chastity' admired in his art (a matter both of pious sentiment and of archaizing taste) anticipated the revivalist aesthetic and the religiosity of the mid 19c. and guaranteed his posthumous reputation.

See also BAILY; BLAKE; EGREMONT; ST PAUL'S; SCULPTURE: EARLY 19C.; ★TURNER.　　NP
□ D. Bindman, ed., *John Flaxman* (1979); D. Irwin, *John Flaxman* (1979).

Flaxman, Achilles lamenting the death of Patroclus, from *The Iliad*, engraved by Piroli, 1793.

Flicke, Gerlach (d.1558), from Osnabrück in Germany, was working in England from *c*.1546, when he painted a portrait of Archbishop Cranmer (NPG) which recalls **Holbein**'s portrait of Archbishop Warham. A diptych including a self-portrait (1554; sold Sotheby's 1975) suggests Flicke was also skilled in small-scale portraiture.　　SF
□ Strong (1969)

Flint, Sir William Russell *see* ROYAL ACADEMY: 20C.

Flower, Barnard (d.1517) was one of the leading glass-painters of the early 16c., and the first foreigner to hold the office of King's Glazier, from *c*.1505 until his death (*see* LONDON SCHOOL OF GLASS-PAINTING). Of German or Netherlandish origin, he was in England by 1496 and obtained important commissions, including the glazing of the Savoy Hospital, London. At the time of his death he had been employed at King's College Chapel, Cambridge, for 2 years and some of the glass there (*see* ★STAINED GLASS: TO 1550) must be by him, although a precise attribution has not proved possible.　　RM
□ H. Wayment, *The windows of King's College Chapel Cambridge* (1972)

Foley, John Henry (1818–74), the most successful of Victorian portrait sculptors, trained in his native Dublin before moving to England in 1834. He introduced and perfected a distinctive naturalism which brought him acclaim and, most notably, the commission for the statue of the Prince and the group of *Asia* on the ALBERT MEMORIAL (*see* ★SCULPTURE: VICTORIAN). His statues of Albert (1866–74; London, Dublin, Birmingham, Cambridge) reveal a refinement of detail in formal costume; his equestrian *Hardinge* (1858) and *Outram* (1864), both originally in Calcutta, were prized for spirited naturalism and energy.　　BR
□ Read (1982)

fonts (medieval) Fonts are known to have existed at least from the 9c., but few pre-Conquest examples survive. ROMANESQUE fonts show considerable diversity. Most are round or chalice-shaped, set on a single pedestal or on 4 or 5 short columns. Figural or animal supports occasionally occur. Their decoration includes foliate ornament, architectural elements, figures, and narrative scenes, sometimes com-

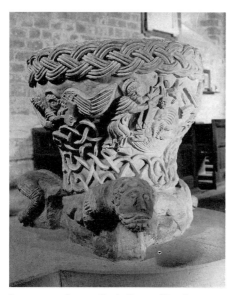

Romanesque **font** at Castle Frome (Here.), *c*.1140.

bined to form a highly ornate ensemble. Historiated fonts, while they are occasionally found on the Continent, are a particularly English feature. Scenes from the Life of Christ and figures of the Apostles are the most common; but scenes from the Life of St Nicholas, Virtues and Vices, the Labours of the Months and Trees of Life also occur. While the majority of English Romanesque fonts were carved from large blocks of freestone, a small number of square fonts carved in black Tournai marble were imported. No less remarkable for their technical accomplishment are those fonts cast in lead, either as sections to be welded together or as sheets to be worked into their final form.

The standard 13c. font is made of Purbeck marble, much plainer in appearance, and without historiated subjects. Fonts of the late 13c.–early 14c. reflect the preference for rich ornament seen in contemporary DECORATED architecture, but rarely include figure scenes. Figure subjects once again become common from the late 14c. until the Reformation. Reliefs depicting the Seven Sacraments were used to decorate fonts in East Anglia, such as that at Walsoken (1544), one of the last genuine Gothic fonts. JW+ND

□ F. Bond, *Fonts and font covers* (1908); C. H.

Eden, *Black Tournai fonts in England* (1909); G. Zarnecki, *English Romanesque lead sculpture* (1957); Stone (1972), 87–90, 222

Forbes, Stanhope Alexander (1857–1947) came to be regarded as founder and leader of the ★NEWLYN SCHOOL: his repeated successes at the ROYAL ACADEMY in the later 1880s and his ability to get on well with both the artists and the fisher folk were vital to the cohesion of the community. Trained at the RA Schools and in Paris and Brittany, he was no friend of WHISTLER or SICKERT, who he feared would destroy the NEW ENGLISH ART CLUB. His conscientious devotion to open-air painting was, in his own words, 'a breath of fresh air in the tired atmosphere of the studios'.

His wife, **Elizabeth Forbes**, née Armstrong (1859–1912), was also a member of the Newlyn School. FG
□ *See* NEWLYN SCHOOL

Forster, Noel (b. 1932) has from the beginning been a non-figurative painter, though references to natural phenomena are ever present in his works. Since 1964 these have generally been based on a grid formed by freehand yet systematic touches of paint which allow for a progressive 'error' to build up between the ostensible intention and the final result. Despite the seemingly narrow premises of his work Forster has achieved a remarkable freshness and variety of effect, revealing a strong commitment to the vitality of painting and its history. He is better known abroad than at home.
 DB
□ *Noel Forster* (exh., Oxford, Mus. Modern Art, 1976)

Foster, Myles Birket (1825–99) trained as a WOOD-ENGRAVER, and by the 1850s was known as an illustrator of books of poetry. By 1860 he had established himself as a watercolourist, and regularly exhibited pretty rustic subjects which now epitomize late Victorian watercolour painting. AW
□ Hardie, III (1968)

Foundling Hospital, London, established by Captain Coram in 1739, quickly became a rendezvous for fashionable society. In the absence of public picture galleries and exhibitions, HOGARTH persuaded colleagues to donate works of art, thus revealing the merits of British rather than Continental painting.

Apart from his portrait of the founder (still in the Hospital), Hogarth contributed *Moses brought before Pharaoh's Daughter*, one of 4 large Biblical histories which decorated the Court Room, depicting the theme of mercy towards children. Other donors included GAINS-BOROUGH, HAYMAN, HIGHMORE, WILSON and RAMSAY. BA
□ B. Nicolson, *The treasures of the Foundling Hospital* (1972)

Frampton, Sir George *see* NEW SCULPTURE; SCULPTURE: VICTORIAN

Francia, François Louis Thomas (1772–1839) was an associate in Dr MONRO's academy and an early imitator of GIRTIN. He exhibited watercolours and taught drawing in London before retiring to his native Calais in 1817. BONINGTON was his pupil, and he remained an important link between French and English artists in the 1820s. PN
□ Hardie, II (1967)

Francia, Peter de *see* FIGURATIVE PAINTING

Freud, *Francis Bacon*, 1952 (Tate).

Francis, John *see* THORNYCROFT

Frederick, Prince of Wales (1707–51), son of George II, arrived in England in 1728 and was notably more sympathetic towards Continental art and architecture than most of his father's court. Contact with the ROCOCO style at the Prussian court established the young Prince's tastes and in England he favoured foreign artists, including ★MERCIER, AMIGONI and VAN LOO. Several of his closest political associates, e.g. Lords Lyttelton and Chesterfield, were also devotees of the Rococo. BA
□ S. Jones, *Frederick, Prince of Wales and his circle* (exh., Sudbury, Gainsborough's House, 1981)

Free Society *see* SOCIETY OF ARTISTS

fresco The technique, known since antiquity, of painting pigment dissolved in water onto wet lime plaster produces a permanently fixed image so long as there is no damp in the wall. It was used in England in the Romanesque period, e.g. for ★WALL-PAINTINGS in the Holy Sepulchre Chapel of Winchester Cathedral. Later experiments, such as the murals by ROSSETTI and his friends in the Oxford Union, have been failures. The term is also used loosely to refer to paintings on dry plaster (*secco*). CH
□ J. Ward, *Fresco painting* (1909)

Freud, Lucian (b.1922) has, within the rich and varied field of English figurative painting, the most exact and penetrating eye of all, and is arguably the country's finest portraitist. His subjects have almost all been family or friends rather than celebrities, although the former have of course included colleagues such as BACON and AUERBACH. The intensity of his observation was initially conveyed with the discomfiting clarity of a miniaturist's technique even though the scale of the works could sometimes be quite large. This yielded in the late 1960s to a more direct and painterly handling, which, though it initially had a distractingly streaky appearance, has become more and more Rembrandtesque in its robustness. In the later commanding and confident nudes and portraits certain sinister elements present in former works have tended to disappear along with the pallid palette which gave his paintings of the 1950s such a doomed and haunted appearance. Some recently exhibited drawings from a sketchbook the artist made before he was 20 testify to his brilliance as

Frith, *The Railway Station* (Paddington), 1862 (Egham, Royal Holloway College).

a draughtsman. His occasional urban landscapes and flower pictures, attracting less attention than his work from the human figure, have yet to be fully appreciated. TP

□ L. Gowing, *Lucian Freud* (1983)

Frith, William Powell (1819–1909) achieved immense success as a genre painter. He began in the 1840s with scenes from humorous classics, then gradually turned to more recent literature. In 1854 he moved to a direct and panoramic portrayal of modern life with *Life at the Seaside* (Royal Coll.) and followed this with similar scenes, the finest being *The Railway Station* (1862; Egham, Royal Holloway College). He had few pretensions to greatness, though he took his role as a chronicler of modern life seriously. *See also* CLIQUE; GAMBART. WV

□ W. P. Frith, *My autobiography and reminiscences* (1887)

Frost, Terry (b.1915), a central figure in the ST IVES SCHOOL, started to paint aged 28 in a prisoner of war camp in Germany and later studied at Camberwell. His first abstracts date from 1949. His work of the 1950s and later sometimes evokes the gentle rocking of boats in harbour. Since *c.*1960 he has explored the interaction of saturated, vibrant colours usually in abstract shapes – circles, segments, triangles and squares. DBr

□ D. Brown, *Terry Frost* (exh., Arts Council/ South West Arts, 1976–7)

Fry, Roger Eliot (1866–1934), connoisseur, writer on art, painter, potter and designer, was from 1910 to his death recognized as the most influential art critic of his time in England. Scientific training at Cambridge was followed by the study of painting and art history in Paris and Italy. From 1903 he was closely associated with *The Burlington Magazine*; and from 1911 he was a central figure of the BLOOMSBURY Group. His role as an apologist for modern French painting was established when he organized the 2 celebrated Post-Impressionist exhibitions at the Grafton Galleries, London, in 1910 and 1912, introducing the work of Van Gogh, Gauguin, Cézanne, Matisse and Picasso to England. Practical involvement with the English avant-garde came with his founding in 1913 of the OMEGA WORKSHOPS, to which he contributed distinguished pottery and textiles.

Too often identified with the theory of significant form (*see* Clive BELL), in his later writings Fry modified his early emphasis on pure form and the relative unimportance of subject-matter in art: see, e.g. *Vision and Design* (1920). Important among his essays are *Giotto* (1900–1901), *An Essay in Aesthetics* (1909), *Art and Socialism* (1912), *Seurat* (1926) and his most substantial monograph, *Cézanne: a Study of his Development* (1927). Some of Fry's most enduring analytical criticism is found in his published lectures on French and British art (1932 and 1934); and his *Last Lectures* (1939) show his percipience when considering art

outside Western Europe. As a painter, Fry's later French landscapes combine sober colour and classic qualities of design. *See also* DOBSON, F. RS
□ V. Woolf, *Roger Fry* (1940); Q. Bell, *Roger Fry* (1964); F. Spalding, *Roger Fry* (1980)

Fullard, George *see* SCULPTURE:20C.

Fuller, Isaac (*c.*1606–72) studied briefly in France before returning to England and working in London and Oxford. His few portraits reveal a liveliness of execution and pose combined with an expressive use of gesture. He also produced altarpieces and decorative mythologies and published *Un Libro di Disegnare* (1654). DD
□ Waterhouse (1978)

Fulton, Hamish (b.1945) like Richard LONG trained at St Martin's School of Art, London, in the later 1960s and is also a sculptor whose work relates to walking. His art is about being out on the land and experiencing the landscape from the inside by walking through it. At some moment during a walk, which may be long and strenuous, Fulton decides that a particular view, which he photographs, contains the quintessence of his feelings about the walk. He presents his work in the form of photographs with brief texts. Fulton is essentially romantic, whereas Long, who imposes a configuration lightly on the landscape, is more classical in spirit. DBr
□ M. Auping in *Art in America* (Feb. 1983), 87–93

Fuseli (or **Füssli**), **Henry** (1741–1825), a painter of Swiss birth, was particularly noted for the expressive extremism of his paintings and drawings of mainly literary subjects, which were often thought to show signs of madness. In reality he was a serious and learned, though undeniably eccentric, man, who brought a unique sensibility to the British school of HISTORY painting.

His attitudes were formed in his native city, Zurich, where he was a pupil of the great literary scholar J. J. Bodmer and was drawn into a circle engaged in rediscovering writers of 'Genius' and imagination like Shakespeare, Milton and Dante. Though ordained as a Zwinglian minister in 1761 Fuseli became increasingly out of sympathy with that church, and a meeting with Rousseau in 1766 marked the end of his involvement with religion.

In 1764 he had made his first visit to London, to report literary developments to the Zurich circle. It was only in 1768, encouraged by REYNOLDS, that he determined to be a painter. He was in Italy 1770–78 and there fell under the spell of Michelangelo, whose stylistic influence was decisive. In Rome he became the major figure in an international group of artists which included BANKS and Alexander RUNCIMAN (see NEOCLASSICISM). He returned via Zurich to London, where he settled in 1780, and made friends with both intellectuals and bankers.

In fashionable London circles Fuseli projected himself as something of a Satanist, while at the same time advancing inexorably through the ROYAL ACADEMY: he was elected ARA in 1788, RA in 1790, was Professor of Painting 1799–1805 and again from 1810, and in 1804 became Keeper, from which position he taught a whole generation of students. His paintings were often sensational and highly personal, like

Fuseli, *Brunhilde watches Gunther, whom she has bound to the ceiling*, drawing, 1807 (Nottingham).

The Nightmare (exh. RA 1781; Detroit), and they attracted much attention, not always favourable (*see* GILLRAY). He was a fascinating conversationalist, and he persuaded many people of his seriousness as a history painter and of the necessity of choosing subjects from the great English authors like Shakespeare and Milton. He was a force behind the BOYDELL Gallery and in 1790 he began his most ambitious project, a Milton Gallery, to be entirely painted by himself. It opened in 1799 to a poor reception, but he was still able to sell a large proportion of the paintings to his wealthy friends.

Though his pictures are varied and imaginative in subject-matter and dramatic in expression, his painterly technique was limited; as a draughtsman, however, he was masterly, and there is a psychological intensity in his innumerable drawings which makes them especially compelling. He was attracted towards outlandish literary subjects, often involving female cruelty; many of the drawings are openly pornographic and sinister, and show a disturbing obsession with women's hair.

His private works seem not to have affected his serious reputation, which was confirmed in his lectures to the RA. Though they put up a strong case for the superiority of expression over beauty, and the legitimacy of depicting terror in art, the lectures are in most respects conservative, emphasizing the supremacy of the Greeks and the role of art as the luxury of a cultivated élite, rejecting its social or moral possibilities. His later years were relatively uneventful and he retained his reputation with young artists. However he was deeply despised by the Victorians (RUSKIN called him 'poor fumigatory Fuseli'), and only with the AESTHETIC MOVEMENT did his reputation begin to revive. *See also* BLAKE; EGREMONT; POLYAUTOGRAPH. DB

☐ G. Schiff, *Johann Heinrich Füssli* (1973); G. Schiff, *Henry Fuseli* (exh., Tate, 1975)

Fuseli, *The Three Witches*, after 1783 (Stratford-upon-Avon, Royal Shakespeare Theatre).

G

Gabo, Naum (1890–1977) was born in Russia, and after working in Paris, Moscow, Berlin and elsewhere came to England in 1936. At the 'Abstract and Concrete' exhibition in that year he was involved in the genesis of CIRCLE, which appeared in the following year. He contributed the editorial, 'The Constructive Idea in Art', in which he stressed that *CONSTRUCTIVIST art stood for 'a spiritual state of generation' and that the artist had 'absolute forms' at his disposal and therefore did not need to copy the external world. In 1939 Gabo moved to Cornwall (see ST IVES SCHOOL) and in 1946 he left for the USA.

Gabo's English work is distinctive. Constructions in plastic such as the model for *Spheric Theme* (c.1937; Tate) have more open, expansive and flowing lines than his earlier work and show his debt to the study of mathematical models in the Science Museum. *Kinetic Stone Carving* (1936; priv. coll.) betrays the influence of MOORE and HEPWORTH, while his use of webs of thread influenced them in turn. LANYON made constructions after seeing Gabo's Cornish works. AG

□ T. Newman, *Naum Gabo* (exh., Tate, 1976); Harrison (1981)

Gainsborough, Thomas (1727–88) was with Richard WILSON one of the founding fathers of the British landscape school in the 18c. and also one of the greatest and most original portrait painters of his day, rivalling even REYNOLDS. Unlike Wilson he did not adhere consciously to the classical tradition, but created works of a delicacy and poetic sensibility which caused CONSTABLE to say 'On looking at them, we find tears in our eyes and know not what brings them'. Though all his works are to a degree consistent in feeling, his work changed considerably as he moved from his provincial origins in Sudbury (Suffolk), spending long periods in Ipswich, Bath and London, where he finally achieved great eminence. About 1739, already, it appears, a prodigy, he was sent to London as a pupil of GRAVELOT who brought him into the orbit of ST MARTIN'S LANE, where he absorbed something of the French ROCOCO and both the elegance of HAYMAN and the directness of HOGARTH. By 1745 he had his own studio in London and in 1748 he presented to the FOUNDLING HOSPITAL a brilliant view of the Charterhouse.

He returned to Sudbury in 1748, remaining there until he moved to Ipswich in 1752. The masterpiece of the Sudbury period is undoubtedly *Mr and Mrs Andrews* (NG), which combines the genial quality of Hayman with a landscape of a naturalism he was never to surpass. At first his Suffolk paintings were strongly Dutch in flavour, showing the influence in particular of Jacob van Ruisdael, but by the mid 1750s he was moving towards a more French pastoral in which rustic lovers are often seen within a warmer and more sympathetic setting. His portraits on the other hand remain relatively conventional, in the HUDSON manner, and it is only towards the end of the Ipswich period that he began to experiment with ways of giving the flesh a greater vibrancy of touch.

With his arrival in Bath in 1759 Gainsborough began to throw off all vestiges of provincialism and make a reputation for himself as a portrait painter of facility and grace, working for more sophisticated patrons and gaining a wider experience of such great predecessors as Rubens and VAN DYCK whose works he could see in neighbouring country houses. His first great portrait in the Van Dyck manner was *Mrs Philip Thicknesse* (1760; Cincinnati), which is notable for the virtuoso handling of the drapery. Many of his Bath portraits, like that of *Sir Benjamin Truman* (c.1770; Tate) are distinguished by a four-square masculinity, but with an exquisite painterly touch.

Though he had difficulty in selling them he continued to paint as many landscapes as portraits, seeking an intense poetic response, not so much from observation of nature as from the inward contemplation of his own feelings for nature. His handling of landscape became more translucent and free, and the subjects more nostalgic and removed from the workaday. With his experience of paintings by Claude Lorrain and especially Rubens, the compositions became broader and more sweeping. His insistence on self-expression led him to disassociate himself from topographical painting, and his acute aesthetic sensibility made him more insistent on the precise placing of his work upon the wall. He was famous enough in 1768 to be invited to become a

Gainsborough, *Mr and Mrs Andrews*, *c*.1750 (NG).

founder-member of the ROYAL ACADEMY, but in 1773 he quarrelled with them over the hanging of his pictures. Such fastidiousness set him apart from most RA painters who were concerned to exhibit a 'bold stroke' in the manner of Reynolds.

The works of his London period, from 1774 until his death in 1788, were at first characterized by an expansiveness and monumentality in both portrait and landscape, presenting a conscious challenge to the greatest masters of the past in each genre. *The Watering Place* (exh. RA 1777; NG) was a direct response to the landscape paintings of Rubens, while *Mrs Graham* (Edinburgh, NGS), exhibited the same year, out-Van Dycks Van Dyck, yet remains distinctive in its shimmering colour. More sympathetic perhaps are his paintings of his musical friends like *Johann Christian Fischer* (exh. RA 1780; Royal Coll.), which is elegant and sophisticated yet also genial, recalling his own delight in playing and hearing music. The great achievements of his last years were in the integration of figure and setting in a series of group portraits, and in the development of 'FANCY PICTURES' in which rustic figures, usually children, are posed in a landscape or by a cottage door. These late pictures present a contrasting vision of the elegance of the town

Gainsborough, *Johann Christian Fischer*, exh. 1780 (Royal Coll.).

Gainsborough, *Peasant Girl gathering Faggots in a Wood*, 1782 (Manchester).

and the simple delights of rustic life which is at the heart of his own complex feelings; they generate a poetic melancholy which is enhanced by an ever greater freedom of brushwork. Though he attempted other genres – seascapes, Lakes views and even classical subjects – in his last works we are above all conscious of what Reynolds, in his Discourse XIV to the RA, described as 'his manner of forming all the parts of his picture together; the whole going on at the same time, in the same manner as nature creates her works'.

See also AQUATINT; *LANDSCAPE PAINTING: 18C.; LOUTHERBOURG. DB
☐ J. Hayes, *Gainsborough* (exh., Tate, 1980); id., *Gainsborough's landscape paintings* (1982); A. Corri in *Burl. Mag.* (Apr. 1983), 210

Gambart, Ernest (1814–1902) was born in Belgium and came to England first as agent for the Parisian dealers Goupils, before establishing his own business. Besides introducing the English public to French art, most conspicuously in the form of Rosa Bonheur, he achieved a virtually unrivalled position as dealer in High Victorian art (*see* e.g. ALMA-TADEMA). Many of the outstanding works of the period passed through his hands, and his associated print speculations – notably FRITH's *Derby Day* and Holman HUNT's *The Light of the World* – proved enormously profitable (*see* PRINTSELLING). Understanding the promotional power of conspicuous largesse, he entertained on a lavish scale before retiring in the early 1870s to sumptuous residences abroad. CF
☐ J. Maas, *Gambart* (1975)

Gardner, Daniel (*c.*1750–1805) established a fashionable practice as a portraitist in crayons (*see* PASTEL) and gouache in the early 1770s. He was briefly an assistant in REYNOLDS's studio, and many of his works employ the poses and compositional formulas of that master, in a more decorative idiom. BA
☐ H. Kapp, *Daniel Gardner* (exh., London, Kenwood, 1972)

Garrard, George (1760–1826), pupil and son-in-law of Sawrey GILPIN, was both a painter and a sculptor. His *plein-air* landscape sketches in oil (e.g. Oppé Coll.) and his bas-relief overdoors of exotic animal subjects (Southill) reveal honest versatility and even originality. In 1798 he secured a Copyright Act for sculptors – in emulation of Hogarth's for engravers – with the help of his staunchest patron, Samuel Whitbread MP. SD
☐ S. Deuchar, *Samuel Whitbread and British art* (exh., Mus. of London, 1984)

Garstin, Norman (1847–1926), an Irishman, was the intellectual member of the NEWLYN SCHOOL, an admirer of Manet and WHISTLER, a painter of superlative small landscapes, of rather strained exhibition pieces, and of one famous work, *The Rain it Raineth Every Day* (1889; Penzance Charter Trustees). FG
☐ *See* NEWLYN SCHOOL

Gaudier-Brzeska, Henri (1891–1915) began working in London in the circle of EPSTEIN and the future VORTICISTS in 1911. Though without formal training, he made a number of innovative carvings inspired by primitive art and some more conventional, modelled works of both figurative and animal subjects before his untimely death in the trenches. His achievement has been overshadowed by his colourful life, which formed, e.g., the subject of Ken

Gaudier-Brzeska, *Hieratic Head of Ezra Pound*, 1914 (priv. coll.).

Russell's film *Savage Messiah*, after H. S. Ede's biography. *See also* LEWIS, W.　　　LC
□ E. Pound, *Gaudier-Brzeska, a memoir* (1916); R. Cole, *Burning to speak, life of Gaudier-Brzeska* (1978)

Gauld, David *see* GLASGOW SCHOOL

Geddes, Andrew (1783–1844) had no formal training as a painter, which may account for his eclecticism. His production included large-scale HISTORY painting (e.g. *The Ascension*: London, St James Garlickhythe) and landscapes in the Dutch manner (Edinburgh, NGS), while his most important achievement was as a painter of portraits, particularly of cabinet size, e.g. that of his close friend WILKIE (Edinburgh, NGS).　　　DM
□ A. Geddes, *Memoir of the late Andrew Geddes* (1844); Brydall (1889); Caw (1908); Irwin (1975)

Geikie, Walter *see* SCOTTISH PAINTING

Gentileschi, Orazio (1563–1639) came to London in 1626 and remained until his death. His most notable commission was for the ceiling of the Queen's House at Greenwich, 9 canvases showing an *Allegory of Peace and the Arts under the English Crown* (these survive, damaged, in Marlborough House, London). Two further ceilings, for his protector the Duke of Buckingham's house in the Strand, and for Cobham Hall in Kent, are both lost. He painted many religious subjects, above all for CHARLES I and Henrietta Maria, but there is no direct evidence for the commissioning of individual mythological works.　　　DF
□ *The age of Charles I* (1972); R. Ward Bissell, *Orazio Gentileschi and the poetic tradition in Caravaggesque painting* (1981)

George III, King 1760–1820 (b.1738), as a young man studied architecture with Sir William Chambers and drawing with Joseph Goupy (*c*.1680–*c*.1768), and his accession was welcomed by artists who had received little encouragement during the preceding reign. After the purchase of Buckingham House in 1762 the King began collecting pictures, books, furniture and *objets d'art* on a grand scale, the most important single purchase being the collection of Consul Smith from Venice including 50 *★*CANALETTOS. Had this momentum been maintained, George III might have rivalled both Charles I and George IV. He had a scholarly taste in painting, preferring WEST for heroic HISTORY painting and RAMSAY, COTES and ZOFFANY for portraiture, and employing the marine painter SERRES. Joseph WILTON was appointed 'Sculptor to His Majesty' in 1761. The King's most important act of patronage was the foundation of the ROYAL ACADEMY in 1768.　　　BA
□ *George III collector and patron* (exh., London, The Queen's Gallery, 1974–5)

Gertler, Mark (1891–1939), painter, a contemporary of NEVINSON, SPENCER and Dora Carrington (1893–1932) at the SLADE 1908–12, entered BLOOMSBURY as an outsider with a strong individual personality. Born of poor Jewish immigrant parents, he was encouraged by ROTHENSTEIN and TONKS. Early works like *Jewish Family* (1913; Tate) have a sophisticated primitivism, with debts to both Picasso and the Italian Quattrocento. After 1917 he became less 'provincial' in his subject-matter and looked to Cézanne for structural forms (*Bathers*, 1917–18; priv. coll.), and to Renoir and Matisse for colour, but his tight-fisted technique and

thickly applied paint retained an earthy intensity of vision. BL

□ J. Woodeson, *Mark Gertler* (1972)

Gheeraerts, Marcus, the Younger (1561/2–1636) was brought to England from the Netherlands in 1567/8 and achieved success in the last decade of the 16c. with his decorative but sensitive portraits. The full-length *Sir Thomas Lee* (1594; Tate) includes a landscape background unusual for the period, while the bare-legged costume, intended to represent the dress of an Irish soldier, introduces a characteristic element of fantasy. The *Ditchley Portrait* of Queen ELIZABETH, rich in symbolism, is attributed to him (*see* ★PORTRAIT PAINTING: 16C.). Under James I Gheeraerts painted royal portraits, but, gradually eclipsed by the new wave of Netherlandish painters, produced appealingly humane portraits of gentry and scholars such as *Richard Tomlins* (1628; Oxford, Bodleian). *See also* OLIVER. SF

□ Strong (1969)

Gibbons, Grinling (1648–1721) was the major exponent of woodcarving in Britain, specializing in rich ornament of flowers, fruit and shells rendered with exquisite naturalism, and freed from architectural restraint. His large workshop also produced less accomplished bronze and marble sculpture. Born in Rotterdam, he came to England after training in Holland. According to VERTUE he worked in Yorkshire before moving to London where LELY recommended him to Charles II. However, EVELYN claims to have engineered an introduction to Wren and, more importantly, Hugh May, resulting in commissions for decorative woodcarvings for Windsor and Cassiobury 1677–82, and his appointment as Master Carver in Wood to the Crown. During the 1680s Gibbons's practice extended to include large-scale sculptural works, probably joint productions with Arnold Quellin (1653–86), e.g. *James II* (1686; London, Trafalgar Square). A major commission with Quellin was the altar of the Catholic chapel in Whitehall Palace (1685–6, dismantled 1688). The modified and refined Baroque of their joint productions gave way to Gibbons's clumsy classicism following Quellin's death, seen in the figure of Faith on the monument to John, Lord Coventry (1690; Croome d'Abitot).

As Master Sculptor to the Crown from 1684

Gibbons, detail of the Carved Room at Petworth (Sussex), *c.*1692.

Gibbons's most ambitious work was the monument to Sir Cloudesley Shovel (1707; London, Westminster Abbey), a pretentious composition which Joseph Addison found offensive in its depiction of the Admiral as 'a beau . . . reposing on velvet cushions'. Far more successful were smaller monuments where the decorative elements predominated. His last decade was spent on decorative carvings of consummate skill for Blenheim, Hampton Court and St Paul's. *See also* BIRD; NOST; SCULPTURE: 17C. AY

□ Gunnis (1953); D. Green, *Grinling Gibbons* (1964); Whinney (1964)

Gibson, John (1790–1866) was the main Victorian champion of Neoclassicism in SCULPTURE. Born in Wales, he studied in Rome under Canova, and remained working there. His conviction that all branches of sculpture (funerary monuments, portraiture, Ideal works) should imitate the practice of the ancients was not simply pedantic antiquarianism. He considered that the subjects of public commemorative statues should be

classically dressed to appear impressive and timeless (e.g. *Huskisson* (1836; London, Pimlico) and *Peel* (1852; London, Westminster Abbey)): any contemporary fashions were ephemeral. His *Narcissus* (1838; RA), though classical in subject and style, was based on direct observation of nature. His *Tinted Venus* (1851–6; Liverpool, Sudley) is exceptional in demonstrating his belief – not entirely unfounded – that the ancients coloured sculpture (*see* ★ALMA-TADEMA).

Gibson was respected for his strongly held principles and patronized by the royal family. He executed 3 portrait statues of Queen Victoria; 2 are classical (1849; Royal Coll.), the third less so in deference to its Gothic setting (1856; Palace of Westminster). Gibson was notoriously naïve in person: one student commented, 'He is a God in his studio. God help him out of it.' *See also* SCULPTURE: VICTORIAN. BR

□ Read (1982)

Gilbert, Sir Alfred (1854–1934) was a leader of the NEW SCULPTURE movement and his best work demonstrates its characteristic features. He trained in Paris and Italy, learning fine modelling and expressing it in skilfully cast bronze. *Perseus Arming* (1882; V&A) so impressed LEIGHTON that he commissioned *Icarus* (1884; Cardiff), a masterpiece in the rendering of modelled flesh, musculature, feathers and veins in bronze. Success soon followed: *Eros* (1886–93; London, Piccadilly Circus), innovatively cast in aluminium, surmounts a large fountain pedestal of intricate, knobbly bronze. *Queen Victoria* (1887; Winchester) and *Joule* (1893; Manchester Town Hall) show Gilbert manipulating his traditional materials (bronze and marble) to a degree hitherto unknown in England. The Clarence Memorial (1892–9; Windsor) represents the climax of his work: bronze, lead and ivory are among the materials used in an astonishing display of overall formal rhythms and intricate modelling on a minute scale. Mishandling his business affairs led to Gilbert's temporary disgrace and exile; he returned rehabilitated to his swansong, the intricately linear and flowing Alexandra Memorial (1928–32; London, Marlborough Road). *See also* SCULPTURE: VICTORIAN. BR

□ Read (1982)

Gilbert, Stephen *see* CONSTRUCTIVISM

Gibson, *Narcissus*, 1838 (RA).

Gilbert, *Icarus*, bronze, 1884 (Cardiff).

Gilbert and George (Gilbert Proesch, b.1943, and George Passmore, b.1942) Their earlier work, from *c.*1967, comprised PERFORMANCES, appearances in matching clothes and with gold-painted faces and hands, film or video tapes, and a variety of signed imprints, including verses and postcards, sent mainly to art-world figures. They considered themselves and all their deliberate activities, including the making of drawings and paintings, as sculpture. They have increasingly produced wall-works made up of arrays of photographs which combine to form images. They tend to evoke a mood of aggression and violence. *See also* FLANAGAN.

MC

□ R. Fuchs, ed., *Gilbert and George* (exh., Eindhoven, 1980)

Gill, Eric (1882–1940) began letter-carving in 1903 and sculpture, in a neo-primitive style, in 1910. After his conversion to Roman Catholicism in 1913 his principal themes were religious (e.g. *Stations of the Cross* for Westminster Cathedral, London). His best work is relief sculpture, often on a public scale, such as *Prospero and Ariel* on the BBC's Broadcasting House, London (1928). Gill is also distinguished for his lettering, engraving and numerous writings on type design and inscription. His habit of wearing medieval dress and of communal living contributed to the legend that surrounds him. *See also* JONES, D.; WOOD-ENGRAVING.

LC

□ E. Gill, *Autobiography* (1940); D. Attwater, *A cell of good living* (1969)

Gillies, Sir William *see* SCOTTISH PAINTING

Gillray, James (1756–1815) is the greatest English political caricaturist. His first caricatures date from *c.*1775, but his early career was divided between satire and conventional reproductive engraving. He enrolled as an engraving student at the ROYAL ACADEMY Schools in 1778, and engraved a number of STIPPLE plates in the style of BARTOLOZZI, but his success was limited and from 1786 he was essentially a professional caricaturist. However, his training gave him a great depth of technique, and to a confident use of AQUATINT and stipple he added a strength of line that owes something to MORTIMER. The bright hand-colouring of most of his prints can sometimes disguise his ingenuity as a printmaker.

In the late 1780s and early 1790s he etched

Gillray, *Titianus Redivivus, or The Seven Wise Men consulting the new Venetian Oracle*: etching satirizing the 'Venetian Secret'. 1797.

some of his most ambitious plates, attacking politicians of both parties, the royal family (particularly the Prince of Wales) and such individual targets as BOYDELL and the Shakespeare Gallery (1789). On a number of occasions he took an existing picture as the basis of a satire, notably *Wierd-Sisters* (1791), an essay in the 'Caricatura-Sublime' which is an affectionate parody of FUSELI (*see* ★CARICATURE), but the pretensions of other Academicians he held in contempt (*see* e.g. VENETIAN SECRET). However, Gillray was a genuine enthusiast for high Baroque composition, and had a stunning ability to deploy masses of figures in absurd but exhilarating configurations.

By 1791 his reputation was established, and his career was further stabilized by the formation of a life-long partnership with the printseller and publisher Mrs Humphrey. In 1795 he was being courted by the Tory party in the person of Canning, and by the end of 1797 was in receipt of an annual pension for services rendered. Increasingly his prints concentrated on the hapless Whigs, notably Fox and Sheridan. The contrast between Fox, gross, scheming and hirsute, and the bony figure of Pitt is one of the great leitmotivs of his work.

He had always been prepared, for a fee, to etch the ideas of amateurs, but now a number of important political satires were based on the ideas of Sneyd, Canning and others. His caricatures of the Revolutionary French show a genuine xenophobia, Frenchmen being represented as inhuman embodiments of malice and ferocity, and Napoleon as an upstart guttersnipe. To the momentous events of the time his John Bull is an oafish but shrewd witness, taxed and exploited beyond endurance.

Gillray's work was not exclusively political. He etched many social satires, particularly mocking decrepit but vain and lustful members of society. From 1807 his production was in decline, and his reason becoming clouded; from 1810 until his death he was hopelessly insane. RG
□ D. Hill, *Mr Gillray, the caricaturist* (1965)

Gilman, Harold (1876–1919), painter, was, with Spencer Gore of the CAMDEN TOWN GROUP, a moving spirit in introducing French Post-Impressionism to England. He began by painting low-toned Edwardian interiors, influenced by his training at the SLADE (1897–1901) and a year in Spain (1902–3) where he admired and copied Velázquez. But by 1909 he was under the spell of SICKERT, and applying his paint in discrete strokes, sometimes loosely and sometimes in a thick, dense mosaic of interlocking touches. The sight of Roger FRY's first Post-Impressionist exhibition (1910–11), followed by a visit to Paris with GINNER, caused him to brighten his colours considerably, although some of his subjects remained Sickertian (*Nude on a Bed*, c.1911–12; Cam-

Gilman, *Leeds Market*, c.1913 (Tate).

bridge, Fitzwilliam). His drawings and some of his paintings of 1912 owe a great deal to Van Gogh. In 1913 he became the first President of the London Group, and 1914 a founder member of the Cumberland Market Group. His later pictures employ powerful colours and very thick paint, and often incorporate relentlessly garish wallpaper patterns. BL
□ Wyndham Lewis and L. Fergusson, *Harold Gilman* (1919); Baron (1979); *Harold Gilman* (exh., Arts Council, 1981–2)

Gilpin, Sawrey (1733–1807), brother of William GILPIN, was an ambitious sporting and animal painter of uneven talent. After 9 years as apprentice and assistant to Samuel SCOTT, he turned to horse painting c.1759, working initially for the Duke of Cumberland. Later important patrons included Samuel Whitbread MP. Though frequently influenced by his more able contemporary STUBBS, Gilpin's HISTORY subjects involving animals – e.g. 4 pictures of *Gulliver and the Houyhnhnms* (1768–72; York; Yale BAC; Southill) – were praised for their originality and encouraged a taste for emotion and drama in animal paintings. SD
□ Waterhouse (1978)

Gilpin, William (1724–1804) was a connoisseur, schoolmaster and country parson whose appreciation and criticism of landscape made him a central figure in the PICTURESQUE movement. He travelled widely in Britain 1769–74, and his views were well known by the time he published them, e.g. in *Observations, relative chiefly to Picturesque Beauty, made in the year 1772, on several parts of England; particularly the Mountains, and Lakes of Cumberland, and Westmoreland* (1786). He judged landscapes by aesthetic standards derived largely from his knowledge of landscape paintings and engravings. His publications encouraged the appreciation of British landscape and helped to popularize the 'picturesque tour'. JS
□ C. P. Barbier, *William Gilpin* (1963)

Ginner, Charles (1878–1952) was born and educated in France, and studied painting in Paris at the Ecole des Beaux-Arts and the Académie Vitti. Seeing his work at the Allied Artists' Association in London in 1908, SICKERT encouraged him to settle in England. He joined the Fitzroy Street Group in 1910, and was a founder member of the CAMDEN TOWN GROUP in 1911, the London Group in 1913 and the

Cumberland Market Group in 1914. He later joined GROUP X. His enthusiasm for Van Gogh, noticeable in his 1908 paintings, was maintained all his life. By 1911 he had evolved a methodical structure for his pictures, which depends upon clear contours and locked-in areas of paint in closely related tones and colours applied thickly in small strokes. Characteristic works are night scenes like *Evening, Dieppe* (1911; priv. coll.) and West Country landscapes of great downs covered in little fields enclosed by hedges. He used a home-made viewing frame with threads to help him plan his compositions, similar to the one used by Van Gogh but small enough to fit into a pocket book. With his close friend GILMAN he published the pamphlet *Neo-Realism* in 1914. His capacity for tackling unfashionable architectural subjects like the ALBERT MEMORIAL (1935; Southampton) earned him the epithet from Malcolm Easton, 'a Betjeman of the brush'. *See also* LEWIS, P. W. BL
□ Baron (1979); M. Easton in *Apollo*, XCI (1970), 204–9

Girtin, Thomas (1775–1802), was with TURNER the leader of the revolution in WATERCOLOUR technique of the 1790s, and is considered one of the greatest masters of the medium. His early work shows the influence of his teacher, DAYES, and he continued to produce fairly modest topographical views until 1794 or later. In that year he exhibited for the first time at the ROYAL ACADEMY, but not until *c.*1796 did he begin to work in his mature style, often choosing broad mountainous subjects, and treating even picturesque architectural motifs with a monumental simplicity that is enhanced by a palette of sombre and vibrant browns and greens, enriched with characteristic flicks of the brush dipped in brown colour to define detail. Subjects sketched in pencil on a tour to the north in 1796 were worked up into some of his most magnificent watercolours, such as the aerial view of *Jedburgh* (priv. coll.); they were exhibited in 1797 and the following years. He was patronized by several noblemen, including Edward Lascelles of Harewood, for whom he made his largest watercolours – views of the house and estate. Unlike Turner, however, he did not regularly work on such a scale, confining his grand effects in economically laid out compositions on modest-sized sheets.

Towards the end of his life he essayed larger forms: his *Eidometropolis* or Panorama of London was executed in oil *c.*1800–1801, and exhibited in Spring Gardens in 1802. It is untraced, and can be reconstructed only from surviving watercolour studies, mostly now in

Girtin, *The Village of Jedburgh, Roxburgh, Scotland*, watercolour, *c.*1800 (priv. coll.).

the BM. Despite its large scale it seems to have been technically successful, though it failed to attract the public. Before showing it, he visited France in the winter of 1801–2, with the intention of making a panorama of Paris. He produced a few impressive watercolours and a series of soft-ground etchings (some impressions of which he washed with grey monochrome) of the city and its environs which rank among his finest works. The Paris panorama was not yet realized when Girtin died of asthma or tuberculosis.

See also MONRO; COZENS, J. R. AW
□ T. Girtin and D. Loshak, *The art of Thomas Girtin* (1954); Hardie, II (1967); F. Hawcroft, *Watercolours by Thomas Girtin* (exh., Manchester, Whitworth/V&A, 1975)

Glasgow School is the name commonly given to the painters working in Glasgow at the end of the 19c. who achieved an international reputation as a group. They were not strictly a school, having no common training or single style, and they themselves objected to the title, preferring to be known as the Glasgow Boys. They were never formally organized, and so it is impossible to produce a definitive list of the group, which fluctuated in its membership. Between 12 and 20 artists are generally seen as central. The group began to coalesce *c.*1880 around the leading figures, W. Y. MacGregor (1885–1923) and James Guthrie (1859–1930). James Paterson (1854–1923), E. A. Walton (1860–1922) and Joseph Crawhall (1861–1913) were early associated with them; a little later came John Lavery (1856–1941), Alexander Roche (1861–1921), William Kennedy (1859–1918) and T. Millie Dow (1848–1919), all of whom had worked in France. E. A. Hornel (1864–1933), George HENRY (*see* *SCOTTISH PAINTING), David Gauld (1865–1936) and D. Y. CAMERON were younger members, while Arthur Melville (1855–1904) was a slightly older artist who was associated with the Glasgow painters but whose original and striking style also influenced them from outside. Others usually seen as belonging are Harrington Mann (1864–1937), Stuart Park (1862–1933), R. Macaulay Stevenson (1854–1952), Grosvenor Thomas (1855–1923) and the sculptor J. Pittendrigh Macgillivray (1856–1938).

In general the work of these artists is characterized by its vigour, its lack of narrative content and its internationalism. During the first half of the 1880s the dominant quality, as it is seen in Guthrie's *To Pastures New* (1883; Aberdeen) and MacGregor's *Vegetable Stall* (1884; Edinburgh, NGS), is direct painterly realism. This made them sympathetic to the art of the Dutch painters of the Hague School and of Bastien Lepage, whose influence is most clearly seen in the work of Lavery. Later, the younger artists tended to a more stylized kind of painting, seen in the work of Henry and Hornel, that had strong links with WHISTLER, whose art they championed. The creative energy of the group did not survive much beyond the end of the century, but during the 1890s they enjoyed great success, exhibiting widely in Europe and America. DM
□ W. Buchanan, *The Glasgow Boys* (exh., Scottish Arts Council, 1969 and 1971); Hardie (1976)

Glazier, Thomas *see* THOMAS OF OXFORD

goldsmiths' work (medieval) The chief concern of goldsmiths was the making of ecclesiastical and secular jewellery and plate in gold and silver and in base metals. They also made dies for seals and coins, cast bronze (particularly bells, but also sculpture: *see* TOREL), worked for clockmakers, and made gold and silver thread for use by weavers and embroiderers.

Wills and inventories testify to the splendour and quantity of plate and jewellery throughout the Middle Ages, but little survives. Church utensils suffered most at the Reformation, whereas domestic objects, prized perhaps more for their intrinsic value than their craftsmanship, were subject to the vagaries of both economics and fashion. The picture is further distorted by the survival of more church than domestic plate. Known examples date mainly from the mid 15c. onwards.

Among ecclesiastical work, in many classes of object no precious metal examples survive at all – large altarpieces, candlesticks, shrines, processional crosses, ciboria and holy water vessels. Something of their character may be judged by base metal survivals, or, in the case of altarpieces, miniature versions (e.g. V&A – *see* *ENAMELS – and New York, Met.). The earliest post-Conquest piece of goldsmiths' work is an altar candlestick of gilt bronze with a unique silver content, made for the abbot of Gloucester before 1113 (V&A) and intricately decorated with intertwined beasts and men. The most

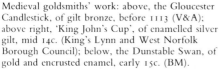

Medieval goldsmiths' work: above, the Gloucester Candlestick, of gilt bronze, before 1113 (V&A); above right, 'King John's Cup', of enamelled silver gilt, mid 14c. (King's Lynn and West Norfolk Borough Council); below, the Dunstable Swan, of gold and encrusted enamel, early 15c. (BM).

numerous ecclesiastical objects from the late 12c. onwards are chalices and patens. Only 3 silver-gilt and enamel croziers remain, of the 14c. and 15c. (Oxford, New College and Corpus Christi; Limerick Cathedral). In other categories only one object survives. Such are the 14c. silver Swinburne Pyx and silver-gilt Ramsey Abbey incense-boat and censer (all V&A), an early 16c. silver pax (Oxford, New College), and the late 15c. gold and enamel Langdale Rosary (V&A), which is not only the sole English rosary of precious metal to survive but the oldest known example of its kind in Europe. The tableau-like *Reliquaire du St Esprit* (Paris, Louvre), of gold set with gems and encrusted enamel, may be English (it was given by the widow of Henry IV to her son in 1412); if so, it too is a unique survivor.

Among known secular plate the most common objects are spoons, of which the oldest is the 12c. Coronation Spoon, reworked in the 17c. (Tower of London). The earliest and most spectacular of several drinking vessels is the 14c. enamelled cup and cover at King's Lynn. Standing salts, of great importance throughout the period, survive from the 15c. and 16c.

Unique are the 14c. silver-gilt Studley Bowl (V&A) and silver dish in Bermondsey parish church, London.

Medieval jewellery is largely represented by Gothic rings and brooches, of which the most outstanding is the Dunstable Swan (BM), of gold and encrusted enamel. Two crowns survive, both embellished with gems and enamel: one in Munich (Residenzmus.), of gold, associated with the marriage in 1402 of Blanche, daughter of Henry IV, and one in Aachen (Cathedral Treasury), of silver gilt, given to Margaret, sister of Edward IV, on her marriage in 1476. MCa

□ C. Oman, *English church plate* (1957); id., *English domestic silver* (4th ed. 1959); J. Evans, *History of jewellery 1100–1870* (2nd ed. 1970); M. Clayton, *A collector's dictionary of gold and silver* (1971); *1066: English Romanesque art* (exh., Arts Council, 1984)

Gordon, John Watson *see* SCOTTISH PAINTING

Gore, Charles *see* MARINE PAINTING

Gore, Spencer (1878–1914) was perhaps the strongest and most original of the younger painters in the CAMDEN TOWN GROUP. He was trained at the SLADE 1896–9, overlapping with Wyndham LEWIS with whom he visited Spain in 1902. His meeting with SICKERT in Dieppe in 1904 was momentous. Many of his paintings of *c*.1907–10 are in a technique derived from Pointillism (learned from his friend PISSARRO). His subject-matter included landscapes, portraits, figures in interiors like Sickert's only

Gore, *From a Window in Cambrian Road, Richmond*, 1913 (Tate).

prettier, and music hall and theatrical performers and audiences. From 1911–12 onwards his style became more versatile, ranging from densely textured, strongly articulated window views in Camden Town to flat, Gauguinesque syntheses of shapes, such as *The Stafford Gallery* (priv. coll.) which shows a 1911 exhibition with Gauguin paintings. In 1912 he directed a scheme for mural decorations in the nightclub 'The Cave of the Golden Calf', and a surviving design suggests affinities with early Kandinsky. Later that year he contributed to Roger FRY's second Post-Impressionist exhibition. His last landscapes are quieter in effect but strongly structured, suggesting a new influence from Cézanne. He died prematurely, from pneumonia. BL

□ Baron (1979); *Spencer Gore* (exh., London, Anthony d'Offay, 1983)

Gospel books were, in the earlier Middle Ages, the most sumptuously decorated class of books. They normally contain the complete texts of the 4 canonical Gospels with some prefatory matter. From them were read the appointed Gospel passages during the mass. (Gospel books should be distinguished from Gospel lectionaries, which contain only the readings, arranged according to their use in the liturgical year. Both were gradually replaced by mass-books which include all variable readings.) Gospel books were sacred objects, much like altar vessels and reliquaries, and were often given opulent metalwork covers.

The internal decoration is usually concentrated at the beginning of the book, in the canon tables (lists of parallel passages, arranged over several pages within architectural frames) and initials to prefaces, and before each Gospel, where there is normally a portrait of the Evangelist as author, and decoration to the enlarged initial and opening words. The Evangelist is often accompanied by (occasionally, in early books, replaced by) his symbol – man, lion, ox and eagle respectively for Matthew, Mark, Luke and John. Miniatures of Christ or of New Testament subjects were sometimes included.

In the early ANGLO-SAXON period many Gospel books were decorated with a profusion of abstract ornament of largely Celtic and Anglo-Saxon origin in a 'Hiberno-Saxon' style shared with Ireland and Celtic areas of Britain. Pages of pure decoration arranged around a cross-shape (carpet pages) may be placed at the

opening of the book and before each Gospel. The *LINDISFARNE GOSPELS belong to this northern tradition, in which the ultimate Mediterranean sources are sometimes scarcely recognizable, but this book also shows the much more direct impact of sub-classical models from Italy. Italian influences are even more obvious in the 8c. *Codex Aureus* (Stockholm, Royal Lib.). From the later Anglo-Saxon period several luxuriously illuminated Gospel books survive, influenced by Carolingian models.

By the 12c. PSALTERS and BIBLES attracted the rich decoration formerly found in Gospel books. JH
□ P. McGurk, *Latin Gospel books from* A D *400 to* A D *800* (1961); Temple (1976); Alexander (1978)

Gothic in English architecture first appeared in a mature form in the choir of Canterbury Cathedral, begun in 1174. In painting and sculpture around the same time the patterned forms and rigid figures of the Romanesque started to give place to a more natural, relaxed manner, and the years *c.*1180–1220 are known as the Transitional period. By 1220 the break was complete. In sculpture such as that of Wells Cathedral (*c.*1220–40) and in painting such as the Psalter of Robert de Lindesey (*c.*1220; London, Soc. of Antiquaries) there are the calm, balanced poses of the Early Gothic style. Decorative linear conventions for drapery systems still persist, but with more relation to figure pose than in the Romanesque.

In the middle years of the 13c. English Early Gothic was strongly influenced by new developments from France, originating in sculpture (best seen in the figures at Reims Cathedral by the Joseph Master, e.g. the famous 'smiling angel'). The new style is characterized by mannered and elegantly balanced figure poses, with much use of bulky cascades of drapery and small pear-shaped heads. It appears clearly in the DOUCE APOCALYPSE, illuminated by an English painter *c.*1270. Variously modified, this figure style persisted in England for over 250 years.

Gothic passed through many phases of development before it gave way to classical motifs and figure poses in the 16c. The Reformation, by effecting an almost total decline in the religious art associated with the Gothic style, brought about its final end.

See also ALABASTERS, ALTARPIECES, APO-CALYPSE ILLUSTRATION, BESTIARIES, BOOKS OF HOURS, BRASSES, CHANTRIES, DECORATED, DOOM PAINTINGS, ENAMELS, GOLDSMITHS' WORK, GROTESQUES, ILLUMINATED MANUSCRIPTS, INTERNATIONAL GOTHIC, MISERICORDS, OPUS ANGLICANUM, PANEL PAINTING, PSALTER ILLUSTRATION, ROOF BOSSES, SCULPTURE, SCREENS, STAINED GLASS, WALL-PAINTING. NM
□ J. Harvey, *Gothic England* (1947); A. Martindale, *Gothic art* (1967); Rickert (1965); Stone (1972); Marks and Morgan (1981)

gouache or bodycolour is watercolour paint made thick and opaque by the addition of white pigment. It was usually applied to a paper support in the 18c., but was also used earlier on parchment for manuscript illumination and for MINIATURES. *See also* WATERCOLOUR. CH
□ M. B. Cohn, *Wash and gouache* (1977)

Goupy, Joseph *see* GEORGE III

Gower, George *see* ELIZABETH I; PORTRAIT PAINTING: 16C.

Gowing, Sir Lawrence (b.1918), painter and writer, was at the EUSTON ROAD SCHOOL and taught at the Camberwell School of Art *c.*1943–8. His paintings show an intense personal response to people, landscapes, and still-life subjects, such as *Green Apples* (14 versions, 1940–46). Well known for his critical and art-historical writings, especially on Cézanne, he became SLADE Professor of Fine Art in 1975. BL
□ *Lawrence Gowing* (exh., Arts Council, 1983)

Graham, W. Barns *see* ST IVES SCHOOL

Grand Tour A recognized way in the 18c. for a wealthy Englishman to complete his education, which normally culminated in a prolonged period in Rome, though Naples, with its newly discovered antiquities at Pompeii and Herculaneum, was also a draw. The aim was the absorption of classical culture *in situ*, and the cultivation of 'connoisseurship', though in practice this ambition was often thwarted by either indolence or over-earnestness. The most tangible result was often the acquisition of a collection of old masters and antique sculptures of varying quality, and perhaps views by CANALETTO or a portrait by BATONI. The presence in Rome and the rest of Italy of so many potential patrons created a

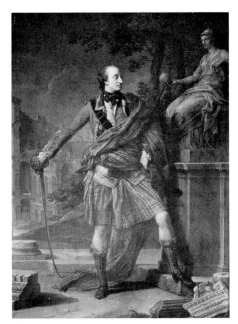

Colonel John William Gordon on the **Grand Tour**, painted in Rome by Batoni, 1766 (National Trust for Scotland, Fyvie Castle).

lively subculture of *ciceroni*, dealers and restorers so that it was possible for young artists like NOLLEKENS to support themselves while completing their own studies of antique art.

The idea of the Grand Tour goes back to the writings of SHAFTESBURY, who hoped it would lead to a cultivated aristocracy which would encourage English artists to aspire to the seriousness of the great Italian masters of the Renaissance. By and large, however, the effect was the opposite, and the Grand Tour tended to reinforce the contempt of connoisseurs for native talent, as HOGARTH frequently observed. *See also* NEOCLASSICISM. DB

□ A. Burgess and F. Haskell, *The age of the Grand Tour* (1967)

Granges, David des (1611/13–75), a Huguenot who converted to Catholicism, began as an engraver. In 1651 he became official MINIATURE painter to the future Charles II, and produced numerous miniature copies after other artists. His best-known work, however, is a painting 'in large', *The Family of Sir Richard Saltonstall* (Tate). DD

□ D. Foskett, *Samuel Cooper and his contemporaries* (exh., NPG, 1974)

Grant, C. J. *see* CARICATURE

Grant, Duncan (1885–1978) studied at the Westminster School and in Paris under J. E. Blanche (1906–7), then in 1911 was radically influenced by Post-Impressionism, and for a few years was a leading avant-garde painter and designer (*see* BLOOMSBURY and OMEGA WORKSHOPS). An extremely various artist, he later worked in 2 distinct manners – solid realism and a lighter, decorative mode blending abstract and figurative elements. He is justly regarded as an original colourist, and is often at his best and most characteristic when realist perception and fluent handling of paint are combined (e.g. *c*.1912–20 and again from *c*. 1966). His enormous output has to be carefully sifted to gauge his achievements in portraiture (*Katherine Cox*, 1913, Cardiff; *Vanessa Bell*, 1942, Tate), the male nude, mythology (*Venus and Adonis*, 1919, Tate), decoration (*Blue Sheep Screen*, 1912, V&A), and still-life. *See also* CAMDEN TOWN GROUP. RS

□ R. Fry, *Duncan Grant* (1924); D. Sutton, *Duncan Grant and his world* (exh., London, Wildenstein, 1964); R. Shone, *Bloomsbury portraits* (1976); *and see* BLOOMSBURY

Grant, Sir Francis *see* PORTRAIT PAINTING: 19C.; ROYAL ACADEMY: 19C.

The Graphic was launched in London in 1869 to compete with *The Illustrated London News* through the expressive freedom and artistic

Duncan **Grant**, *Interior*, *c*.1918 (Belfast). The painter on the left is Vanessa Bell.

excellence of its WOOD-ENGRAVINGS. Contributors included *FILDES, HERKOMER, HOLL, HOUGHTON, William Small (1843–1929) and others who had been active in the revival of English book and literary magazine illustration in the 1860s. Its subject-matter was always varied, but featured, especially at Christmas, images of the modern urban poor and oppressed. *The Graphic* merged with *Sphere* in 1932. TG

Gravelot, Hubert (1699–1773) came to England in 1732 having been a pupil of Restout and Boucher in Paris. His accomplished drawings and engravings for book illustrations, characterized by a sinuous, spidery line, transmitted something of the ROCOCO spirit of WATTEAU to a whole generation of English artists. He helped HAYMAN with designs for VAUXHALL. Although oil paintings by him are rare, Gravelot played an active role as a teacher of drawing at the ST MARTIN'S LANE ACADEMY, where the young GAINSBOROUGH was his most

Gravelot, engraving from John Gay's *Fables*, 1738.

distinguished pupil. He returned to Paris in 1745. BA
☐ Hammelmann (1975); *Rococo* (1984)

Graves, Henry (1806–92), a notable 19c. printseller in London, assisted Samuel Woodburn before being employed by Hurst, Robinson & Co., the successors to the BOYDELL business. He was in partnership 1825–44 with Moon and Boys, and then set up his own business. He published works after all the leading artists of the day, and had a particular association with LANDSEER. He was a founder of the *Art Journal* and an active member of the Printsellers' Association, which sought to raise professional standards. *See* *PRINTSELLING. CF
☐ Graves Papers (BL, MSS Add. 46, 140)

Great Queen Street Academy *see* ST MARTIN'S LANE ACADEMY

Greaves, Walter *see* WHISTLER

Green, Anthony (b.1939) has created a popular genre in painting which mythologizes his own elaborate domestic life. Working on a large scale, he recreates each milieu – bathroom, tent, garden – in compelling, almost fetichistic detail, often within an eccentrically shaped format. His pictorial language (owing much to Stanley SPENCER and Jeffery Camp (b.1923)) has deliberately challenged contemporary taboos against depiction. TH
☐ A. Green, *A Green part of the world*, ed. M. Bailey (1984)

Green, Valentine *see* MEZZOTINT; REYNOLDS

Greenbury, Richard *see* PORTRAIT PAINTING: 17C.

Greenhill, John (c.1640–76) was a member of LELY's studio until 1665. Posture and draperies echo his master's work, though he lacks Lely's quality in handling paint. His later work suggests a departure from Lely and the development of a personal style. DD
☐ Waterhouse (1978)

Greenwich *see* RUBENS; THORNHILL

Griffier, Jan, the Elder (1652–1718), etcher, draughtsman and topographical painter, came to England from Holland in 1666. His bird's-eye-views of the Thames Valley and houses

such as Hampton Court and Syon combine elements of fantasy and Rhineland scenery with minute detailing.

The work of his sons, **Jan the Younger** (fl.1738–73) and **Robert** (d.c.1750), blended many of these traditional features with the contemporary English landscape painting of George LAMBERT and his followers. DD
□ Croft-Murray (1960); Harris (1979)

Griggs, Frederick Landseer (1876–1938) was a book illustrator and an etcher of elaborately worked and slightly hallucinatory views of real and imagined Gothic buildings, full of romantic yearning for pre-Reformation England. Their dense texture of carefully bitten lines reveals the influence and something of the poetry of Samuel PALMER's prints. RG
□ F. A. Comstock, *A Gothic vision: F. L. Griggs and his work* (1966)

Grimshaw, Atkinson (1836–93), a Leeds artist, is known for his later atmospheric paintings of moonlit docks and glistening city streets. Led first to RUSKIN by INCHBOLD and William Henry HUNT, he used photography, and from c.1875 experimented with literary and genre subjects. He depended on private

Grimshaw, *Piccadilly at Night*, 1885–6 (priv. coll.). On the left is Burlington House, home of the Royal Academy.

northern patrons and showed only 5 works at the ROYAL ACADEMY. RT
□ D. Bromfield, *Atkinson Grimshaw* (exh., Leeds, 1979)

grisaille or white glass was an important element in English medieval window design. In the first half of the 13c. designs based on diamond-shaped quarries and using geometric shapes, as at Lincoln Cathedral, have many affinities with floor tiles but little in common with contemporary French *grisaille*. Frequently the glass is decorated with stylized leaf forms (e.g. Salisbury Cathedral), which in the late 13c. were gradually superseded by naturalistic foliage. Simultaneously, windows with bands of figures or scenes in coloured glass framed by ornamental *grisaille* were introduced (an idea imported from France), as at Merton College, Oxford (*see* ★STAINED GLASS: TO 1550). As the 14c. progressed *grisaille* backgrounds diminished in importance as canopies became larger, although this was counterbalanced by an increasing use of white glass for figures. *Grisaille* quarries retained their popularity through the 15c. and early 16c., exhibiting a wide variety of designs, including birds, insects, badges, mottoes and rebuses. RM
□ A. W. Franks, *A book of ornamental glazing quarries* (1849); N. J. Morgan, *The medieval painted glass of Lincoln Cathedral* (1983), 18, 38–41

Gross, Anthony (b.1905) was one of the first English printmakers to break from the conventional mould of 1920s etching (*see* ETCHING REVIVAL). He spent much time in France, and the sprightly lines of his plates, with their abundance of vegetation and hyper-active figures, reflect Continental influences, notably James Ensor and Joseph Hecht. RG
□ Godfrey (1978)

Grosvenor Gallery Founded in London in 1877 by Sir Coutts Lindsay and Charles Hallé, the gallery in its early years staged exhibitions that mixed 'advanced' work by WHISTLER, Gustave Moreau, CRANE, LEGROS and others with academic work by LEIGHTON, POYNTER, etc. Its association with the AESTHETIC MOVEMENT led W. S. Gilbert to call it the 'Greenery-Yallery Grosvenor Gallery'; it can also claim fame as the setting of the scene that led to the Whistler-RUSKIN 'paintpot in the face of the

public' trial. Later it showed more academic than avant-garde art. *See also* BURNE-JONES; MOORE, A.; WATTS. TG

grotesques are the diverse beasts, hybrid creatures and fantasy scenes involving animals and humans found in various forms of GOTHIC art. The ultimate source of much of this imagery is in Roman art; some themes came from the combat scenes between men and beasts used in the sculpture and decorative initials of the Romanesque period (*see* *ILLUMINATED MANUSCRIPTS: ROMANESQUE). The late 13c. and 14c. saw an unprecedented elaboration of this type of fantasy subject, in the borders of manuscripts (*see* *EAST ANGLIAN ILLUMINATION), and in decorative sculpture and woodwork – especially MISERICORDS. The placing of these grotesques, blatantly secular and even occasionally erotic, in a religious context is a mixture very characteristic of the later Middle Ages.

The popularity of grotesques declined after *c.*1350, though they still occur in the 15c., particularly in sculpture and woodcarving. In this later period they were called 'babewyneries' ('babooneries') because predominant in many animal scenes is the ape. NM
☐ J. Baltrušaitis, *Reveils et prodiges: le gothique fantastique* (1960); L. M. C. Randall, *Images in the margins of Gothic manuscripts* (1966)

grounds *see* PAINTING

Group X was formed in 1919 by Edward McKnight Kauffer (1891–1954) and Wyndham LEWIS to give focus to London's avant-garde and to provide an alternative exhibiting site to that of the London Group (*see* CAMDEN TOWN GROUP). Only one exhibition was held, in 1920. The other members were Jessica Dismorr (1885–1939), Frank DOBSON, ETCHELLS, GINNER, Cuthbert Hamilton (1884–1959), William ROBERTS, John Turnbull and Edward WADS-WORTH. JB

Guelfi, Giovanni Battista (fl.1714–34) was trained by the Roman sculptor Camillo Rusconi and brought to England *c.*1715 by the Earl of Burlington. After restoring some of the antique marbles formerly in the ARUNDEL collection he executed various monuments, including that to James Craggs in Westminster Abbey, London (1727). Designed by the architect James Gibbs, this striking composition

set the pattern for the many English monuments which employ a standing figure with legs crossed, leaning on an urn. Around 1731 he carved some busts of modern 'worthies' for Queen Caroline's Grotto at Richmond, but this commission was transferred to RYSBRACK. His work is competent but bland, and Lord Burlington not surprisingly 'parted with him very willingly' when he returned to Italy in 1734. MB
☐ M. Webb in *Burl. Mag.*, XCVII (1955), 139, 260; Whinney (1964)

Guthrie, James *see* GLASGOW SCHOOL; SCOTTISH PAINTING

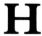

H

Haden, Sir Francis Seymour (1818–1910), a surgeon and, from 1843, amateur etcher, executed his finest prints in the years following his brother-in-law WHISTLER's return from Paris in 1859. Most of his 250 plates are landscapes, worked directly on the plate in the open and displaying his mastery of foliage, water and atmosphere. He was the first President of the Royal Society of Painter-Etchers and Engravers (*see* *ETCHING REVIVAL). CF
☐ M. Salaman, *The etchings of Sir Francis Seymour Haden* (1923)

Hall, Frederick *see* NEWLYN SCHOOL

Hamilton, Cuthbert *see* GROUP X; VORTICISM

Hamilton, Gavin (1723–98) was a Scottish painter who spent most of his life in Rome. In the 1760s he pioneered the depiction of Homeric subjects in a severe and archaic manner which may have decisively influenced the development of an international NEO-CLASSICAL style in painting (*see also* *SCOTTISH PAINTING). In later years he was well known as an archaeologist and dealer. DB
☐ E. Waterhouse in *Proc. Brit. Acad.*, 40 (1954), 57–74; D. Wiebenson in *Art Bull.*, XLVI (1964), 23–7

Gawen **Hamilton**, *A Conversation of Virtuosis . . . at the Kings Arms*, 1735 (NPG). The sitters are, from left to right, Vertue, Hans Hysing, Michael Dahl, William Thomas, James Gibbs, Joseph Goupy, Matthew Robinson, Charles Bridgeman, Bernard Baron, Wootton, Rysbrack, Hamilton himself, and Kent.

Hamilton, Gawen (*c.*1697–1737) moved *c.*1730 from his native Scotland to London where he was one of HOGARTH's main rivals as a painter of small-scale CONVERSATION PIECES. His figures and compositions are less animated than Hogarth's, as can be seen in his best-known work, *A Conversation of Virtuosis* (1735; NPG; *see* VIRTUOSI and WOOTTON). BA
□ Vertue III (Walpole Soc., XXII, 1933–4), 71, 81

Hamilton, Richard (b.1922) may be considered the first POP painter. In the early 1950s he made a series of pictures by inventing a perspectival notation for viewpoints and objects moving relative to one another. Then, following extended discussions at the ICA, he produced his well known characterization of 'Pop art' in January 1957: 'Popular (designed for a mass audience); Transient (short term solution); Expendable (easily forgotten); Low

Cost; Mass Produced; Young (aimed at youth); Witty; Sexy; Gimmicky; Glamorous; Big Business'.

These phrases were applied to commercial products and media, but Hamilton determined to make paintings with similar qualities, combining the imagery of consumer durables and the advertisements which associate them with cultural values. He used notations from both the mass media and Fine Art – a variety of marks, signs, lettered balloons, profiles, dotted lines, sharp and soft focus, etc. Their deeply ironic approach still links them to the Fine Art tradition. Hamilton has relatively few ideas for pictures, but each one forms the theme for a number of finished drawings and prints. Characteristically, he reconstructed the *Large Glass* of Marcel Duchamp (Tate) not by reference to the finished original but from the notes, studies and other clues published by the artist.

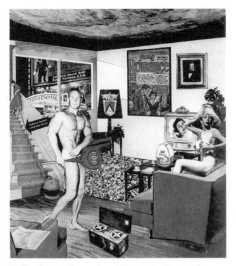

Richard **Hamilton**, *Just What Is It That Makes Today's Homes So Different, So Appealing?*, photomontage, 1956 (Edwin Janss Jr).

He has continued to be acutely aware of social and political matters and to paint pictures or make prints alluding to them. However, he has been equally committed to Fine Art and to the media and styles traditionally associated with it. His pictures are by no means 'expendable', 'low cost' or even 'popular' – but they are still 'sexy', 'witty' and 'gimmicky'. *See* *HOCKNEY. MC
□ R. Morphet, *Richard Hamilton* (exh., Tate, 1970); R. Hamilton, *Collected works* (1982)

Hamilton, William (1750/51–1801) was a portrait, HISTORY and subject painter, and a book illustrator. He painted many pictures for BOYDELL's Shakespeare Gallery, and his illustrations include Thomson's *Seasons* (1797). His mannered, light-weight but elegant style unites the decorative quality of his master Zucchi with the attenuated figures of FUSELI. JS
□ Hammelmann (1975); Waterhouse (1981)

Harcourt, 2nd Lord *see* AMATEUR ARTISTS

Harding, J. D. *see* RUSKIN

Harlow, George Henry *see* THEATRICAL PAINTING

Harris, Edwin *see* NEWLYN SCHOOL

Harvey, Sir George *see* SCOTTISH PAINTING

Haworth, Jann *see* RURALISTS

Haydon, Benjamin Robert (1786–1846) was a HISTORY painter whose life and extremely revealing journals have proved more memorable than his art, though it is not without vigour. Fired by REYNOLDS he set out to be a painter in the grand manner. He had some success in London with large paintings, mainly of classical subjects, which attracted the admiration of Wordsworth and Keats. His self-conceit was comical, and he continued to paint grandiloquent and unsaleable pictures while his financial position deteriorated. He was constantly in debt and more than once imprisoned. After a disastrous showing of a painting in 1846 he killed himself. *See also* *ELGIN MARBLES. DB
□ *Haydon's diaries*, ed. W. T. Pope (1960–63)

Hayman, Francis (1708–76) was one of the most versatile and original artists of his generation. He trained as a decorative painter and also painted scenery at the Drury Lane Theatre, where he made useful professional contacts, including the actor Garrick, whom he painted on several occasions. He was the most prolific THEATRICAL painter before ZOFFANY. His most famous commission was to supply more than 50 large pictures for the supper-boxes at VAUXHALL, which were designed by Hayman (some with the aid of GRAVELOT) and completed largely by his studio assistants in the early 1740s. These employed a novel range of subject-matter, including scenes from literature, the theatre, popular pastimes, ancient customs, etc.

In the 1740s and 1750s Hayman painted a number of portraits and delightful outdoor CONVERSATION PIECES, his sitters predominantly drawn from the same middle-class professionals as HOGARTH's. Hayman was a leading teacher at the ST MARTIN'S LANE ACADEMY, where, alongside Gravelot, he disseminated something of the French ROCOCO style so clearly visible in his numerous book illustrations (e.g. Samuel Richardson's *Pamela*, 1742).

In his lifetime Hayman's reputation rested on his HISTORY paintings. Those surviving include *The Finding of Moses* (1747; FOUNDLING HOSPITAL) and an altarpiece, *The Good Samaritan* (1752; Yale BAC). Four enormous scenes from the Seven Years War (now lost), painted for Vauxhall in the early 1760s, are important as

Hayman, *May Day*, or *The Milkmaids*, installed in Vauxhall Gardens *c*.1741–2 (V&A).

precursors of the popular history piece exploited later by WEST and COPLEY.

Hayman was much involved in the art politics of his day: he led those artists who established the SOCIETY OF ARTISTS and public exhibitions in 1760, and became a founder member of the ROYAL ACADEMY and its first Librarian in 1771. *See also* LAMBERT. BA

□ M. Crake, *Francis Hayman* (exh., London, Kenwood, 1960); *Rococo* (1984)

Hayter, Sir George *see* PORTRAIT PAINTING: 19C.

Hayter, Stanley William (b.1901) is among the most influential 20c. printmakers. He developed the use of the ENGRAVING burin as a free and creative tool, and invented ingenious methods of multi-colour printing from an ETCHING plate. Born in London, he moved in 1926 to Paris, where he founded a printmaking studio eventually known as Atelier 17. There (and in New York where the studio took refuge during the war) he encouraged in many artists an exploratory attitude to technique. The dynamic line of his earlier prints and paintings reflects the spirit of the SURREALISTS, with whom he exhibited from 1929. RG

□ S. W. Hayter, *New ways of gravure* (1949)

Hazlitt, William (1778–1830), essayist, is best known as a literary and dramatic critic and as a political radical; barely a quarter of his literary output was devoted to the fine arts. Nevertheless, he was the most effective and important British writer on art in the period between REYNOLDS and RUSKIN. Employing the essay form and publishing his articles in radical journals like *The Morning Chronicle* and *The Examiner*, he was the first British art critic (not counting hack reviewers) to address the general reader rather than the artist or connoisseur. Unlike Reynolds, BARRY and FUSELI, whose purpose was to expound artistic theory, Hazlitt relied on his intuitive responses to works of art to pass critical judgments. This is not to say, however, that he had no artistic theory of his own.

Born the son of a Unitarian minister at Maidstone, he had the good fortune when young to meet Wordsworth and Coleridge in Shropshire, who encouraged him to pursue his early interest in philosophy. A sight of the Orléans Collection on exhibition in London in 1798 converted him to a love of painting, and this was confirmed by a crucial visit to the Louvre in 1802 to see the art treasures brought from Italy by Napoleon. He also studied painting in a desultory fashion and executed a

few portraits. However, marriage in 1808 compelled him to earn an income from journalism and he lived by his pen until his death.

His first essay on art was prompted by the Reynolds retrospective exhibition at the BRITISH INSTITUTION in 1813. He took a favourable view of the painter but attacked his ideas, which he criticized at length in 2 articles entitled 'On Certain Inconsistencies in Sir Joshua Reynolds's Discourses', printed in *Table Talk* (1821–2). Hazlitt's attitude to art can best be summarized in terms of his disagreement with Reynolds. He repudiated Reynolds's distinction between particular and ideal nature, maintaining instead that 'nature is the end and test of art'; the ideal, according to Hazlitt, so far from involving the sacrifice of the particular, resulted from depicting the latter with abnormal intensity. Whereas Reynolds believed that excellence in art could be achieved by pains and study, Hazlitt emphasized the role of genius, which he defined as 'some strong quality in the mind, answering to and bringing out some new and striking quality in nature'.

However, despite affirming views on the relationship between art and nature in sentences which might almost have been written by CONSTABLE, and despite admiring HOGARTH's skill in rendering human character, Hazlitt was no devotee of pictorial naturalism. He took virtually no interest in contemporary art and reserved his strongest enthusiasm for past masters of the ideal style like Raphael, Titian, Poussin and Claude, and what he admired in them was the creative energy, or *gusto*, which enabled them to realize their conceptions. It is this response to the force of creativity, coupled with his readiness to see a work of art as a reflection of the artist's mind rather than as a task well or ill performed in accordance with rules, that makes Hazlitt a Romantic critic. Having quarrelled with his wife and nearly all his friends and ever defiant of conventional opinion, he died in poverty. MK
□ W. Hazlitt, *Criticisms on art*, ed. W. C. Hazlitt (1843); id., *Table talk* (Everyman ed., 1959); H. Baker, *William Hazlitt* (1962)

Head, Tim (b.1946) makes installations which reflect his primary concern with illusion and reality as they are manifest in space. He uses mirrors, slide projectors and photographs, all normally verifying devices, to question familiar expectations about space and the ways in which illusion and allusion (imaginative engagement) affect an understanding of any context. His spaces are mental as much as physical, for he demonstrates that the 2 cannot easily be separated. LC
□ *Tim Head* (exh., Venice Biennale, 1980)

Hearne, Thomas (1744–1806) trained as an engraver, and worked for 3 years as draughtsman in the Leeward Islands before establishing himself in London as a topographical and picturesque watercolourist. He specialized in antiquities and views of country seats, executing a series at Downton Castle for Payne KNIGHT. He collaborated with the engraver William Byrne on an influential series of views, *The Antiquities of Great Britain* (1777ff). His work was collected by his friend Dr MONRO, and had a formative effect on TURNER. AW
□ Williams (1952); Hardie, 1 (1966).

Heath, Adrian *see* CONSTRUCTIVISM

Heemskerck, Egbert van *see* CONVERSATION PIECE

Henry III, King 1216–72 (b.1207), was with RICHARD II and HENRY VII the most active of English medieval kings in patronage of the arts, and it is particularly regrettable that so little survives of his very fully documented commissions. His main interest was the building and decoration of the palace and abbey of Westminster. The former was destroyed by fire in 1834, but at the latter sufficient sculpture and painting of the years c.1240–70 exists to show the quality of the artists working for the King. Henry is also recorded as making numerous gifts of goldsmiths' work and vestments (OPUS ANGLICANUM) to major religious foundations.

In the last 30 years of Henry's reign and the early part of that of his son, Edward I, from c.1240 to c.1280, there is reasonable evidence for the existence of a Court School of painting. The WESTMINSTER RETABLE falls within this period, though its exact date and origin are controversial. No manuscripts made for the King himself have survived, but the DOUCE APOCALYPSE, the chief illuminated manuscript of the Court School, belonged to his son Edward. *See also* ★TOMBS; TOREL. NM
□ T. Borenius in *Journ. Warburg and Courtauld Inst.*, VI (1943), 40–50; E. W. Tristram, *English medieval wall painting. The 13c.* (1950); H. M. Colvin, ed., *History of the King's Works*, 1 (1963)

Henry VII, King 1485–1509 (b.1457), initiated an extensive series of works reflecting his concern with the maintenance of his dynasty and his spiritual welfare. Virtually nothing remains of Richmond and Greenwich Palaces or the Savoy Hospital in London, but the elaborate heraldic displays and iconographical schemes at Henry VII's Chapel in Westminster Abbey (1503–c.1512) and King's College Chapel, Cambridge (1508–15; see SCULPTURE: GOTHIC, STONE) well illustrate his interests.

Many of the artists he patronized were foreigners. Nothing now known can be attributed with certainty to Meynnart Wewicke, the King's Painter, but there exists a fine portrait of Henry by Michiel Sittow (1505; NPG). Flemish carvers made the stalls in Henry VII's Chapel, and the statues there represent a blend of English, Flemish and German sculptural traditions. Henry was also probably one of the first English patrons of TORRIGIANO, to whom the execution of his tomb was ultimately entrusted by his son Henry VIII (*see* *SCULPTURE: 16C.). NR
□ Stone (1972); H. M. Colvin in *History of the King's Works*, III (1975), 187–222

Henry VIII, King 1509–47 (b.1491), was at first principally concerned with the acquisition of Flemish tapestries and the creation of temporary festival buildings, rather than the employment of artists, although the Italian sculptor TORRIGIANO was at work on the tomb of Henry VII in 1512–18. By 1530, however, salaried artists included the Florentine Toto del Nunziata, a painter of pictures as well as decorative work, and the Fleming Lucas Horenbout or Hornebolte (c.1490/95–1544), made King's Painter in 1531; by 1537 HOLBEIN was also on the payroll, by 1546 SCROTS. A major stimulus was Henry's acquisition in 1530 of Wolsey's palaces at Hampton Court and Whitehall. Colourfully decorated by teams of painters, English and foreign, Whitehall featured a wall-painting of the King's coronation, as well as Holbein's imposing group portrait of Henry VIII and his family (destroyed). At Nonsuch Henry followed François I in employing the stuccoist Nicholas Bellin of Modena. Henry's taste as it appears from inventories was chiefly inspired by that of northern European courts, though one of the few pictures to survive is by an Italian in his service, Girolamo da Treviso, depicting *The Evangelists stoning the Pope* (Royal Coll.). *See also* *SCULPTURE: 16C. SF
□ Auerbach (1954)

Henry, George (1856/8–1938) was a member of the GLASGOW SCHOOL, and his best-known work, *Galloway Landscape* (1889; Glasgow) is characteristic in its remarkable Post-Impressionist qualities (*see* *SCOTTISH PAINTING). An enthusiastic admirer of Japanese art, he visited Japan in 1893–4 with his friend E. A. Hornel. DM
□ Irwin (1975); Hardie (1976); *Mr Henry and Mr Hornel visit Japan* (exh., Scottish Arts Council, 1978)

Hepworth, Barbara (1903–75) developed her mature style as a sculptor during the 1930s, after contact with the work of contemporary European artists, specifically Brancusi, GABO and Arp. Characteristic of her work is a great sensitivity to materials and a love of abstract or biomorphic shapes which are resonant with lyrical organic metaphors. Though modelling took precedence over carving after World War II, her basic repertoire of forms did not change markedly: if anything, working at ST IVES in Cornwall (where she moved during the war) heightened the associations in her sculpture with landscape and vegetal forms. She also executed a considerable number of figurative pieces, often female or maternity subjects, but these are rarely amongst her strongest works.

Unlike MOORE, with whom she is often

Hepworth, *Pelagos*, wood, 1946 (Tate).

compared, Hepworth responded to soft, sensual fecund forms in nature, eschewing its tensile, aged, weathered and decaying aspects, a preference which partly accounts for the harmonious elegance of her finest works, carvings like *Pelagos* (1946; Tate) and *Pendour* (1947; Washington, Hirshhorn Mus.). LC
□ A. Bowness, *Barbara Hepworth, complete sculpture* (1971); B. Hepworth, *A pictorial autobiography* (1978)

Herbert, John Rogers (1810–90) followed the architect Pugin into Catholicism in 1840 and, having previously painted portraits, history and sentimental genre, thereafter specialized in painstakingly detailed, mirror-finished Biblical and religious scenes. One of the decorators of the Palace of WESTMINSTER, he was deeply influenced by DYCE and the German Nazarene painters. RT
□ Wood (1978)

Herkomer, Hubert (1849–1914), GRAPHIC illustrator, subject and portrait painter, RA (1890), Wagnerian, ruralist, Welsh Nationalist, teacher, *bâtissomane*, motorist and film maker, reminds us of the variety and vigour of English academic art in the last quarter of the 19c. His family emigrated from Bavaria to the USA, then settled in Southampton in 1856. He illustrated books and periodicals in the late 1860s, making his name with a *Graphic* illustration and related painting, *The Last Muster* (1875; Port Sunlight). He had much success with peasant subjects and portraits, though he never entirely abandoned social-realist themes (*On Strike*, 1891; RA). At his house in Bushey, Herts. (designed by the American architect H. H. Richardson), from 1883 to 1904 he ran an art school, whose pupils included William NICHOLSON and James Pryde. TG
□ *Hubert Herkomer* (exh., Watford, 1981)

Herman, Josef (b.1911) is best known for his sombre paintings of Welsh mining people, culminating in a vast mural for the Festival of Britain in 1951. Born in Warsaw, influenced by Permeke in Brussels, Herman arrived in Britain in 1940. He has created a kind of archetypal working figure, based partly on African tribal sculpture. TH
□ J. Herman, *Related twilights* (1975)

Heron, Patrick *see* ST IVES SCHOOL

Herring, John Frederick, Sen. (1795–1865) was a prolific and prosperous painter of SPORTING, animal, and rural subjects. The documentary nature of his unambitious but meticulous racehorse portraits, including those of 33 consecutive winners of the St Leger, was characteristic of much 19c. sporting art. SD
□ O. Beckett, *J. F. Herring & Sons* (1981)

Hicks, George Elgar (1824–1914) was a genre painter who rose to fame with such pictures as *Dividend Day at the Bank of England* (1859; London, Bank of England) which closely emulated the panoramic modern life scenes of FRITH. He also painted moralizing domestic and literary pictures. WV
□ Treble (1978); *G. E. Hicks* (exh., London, Geffrye Mus., 1982)

Highmore, Joseph (1692–1780), portrait and subject painter, visited Paris in 1734 and the influence of the ROCOCO is subsequently visible in his paintings, particularly in the mid-1740s in his illustrations to Samuel Richardson's *Pamela* and CONVERSATION PIECES. *Mr Oldham and his Friends* (c.1750; Tate) rivals HOGARTH in its character and intimacy. He occasionally aspired to HISTORY painting, as in *Hagar and Ishmael* (1746; FOUNDLING HOSPITAL). BA
□ *Joseph Highmore* (exh., London, Kenwood, 1963); A. S. Lewis (PhD, Harvard, 1975)

Hill, Anthony (b.1930) studied under PASMORE and Robert Adams (1917–84) at the Central School in London 1949–51, then as a member of the constructed abstract art group in

Highmore, *Mr Oldham and his Friends*, c.1750 (Tate).

London exchanged ideas with Max Bill and Charles Biederman (*see* CONSTRUCTIVISM). In 1956 he abandoned black-and-white geometric paintings for constructed orthogonal reliefs of metal and plastic. From *c*.1962 he used mathematical systems in reliefs with compositions built up of 120° units. Since *c*.1975 he has made shallow reliefs of white laminated plastic with black line compositions. AG
□ *Anthony Hill* (exh., Arts Council, 1983)

Hilliard, Nicholas (1547–1619), miniaturist, was the son of an Exeter goldsmith, and was apprenticed to the Queen's jeweller, Robert Brandon. His earliest surviving effort as a miniature painter, dated 1571, reveals a remarkable proficiency in the craft as it was initially practised in England by Lucas Hornebolte (*c*.1490/95–1544) and HOLBEIN. It is uncertain from whom Hilliard learned portrait limning; he later claimed in his *Treatise Concerning the Arte of Limning* that his model had always been Holbein. Recently it has been argued that he studied with Levina Teerlinc (1483?–1576), a minor court painter, but her miniatures are scarcely known and the argument is inconclusive.

It is clear that Hilliard's prodigious talent was appreciated at an early date. He became the most important portraitist in London in the 1570s and, *de facto*, principal painter to the Queen. ELIZABETH, a more penurious patron of the arts than her father, Henry VIII, granted him a patent on her portraiture in 1584 (*see* ★MINIATURE PAINTING), and commissioned his design for the Second Great Seal of England, but never gave him an annuity. To support his large family and to compensate for unsuccessful commercial speculation he was forced to paint miniatures on commission from a broad spectrum of society: thus began in England the popularization of a courtly art.

Hilliard worked in France 1576–8, and returned to London with a style enriched by the refinement of Clouet and French court portraiture. He standardized the use of the oval format, and in the late 1580s introduced the large, full-length miniature of which the *Young Man among Roses* (V&A) is perhaps the earliest, and certainly the most splendid, example. Up to *c*.1595 he promoted an iconic portraiture, often obscure in symbolism and decorative in its calligraphic embellishments, richly gemmed surrounds, and vigorous linear modelling. It was the model of the age for painting in every

Hilliard, *Young Man among Roses*, *c*.1587 (V&A).

medium, including oil, which he himself employed occasionally for life-size portraits of Elizabeth.

Among Hilliard's pupils before 1600 were his son **Laurence** (1581/2–1647/8), Rowland Lockey (*c*.1565–1616), and Isaac OLIVER. The last rapidly emerged as a strong competitor, and by 1595 his more pronounced naturalism was exerting an influence on Hilliard.

With Elizabeth's death, Hilliard lost much of his position at court. The decline in his fortunes was steep, but he was regularly employed by James I who eventually granted the monopoly on his portraiture in 1617. Much of his late work consists of dry replicas of royal portraits; however, at their finest, his last miniatures fully justify his reputation as one of England's supreme portraitists. PN
□ E. Auerbach, *Nicholas Hilliard* (1951); G. Reynolds, *Nicholas Hilliard and Isaac Oliver* (1947, rev. 1971); Murdoch, Murrell, Noon and Strong (1981)

Hillier, Tristram *see* UNIT ONE

Hills, Joan *see* BOYLE

Hilton, Roger (1911–75) was one of the few British abstract painters in the early 1950s. His family name, changed in 1916, was Hildesheim, and his father was a first cousin of the art historian Aby Warburg. Hilton trained at the SLADE 1929–31 and spent about 2½ years in Paris in the 1930s. His first abstracts date from 1950. In 1953 he simplified his paintings to a few ragged forms in primary or earth colours and black and white, with no illusory pictorial space; some hint at the female figure or at landscape but others are uncompromisingly abstract. From 1955 his imagery alluded more to the visible world and he reintroduced shallow pictorial space.

He first visited ST IVES in 1956 and from then on his painting often suggested floating figures or boats. American paintings of the 1950s had little influence on him, except perhaps to stimulate him to paint a few large pictures. In 1961, when abstraction had become a powerful force in British art, he executed the first of a small series of paintings of female figures. In the last 2½ years of his life he was confined to bed and able to paint only in gouache – female

Hilton, *Oi yoi yoi*, 1963 (Tate).

figures, animals and plants, as well as abstracts, the colours more joyful as death approached. He had an unusual sensitivity in the handling of paint and his work often has an edgy eroticism and humour. DBr
□ *Roger Hilton* (exh., Arts Council, 1974)

history painting is a term used mainly in the 18c. to denote the painting in the grand manner of heroic subjects derived from the Bible, classic literature or great historical events. It derives from the Italian *istoria*, and the classical idealism of its Italian proponents was very much in the minds of those like RICHARDSON and REYNOLDS who proclaimed the need for British artists to vie with Raphael and Michelangelo. They assumed the intellectual and moral superiority of history painting over the supposedly 'imitative' genres of portrait and landscape, though this was by no means universally accepted by artists or critics; HOGARTH for instance fought vigorously on behalf of the observation of daily life.

An aspiring history painter – and there were many to take up the call after the founding of the ROYAL ACADEMY in 1768 – would hope to spend many years in Rome studying antiquity and he would expect on his return to be given commissions for large paintings on high-minded themes. The reality was somewhat different: though many patrons paid lip-service to the ideal, few – perhaps wisely – were prepared to commission such works, and the art world of the late 18c. was littered with the broken hopes of would-be history painters. Only Benjamin WEST, thanks to royal patronage, managed to make a successful career of it, while BARRY, ROMNEY and HAYDON all died in abject despair at the refusal of their contemporaries to understand the need for elevated art. The movement reached a kind of fulfilment in the immense paintings for the Palace of WESTMINSTER in the 1840s, but by then the ideals of history painting carried considerably less conviction than they would have done 50 years before. DB
□ Boase (1959); Waterhouse (1978), 271–84

Hitchens, Ivon (1893–1979), a landscape painter, sought in his early work to assimilate the lessons of Cubism with an essentially romantic view of the English countryside. He exhibited with the 7 AND 5 SOCIETY 1921–35 and was influenced by SURREALISM during the 1930s. Bold colours and fluid brushwork

characterize the 'long landscapes' which he painted from 1936. DR
□ A. Bowness, *Ivon Hitchens* (1973)

Hoare, William (1707–92) settled in Bath by 1739 after study in Italy, and soon became the most fashionable portrait painter in oils and pastel. Despite being overshadowed by GAINS-BOROUGH, who arrived in 1759, Hoare's practice continued to flourish. BA
□ M. Holbrook in *Apollo*, XCVIII (1973), 375–7

Hockney, David (b.1937) sprang to fame even before he left the ROYAL COLLEGE in 1961 (see POP ART). In a so far uneven career his brilliance and sensivity have had difficulty in keeping pace with an initially self-engineered celebrity which now tends to dwarf his achievement as an artist. His witty and inventive paintings of the early 1960s were succeeded by the better known Californian works which often centre around swimming pools. These seemed to lead into an impasse of laboriously academic portraiture, usually based on photographs. Commissions to design sets for Glyndebourne were a liberating force both in his own work and in the world of theatre design in general. As printmaker and book artist he has made memorable contributions, especially with a suite of etchings, *The Rake's*

Hockney, *Richard Hamilton*, etching, 1971.

Progress (1961–3), and his edition of Grimm's *Fairy Tales* (1969). The overt homosexuality in his work has played an important part in steering public opinion towards greater tolerance. His seemingly effortless draughtmanship is the envy of fellow artists: the innumerable drawings of people and places have in their elegance and fine observation been the most notable and consistent feature of his work. He is a fine photographer and an astute commentator on art in general. *See also* WATERCOLOUR. TP
□ *David Hockney by David Hockney* (1976)

Hodges, William *see* WILSON

Hodgkin, Howard (b.1932) is the outstanding colourist in contemporary British painting, and none can match the vibrancy of his best work which deals with remembered locales, often the interiors of friends' houses. Akin to the savoured memories of Proust, these evocations use an iconography so private as to risk preciousness: this danger is usually overcome by the boldest pictorial inventions, often involving the frame in the fabric of the picture. His love and expert knowledge of Indian miniature painting is apparent both in the colour and in the relatively small format of his paintings, the finest of which, quirky and personal, feature daringly strident solutions (though he has a tendency too often to repeat successful strategies). Recent forays into printmaking have been uneven, but his oeuvre already represents, for all its idiosyncrasy, a solid and assertive achievement. Hodgkin is an active figure in both the politics of art and its social world. *See also* PORTRAIT PAINTING; 20C. TP
□ *Howard Hodgkin* (exh., Oxford, Mus. Modern Art, 1976)

Hodgkins, Frances *see* 7 AND 5 SOCIETY

Hogarth, William (1697–1762) was the dominant artistic personality in England in the first half of the 18c. and the painter who did most to make a reality of the idea of a distinctive English school. Among other achievements he established the new genre of 'Modern Moral Subject', in which a story from contemporary life is told in a series of paintings which were subsequently engraved. In recent years his great gifts as a painter have become increasingly evident, though in previous

centuries his fame rested almost entirely on his engravings.

A man of many contradictions, he was, like his father-in-law THORNHILL, a shrewd careerist, but he was also deeply vulnerable to criticism; prone to high spirits but also melancholic. These contradictions can partly be explained by his upbringing as the son of a bankrupt author and schoolmaster, which obliged him to enter in 1713 the lowest rung of the artistic profession as an apprentice to a silver engraver. He set up as an independent engraver in 1720, enrolling also at the Vanderbank Academy (see ST MARTIN'S LANE ACADEMY), where he met well-known painters and picked up some instruction in drawing. In the 1720s he rose steadily through his profession, making funeral tickets, book illustrations and social and political satires. Having his eye set on higher things, however, he learned, perhaps from Thornhill, enough painting technique to make rapid progress on his own, and by 1729 he had achieved a major success with a painting of *The Beggar's Opera* which he was obliged to repeat at least 5 times (Tate; Yale BAC; etc.). Though highly original in its depiction of a stage scene, its success was due as much to Hogarth's grasp of public taste, a talent that led VERTUE to describe him as 'a good Front and a Scheemist'.

This success led him into the field of the small CONVERSATION PIECE where his brilliant and lively manner gained him further applause. Restless as ever for fame he tells us that 'he embarked on painting and Engraving modern moral subject[s] a Field unbroke up in any Country or any Age', beginning with *A Harlot's Progress* (1730–32) which told in a series of 6 paintings (now lost) the tragic story of a country girl who fell for the temptations of city life. The engravings had an immediate success through their humour, pathos and topicality, and they were followed by the paintings of *The Rake's Progress* (c.1733; London, Soane Mus.), but he did not release the engravings until he had instigated an engraver's copyright act in 1735. The Rake himself was, like the Harlot, a vehicle for exposing the corruption and foolishness of polite society and its hangers-on: aristocrats, merchants, doctors, lawyers, clergymen and foreigners. With the even greater success that followed his second series Hogarth branched out, making paintings of London life in the *Four Times of Day* (Upton House; priv. coll.); portraits, culminating in the spectacular one of *Captain Coram* (1740; FOUNDLING HOSPITAL); and, surprisingly, DECORATIVE paintings in the manner of Thornhill, to whose eminence he aspired (see AMIGONI; KENT). Furthermore in the late 1730s he appointed himself spokesman for British painters and challenged the taste for foreign and old masters by public statements and the encouragement of the Foundling Hospital as an exhibition place for native talent.

In the 1740s Hogarth became increasingly preoccupied with answering the suggestion (not as widespread as he thought) that he was merely a comic painter. With the support of the novelist Henry Fielding he proclaimed himself a 'Comic History Painter' and dissociated himself from 'low' genres like caricature; the result was the most accomplished of his moral cycles, *Marriage-a-la-Mode* (c. 1753; NG), in which the figures are painted with French elegance, which in turn is satirized in its association with the affectation of aristocratic life. He also began work on *The Analysis of*

Hogarth, *Captain Thomas Coram*, 1740 (London, Thomas Coram Foundation for Children).

Hogarth, *The Marriage Contract*, from *Marriage-a-la-Mode*, c.1743 (NG).

Beauty (1753), a brilliant treatise which considers painting from the viewpoint of visual effect rather than moral purpose. Yet he also sought to make his art more directly responsive to social evils in a series of POPULAR prints beginning with *Industry and Idleness* (1747), which shows schematically the contrasting fates of a good and a bad apprentice. Other series were directed towards cruelty and the effects of gin, and, though still humorous, they exhibit a more sombre attitude which can be paralleled in Fielding's writings.

In the 1750s he became the target of caricature himself and attacks on satire in general; his response was morbid depression and apocalyptic feelings of national decline. Yet his painting became more sensuous than ever, and nothing is more poignant than the contrast between the despairing message of corruption in his last great moral series, *An Election* (c.1754; Soane Mus.) and the attentive depiction of individual objects and figures. By the end of the decade his strident Toryism brought upon him further assault, but his late portraits, like *Hogarth's Servants* (1750–55; Tate) have a Rembrandtesque depth which reflects his own sense of the human tragedy.

By the end of his life he began to be overtaken by the urbanity of such artists as REYNOLDS, but by showing that a painter could be a man of intellect and wit he had made possible the elevated position that painting was to enjoy in the next generation. Furthermore, by using engraving he had shown the way for artists to survive economically by appealing to a public beyond the narrow circle of connoisseurs. He had no pupils, but almost all subsequent art in England bears the mark in one way or another of his personality. *See also* CARICATURE; LAMBERT; *LANDSCAPE: 18c.; RO-COCO; *TERRACOTTA; VAUXHALL GARDENS. DB
□ R. Paulson, *Hogarth's graphic* works (1965); id., *Hogarth* (1971); D. Bindman, *Hogarth* (1981)

Holbein, Hans, the Younger (1497/8–1543) arrived in England in 1526 with the encouragement of the humanist Erasmus. Although born in Augsburg, he had established himself at Basel, where he made a reputation as a painter of religious subjects and house exteriors and a designer of woodcuts, as well as a portraitist.

In England his earliest commissions included a richly coloured, incisive characterization of Sir Thomas More (1527; New York, Frick: see *PORTRAIT PAINTING: 16C.) as well as an ambitious group portrait of the More family, now known only through preparatory drawings and early copies (e.g. Nostell Priory). In 1528 he returned to Basel, but in 1532, after iconoclasm threatened his livelihood, he settled in England. There he quickly attracted commissions from Hanseatic merchants, courtiers and French envoys, 2 of the latter spectacularly depicted in a full-length double portrait, *The Ambassadors* (NG). Before 1537 he became painter to HENRY VIII, for whom he executed a life-size dynastic portrait of the King, his parents and Queen Jane Seymour on the wall of Whitehall Palace (known from a copy and Holbein's own cartoon (NPG)). In 1538–9 he was sent on journeys abroad to portray the King's prospective wives: in 1538 he painted an elegant, seductive portrait of Christina of Denmark (NG) and in 1539 Anne of Cleves (Paris, Louvre). During his second English stay Holbein learned to paint portrait miniatures (see below). He also designed a fine

Holbein, *Mrs Pemberton*, c.1536 (V&A).

woodcut titlepage for the *Coverdale Bible* (1535) and produced drawings for goldsmiths' work.

Holbein's success in England was overwhelming: he portrayed nearly a quarter of the peerage, and although many works are lost a record of great beauty and extraordinary perception remains in the series of over 80 drawings in the Royal Coll. SF
□ K. T. Parker, *The drawings of Hans Holbein in the collection of H.M. the King* (1945); P. Ganz, *The paintings of Hans Holbein* (1950).

As a miniaturist Holbein began c.1534, having learned the technique of WATERCOLOUR painting on vellum from Lucas Hornebolte (c.1490/95–1544). Notwithstanding the diminutive scale, Holbein approached this new discipline with his characteristic naturalism and monumentality. He appears also to have followed his normal procedure, painting these portraits from large chalk studies drawn from the life. Although only a few of his limnings of prominent court figures survive, such works as *Mrs Pemberton* (c.1536; V&A) and *Anne of Cleves* (1539; V&A) rank with the finest examples of the art. PN
□ Murdoch, Murrell, Noon and Strong (1981)

Holding, Eileen *see* CONSTRUCTIVISM

Holiday, Henry *see* STAINED GLASS: 19–20C.

Holl, Frank (1845–88), son of the engraver Francis Holl, made his name as one of the GRAPHIC's stable of artists, and, like FILDES and HERKOMER, made celebrated paintings based on his wood-engravings. He studied at the ROYAL ACADEMY Schools in the early 1860s, became RA in 1883, and was successful enough as a portrait painter to commission houses in London and the country from Norman Shaw. His most famous picture is probably *Newgate. Committed for Trial* (Egham, Royal Holloway College), shown at the RA in 1878. TG
□ Farr (1978)

Hollar, Wenceslaus (1607–77) was the first great ETCHER to practise in Britain. Born in Prague, he worked extensively in Germany before being brought to England by the Earl of ARUNDEL in 1636. His range of subjects was enormous: portraits, landscape, topography, copies of works in the Arundel collection, and portrayals of fashionable women. Most useful to the historian are his views of London before and after the Great Fire of 1666, while his

Hollar, *By Islington (London from Islington)*, etching, 1665.

LANDSCAPES stand at the beginning of the English tradition.

The Civil War forced him to flee in 1644 to Antwerp where, vastly productive, he made many plates from drawings done in England, and etched many of his best prints, including the beautiful series of fur muffs (1642–7). He returned to England in 1652 and worked increasingly for the book trade, but was tragically frustrated in his ambition to produce a vast map-view of London. He died in poverty, having etched nearly 2,800 plates. *See also* EVELYN; WATERCOLOUR. RG
□ R. Pennington, *Descriptive cat. of the etched work of Wenceslaus Hollar* (1982)

Hone, Evie *see* 7 AND 5 SOCIETY; STAINED GLASS: 19–20C.

Hone, Galyon (d.*c.*1551/2) succeeded FLOWER as King's Glazier in *c.*1520. Of Dutch birth, he was in England by 1517, and like many of the foreign glass-painters resided in Southwark (*see* LONDON SCHOOL OF GLASS-PAINTING). Hone became one of the main exponents of the Renaissance style in English glass and glazed a number of royal palaces, including Hampton Court (armorial glass from here is now in Earsdon church, Northumb.). His major surviving work is in King's College Chapel, Cambridge, where in 1526 he and 3 others contracted to glaze 30 of the windows (*see* ★STAINED GLASS: TO 1550). RM
□ H. Wayment, *The windows of King's College Chapel Cambridge* (1972)

Hook, James Clarke (1819–1907) at first painted Italianate literary subjects, but in 1859

Luff Boy! (priv. coll.) was acclaimed by RUSKIN, and Hook specialized thenceforth in sturdy, picturesque fisherfolk, in settings painted from nature with a Venetian taste in colour. RT
□ Treble (1978)

Hoppner, John (1758–1810) as a portraitist at first based his style on late REYNOLDS. He became portrait painter to the Prince of Wales (the future George IV) in 1789 and RA in 1795. His most distinguished works were executed before he was eclipsed in the 1790s by the talent of the young LAWRENCE. Many of his clients were prominent Whigs. BA
□ W. McKay and W. Roberts, *John Hoppner* (1909)

Hornebolte (or **Horenbout**), **Lucas** *see* HENRY VIII; HOLBEIN; MINIATURE PAINTING

Hornel, E. A. *see* GLASGOW SCHOOL; HENRY

Horsley, John Callcott (1817–1903) began his career as a HISTORY painter, winning a commission to paint *Religion* in the new Palace of WESTMINSTER. Later he became a member of the CRANBROOK COLONY, specializing in piquant moments from rural and domestic life. WV
□ J. C. Horsley, *Recollections of a Royal Academician* (1903)

Hoskins, John *see* COOPER; MINIATURE PAINTING

Houghton, Arthur Boyd (1836–75) was one of the leading 'Illustrators of the '60s' (*see* WOOD-ENGRAVING), whose compelling personality, dramatic appearance and East India Company family background informed his vigorous, flamboyant line and exotic subject-matter. Early oils of street entertainments and family life reflected his brief but intensely happy marriage. Widowed in 1864, he became deliberately, self-destructively and notoriously drunken. At his final acerbic best in the controversial GRAPHIC illustrations of America (1870–75), he declined into religious mania after 1872 in his (now lost) last oils. RT
□ P. Hogarth, *Arthur Boyd Houghton* (1981)

Hours *see* BOOKS OF HOURS

Hoyland, John (b.1934) is the chief British exponent of a kind of painterly abstraction that has been associated with the theories of the

American critic Clement Greenberg and his followers. His mature style is characterized by the juxtaposition and superimposition of very rich fields of colour, generally in the form of freely executed rectangles or other simple quadrilaterals. His paint is conspicuously textured by the evidences of its own physical characteristics and by those of the instruments with which it is applied. *See also* SITUATION.

MC

□ *John Hoyland* (exh., Arts Council, 1979)

Hudson, Thomas (1701–79) was the most fashionable and prolific ★PORTRAIT painter in London between *c*.1740 and *c*.1755. His sombre early works reflect the style of his teacher RICHARDSON, but he developed a wider range of poses and, like his rival RAMSAY, employed VAN AKEN to paint most of his draperies. REYNOLDS was his most illustrious pupil, but he also taught

Hughes, *The Long Engagement*, 1859 (Birmingham).

WRIGHT OF DERBY and MORTIMER before giving up painting professionally in the early 1760s. *See also* MCARDELL. BA

□ E. Miles and J. Simon, *Thomas Hudson* (exh., London, Kenwood, 1979)

Huggins, W. J. *see* MARINE PAINTING

Hughes, Arthur (1831–1915) was a subject painter closely associated with the PRE-RAPHAELITES. During the 1850s he exhibited pictures which shared their concern for closely observed nature. The themes were often highly emotive – as in *The Long Engagement* (1859; Birmingham) – but they are saved from sentimentality by the poignancy of their mood and the sensitive treatment of colour effects. He was also a highly effective illustrator. WV

□ Ironside and Gere (1948)

Hughes, Malcolm *see* CONSTRUCTIVISM

Hugo, Master *see* BURY BIBLE; IVORY CARVING

Hunt, Alfred William (1830–96) is with Samuel Palmer perhaps the most distinguished of the true followers of TURNER in WATER-COLOUR. Works like his *Watendlath* (1858; BM), employing Turner's elaborate systems of hatching and scraping-out, attracted the approval of RUSKIN and approximate closely to the effects achieved in oil by the PRE-RAPHAELITES. AW

□ Hardie, III (1968)

Hunt, William Henry ('Bird's-Nest') (1790–1864) was a pupil of John VARLEY, through whom he met LINNELL and MULREADY, and it was their bent for informal realism that he followed. He was also employed by Dr MONRO. In the late 1820s his charming portrait and landscape studies in watercolour and pen gave way to poetic small-scale interiors, often by lamplight, and still-lifes. His success in this line was great, though later his work became excessively minute and illusionistic. His combination of watercolour with bodycolour to produce a malleable medium akin to TEMPERA was much imitated. *See also* OUTDOOR PAINTING; WATERCOLOUR. AW

□ J. Ruskin, *Notes on Samuel Prout and William Henry Hunt* (1879); Hardie, III (1968); J. Witt, *William Henry Hunt* (1982)

Hunt, William Holman (1827–1910) was a leading member of the PRE-RAPHAELITE BROTHERHOOD. Although less naturally gifted than his fellow leaders MILLAIS and ROSSETTI, he was a stubborn man of fierce resolve, and pursued the original aims of the Brotherhood with greater singlemindedness. At his best he achieved works of remarkable, almost hypnotic, force. His *Light of the World* (1853; Oxford, Keble College) was for generations one of Britain's best-known pictures.

The son of a London warehouse manager, Hunt entered the ROYAL ACADEMY Schools in 1844. There he met Millais and Rossetti and formed with them the idea of setting up the Brotherhood. He also fell under the spell of RUSKIN's *Modern Painters*, which inspired him to paint in an obsessively detailed manner and suggested ways in which naturalistic images could be used symbolically.

His earliest Pre-Raphaelite pictures have an archaizing quaintness. By 1851 in *The Hireling Shepherd* (Manchester) he essayed a more contemporary form of realism. His habit of finishing his pictures as much as possible in the open air using the 'wet white' technique (*see*

PRE-RAPHAELITE BROTHERHOOD) led to a remarkable perception of colours and light effects, as in *Our English Coasts* (1852; Tate), a directly observed landscape full of symbolic overtones. Hunt's developing spiritual purpose led him to paint a didactic critique of modern life in the form of 2 interrelated pictures, *The Awakening Conscience* (1953–4 etc.; Tate) and the religious allegory *The Light of the World* (1851–3, etc.; Oxford, Keble College). Both are distinguished by the principal figure's direct gaze and the symbolical use of observed detail.

In 1854 Hunt travelled to Palestine, to paint Biblical scenes in their natural setting. His *Scapegoat* (1854; Port Sunlight) – an allegory painted from a real goat tethered in front of the Dead Sea – was not well received; though it has fascinated modern observers by its inadvertently Surrealistic effect. His more accessible *Finding of the Saviour in the Temple* (1854–60; Liverpool) was an immense success, and was bought by GAMBART for an unprecedented sum.

Hunt made further trips to the Middle East in 1869 and 1873 and continued to paint well-received religious pictures. (He was one of the prosperous artists who lived in Melbury Road, Kensington.) The garish effects of his later works have proved less appealing. WV
□ Hunt (1905); M. Bennett, *William Holman Hunt* (exh., Liverpool/V&A, 1969)

Hunter, Leslie *see* SCOTTISH COLOURISTS

Hurrell, Harold *see* ART AND LANGUAGE

Hussey, Giles (1710–88) was regarded as the first British HISTORY painter in a long succession (ending with BARRY and HAYDON) to be a martyr to the lack of native patronage of the elevated style. However nothing in his surviving work suggests that the neglect was unjustified. DB
□ Pye (1845); Waterhouse (1978)

Huysmans, Jacob (*c.*1633–96), born in Antwerp, settled in England after the Restoration and was seen by Catherine of Braganza's supporters as a Catholic rival to LELY. His portrait of *Catherine of Braganza as a Shepherdess* (*c.*1664; Royal Coll.), with its metallic colouring, allegorical allusions and foreground flora, is characteristic of his style. He was also a HISTORY and religious painter. DD
□ Waterhouse (1978)

Holman **Hunt**, *The Awakening Conscience*, 1853–4 etc. (Tate).

I

Ibbetson, Julius Caesar (1759–1817) began as a scene painter and pasticheur of Dutch landscapes. His best works are small-scale English views of rustic and PICTURESQUE subjects painted with a freshness reminiscent of de LOUTHERBOURG and early GAINSBOROUGH. After 1799 he concentrated on the scenery of the Lakes and his native Yorkshire. EE
□ R. M. Clay, *Ibbetson* (1948)

ICA The Institute of Contemporary Arts was founded and grew under the leadership of Sir Roland PENROSE. In its rooms in London from 1947 to 1967 discussions took place on everything that could be related to contemporary art. The Independent Group (1952–5) was the forum which contributed to the emergence of POP ART. Since 1968 the ICA's emphasis has shifted towards the performing arts. MC
□ *ICA Bulletin*

illuminated manuscripts *Anglo-Saxon: see* ANGLO-SAXON ART.
Romanesque manuscripts are generally characterized by stern, hieratic figures delineated by solid outlines and painted in full colours, and by symmetrical compositions with indications of physical space limited to oblong background panels. The main emphasis is on solemn religious drama, communicated by facial expression (particularly of the eyes) and rhetorical gestures of hands and fingers. There is no single ROMANESQUE style, however, although these features predominate in the period from the Norman Conquest to the 1190s, and the term should be regarded as a historical rather than stylistic label.

By far the greatest patrons of book illumination, some of them among the largest landholders in the country, were the monasteries, which, after 1066, became an essential part of the Norman hegemony. Under Archbishop Lanfranc strenuous efforts were made at monastic reform to bring England into line with Norman discipline, liturgy and learning. One result was the widespread

Initial A from a manuscript of Josephus' *Jewish Antiquities* illuminated at Canterbury *c*.1130 (Cambridge University Lib., MS Dd.1.4).

establishment of monastic scriptoria, with the highest standards of calligraphy and book production, to copy texts that were standard in the larger Continental monastic libraries. This increase in the actual number of books produced lies at the base of the flowering of Romanesque illumination. It should be seen as an indication of the increasing wealth and part of the growth of learning and literacy in 12c. England.

In the course of the 12c. Christ Church and St Augustine's at CANTERBURY, the abbeys of ST ALBANS and Bury St Edmunds, the New Minster and Hyde Abbey at Winchester, and Durham Cathedral Priory were among the principal patrons of illuminated books. However, it is not clear how much of the writing was done by monks and how much by professional scribes, probably clerics in minor orders. Certainly, most of the main artists were lay professionals, and in some cases it is possible to trace their movements as they executed commissions for different houses (*see* LAMBETH BIBLE, WINCHESTER BIBLE).

While many features of Anglo-Saxon style are to be found long after 1066, the Norman Conquest appears to have interrupted the

The Visitation, from the St Albans Psalter,
c.1120–30 (Hildesheim, St Godehard).

Initial to Isaiah from the Winchester Bible, by the
Master of the Gothic Majesty, c.1170–85
(Winchester Cathedral).

development of narrative illustration in English manuscripts; at least no narrative cycles exist between 1070 and c.1100 (Bede, *Life of St Cuthbert*: Oxford, Univ. College, MS 165). The early development of English Romanesque illumination can best be traced in the decorated initials of the Canterbury School. Indeed, it is one of the principal attractions of Romanesque illumination that the stern seriousness of the religious imagery is balanced by some of the liveliest and most humorous decoration ever invented. Typically, dragons, beasts and human figures struggle against each other while enmeshed in the thick tendrils of engulfing foliage and large acanthus blossoms. The peak of this development was c.1130–50, though the essential ingredients are to be found from the 1070s.

A cycle of narrative miniatures in a fully developed Romanesque style appears c.1120–30 in the ST ALBANS PSALTER. The St Albans style remained influential until it was superseded by that of the *BURY BIBLE (c.1135), characterized by strong Byzantine influence and by a method of articulating the body beneath the drapery by clinging, curvilinear folds, which remained a hallmark of English illumination c.1140–70.

The 1170s saw fundamental changes in the style of both figures and decoration which mark the late Romanesque period and herald the transition to Gothic. Books and script tend to become smaller, often containing the new Biblical glosses imported from Paris. These glosses were written in columns surrounding the text and they required a series of small initials running parallel to the large ones in the main text. The foliage decoration becomes thinner and more tightly wound, the background usually gold, and tiny white lions the main decorative feature.

In the same period, Byzantine influence ushered in a greater realism of modelling for faces and for drapery, on which multiple folds gradually replaced the abstract pattern of the mid 12c. (e.g. in the Winchester Bible). Figures imbued with classical calm, rather than hieratic solemnity, mark the period of transition to Gothic realism. CMK

□ Kauffmann (1975); W. Oakeshott, *Two Winchester Bibles* (1981); Thomson (1982); *1066: English Romanesque art* (exh., Arts Council, 1984)

Gothic illumination of the mid 13c.: dedication page of the Missal of Henry of Chichester, by the Sarum Illuminator (Manchester, Rylands Lib.).

Italian-influenced illumination of c.1330: Crucifixion from the Gorleston Psalter (BL). (*See* East Anglian illumination.)

Gothic illumination began to emerge in the years around 1200, as the distortion of figure poses and patterned effects of Romanesque painting gave way to calmer poses with drapery falling in more natural folds. In the mid 13c. under strong influence from France the mature GOTHIC style developed, and in various forms it continued until the decline of English illuminated manuscript production in the second half of the 15c. The range and quantity of illuminated manuscripts make these 250 years the richest period for this form of English painting, with many works of the quality and artistic invention of the better known masterpieces of Anglo-Saxon and Romanesque illumination.

In contrast to the situation before 1200, Gothic manuscripts were almost all produced by workshops of lay artists rather than in monastic scriptoria. Documentary and circumstantial evidence indicates that by c.1250 illuminated books were being produced in towns, e.g. Oxford (the location of the workshop of William de *BRAILES), and by the beginning of the 14c. London, Cambridge, Norwich and York were important centres. Some groups of artists seem to have moved

from place to place according to commission. In some cases a group was employed by a single family, such as the *BOHUN family. In the late 14c. and 15c. Flemish artists worked in England, or, as is more likely, made manuscripts in Flanders for export to English patrons (*see* INTERNATIONAL GOTHIC).

Patronage in the Gothic period ranged from aristocratic laymen and high ecclesiastics to minor gentry and, in the 15c., the merchant class. The most popular types of illuminated manuscripts were devotional texts – PSALTERS and *BOOKS OF HOURS – but picture books such as APOCALYPSES, BESTIARIES and Lives of saints were also fashionable at various times. Liturgical books for the public services of the church, such as the Missal, also exist in luxury copies, although few survived the Reformation; examples are the *SHERBORNE MISSAL and Lytlington Missal (London, Westminster Abbey).

Books were decorated in various ways: with full-page illustrations, framed miniatures set within the columns of text, initials containing figure subjects or ornament, frame borders, and illustrations in the lower margin (*bas-de-page*). The use of decorative borders framing the text page was of great importance in the 14c. and

International Gothic illumination of *c.*1404–7: Annunciation with patrons, from the Beaufort Hours, by Herman Scheerre (BL).

15c. In the 14c. they served as a stage for fantasy subjects termed GROTESQUES (*see* *EAST ANGLIAN ILLUMINATION).

The phases of Gothic figure style are broadly divided into 6 periods: (i) Early Gothic, *c.*1200–1250; (ii) a period of strong French influence with the emergence of an English Court School, *c.*1250–1300; (iii) the period *c.*1300–1330, in which works in a French-derived style (e.g. the *QUEEN MARY PSALTER),whose origins are in the Court School, coexist with others in the true DECORATED style, occurring in regional schools in East Anglia and the diocese of York; (iv) the period *c.*1330–90, characterized by influences from Italy and Flanders; (v) the International Gothic, *c.* 1390–1430; and (vi) a final phase, *c.*1430–80, in which there is a move away from the graceful elegance of the International Gothic to harder figure and facial types with much influence from Flanders.

After *c.*1450 manuscript illumination in England was a declining art form. Imported French and Flemish books were of better quality, and the best work in English painting was to be found not in manuscripts but in STAINED GLASS.

See also ABELL; *DOUCE APOCALYPSE; *PARIS; ST ALBANS SCHOOL; SARUM ILLUMINATOR; SCHEERRE; SIFERWAS.　　　　　　　NM
□ Rickert (1965); Marks and Morgan (1981); Morgan (1982)

Inchbold, John (1830–88) became a major PRE-RAPHAELITE landscapist under RUSKIN's influence 1852–7, but subsequent travels in Italy and Spain led him back to a more subjective painterliness. He had an awkward personality and chronic financial problems; he spent his last decade in Switzerland.　　　　　　　RT
□ Staley (1973)

Industrial Revolution　　Industrialization gathered momentum in the mid 18c. with advances in the textile and iron industries and the development of steam power, and by 1850, though most of the population still worked in traditional ways, the economy was transformed. Industrialization provided British artists with subjects they treated in ways SUBLIME, PICTURESQUE, moralizing or reportorial, yet rarely were they critically engaged with its implications.

*WRIGHT OF DERBY's paintings of the *Air Pump* and *Orrery*, and of smithies and forges, are often taken as instances of an interest in industrialization, but this has clearly been exaggerated, and his work does not inaugurate any tradition of depicting productive processes. Though elements of industrialization, like canals and barges, appear in CONSTABLE's paintings, and lime-kilns and foundries in TURNER's, productive work itself is rarely central. In the late 18c. topographical artists often depicted novel industrial sites like Coalbrookdale (*see* *LOUTHERBOURG, *SANDBY), but in the 19c. as industrialization spread painters tended to emphasize instead the continuity of rural tradition. There is nothing comparable to the German architect Schinkel's sketch of Manchester factories made on his tour of England in 1825; and some other Continental artists, like Géricault in 1820–22, Gavarni in 1849, and later Doré, showed the consequences of industrialization on English life in a way that English artists hardly ever did. The most significant exceptions are J. C. BOURNE and James SHARPLES, and Madox BROWN in his remarkable paintings of modern life of the 1850s. In general, artists throughout Europe were reticent about depicting industrial production.

Industrial Revolution: Bourne, lithograph of the Kilsby Tunnel, from *Drawings of the London and Birmingham Railway*, 1838–9.

The Industrial Revolution was, however, of importance in providing new techniques and working conditions, and changing the relationship between the production of art and of other types of object, which in turn led to changes in the status of art objects and hence of their producers. Iron and steam applied to printing made it possible to produce high-quality prints more cheaply by taking advantage of BEWICK's innovations in WOOD-ENGRAVING. Steel-engraving became practicable in the wake of late 18c. advances in metallurgy. LITHOGRAPHY was developed just before 1800, and photography in the 1830s. Electrotyping, a product of the electrochemical revolution, changed the economics of print-making and illustrated journalism in the 1840s. Furthermore, Britain's commercial and industrial pre-eminence transformed both the size and the nature of the markets for which artists worked. The Industrial Revolution perhaps contributed indirectly to the success of a Romantic conception of art, which now justified itself not by its utility for society but by its relationship to its creator: in other words, art might be seen as deliberately differentiating itself from the manufactured object. TG
□ Klingender (1968); D. S. Landes, *The unbound Prometheus* (1969); A. Briggs, *Iron Bridge to Crystal Palace* (1979)

Innes, J. D. *see* CAMDEN TOWN GROUP

Inshaw, David *see* RURALISTS

Insular art *see* ANGLO-SAXON ART: EARLY

International Gothic is a phase of the GOTHIC style lasting from the late 14c. up to c.1430. It is characterized by mutual influences between various European centres of art, and is chiefly associated with courtly patronage. In England RICHARD II was the most important royal patron, and William of WYKEHAM the chief episcopal patron. The leading artists whose names are known to use are the illuminators Herman SCHEERRE (*see* *ILLUMINATED MANU-SCRIPTS: GOTHIC) and John SIFERWAS and the glaziers THOMAS OF OXFORD and John THORNTON. Major works characteristic of the style are the great east window of York Minster (*see* *STAINED GLASS: TO 1550), the Beaufort Hours (BL) and the *SHERBORNE MISSAL.

The style is characterized by the fusion of multiple influences rather than direct dependence. The sources of English International Gothic lie in France, Flanders, the Cologne region, Italy, and perhaps also Bohemia. Influences were transmitted through foreign artists working in England, and through imported works of art. Among the former were the painter of the Apocalypse WALL-PAINTINGS in Westminster Abbey Chapter House, and Herman Scheerre, whose elegant, brightly coloured painting was formed in Cologne and Bruges. Bruges was also the base for the first Flemish workshop to specialize in export production for England: headed by an artist called the Master of the Beaufort Saints, after his paintings in the Beaufort Hours, the group produced many BOOKS OF HOURS for English patrons.

In painting, these foreign artists introduced new features: a distinctive palette dominated by bright reds, pinks and blues, the use of 3-dimensional architectural structures, and more elaborate attempts at landscape. The 2 latter features reflect the practice of contemporary French and Flemish painters such as the Boucicaut Master and Melchior Broederlam. A mannered elegant figure style is combined with an interest in portraiture and realism of facial expression.

The stained glass of Thomas of Oxford and John Thornton shows the same elements, possibly derived from German sources.

In sculpture, with the exception of TOMBS, few major works survive and developments are poorly understood. Tombs in the International Gothic style are characterized by elaborate costumes and headgear (best seen in the female figures), rendered with great attention to detail.

The few surviving PANEL PAINTINGS include the *WILTON DIPTYCH and the NORWICH RETABLE (*see* *PANEL PAINTING). They display in monumental form the same features that distinguish manuscript illumination: elegant mannerism of figure forms, combined with realism of portraiture. NM

☐ Rickert (1965); Stone (1972); Marks and Morgan (1981), 23–9, 86–113

ivory carving *Medieval ivories* are best studied together with ILLUMINATED MANUSCRIPTS, GOLDSMITHS' WORK and monumental SCULPTURE. From the ANGLO-SAXON period onwards it appears that ivory carvers worked alongside illuminators in monastic scriptoria, and some craftsmen practised both arts. In one well-known case, Master Hugo, the artist responsible for the illuminations in the 12c. BURY BIBLE, is also recorded as carving an altar cross and casting a bell, and there have been many attempts by scholars to assign to him a famous walrus ivory cross in New York (Cloisters). Earlier, in the late 10c., the carver of a beautiful small plaque in Liverpool showing the Nativity (Merseyside County Mus.) was clearly in the circle of the artist who painted the same scene in the sumptuously illustrated BENEDICTIONAL OF ST ETHELWOLD, executed at Winchester *c*.980. In like manner, 2 ivory liturgical combs (V&A; Verdun, Mus. de la Princerie) may be confidently assigned to St Albans *c*.1120, for they show a remarkable similarity in their crowded compositions and animated figures to the ST ALBANS PSALTER of *c*.1119–23.

One of the most striking features of English ivories up to the Gothic period is that they were nearly all carved from walrus rather than elephant ivory. Occasionally whalebone was used, as for the Franks Casket (BM), probably made in Northumbria *c*.700 (*see* *ANGLO-SAXON ART). Partly because English carvers were not dependent on imported elephant ivory, likely to be unobtainable in times of war, pieces exist from the Anglo-Saxon to the Gothic period, valuably illustrating changes in style where monumental sculpture has so often been destroyed.

The medieval ivory carver was in the service

Anglo-Saxon ivory plaque depicting the Nativity, late 10c. (Liverpool, Merseyside County Mus.).

of the church and, in the Anglo-Saxon and ROMANESQUE periods, normally worked in a monastery, producing plaques for book covers, croziers, tau-crosses, pyxides (small boxes for the host), altar crosses and other items. Just as regional schools emerged in monumental sculpture after the Norman Conquest, so one finds ivories which may be associated with particular centres: St Albans and Winchester have already been mentioned; Canterbury was another.

By *c*.1250 a transformation had taken place in the patronage of the ivory carvers. After the mid 13c. secular patrons increasingly commissioned and bought small diptychs and triptychs for private devotion, and other objects for daily use such as combs, caskets and mirror-cases. Although the centre of production was undoubtedly Paris, there is a small group of ivories which may be attributed to England for stylistic reasons. The church continued to employ the best craftsmen to make objects of the highest quality, notably a triptych (BM) and a diptych (BM; Paris, Louvre) made for John Grandisson, Bishop of Exeter 1327–69. The main difference between these works and their French counterparts is a more contrived monumentality, a solidity lacking in the French

The Salting Diptych, an ivory of the early 14c. (V&A).

examples. Perhaps the most beautiful manifestation of this affinity with large-scale sculpture is the Salting Diptych (V&A), of the early 14c., which shows the solitary standing figures of Christ and the Virgin, deeply undercut and statuesque. In spite of the excellence of 14c. ivories, by the beginning of the following century the art of the ivory carver was virtually extinguished throughout Europe: it was not to be resuscitated for some 300 years. PW

□ M. Longhurst, *English ivories* (1926); J. Beckwith, *Ivory carvings in early medieval England* (1972); P. Williamson, *An introduction to medieval ivory carvings* (1982)

From the late 17c. onwards ivory carving enjoyed a modest popularity in England. Some distinguished immigrant carvers, including Jean Cavalier, LE MARCHAND and VAN DER HAGEN, worked in a late Baroque tradition already well established in France, Germany and the Netherlands. Their work consists largely of portrait reliefs, some taken from the life and others being reductions of full-scale busts in marble, although a few mythological

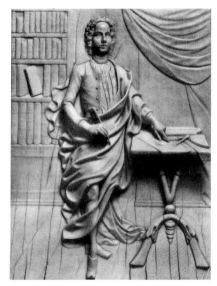

Portrait of Matthew Raper in ivory by Le Marchand, 1720 (V&A).

and religious compositions of the type common on the Continent are known. Also popular in ivory were reliefs of English 'worthies' such as Milton and Newton. MB

J

Jackson, Gilbert *see* PORTRAIT PAINTING: 17C.

Jackson, John (1778–1831), a fashionable portrait painter probably influenced by Dutch and Flemish art, was supported by Sir George BEAUMONT and Lord Mulgrave. His clients included many leading aristocratic patrons.
BA
☐ R. and S. Redgrave, *A century of painters of the English School* (1866), II

Jackson, Samuel *see* BRISTOL SCHOOL

Jamesone, George (1590–1644) was born in Aberdeen and worked exclusively in Edinburgh from 1633. His most characteristic paintings are bust and half-length portraits comparable to those of Cornelius JOHNSON. John Michael WRIGHT was in his studio 1636–41. He was briefly imprisoned for episcopalianism. *See also* ★SCOTTISH PAINTING.
DD
☐ D. Thomson, *The art and life of George Jamesone* (1974); Waterhouse (1978)

Jefferys, James (1751–84) has recently been identified as the author of a group of drawings made largely in Rome in the 1770s in an energetic mode allied to that of FUSELI and BARRY. He might have had a remarkable career had he not died young. *See also* MASTER OF THE GIANTS. DB
☐ *The rediscovery of an artist: the drawings of James Jefferys* (exh., V&A, 1976); N. L. Pressly in *Burl. Mag.*, CXIX (1977), 280–84

Jennings, Humphrey *see* SURREALISM

Jervais, Thomas *see* STAINED GLASS: 16–18C.

Jervas, Charles (*c.*1675–1739), portrait painter, was a pupil of KNELLER and after extensive

travels settled in London in 1709. He soon gained a reputation, mainly through friendship with the writers Steele, Swift and Pope, whose portraits he painted. He succeeded Kneller as Principal Painter to the King in 1723. BA
☐ Waterhouse (1978); M. Brownell, *Alexander Pope and the arts of Georgian England* (1978)

John, Augustus (1878–1961) was the most notable British painter of the generation after SICKERT. Born in Wales, he went to the SLADE in 1894, and in 1898 won a prize with *Moses and the Brazen Serpent* (London, University College). On the proceeds he made the first of many visits to France, where he was impressed by Puvis de Chavannes, Post-Impressionism, and the modern School of Paris. He was an exceptionally gifted draughtsman, combining spontaneity of vision with a degree of mannerism adapted from the old masters. His most ambitious works were large decorative canvases on the theme of wandering gypsies in ideal lands. The strange, attenuated figures in *Lyric Fantasy* (*c.*1911; Tate) are not unlike Picasso's *Saltimbanques* of 1906. The even larger *Galway* (*c.*1916, unfinished; Tate), nearly 40 ft (12 m.) long, might be Puvis translated to Ireland. On a similar scale John planned a war picture, *Canadians at Lens*, which only reached the stage of a huge cartoon in charcoal on paper (*c.*1918; Ottawa). After the war he achieved international success as a portrait painter of

Augustus **John**, *Madame Suggia*, 1920–23 (Tate).

exceptional frankness. He was uneven, but when sympathetic he could strongly characterize men, and convey his 'instinctive relationship' with women. His most famous model was his second wife, Dorelia McNeill. After about 1927 the legend of John as the last great bohemian artist began to supersede his real achievements, and his reputation declined. *See also* CAMDEN TOWN GROUP. BL
□ M. Holroyd, *Augustus John* (1974–5); M. Easton and M. Holroyd, *The art of Augustus John* (1974)

John, Gwen (1876–1939), painter, was as gifted as her more famous brother Augustus, but the very opposite to him in character. She left the SLADE in 1898 to study for 2 years at WHISTLER's 'Academy' in Paris, where she developed her methodical technique and acute eye for tone. After returning to England briefly, in 1903 she set out with Dorelia McNeill to walk to Rome. They got as far as Toulouse, then returned to Paris, where she spent most of the remainder of her life. Her few friendships included the poet Rainer Maria Rilke, and a passionate attachment to Rodin, for whom she modelled. In 1913 she was converted to Roman Catholicism, and moved to the suburban village of Meudon. She painted

Gwen **John**, *Self-portrait*, c.1899–1900 (Tate).

mostly small-scale portraits and still-lifes. Up to about 1907 her oil paintings have a considerable tonal range, and employ glazes. Around 1907–9 colours increase in brightness, and some domestic interiors have a Nabi-like intensity. Thereafter her designs become simpler and flatter, with narrow tonal ranges of matt greys and pinks, and depict single figures, often nuns. The exquisite sensibility concealed behind these austere works is more easily discovered in her spontaneous drawings and watercolours. BL
□ *Gwen John* (exh., Arts Council, 1968); Farr (1978); S. Chitty, *Gwen John* (1981)

Johnson family of sculptors *see* BRASSES; SCULPTURE: 16C.

Johnson, Cornelius (1593–1661), painter, was of Flemish parentage but his early training is obscure. His most characteristic work is the half- or bust-length portrait showing the sitter within a simulated oval frame. Appointed 'His Majesty's servant in ye quality of picture maker' in 1632, he also painted country squires and gentry. While influences of VAN DYCK, MYTENS and DOBSON are present in his work, he had a particular ability to convey individual personality. He left England in 1643 and settled in Holland. DD
□ *The age of Charles I* (1972); Waterhouse (1978)

Johnson, James *see* BRISTOL SCHOOL

Johnson, Robert *see* BEWICK

Johnstone, William *see* SCOTTISH PAINTING

Jones, Allen (b.1937) is a painter who is classified as a POP artist, but he does not make direct use of mass media images. Instead, he contructs fantasies in painting or sculpture. These are very often erotic, an artist's personal version of what you may see in calendars (which he has also designed) and girlie magazines. At the same time they incorporate certain of the qualities of abstract art in the tradition, particularly, of Kandinsky. His reputation has been as high in Continental Europe as in Britain. MC
□ M. Livingstone, *Allen Jones* (exh., Liverpool, 1979)

Jones, David (1895–1974) elaborated his essentially religious vision in long epic poems

and complex watercolours. He was trained at Camberwell, but shaped more by the trenches (he was wounded in 1916). As a Roman Catholic convert, he lived from 1921 at Ditchling in community with Eric GILL, who influenced the stylized forms of his early engravings, *The Deluge* (1927) and *The Ancient Mariner* (1929). After a breakdown in 1933, Jones began to write, publishing *In Parenthesis* in 1937. Meanwhile he exhibited in the 7 AND 5 SOCIETY, alongside Paul NASH and Ben NICHOLSON; his landscapes and still-lifes are phrased in an increasingly vulnerable language, where forms are tentative and focus uncertain. The pale tonality sometimes recalls BLAKE. This evanescence serves him well in the allegorical compositions of the 1940s, crammed with fluid and overlapping allusions to many traditions. Writing his long poem *The Anathemata* (1952) Jones aimed to 'make a heap of all that he could find'; and paintings like *Aphrodite in Aulis* (1941; Tate) or *Vexilla Regis* (1947; Cambridge, Kettle's Yard) are 'heaps' of this same kind. Most of his beautiful inscriptions also date from the 1940s, but after another breakdown in 1947 Jones's main creative focus became literary. His refinement, sometimes bordering on preciosity, has endeared him to several less robust artists and he is often placed in a visionary tradition reaching from Blake to the mystical Cecil Collins (b.1908). *See also* WOODENGRAVING. TH
□ D. Jones, *Epoch and artist* (1973); P. Hills, *David Jones* (exh., Tate, 1981)

Jones, Inigo (1573–1652) produced drawings which were, according to VAN DYCK, 'not equalled by whatsoever great masters in his time for boldness, softness, sweetness and sureness of touch'. In the favoured media of lead, pen and ink and wash, he made innumerable designs for masque scenery and costumes, architectural drawings and plans, and a 'Roman Sketchbook' copied in Italy from engravings after 16c. Italian masters. DD
□ J. Harris, *RIBA Drawings Coll.: Jones and Webb* (1972); J. Harris, S. Orgel and R. Strong, *The King's Arcadia* (exh., Arts Council, 1973)

Jones, Thomas (1742–1803) aspired to be a classical landscape painter in the manner of his teacher WILSON, but his best works – recently discovered – are vividly direct sketches painted OUTDOORS in and around Naples and Rome. His *Memoirs* of his stay in Italy 1776–83 are an important and lively record of the period (*Walpole Soc.*, XXXII, 1946–8). He produced a few large stiffly classical landscapes, as well as occasional landscape backgrounds for his friend MORTIMER, but gave up painting professionally after his return to Britain. He continued to make oil sketches on his Welsh estate. EE
□ R. Edwards and J. Jacob, *Thomas Jones* (exh., London, Marble Hill/Cardiff, 1970)

Joseph, Samuel (1791–1850) made his reputation through the consistently high quality of his portrait busts and statues, in which he achieved a degree of naturalism equal to CHANTREY. The assertiveness of his masterpiece, *William Wilberforce* (1838; London, Westminster Abbey) almost verges on caricature. BR
□ Read (1982)

Thomas **Jones**, *Buildings in Naples*, 1782 (Cardiff).

K

Kauffer, E. McKnight *see* GROUP X

Kauffmann, Angelica (1740–1807), the most successful woman painter in England in the 18c., was born in Switzerland, and after study in Italy 1760–66 arrived in London. She established herself immediately as a HISTORY painter and was a foundation member of the ROYAL ACADEMY in 1768. Until 1781 when she returned to Italy she had a distinguished career making historical and 'poetical' subject pictures for architectural schemes and also for reproduction as decorative prints, most notably by BARTOLOZZI. She was married to the decorative painter Antonio Zucchi (1728–95). She was admired for her wit and intellect, and in her later years in Rome she included Goethe among her close friends. DB
□ V. Manners and G. C. Williamson, *Angelica Kauffmann* (1924); *Angelika Kauffmann und ihre Zeitgenossen* (exh., Bregenz–Vienna, 1968–9)

Keene, Charles (1823–91) was apprenticed to a wood-engraver before becoming one of *Punch*'s most famous comic artists. From *c*.1855 to 1870 he made prints simply to please himself, which display the same vitality and virtuosity of line as his drawings, capturing the textures of nature with understated economy. His finest etchings are of Suffolk (where he was brought

Kauffmann, *Painting*, from the ceiling of the Royal Academy in Somerset House, *c*.1780, now in Burlington House.

King, *Genghis Khan*, plastic, 1963 (Peter Stuyvesant Foundation).

up) and Devon, but he also made informal portraits of friends and life studies at the Langham Sketch Club. CF
□ G. S. Layard, *The life and letters of Charles Samuel Keene* (1892)

Kennedy, William *see* GLASGOW SCHOOL

Kenny, Michael *see* SCULPTURE: 20C.

Kent, William (1685–1748) was, despite his Italian training, an indifferent DECORATIVE painter, who earned his fame as an architect and garden designer. He is important, however, as a protégé of the Earl of Burlington, and for his enmity towards THORNHILL and HOGARTH, whose careers he blighted. *See also* ★HAMILTON, GAWEN; ★RYSBRACK. DB
□ Croft-Murray, II (1970)

Kidner, Michael *see* CONSTRUCTIVISM

Kiff, Ken (b.1935) is a painter best known for his 'sequence' of over 200 images, tracing a process of integration through fantasy, often invoking archetypal and primitive material. Painted in ACRYLIC on paper, intimate in scale and handling, radiant in colour, they have a humour and vulnerability that have influenced many younger artists. *See also* FIGURATIVE PAINTING. TH

King, Phillip (b.1934) is both the finest and the most individual of the NEW GENERATION sculptors. If his abstract sculptures are diverse in appearance, this is not the result of rampant eclecticism or loss of direction, but of an extraordinary imagination responding to certain basic principles which underlie all his work, principles which evolved out of a consideration of the precepts of early 20c. artists like Brancusi and the ethos of American art of the post-war years. King believes that a sculpture must be a solid object inhabiting the spectator's space; by exploring it the viewer will discover not only more about the character of the object in front of him – its particular properties – but, reciprocally, will discover aspects of his own nature, his physical and emotional being, as well. LC
□ *Phillip King* (exh., Arts Council, 1981)

Kirby, Joshua *see* AMATEUR ARTISTS

Kitaj, R. B. (b. 1932), born in Cleveland, Ohio, has, since his arrival to study at the Ruskin School of Drawing on a G.I. scholarship in 1958, built his career in Britain. One of the brilliant generation that emerged from the ROYAL COLLEGE in the early 1960s (*see also* POP ART), he has brought, from his first exhibition at the Marlborough Gallery, London, in 1963, political stance, literary allusion and a general fierceness of intellect back into British painting, almost single-handed. In the 1960s and early 1970s he produced a large number of SCREENPRINTS at Kelpra Studios which, though some now have an air of fashions past, asserted his strong taste for matters of the mind via often arcane and personal juxtapositions of images. These culminated in a suite of aggressively spartan *Book Covers*. He has collaborated closely with poets such as Robert Creeley and Jonathan Williams. In recent years the overt intellectualism has given way to a sensual genre

Kitaj, *If not, not*, 1975–6 (Edinburgh, Mus. of Modern Art).

of figure painting in which he has quite consciously invoked comparison with Degas.

By example and public statement he has testified to his view that drawing and painting from the life are still the central acts of true art. In support of this thesis he organized an influential exhibition, 'The Human Clay', at the Hayward in 1976 which helped to pave the way for the large-scale return to figuration in the early 1980s (see FIGURATIVE PAINTING). He has also revived pastel drawing as a medium for serious and ambitious work. TP
□ J. Ashbury, J. Shannon, J. Livingston and T. Hyman, *Kitaj* (1983)

Knapton, George *see* AMATEUR ARTISTS

Kneller, Sir Godfrey (1646/9–1723) was born in Lübeck, the son of the city's surveyor. After studying mathematics in Holland and considering a military career, he entered the studio of Ferdinand Bol; there he perhaps came into contact with Rembrandt, whose chiaroscuro effects can be seen in his *Elijah and the Angel* (Tate) of 1672. In that year he travelled to Rome, where he copied Raphael and the antique, and then to Venice, where he produced portraits for the Venetian nobility. In *c.*1676 he was in England under the patronage of John Bankes, a Hamburg merchant, whose introduction to the Duke of Monmouth's secretary resulted in a royal sitting, apparently in 'competition' with LELY, who had a virtual monopoly of court portraiture.

After Lely's death in 1680 Kneller was able to succeed him, producing further portraits of Charles II, state portraits of James II and his Queen, and Louis XIV (1684). At William III's accession in 1688 Kneller and RILEY were jointly appointed Principal Painters to the Crown; after Riley's death in 1691, Kneller held the office alone for the next 32 years. In addition to royalty he enjoyed the patronage of the Whigs, producing the famous series of portraits of 40 leading politicians and men of letters, all members of the Kit-Cat Club (1701–21; NPG). A personal development of the 'series' portrait initiated by Lely, these introduced a new formula: the 'Kit-Cat' length of a head and one hand, 36 × 28 in. (91 × 71 cm.).

The thin paint texture of his early canvases is replaced by a much freer *alla prima* handling after 1698, when he saw Rubens's work. In paintings such as *The Chinese Convert* (1687;

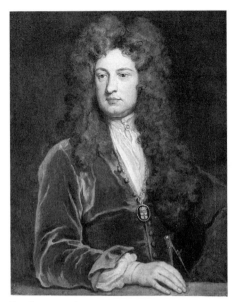

Kneller, *Sir John Vanbrugh*, a member of the Kit-Cat Club, *c.*1704–10? (NPG).

Royal Coll.) and *John Dryden* (1698; Cambridge, Trinity College – where Rococo silvery greys have replaced the earlier brown tones) the qualities praised by REYNOLDS and others are evident. But pressure of work, a lavish life style, and a stipulation in his will that unfinished canvases could be completed by assistants, resulted in many sub-standard 'Knellers' leaving his large and well-organized studio.

Created a Knight of the Holy Roman Empire in 1700 and an English baronet in 1715, he was Governor of the 'Kneller Academy of Painting and Drawing' 1711–18 (see BIRD; DANDRIDGE; ST MARTIN'S LANE ACADEMY). DD
□ Whinney and Millar (1957); *Kneller* (exh., NPG, 1971); Waterhouse (1978)

Knight, Richard Payne (1751–1824), collector and writer, is mainly important for his interest in the PICTURESQUE. In *The Landscape: A Didactic Poem* (1794) he attacked Capability Brown and called for more roughness and variety in landscape gardening. His *Analytical Inquiry into the Principles of Taste* (1805) criticized Uvedale PRICE, pointing out that Price confused the real characteristics of objects with their visual representation, and claimed that 'The Picturesque is merely that kind of

beauty which belongs exclusively to the sense of vision; or to the imagination, guided by that sense.' *See also* COZENS, J. R.; HEARNE. JS
☐ M. Clarke and N. Penny, *The arrogant connoisseur* (exh., Manchester, 1982)

Knox, John (1778–1845), a landscape painter who worked in Glasgow, may have trained with Alexander NASMYTH. His most interesting works, apart from a panorama of the view from the top of Ben Lomond (*c*.1829; Glasgow), record the life and environment of the city, e.g. *The First Steamboat on the Clyde* (1812–20; Glasgow). He was also important for his encouragement of the young Horatio MCCULLOCH. DM
☐ Caw (1908); Irwin (1975); Hardie (1976)

Knyff, Leonard *see* LANDSCAPE PAINTING: 17C.

Kossoff, Leon (b.1926), painter, suffered more neglect in the 1950s and early 1960s than his fellow pupil under BOMBERG, AUERBACH. Despite the apparently similar use of an impasto of unprecedented thickness their approach to figuration has been quite different, Kossoff leaning towards Soutine and a more identifiably Jewish mode of expressionism. A departure in subject-matter in the late 1970s accompanied by a lightening of his palette extended his range and defined a clearer artistic personality via a group of ambitious paintings of a swimming bath; populous and alive with incident, these possess a *joie de vivre* hitherto absent from his generally somewhat lugubrious work. TP
☐ *Leon Kossoff* (exh., London, Whitechapel, 1972)

L

Ladbroke, J. B. and **Robert** *see* NORWICH SCHOOL

Laguerre, Louis (1663–1721) was the first major DECORATIVE painter after VERRIO to arrive in England from France, *c*.1683/4. He worked with Verrio at Chatsworth and at the end of his life at Blenheim. Though a competent artist, he increasingly lost ground to THORNHILL. DB
☐ Croft-Murray, I (1962)

Lamb, Henry *see* BLOOMSBURY; CAMDEN TOWN GROUP

Lambert, George (1700–1765) was probably the first native-born painter before WILSON to devote himself entirely to *LANDSCAPE. After initially imitating WOOTTON, he developed his own somewhat rigid style of composing landscapes in the manner of Gaspard Dughet or Dutch masters. In the 1740s he also painted in PASTELS. His main achievement lay in applying the simpler rules of classical and Dutch landscape painting to English topography and country house views for greater dramatic effect. His figures were often supplied by HAYMAN, HOGARTH and others, and on off-shore views he collaborated with SCOTT. He was also an eminent scenographer and DRAWING MASTER, and the first Chairman of the SOCIETY OF ARTISTS. EE
☐ E. Einberg, *George Lambert* (exh., London, Kenwood, 1970)

Lambeth Bible (vol. I: London, Lambeth Pal.; vol. II, fragmentary: Maidstone Mus.) A great mid 12c. Bible containing 6 framed miniatures and numerous historiated and decorated initials. There is no internal evidence for its original provenance. Arguments have been put forward for St Augustine's Abbey at Canterbury (by Dodwell, most cogently), Bury (Denny), and St Albans (Thomson). In any case, the artist was clearly an itinerant professional, for he illuminated a GOSPEL BOOK for the abbey of Liessies in Hainault in 1146 (2 leaves in Avesnes, Soc. Archéol.), and 2 miniatures associated with St Albans (Oxford, Corpus Christi College, MS 2) may also be by his hand.

The figure style, in which clinging curvilinear folds delineate the body beneath the drapery, is a mannered version of that of the *BURY BIBLE. *See also* *BIBLICAL ILLUSTRATION. CMK
☐ C. R. Dodwell, *The Canterbury School* (1954), 45ff, 81ff; id., *The great Lambeth Bible* (1957); Kauffmann (1975), no. 70; D. Denny in *Gesta*, 16 (1977), 51–64; Thomson (1982), 31–3, no. 81

landscape painting *During the 17c.* what
Edward Norgate in 1649 called that 'harmless
and honest Recreation' which 'diverts and
lightens the mind' emerged as a genre; and
while by the end of the century it was still a
relatively minor one, an increasing number of
references in literature, stage scenery and
designs for tapestry, plus developments in the
manner of painting landscape, indicate its
growing popularity.

The genre was dominated by Flemish and
Dutch artists. The earliest landscapes were
topographical views such as Stalbemt and
Belcam's *View of Greenwich* (Royal Coll.), de
Jongh's *Old London Bridge* (1630; London,
Kenwood), VAN DYCK's pen-and-ink drawings
of Rye, the carefully drawn and etched
'prospects' of ★HOLLAR, and, slightly later, the
watercolours and paintings of ★PLACE and
Leonard Knyff (1650–1721). The elevated
viewpoint and precise detailing of the country
house portrait developed by GRIFFIER and
SIBERECHTS was another form of topography.
The early paintings of TILLEMANS incorporate a
panoramic sweep of the English countryside
with a foreground of sporting and hunting
activities.

The classically inspired works of Brill,
Elsheimer, Van Poelenburgh and Claude also
became increasingly popular. STREETER's only
surviving landscape (Dulwich) depicts a classi-
cal scene, and in the 1660s Hendrik Danckerts
was producing large-scale Italianate decorative
landscapes for Charles II and James II and other
collectors. Many of these landscapes, e.g.
Danckerts' Roman prospect for Pepys and Van
den Bergen's canvases at Ham House, were
produced as overdoors and overmantels, and
continue an earlier tradition (at Langley

Siberechts, *View of Longleat*, 1675/6 (The Marquess
of Bath, Longleat).

Lambert, *View of Westcombe House, Blackheath,*
*c.*1735 (The Earl of Pembroke, Wilton House).
The figures are traditionally ascribed to Hogarth,
and the ships to Samuel Scott.

Marrish, Berks., and Castle Ashby, Northants.)
of landscapes as interior decoration.

See also ★RUBENS. DD
□ H. and M. Ogden, *English taste in landscape in*
the 17c. (1955); Whinney and Millar (1957);
Waterhouse (1978)

In the 18c. landscape painting initially continued
to be divided into 2 main branches. One, the
topographical, included the delineation of
estates and country houses, while the other, the
'ideal', tended to be purely decorative, but was
increasingly expected to carry some notion of
an 'idea' above mere reality, usually referring to
classical antiquity and literature.

As Britain had no 17c. tradition of her own
to build on, the main impulses in both branches
continued to come from abroad, and the first
stirrings of a native school were timid, imitative
and sporadic. Writing in 1743, VERTUE could
name only 4 native-born landscape painters, of
whom only 2, WOOTTON and LAMBERT, had any
lasting influence. Wootton's main achievement
lay in the field of ★SPORTING art and Lambert's
in scenery painting, but both applied them-
selves with equal success to the topographical
and the classical modes, and did well enough
without having to resort to the more lucrative
business of 'face-painting'. It was they who
began the process of blending the ideal and the
real, Wootton by setting English sporting
groups into classical landscapes, and Lambert
by applying classical rules of composition to
country house views. From the 1730s Lambert
also showed a pronounced interest in Dutch
17c. landscape. Other painters were content to

keep the accepted categories well apart, even if they practised several of them.

In topography immigrants and visitors from the Low Countries continued to predominate, such as TILLEMANS, Pieter Rysbrack (c.1684–1748), the GRIFFIERS and others, although Balthazar Nebot (fl. c.1729–62), the author of a remarkable series of views of the gardens at Hartwell House, Bucks. (Aylesbury Mus.), was Spanish. The genre was brilliantly advanced with the arrival of *CANALETTO in 1746, causing *SCOTT to abandon marine painting for the beautifully perceived Thames views he is now best known for, and spawning countless imitators. Topography continued to flourish for as long as the English wanted views of their houses and estates, and many minor painters of charm, from William Tomkins (c.1734–92) to John Inigo Richards (1731–1810), made a respectable living out of it.

'Ideal' landscape continued for some time along the path of superficial imitation of Claude, Poussin and Gaspard, best exemplified by George Smith of Chichester (1714–76) and his brothers, but the first British painter to develop a real understanding of its intellectual and poetic potential was *WILSON after his arrival in Italy in 1750. He returned to London in 1757 with an enhanced conception of landscape painting which paralleled REYNOLDS's intellectualization of British portraiture and was in tune with the growing self-awareness of the artistic community in general. The reinterpretation of classical rules in a modern idiom led to looking at reality afresh, and it is significant that Wilson's pupil Thomas *JONES sketched in the 1770s and 1780s some of the most intensely perceived views of Italy and Britain of the period. Wilson's own late British views ennobled native landscape with a poetic awareness that would not have been possible without an understanding of the old masters. At the same time, they are the acknowledged origin of the dynamic developments in naturalistic landscape of the 19c.

GAINSBOROUGH's achievement as a landscape painter covered no less remarkable an evolution, from the early Dutch-inspired visions of Suffolk c.1750 to the Rococo-based Arcadia, with its echoes of Rubens and Poussin, of his maturity, though he was never primarily regarded as a landscape painter. He did not share his friend de *LOUTHERBOURG's passion for movement and violence in nature, but both painters were fascinated at a technical level with

Gainsborough, *Going to Market*, c.1770 (London, Kenwood).

the dramatic possibilities of light. This typically PICTURESQUE concern was translated into painterly terms most, nobly by WRIGHT OF DERBY, and ultimately culminated in the light-worship of TURNER.

Gainsborough's gentle rusticity can be seen more justly as the ancestor of the bucolic scenes of *MORLAND and the breezy views of IBBETSON and his ilk. It is in some ways also the precursor of CONSTABLE's contemplative but intense observation of the English countryside, which, along with Turner's precocious genius and the explosive development of the British WATERCOLOUR school, transcended the original conventions of the 18c.

See also BARRET; BEAUMONT; CLAUDE GLASS; *CLERK OF ELDIN; *COZENS; GARRARD; HEARNE; MARLOW; MORE; *NASMYTH; POCOCK; SUBLIME. EE
□ Herrmann (1973)

The 19c. began with great achievements. In the early decades *CONSTABLE and TURNER established landscape unequivocally as an elevated genre, yet also brought to the fore its descriptive possibilities. WATERCOLOUR became a genre in its own right, and landscape became the focus for regional schools, especially *NORWICH and *BRISTOL. In SHOREHAM was developed a religious landscape of peculiar intensity (*see* *PALMER). A classical mood and structure persists, however, in different forms in the work of all the major painters, even Constable. Though OUTDOOR PAINTING became popular it almost always represented a stage in the painting process rather than an end in itself. One of its effects was the freshness of touch

Millais, *Chill October*, 1870 (priv. coll., on loan to Perth).

Constable, *Boat Building*, 1815 (V&A). (*See* outdoor painting.)

which was to foreigners the hallmark of English landscape painting.

*RUSKIN was largely responsible for the rejection by a number of painters of a lingering classicism in favour of uncomproming truth, and artists associated with the PRE-RAPHAELITES, like Holman HUNT, INCHBOLD and BRETT, approached nature with reverence and a microscopic technique. Their intensity of observation was unable to sustain itself and a broader and more allusive handling became

Brett, *Val d'Aosta*, 1858 (Sir Frank Cooper, Bt).

established, most notably with MILLAIS, whose *Chill October* (1870; priv. coll.) is representative also of the bleak mood of much landscape in the later part of the century. The artists who achieved the greatest popular success, however, were still those like LINNELL who in his later years produced idyllic works evoking the supposedly lost world of pre-industrial harmony in scenes of rustic labour and contentment. Such works suggest a deliberate avoidance of industrial landscape, and landscape painters, with the exception of Turner, rarely actually confronted the physical effects of industrialization. Nor was landscape painting in England in the second half of the 19c. responsive to the new scientific and philosophical attitudes as it was in France. Until near the end of the century French influence – in the NEWLYN SCHOOL for instance – stemmed mainly from the academic naturalism of the Salon, and only with the NEW ENGLISH ART CLUB did Impressionism become a major force in British art.

See also BROWN, F. M.; CALLCOTT; COTMAN; COX; CRISTALL; CROME; DANBY; GARRARD; GEDDES; HUNT, A. W.; HUNT, WILLIAM HENRY; IBBETSON; LEAR; MCCULLOCH; MCTAGGART; NASMYTH; *SCOTTISH PAINTING; SUBLIME: WATTS. DB

□ *Landscape c.1750–1850* (1973); Staley (1973); Farr (1978); Rosenthal (1982); *Landscape 1850–1950* (1983)

In the 20c. the influence of WHISTLER and Wilson STEER combined with the Anglo-French priorities of the NEW ENGLISH ART CLUB to dominate the opening years of the century. They were

challenged before long by BEVAN, GORE, and other painters associated with SICKERT'S CAM-DEN TOWN GROUP. These younger artists updated the French connections which the NEAC had been established to foster. Pont Aven replaced Paris as a centre of attention; Gauguin and Van Gogh took precedence over Monet and Degas. Among Wilson Steer's pupils at the SLADE historical interests of a more native kind were pronounced; for Paul NASH and Stanley SPENCER, the visionary landscapes of Samuel PALMER served as a direct source of inspiration.

A number of artists who experimented with abstraction before the First World War re-examined their attitudes to representation from 1918 onwards. Several, like BOMBERG, turned to landscape for subject-matter. In doing so, they often modified their essentially romantic responses to nature with a knowledge of contemporary European trends, among which SURREALISM was, for the landscape painters, the most compelling. Their efforts resulted in a remarkable diversity of achievement, from the detailed horticulture brushed by John Nash (1893–1977) and Spencer to the landscapes of dreams painted by Paul Nash and *SUTHER-LAND. It is equally important to remember that Henry MOORE drew heavily upon landscape as a source for his sculptural forms and that Ben NICHOLSON's painted reliefs, with their textured surfaces and natural colours, owe as much to landscape as they do to theories of abstract art.

More recent developments are equally diverse. Peter BLAKE and his fellow RURALISTS have proclaimed a new return to nature by the traditional means of drawing and painting in oils and watercolour. On the other hand, Richard *LONG conveys his experience of the

Landseer, *The Old Shepherd's Chief Mourner,* 1837 (V&A). Bought from the artist by Sheepshanks.

landscape by means of maps, photographs, driftwood and stones.

See also BURRA; CAMERON; GINNER; GOWING; HITCHENS; JONES, D.; NEO-ROMANTICISM; NICHOLSON, W. DR

□ *Landscape 1850–1950* (1983)

Landseer, Sir Edwin (1802–73) was the most famous and successful of all British animal painters. His skills were particularly appreciated by Queen Victoria, but he was also admired abroad, e.g. by Géricault and Delacroix. His pictures are distinguished by their brilliant, fluently naturalistic technique, and by his tendency to endow his animals with human sentiments and expressions. Curiously this latter characteristic was taken at the time to be pertinent observation of animal psychology. Often Landseer's subjects were humorous, as in *Dignity and Impudence* (1839; Tate). But he was also concerned with heroic pathos, and used this in his scenes of Scottish wild life. In later years he became increasingly morbid and tended to paint pictures showing the relentless savagery of nature. *See also* GRAVES; SPORTING PAINT-ING. WV

□ R. Ormond, *Landseer* (exh., Tate, 1982)

Langham Sketch Club *see* KEENE; SKETCHING CLUBS

Langley, Walter *see* NEWLYN SCHOOL

Lanyon, Peter (1918–64), landscape painter, was the only Cornishman among the central members of the *ST IVES SCHOOL. Born in St

Paul Nash, *Landscape from a Dream,* 1936–8 (Tate).

Ives, where he lived most of his life, he studied briefly at the Penzance School of Art and at the EUSTON ROAD SCHOOL in the later 1930s. In the 1940s he was much influenced by Naum GABO and Ben NICHOLSON, who had gone to live in St Ives in 1939.

From 1950 onwards Lanyon's work was largely abstract, at first grounded in Cubism, with clear allusions to Cornish landscape and occasionally to figures. A central source of imagery was his direct experience of the coastal strip westwards from St Ives to St Just and the activities of farming, fishing and tin-mining. In the early 1950s he often resolved spatial relationships with the help of constructions (*see* CONSTRUCTIVISM). In the later 1950s his forms became more open and the handling of paint looser, with more overt references to weather, winds and sky. This tendency was reinforced when he took up gliding in 1959. During the last years of his life he often used strong saturated colours, reds, greens and blues, applied in large flat areas. He died as a result of a gliding accident. DBr
□ A. Causey, *Peter Lanyon* (1971)

Larkin, William *see* PORTRAIT PAINTING: 17C.

Laroon, Marcellus (1679–1772) was an amateur artist and soldier who retired from the army in 1732. His unusual style, which has been described as like 'stained tapestry', is a fusion of the Rococo *fête galante* (derived from WATTEAU) and the peasant genre of Teniers. BA
□ R. Raines, *Marcellus Laroon* (1967)

Latham, John (b. 1921) has worked in a variety of media, including PERFORMANCE and films, in addition to making objects and environmental sculpture. The strongly conceptual nature of his approach has gradually directed his work away from a questioning of preconceptions in the realm of aesthetics towards social and political issues. LC
□ *John Latham* (exh., Tate, 1976)

La Thangue, Henry Herbert (1859–1929) was a leader of the French-inspired naturalist painters who founded the NEW ENGLISH ART CLUB in 1886. He painted, entirely in the open air and with his famous 'square' brushstroke, the fast-disappearing traditional rural occupations of southern England and France. RT
□ K. McConkey, *A painter's harvest: H. H. La Thangue* (exh., Oldham, 1978)

Lauder, Robert Scott (1803–69), painter of history, portraits and landscape, worked in Italy and London after training in Edinburgh at the Trustees' Academy. In 1852 he returned to the Academy as master and during the 9 years he taught there he influenced a whole generation of Scottish painters. His pupils became known as the Scott Lauder school, and included MCTAGGART, ORCHARDSON, John Pettie (1839–93), George Paul Chalmers (1833–78), John MacWhirter (1839–1911), Hugh Cameron (1835–1918), and a number of others who left their mark on late 19c. British art. DM
□ Caw (1908); Irwin (1975); Hardie (1976); *Master class* (exh., Edinburgh, NGS, 1983)

Lavery, John *see* GLASGOW SCHOOL

Lawlor, John (1820–1901) *see* ALBERT MEMORIAL

Lawrence, Sir Thomas (1769–1830) was the most gifted and successful portrait painter in the

Lawrence, *Miss Farren (Elizabeth Farren, later Countess of Derby)*, 1790 (New York, Met., Bequest of Edward S. Harkness, 1940).

generation following GAINSBOROUGH and REYNOLDS, and will always be associated with the Regency and the reign of George IV. He was, arguably, the most sheerly virtuoso of all British portraitists. Handsome and charming, he was also highly precocious, drawing likenesses of visitors to his father's West Country inn by the age of 10. And throughout his life he continued to produce meticulous drawings.

Lawrence appears to have been largely, if not entirely, self-taught in all media, including oil paint. He first exhibited at the ROYAL ACADEMY in 1787 (a pastel), and could soon assure his family that, except for Reynolds, 'I would risk my reputation with any painter in London'. In 1789 came his first major royal commission: a full-length portrait of Queen Charlotte (NG), shown at the RA in 1790, along with 11 other paintings by him, including the glittering and vivacious *Miss Farren* (New York, Met.). His gift for a likeness and feeling for costume, combined with bravura handling of paint, were widely recognized; and his rise was rapid. He became ARA in 1791, painter-in-ordinary to the King in 1792 and RA in 1794.

He remained greatly in demand as a portraitist, though aspiring less successfully towards HISTORY painting, e.g. *Satan summoning his legions* (exh. RA 1797; RA). FARINGTON became a close friend, and his *Diary* records Lawrence's increasingly tangled affairs, financial and emotional, the crippling burden of his commissions and his alternations of energy and inertia. Yet, if his career seemed not advancing, his art was maturing.

Only in 1814 did the Prince Regent first sit to Lawrence, but thence onwards his patronage proved a powerful stimulus. He knighted Lawrence in 1815, in preparation for travel on the Continent, when he was to portray for the Regent the sovereigns and statesmen involved in Napoleon's overthrow: a unique commission, resulting in the romantic yet shrewdly characterized series (Royal Coll.) that culminate in *Pope Pius VII*. In them Lawrence found a way to fuse modern heroism and history.

The last decade of his life was both triumphant and hectic. Elected PRA in 1820, he was in demand as art adviser as well as artist, and aided the founding of the NG in 1824. Generous and admiring of distinguished contemporaries like WILKIE and TURNER, he helped younger artists like EASTLAKE. In Sir

Robert Peel he gained another discriminating, friendly patron, for whom he painted some of his best portraits, e.g. *Lady Peel* (New York, Frick). He painted until the end, dying suddenly, 'in harness', as he wished. He left a mass of unfinished work, heavy debts and a superb collection of old master drawings.

His reputation suffered a rapid decline and has never entirely recovered. Even today, some of his finest, once-popular achievements, especially in child-portraiture, are often denigrated. Lawrence is a dazzling, unexpected phenomenon in British painting; he left no followers and had no successors – except possibly SARGENT. ML
□ K. Garlick, *Sir Thomas Lawrence* (1954); id., *A catalogue of . . . Sir Thomas Lawrence*, Walpole Soc., XXXIX (1964); M. Levey, *Sir Thomas Lawrence* (exh., NPG, 1979)

lead is a soft metal with a low melting point, which makes it suitable for the multiple reproduction of large-scale statuary by the use of piece-moulds (*see* PLASTER). Lead casts lack the durability and precision of BRONZE casts, but were cheaper than bronze or marble. Pioneered by the elder NOST *c.*1700, lead sculpture became popular for the decoration of gardens, the figures often being painted white in imitation of marble. Lead was also used for some public monuments (e.g. SCHEEMAKERS' *William III* at Hull) where bronze was considered too expensive. MB
□ L. Weaver, *English leadwork* (1909)

Lear, Edward (1812–88) was a serious zoological and topographical draughtsman when he published his first *Book of Nonsense* (1846). A landscapist with a passion for accurate detail and a traditional watercolour method, he repeatedly visited Italy and the Middle East. He published several illustrated journals, exhibited watercolours, and, after 1850, also painted in oils. PN
□ P. Hofer, *Edward Lear as a landscape draughtsman* (1967)

Leathart, James (1820–95), a director of leadworks and of Newcastle shipping companies, is a good representative of the kind of Northern manufacturer who bought extensively from the PRE-RAPHAELITES, collecting their work from 1859 onwards with the advice of William Bell SCOTT. He was the subject of a remarkable portrait by Madox BROWN, which

Leathart painted by Madox Brown, 1863–4 and
1869 (priv. coll.). Behind him on the right is a
version of Brown's *Work*, which he had recently
bought.

shows him seated before one of his leadworks
(priv. coll.). He may be contrasted with
SHEEPSHANKS, whose preference was for anec-
dotal painting. DB
□ *Paintings and drawings from the Leathart coll.*
(exh., Newcastle, 1968)

Lee, Lady *see* AMATEUR ARTISTS

Lee, Lawrence *see* STAINED GLASS: 19–20C.

Leech, John *see* CARICATURE

Legros, Alphonse (1837–1911), a French
painter who worked in England, had studied
with Lecoq de Boisbaudran (who emphasized
memory training), and was strongly influenced
by Courbet. His close friend WHISTLER per-
suaded him to settle in England, where in 1876
he was appointed Professor at the SLADE. There
the technical facility of his demonstrations had
considerable influence, though he never learned
to speak English fluently. Some of his best
work is to be found in his etchings (*see* ETCHING
REVIVAL) and fine silverpoint portrait drawings.
See also GROSVENOR GALLERY. BL
□ Farr (1978); G. Weisburg, *The Realist tradition*
(1981)

**Leighton, Frederic, Baron Leighton of
Stretton** (1830–96) was the single most
important figure in the later Victorian art
world. Acknowledged leader of the Victorian
classical school of painters, intelligent, distin-
guished and slightly aloof in manner, he was a
lion of cultured London society and occupied a
position between the GROSVENOR GALLERY
aesthetes (*see* AESTHETIC MOVEMENT) and the
ROYAL ACADEMY, of which he was President
from 1878. Unusually for an English artist, he
had an entirely Continental art education,
notably under the Nazarene Steinle at Frank-
furt, and in Italy, where he lived in Rome
1852–5 in the circle of Giovanni Costa, and
finally in Paris. He settled in London in 1859.
His first great success, *Cimabue's Madonna
carried in Procession through the Streets of Florence*
(exh. RA 1855), was bought by the Queen. He
remained with historical and Biblical themes
until he turned in the mid 1860s towards the
Greek classical subjects which dominated the
rest of his work.

Leighton was an extraordinarily talented and
versatile artist – portraitist, brilliant and prolific
draughtsman, and colourist of opulent and
sensual richness, aware from his exotic travels
of the effects of intense light and heat on
pigment. His bronze *Athlete struggling with a
Python* (1874–7; London, Leighton House) was
a beacon of the NEW SCULPTURE, and he was a
patron of Alfred GILBERT. In 1864–6 he built a
remarkable house and studio at 2 Holland Park

Leighton, *The Garden of the Hesperides*, 1892 (Port
Sunlight).

Road, now a museum of his life and work, and in 1896 became the only artist ever to receive a barony. RT

□ L. and R. Ormond, *Lord Leighton* (1975)

Lely, Sir Peter (1618–80), Pepys's 'mighty proud man and full of state', was born Pieter van der Faes in Soest, Westphalia, and took his name from his family house at The Hague, 'de Lely'. After an apprenticeship with the Haarlem painter de Grebber, he arrived in England in 1641 or 1643.

Pursuing what his biographer Richard Graham called 'the natural bent of his Genius in Landtschapes with small Figures and Historical Compositions', his earliest English works – *Sleeping Nymphs* (Dulwich) and *The Concert* (London, Courtauld) – reflect influences ranging from the Dutch-Italianate landscapist Van Poelenburgh to VAN DYCK and the Venetians. However he soon moved towards the more lucrative genre of portraiture. *The Children of Charles I* (1646/7; Petworth) displays his early style, reminiscent of Van Dyck but strongly individual in the colouring, the solidity of the design, and the rich paint texture. In 1661, although he had worked for the Commonwealth, he was appointed Charles II's Principal Painter and began a career that was virtually unchallenged for almost 20 years.

Lely's work of the 1660s is best represented by the series of 'Windsor Beauties' painted for the Duchess of York (Royal Coll.). Rich in colouring and texture, they have a provocative air of *deshabillé* and a languor that became the hallmarks of Lely's style. An anonymous contemporary remarked, 'all his pictures had an Air one of another, all the eyes were sleepy alike.' Against this can be set the series of 'Flagmen' (Greenwich), commissioned by the Duke of York about the same time, 12 portraits which reveal far greater variety of pose and a vigorous interpretation of character. In both series the paint is thick and fluid.

In the 1670s Lely's paint becomes much drier and thinner, often revealing the reddish-grey underpaint. The poses are more upright, with the sitter often placed, à la Van Dyck, on a step leaning on an urn or column. Except for the heads, many of these later works were delegated to numerous assistants, who included the Flemish landscape artist Lankrink, the drapery painter Gaspars, WISSING, GREENHILL, and (briefly) Nicolas Largillière. In the studio Lely's fashionable sitters would choose from a

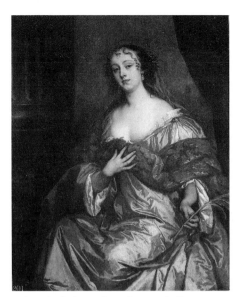

Lely, *Elizabeth Hamilton, Comtesse de Gramont*, a 'Windsor Beauty', *c*.1663 (Royal Coll.).

variety of drawn or painted poses, after which the general outline of the body would be sketched onto the canvas and the head painted from life.

Lely had a superb collection of 16c. and 17c. paintings, and his prints and drawings were described by Charles Beale as 'the best in Europe'.

See also CROMWELL; FAITHORNE. DD

□ Whinney and Millar (1957); Waterhouse (1978); O. Millar, *Sir Peter Lely* (exh., NPG, 1979)

Le Marchand, David (1674–1726) was born in Dieppe, an important centre of ★IVORY carving, but by 1723 had been 'many years' in England. His ivory portrait reliefs (e.g. *Charles Marbury*, V&A) draw on French and Netherlandish late Baroque conventions and rival the work of the finest Continental carvers in their delicacy of execution and monumentality of form. MB

□ T. Hodgkinson in *V&A Bull.* (Apr. 1965), 29–32

Lens family At least 10 DRAWING MASTERS came from this family in 5 generations; Bernard

II (1659–1725; *see* AMATEUR ARTISTS) and his son Edward (1685–1749) taught at Christ's Hospital, and Bernard III (1681–1740) taught Horace Walpole and members of the royal family (*see* AMATEUR ARTISTS *and* MINIATURE PAINTING). Others gave lessons in London, Eton, Richmond and Norwich and were mainly engravers, topographers and miniaturists. KS
□ I. Fleming-Williams in Hardie, III (1968), 212–5; Foskett (1972)

Le Piper, Francis (d.1695), a well travelled amateur draughtsman, came from a Kent-based Flemish family. His landscape drawings are all lost; he is best known for his *Don Quixote* paintings, which appear to anticipate HOGARTH. DD
□ Croft-Murray (1960)

Leslie, Charles Robert (1794–1859), an artist of American parentage who settled in London in 1811, became highly successful as a painter of humorous and ANECDOTAL scenes, chiefly drawn from literary sources such as Molière, Goldsmith and Cervantes. He wrote the classic biography of his friend CONSTABLE. WV
□ C. R. Leslie, *Recollections* (1860)

Lessore, Helen *see* SLADE

Le Sueur, Hubert (fl.1610–43) was a French sculptor who perpetuated the Italian BRONZE tradition whilst working for the Carolean court. Trained in Paris, he was in England by 1626 employed on Inigo Jones's catafalque for James I, and he completed a major tomb to the Duke of Lennox and Richmond (1628; London, Westminster Abbey). Although he is chiefly remembered for his bronze equestrian *Charles I* (1630–33; London, Trafalgar Square), his principal contribution was to popularize the portrait bust as something separate from tomb sculpture, notably in his much-reproduced bust of Charles I (*see* ★SCULPTURE: 17C.). AY
□ Whinney (1964)

Lewis, John Frederick (1805–76), painter, began his career as an *animalier*. A tour of northern Italy in 1827 resulted in a series of spirited WATERCOLOURS, his preferred medium until the 1850s. After a visit to Spain, which provided the material for lithographs, he travelled to Egypt by way of Constantinople, reaching Cairo in 1841 and settling there for 10

J. F. **Lewis**, *A School in Cairo*, watercolour (V&A).

years. On his return to London, he painted Near Eastern subjects exclusively. His exacting technique and vivid colouration aroused the excited admiration of RUSKIN and the PRE-RAPHAELITES. PN
□ M. Lewis, *John Frederick Lewis* (1978)

Lewis, Percy Wyndham (1882–1957), born in Nova Scotia, studied at the SLADE 1898–1901 and spent the next 7 years on the Continent. He worked in Munich and Madrid, but was mostly in Paris with Augustus JOHN and in Brittany. Much of his early work is lost. On his return to England in 1909 he published stories; and criticism, essays, novels and plays remained a central part of his work, closely connected with his art. This is apparent in the 1914–17 ★VORTICIST paintings and drawings and in the novel *Tarr* (1918) and polemical pieces in *Blast* 1 and 2. The relationship between Lewis's forceful political texts of the 1920s and 1930s and his art is rather less clear.

From 1911 Lewis began to incorporate a Cubist syntax into his work, integrating figures, often in dynamic action, with a background in which depth is constructed through interconnecting small planes and strong directional lines, as in the *Timon of Athens* series of 1912. This series was shown in Roger FRY's Second Post Impressionist Exhibition in 1912 and owes a debt to Italian Futurist work. From 1912 Lewis emerged as an important figure within the English avant-garde. With GINNER, GORE and EPSTEIN he decorated the fashionable Cave of the Golden Calf in 1912. He worked briefly for the OMEGA WORKSHOPS, withdrawing and taking with him the group which became the Vorticists.

Few paintings of before 1914 survive, and most of the major works of the 1920s are lost. His output can only be guessed from drawings, watercolours, a few canvases, and critical descriptions. Between 1913 and 1915 he developed a high degree of abstraction: figures take on a machine-like structure of angular and regular forms, as in the *Combat* drawings (1914; V&A) or *The Crowd* (1914–15; Tate). The figures become increasingly like automata, often in clusters, and there is a greater use of architectural scaffolding structured diagonally, giving a vertiginous effect to the compositions. In 1914 with Ezra Pound and GAUDIER-BRZESKA he founded the *Review of the Great English Vortex – Blast*, and as its editor he published polemical pieces such as the Vorticist Manifesto.

Lewis served as a bombardier in 1915; for the Canadian War Memorials Fund he painted *A Canadian Gun Pit* (Ottawa), and for the Imperial War Mus. in London *A Battery Shelled*. In 1919 he attempted to revive the avant-garde by founding GROUP X. Between 1919 and 1921 he painted 7 self-portraits, including *Self-portrait as a Tyro* (Hull), which coincided with the publication of *The Tyro* in 1920–21. The Tyros were for Lewis elemental and aggressive. In the late 1920s and 1930s he devoted more time to writing, and under the influence of de Chirico painted works based on mythological and historical subjects. JB
□ G. Wagner, *Wyndham Lewis* (1957); W. Michel, *Wyndham Lewis* (1971); id. and C. J. Fox, eds., *Wyndham Lewis on art* (1971)

limning *see* MINIATURE PAINTING

Lindisfarne Gospels (BL) An Anglo-Saxon GOSPEL BOOK written in the monastery at Lindisfarne in Northumbria between *c*.698 and 721. The script and decoration, seen in slightly earlier forms in the perhaps Northumbrian Book of Durrow (Dublin, Trinity College), derive from Irish traditions. Canon tables, carpet pages and initials are treated as fields for dense, extremely precise, rigid yet energetic ornament much influenced by metalwork. The combination of Anglo-Saxon animals and Celtic spirals with interlace and rectilinear patterns is a very early example of the 'Hiberno-Saxon' style (*see* ANGLO-SAXON ART: EARLY). The rather stiff Evangelist portraits, however, are a compromise between the native taste for abstraction and the unfamiliar

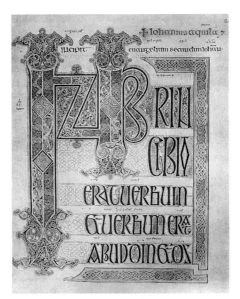

Opening page of the Gospel of John from the **Lindisfarne Gospels**, *c*.698–721 (BL).

naturalism of the models imported from Italy. JH
□ Alexander (1978), 35–40; J. Backhouse, *The Lindisfarne Gospels* (1981)

Linnell, John (1792–1882) was a landscape painter and a member of the SHOREHAM group. Though he is best known for the help he gave to his friends BLAKE and Samuel PALMER, recent discoveries have established him as an artistic personality in his own right and the creator of some of the most intensely observed landscape paintings of the period. He was initiated into naturalistic sketching by John VARLEY, and though he became a rival to CONSTABLE as a naturalist, he took the road of concentrated study from nature rather than broad and spirited handling, as in *The River Kennet, near Newbury* (1815; Cambridge, Fitzwilliam). His pioneering taste for early Northern European art, especially Dürer, was imparted to Palmer and Blake. In the 1830s his handling broadened and like Palmer his pastoralism became more ideal and conventional and therefore more popular. He remained devoted to the memory of Blake, whose works he continued to publish. *See also* OUTDOOR PAINTING. DB
□ K. Crouan, *John Linnell* (exh., Cambridge, Fitzwilliam, 1982)

lithography is a printmaking process based on the fact that marks drawn on a prepared surface (originally fine limestone, now zinc) with a greasy medium will repel water but attract printing ink. It was invented by the German Senefelder, who arrived in England in 1800 to take out a patent for his discovery. This was taken over by Philipp André, who published a series of lithographs in 1803 (see POLYAUTO-GRAPH). The technique did not become fully established in England until the 1820s. See also CHROMOLITHOGRAPH. RG
□ Twyman (1970); Griffiths (1980)

lithotint is a lithographic technique of establishing tone by ink washes, patented in London by Hullmandel in 1840. RG

Lockey, Rowland see HILLIARD

London Gallery The centre of English SURREALIST activity after E. L. T. MESENS became director in 1937; close contact was maintained with French and Belgian Sur-realists. The Gallery closed during the war and re-opened from 1946 until the early 1950s, showing a mixture of contemporary artists and classic Surrealists. It also acted as a publisher. DA

London Group see BELL, C.; BEVAN; CAMDEN TOWN GROUP; GINNER; GROUP X; NEW ENGLISH ART CLUB

London School of glass-painting comprised 3 groups. First were the glaziers resident in the City itself. Although no identifiable traces of their work remain they were sufficiently numerous by 1364–5 to have a set of craft ordinances. The second group was based at Westminster from the late 14c. and consisted of the successive holders of the office of King's Glazier, whose primary responsibility was the royal residences, although they also undertook outside commissions, e.g. PRUDDE at the Beauchamp Chapel, Warwick. Barnard FLOWER and Galyon HONE held this office in the early 16c. Previously they had both belonged to the third group of London-based glaziers, who during the late 15c.–early 16c. established themselves across the River Thames in South-wark in order to circumvent the 1364–5 craft ordinances. See *STAINED GLASS: TO 1550. RM

Long, Edwin (1829–91) achieved fame and a place in the saleroom recordbook with *The Babylonian Marriage Market* (exh. RA 1875; Egham, Royal Holloway College), one of a series of usually large-scale, Biblical, Middle Eastern and Egyptian subjects that he com-bined with a flourishing portrait practice. RT
□ J. Chapel, *Victorian taste . . . cat. of paintings in the Royal Holloway College* (1982)

Long, Richard (b.1945), a land artist since 1965, works lightly on the earth. His art is concerned with ideas about time, movement and places and making marks upon the earth by walking or by rearranging things found in the landscape, including stones, sticks or seaweed, creating such ancient and basic shapes as straight lines, circles, zigzags, spirals and squares. Long's art is shown in galleries by photographs of the marks he has made or places where he has worked, by maps, drawings or printed texts as well as by stones, slates, wood and other materials brought in from the landscape

Richard **Long**, *Sea Level Water Line, Death Valley, California*, photograph, 1982 (London, Anthony d'Offay Gall.).

arranged in simple shapes on the floor. *See also* CONCEPTUAL ART. DBr
□ *Richard Long* (exh., Eindhoven, 1979); *Richard Long* (exh., London, Anthony d'Offay, 1980)

Lough, John Graham (1798–1876) was a sculptor whose unevenness reflected the transition from strict NEOCLASSICISM to freer conventions. Initially successful with public statuary in his native north-east (*James Losh*, 1836; Newcastle-upon-Tyne), his London commissions (*Queen Victoria*, 1845, and *Prince Albert*, 1847, for the Royal Exchange) were not widely acclaimed. Falling on hard times, he was largely supported through commissions from landed north-eastern families (e.g. *Milo*, 1863; Blagdon). The memorial effigy to his daughter Lady Bourchier (1868; London, Kensal Green Cemetery) shows how good he could be. BR
□ Read (1982)

Lound, Thomas *see* NORWICH SCHOOL

Loutherbourg, Philippe Jacques de (1740–1812) was a skilful and versatile painter of PICTURESQUE and SUBLIME landscape subjects who also turned his hand successfully to genre scenes, marines, religious subjects, HISTORY and battle pictures, and theatrical scenery.

He was born in Strasbourg, and in Paris was a pupil of Carle van Loo and J. G. Wille. Quickly successful, he exhibited at the *salons* and after travelling in Europe moved to London in 1771. Helped by the actor David Garrick, he became a scene designer and painter in the 1770s and early 1780s. In 1781 he invented the 'Eidophusikon' ('image of nature'), a small-scale animated stage-set with sound and lighting effects used to present literary stories and Sublime landscape phenomena. Much praised, it encouraged GAINSBOROUGH to experiment with artificially lit paintings on glass. From 1789 to 1800 he worked on religious and history subjects for the publishers Macklin and Bowyer and painted some large pictures of contemporary naval battles. He became interested in faith-healing, pharmacy and alchemy, and in the late 1780s for a short time preferred them to painting. JS
□ R. Joppien, *Philippe Jacques de Loutherbourg* (exh., London, Kenwood, 1973)

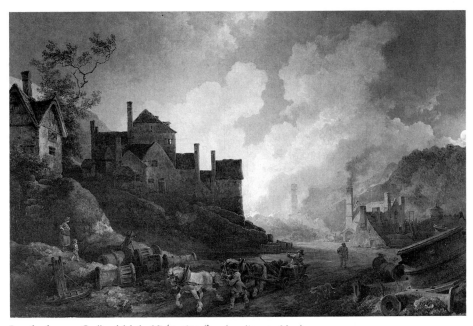

Loutherbourg, *Coalbrookdale by Night*, 1801 (London, Science Mus.).

Louw, R. *see* CONCEPTUAL ART

Low, Sir David (1891–1963) was the most influential political cartoonist to work in Britain this century. Born in New Zealand, he came to England in 1919, and joined the London *Evening Standard* in 1927. There he produced a long series of cartoons which were independent in view – he was a Socialist working for a Conservative paper – and of great political percipience. Particularly telling are those of the Appeasement years, which caused his work to be banned in Germany and Italy. His most famous invention is Colonel Blimp, an embodiment of the die-hard British reactionary. *See also* *CARICATURE. RG
□ D. Low, *Low's autobiography* (1956)

Lowe, Peter *see* CONSTRUCTIVISM

Lowry, L. S. (1887–1976) created a popular vision of the industrial north of England. His painting developed parallel to 40 years of working life in Manchester and Salford (rising from rent-collector to chief cashier). Before 1925 he studied under Adolphe Valette (a disciple of Degas) and had his first one-man exhibition only in 1939. His impressive panoramic landscapes, with Chaplinesque figures crowded on a white ground, his empty seascapes, and larger compositions such as *The Cripples* (1949; Salford), all convey a bleak but compelling view of life, where loneliness is the underlying theme. TH
□ *L. S. Lowry* (exh., RA, 1976)

Lucas, David *see* CONSTABLE; MEZZOTINT

Lumley Inventory (priv. coll.) A list made *c*.1590 of one of the largest and most important 16c. collections of paintings (mostly portraits) and sculpture, that of John, 1st Lord Lumley (d.1609). Unusually for the period it records the names of many artists, and a number of the works have been identified. Some of the sculpture is illustrated. SF
□ *Walpole Soc.*, VI (1917–18), 15–35

Lye, Len *see* SURREALISM

M

McArdell, James (*c*.1729–65) was the most brilliant of the group of Irish MEZZOTINT engravers who flourished in London in the 1750s and 1760s. He arrived from Dublin in 1746 and soon established a reputation by his plates from Rubens, VAN DYCK, and contemporary portrait painters such as HUDSON, RAMSAY and REYNOLDS. Reynolds painted his portrait (NPG) and, according to NORTHCOTE, said: 'By this man, I shall be immortalised.' RG
□ T. Clifford, A. Griffiths and M. Royalton-Kisch, *Gainsborough and Reynolds in the BM* (exh., BM, 1978)

MacBryde, Robert *see* COLQUHOUN

MacColl, D. S. *see* NEW ENGLISH ART CLUB

McCulloch, Horatio (1805–67) was more than any other artist responsible for creating the iconography of Highland scenery that found so many followers in 19c. *SCOTTISH PAINTING. He was born in Glasgow and received his early training there from John KNOX, but a more important influence was the loosely handled romantic landscapes of John THOMSON, who encouraged him after his move to Edinburgh in 1825. His mature works are often large, like *Glencoe* (1864; Glasgow); they combine fairly precise observation with free handling of paint, giving a strong sense of light and atmosphere. In construction they sometimes reflect the 18c. tradition of Alexander NASMYTH, but their mood is that of the new romantic appreciation of the Highlands. DM
□ Caw (1908); Irwin (1975); Hardie (1976); L. Errington and J. Holloway, *The discovery of Scotland* (exh., Edinburgh, NGS, 1978)

MacDowell, Patrick (1799–1870) *see* ALBERT MEMORIAL

McEvoy, Ambrose (1878–1927), a contemporary of Augustus JOHN and ORPEN at the SLADE in the 1890s, painted quiet genre scenes (*The Ear-Ring*, *c*.1911; Tate) up to 1912, portraits of service officers during World War I, and became devoted to rapid sketch-portraits of beautiful society women. BL
□ R. M. Y. Gleadowe, *Ambrose McEvoy* (1924)

Maclise, *John Constable late in life*, drawing, *c*.1831 (NPG).

MacGillivray, T. P. *see* GLASGOW SCHOOL

MacGregor, W. Y. *see* GLASGOW SCHOOL; SCOTTISH PAINTING; SLADE

Mackintosh, Charles Rennie (1868–1928), the great Glasgow architect, also made many stylized and incisive drawings of flowers and picturesque views. By the end of the First World War he had almost given up architecture for watercolour painting, living 1923–7 in Port Vendres in the French Pyrenees.　　DB
□ R. Billcliffe, *Architectural sketches and flower drawings by Charles Rennie Mackintosh* (1977); id., *Mackintosh watercolours* (1978)

McLean, Bruce (b.1944) became a PERFOR-MANCE artist in trying to extend the nature of sculpture. His first performance, or action as he describes it, *Mary Waving Goodby to the Trains*, took place in London in 1965, and in 1969 he collaborated on a work with GILBERT AND GEORGE. During the 1970s his performances concentrated on social issues and art world politics and were characterized by carefully orchestrated movement, the use of objects, and critical humour. In the 1980s these themes were also taken up in painting and sculpture. *See also* CONCEPTUAL ART.　　WF
□ W. Furlong, *Hayward Annual* (exh., Arts Council, 1979); N. Dimitrijevic, *Bruce McLean* (exh., London, Whitechapel, 1981)

Maclise, Daniel (1806–70) was the most prominent HISTORY painter of the mid Victorian period. Coming to London from Cork in 1827, he first made a reputation with literary portraits and light-hearted literary and genre scenes. In the 1840s his style and subject-matter became more severe under the influence of French and German history painting. He was employed to do decorations for the Palace of WESTMINSTER, the most impressive being the vast murals on the death of Nelson, and Wellington at Waterloo (1857/64). A handsome man of great charm, Maclise was popular in society and amongst his fellow artists.
　　WV
□ W. J. O'Driscoll, *A memoir of Daniel Maclise* (1871); *Daniel Maclise* (exh., NPG, 1972)

McTaggart, William (1835–1910) was one of the most original British artists of the later 19c. He was born at Macrahanish on the Mull of Kintyre and, like ORCHARDSON, studied painting under Robert Scott LAUDER at the Trustees' Academy in Edinburgh. Thenceforth Edinburgh remained his base, though he painted much on the west coast, especially in later life. His early work was mostly genre and portraiture in the WILKIE tradition. One of his earliest mature landscapes, *Spring* (1864; Edinburgh, NGS), still shows a hint of another influence, MILLAIS, but in it McTaggart, in keeping with the teaching of Scott Lauder, was already seeking unity of mood through freedom of handling. The subject of spring, and the identification of the innocence of children with the innocence of nature, anticipates an essential theme of his later work, and reveals its Romantic roots. From the early 1870s he

McTaggart, *The Storm*, 1890 (Edinburgh, NGS).

painted seascapes as well, and the tone and colour of the sea affected all his painting, which became increasingly light and pure in colour and free in handling.

In his mature work, from the 1880s onwards, the whole surface of the canvas is animated dramatically by the flow of paint. In *The Storm* (1890; Edinburgh, NGS), figures, houses, cliffs and boats are all lost in the confusion. He was also capable of great simplicity, however, as in *The Wave* (Kirkcaldy), or in small works like *Snow in April* (*c.*1892; Edinburgh, NGS), where handling, colour and composition relate to mood as well as to observation. Like Monet he was a naturalist, and his distinctive qualities all evolved from his experience in front of the motif, but his aim was to express a subjective state of identification with nature. In late paintings like *The Return of St Columba* (1898; Edinburgh, NGS) he restated the Romantic idea that the poetry of landscape depends upon the exchange between man and nature.

As with all the great Scottish landscapists, his painting depends upon personal associations. He depicted only Scotland, and often scenes of his boyhood. In the end he thus has more in common with CONSTABLE than with the Impressionists. His ideas and manner were influential: *see* SCOTTISH PAINTING.

For his grandson, **Sir William McTaggart** (1903–80), *see* SCOTTISH PAINTING. DM
□ Caw (1908); id., *William McTaggart* (1917); Irwin (1975); Hardie (1976)

McWilliam, F. E. (b.1909) was, next to Henry MOORE, the foremost sculptor in Britain in the 1930s working in a SURREALIST vein. A number of his works relate thematically to Ireland, his birthplace, though he has lived mostly in London. Among his best works are hieratic figurative pieces commissioned for public sites, e.g. *Princess Macha* (1957; Londonderry) and *Puy de Dome* (1962; Southampton Univ.). LC
□ *F. E. McWilliam* (exh., Arts Council of Ireland, 1981)

Maddox, Conroy (b.1912) has remained a committed SURREALIST since the late 1930s. His paintings and collages depict city, landscape and interior settings with dream-like juxtapositions of objects. DA
□ *Conroy Maddox: Surrealism unlimited 1968–78* (exh., London, Camden Arts Centre, 1978)

Malchair, John *see* AYLESFORD; DRAWING MASTERS

Mann, Harrington *see* GLASGOW SCHOOL

Manson, J. B. *see* CAMDEN TOWN GROUP

marble is a crystalline limestone and the material, other than BRONZE, most prized for large-scale sculpture in England from the 17c. onwards. With Maximilian COLT and Nicholas STONE, marble replaced the traditional freestone and alabaster for monuments and by the late 17c. it was also being employed for portrait busts. Most marble was imported; the white 'statuary' marble preferred for figure sculpture came from Carrara in Italy, the black marble that forms the background of many 18c. monuments from Belgium, and the various coloured 'breccia' marbles popular *c.*1720–80 from other Italian quarries.

The carving process would be preceded by the preparation of drawings and models in TERRACOTTA or PLASTER, sometimes bearing a scale of measurement. By the early 19c. a full-size model in plaster would also usually be made. The model would then be marked with pointing crosses, allowing the sculptor's assistants to transfer the measurements to the block of marble. The approximate form would be roughed out with a mallet and flat chisels and the more detailed work executed with a combination of toothed or 'claw' chisels, pointed chisels, drills and files. The sculptor himself would usually undertake the final stages of the carving; but by the mid 19c. the use of the mechanical pointing machine and a large team of assistants often meant that he was directly concerned only with the model. The last stage involved the polishing of the surface with fine abrasives, a process that was of particular importance in the creation of the smooth finish of Neoclassical sculpture. *See also* SCULPTURE: 17c.ff. MB
□ R. Wittkower, *Sculpture, processes and principles* (1977); N. Penny, *Church monuments in Romantic England* (1977), 3–16

marine painting as a serious art form was introduced to England by the VAN DE VELDES and their followers in the 1670s. Before the arrival of the émigré Dutchmen, marine art was mostly confined to manuscript illustrations, decorative additions to charts and maps, and occasional pictures commemorating historic

Willem van de Velde the Younger, *The English Ship 'Resolution' in a Gale*, c.1676 (Greenwich).

events such as the defeat of the Spanish Armada.

For many years the work of the Van de Velde studio was dominant, and artists such as Robert Woodcock (1692–1728), Peter Monamy (1681–1749), and Charles Gore (1729–1806) frequently based their pictures on compositions by Willem van de Velde the Younger. Only in the 1730s did an English style begin to emerge. The movement was led by a group of artists who lived and worked along the Thames. John Cleveley the Elder (c.1712–77), a former shipwright, painted bold and decorative pictures of London's shipyards; Samuel SCOTT made his name with views of London's waterfront; and the gifted Deptford artist Charles BROOKING succeeded in combining the accurate portrayal of shipping with a sensitive awareness of weather and the changing patterns of light and shade.

The growth of a native school of marine art was encouraged by 2 distinct developments. The first was the emergence of the Royal Navy as a formidable sea power during the 18c. The victories of Howe, Rodney and Nelson led to a steady demand for pictures of sea battles, and a number of artists with seafaring experience, such as SERRES, POCOCK, and William Anderson (1757–1837) made a good living from naval commissions. The second factor was a changing attitude towards the sea and the seashore. Many of the novelists, poets and artists associated with the Romantic movement turned to the sea as a source of inspiration. Storms and shipwrecks appeared as a vivid demonstration of man's frailty in the face of the elements; the beauty of nature was revealed in atmospheric calms. De LOUTHERBOURG and TURNER produced the most spectacular marine paintings in this category, but many examples can also be found in the work of BONINGTON, CONSTABLE and COTMAN.

By the beginning of the Victorian period marine subjects of all types were common on the walls of the ROYAL ACADEMY. The powerful realism of Clarkson STANFIELD's seascapes attracted the admiration of RUSKIN. George Chambers (1803–40) and E. W. COOKE were particularly adept at portraying fishing boats in all weathers. A. W. CALLCOTT, Copley FIELDING and J. W. Carmichael (1800–1868) made their reputations with picturesque views of harbours and river estuaries. The expansion of Britain's overseas empire, and the trade which was dependent on a great fleet of merchant ships, ensured success for artists who specialized in ship portraits. Samuel Walters of Liverpool (1811–82) and W. J. Huggins (1781–1845) are typical, and there were many others based in seaport towns such as Bristol and Hull. DC
□ D. Cordingly, *Marine painting in England 1700–1900* (1973); E. H. H. Archibald, *Dictionary of sea painters* (1980)

Brooking, *Ships in a Light Breeze*, c.1750 (Greenwich).

Marlow, *Capriccio: St Paul's and a Venetian Canal*, *c*.1795? (Tate).

Marlow, William (1740–1813) learned his sound topographical style during his 5-year apprenticeship to Samuel SCOTT, though his inclination towards the picturesque suggests a close study of WILSON and Vernet. He travelled extensively in England and Wales 1762–5, and in France and Italy 1765–8. From sketches made then he repeated compositions for the rest of his life. His country house views are more literal than Wilson's, and usually more silvery in tone. He also painted *capricci* in which topography and the picturesque are fused. From 1785 he lived in retirement at Twickenham, but continued to paint for his amusement.　　EE
☐ M. Liversidge in *Burl. Mag.*, CXXII (1980), 549ff

Marochetti, Baron Carlo (1805–67), in England from 1848, epitomized the style most opposed to the classicizing naturalism of conventional High Victorian SCULPTURE. His fine modelling and dramatic style (e.g. *Richard Coeur de Lion*, 1851/60; London, Westminster) were unexceptional on the Continent where he trained, but the English (except for Prince Albert) largely regarded his work as flashy and 'effectist'.　　BR
☐ Read (1982)

Marshall, Benjamin (1768–1835) was a painter of *SPORTING pictures notable for their accomplished portraiture and freshly observed landscape backgrounds. As a racing correspondent and teacher of Abraham Cooper (1786–1868) and John Ferneley (1782–1860), his influence in sporting circles was considerable.
SD
☐ A. Noakes, *Ben Marshall* (1978)

Marshall, Edward see BRASSES

Marshall, William Calder (1813–94) *see* ALBERT MEMORIAL

Martin, John (1789–1854) was famous in the early 19c. mainly for his large paintings of cataclysmic events containing immense numbers of tiny figures; after his death they dropped out of fashion until their revival in recent years. He was born at Haydon Bridge (Northumb.), and after working as a china and glass painter in London first began to exhibit landscapes at the ROYAL ACADEMY in 1811.

His real breakthrough came with the exhibition in 1821 of *Belshazzar's Feast* (formerly Toronto, Tanenbaum Coll.), described as a 'poetical and sublime conception in the grandest style of the art'. The immensity of scale of the architecture and the overwhelming detail in this and subsequent works secured his popularity, and they can be seen as late yet original attempts in the SUBLIME manner, deriving partly from early Biblical paintings by TURNER. It has recently become clear that Martin, like LOUTHERBOURG and BLAKE, was influenced by popular millenarianism which claimed that the materialism and war which characterized the age heralded the imminent destruction of man, as prophesied in the Bible. His pictures of destruction may, therefore, have been meant as allegorical of contemporary life, though he was reticent about proclaiming this. Martin also had a lifelong interest in urban improvement, e.g. in providing pure water for London, and he made inventions concerned with mines, railways and ships. Such interests, like his paintings, may reflect a concern to transform London from a Nineveh or Babylon into a New Jerusalem in fulfilment of Biblical prophecy.

Martin achieved considerable prosperity from his paintings and engravings and MEZZOTINT book illustrations (e.g. Milton's *Paradise Lost*), which were particularly popular in

John **Martin**, *The Fall of Babylon*, mezzotint after the painting of 1819.

France. The culmination of his career was the series of 3 enormous pictures of the Last Days (1851–3; Tate) consisting of *The Great Day of His Wrath*, *The Last Judgment* and *The Plains of Heaven*. *See also* BRISTOL SCHOOL; POPULAR ART. DB
□ T. Balston, *John Martin* (1947); W. Feaver, *The art of John Martin* (1975)

Martin, Kenneth (b.1905) turned to abstract art in 1949 after a long period as a realist painter. In the early 1950s he played a leading role, with his wife **Mary** (1907–69), PASMORE, HILL, Adrian Heath and Robert Adams, in establishing a constructed abstract art group in London (*see* ★CONSTRUCTIVISM). From his first abstract paintings of 1949–51 he has constructed his works systematically, with elements related proportionally and sequentially. His first mobiles, made in 1951 from rectangles of tin, developed from his paintings. In 1953 began a series of 'screw mobiles' constructed from strips of commercial stock brass in spiral formation on vertical steel rods. These were followed in 1956 by more sinuous mobiles of phosphor bronze. In the 1960s he made static 'Linear

Constructions' and 'Oscillations' and kinetic 'Transformables' and 'Rotary Rings', some of which had parts which could be moved by the onlooker. The element of chance in these works led him in 1969 to begin the *Chance and Order* series, in which lines drawn between points are ordered according to numbers drawn randomly from a pack of cards. Though most of his work is on a domestic scale, he has completed several public commissions, including fountains and large constructions. AG
□ *Kenneth Martin* (exh., Tate, 1975); *Kenneth Martin* (exh., Yale BAC, 1979)

Martineau, Robert Braithwaite (1826–69) was a genre painter who worked *c.*1851–2 in Holman HUNT's studio. His pictures show a PRE-RAPHAELITE concern for detail, though their mood is coarser and their morality more laboured – as in his best-known work, *The Last Day in the Old Home* (1862; Tate). WV
□ Maas (1969)

Massingham, John is the only medieval English sculptor for whom there is reasonably good documentation. In 1409 he was an

Massingham, effigy of the Earl of Warwick, gilt copper, cast by William Austen, c.1448–9 (Warwick, St Mary's).

apprentice carpenter in London. From 1438 to 1442 he worked for All Souls College, Oxford, on the figures of the reredos of the chapel, all of which have been destroyed. It has been suggested that he also carved the figures of Henry V's CHANTRY in Westminster Abbey, London, although this is not documented (*see* *SCULPTURE: GOTHIC, STONE). In 1448 he is mentioned in the contract for the effigy of the Earl of Warwick in the Beauchamp Chapel in St Mary's, Warwick; the extent of his involvement in the tomb as a whole and the sculptural decoration of the chapel is controversial.

Massingham's style has a preference for calm bulky figures of rather rigid pose. In the effigy of the Earl of Warwick he shows a great interest in realistic details, paralleling that displayed in the works of contemporary Flemish sculptors and painters. NM
□ Stone (1972)

Master of the Giants (fl. c.1779) is the name given to the anonymous author of a sketchbook (now widely dispersed) made in Rome in the late 1770s containing grotesque and distorted figures in the manner of FUSELI. He has been identified as James JEFFERYS, the author of a group of drawings in a similar mode, but he may have been a talented amateur. DB
□ F. Cummings and A. Staley, *Romantic art* (1968); Pressly (1979)

Meadows, Bernard *see* SCULPTURE: 20C.

Melville, Arthur *see* GLASGOW SCHOOL; SCOTTISH COLOURISTS; SCOTTISH PAINTING

Menpes, Mortimer *see* WHISTLER

Mercier, Philip (1689?–1760), a painter of French Huguenot origin, was born and trained in Berlin under Antoine Pesne. He came to England c.1716 and was patronized mainly by Hanoverian courtiers who had a taste for his CONVERSATION PIECES in imitation of WATTEAU and his followers. From 1729 to 1736 he was Principal Painter to FREDERICK, Prince of Wales, but in the late 1730s moved to York and began to paint a new type of FANCY PICTURE similar to Chardin's domestic genre paintings. These established a fashion later exploited by Henry Robert Morland (c.1719–97) and WHEATLEY.
 BA
□ J. Ingamells and R. Raines, *Philip Mercier* (exh., York/London, Kenwood, 1969); id., cat. of Mercier's work in *Walpole Soc.*, XLVI (1976–8), 1–70

Mesens, E. L. T. (1903–71) was active as a poet, artist and entrepreneur within the SURREALIST groups in Belgium and England. In 1937 he came to England, where he ran the LONDON GALLERY and edited the *London Bulletin*. Collage was his preferred visual medium. DA
□ *Dada and Surrealism reviewed* (exh., Arts Council, 1978)

Meyer, Jeremiah *see* MINIATURE PAINTING

mezzotint is a tone ENGRAVING process in which the artist works from dark to light by scraping out his design from a roughened or grounded plate. It was developed in Germany

Mercier, *Frederick, Prince of Wales, and his Sisters*, 1733 (NPG).

Millais, *Christ in the House of his Parents,* 1850 (Tate).

by Ludwig von Siegen in the 1640s and introduced to England by Prince Rupert, the first example being a print by him in EVELYN's *Sculptura* (1662). Ideally adapted to the reproduction of portraits, it flourished in England more than anywhere, the French calling it 'la manière anglaise'. It reached an apogee in the 18c., notably in prints by MCARDELL and Valentine Green (1739–1813) after ★REYNOLDS and the candle-lit scenes of WRIGHT OF DERBY, but was also used to great effect in the 19c. by TURNER and in prints after CONSTABLE by David Lucas (1802–81). *See also* ★MARTIN, J.; PLACE; WARD. RG
□ Chaloner Smith (1878–83); Griffiths (1980)

Middleton, John *see* NORWICH SCHOOL

Millais, Sir John Everett, Bt (1829–96) was a leading member of the PRE-RAPHAELITE BROTHERHOOD who in later life pursued a brilliantly successful career as an academic and society painter. He lacked the imaginative genius of ROSSETTI and the intellectual rigour of Holman HUNT, but he was more technically gifted, and in his early years he produced some of the most memorable of all Pre-Raphaelite paintings.

A native of Jersey, he entered the ROYAL ACADEMY Schools at 11, and won all the prizes. He would probably have proceeded directly to a successful academic career had not his friendship with Hunt and Rossetti involved him in the formation of the Pre-Raphaelite Brotherhood, in 1848. He saw clearly the pictorial potential of the archaizing naturalism of early Pre-Raphaelitism, and his *Lorenzo and Isabella* (1849; Liverpool) is a *tour de force* of gothicness executed in glowing colours with a consummate technique. His *Christ in the House of his Parents* (1850; Tate) showed the Holy Family with radical realism, though great devotional intensity; it was savagely attacked in the press, suspected of blasphemy and connections with the Anglo-Catholic movement.

Like the other Pre-Raphaelites, Millais' reputation was saved by the intervention of RUSKIN. His style began to move from archaism towards the careful observation of natural scenery (e.g. in *Ophelia*, 1852; Tate). Ruskin had hopes of educating him to become a 'second Turner'. These were dashed after their visit to Glenfinlas in Scotland precipitated the breakdown of Ruskin's marriage and the eventual remarriage of Effie Ruskin to Millais. In the late 1850s Millais continued to paint

pictures of great lyrical sensibility, but gradually his style broadened and he made increasing concessions to popular taste. Appropriately one late picture, *Bubbles* (1885–6; A. & F. Pears Ltd), was used for a soap advertisement. The most distinguished parts of his later work were his *LANDSCAPES and his book illustrations.

A genial, easy-going man, Millais enjoyed his success, claiming to be the highest-paid artist in history. He was the first painter to be created a baronet (in 1885) and was made President of the *ROYAL ACADEMY months before his death. *See also* PORTRAIT PAINTING: 19C.; WOOD-ENGRAVING. WV

□ J. G. Millais, *Life of Millais* (1899); M. Bennett, *Millais* (exh., Liverpool/RA, 1967)

miniature painting, or limning, is a particular technique of painting. The traditional materials of miniaturists were WATERCOLOUR and body-colour or GOUACHE applied with minute finish to a primed vellum support or to thin ivory sheets. Although generally confined to portraiture from the life, the limner's craft was also employed for the small-scale replication of oil paintings. It was an art form practised

throughout Europe but most successfully and continuously in Britain.

In England it originated in the ateliers of Flemish manuscript illuminators attached to the Tudor Royal Library. Lucas Hornebolte (c.1490/95–1544), painter to HENRY VIII, is credited with painting the first portrait miniature in England and with communicating his technique to *HOLBEIN. Following Holbein's death, there was little activity until *HILLIARD emerged, in the 1570s, as ELIZABETH I's principal portraitist. His formalized and decorative style merged aspects of Hornebolte's technique, Holbein's linearism, and the precious sophistication of French court portraiture. Hilliard transmitted the secrets of his craft to Isaac OLIVER, who rapidly challenged his mentor with an approach that was the antithesis of Hilliard's, aiming at a penetrating psychological study of character.

With the decline of Hilliard's influence in the 1620s, the London school of limners moved away from the miniature as an iconic emblem in a jewelled setting towards a naturalistic Baroque iconography and techniques more comparable to oil painting. The heirs of 16c. expertise were Peter Oliver (c.1589–1647),

Hilliard, *Queen Elizabeth I*, c.1600 (V&A).

Cooper, *Oliver Cromwell*, c.1650 (The Duke of Buccleuch and Queensberry).

whose granular style was a sophistication of his father's method, and John Hoskins (*c.*1590–1664/5), a Hilliard protégé whose innovative polychromatic stippling allowed him in the 1630s to imitate VAN DYCK's portraiture with startling accuracy. Among Hoskins's students was Samuel COOPER, the incomparable master of 17c. English limning. While still apprenticed to Hoskins, Cooper developed a unique painterly technique of broad, vigorous brushwork. He only painted from life, with the result that his portraits were valued for their truth and vivid realization of character. Although few limners could approach his executive brilliance, Cooper's virtuosity inspired a certain individuality in the second half of the century when styles ranged broadly from extreme ruggedness to the softest *sfumato* effects.

Towards the end of the 17c. foreign artists began to dominate the miniature trade in England (e.g. des GRANGES), and by 1710 Bernard LENS III (1681–1740) was the only native limner of note practising in London. Although an uneven portraitist, he revolutionized the craft by introducing ivory as a support and by adapting earlier watercolour

techniques to its highly reflective surface. In addition to talented foreigners, Lens had to compete with a vogue for the technically different art of enamel portraiture, introduced from the Continent, which flourished with the accession of the Hanoverians (see ZINCKE).

By 1750 watercolour painting on ivory had supplanted enamel in the public's favour, and a truly national school began to emerge. The second half of the 18c. saw the remarkable achievements of Jeremiah Meyer (1735–89), Richard COSWAY and John SMART, and the mass popularization of the medium in London and the provinces by a host of able practitioners (e.g. DAYES).

By 1800 the necessity of exhibiting publicly at such institutions as the ROYAL ACADEMY and the confidence which miniaturists had acquired encouraged them to attempt more ambitious works. Following the example of Andrew Robertson (1777–1845), the new generation modified their techniques in order to imitate the finish, the chromatic depth and range, and the compositional complexity of large-scale portraiture in oils. Although the oval locket continued in use, the preferred format became, for the first time, a rectangular ivory panel set in an ornate gilt frame. Of the many miniaturists active before 1850, it was William Charles Ross (1794–1860) who demonstrated, with uncommon versatility and refinement, the full potential of this 19c. virtuosity.

After Ross's death in 1860, the miniature declined rapidly in popularity. The best masters of Ross's generation had failed to train a school and many of them, threatened by the incursions of photography, had abandoned the genre altogether. What had been a professional industry from the time of Hilliard became, by 1900, the province of amateurs.

See also BEALE; BETTES; BROWN, J.; RAEBURN. PN

□ Reynolds (1952); Murdoch, Murrell, Noon and Strong (1981)

Minton, John (1917–57) was one of the central figures in the NEO-ROMANTICISM of the 1940s. Though initially influenced by French post-Cubist painting, his mature style developed also out of the English tradition of Samuel PALMER and the earlier work of SUTHERLAND. His main concern was with the relationship of figure to landscape. A strong decorative strain led him towards book illustration. His art fell abruptly out of fashion in the early 1950s, and he was

Cosway, *Self-portrait*, pencil and wash (NPG).

unable to respond to the new French and American influences. DB

□ *John Minton* (exh., Arts Council, 1958); *John Minton, 1917–57* (exh., Reading/Sheffield, 1974–5)

misericords are small ledge-like projections on the undersides of choir stall seats, designed to give support during the singing of long sequences of Psalms in the daily offices, when the liturgy required the participants to stand. They show some of the best preserved medieval woodcarving, with subjects that include scenes from the Bible, secular romances and daily life, and representations of saints, angels, devils, musicians, animals, birds, fantasy creatures from the BESTIARY, GROTESQUES, foliage, flowers and heraldic motifs. Misericords are found in the greatest numbers in cathedral choir stalls, notably at Salisbury, Lincoln, Winchester, Ely, Chester, Norwich and Exeter. Many fine smaller sets exist in parish churches. Some (e.g. Exeter) are of the 13c., but the majority are of the 14c. and 15c. See ★SCULPTURE: GOTHIC, WOOD. NM
□ G. L. Remnant, *Cat. of misericords in Great Britain* (1969)

Mitchell, Denis *see* ST IVES SCHOOL

Moholy-Nagy, László (1895–1946) first visited England in 1933, and settled from May 1935 until July 1937, when he left for Chicago. Though his English career was extremely short, his work was wide-ranging and influential. He made commercial designs, films, and special effects for films, and also photographs for books. In his art he used Rhodoid sheet to create translucent and overlapping effects. He exhibited in the 'Abstract and Concrete' exhibition of 1936, and had a one-man show at the LONDON GALLERY in the winter of 1936–7. AG
□ T. Senter, *L. Moholy-Nagy* (exh., Arts Council, 1980)

Monamy, Peter *see* MARINE PAINTING

Mondrian, Piet (1872–1944) had been visited in his Paris studio by Ben NICHOLSON in 1934. In 1936 he showed 3 pictures at the 'Abstract and Concrete' exhibition in London, and in 1937 he contributed an important essay and several reproductions to CIRCLE. He moved to London in 1938, settling close to Nicholson, HEPWORTH, GABO and MOORE, and continued to develop

compositions with grids of closely set parallel lines and small rectangles of colour set at the edges of the canvas. English patrons included Alastair MORTON, Helen Sutherland, Nicolete Gray, J. L. and S. Martin, and Nancy Roberts. He left for New York in 1940, taking his canvases with him. AG
□ *Studio International*, no. 884 (1966), 285–92

Monnington, Thomas *see* SLADE

Monnot, Pierre Etienne (1657–1733) was French-born but played a prominent role in the evolution of late Baroque sculpture in Rome. Though he did not come to England, for his major English patron, the 5th Earl of Exeter, he executed busts, allegorical groups and a lavish tomb at Stamford, Lincs. (1704), which strongly influenced RYSBRACK and other English sculptors. *See also* SCULPTURE: EARLY 18C. MB
□ Whinney (1964); R. Engass, *Early 18c. sculpture in Rome*, I (1976)

Monro, Dr Thomas (1759–1833) was Physician to George III and Bethlem Hospital, where he cared for J. R. COZENS. At an informal 'Academy' in Adelphi Terrace he encouraged young artists, including TURNER and GIRTIN, to copy drawings by Cozens, DAYES, HEARNE and others. Later J. VARLEY, COTMAN, DE WINT and William Henry HUNT were taken up by him. His own rather monotonous drawings reflect his admiration for the landscapes of GAINSBOROUGH. *See also* CRISTALL; FRANCIA; ROYAL ACADEMY: 19C. AW
□ Hardie, III (1968); *Dr Thomas Monro and the Monro Academy* (exh., V&A, 1976)

Moon, Jeremy (1934–73) was an abstract painter of sharply defined forms such as parallel bands or reticulations that articulate the whole surface of the canvas. Sometimes they determine or follow it in non-rectangular configurations. His choice of colour was personal, comprising many secondary or tertiary hues. MC
□ C. Harrison in *Studio International* (Jan. 1968), 134–9

Moore, Albert (1841–93) entered the ROYAL ACADEMY Schools in 1858, visited France in 1859 and was briefly in Rome 1862–3. His earliest pictures show a strong PRE-RAPHAELITE influence and in the 1860s he produced a

Albert **Moore**, *Blossoms*, 1881 (Tate).

number of designs for tiles, fabrics, wallpapers and stained glass; he also completed some large wall-paintings. From 1864 onwards his study of ancient sculpture, particularly the *ELGIN MAR-BLES, helped to form his mature style. The decorative qualities of classically – and often diaphanously – draped figures, usually female, disposed singly or in groups in cool, shallow spaces, convey an atmosphere of reverie rather than a specific time or place. Each composition was meticulously thought out in preparatory sketches and the bulk of Moore's oeuvre reveals a subtle, usually successful, reworking through line and colour of essentially the same motifs. His art is the direct antithesis to that of the archaeologically minded ALMA-TADEMA.

Moore met WHISTLER in 1865 at a time when he was similarly preoccupied with 'subjectless' pictures, and each was inspired by the other's Oriental and classical themes. Together, they were the most significant exponents in painting of the ideas of the AESTHETIC MOVEMENT. RH
□ A. L. Baldry, *Albert Moore* (1894)

Moore, Henry (b.1898) is often considered amongst the greatest sculptors of this century. His international reputation, which dates from the late 1940s, when he had a one-man show in New York and represented Britain at the Venice Biennale, rests most securely on the series of reclining female figures made in a variety of stones and metals over 4 decades. The fame of his string pieces (cf. GABO) depends more on innovation than quality. His most original works were perhaps the abstract biomorphic sculptures of the 1930s (*see* *SCULPTURE: 20C.*) such as *Composition* (1931; priv. coll.) and *Square Form* (1936; Norwich, Sainsbury Centre). They reflect his contact with European SURREALISM and in particular with the work of Picasso, Arp and Brancusi. There is also evidence of that other major stimulus to his work, primitive art. Compared with contemporary European art, Moore's work is distinguished by its constant preference for analogies between the figure and landscape rather than between the figure and the bestial world, and by a lyrical mood, benevolent in character, which is far removed from the aggressive violence so beloved of the Surrealists.

Two other precepts dominated Moore's thinking in the interwar years: direct carving and truth to material. These tenets required that the artist work on his block of material without the aid of either preliminary drawings or maquettes. Thus a dialogue could be established in which the shape of the block and the nature of the material, its tensile strength, density, texture and so forth, would contribute to the final image. These principles, which had earlier been adopted by EPSTEIN and Brancusi, were interpreted by Moore and HEPWORTH, who followed a similar path, with considerable licence. They did, however, encourage the younger artists to experiment with a wide range of stones and woods.

As an official war artist during World War II, Moore's most notable achievement was the series of drawings known as the *Shelter Sketchbooks*, depicting civilians sleeping in the London Underground during the blitz. These drawings carry references to masters of the past, notably Millet and Michelangelo. During the early 1950s Moore's interest in antique and

Henry **Moore**, *Reclining Figure*, 1938 (Tate).

Renaissance art was rekindled by a visit to Greece and further study of Michelangelo, and in his subsequent work echoes of the classical world are fused with or replace those of Surrealism (*Draped Torso*, 1953; Hull, Ferens AG). Perhaps as a consequence, the theme of the reclining female figure gradually gained pre-eminence, although a number of new subjects, such as the *King and Queen*, *Falling Warrior* and *Upright Motive*, entered his work at this time. Since modelling now took precedence over carving, Moore's formal language changed considerably: bony, attenuated, angular forms, often suggesting a mood of turbulence and anxiety, were increasingly evident (*Mother and Child*, 1953; Tate). If the mood became more subdued in the late 1950s, metaphors between the figure and those forms in nature which are aged, weathered and fragmented still persisted.

The scale of Moore's work increased considerably in the 1960s as the forms, now often composed of several elements grouped together rather than a single object, came to resemble landscape, especially cliffs and bare mountain terrain, almost more than figures. Unequivocally a humanist, Moore has attempted by means of an evolving language of forms and moods to chart modern man's changing sense of himself over this century. A tendency to overproduction, to a rhetorical monumentality, and to a facile transforming of found forms (bones, shells, rocks) into sculpture, has meant that his post-war production is very uneven in quality. It also bears little relation to the most innovative and fertile trends in contemporary sculpture. Yet it includes a number of works which fully justify Moore's stature, ranging from *Reclining Figure* (1950; Arts Council) and the *Time-Life Screen* (1952; London, Time-Life Building) to *Sheep-Piece* (1971–2; Kansas City). LC
□ D. Sylvester, H. Read and A. Bowness, *Henry Moore, sculpture and drawings* (1944–)

More, Jacob (*c.*1740–93) was the most distinguished NEOCLASSICAL Scottish LANDSCAPE painter of the 18c. Trained in the Norie

family firm of decorative painters in Edinburgh, his bent was for classicism and Vernet. In 1773 he went to Rome, where he settled for the rest of his life, though he continued to exhibit in Britain. *See also* OUTDOOR PAINTING.

EE

☐ D. Irwin in *Burl. Mag.*, CXIV (1972), 775ff; Irwin (1975)

Morland, George (1763–1804) was apprenticed to his father, **Henry Robert Morland** (*c*.1719–97), for 7 years from 1777 and became adept at copying and forging Dutch landscapes. His precocious talent was first manifested in small, sentimental genre subjects, exhibited at the SOCIETY OF ARTISTS and the ROYAL ACADEMY from the late 1770s. By the 1790s he was producing larger, more ambitious rustic scenes as well as coastal landscapes with smugglers, etc., which must owe something to de LOUTHERBOURG both in composition and in their rather saccharine tonality. Despite his considerable technical gifts his talent was frequently wasted producing endless versions of his most popular compositions to maintain his notoriously dissolute lifestyle. Nevertheless, it is some testament to his reputation that his works were consistently copied and faked. For H. R. Morland *see also* MERCIER.

BA

☐ D. Thomas, *George Morland* (exh., Arts Council, 1954); D. Winter (PhD, Stanford, 1978)

Moro, Antonio (*c*.1517–76/7), born Anthonis Mor van Dashorst in Utrecht, was one of the most accomplished portraitists of 16c. Europe

Morland, *Morning: Higglers preparing for Market*, 1791 (Tate).

and a masterly depictor of the Habsburg family. In 1554 he was sent to England to paint Mary Tudor, Philip II's wife: 3 principal versions survive of an arrestingly severe image of the seated Queen (Boston; Madrid; Castle Ashby, Northants.). He did not stay long, and a vivid portrait of another English sitter, Sir Henry Lee (1568; NPG), was probably painted when Lee visited the Low Countries.

SF

☐ H. Hymans, *Antonio Moro* (1910)

Morris, William (1834–96), though his main achievements are outside the scope of this volume, did briefly aspire to a career as a painter in the years 1856–9. In 1853 he went up to Oxford, where he became friendly with BURNE-JONES and got to know the PRE-RAPHAELITES. After leaving Oxford in 1855 he entered the office of the architect G. E. Street, and was also drawn into the circle of ROSSETTI, who persuaded him to abandon architecture for painting. He was involved in Rossetti's ill-fated mural scheme for the Oxford Union (1857); *La Belle Iseult* (1858; Tate), of his fiancée Jane Burden, is his only known easel painting. He finally gave up painting in 1859. In 1861 he founded the decorative arts firm which became Morris and Co., and for it he designed some ★STAINED GLASS as well as textiles and wallpapers. He also founded the Kelmscott Press (*see* WOOD-ENGRAVING).

DB

☐ J. W. Mackail, *Life of William Morris* (1899); R. Watkinson, *William Morris as designer* (1967)

Mortimer, John Hamilton (1740–79) was apprenticed *c*.1757 to HUDSON but in 1759 found a more interesting teacher in Robert Edge Pine (1730–88), a HISTORY painter of radical political views. After winning prizes for drawing at the SOCIETY OF ARTS he won the top prize for history painting in 1764 with his *St Paul preaching to the Britons* (High Wycombe, Guildhall). Lively and high-spirited, if not reckless, he became an important figure in the radical element in the SOCIETY OF ARTISTS, and stayed with that society after more established painters split off to form the ROYAL ACADEMY in 1768.

During his short career of some 20 years he painted portraits and CONVERSATION PIECES in the manner of ZOFFANY (e.g. *The Witts Family*, 1769; priv. coll.), but his major contributions were in the areas of British history painting, literary illustration, and especially after 1770 depictions of *banditti* and monstrous figures,

Mortimer, *Doctors dissecting*, pen drawing, 1770s (New Haven, Yale Medical Lib., Clements C. Fry Coll.).

inspired by the 17c. artists Salvator Rosa and Stefano della Bella but prefiguring a Romantic attitude to horror and bestiality.

His etchings of *Shakespearean Heads* (1775–6) and those dedicated to REYNOLDS (1778) demonstrate the inventiveness and skill of his mature draughtsmanship, together with his imaginative and original handling of subject-matter. He married in 1775 and settled down, but died only 4 years later. See also JONES, T.; STAINED GLASS: 16–18C. JS
□ B. Nicholson, *John Hamilton Mortimer* (exh., Eastbourne/London, Kenwood, 1968)

Morton, Alastair (1910–63), a patron of modern art and himself a painter, entered the family textile firm of Morton Sundour in 1931 and became artistic director of its subsidiary, Edinburgh Weavers. He began to paint in 1936, under the influence of his friend Ben NICHOLSON and of MONDRIAN, MOHOLY-NAGY and HEPWORTH. He patronized the CIRCLE group of artists, and in 1937 launched a range of 'Constructivist Fabrics'. AG
□ *Alastair Morton and Edinburgh Weavers* (exh., Edinburgh, Scottish NG Modern Art, 1978)

Moser, George Michael *see* ST MARTIN'S LANE ACADEMY

Moss, Marlow (1890–1958) moved in 1927 to Paris, where she was taught by Léger and Ozenfant. She became a Neo-Plastic artist, using orthogonals, primary colours and black on white grounds, under the influence of MONDRIAN, whom she met in 1929. In 1930 she developed the use of parallel lines and then made shallow reliefs with strips of cord, wood and canvas. In 1940 she escaped to England, and settled in Penzance. AG
□ *Marlow Moss* (exh., London, Gimpel Fils, 1975)

Muller, William James *see* BRISTOL SCHOOL; COX

Mulready, A. E. *see* CRANBROOK COLONY

Mulready, William (1786–1863) was an Irish-born genre painter of unusual technical accomplishment and lyrical power. In his early years he painted local views of remarkable vividness. Such works – the outcome of his association with the landscapists John VARLEY, LINNELL and William Henry HUNT – were not well received because of their extreme realism. After 1809 Mulready turned to rural and domestic scenes in which the influence of WILKIE is evident. In the 1820s he began to develop a more individual style, using a light palette over white ground (*see* PAINTING). His later pictures are also distinguished for their precision of draughtsmanship. Some, notably *The Sonnet* (1839; V&A), have a poetic intensity that looks forward to the PRE-RAPHAELITES. WV
□ F. G. Stephens, *Mulready* (1890); K. Heleniak, *Mulready* (1979)

Mulready, *The Sonnet*, exh. c.1839, painted for Sheepshanks (V&A).

Munnings, Sir Alfred *see* ROYAL ACADEMY: 20C.; SPORTING PAINTING

Munro, Alexander (1825–71) provided a style of PRE-RAPHAELITE sculpture different from WOOLNER's. In the orbit of ROSSETTI he executed works of dramatic and emotional intensity (e.g. *Paolo and Francesca*, 1852; Birmingham), while his portrait busts, statues and medallions maintain a distinctively purist refinement of form. BR
□ Read (1982)

Mytens, Daniel (*c*.1590–1647), a Dutch painter and pupil of Miereveld, is first recorded in London in 1618, when, described as ★ARUNDEL's painter, he produced the famous full-length portraits of the Earl and his wife (NPG, at Arundel Castle). Granted his first royal commission in 1620, he was appointed one of CHARLES I's 'picture drawers in ordinaire' in 1625. With his sensitive handling, subtle grey-green colour range, and greater movement, he dominated English portraiture with Cornelius JOHNSON until VAN DYCK's arrival in 1632. His reputation then declined, and by 1637 he had returned to The Hague, where he continued to act as Arundel's agent. DD
□ Whinney and Millar (1957)

N

Nash, John *see* LANDSCAPE: 20C.; WOOD-ENGRAVING

Nash, Paul (1889–1946) held a rare balance between European modernism and a strong attachment to nature. His closest relationship was with SURREALISM, and it was fruitful, if selective. His earliest works are symbolist and an intense, visionary character persists in his later ★LANDSCAPES.

Nash attended the SLADE, and began to exhibit in 1912 with support from FRY and ROTHENSTEIN. In 1917, after being invalided from the Front, he returned as an official war artist.

The 1920s and early 1930s were Nash's most experimental period. Semi-abstract works (e.g. *Lares*, 1929–30; priv. coll.) were adaptations of late decorative Cubism, based on specific motifs. Doubtful about pure abstraction, and about Surrealist automatism, Nash never abandoned nature, but sought 'a different angle of vision . . . This I am beginning to find through Symbolism and in the power of association.' A de Chirico exhibition in London (1928) suggested the dramatic possibilities of deep space, distorted perspective, and structured juxtapositions of planes and objects using frames or mirrors (e.g. *Harbour and Room*, 1932–6; E. James Foundation). *Landscape of the Megaliths* (1934–7; British Council) is his first painting of the prehistoric Avebury monoliths. Other works explore the personality of natural objects: driftwood, stones, flints, bones. He exhibited 'found natural objects' at the International Surrealist Exhibition (1936), and his photographs exploit the unexpected in nature. His attempt to form a group of contemporary English artists, UNIT ONE, in 1933, was short-lived. *See also* BURRA; WATER-COLOUR; WOOD-ENGRAVING. DA
□ *Paul Nash* (exh., Tate, 1975)

Nasmyth, Alexander (1758–1840) trained in Edinburgh as a decorative painter and with Alexander RUNCIMAN before going to London, where he was for a time an assistant to RAMSAY. In 1778 he set up in Edinburgh as a portrait painter specializing in open-air CONVERSATION PIECES. After travels in Italy 1782–4 he concentrated on landscape painting, achieving a blend of the classical tradition with the representation of actual Scottish landscapes to great poetic effect. His paintings almost always include buildings, frequently with strong historical associations (e.g. *Landscape with a Distant View of Stirling*, Edinburgh, NGS). He also worked as a stage designer and as a landscape and architectural consultant. He was important as a teacher, and his influence on the younger generation of landscape painters in Scotland was significant.

Among his numerous artistic children, **Patrick Nasmyth** (1787–1831) was the most gifted. With a style similar to his father's, he

Alexander **Nasmyth**, *Robert Burns, c.*1787 (Edinburgh, Scottish NPG). In the background is the Brig o' Doon.

moved to London in 1810 and became increasingly absorbed in the imitation of Dutch landscape, first Hobbema (*View in the New Forest near Lyndhurst*, 1815; Tate), then Ruisdael (*View of Leigh Woods*, 1830; Cambridge, Fitzwilliam). DM
□ Brydall (1889); Caw (1908); Irwin (1975); Hardie (1976)

Nebot, Balthazar *see* LANDSCAPE: 18C.

Neoclassicism (or Neo-Classicism) emerged as an international movement in the mid 18c., and a number of British artists influenced or were influenced by its reformist principles in Rome in the 1760s and 1770s. Gavin HAMILTON and Benjamin WEST and some other British painters made strenuous attempts to interest English aristocrats on the GRAND TOUR in large paintings of classical subjects in the grave and severe antique manner advocated by the German theorist Winckelmann, but with only limited success: Neoclassicism did not establish itself as a coherent style in England.

In reality the art of Hamilton and West was as much beholden to contemporary Roman painting and Poussin as to antique prototypes, and the static quality of this first phase of Neoclassicism appeared to other artists in Rome, like Alexander RUNCIMAN and FUSELI, to be inadequate to depict the primitive energy and emotionalism they found in Homer and also in Northern mythologies.

Classical subject-matter rarely found favour in England in the later 18c., and what remains of Neoclassicism in the work of such painters as BARRY and the sculptor FLAXMAN is a commitment to serious and even elemental subject-matter, an emphasis on the expressive potential of the naked human form, and the use of a clear outline or contour, all of which could readily be placed at the service of anti-classical ideals – as in the case of the visionary artist William BLAKE.

In recent years Neoclassicism has tended to be seen not as a self-contained movement, implicitly opposed to Romanticism in its essential rationalism, but rather as a forerunner or preliminary phase of 19c. Romanticism.
See also SCULPTURE: NEOCLASSICAL. DB
□ Irwin (1966); H. Honour, *Neo-Classicism* (1968)

Neo-Romanticism is the name often given to a type of landscape painting which flourished in the late 1930s and 1940s. It represents a conscious revival of early 19c. landscape, especially of the SHOREHAM group but also of TURNER, with elements derived from French painting of the 1930s. The dominant figures were undoubtedly SUTHERLAND and to a lesser degree PIPER, though the term was more specifically applied to artists who came to prominence in the 1940s like MINTON and Michael Ayrton (1921–75), whose anguished view of nature was quite alien to their early 19c. forebears. Other artists who also passed through an identifiably Neo-Romantic phase were John Craxton (b.1922), VAUGHAN and COLQUHOUN. Neo-Romanticism's provincialism was fostered by the isolation of wartime, and it fell rapidly out of fashion in the 1950s with the influence of 'painterly' painting from abroad. DB
□ *The Neo-Romantics: drawings and watercolours* (exh., London, Imperial War Mus., 1981–2); *The British Neo-Romantics* (exh., London, Fischer/Cardiff, 1983)

Nevinson, Christopher (1889–1946) studied at the SLADE and from 1912 in Paris. His early

work is based on urban motifs. Under Severini's influence the scenes took on the heightened tone and fractured structure of Futurist painting. In London he became a member of the Rebel Art Centre (*see* VORTICISM), though he did not join the Vorticists. After war service 1914–17 in the Red Cross and RAMC and a period as a war artist he returned to urban subjects. JB

□ O. Sitwell, *C. R. W. Nevinson* (1925); C. R. W. Nevinson, *Paint and prejudice* (1937)

New English Art Club was the title adopted by a society of artists founded in 1886 in reaction against the restrictive selection policies of the ROYAL ACADEMY. The original members were a coalition of 'progressive' RA exhibitors including Mark Fisher (1841–1923), CLAUSEN, SARGENT and Edward Stott (1859–1918) – all trained in Paris – of painters of the NEWLYN SCHOOL, and of the GLASGOW SCHOOL. By 1888 all these had drifted away, leaving control in the hands of a group some of whom were close to French Impressionism and others to WHISTLER. SICKERT and STEER were the most prominent of the 10 artists who put on the exhibition 'London Impressionists' in December 1889. Fred Brown (1851–1941), another founder member, after he was appointed Professor at the SLADE in 1892, turned the NEAC into a forum for some of his most promising pupils. In the 1890s other outstanding exhibitors were TONKS, Charles Conder (1868–1909) and ROTHENSTEIN (the last 2 recently back from Paris), and the painter-critics D. S. MacColl (1859–1948) and Roger FRY. After 1900 the NEAC was effectively controlled by Brown, Tonks and Steer; after *c.*1910 it lost its avant-garde initiative to the CAMDEN TOWN GROUP and London Group. *See also* CONSTABLE; LANDSCAPE: 20C.; PISSARRO.

BL

□ A. Thornton, *Fifty years of the New English Art Club* (1935)

New Generation Sculpture was the title of an exhibition at the Whitechapel Gall., London, in 1965 of the work of 9 young British sculptors, many of them associated with St Martin's School of Art where CARO was then teaching. They included Phillip KING, Tim Scott (b.1937) and William TUCKER, who used unconventional materials like plastics and sheet metal to make highly original abstract sculpture. The brightly painted surfaces and playful

spirit caused their works to be linked with the painting of contemporary abstract and POP artists like Bernard COHEN and Allen JONES. LC

□ L. Cooke in *British sculpture in the 20c.* (exh., London, Whitechapel, 1981)

Newlyn School An important force in British painting for 10 years from 1885, when Stanhope FORBES's *Fish Sale on a Cornish Beach* (1884; Plymouth) was shown at the ROYAL ACADEMY and established the Newlyners as the most prominent representatives of the new French influence, in opposition to the insularity of British painting. Although many of the artists were involved with the NEW ENGLISH ART CLUB, the RA remained the only suitable showplace for their ambitious exhibition pieces. It was the last occasion when the Academy kept pace with progressive British art.

Stanhope Forbes had come to the Cornish fishing village of Newlyn in 1884, 2 years after the first artists settled there: Walter Langley (1852–1922) and Edwin Harris (1855–1906), both from Birmingham. Harris, typically, had trained in Antwerp and painted at Pont Aven in Brittany; and, as Norman GARSTIN was to write, it was the 'friendship and *camaraderie* of the ateliers of Paris and Antwerp, a sympathy with each other's intentions, [and] a mild climate suitable for out-of-door work' that attracted them all to the Cornish coast.

The artists of Newlyn were, at first, passionate 'plein-airists', painting ordinary people in their own setting, in which the artist had to live in order to be fully familiar with his subject. The square brush technique initially

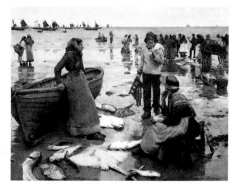

Newlyn School: Forbes, *Fish Sale on a Cornish Beach*, 1884 (Plymouth)

employed deliberately blurred outlines, emphasizing effects of light and atmosphere.

The Newlyn School included notably Frank BRAMLEY, H. S. TUKE, Alexander Chevalier Taylor (1857–1926), Fred Hall (1860–1948), Elizabeth FORBES and F. W. Bourdillon (1851–1924). FG
□ C. Fox and F. Greenacre, *Artists of the Newlyn School* (exh., Newlyn, Orion Gall./etc., 1979)

The New Sculpture flourished between the 1880s and *c*.1910. Its novelties included naturalistic modelling reflected accurately in lost-wax cast BRONZE; an increased spiritual and symbolist tendency in subject-matter, sometimes expressed in polychromatic materials (*see* SCULPTURE: VICTORIAN); and commitment to a new physical context for sculpture, as domestic statuettes and architectural decoration.

Works by the movement's protagonists – Alfred *GILBERT, George Frampton (1860–1928) and Hamo THORNYCROFT – demonstrate these features. Notable bronze statuettes are Gilbert's *Perseus Arming* (1882; V&A) and *Icarus* (1884; Cardiff); symbolism and polychromy are combined in Frampton's *Mysteriarch* (1892; Liverpool, Sudley: *see* *SCULPTURE: VICTORIAN) and *Lamia* (1900; RA); Thornycroft's *Mower* (1884: Liverpool, Walker) is a typical naturalistic bronze; and architectural sculpture is exemplified in Thornycroft's frieze on the Institute of Chartered Accountants in London (1889–93). *See also* LEIGHTON. BR
□ Read (1982); S. Beattie, *The New Sculpture* (1983)

Newton, Algernon (1880–1968) was dubbed 'the Regent's Canaletto' for his paintings of Camden Town and Paddington around the Regent's Canal. His still, unpeopled canvases owe less to contemporary Surrealism that to the meticulous study of old masters and to his conviction that 'a gasometer can make as beautiful a picture as a palace on the Grand Canal in Venice'. DR
□ *Algernon Newton* (exh., RA, 1980)

Nicholson, Ben (1894–1982) was the son of William NICHOLSON and Mabel Pryde. He studied at the SLADE 1910–11. After 1920 he painted in Cumberland and London, with winter visits to the Ticino in 1920–23, and made several trips to Paris, where he admired the work of Douanier Rousseau, Cézanne and the Cubists. In the mid-1920s he painted still-lifes, and also landscapes which often have naïve characteristics and evoke a strong sense of space and light by abstracted form and colour. He was friendly with HITCHENS, Paul NASH, and Christopher WOOD, with whom he discovered the work of Alfred WALLIS. He increasingly scraped and rubbed the surfaces of his own paintings, flattening and balancing the forms against each other, making his own simple box frames. In 1932 he visited the Paris studios of Brancusi, Arp and Braque with HEPWORTH, whom he later married. He was also impressed by the free forms and saturated colours of Miró and Calder. This period of exploration culminated in December 1933 in Paris with his first abstract relief of circles and rectangles carved into board. Early the next

Ben **Nicholson**, *White Relief,* oil on wood, 1935 (Tate).

year he began work on the *White Reliefs* series, in which a sense of purity is achieved by the use of light to reveal balanced basic shapes in subtly modulated planes. They are comparable in spirit to the work of MONDRIAN, whom he first visited in 1934, but they remain a major contribution to the Modern Movement. From 1932 he lived in Hampstead, where he was part of a large circle, including READ, Cecil Stephenson (1889–1965) and MOORE, which was extended by the arrival of outstanding émigrés like GABO, MOHOLY-NAGY, and Mondrian himself. At this time Nicholson produced a group of major paintings composed of balanced rectangles and circles of strong, unmodulated colour. Though drawn with a ruler and compass, they were not composed according to a mathematical system. In 1937 he was a co-editor of CIRCLE.

In 1939 he moved to Cornwall, first to Carbis Bay and then to ST IVES, where he lived 1943–57. In this period he returned to still-life and landscape but with no real distinction between figurative and non-figurative forms, and without the purity of his pre-war work. In 1950 he visited Tuscany and began a series of drawings inspired by Italian towns and landscape. In 1958 he went to live in the Ticino, and travelled in Italy, Greece and Brittany, making a large number of etchings, drawings and paintings in oil-wash of still-life and landscape. He also continued to make reliefs, often large, composed of slanting, interlocked planes of masonite with rubbed and scratched surfaces and subdued colours. In 1971 he returned to England. His last works were small in scale and irregular in shape, with intricate compositions of balanced curves inspired by familiar subjects. *See also* CONSTRUCTIVISM.

AG

□ *Ben Nicholson* (exh., Tate, 1969)

Nicholson, Sir William (1872–1949) made his name in 1893–5 in partnership with his brother-in-law, the Scottish artist James Pryde (1869–1941), as the Beggarstaff Brothers. They designed posters in a bold and simplified style reflecting Toulouse-Lautrec, in reaction against the elaboration of much Victorian graphic art. Nicholson then went on to design several series of woodcuts influenced by Japanese prints and English POPULAR ART for the publisher Heinemann, who had been impressed by his woodcut of Queen Victoria (1897); they include *The Alphabet* and *London Types* (both 1898). His

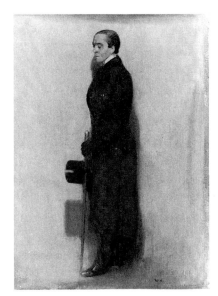

Sir William **Nicholson**, *Max Beerbohm*, 1905 (NPG).

later career was devoted to painting landscapes, still-lifes and portraits, of which *Max Beerbohm* (1905; NPG) is a fine example. Their colour is low-keyed, their design meticulous in balance, and their influence may be seen in the work of his son Ben NICHOLSON.

RG

□ Farr (1978)

Nicholson, Winifred *see* 7 AND 5 SOCIETY

Nicol, Erskine (1825–1904), a Scot, painted mostly comic genre scenes of Irish life. His peasants, usually grotesque stereotypes, won a wide public in Britain and, surprisingly, in France. A few pictures, like *The Emigrants* (1864; Tate), revealed some social concern and historical sense.

RT

□ Irwin (1975)

Nollekens, Joseph (1737–1823) was the first British sculptor to gain his reputation and fortune chiefly from making portraits. Among his vivacious and varied busts, those of Fox and Pitt were mass-produced in unprecedented quantities by his assistants. In Rome in the 1760s he had derived great benefit, and financial profit, from contact with ancient art (not only studying and copying it but also restoring, faking and dealing in it: *see* GRAND TOUR), and

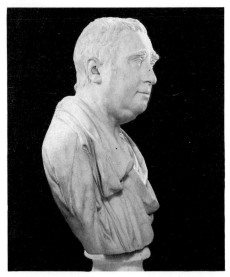

Nollekens, *Charles James Fox*, *c*.1802 (V&A).

this is obvious from the best works created on his return – the Minerva-like Britannia in the Three Captains monument (1784–93) in Westminster Abbey, London, and the Niobe-like Mrs Howard of *c*.1800–1803 in Wetheral church (Cumb.) – and in the gallery statues he made, of which the most remarkable is the very human seated goddess at Petworth, posthumously executed in marble from his plaster model. His poetic gifts are more obvious in the numerous freely handled TERRACOTTA groups he delighted in. They make one wonder what he might have achieved had he worked in France. *See also* BIRD. NP

(His father, the painter **Joseph Francis Nollekens** (1702–47), born in Antwerp, was a pupil of WATTEAU and among the earliest exponents of the ROCOCO style in England. – BA)
□ J. T. Smith, *Nollekens and his times* (1828); Gunnis (1953); Whinney (1964)

Northcote, James (1746–1831) was a pupil and assistant to REYNOLDS in 1771–5 and then spent 3 years in Rome (1777–80) before settling again in London in 1781. He exhibited a considerable number of portraits and FANCY PICTURES at the ROYAL ACADEMY between 1773 and 1828 but is perhaps best remembered for his paintings for the BOYDELL Gallery. He was an intelligent commentator on the artistic scene and many of his anecdotes and conversations (*see* e.g. MCARDELL) have been published. BA
□ S. Gwynne, *Memorials of an 18c. painter* (1898)

Northumbrian art *see* ANGLO-SAXON ART: EARLY

Norwich Retable (Norwich Cathedral; *see* *PANEL PAINTING) An ALTARPIECE painted *c*.1390 comprising 5 vertical divisions in which are depicted the Flagellation, Way of the Cross, Crucifixion, Resurrection and Ascension. The panel was rediscovered in the 19c., having been used as a table top, and its upper parts are lost. Armorials in the border include those of Henry Despencer, Bishop of Norwich 1370–1406, after whom the retable is sometimes erroneously named.

The drapery style consists of clinging folds on slight figures, and a shallow space is established in the architectural backgrounds. Both features look forward to later EAST ANGLIAN painting. There are compositional and stylistic similarities with the earlier of 2 sets of panels from St Michael-at-Plea, Norwich, which appear to date from *c*.1430 (*see* PANEL PAINTING), especially in the type of the head of St John in the Crucifixion. The Norwich Retable also has resemblances beyond the world of East Anglian painting. Similar high-eyebrowed expressions occur in the Lytlington Missal (London, Westminster Abbey), made in London in the 1380s. Iconographical links can be made with Bohemian painting in the type of the resurrected Christ. The crowded compositions, which push figures to the front of the picture plane, are close to English ALABASTER work of the late 14c. *See also* INTERNATIONAL GOTHIC. MM
□ P. Lasko and N. Morgan, eds., *Medieval art in East Anglia* (exh., Norwich, Castle Mus., 1973), no. 51

Norwich School The name given to a group of LANDSCAPE painters working in Norwich in the early 19c. who established a collective identity mainly through the Norwich Society of Artists. The central figures were John CROME and John Sell COTMAN, but Robert Dixon (1780–1815), Robert Ladbrooke (1769–1842) and John Thirtle (1777–1839) also made significant contributions. Of the second generation the most important were Crome's pupils John Berney Crome (1794–1842), James

Stark (1794–1859) and George Vincent (1796–1832), Cotman's sons Miles Edmund Cotman (1810–58) and John Joseph Cotman (1814–78), and Ladbrooke's pupil Joseph Stannard (1797–1830). Henry Bright (1810–73) and John Middleton (1827–56) were taught by the minor artists Alfred Stannard (Joseph's brother, 1806–89) and J. B. Ladbrooke (Robert's son, 1803–79). Several exceptional amateurs also worked in Norwich, notably Thomas Lound (1802–61) and E. T. Daniell (1804–42). Works from as late as the 1880s have been regarded as of the Norwich School, but no major artist was based in the city after 1833.

The Norwich Society was founded in 1803 as a club for artists and amateurs. It ran annual exhibitions (which seem to have been unprofit-able) from 1805 to 1825, and, after its re-formation in 1827 as the Norfolk and Suffolk Institution for the Promotion of the Fine Arts, from 1828 to 1833. After 1833 it was basically defunct, though advertisements for it con-tinued to appear until 1839. Later Norwich exhibition societies did not provide the same kind of focus. The Norwich Society was run mainly by the artists themselves, and it was partly a dispute over the role of amateurs within it which caused a group led by Robert Ladbrooke to secede and organize separate exhibitions 1816–18.

While the Norwich Society was the first provincial institution to maintain regular exhibitions, by 1830 more than 20 other towns had also held them, some larger and more remunerative. Schools too developed else-where, notably in BRISTOL, but no other city kept such major talents for so long. Provincial art was fostered by the growing leisured middle class, eager to establish its status through culture, and exemplified by Norwich patrons such as the Gurney and Dawson Turner families. They provided the artists' principal source of income by employing them to teach drawing to their daughters; and, making a hobby of antiquarianism and topography, they also commissioned and bought topographical drawings. Both teaching and topography encouraged artists to take up printmaking, and etchings of high quality were produced by Crome, Cotman and Daniell.

Norwich art has no unified style and attempts to reduce it to 2 traditions stemming from Crome and Cotman oversimplify the problem Inevitably there was interaction within the School, but outside influences need

John Sell Cotman, *Chirk Aqueduct*, watercolour, c.1804 (V&A).

John Crome, *Scene on the River at Norwich* (traditionally called *The Wensum at Thorpe: Boys Bathing*), c.1818 (Yale BAC)

more consideration. Norwich painting belongs to the more general movement to exploit the associations of English landscape and to dignify it through breadth of treatment. It was strongly influenced by the naturalistic trend in the years 1810–20, and the artists did much sketching OUTDOORS. Interest in Dutch painting is evident, but this reflects a wider tendency seen equally in WILKIE and CONSTABLE, and has frequently been exaggerated. In watercolour the School was in the mainstream of contemporary development. The influence of TURNER and the fashion for Continental subjects affected several painters after 1815.

The cohesion of the Norwich School depends partly on common subject-matter. Norwich art has an essentially urban vision, which comprehends the city's monuments, its commercial waterfronts and the rivers which served them, nearby holiday spots and the local seaside resorts of Cromer and Yarmouth. Rural scenes show more awareness of Dutch prototypes than of Norfolk's progressive agriculture. AH
□ T. Fawcett, *The rise of English provincial art* (1974); A. Hemingway, *The Norwich School of painters* (1979)

Norwich School of glass-painting The most distinctive of the regional schools of glaziers in 15c. England to have been identified. Its works can be seen throughout East Anglia, and although several different ateliers were involved, they conformed to the same basic stylistic canons, characterized by excellent drawing and colouring, and lively presentation of scenes, together with certain common decorative motifs, e.g. an 'ears of barley' pattern for grounds and borders composed of leaves wrapped around a vertical stem. The school begins to emerge c.1430, and from the large numbers of glaziers recorded in Norwich seems to have been centred there. Major monuments include St Peter Mancroft in Norwich and East Harling (Norf.). RM
□ C. Woodforde, *The Norwich School of glass painting in the 15c.* (1950)

Nost or **Van Ost, John** (d.1729) was a Flemish sculptor working in England from c.1678. Little is known of his early training, but he worked for GIBBONS and Arnold Quellin before setting up a successful practice which specialized in LEAD garden sculpture following Italian and Flemish models. The largest extant

group of these works, executed 1699–1705, is at Melbourne Hall (Derbys.), with other examples at Chatsworth and Hampton Court. His tomb sculpture was less important, rendered in a curiously stiff Baroque manner (e.g. the monument to the 3rd Earl of Bristol in Sherborne Abbey, Dor., 1698).

His nephew, **John Van Nost the Younger** (c.1712–80), worked with him and then after c.1749 made his career in Ireland. AY
□ Gunnis (1953); Whinney (1964)

oil painting was known in England in the Middle Ages in a simple form (there are traces of it on the walls of St Stephen's Chapel, Westminster, London). The complex oil painting technique of the Flemish, who in the 15c. had developed a workable, versatile medium from the previously intractable linseed oil, was first displayed in England in the early 16c. by HOLBEIN and his contemporaries. CH
□ Laurie (1967)

Old Water-Colour Society (or Society of Painters in Water-Colour) *see* ROYAL ACADEMY; WATERCOLOUR

Oliver, Isaac (c.1565–1617), MINIATURIST, was the son of a Huguenot goldsmith who moved to London in 1568. He trained under HILLIARD, whom he later influenced. His earliest known portrait is dated 1587, and he was established in his own practice by 1590. A trip to Venice in 1596 and contact with Italian art probably fortified an already keen interest in Mannerism. Unlike Hilliard, he drew many figure subjects (e.g. *The Entombment*, 1616; Angers).

Oliver's appointment as limner to Anne of Denmark placed him at the centre of a group of artists patronized by the court and Henry,

Isaac **Oliver**, *Henry, Prince of Wales*, *c.*1612 (Royal Coll.)

Prince of Wales. The frequently noted affinities between his polished mature style and that of his brother-in-law GHEERAERTS suggest a sensitivity to the growing concern of English portraiture with psychological rather than emblematic characterization. He was Hilliard's equal as a portraitist, and it was Oliver's style, propagated by his son **Peter** (*c.*1598–1647), that anticipated the important developments in 17c. miniature painting. PN
□ G. Reynolds, *Nicholas Hilliard and Isaac Oliver* (1947, rev. 1971)

Omega Workshops A co-operative work-shop-cum-showroom at 33 Fitzroy Square, London, run by Roger FRY 1913–19 for the production of painted furniture, textiles, artefacts and decorative commissions. Spontaneity, bright colour and abstract design were the keynotes. Associated artists included Vanessa BELL and GRANT (co-directors), WADSWORTH, LEWIS and ETCHELLS. RS
□ R. Shone, *Bloomsbury portraits* (1976); I. Anscombe, *Omega and after* (1981); J. Collins, *The Omega Workshops* (1984)

O'Neil, G. B. *see* CRANBROOK COLONY

O'Neill, Hugh *see* BRISTOL SCHOOL

Opie, John (1761–1807), Cornish portrait and HISTORY painter, was discovered and trained by Dr John Wolcot, the political satirist, who brought him to London in 1781. He was an instant success and exhibited at the ROYAL ACADEMY from 1782, becoming Professor of Painting in 1805. Apart from his numerous portraits, which display his gift for characterization, he also painted subject pictures (particularly Cornish peasant scenes) and histories for the BOYDELL Gallery. BA
□ A. Earland, *John Opie and his circle* (1911); M. Peter, *John Opie* (exh., Arts Council, 1962–3)

opus anglicanum is the medieval term used to denote English embroidery, which from the mid 13c. until the third quarter of the 14c. was unsurpassed in its sumptuousness, technical refinement and reputation. The finest products (and the only ones to survive) were ecclesiastical VESTMENTS. The prominence of papal patronage is therefore no surprise. Several great processional copes presented by popes to their native towns still survive, e.g. at Ascoli Piceno, St Bertrand-de-Comminges and Pienza. In 1246 Matthew PARIS described Pope Innocent IV's greed in terms of his gluttony for English orphreys, and incidently hints that the manufacture and trade in *opus anglicanum* was already controlled by London merchants. This is also supported by the evidence of payments to embroiderers from HENRY III's account books.

None of Henry's own commissions survives, although the Clare Chasuble (1272–94; V&A) can be associated with his nephew, Edmund of Cornwall. This blue silk mass vestment, now cut down from its original bell shape, has typical 13c. scroll work in silver and gold with historiated quatrefoil medallions down the spine. The metallic threads are applied in the characteristic medieval technique of underside couching, where the unsightly couching thread is hidden. Otherwise split stitch is most usual, especially for the faces, minutely worked in spirals.

Some embroideries of the 1260s and 1270s reflect painting styles found in manuscripts connected with the English court. The cope at Ascoli Piceno (Mus. Communale), probably made for Clement IV (1265–8) or Gregory X (1271–6), has roundels containing unique scenes of the lives of popes worked on a gold ground.

opus anglicanum: detail of the Pienza Cope, c.1325–50 (Pienza, Mus. Capitolare).

Its tall figures have draperies in the flat broad-fold style seen in the later parts of the Lambeth Apocalypse (London, Lambeth Pal. Lib.).

The Vatican Cope (Vatican Lib.) is an example of *opus anglicanum* c.1280–1300, when certain stylistic constants emerge. In particular the figures have large hands and feet and heads, and neatly arranged hair, often striped. The framework of this cope again consists of repeating medallions, but here they are 8-pointed stars identical to those on the WESTMINSTER RETABLE. The Cope of the Passion in St Bertrand-de-Comminges Cathedral, of before 1314, is especially notable for its early use of a gold ground worked into a damask-like pattern of quatrefoils and heraldic beasts. The lively narrative scenes are framed by compartments containing naturalistic birds and animals that recall the borders of contemporary EAST ANGLIAN manuscripts.

The Pienza Cope (Mus. Capitolare), of the second quarter of the 14c., shows in its complex narrative scenes elegantly posed figures with ample draperies and scrolling hems, which avoid the awkwardness but also the liveliness of earlier *opus anglicanum*. It is especially sumptuous: the scenes are separated by concentric ogee arcades formed from twisting stems (a motif unique to *opus anglicanum*), the patterned ground varies from scene to scene, and the embroidery was embellished with an unusual quantity of pearls. The elegantly decorative style is suggestive of the 'Madonna Master' of the De Lisle Psalter (BL) although the figures on the embroidery are squatter.

Sometimes in this period the ground consists of the rich yet contrasting surface of velvet, as in the slightly later Chichester-Constable Chasuble (New York, Met.), with its even more elegant, almost frivolous figures.

In complete contrast to these stylistic trends is the solemn monumentality of the impressive but problematic Bologna Cope (Mus. Civico). The solid figures recall the mood of the 13c. DOUCE APOCALYPSE, and despite a probable date c.1300 betray no Giottesque influence. However the Italianate style of East Anglian manuscripts c.1330–40, e.g. the St Omer Psalter (BL), is echoed by the Lateran Cope (Vatican, Pinacoteca). It has formal and iconographical connections with the Pienza Cope, but has distinctive sprightly bony figures set within arcades formed from stringy interlace. At the same time the ground pattern becomes reduced to a rectilinear lattice, a simplification which foreshadows the decline in the quality of English embroidery in the later 14c. ET

□ A. G. I. Christie, *English medieval embroidery* (1938); D. King, ed., *Opus anglicanum* (exh., Arts Council, 1963)

Orchardson, Sir William Quiller (1832–1910), a painter of genre and portraits admired by WHISTLER, SICKERT and Degas, was born in Edinburgh and studied at the Trustees' Academy under Robert Scott LAUDER, which decisively affected his style. He moved to London in 1862 and made his career there as a painter of historical genre. As Sickert observed, he was the last great heir to the WILKIE tradition in Scottish painting. He was also a great stylist. In such paintings as *The First Cloud* (1887; Tate and Melbourne) empty space is used to great effect, though the starting point is the interpretation of the subject (in this case, the beginnings of marital disaffection). His command of the psychology of style and of abstract design led in his late work to some dramatically original images, e.g. *The Borgia* (1902; Aberdeen), which depend on atmospheric unity achieved by a painterly execution which still reveals the influence of his teacher and links him

Orchardson, *The First Cloud*, 1887 (Tate).

unexpectedly to Scott Lauder's other great pupil, MCTAGGART.

Orchardson was also a very gifted portrait painter; *Mrs John Pettie* (1865; Manchester), painted as a wedding present for his closest friend, has a delicacy worthy of RAMSAY. DM
□ Caw (1908); H. Orchardson Gray, *Life of Sir William Quiller Orchardson* (1930); W. Hardie, *Sir William Quiller Orchardson* (exh., Scottish Arts Council, 1972); Irwin (1975); Hardie (1976)

Orpen, Sir William (1878–1931) promised brilliance as a student, rivalling Augustus JOHN at the SLADE. *The Mirror* (1900; Tate) demonstrates his technical facility, and the figures in *Hommage à Manet* (1907; Manchester) his power of characterization. Thereafter his work coarsened, despite prodigious energy expended on many types of painting. BL
□ Rothenstein, I (1952); B. Arnold, *Orpen, mirror to an age* (1981)

Ottley, William Young (1771–1836), like many AMATEURS, received his first lessons from local DRAWING MASTERS while at school. From 1787, he studied under John BROWN and at the ROYAL ACADEMY. Although later well known as a connoisseur of Italian drawings, his own style remained NEOCLASSICAL. KS
□ J. A. Gere in *BM Quarterly*, XVIII (1953), 44–53

outdoor painting has, chiefly through the prestige of CONSTABLE, come to be seen as the hallmark of the English approach to LAND-SCAPE; and yet, until the end of the 19c., it was the exception rather than the rule. As early as the 16c. a few artists like Leonardo and Dürer occasionally gathered landscape material by sketching out-of-doors, and by the middle of the following century this had become a fairly standard practice, especially in Rome. English artists working there in the 17c. and 18c., such as Richard Symonds (1617–92?), and Jonathan SKELTON and Thomas JONES (both of whom worked outside in oil and watercolour) took up the practice, which was partly prompted by the belief that Claude Lorrain had used this method; Constable, for example, thought that Claude's small *Landscape with Goatherd and Goats* (NG) was an outdoor painting. The outdoor works of these artists were sketches, but towards the end of the 18c. a number of landscape painters were coming to feel that it was only by completing substantial paintings in the open air that the truth of nature in her changing effects of light and atmosphere could be rendered. Views of Tivoli by WILSON (Dulwich and Dublin) include the artist himself apparently painting at an easel, and a *Self-portrait* by the Rome-based Scottish artist Jacob MORE (Florence, Uffizi) shows him working in oils on a large scale in a wood. The Anglo-Irish painter William Ashford (d.1824) seems to have adopted the practice at home, for in a *View of the Casino at Marino near Dublin* (before 1800?; Manchester, Whitworth) he presented himself working with a large easel and palette in the park.

Yet the work of none of these artists seems to us to bear the stamp of outdoor painting: for all of them the spontaneous notations of the sketch – analogous to the fleeting effects which they sought to render – and the more formal structures of the picture were never confused; and it was not until the early years of the 19c. that the qualities of sketch and picture began to merge. A group of London painters, including William Henry HUNT, LINNELL and TURNER, began to paint in oil along the Thames, and Turner specifically worked on large exhibition canvases in a boat moored at the water's side. It is impossible to deduce whether he completed these works on the spot, precisely because his methods of handling paint in the studio and outside had become so similar. A decade or so later Constable, who had been sketching out-of-doors in oils and watercolours since c.1802, also executed a number of exhibition works on the spot, including *Boat Building* (V&A), shown at the ROYAL ACADEMY in 1815. It is not a large picture, yet its handling betrays signs of labour,

and there are studio elements among the figures (*see* *LANDSCAPE PAINTING: 19C.).

Constable and the other painters mentioned above did not remain outdoor painters for very long. The problems they faced in manipulating oil paints in the open air cannot have encouraged the practice: one advantage that outdoor painters in the later 19c. enjoyed was the opportunity to squeeze substantial quantities of paint ready-mixed from tubes, which were introduced in the 1840s. But other problems were due to sheer manual incompetence in the face of fleeting natural effects. The Pre-Raphaelite Brotherhood showed a surprising liking for working on their paintings out-of-doors, but they confined themselves to small areas of the picture, which, quite inconsistently, they would paint in different locations. The struggles which Ford Madox BROWN encountered in completing even the tiny panel *Carrying Corn* (Tate) in September and October 1854, which he records so pathetically in his diary, indicate that the ideal of outdoor painting was not a very practicable one; and even the Impressionists, who made it a central tenet in the 1870s, could not maintain it consistently. As Renoir said, 'you always fudge it in the open air'.

See also NEWLYN SCHOOL; NORWICH SCHOOL.

JG

□ J. Gage, *A decade of British naturalism* (exh., Norwich/V&A, 1969); *Landscape c. 1750–1850* (1973); *Painting from nature* (exh., Cambridge, Fitzwilliam/RA 1981)

Ovenden, Graham *see* RURALISTS

P

painting: supports, grounds and pigments
Supports are the structures on which the image is painted. First wooden PANELS, then CANVASES, have been the commonest choice, but other materials have been tried, including tin and copper, which had their greatest popularity in the 18c. when sheet metal became cheap. From the mid 17c. the colourmen began to produce ready-to-use panels and canvases, and in the 19c. their catalogues included pasteboard supports known as mill board or academy board.

For 20c. paintings the support is often visually as well as structurally significant, and artists may use hardboard, building board, plastic, fibreglass, even aluminium, alongside traditional stretched fabric.

Grounds Some paints can be applied directly to the support, but normally a base layer is needed to create a flat, non-absorbent surface. The earliest grounds were invariably white and consisted of chalk bound in glue. Unlike the softwood PANELS of southern Europe, English oak panels needed only a very thin coating. In the 17c. these grounds were replaced by more flexible oil ones when CANVAS became more widely used than panel. Oil grounds could be thinly brushed on, and allowed more of the support texture to show through.

Grounds can perform a secondary function as background colour for the finished work. From *c.*1600 onwards many painters chose to use a dark ground, usually a warm brown, because working from a mid-tone was easier and encouraged a freer handling of the paint. In the 19c. interest in capturing the effects of natural light led to a return to a white base layer, with its greater luminosity (*see* PRE-RAPHAELITE BROTHERHOOD). In the 20c. the use of grounds or priming has often been abandoned.

Pigments In the Middle Ages and Renaissance English painters would have had access to the basic range of earth colours, to the mineral blues azurite and ultramarine, to green malachite, to red vermilion and lac, to yellow orpiment, etc. Many organic pigments would have been extracted and refined on a small scale by the painter himself, but some, such as woad and saffron, were grown in England for trade.

By the mid 17c. the emerging trade of colourmen took over much of the work formerly done in the artist's workshop, grinding pigments, preparing supports, making brushes, inks and drawing implements, and gradually introducing ranges of ready-mixed and packaged OIL and WATERCOLOUR paints. Concern in the 19c. over the permanence of certain pigments led to considerable improvements in quality and standardization, and to the marketing of new pigments, some based on the newly isolated elements chrome, cadmium,

zinc and cobalt, and others derived from the distillation of coal tar (an English development).

See also ACRYLIC; OUTDOOR PAINTING; TEMPERA. CH

□ Gettens and Stout (1966); Laurie (1967)

Palmer, Samuel (1805–81) was the most important of the SHOREHAM painters, though he long outlived his association with that Kentish village, which he left in the early 1830s. He has a unique place for his small sepia drawings, executed in London and Shoreham in the 1820s, which are characterized by a startling intensity. Pastoral landscape is infused with a Christian vision to create works which are, in the words he himself used to describe the wood-engravings of BLAKE, 'visions of little dells, and nooks, and corners of Paradise; models of the exquisitest pitch of intense poetry'.

His mind was, in his 20s at least, a rich mix of the Bible, Milton, Bunyan and mysticism, all of which emerge in his work as a fervent longing for the world of the Second Coming that could be glimpsed in nature but was only to be fully experienced in the 'Valley of Vision', existing in the human mind. Nature could be 'the gate into the world of vision', but the real subject of Palmer's art was a dream of Paradise.

Palmer began his career as a landscape painter as a prodigy, selling his first painting at the age of 14. His transformation as an artist came in the years 1822–4, when under the influence of LINNELL and Blake he developed the visionary and archaizing side of his imagination, by studying nature with intense

Palmer, *Early Morning*, sepia drawing, 1825 (Oxford, Ashmolean).

concentration and recording it in a hard linear manner derived from prints by Dürer and Lucas van Leyden. Like some of his contemporaries in Germany, he wanted to create religious paintings of a medieval type in which figures and landscape would play an equal part; only later in the 1820s do figures become subordinated to landscape. The high point of his early visionary style is the great series of varnished sepia drawings of 1825 (Oxford, Ashmolean), in which microscopic description coexists with deliberate archaism. Though in the years following the handling becomes broader, his subject-matter remained visionary, the one exception being a remarkable group of naturalistic drawings done at Linnell's behest in 1828.

In 1826 he had moved to Shoreham, but he became increasingly alarmed by the signs of rural discontent which culminated in the 'Captain Swing' riots. He was violently hostile to political and religious radicalism, producing in 1832 a political pamphlet in support of a local Tory candidate. His disillusionment with the real countryside undoubtedly contributed to a slackening of visionary intensity in his work and was responsible for his gradual withdrawal from Shoreham in the early 1830s.

The final break came with his visit to Wales in 1835, followed by marriage to Hannah, the daughter of Linnell, in 1837 and their subsequent 2-year honeymoon in Italy. The result was a complete transformation of his style. He became an outstanding exponent of the classical pastoral, especially in his watercolours of Milton's *L'Allegro* and *Il Penseroso* (commissioned 1864; Amsterdam, Rijksmus.; etc.) and his late etchings, though nothing in his later career has the almost adolescent intensity of his Shoreham years.

Palmer's early work was largely forgotten in the 19c. and it was only in this century that he was rediscovered. He was thought of initially as a follower of Blake, but this is an exaggeration of the older artist's influence. See also SUTHERLAND; WATERCOLOUR. DB

□ G. Grigson, *Palmer* (1947); D. B. Brown, *Samuel Palmer* (exh., London, Hazlitt, Gooden & Fox, 1982)

panel was a popular choice of painting support in England well into the 17c. Because of the abundant supply of suitable hardwood for panels, English painters, unlike those in southern Europe, did not have strong motives

for changing to canvas when it became clear in the 16c. that oil paint worked very well on a fabric support. CH

□ Gettens and Stout (1966)

panel painting (medieval) Surviving English examples date from the 13c. or later. They include painted ceilings, all heavily restored (e.g. Peterborough, c.1220); ALTARPIECES; sedilia; wooden chests; tomb testers; and a large number of mutilated rood screens.

The WESTMINSTER RETABLE (c.1280), made in London, displays many features characteristic of later English altarpieces, notably a long, narrow horizontal format with vertical subdivisions, and an oil-based painting technique (used on a gesso or white lead ground) which allows the artist to experiment with modelling. The illusionistic use of imitation enamel, glass and jewels to create the effect of goldwork, seen on its frame, appears also on Edward I's Coronation Chair, the sedilia, and other monumental painting at Westminster.

The Westminster sedilia panels display the more severe head types and heavier poses of English painting in the late 1320s. Related to them are 2 important retables, now at Thornham Parva in Suffolk (c.1330) and the Musée de Cluny in Paris (c.1330–40), both with the long narrow format of the Westminster Retable and with raised stamped diaperwork in the backgrounds. The Thornham Parva Retable has a central Crucifixion flanked by standing saints, whose head types combine the square-profile chins seen in the Westminster sedilia with the oval shape favoured by the 'Madonna Master' of the De Lisle Psalter (BL). The Paris retable illustrates the Life of the Virgin, in a more developed and elongated figure style.

An alternative tradition is represented by 2 painted wooden chests of the late 13c.–early 14c. The earlier one, at Newport (Essex), probably served a dual purpose, as repository for vestments and church plate and as portable altar, for the inside of its lid is painted with the

Detail of the Westminster Retable, c.1280 (Westminster Abbey).

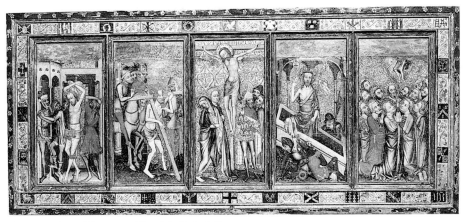

The Norwich Retable, c.1390 (Norwich Cathedral).

Crucifixion and saints; it is roughly contemporary with the Westminster Retable, but is related stylistically to a group of manuscripts centering on a Book of Hours in the BL (MS Harl. 928). The second chest, presented to Winchester Cathedral in 1328, is also painted directly onto wood without a ground; its figures have the flat unmodelled drapery seen in the Walter of Milemete Treatise (1327; BL and Oxford, Christ Church).

It is clear from the St Stephen's Chapel paintings (see WALL-PAINTING) that the experiments with illusionism seen earlier at Westminster were developed into extremely daring compositions and spatial effects, but no major panel painting of c.1340–60 survives. A panel at Forthampton Court (Glos.) belongs to the period after c.1360, resembling as it does some of the BOHUN FAMILY manuscripts of c.1360–90 and the Ramsey Psalter (Holkham Hall); it seems never to have been part of an altarpiece, and is most unusual in depicting Edward the Confessor and the Pilgrim. More securely dated is the tester of the tomb of the Black Prince (d.1376) at Canterbury; the head of St Matthew has the rounded shape and modelled eyes and lips seen in the Italianate Last Judgment wall-painting in the Westminster Chapter House.

A major panel of c.1390 is the NORWICH RETABLE. It has iconographic links with Bohemian painting, but stylistically is related both to a pair of panels of c.1400 from St Michael-at-Plea, Norwich (now in the Cathedral) and to manuscripts produced in London. A panel at Battel Hall (Kent) of c.1400, which shows the soft modelling and counterbalanced drapery of Bohemian painting, depicts the Virgin and Child with saints standing on a grassy flowered ground in the same picture space, which was still unusual at the time. The only surviving English triptych was also made c.1400, perhaps for the D'Estouteville family (London, Courtauld)

The portrait of RICHARD II at Westminster and the *WILTON DIPTYCH have both been associated with the 'Italianate tradition' of Westminster painting; iconographically, however, they are closer to the work of André Beauneveu (e.g. Psalter of Jean de Berry: Paris, BN, MS fr. 13019). Like the tester above the tomb of Richard and his Queen at Westminster, they reflect the new INTERNATIONAL GOTHIC style which developed in England c.1380–1400.

From the period c.1400–1430 several panels survive which may have originated in East Anglia. They include a set in Cambridge (Fitzwilliam) depicting miracles of Christ which are particularly interesting, as they seem originally to have formed a continuous narrative – something hitherto unseen in English panel painting. In addition to the pair already mentioned, there is another set of panels from St Michael-at-Plea in Norwich Cathedral, which include a Crucifixion and standing saints; they show an awareness of new techniques for opening out interior space,

hinted at in the Norwich Retable, and a hard angular drapery and figure style pointing to a date *c*.1430.

As well as these fragments from altarpieces, many 15c. and early 16c. painted *SCREENS still exist, particularly in East Anglia and Devon. Typically, they show standing Apostles and locally venerated saints; the paintings are often integrated with the carved screens, at times looking like sculpture in niches. Stylistically, many later 15c. East Anglian screens have head and figure types close to Flemish illumination of the later 15c., and it is clear that foreign painters may sometimes have been involved. MM
□ Rickert (1965)

Matthew **Paris**, the martyrdom of St Alban, from the Life of St Alban, *c*.1240 (Dublin, Trinity College).

Paolozzi, Eduardo (b.1924), born in Scotland, is well known as a printmaker and sculptor. His work as a whole is infused by his interest in popular culture (*see* POP ART) and modern technology. In the early 1950s he made figurative sculpture with a robot-like totemic quality, such as *Jason* (1956; New York,

Paolozzi, *The City of the Circle and the Square*, 1963, in the workshop, before the painting of its bronze surface with acrylic (now Tate).

MoMA), by pressing numerous small objects into wax sheets and then casting the imprinted surfaces. They tended to be pathetic rather than heroic symbols, and this ambivalence towards the modern world continued into the 1960s in works which were now usually abstract in form. These sculptures were constructed from industrial components which Paolozzi ordered from a factory and then had assembled by technicians. Thus he played down the subjective role of the artist, and sculpture became for him a process that was akin to his printmaking (*see* SCREENPRINTING) in its reliance on skilled workmen and pre-formed elements or constituents. LC
□ D. Kirkpatrick, *Eduardo Paolozzi* (1970)

Paris, Matthew (d.1259) was a Benedictine monk of ST ALBANS who was chronicler of the abbey and illustrator of his own chronicles. He became a monk there in 1217/18, and took up the office of chronicler in 1236. His chief work, the *Chronica Maiora* (Cambridge, Corpus Christi College, MSS 26, 16; BL, MS Roy. 14.C.VII), is illustrated by lively marginal tinted DRAWINGS almost all by Matthew himself, continuing a tradition established in the Anglo-Saxon period. He also illustrated a Life of St Alban (Dublin, Trinity College, MS E.I.40), other volumes of chronicles (BL), and a book on astrology and fortune-telling (Oxford, Bodleian, MS Ashmole 304). His work shows a great interest in vivid narrative and a liking for the anecdotal in his choice of subjects for illustration.

As a monk artist, Matthew Paris was exceptional in a period when the majority of artists were laymen. His well documented life

contrasts with the negligible information on the many other artists of his time, and this has led to an overemphasis on his influence and to the false conception of him as the head of a School of St Albans.

See also OPUS ANGLICANUM. NM
□ R. Vaughan, *Matthew Paris* (1958, repr. 1979); Morgan (1982); S. Lewis, *The art of Matthew Paris in the Chronica Maiora* (1984)

Park, Stuart *see* GLASGOW SCHOOL

Parker, Richard *see* SCULPTURE: 16C.

Pars, William (1742–82) established himself as a portrait painter in London, but was commissioned by the Society of Dilettanti to accompany an expedition to Asia Minor and Greece in 1764. His work there, including many watercolour views and a set of drawings of the Parthenon marbles, was published in the influential *Ionian Antiquities* (1769 and 1797) and *Antiquities of Athens* (II, 1789). Equally innovative were the watercolours of Alpine scenes made for Lord Palmerston in 1770. He also worked for Horace Walpole at Strawberry Hill. In 1775 he departed with a Dilettanti subsidy for Rome, where he died of pleurisy.

 AW
□ T. Jones, 'Memoirs', *Walpole Soc.*, XXXII (1946–8); A. Wilton in R. Chandler, *Travels in Asia Minor*, ed. E. Clay (1971); A. Wilton, *William Pars Journey through the Alps* (1979)

Partridge, John *see* ROYAL ACADEMY: 19C.

Pasmore, Victor (b.1908) painted only in his spare time 1927–37. In 1938–9 he taught at the EUSTON ROAD SCHOOL. In the 1940s he painted scenes of the Thames and of London parks, and then in 1948, influenced by Paul Klee and the theories of harmonious proportion propounded by J. Hambidge, J. W. Power and M. Ghyka, he converted to abstract paintings and collages. In 1950–51 he made paintings and a tile mural composed of spirals and hatched lines; these were followed, under the influence of Charles Biederman, by orthogonal reliefs constructed from synthetic materials. He went on to explore architectural space in environmental exhibitions and in the design of part of Peterlee New Town, Co. Durham (1955–77). From *c*.1957 he used large, flowing areas of paint in reliefs, and, after his move to Malta in 1966, he abandoned deep relief

Pasmore, *Linear Motif in Black and White*, mixed media, 1960–61 (Tate).

construction for paintings and prints with forms undergoing metamorphosis. *See also* CONSTRUCTIVISM. AG
□ *Victor Pasmore* (exh., Arts Council, 1980); A. Bowness and L. Lambertini, eds., *Victor Pasmore oeuvre cat.* (1980)

pastel crayons are sticks of pigment weakly bound by a gum. The soft friable medium we recognize today first appeared in the 18c. for use in pastel 'painting'. In England, unlike France, pastel has never been fully exploited, though it was popular in the 18c. for modest portraits, especially by Daniel GARDNER. CH
□ J. Watrous, *The craft of old master drawing* (1975)

Patch, Thomas *see* CARICATURE

Paterson, James *see* GLASGOW SCHOOL

Paton, Sir Joseph Noel (1821–1901) was a Scottish painter closely associated with the PRE-RAPHAELITES, through his friendship with MILLAIS, whom he met at the ROYAL ACADEMY Schools in 1842–3. *The Reconciliation of Oberon and Titania* (1847; Edinburgh, NGS) and his contemporary illustrations to Shelley and Coleridge show that he initially modelled himself on David SCOTT. In the 1850s he produced a number of works in the Pre-

Raphaelite idiom, notably *The Bludie Tryst* (Glasgow). His later work is sententious and melodramatic (*Dawn: Luther at Erfurt*, 1861; Edinburgh, NGS).　　　　　　　　　DM
☐ Caw (1908); Irwin (1975); Hardie (1976)

Peake, Robert, the Elder (fl.1576–1626?) was a successful and prolific associate of John de Critz, Isaac Oliver and Marcus Gheeraerts the Younger and produced starched costume pieces characteristic of early Jacobean portraiture (*see* PORTRAIT PAINTING: 17C.). Appointed Serjeant-Painter with de Critz in 1607 and described as painter to Prince Henry in 1610, he was later considered outdated and was overshadowed by the new wave of Dutch painters at court. DD
☐ Strong (1969); Waterhouse (1978)

Pearson, James *see* STAINED GLASS: 16–18C.

Peckitt, William *see* STAINED GLASS: 16–18C.

Pellegrini, Giantonio (1675–1741), a pupil of Sebastiano RICCI, was the first major Venetian DECORATIVE painter to arrive in England. He came in 1708 under the aegis of the Earl of Manchester to work at Kimbolton, where he painted perhaps the mostly lively of all the decorative schemes to be found in England. His lightness and felicity can also be seen at Narford. His stay in England was regrettably brief: he left for Düsseldorf in 1713, returning to England only for a short visit in 1718/19.　　　　　　　　　　　　DB
☐ Croft-Murray, II (1970)

Penny, Edward (1714–91) painted portraits, HISTORY and domestic figure subjects with a moral content often associated with Greuze. He studied under HUDSON and went to Rome, where he was taught by Benefial. The ROYAL ACADEMY's first Professor of Painting (1769–83), he specialized in such subjects as *The Virtuous Comforted* and *The Profligate Punished* (both 1774; Yale BAC). He also painted contemporary history such as *The Death of Wolfe* (1746; Oxford, Ashmolean).　　　JS
☐ Waterhouse (1981)

Penrose, Sir Roland (1900–1984), painter and writer, was one of the most vigorous advocates of contemporary art in England. A close friend of Picasso and Ernst, he helped to introduce SURREALISM in 1936, and to organize

the ICA in 1947. As well as painting, he made collages and objects.　　　　　　　　　DA
☐ R. Penrose, *Scrap Book* (1981)

Peploe, S. J. *see* SCOTTISH COLOURISTS

Pepysian Sketchbook (Cambridge, Magdalene College, Pepysian Lib.) A rare survival of a late 14c. artists' model-book. Most of the sketches, which are by several hands, date from the 1380s or 1390s, but there are signs that the book was used until c.1475. To judge by the variety of subjects, it served an atelier responsible for manuscript illumination, panel and wall-painting, and possibly also metal-work, embroidery and stained glass. Several designs appear to be of French origin; the coloured sketches of birds have been linked with John SIFERWAS.　　　　　　　　　NR
☐ M. R. James in *Walpole Soc.*, XIII (1924–5), 1–17; R. W. Scheller, *A survey of medieval model books* (1963), 112–19; W. B. Yapp in *Proc. Dorset Nat. Hist. and Archaeol. Soc.*, 104 (1982), 5–15

Performance art (also known as 'live' or 'time-based' work) came to the fore in Britain

Page from the **Pepysian Sketchbook** (Cambridge, Magdalene College, Pepysian Lib.).

Performance art: Stuart Brisley's *And for Today – Nothing*, at Gallery House, London, 1972.

in the 1970s when CONCEPTUAL ART had begun to challenge the validity of the art object and its claim to permanent value. It was created by a younger generation of artists who sought a more positive relationship with the audience. These artists had been the first generation of art students to be able to work creatively in art schools with video, film and sound. The 'happenings' of the 1950s and 1960s had been marked by a sense of theatricality; Performance art, on the other hand, derived from a fine-art aesthetic and the desire to work 'live' and in real time. The artist him- or herself, the spatial context of the performance, the control of light, electronically produced imagery and sound, and the tension of a live event all became elements in the work.

Because Performance art was not primarily concerned with the production of objects, it could not readily fit within the commercial gallery structure. Artists therefore tended to work within the more sympathetic environment of newly established art centres and public galleries prepared to accommodate experimental work. Performance events largely depended on public funding from the Arts Council and regional art associations, but in the late 1970s a lack of financial support began to affect the number of performances taking place. In the 1980s Performance art is more integrated into the general fabric of creative activity and as such is seen much less as a separate category of art practice.

It is independent of stylistic and ideological groupings and has become an important option within the wider vocabulary of contemporary art.

See BRISLEY; GILBERT AND GEORGE; LATHAM; MCLEAN. WF
□ *Studio International* (July–Aug. 1976); W. Furlong, *Performance art or is it?* (exh., Arts Council of N. Ireland, 1978); R. L. Goldberg, *Performance: live art 1909 to the present* (1979)

Peters, The Rev. Matthew William (1741/2–1814), trained in Dublin and under HUDSON, is best known for softly pornographic pictures of young women, painted in the late 1770s in a style dependent on Rubens and the Venetians. He also painted portraits, subject and genre pictures, some religious works (after his ordination in 1781), and 5 pictures for BOYDELL's Shakespeare Gallery (1786–90). JS
□ Waterhouse (1981)

Pettie, John *see* LAUDER; ORCHARDSON; SCOTTISH PAINTING

Philip, John Birnie (1824–75) *see* ALBERT MEMORIAL

Phillip, John (1817–67) painted scenes of Spanish life and history characterized by full-blown colour, intricate composition, dramatic lighting and an essentially Victorian understanding of Velázquez and Murillo. In the CLIQUE from his ROYAL ACADEMY student days, he imitated his fellow-Scot WILKIE until a convalescence in Spain in 1851 led to royal patronage and fame as 'Spanish' Phillip. RT
□ Irwin (1975)

Phillips, Peter *see* POP ART

Phillips, Thomas *see* PORTRAIT PAINTING: 19C.

Phillips, Tom (b.1937) after study in London at Camberwell emerged in the mid 1960s as a painter like KITAJ and TILSON for whom words and imagery were of central importance. Since *A Little Art History* (1965; priv. coll.) his work has been essentially concerned with creating

Tom **Phillips**: *Benches*, acrylic, 1970–71 (Tate).

unity out of a wide diversity of ideas derived from observation, reading and reflection, what he has called 'the collage in the head'. There has been persistent concern with chance procedures and the detritus of ordinary living, and the unifying possibilities of musical and literary structures. His most important single painting to date has been *Benches* (1970–71; Tate), in which postcards are used to express the idea of the park bench as an emblem of mortality. The painting reflects a close study of Dante, which culminated in a grand illustrated edition of the *Divine Comedy* (1983) for which the artist made his own translation. Since 1966 he has extensively used texts derived from a Victorian novel, W. H. Mallock's *A Human Document*, making a treated book, *A Humument* (1971–6), and many by-products, including an opera, *Irma* (1973). DB
□ T. Phillips, *Works texts to 1974* (1975)

Pictish art flourished in the east and north of Scotland during the last 2 centuries before Pictish independence gave way to Scottish rule in the mid 9c. Especially in its later phases, it is closely related to Anglo-Saxon and Irish art.

Although very little is known about the Picts themselves, their carved stones are among the most eloquent works of Dark Age art. Pictish sculpture can be divided into 2 classes, both of which bear now enigmatic 'Pictish symbols'. In the earlier Class I the carving is incised and often includes vigorous and lifelike depictions of animals, which resemble and perhaps influenced the drawing of Evangelist symbols

in the 7c. Book of Durrow (Dublin, Trinity College) and some other Insular books. Class II monuments are carefully shaped and are carved in relief, a technique probably learnt from Northumbrian craftsmen in the early 8c. Many are 'cross-slabs', large slabs with a cross in relief on one side. Christian and apparently secular subject-matter is combined with rich 'Hiberno-Saxon' decoration (*see* ANGLO-SAXON ART: EARLY). The prominent bosses on some later Class II stones are related to and are possibly the source of those on stone CROSSES on Iona and in southern Ireland.

Some fine metalwork, most importantly the St Ninian's Isle Treasure (Edinburgh, Nat. Mus. Antiquities of Scotland), also survives. JH
□ I. Henderson, *The Picts* (1967)

A Class I **Pictish** monument: slab incised with a bull from Burghhead (Morayshire), 7c.? (BM).

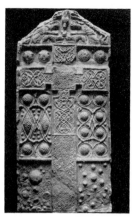

A Class II **Pictish** monument: cross-slab in Nigg churchyard (Ross and Cromarty), late 8c.-early 9c.

Picturesque A term covering a set of ideas about, and attitudes to, actual landscape, landscape painting and landscape gardening, current c.1770–1820. (The word has also been used since, with varying degrees of precision.) It was not a coherent aesthetic theory, but it was endlessly discussed, first by William GILPIN and later by Uvedale PRICE and Payne KNIGHT. Gilpin wrote in 1768 that the Picturesque was 'expressive of that peculiar kind of beauty, which is agreeable in a picture': landscape was seen through art, in particular that of 17c. landscape painters like Claude, Poussin, Salvator Rosa and the Dutch.

Price refined and expanded Gilpin's definition to make the Picturesque a middle term between the SUBLIME and the Beautiful as defined by BURKE. Picturesque scenes were those which were neither savage and awe-inspiring nor mild and serene, but rough and irregular, full of variety and interesting texture. These qualities were often manifested in woodland scenes with sandy tracks, peopled by peasants or gipsies, as in the landscapes and genre pictures of GAINSBOROUGH, MORLAND and WHEATLEY. Medieval ruins and irregular architecture, popular for topographical and antiquarian reasons, were also considered Picturesque.

The Picturesque Tour in search of landscape in Britain became increasingly popular from c.1770, fuelled by an expanding literature of guide books, often illustrated, with Gilpin as the most important author. It encouraged topographical and landscape painting, especially in watercolour, and the appreciation of British landscape. JS
□ Hussey (1927, 2nd ed. 1967); Hipple (1957); E. Moir, *The discovery of Britain* (1964); P. Bicknell, *Beauty, horror and immensity: Picturesque landscape in Britain 1750–1850* (exh., Cambridge, Fitzwilliam, 1981)

pigments see PAINTING

Pinwell, George see WOOD-ENGRAVING

Piper, John (b.1903) joined the 7 AND 5 SOCIETY in 1934. Together with his wife Myfanwy Evans he contributed regularly to AXIS 1935–7. His long association as a printmaker with the Curwen Press dates from the same years. Towards the end of the decade, Piper began to revise his commitment to abstract art. An official war artist 1940–42, he depicted the effects of bombing upon Britain's cities. In images such as *All Saints' Chapel, Bath* (1942; Tate) his talents as an architectural draughtsman are fully realized. They have continued to play an important part in his subsequent activity as painter, printmaker, book illustrator and stage-designer.
See also NEO-ROMANTICISM; *STAINED GLASS: 19–20C.; WATERCOLOUR. DR
□ *John Piper* (exh., Tate, 1983)

Pissarro, Lucien (1863–1944), painter, was the eldest son of Camille Pissarro, trained by his father, and influenced by Seurat. In 1890 he

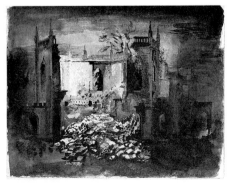

Piper, *All Saints Chapel, Bath*, wash drawing, 1942 (Tate).

emigrated to England intending to make his career as an illustrator, and set up his Eragny Press in Epping (*see* WOOD-ENGRAVING). Befriended by SICKERT and STEER, he exhibited paintings at the NEW ENGLISH ART CLUB from 1904, joined the Fitzroy Street Group in 1907, and was a founder member of the CAMDEN TOWN GROUP. BL
□ W. S. Meadmore, *Lucien Pissarro* (1962); Baron (1979)

Place, Francis (1647–1728) worked mainly in York as an antiquary, amateur topographical draughtsman and etcher, and made frequent sketching tours to Wales, Ireland and the Low Countries. He was one of the first native artists interested in LANDSCAPE drawing as an art form and was influenced initially by the linear style of HOLLAR, with whom he may have studied. His later works are softened by tonal watercolour washes and bistre shading. He also worked in crayons, experimented in pottery manufacture and was an early MEZZOTINT engraver. DD
□ Croft-Murray (1960); Harris (1979)

Plackman, Carl *see* SCULPTURE: 20C.

plaster was used by sculptors as a medium for preliminary models, particularly in the 19c., but was employed primarily for casts after sculpture in other materials. The marble original would be coated with a separating agent and a mosaic of plaster built around it; these plaster 'piece moulds' would then be removed and reassembled and liquid plaster poured into them.

Plaster casts after celebrated antique sculptures were occasionally collected in the 17c.,

Place, detail of a drawing of Chester Castle, 1699 (V&A).

notably by Charles I (*see* SCULPTURE: 17C.); in the 18c. they became more widespread, both in artists' studios and as decoration for country house interiors. They assumed added importance with the development of NEOCLASSICISM, when drawing after casts became an essential part of any artist's training. During the 19c. the repertoire was extended to include casts of medieval and Renaissance sculpture and architectural decoration.

See also RYSBRACK; SCHEEMAKERS. MB
□ F. Haskell and N. Penny, *Taste and the antique* (1981); M. Baker, *The Cast Courts (V&A)* (1982); id. in *V&A Album*, I (1982)

Plumier, Denis (1688–1721) was an Antwerp sculptor who came to London *c.*1720 and was briefly, before his early death, associated with DELVAUX and SCHEEMAKERS. EL
□ Gunnis (1953); Whinney (1964)

Pocock, Nicholas (1740–1821) was a Bristol sea captain who took up MARINE painting and, after moving to London, established a flourishing practice specializing in sea battles. He was also a skilful painter in watercolour of picturesque landscapes. DC
□ D. Cordingly in *Old Water-Colour Society's Club*, LIV (1979); F. Greenacre, *Marine artists of Bristol* (1982)

polyautograph The name given to the first LITHOGRAPHS published in England, the *Specimens of Polyautography* issued in 1803 by Philipp André and in 1806–7 by G. J. Vollweiler. They included prints by WEST, FUSELI, STOTHARD and BARRY. RG
□ Twyman (1970)

Poole, Paul Falconer *see* BRISTOL SCHOOL

Pop art in England was essentially the creation of individual artists and their friends, though it was supported by a theory that society contains a number of subcultures, defined by vocabulary, dress style, and so on, of equal value to the mandarin culture of 'High Art' and requiring comparable skill from both creator and consumer. The term 'Pop art' was originally meant to refer to the films, advertisements, etc., produced for the large subcultures not interested in 'High Art'.

Pop art as a kind of fine art itself developed in several distinct phases that have still not coalesced. The prologue was the 'social realism'

of John Bratby (b.1928), Jack Smith (b.1928), and later KOSSOFF and others, supported by the Marxist critic John Berger. The first phase was dominated by Richard *HAMILTON and PAOLOZZI at the ICA, whose interest in modern popular culture, called 'Pop art' by Lawrence ALLOWAY, led them to include it directly, or by allusion, in their own work. The next phase belongs to Peter *BLAKE, who used popular imagery, postcards, packaging, etc., with little regard for theory. Roughly contemporary with him at the ROYAL COLLEGE OF ART were a group of students including Richard SMITH and Robyn DENNY, who were concerned with the mass media but developed towards abstraction.

The next and decisive phase, also at the Royal College, was influenced partly by Blake, but also by KITAJ. Artists included HOCKNEY, Allen JONES, Peter Phillips (b.1939), and Derek Boshier (b.1937). Their work, exhibited at the 'Young Contemporaries' exhibitions in the years 1960–63, led to Pop art becoming a household phrase.

The popular media in turn established Pop art and especially Hockney and Blake as stars of the 'swinging '60s'. Most of the artists, despite such attention, have maintained the quality of their work and have continued to develop consistently since then – partly because, apart from their delight in ephemera and the imagery of the mass media, they have little in common. MC
□ *Pop art in England* (exh., British Council, 1976)

Pope, Nicholas (b.1949) uses a wide range of stones and woods in his sculptures, which are abstract but metaphorical in spirit. His relationship to tradition is ironic rather than nostalgic, and he will pick up an electric saw to carve a piece as readily as a chisel. His forms, which tend to be simple and organic, are often placed directly on the ground or stacked into configurations. *See also* FLANAGAN. LC
□ *Nicholas Pope* (exh., Venice Biennale, 1980); L. Cooke in *Artmonthly*, no. 53 (Feb. 1982), 14, 15

popular art cannot always be separated from 'High' or 'Polite' art; nonetheless a great many prints in the form of broadsheets or illustrated pamphlets were sold on the streets rather than in bookshops or print shops from the 16c. to the end of the 19c., and to a degree they represent an alternative tradition. They have been little

Popular art: *The Tree of Life*, a woodcut issued by W. S. Fortey who *c*.1840 had bought the Catnach Press, with its much older blocks.

studied and survive fitfully, but their prevalence was often commented on and their decline lamented from the early 19c. onwards.

The tendency of most popular prints appears to have been moralizing, though there are also traditions of reportage, ballad illustration and humorous bawdy. In the 16c. and 17c. a great many anti-papal satires were produced, often deriving from German and Dutch prototypes. One clear development that can be observed in the 18c. is the separation of political satire (in the form of the CARICATURE print) from popular culture, though popular imagery is often referred to in the satires of GILLRAY and others.

The type of popular print which seems to have had the longest life was the moralizing 'Scripture Print', known also as 'Penny Godlinesses' (Pepys) and 'Hieroglyphicks'; these often preserve early image types such as 'The Ages of Man', reprinted in ever cruder versions to the end of the 19c. In the 18c. topical

woodcuts of battles and heroic deeds seem to have become more popular, and it is possible to identify the major centres of production, like Aldermary Churchyard in the City of London and later Seven Dials in Covent Garden. The 2 main publishers in Seven Dials, Pitts and Catnach, had acquired an enormous number of earlier woodblocks which they continued to print and adapt, also bringing out sensational prints describing recent hangings and murders. By the early 19c. the popular print market had become a picturesque feature of London life, and though many of the firms survived until the end of the century they gradually gave way before new printing technology and the rise of the modern newspaper.

The vigour and directness of popular imagery have in all periods made an impact on British art, and HOGARTH even attempted popular prints of his own design. Traces of 'Hieroglyphick' images can also be found in BLAKE, John MARTIN and Samuel COLMAN, and as the genre declined artists of the late 19c. like William NICHOLSON attempted to revive its unaffected directness. DB

□ L. Shepherd, *John Pitts* (1969); R. Paulson, *Popular and polite art in the age of Hogarth and Fielding* (1979); T. Gretton, *Murders and moralities: English catchpenny prints, 1800–1860* (1980)

portrait painting *From 16c. England* almost all the paintings that survive are portraits, though other types of subject-matter, religious and secular, were almost certainly more prevalent until the second half of the century. Very few portraits are known from before HOLBEIN's first visit in 1526, and those who wanted portraits of themselves rather than of the King probably had to go abroad. Holbein's work dominated the period until *c.*1550; his vivid and masterly depictions were not easily imitated, and his status as a foreigner prevented the establishment of a studio, though he influenced the Fitzwilliam Master and John BETTES.

After Holbein's death in 1543, more foreign portraitists came to England: Gerlach FLICKE from Germany, and from the Low Countries Guillim SCROTS, Hans *EWORTH and Antonio MORO. It is not, however, the sophisticated and monumental style of Habsburg court portraiture, exemplified in the work of Moro and reflected in that of Scrots, that is seen in English portraits from the mid-century, but a more stylized, decorative manner, and more reticent characterization. This is typified in the work of native painters like George Gower (d.1596) and William Segar (d.1633 – who was also, significantly, a heraldic painter), of the Netherlandish immigrant Marcus GHEERAERTS, and of the so far unidentified and probably provincial artist known as the Warwick Master. In a group portrait of Lord Cobham and his family (1567; Longleat), attributed to the latter, the sitters' stiff isolation and precarious relation to the background space is relieved by the charm of the still-life before them and the tame animals with which the children play. The painting contrasts markedly with Holbein's relaxed, naturalistic group of Sir Thomas More and his family painted 40 years earlier (*see* HOLBEIN).

The most splendid expression of the Elizabethan style is found in the portraits of ELIZABETH herself, the most delicate and expressive in the portrait *MINIATURES of Nicholas *HILLIARD. Though this formalized manner of painting is in some measure due to England's isolation from Continental influence during the Queen's reign, the emphasis on costume rather than facial individuality is also seen in some contemporary European portraiture.

Full-length portraits were relatively rare until the end of the century, when the format

Holbein, *Sir Thomas More*, 1527 (New York, Frick).

Gheeraerts, *Ditchley Portrait of Queen Elizabeth I,* c.1592 (NPG).

was popularized by Gheeraerts and others. Holbein's full-lengths were mostly confined to foreign sitters and royalty. More typical was the less expensive half-length format of Gower's portraits of Sir Thomas and Lady Kytson (1573; Tate). Such images often emphasized coats of arms and underlined the status of the sitter by dress and accessories. Sometimes 16c. portraits reveal a preoccupation with the sitter's progress towards death (e.g. Eworth). Family pride was also an important factor: collections of family portraits were built up (or manufactured) to hang in long galleries beside other series like Protestant reformers or the monarchs of England. The LUMLEY INVENTORY provides the outstanding record of such a collection. These portraits were not usually of high quality, however, and the painters who produced them can rarely be identified today. *See also* OLIVER. SF
□ Strong (1969); Waterhouse (1978)

Portraiture in the 17c., despite the resistance of the Painter-Stainers Company, was largely dom-inated by foreign artists, and in particular by *VAN DYCK.

Early portraits, such as those produced during the reign of James I by Marcus GHEERAERTS, John de Critz (c.1552–1642) and the English-born Robert PEAKE and William Larkin, show sitters at full length, placed formally (often awkwardly) in a Turkish-carpeted interior, which, like the subjects' elaborate and richly decorative costumes, emphasizes social status and wealth rather than individual character.

These rigid conventions were gradually replaced by a greater naturalism, in the work of Daniel MYTENS (*see* *ARUNDEL), Paul van Somer (c.1576–c.1622) and Cornelius JOHNSON, but it was the arrival of Van Dyck in 1632 that brought about the greatest transformation of English portraiture. Although at his death in 1641 he left no apparent successor to continue his elegant style of courtly flamboyance, many elements of Van Dyck's portraiture are echoed in subsequent artists' work. The postures and sculptural and landscape backdrops can be followed through the Civil War and Commonwealth portraits of William DOBSON and Robert Walker (fl.1641–58), and the Restoration works of *LELY and KNELLER, to the portraits of GAINSBOROUGH and REYNOLDS in the 18c. The careers of Dobson and John RILEY (and the miniatures of Samuel COOPER and John Hoskins: *see* *MINIATURE PAINTING) prove the existence of successful native talent, but many of their contemporaries, e.g. Gilbert Jackson (fl.1622–40), Edward Bower (d.1666/7) and

Dobson, *Portrait of the Artist* [*centre*] *with Nicholas Lanier* [?] *and Sir Charles Cotterell,* 1646? (The Duke of Northumberland).

Richard Greenbury (fl.1622/3–51), exhibit a derivative and provincial style.

The second half of the century saw the consolidation of the studio's role in portrait production and the development of the 'series' portrait. This latter genre, initiated by Lely's *Beauties* and adopted with equal success by Kneller, was encouraged by many livery companies in the City of London and by Oxford colleges. Their portrait collections underline the gradual shift away from royal and aristocratic patrons towards City merchants and institutions. At the same time, the line engravings of William FAITHORNE and the invention of the MEZZOTINT ensured a wider appreciation and awareness of different artists' work.

See also BACON, N.; BARLOW; ★BEALE; CANVAS; CLOSTERMAN; CROMWELL; FULLER; GRANGES; GREENHILL; HUYSMANS; JAMESONE (★SCOTTISH PAINTING); OLIVER; WISSING; ★WRIGHT, J.M. DD
□ Whinney and Millar (1957); Strong (1969); Waterhouse (1978)

The 18c. was the great age of British portraiture, though it began unpromisingly. By 1700 British portrait painting was in a state of torpor: dominated by ★KNELLER, Principal Painter to the King, and his chief rival, the Swede Michael Dahl (*c.*1659–1743), its conventions had been standardized to suit the taste of the age. Kneller was largely responsible for the polite Augustan mask which denied the quest for individual character or likeness. Indeed, as RICHARDSON noted in his *Theory of Painting* (1715), likeness was simply not enough: the portrait painter's aims should be 'to raise the Character: To divest an Unbred Person of his Rusticity, and give him something at least of a Gentleman. To make one of a moderate Share of good Sense appear to have a Competency, a Wise Man to be more Wise, and a Brave Man to be more so . . . is absolutely necessary to a good Face-Painter.'

The instant success of VAN LOO on his arrival from Paris in 1737 resulted not only from the prevailing French fashion but also from his ability to capture a more distinct likeness than his native rivals. The exception is ★HOGARTH, whose success as a portrait painter in the 1740s was partly inspired by the French challenge. His achievement lay in a fresh, direct and solid appreciation of the sociability of his sitters, who were often middle-class. Only ★HIGHMORE could occasionally match Hogarth's vein of

Hudson, *George Frederick Handel*, 1756 (NPG).

informality. Informality is also the most distinguishing characteristic of the CONVERSATION PIECE – portraiture in a social context – which became increasingly popular from the 1720s.

In the mid-century fashionable portraiture was dominated by the prolific HUDSON, and by ★RAMSAY, who both employed the services of VAN AKEN for their drapery painting. Ramsay, with his Italian training, could at his most accomplished rival the best in Europe, and until the young REYNOLDS returned from Italy in 1753 his supremacy was unchallenged. Despite his technical shortcomings, Reynolds was the most original and creative portrait painter of the century. In attempting to elevate portraiture from the mundane level of 'face painting' to the more esteemed academic genre of HISTORY, Reynolds used his breadth of learning and knowledge of the old masters to achieve that almost inexhaustible variety of pose that occasioned GAINSBOROUGH's envious outburst, 'Damn him, how various he is!'

Reynolds, *Three Ladies adorning a Term of Hymen* (*The Montgomery Sisters*), 1773 (Tate).

Gainsborough and Reynolds, the supreme portrait painters of the later 18c., could hardly be more different. Unlike Reynolds (who used assistants) Gainsborough revelled in painting sumptuous draperies and shimmering reflections on rich surface textures with a delicacy and ease of handling rarely found in the work of his fellow countrymen. His mature style of the 1760s and 1770s owes much to VAN DYCK.

*ROMNEY, who in the late 1770s seriously challenged his elder rivals, seems to have modelled his style on the casual nonchalance of BATONI, whose works he saw in Rome in 1773–5. After the death of Gainsborough and Reynolds the vacuum was filled by BEECHEY and HOPPNER until the dazzling and vivacious talent of *LAWRENCE eclipsed his rivals in the last years of the century.

See also ALEXANDER; *BEARE; CANVAS; CLOSTERMAN; COPLEY; COSWAY; COTES; *DEVIS; GARDNER; *HAMILTON, GAWEN; HAMILTON, W.; HAYMAN; HOARE; JERVAS; *NASMYTH, A.; OPIE; PARS; PASTEL; PENNY; PETERS; RAEBURN; WHEATLEY. BA

□ D. Piper, *The English face* (1957); Waterhouse (1978 and 1981)

In the 19c. the tradition of formal portraiture which had reached such heights with Reynolds failed to sustain itself, and LAWRENCE's successors rarely matched his brilliance. Artists like Thomas Phillips (1770–1845), Sir George Hayter (1792–1871) and Sir Francis Grant (1803–78) who specialized in grand manner portraits settled into professional competence, and the most memorable portraits of the century were almost all by artists who did not specialize in the genre. A PRE-RAPHAELITE approach could be applied successfully to portraiture (*see* *LEATHART), LANDSEER could turn from animal to royal portraits with effect, and there are remarkable character studies by

Watts, *Alfred, Lord Tennyson, c.*1863–4 (NPG).

such artists as Alfred STEVENS (*Mrs Collmann,* 1857; Tate), LEIGHTON (*Richard Burton, c.*1872–5; NPG), and TISSOT (*Captain Frederick Burnaby,* 1870; NPG).

The one artist in the second half of the century who could perhaps bridge the gap between the private and public portrait was G. F. WATTS, who succeeded better than anyone else in capturing the intellectual qualities of his sitters. He rarely made formal portraits: the moving rendering of Cardinal Manning in old age (1882; NPG) is an exception. A Titianesque manner for political portraits was attempted by MILLAIS, but these are too respectful to be really impressive. In the end it was left to SARGENT to breathe life back into the grand portrait, and he dominated the genre almost totally by the end of the century. With Sargent there arose again an almost complete hiatus between the professional portraitist and painters of the NEW ENGLISH ART CLUB like SICKERT who strove to avoid artifice.

See also BEECHEY; FILDES; GEDDES; HERKOMER; HOPPNER; HUNT, WILLIAM HENRY; JACKSON; LONG; *RAEBURN; SANDYS. DB
□ Boase (1959); *Early Victorian portraits* (cat., NPG, 1974)

In the 2oc., when the individual has not always been valued, and when portraiture has been threatened by abstraction as much as by the photograph, the genre has remained surprisingly central to British painting. The flamboyant Augustus *JOHN created one persistent popular archetype; his sister Gwen *JOHN exemplifies a more reticent tradition, both documentary and tentative, which survives in *COLDSTREAM and the EUSTON ROAD SCHOOL. SICKERT, making brilliant use of press photographs (*George V and his Racing Manager,* 1927–30; H.M. The Queen Mother), bypasses any psychological questioning; Stanley SPENCER, in his extraordinary nude self-portraits, confronts us with it; while in BACON the portrait is revealed as, in his own words, the 'most important' issue of the present, because the individual may be all we can hold in a shifting world. This existential view is affirmed in *FREUD's tiny hallucinatory head of Bacon (1952; Tate), as in AUERBACH's many images of 'E.O.W.'. A sense of the personality as too powerful to tackle directly ('like staring at the sun') underlies the oblique portraits of Howard HODGKIN. *HOCKNEY has revived the possibility of neo-classical delineation, and of drawing in general. *See also* ANDREWS; FILDES; GRANT, D.; MCEVOY; *NICHOLSON, W. TH

Sargent, *The Wertheimer Sisters (Ena and Betty, Daughters of Asher and Mrs Wertheimer),* 1901 (Tate).

Auerbach, *Head of Helen Gillespie I*, 1964 (priv. coll.).

Power, Robert was a glass-painter of Burton-on-Trent who in 1482 glazed several nave windows in Tattershall church (Lincs.). One panel and several fragments of the Holy Cross window survive. RM
□ R. Marks in *Archaeologia*, CVI (1979), 139–40, 145–6, 149

Poynter, Sir Edward John (1836–1919), consummate late Victorian artist-administrator, trained in Rome, where he found a lifelong reverence for Michelangelo and friendship with LEIGHTON, and spent 3 years in Gleyre's Paris studio (immortalized in Du Maurier's *Trilby*). He showed at the ROYAL ACADEMY from 1861 and joined the Dalziels' stable of illustrators. From his first major success, *Israel in Egypt* (exh., RA 1867; London, Guildhall), to the huge *Visit of the Queen of Sheba to King Solomon* (1890; Sydney), he remained devoted to subjects from ancient history with heroically drawn figures and monumental architectural effects. His admiration for French academic art training made him controversial as first SLADE Professor (1871–5), Director for Art at the South Kensington Museum, and Principal of the National Art Training School (1875–81). As Director of the NG 1894–1904 he supervised

the opening of the Tate. *See also* GROSVENOR GALLERY. RT
□ Treble (1978)

Pre-Raphaelite Brotherhood A society formed in 1848, largely by ROYAL ACADEMY students, whose stated intention was to break with academic art and return to the moral and descriptive truthfulness which they felt had flourished in art before the High Renaissance. The principal members were *ROSSETTI, Holman *HUNT and *MILLAIS; with them were the sculptor *WOOLNER, the painter COLLINSON, and the critics F. G. Stephens and Rossetti's brother William.

The idea of emulating the values of medieval art was not new. The German Nazarenes had been formed with a similar intention some 30 years previously and had affected DYCE and MACLISE. The Pre-Raphaelites went further, however, in their individualized detail and avoidance of stereotyped figures and compositions. They were encouraged by RUSKIN who, in the first 2 volumes of *Modern Painters* (1843–6), had associated such qualities with Quattrocento art.

The Brotherhood in fact knew little of early Italian art beyond what they had seen in engravings. Their actual technique owed more to early Flemish art – particularly Van Eyck – which they could have studied in the NG. To emulate the glowing colours and fine detail they evolved a new method of applying delicate touches of colour over a brilliant white ground, the upper layer of which was still wet. The 'wet white' technique was notoriously difficult and laborious, and was abandoned by all but Hunt after a few years. However it was critical in stimulating a new naturalistic vision, particularly when used for direct painting in the open air (*see* OUTDOOR PAINTING).

Most members of the Brotherhood were deeply concerned with the narrative side of their art. Apart from traditional sources like Shakespeare and the Bible they frequently drew from recent poetry, notably Keats and Tennyson. They applied much original thought to their subjects, and this made them excellent illustrators, as in the Moxon edition of *Tennyson* (1857).

The first Pre-Raphaelite pictures – inscribed 'P.R.B.' – were unfavourably received. Millais' *Christ in the House of his Parents* (exh. 1850; Tate) provoked particular hostility, perhaps because its unidealized treatment of the Holy

Family seemed sacrilegious. After Ruskin had defended them in *The Times* in 1851, however, their fortunes improved. As they became more successful they drifted apart, particularly after 1853 when Millais was elected ARA. 'Pre-Raphaelitism', however, remained a potent force in British art for many years. At first the more realistic side of the movement predominated; largely inspired by Hunt and Millais, this led to a new vivid style of LAND-SCAPE painting and more probing exploration of contemporary themes. Later the mystical medievalism of Rossetti became more influential, particularly in the hands of his followers *BURNE-JONES and MORRIS. Other artists associated with or influenced by the Pre-Raphaelites include BOWLER; BRETT; COLLINS, C. A.; DEVERELL; EGG; *HUGHES; INCHBOLD; LEWIS, J. F.; MARTINEAU; MUNRO; SCOTT, W. B.; SEDDON; SIDDAL; WALLIS, H. *See also* *LEATHART; WATERCOLOUR. WV
□ Hunt (1905); W. E. Fredeman, *Pre-Raphaelitism* (1965); T. Hilton, *The Pre-Raphaelites* (1970); *The Pre-Raphaelites* (exh., Tate, 1984)

Price family of glaziers *see* STAINED GLASS: 16–18C.

Price, Sir Uvedale (1747–1829), a country gentleman and near neighbour of Payne KNIGHT, developed the most ambitious theory of the PICTURESQUE, seeing it as a middle term between the SUBLIME and the Beautiful. He expressed his ideas in a number of publications, notably *Essays on the Picturesque* (1794). JS
□ Hussey (1927, 2nd ed. 1967)

Pringle, John Quinton (1864–1925) was an amateur, influenced by his contemporaries among the GLASGOW SCHOOL, but he was an independent and original painter. He developed a curiously Pointillist style, apparently derived from the patterned brushwork of James Guthrie (1859–1930) and others. DM
□ Hardie (1976); *J. Q. Pringle* (exh., Scottish Arts Council, 1981)

printmaking The early history of English prints is undistinguished. From the 1480s numerous woodcuts were used in books, but they are of low quality (*see* POPULAR ART). Line ENGRAVING was introduced in the mid 16c., mainly for portraits and emblematic titlepages, but for nearly 100 years the best engravers were

immigrants from the Netherlands. The practice of ETCHING was established by *HOLLAR in 1636, and his example encouraged such artists as *BARLOW and PLACE. The MEZZOTINT was introduced to England by Prince Rupert in 1662; it soon became a national speciality, and the first major British contribution to European print history. Largely used for the reproduction of portraits, it was a vital adjunct to that tradition, especially in the age of *REYNOLDS.

The 18c. is the age of the reproductive print, at its most elevated form in line engravings and mezzotints. However, new methods were introduced to imitate more closely techniques of painting or drawing. Colour printing had its pioneers, notably J. C. Le Blon (1667–1741), who approximated to the chromatic range of paintings by printing the 3 primary colours from separate mezzotint plates. They were a commercial failure, as were the sophisticated attempts by J. B. Jackson (*c*.1700–*c*.1770) in 1744 to reproduce paintings and drawings by overprinting colours from several wooden blocks. Attempts to make facsimiles of drawings were a constant preoccupation, and the 'crayon manner' introduced from France in 1764 had this purpose. It was soon developed into STIPPLE ENGRAVING which could reproduce the full tonal effects of painting. AQUATINT was introduced to England in 1771; taken up with enthusiasm by artists such as Paul *SANDBY, GAINSBOROUGH and BARRY, it soon became a handmaiden to the WATERCOLOUR tradition, used to produce countless books of views. Eventually it was supplanted by LITHOGRAPHY, introduced to England in 1801 and established in the 1820s, which became the dominant 19c. technique (*see* e.g. *CARICATURE). At the end of the 18c. book illustration was given new impetus by *BEWICK through his perfection of WOOD-ENGRAVING. His effects have harmony and simplicity as their keynotes, but in the 19c., particularly the 1860s, wood-engraving became complex and sophisticated (*see* e.g. *FILDES).

The technical refinements of the 19c. are endless. One of major significance was the development in the 1820s of the steel plate, which was much harder than copper and allowed the production of many more impressions. However, the mass production and mechanical nature of steel engraving led to a reaction in the 1850s and 1860s by artists such as WHISTLER, who in their etchings made a fetish

of free line and spontaneity (*see* *ETCHING REVIVAL). From this period dates the custom of artists signing their prints in pencil and producing only limited editions.

The legacy of Whistler continued into the 20c., but the large and flourishing market for original etchings collapsed in the 1930s, and from then until the early 1960s vital print-making was the exception rather than the rule. The one truly 20c. technique is the SCREEN-PRINT, which had a great vogue in the 1960s and 1970s. Adapted to resemble current painting modes, it is also suited to printing large colourful images for framing, a major requirement of the modern print. RG
□ Godfrey (1978); Griffiths (1980)

printselling in the 19c. was the principal means by which an artist's work reached a wider audience, and because of the importance attached to artistic education, the role of the print in the diffusion of taste attained a special significance. Three parties were involved in the process: artist, engraver and dealer. Artists like WILKIE, LANDSEER, MILLAIS and FRITH derived part of their fame and a considerable income from selling the copyright of paintings to a

Printselling: William MacDuff's *Shaftesbury, or Lost and Found*, of 1862 (priv. coll.), shows the window of the printseller Graves. Among the pictures, in addition to a portrait of the philanthropist Shaftesbury, is Millais' *The Order of Release*.

dealer (e.g. GAMBART or GRAVES). The dealer commissioned an engraver (sometimes specified by the artist) to provide a print 'in his best manner' after the work, paying him in stages as the engraving was completed. The dealer arranged the publicity and sales, sometimes touring the country with the original picture, together with prospectuses and a subscription book in which to record advance orders for the print. The whole enterprise was often extremely lucrative for artist, engraver and dealer, although each party grumbled at the profits made by the others. Contrary to high-minded ideals of mass artistic education, the trade was essentially middle-class, with prices artificially protected by limited editions long after it became technically possible to produce an unrestricted flow of prints from the same plate. CF
□ J. Maas, *Gambart* (1975)

Prout, Samuel (1783–1852) was essentially self-taught as a WATERCOLOURIST. In 1801 he was engaged as a draughtsman for John Britton's *Beauties of England and Wales*. After several tours of southern England, he settled in London in 1808, where he published numerous drawing manuals. He exhibited regularly at the Old Water-Colour Society after 1819, the year of the first of his many excursions to the Continent. During the 1820s he was well known to both BONINGTON and BOYS. Most of his later watercolours depicted Continental architecture and many were engraved. Prout's cursive pen-and-ink technique, derived ultimately from CANALETTO and calculated to maximize picturesque architectural effects, was esteemed by RUSKIN. PN
□ Hardie, III (1968)

Prudde, John (d. by 20 Nov. 1473) was one of the most important glass-painters of the 15c. Between 1440 and 1461 he was King's Glazier and during this period he glazed windows in several royal palaces and foundations. He also undertook other commissions, of which the most important (and the only one which survives) was the glazing of the Beauchamp Chapel, Warwick, begun in 1447. In its greater range and quantity of coloured glass than had hitherto been seen in 15c. England, and its use on an unprecedented scale of coloured glass inserts to represent jewels, the Beauchamp Chapel was very influential on other wealthy

Pryde

patrons and fellow glaziers (*see* ★STAINED GLASS:
TO 1550). *See also* LONDON SCHOOL OF GLASS-
PAINTING. RM
☐ H. Chitty in *Notes & Queries*, 12th ser. (1917),
419–21

Pryde, James *see* HERKOMER; NICHOLSON, W.

Psalter illustration In the Middle Ages the
Book of Psalms was used for devotional
reading as well as for the extensive psalmody
which formed an important part of the daily
offices of the church as found in the Breviary.
Those Psalter texts which have rich illustration
often have additional sections of prayers and
were mostly intended for private devotion
rather than for use in church.

The earliest richly illuminated Psalters are
found in the 8c.; the Vespasian Psalter (BL) has
a full-page miniature of David, the author of
the Psalms, with musicians. In this manuscript
we see the beginnings of a system of decoration
in which ornamental or figure initials are placed
at the start of those Psalms which mark the
divisions of the Psalter in the liturgy.

In the later ANGLO-SAXON period of the
10–11c. a Carolingian Psalter, the Utrecht
Psalter (Utrecht, University Lib.), in which a
DRAWING was placed at the head of each Psalm,
was brought to England and came into the
possession of the Cathedral Priory at Canter-
bury. Each drawing combines into a single
complex composition literal illustrations of the
diverse images alluded to in the particular
Psalm. It was copied at Canterbury 3 times: first
*c.*1000 (BL, MS Harley 603), then in the mid 12c.
(the Eadwine Psalter; Cambridge, Trinity
College), and finally at the end of the 12c.
(Paris, BN, MS lat. 8846). For the first 2, *see*
★CANTERBURY SCHOOL; the last version aban-
doned the drawing technique and transformed
the pictures into fully painted and gilded
illuminations.

An Anglo-Saxon Psalter of *c.*1060 (BL, MS
Cotton Tib. C. VI) places framed drawings
before the text and is the prototype for a 12c.
form of Psalter illustration, in which a series of
full-page miniatures of Old and New Testa-
ment scenes appear at the beginning of the
Psalter text as a sort of picture-book section.
Their purpose was primarily devotional, but
they must also have served a didactic purpose to
illustrate Biblical stories. The earliest painted
example, the ST ALBANS PSALTER (*see* ★ILLUMI-
NATED MANUSCRIPTS: ROMANESQUE), was made

The Marriage at Cana, from the **Queen Mary
Psalter**, early 14c. (BL).

*c.*1120–30 for a hermitess, Christina of Mark-
yate. In the later 12c., 13c. and 14c. these
luxury Psalters were one of the most important
types of book on which illuminators lavished
their art (e.g. the ★QUEEN MARY PSALTER).

In the late 13c. and 14c. border bars
surrounding the text are inhabited by narrative
figure scenes and fantasies involving hybrid
creatures and animals. These GROTESQUES form
a major part of the decoration (e.g. in the
Gorleston and Ormesby Psalters; *see* ★EAST
ANGLIAN ILLUMINATION), framing a religious
text with wholly secular and often irreverent
imagery. In the late 14c. and 15c. the Psalter
text is often combined with a BOOK OF HOURS,
and increasingly more attention is paid to the
decoration of that section of the manuscript.
NM
☐ Rickert (1965); Kauffmann (1975); Temple
(1976); Alexander (1978); Marks and Morgan
(1981); Morgan (1982)

Pugin, A. C. *see* ★ACKERMANN

Pye, John *see* ROYAL ACADEMY: 19C.

Pyne, James Baker *see* BRISTOL SCHOOL

Q

Queen Mary Psalter (BL) An early 14c. manuscript containing the largest surviving English cycle of PSALTER illustrations. It is prefaced by a series of 223 tinted DRAWINGS of Old Testament subjects; in the text there are *bas-de-page* scenes on every folio, both historiated initials and three-quarter-page illustrations in full paint at the liturgical divisions of the Psalter, and a series of standing saints accompanying the Litany. It was executed by a single artist, one of a large group who appear to have been working in London after 1321 and who produced a small Psalter for Edward III's Queen, Philippa of Hainault (after 1327; London, Dr Williams's Library). Their style is derived from manuscripts produced for EAST ANGLIAN patrons *c.*1310–20, but it has a stronger French flavour which indicates the artists' association with the court and London. Their restrained figure and drapery style, relying on elegant s-curves and courtly gestures of the hand, and their delicate decorative borders stand in contrast to the exuberant manner of the DECORATED style. Such a lavish book is likely to have been made for a member of the high aristocracy. MM
□ G. Warner, *Queen Mary's Psalter* (1912)

Quellin, Arnold *see* GIBBONS; NOST; SCULPTURE: 17C.

R

Raeburn, Sir Henry (1756–1823) was the first Scottish painter to establish a wide reputation on the basis of a purely Scottish achievement. He was apprenticed to a goldsmith in Edinburgh, and also painted miniatures when he was young. About 1776 when he was beginning to work in oil he met RAMSAY's former assistant David Martin, who introduced him to Ramsay's painting and also to REYNOLDS's grander type of portrait. Alexander RUNCIMAN may also have been a crucial influence, for Raeburn did not follow Ramsay's practice of using careful drawings but, like Runciman, cultivated spontaneity to record the impact of the sitter's presence.

In 1784 he travelled to Italy for 2 or 3 years. On his return his painting was marked by new elegance and breadth, and superficially he might be compared at this stage to ROMNEY or HOPPNER. In reality he was still Ramsay's heir in his respect for the individual and in his directness. The awkward but undeniable strength of his pre-Italian work matured with breathtaking effect in an early masterpiece like *Dr Nathaniel Spens* (1790; Edinburgh, Royal Company of Archers).

By the early 1790s he had developed a characteristic way of working. He painted without underdrawing, directly onto a fairly coarse canvas, using a square brush to lay one tone beside another without gradation in the modelling, achieving a sense of living presence matched by the sharpness of his characterization. Typical of his best portraits is *Principal William Robertson* (1792; Edinburgh University). In later works he combined these qualities with greater economy of means to create the extraordinary power of the simple half-length *Lord Newton* (*c.*1810; Lord Rosebery, Dalmeny House), surely the inspiration for R. L. Stevenson's *Weir of Hermiston*. When dealing with beautiful women like Mrs Robert Scott Moncrieff (*c.*1814; Edinburgh, NGS) he may have sacrificed likeness for effect at times, but with those less well-favoured he was every bit as frank as in his male portraits.

Though Raeburn's technique involves approximation it is the approximation of natural vision (as in Hals), not the generalization of Reynolds or LAWRENCE. His painterliness and dash equipped him well to handle full-length portraiture, rarely practised in Scotland, and it is here that he came closest to his English contemporaries. Though he was occasionally tempted into melodrama, it is still the force of characterization that catches our attention, even in such picturesque full-lengths as *Col. Alastair Macdonell* (Edinburgh, NGS), shown in Highland dress.

Raeburn, *Col. Alastair Macdonell of Glengarry*, exh. 1812 (Edinburgh, NGS).

Ramsay, *Margaret Lindsay, the Painter's Second Wife*, 1754–5 (Edinburgh, NGS).

Raeburn's success was considerable: in 1822 he became the first Scottish painter to be knighted since the Union in 1707. He was, however, frequently criticized for lack of finish, and a body of opinion in Scotland, including Sir Walter Scott, found his bluntness too whiggish. *See also* SCOTTISH PAINTING. DM

□ W. Armstrong and J. L. Caw, *Sir Henry Raeburn* (1901); Caw (1908); Irwin (1975)

Ramsay, Allan (1713–84), son of the Scottish poet of the same name, left his native Edinburgh in the early 1730s to study in London with the Swedish portrait painter Hysing. He spent 1736–8 in Italy, studying in Rome under Imperiali and in Naples with Solimena, from whom he must have acquired his characteristic elegance and richness of colour and tone.

On his return to London in 1738 his chief rivals were HUDSON, HIGHMORE and the foreigners VAN LOO and Andrea Soldi (*c.*1703–71), but his stylish adaptation of the European Baroque court style ensured his success. Like Hudson he used the drapery painter VAN AKEN, particularly in his larger works, such as *Dr Mead* (given to the FOUNDLING HOSPITAL in 1747) and *Macleod of Macleod* (1747–8; Dunvegan Castle), the latter striding forward in the attitude of the *Apollo Belvedere*.

The return of REYNOLDS from Italy in 1753 was a serious challenge to Ramsay's supremacy, but by then his style had begun to move towards a delicate naturalism that echoes French pastellists like La Tour and Perroneau, as in the ravishing portrait of *Margaret Lindsay*, his second wife (Edinburgh, NGS), painted in Rome during his second excursion to Italy (1754–7). He became the King's Principal Painter in 1761 and did many repetitions of the BATONI-like coronation portrait of GEORGE III (Royal Coll.) before he abandoned painting altogether *c.*1770. *See also* MCARDELL; SCOTTISH PAINTING. BA

□ A. Smart, *The life and art of Allan Ramsay* (1952)

Ratcliffe, William *see* CAMDEN TOWN GROUP

Ray, Man *see* SURREALISM

Read, Sir Herbert (1893–1968) was for a generation the champion of modern art in Britain, as well as a poet, critic and philosopher

of literature and society. His first art books were historical, on stained glass and pottery, but they already show his concern for art as a reflection of society. In 1931 he became Professor of Art at Edinburgh University and wrote articles on Henry MOORE and Klee. Increasing involvement with contemporary art brought him back to London in 1933, when *Art Now* appeared, the first comprehensive English theoretical defense of modern European art. In 1934 he edited the modernist art-manifesto UNIT ONE. He became particularly close to certain artists (Moore, Ben NICHOLSON, HEPWORTH, GABO), but he campaigned also for SURREALISM and for Abstract and Concrete art. Interest in psychology led him to analyse children's art (*Education through Art* (1943), his most influential book). Following his social and political ideas he came to justify a great variety of art, defending the individual's right to freedom of expression. His writings became as much generally philosophic as critical (*The Art of Sculpture* (1956); *The Forms of Things Unknown* (1960)). By the 1960s he was disenchanted with later artistic developments, but he was by then known, not unjustly, as 'The Pope of Modern Art'. BR

Redgrave, Richard (1804–88) was an ANECDOTAL painter who originated an important form of social problem picture in the 1840s. He first specialized in humorous literary subjects in the manner of LESLIE, but in 1843 he exhibited *The Poor Teacher* (Gateshead). It and other pictures deal with the fashionable concern for the plight of defenceless young ladies, in idealized forms and sombre colours.

From 1847 Redgrave became increasingly involved in art administration, becoming Director of the South Kensington Mus. (later V&A) and writing didactic works. WV
□ F. M. Redgrave, *Richard Redgrave* (1891)

Redpath, Anne see SCOTTISH PAINTING

Reid, George see SCOTTISH PAINTING

reliquaries, containers for the relics of saints, were from an early date commonly of metal or ivory, and gradually assumed various shapes.

The shrine of a saint, normally at first his place of burial, often consisted of a stone structure upon which was placed a chest – the shrine proper – containing the body or part of it. The chest was usually coffer-shaped, of wood covered with silver or gold and perhaps enriched with gems. Interest in relics as an aid to devotion reached its peak in the 13c. and 14c., and the resulting dismemberment of saints' bodies led to the making of other types of reliquary. These often took the shape of the relic in question (arm, hand, finger, leg, foot or head), but could also be caskets, ampullae, crosses and pendants. Many are recorded in the possession of ecclesiastical institutions and individuals, but few escaped the Reformation.

An early intact English reliquary (late 12c.) is of casket shape, in silver and niello, decorated with the martyrdom of St Thomas Becket (New York, Met.). Other casket-shaped examples of copper or bronze gilt are known from the 15c., e.g. one engraved and enamelled with saints including St Etheldreda, perhaps from Ely Cathedral (V&A). Also 15c. are 2 extremely rare reliquary jewels, to be worn on the person: the Clare Reliquary Cross, of gold and enamel (Royal Coll.) and the Matlaske Reliquary Pendant, of silver enamelled with the Crucifixion and St John the Baptist (Norwich, St Peter Hungate Mus.). MCa
□ J. C. Wall, *Shrines of British saints* (1905); *English medieval art* (exh., V&A, 1930); C. Oman, *English church plate* (1957)

Reynolds, Sir Joshua (1723–92), though not necessarily the greatest, was beyond doubt the most important of 18c. British painters. Everything he touched bore the stamp of his authority. He was the most accomplished, intelligent and varied portraitist in a society which appreciated portraiture above all other art forms. As a writer on art, he established a body of ideas against which the writings of all his contemporaries and immediate successors can be measured, even when they violently disagreed with him. As first President of the *ROYAL ACADEMY, he gave the artistic profession in Britain a quality of leadership which it had never known before. Like his friend Dr Johnson, Reynolds was a conservative in a period with leanings towards Romanticism and *sensibilité*. But by a combination of intellectual flexibility and the defence of classical values, from which that period had not yet cut itself free, he was able to give the British School a coherence it might otherwise have lacked.

Reynolds was born in Plympton, Devon, the son of a schoolmaster in holy orders. After

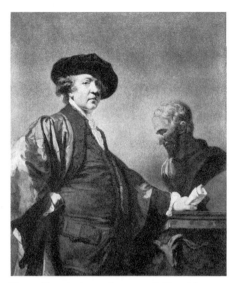

Reynolds, robed as an honorary DCL, with a
bust of Michelangelo: mezzotint by Valentine
Green after Reynolds's self-portrait of 1780.

serving an apprenticeship in London, 1740–43,
under the fashionable portraitist Thomas
HUDSON, and subsequently practising in Lon-
don and Devon, he went to Italy where he
stayed, chiefly in Rome, 1749–52. While in
Italy Reynolds studied the art of the 16c. and
17c. and to a lesser extent the antique with a
conscientiousness rare among artists of any
nationality at that date. He spent his time not in
the academies, but in the churches and palaces
filling his sketchbooks (still largely un-
published) with rapidly executed sketches of
the paintings and sculptures he saw. The
knowledge so gained, coupled with his
instinctive breadth of taste, became of lasting
importance to his own painting.

Reynolds's Italian experience, reinforced by
his reading, confirmed him in the traditional
belief that the highest form of art was HISTORY
painting. Portraiture, landscape, still-life and
the painting of everyday scenes were all in
varying degrees lesser genres. History painting
required the adoption of an appropriate style –
the 'grand' style – whose foundation was the
study of nature but whose attainment depended
on a process of idealization. The artist's duty
was to rise above the depiction of particular
nature, which always contained blemishes and
defects, in order to represent what Reynolds

called 'general' nature. How was this task to be
fulfilled? Partly by choosing the typical, or
'central', forms of objects, as distinct from the
individual, and partly by following the
example of the old masters, whose conception
of general nature, derived ultimately from the
antique, was held to be valid for all time.
Michelangelo and Raphael, together with their
17c. Bolognese successors, were the preferred
models, in Reynolds's view, as their approach
to art was intellectual. The Venetians, by
contrast, appealed primarily to the eye and thus
were masters of an inferior, or 'ornamental',
style. However, Reynolds was not above
advocating the use of a judicious mixture of
styles and he thought that 'invention, strictly
speaking, is little more than a new combination
of those images which have been previously
gathered and deposited in the memory'. As this
shows, he instinctively tended to the view that
art could be learnt and that great artists were
made, not born, though he was too intelligent
not to realize that inspiration and genius must
play some part. The problem of deciding
where, in the creative process, the dependence
on rules ends and genius takes over was one
which was to perplex him all his life.

Such were the ideas which dominated
Reynolds's principal writings, his 15 *Discourses
on Art* delivered at the RA between 1769 and
1790. Both before and during this time,
however, he created a pictorial *oeuvre* which
was in important respects at variance with his
theory, as contemporaries were not slow to
point out. For one thing, there was a
contradiction between his recommendation of
history painting and his practice of portraiture,
which he himself explained by saying –
truthfully – that he had no talent for the former
(he could hardly be expected to add that
portraiture paid better). For another, he
allowed himself to be influenced more by the
Venetian artists and their followers, Rubens,
VAN DYCK and Rembrandt, whom he had
warned his students against on the ground that
their work was too sensuous, than by the
masters of the grand style.

To narrow the gap between portraiture and
history painting, Reynolds devised a category
of historical portrait, in which he idealized the
figure or figures, used poses, costumes and
gestures taken from the old masters, and treated
the composition as if it were a subject picture
with an allegorical theme. Examples of this are
his *Three Ladies adorning a Term of Hymen* (1774;

Tate: see *PORTRAIT PAINTING: 18C.) and *Mrs Siddons as the Tragic Muse* (1784; San Marino, Huntington). In other paintings he shed the allegorical subject-matter but retained the formal allusions to the art of the past, apparently expecting his borrowings to be recognized as a form of wit, like a concealed classical quotation in a passage of 18c. poetry. Arguably, however, Reynolds's most successful portraits are those, like *Capt. John Hayes St Leger* (1778; Waddesdon), in which the historical references are least obtrusive and in which the motifs and classical qualities he had learnt from the old masters became translated into the expression of 18c. concepts of personal refinement and social good form. Not the least of Reynolds's gifts was an acute understanding of the social world in which his sitters lived, and he represented the image those sitters wished to project of themselves with sympathy, vividness and an almost inexhaustible variety. It was this, perhaps, above all which gained him the respect of the British social and political establishment, a respect which rubbed off on the artistic profession as a whole.

Knighted soon after becoming President of the RA in 1768 and made an honorary DCL of Oxford University in 1773, Reynolds was given a lavish funeral in St Paul's Cathedral after his death – the first painter to be buried there since Van Dyck.

See also CARICATURE; HAZLITT; MCARDELL; *STAINED GLASS: 16–18C. MK

□ J. Reynolds, *Discourses on art*, ed. R. Wark (1959); E. K. Waterhouse, *Reynolds* (1941 and 1973).

Ricci, Sebastiano (1659–1734), a Venetian DECORATIVE painter of high quality, first came to England in 1711–12 with his nephew **Marco Ricci** (1676–1729), who had previously come over with Sebastiano's pupil PELLEGRINI in 1708. Though he stayed for only about 4 years he left some splendid works behind, most notably in London the *Resurrection* fresco in Chelsea Hospital Chapel and 2 wall-paintings and a ceiling still in Burlington House. Significantly THORNHILL was preferred to him for major works at Hampton Court and St Paul's, and his departure *c.*1716 signalled the end of the dominance of foreign decorative painters. DB
□ Croft-Murray, II (1970)

Richard II, King 1377–1400 (b.1367), was a major patron of the arts, though his personal interest has perhaps been exaggerated. His taste for extravagant refinement was in keeping with the prevalent INTERNATIONAL GOTHIC style. Of the decorations in his residences the wall-paintings in the Byward Tower of the Tower of London are noteworthy survivors. The most important manuscript connected with him is the *Liber Regalis* (1382?; London, Westminster Abbey), illuminated in a peculiar Anglo-Flemish style. Also at Westminster are the tomb of Richard and his Queen, Anne of Bohemia, with gilt-bronze effigies by Nicholas Broker and Godfrey Prest (begun 1395), and a full-length PANEL PAINTING of the King, probably by a Netherlandish artist, which, like the *WILTON DIPTYCH, exemplify the novel interest in portraiture and Richard's view of his kingship. NR
□ A. Steel, *Richard II* (1952); G. Mathew, *The court of Richard II* (1968); *see also* WILTON DIPTYCH

Richards, Ceri (1903–71) was influenced by SURREALISM in the 1930s, but took little part in the movement. Among his most original works are painting/reliefs using wood and metal, inspired by Picasso's constructions and by Ernst. Figures are abstracted, becoming almost totemic. Music and poetry provided important sources for his work. DA
□ *Ceri Richards and David Jones* (exh., Tate, 1982)

Richards, J. I. *see* LANDSCAPE PAINTING: 18C.

Richardson, Jonathan (1665–1745) was a portrait painter, but more important as the author of a series of writings on painting which made a powerful claim for its moral seriousness (*see* HISTORY PAINTING). By proclaiming it as an area of knowledge and therefore a Liberal Art, rather than an 'Innocent Amusement', he sought to attract to painting practitioners of intellect and patrons of discrimination. His main writings, *The Theory of Painting* (1715), *Essay on the Art of Criticism* and *The Science of a Connoisseur* (1719), and *An Account of Some of the Statues, Bas-reliefs, Drawings and Pictures in Italy* (1722), provided influential textbooks which looked forward to the high ambitions of the ROYAL ACADEMY. DB
□ L. Lipking, *The ordering of the arts in 18c. England* (1970); Dobai, I (1974)

Bridget **Riley**, *Crest*, emulsion, 1964 (priv. coll.).

John **Riley**, *Bridget Holmes, A Royal Housemaid*,
1686 (Royal Coll.).

Richmond, George (1809–96), the youngest
member of the SHOREHAM group, produced
figure paintings influenced by BLAKE and
drawings of a powerful and tortured linearity
in the 1820s, but gradually withdrew from
imaginative work to become a solid Victorian
portraitist. He was the father of **Sir William
Blake Richmond** (1842–1921). DB
□ R. Lister, *George Richmond* (1981)

Ricketts, Charles (1866–1931) was a much
exhibited painter but his most important
achievement was as an illustrator and designer
of classic *fin-de-siècle* books, including some by
Oscar Wilde. He was something of a rival to
BEARDSLEY, though his extremely mannered
style derives essentially from Continental
Symbolism. He and his inseparable companion
Charles Shannon (1863–1937) eventually
became as well-known for their collection of
exquisite objects as for their artistic endea-
vours. DB
□ S. Calloway, *Charles Ricketts* (1979); J.
Darracott, *All for art: the Ricketts and Shannon
collection* (1979)

Riley, Bridget (b.1931) came to notice first in
the mid 1960s as the most striking of the British
'Op' artists. Her pictures were characteristically
in black and white and created drama by the
systematic variation of elementary shapes
vertically and horizontally across the picture, or
radially from a point. She soon re-introduced
colour, taking ranges of hue and saturation and
distributing them methodically among the
geometric elements, often simple stripes of
different widths. She has been influenced by
Seurat and her colours, as his, when looked at
under suitable conditions, produce an illusion
of radiant light. MC
□ R. Kudielka, *Bridget Riley* (exh., British
Council, 1978)

Riley, John (1646–1691) was a pupil of Gerard
Soest (d.1681). In 1681 CLOSTERMAN is recorded
as his drapery painter; in 1688 he and KNELLER
were appointed Principal Painters to the
Crown. His most sympathetic portraits are of
servants, e.g. *The Scullion* (Oxford, Christ
Church). Like Lely, he built up a valuable
collection of prints and drawings. His portrait
style was passed on to RICHARDSON and
HUDSON. DD
□ Waterhouse (1978)

Rippingille, E. V. *see* BRISTOL SCHOOL

Roberts, David (1796–1864) began his career as a scenery painter in Scotland and then London, where he collaborated with STANFIELD. He turned to topographical painting after 1830, indefatigably touring Europe and the Mediterranean basin, producing the compendious *Sketches in the Holy Land, Syria, Idumea, Arabia, Egypt and Nubia* (1842–9). Equally proficient in oils and in watercolours, he combined precise observation with spirited handling and often dramatic design. PN
□ Hardie, III (1968); H. Guiterman, *David Roberts* (1978)

Roberts, William (1895–1980), painter, after leaving the SLADE, where he studied 1910–13, travelled extensively in France and Italy. His early subjects were religious and mythological, elegantly drawn with an increasingly simplified figure style. He joined the OMEGA WORKSHOPS but was persuaded by Wyndham LEWIS to leave and join the Rebel Art Centre. A growing awareness of Cubism is apparent 1914–15, e.g.

David **Roberts**, *Interior of the Hypostyle Hall, Karnak, Egypt*, watercolour, 1838 (Manchester).

in *Religion* (lost), reproduced in *Blast* 1, where Roberts signed the VORTICIST Manifesto. He reduced his figures to more mechanical, angular forms in works based on popular dances, using the strident colours of Vorticism. In *The First German Gas Attack at Ypres* (1917; Ottawa) he returned to the figure style of his Slade work, modifying it again in the 1920s to rounded simplification and clear tonalities, and painting mainly London scenes. *See also* GROUP X. JB
□ *William Roberts* (exh., Tate, 1965); Cork (1975–6)

Robertson, Andrew *see* MINIATURE PAINTING

Roche, Alexander *see* GLASGOW SCHOOL

Rococo The term, derived from the French word *rocaille* (rockery or shell incrustation), originally referred to a subordinate style used for ornament in interior decoration and the applied arts *c.*1730–50, based on an extravagant use of sinuous scrolls and curves, but it may also be applied to painting and to sculpture. (For the latter, *see* SCULPTURE: ROCOCO.) In painting, Rococo implies an emphasis on frivolity of subject-matter combined with the brightness of palette found in the work of French artists like WATTEAU and Boucher. In England the style was too closely associated with the extravagance of the Catholic French court ever to become widespread, but visits from French artists in the 1720s and 1730s and engravings after French paintings influenced in particular artists associated with the ST MARTIN'S LANE ACADEMY, who produced the most exuberant expression of the Rococo in England, the decoration of VAUXHALL GARDENS in the 1740s (*see* ★HAYMAN).

Foreign artists like ★MERCIER and J. F. Nollekens (1702–47, father of Joseph NOLLEKENS) translated the Watteauesque into a more English idiom and British artists soon followed. Despite his xenophobic sentiments, some of ★HOGARTH's early works *c.*1730, like *Before* and *After* (Cambridge, Fitzwilliam), are in composition and handling indebted to French Rococo. The same may be said of his *Marriage-a-la-Mode* series (*c.*1743; NG) for which, significantly, the artist made a trip to Paris to secure the services of the best French engravers. HIGHMORE's essays in the French manner (e.g. his paintings for Samuel Richardson's *Pamela*) were the result of a Parisian visit in 1734 and of

the presence of *GRAVELOT in England 1732–45. Gravelot's influence was widespread and appears in the work of his most illustrious pupil, the young GAINSBOROUGH: see, e.g., the pale tonality and crisp handling of paint in the ravishing small *Self-Portrait with his Wife Margaret* (c.1746–7; Paris, Louvre). Gainsborough was the only British artist with the painterly gifts and confidence of touch to rival his Continental counterparts, and a comparison with Fragonard is instructive. But the Rococo in English painting is a good deal more elusive than its French source, and it is significant that British artists were in the vanguard of the succeeding sombre NEOCLASSICAL style, with its emphasis on stoic Greek and Roman virtue.

See also FREDERICK, PRINCE OF WALES; LAROON. BA
□ E. Waterhouse in *Journ. Warburg and Courtauld Inst.*, XV (1952), 122–35; J. Hayes in *Apollo*, XC (1969), 114–24; *Rococo* (1984)

Rogers, Claude (1907–79), trained as a painter at the SLADE under TONKS, was an outstanding draughtsman and a strong colourist. He was an initiator of the EUSTON ROAD SCHOOL and its most regular teacher. After World War II he taught at Camberwell and the Slade, and was Professor of Fine Art at Reading 1963–72. Some of his best works are Suffolk landscapes, e.g. the *Burning Stubble Fields* series. BL
□ *Claude Rogers* (exh., London, Whitechapel, 1973); B. Laughton, *The Euston Road School* (1985)

Romanesque is a term used to describe a stylistic movement lasting from the mid 11c. until the end of the 12c. This period in the history of English architecture is more generally referred to as 'Norman' because it was marked by the new architectural style introduced from Normandy after the Conquest. In painting and sculpture there are Romanesque elements in late ANGLO-SAXON art of c.1025–50.

In the figure arts there are many variations in the style of the Romanesque period, and the term can never be used as a clear definition of stylistic features. General characteristics common to most but not all Romanesque art are: (i) distortion, hardening and abstraction of figure forms, (ii) patterned formal organization of figure compositions, (iii) integration of figures with ornament, (iv) narrative conveyed by mannered gestures of hands and body forms. Many works have individual stylistic solutions

in which artists show interests in Anglo-Saxon, Ottonian, Italian, Italo-Byzantine and Byzantine art.

The Romanesque style was abandoned in the closing years of the 12c. From a complicated period of diverse artistic experiment, called Transitional, there eventually evolved the style called GOTHIC.

See also BIBLICAL ILLUSTRATION; BURY BIBLE; CANTERBURY SCHOOL; ENAMELS; FONTS; ILLUMINATED MANUSCRIPTS; IVORY CARVING; LAMBETH BIBLE; PSALTER ILLUSTRATION; ST ALBANS PSALTER; SCULPTURE; TOMBS; WALL-PAINTING; WINCHESTER BIBLE. NM
□ T. S. R. Boase, *English art 1100–1216* (1953); G. Zarnecki, *Romanesque art* (1971); *1066: English Romanesque art* (exh., Arts Council, 1984)

Romney, George (1734–1802) achieved his greatest fame as a PORTRAIT painter and at his height in the 1770s and 1780s was a rival even to REYNOLDS and GAINSBOROUGH. Yet his real ambition was to succeed as a painter of HISTORY, and he spent much of his later life working on grandiose schemes for series of paintings on elemental themes which came to nothing, but for which thousands of rapid sketches survive.

He was born in Lancashire and remained in the provinces until he came to London in 1762, setting himself up as a portrait painter. A visit to Italy in 1773–5 was instrumental in firing his love of 'those delightful regions of the imagination', and at its best his portraiture has a strong classical feeling (e.g. *The Leveson-Gower Children*, 1777; Kendal, Abbot Hall), and can be

Romney, *The Leveson-Gower Children*, 1777 (Kendal, Abbot Hall).

distinguished by lively handling, but usually suffers from a lack of incisive characterization. He was taken up by the poet William Hayley (*see* BLAKE), and made a great number of paintings of his favourite model Emma Hart, later Lady Hamilton. His last years were marred by a deep sense of artistic failure and he died insane. DB

☐ H. Ward and W. Roberts, *Romney* (1904); P. Jaffé, *Drawings by George Romney* (exh., Cambridge, Fitzwilliam, 1977)

roof bosses are carved projections of stone or wood placed at the intersections of ribs in vaults or of beams in flat timber ceilings. They were occasionally employed in Norman architecture, but did not become common in England until used in the choir at Canterbury erected in 1174–9. The Canterbury bosses are distinguished from earlier examples by their elaborate design and depth of cutting. Similar bosses are found in France, but whereas those form a restricted group, in England this type became usual.

Bosses remained an important field for sculpture until the Reformation and include several historiated cycles (e.g. the Passion and APOCALYPSE in the cloister at Norwich). The majority were decorated with foliate designs, isolated religious subjects, or single heads, including many GROTESQUES. Heraldic bosses were increasingly popular from the early 14c. onwards. *See also* SCULPTURE: GOTHIC, WOOD. ND

☐ C. J. P. Cave, *Roof bosses in medieval churches* (1948); Stone (1972)

Ross, Charles *see* MINIATURE PAINTING

Rossetti, Dante Gabriel (1828–82) was a painter and poet whose outstanding imaginative gifts led him to have enormous influence on the cultural life of Victorian England. A leading member of the PRE-RAPHAELITE BROTHERHOOD, he was largely responsible for the symbolism and the mystique of the Middle Ages in later Pre-Raphaelitism. He was also one of the first to rediscover BLAKE.

The son of an exiled Italian patriot and scholar, and brother of the poetess Christina Rossetti, he grew up in a strongly literary environment. Indeed, it was his enthusiasm for the poetry of Keats that first brought him into contact with Holman HUNT when they were both students at the ROYAL ACADEMY 1845–7.

A **roof boss** from Hailes Abbey (Glos.), showing Samson and the Lion, mid 13c.

Their meeting was a key event in the formation of the Pre-Raphaelite Brotherhood (1848). Previously Rossetti's interest in medievalism had led him to study under Madox BROWN, but he had become discouraged by that artist's emphasis on technique, which never interested him greatly. Even his first work painted as a member of the Brotherhood, *The Girlhood of Mary Virgin* (1849; Tate), shows as much interest in symbolic effect as it does in detailed observation. In the next year he painted *Ecce Ancilla Domini* (Tate), his early masterpiece, in which the story of the Annunciation is given a startling freshness by emphasizing the psychological response of the Virgin. The picture is also remarkable for its striking use of bands of blue and red against a broad expanse of white.

After the hostile reception of the Pre-Raphaelites, Rossetti devoted a decade largely to watercolours of subjects from medieval literature. His only large oil during this period was *Found* (Wilmington, Del.), which remained unfinished. In 1856 he came into contact with BURNE-JONES and MORRIS, who

Rossetti, *Beata Beatrix*, 1864 (Tate).

had been greatly impressed with one of his illustrations. With them he formed a 'second' Pre-Raphaelite group, decorating the Oxford Union with FRESCOES of the Arthurian legends (1857).

Around 1860 Rossetti returned to oil painting. His friendship with WHISTLER encouraged him to specialize in idealized female figures. The most impressive of these, *Beata Beatrix* (1864; Tate), is of his wife, Elizabeth SIDDAL, whose death in 1862 had filled him with remorse. Identifying himself with Dante, he has cast her in the role of Beatrice at the moment of her death. In later years he became increasingly ill and the quality of his work declined. WV

□ V. Surtees, *The paintings and drawings of Dante Gabriel Rossetti* (1971); A. Grieve, *The art of Dante Gabriel Rossetti* (1973)

Rossi, J. C. F. *see* ST PAUL'S; SCULPTURE: EARLY 19C.

Rothenstein, Sir William (1872–1945), painter and draughtsman, studied at the SLADE and in Paris, where he made friends with WHISTLER, Degas, Toulouse-Lautrec, Verlaine, Oscar Wilde and Charles Conder. Back in England he became known for his portrait

drawings, particularly of the famous. He was principal of the ROYAL COLLEGE 1920–35. His memoirs and correspondence are a rich source of information on his times. BL
□ W. Rothenstein, *Men and memories* (1931); R. Speaight, *William Rothenstein* (1962)

Roubiliac, Louis François (1702/5–62) is generally recognized as the most gifted sculptor to have worked in England in the 18c. Though he was frequently mentioned with approval by contemporaries like VERTUE, his date of birth, his training, and his first arrival in England are still matters for speculation. He was born in Lyons to a prosperous family with Huguenot connections and won second prize at the Paris Academy in 1730 under the Presidency of Nicolas Coustou, whose pupil he may have been. According to J. T. Smith, a by no means reliable source, he worked with Balthazar Permoser on the Zwinger in Dresden. This would seem to be confirmed by recent documentary evidence and an exuberance in his work which suggests experience of Central European Baroque. An early visit to Rome cannot be ruled out, though it is not mentioned in contemporary sources.

Despite Mrs Esdaile's claim, on the basis of unsound attributions, that Roubiliac came to England as early as the mid-1720s, there is no reason to suppose that he arrived in England much before 1735, when he married the first of his 4 wives, who was a Huguenot. According to early accounts he initially assisted the CARTER family and CHEERE, emerging in his own right with a remarkable statue of Handel commissioned by Jonathan Tyers for VAUXHALL GARDENS in 1738 (V&A). This statue marks the high point of the Rococo style in English sculpture (*see* ★SCULPTURE: ROCOCO), and it brought Roubiliac into a close association with the artists of the ST MARTIN'S LANE ACADEMY.

Although the *Handel* was greatly admired, it did not lead immediately to major commissions, except for marble busts, especially one, often repeated, of Alexander Pope. Roubiliac's busts are of a penetrating realism and vivacity, in contrast to the sober dignity cultivated by RYSBRACK, and they had a particular appeal to professional men. There was much demand also for historical busts, the most notable ensemble, dating from the 1750s, being still in the library of Trinity College, Cambridge, along with the great statue of Newton in the chapel.

Roubiliac, detail of the monument to J. G. and Lady Elizabeth Nightingale in Westminster Abbey, 1761.

His first large-scale tomb was to Bishop Hough in Worcester Cathedral (erected 1746), and this was followed by his first London monument, to the 2nd Duke of Argyll in Westminster Abbey (begun 1745). The former introduced to England the full-scale dramatic tomb, derived ultimately from Bernini's papal tombs, in which the deceased and attendant figures re-enact allegorically the end of life and the beginning of Redemption. All his later large-scale tombs employ eschatological imagery and they achieve in some cases a religious intensity without parallel in English sculpture, and which superficially appears to be at odds with the rationalism of his age. From the completion of the Argyll monument in 1749 until his death in 1762, Roubiliac was almost always at work on a major monument in Westminster Abbey, completing 7 altogether, which were all greeted with enthusiasm despite their awkward placing in the already over-crowded abbey. The most striking, the

Hargrave (1757) and Nightingale tombs, commemorate people of no worldly distinction, and this enabled the sculptor to emphasize the universality of death (no doubt under the influence of Young's *Night Thoughts*, 1744): Hargrave is shown rising from the tomb at the sound of the Last Trump, and Mr Nightingale vainly attempting to fend off Death's dart from his dying wife. Both these tombs, unlike most from the 18c., retained some popularity throughout the 19c., when taste turned completely against the Baroque.

Roubiliac, especially in later years, also made many monuments for parish churches. None is without some distinctive touch, whether it be an incisively realized medallion or a drape enfolding an urn, yet the predominance of stock patterns suggests a well organized studio with assistants. The standard of finish is always extremely high, and Roubiliac showed an exceptional concern with the placing of the sculpture in its setting and the fall of light upon

it. In the case of the 2 grand Montagu tombs at Warkton (1749–54), Roubiliac apparently designed the chancel in which they were placed.

As a man Roubiliac fitted the stereotype of a volatile Frenchman, being small in stature and excitable in conversation. Apart from his artistic contacts he seems to have mixed mainly in Huguenot circles. In 1752 he travelled to Italy with a group of artists including Thomas HUDSON. *See also* ★TERRACOTTA. DB
☐ K. A. Esdaile, *L. F. Roubiliac* (1928); Whinney (1964); *Rococo* (1984)

Rowbotham, T. L. S. *see* BRISTOL SCHOOL

Rowlandson, Thomas (1756–1827) stands
with GILLRAY at the head of the CARICATURE tradition, but complements him, his gift being for social rather than political satire. He enrolled at the ROYAL ACADEMY Schools in 1772, and shortly after, probably in 1774, spent some time in France; however, the primary influence

Rowlandson, *The Exhibition 'Stare-case', Somerset House*, watercolour, *c.*1800 (Yale BAC). The scene is the **Royal Academy**.

on his early etchings and pen drawings was MORTIMER. In the 1780s he etched numerous political satires, but printmaking generally was always subservient to his watercolours, of which many of the finest examples were produced in this decade. They include large exhibition pieces such as *Vauxhall Gardens* (1784; V&A), which are freshly tinted with colours, and drawn with a ROCOCO sense of rhythm tempered by homely rotundity of line. Like many of his drawings they are crammed with varying human types, from buxom girls to lecherous old wrecks, disposed with a natural sense of grouping that shows the artist's enthusiasm for Rubens. The character of his work remained consistent: essentially it is one of jollity, and though this is occasionally darkened by grotesque extremes of vice and ugliness, to Rowlandson virtue and depravity, beauty and ugliness, were spectacles equally to be enjoyed.

In the later part of his career his work sometimes became careless, but it was marked by triumphs such as *The English Dance of Death* (coloured etchings, 1814–16) and by a never-failing facility of draughtsmanship. His output over a long life was enormous, and he made replicas of many of his watercolours. The best collection is in San Marino (Huntington). *See also* ★ACKERMANN. RG
☐ J. Hayes, *Rowlandson, watercolours and drawings* (1972)

Royal Academy of Arts The Academy was established in London in 1768, the culmination of many years of planning by artists of the ST MARTIN'S LANE ACADEMY spurred on by the realization that corporate status could raise them above the rank of artisans. In the autumn of 1768 a group of younger members of the SOCIETY OF ARTISTS used their votes to oust senior colleagues, including HAYMAN and WEST, who they claimed had unfairly dominated its management. West and the architect Sir William Chambers responded by persuading GEORGE III, to whom they both had personal access, to establish a Royal Academy. The royal connection was vital, since, as Reynolds tells us, during its early years the King gave 'unlimited power to the Treasurer to draw on his Privy Purse for whatever mony shall be wanted for the Academy', a privilege the rival societies could not hope to match.

The main aims of the RA were the establishment of formal Schools (where tuition

The Life Class at the Royal Academy, 1772, by Zoffany (Royal Coll.). The picture records all the Academicians in 1771–2; among them are Reynolds (centre, with glasses and ear-trumpet) and Zoffany himself (far left, foreground).

was free), the continuance of the annual exhibitions begun by the Society of Artists, and the disbursement of profits from the exhibitions for the relief of poor artists and their families. The RA was administered on much more formal lines than the Society of Artists. Its 40 members were expected to abide by a constitution; government was in the hands of the elected President (PRA) and 8 Academicians who formed the Council, and Professors were appointed to the various branches of art.

Annual exhibitions were held from 1769 in rather shabby premises in Pall Mall; a move in 1780 to more salubrious apartments in the Strand block of the newly rebuilt Somerset House made it possible to include considerably more exhibits in the annual shows. In the Great Room at Somerset House, with its ample top-lighting, the pictures were hung in close proximity by a hanging committee comprising the Secretary, Keeper and 3 Academicians.

The first President, REYNOLDS, consciously set out to educate both students and public with his published lectures (*Discourses*), which were a sort of manifesto for HISTORY PAINTING. On the whole the RA's exhibitions did not reflect Reynolds's precepts, but because of the limited patronage for the grand manner continued to be dominated by portraits. BA

In the 19c. the RA's supremacy was repeatedly challenged by groups and individuals. Right at the beginning of the century under WEST (PRA 1792–1805, 1806–20) the first artists seceded, in Norwich (1803) and Liverpool (1810), protesting at the RA's London bias against provincials. Under LAWRENCE (PRA 1820–30) their example was followed by the Irish (1823), Scots (1826) and Manchester (1827). Watercolourists, too often ill-hung or squeezed out altogether, with Dr MONRO set up the (Old) Water-Colour Society in 1804 (*see* WATERCOLOUR), while the BRITISH INSTITUTION, founded 1805, offered more exhibiting (and therefore selling) space for contemporary artists, and regular loan exhibitions of old masters – invaluable for students before the opening of the Dulwich Gallery (1814) and the National Gallery (1824); the RA itself only provided these in 1870.

The Council of the Royal Academy selecting Pictures for the Exhibition, 1876, by C. W. Cope (RA). In the centre foreground is Millais.

The 18c. values and hierarchies of art bequeathed to the RA by Reynolds continued to dominate its policies, blinding both it and the public to CONSTABLE. The standard of Victorian popular success was set 15 years before Victoria's accession with the famous protective railing around WILKIE's *Chelsea Pensioners* (1822; V&A, at Apsley House).

Somerset House proved hopelessly cramped for the Academy's exhibiting and teaching needs. In 1837 Sir Martin Archer Shee (PRA 1830–50) moved the RA temporarily to the new National Gallery building. Before the 1836 Parliamentary SELECT COMMITTEE he overcame the complaints of HAYDON and other disaffected artists, who had formed the Society of British Artists in 1824; they opposed the whole idea of academic institutions, as well as sharing premises with the national collection.

Under Shee and the remarkable EASTLAKE (PRA 1850–65) the RA was the essential testing-ground of quality, critical recognition, public reputation and financial success. Its unique role was complemented by 2 significant developments: the ART UNION, and dealers. The non-profitmaking Union, which functioned through subscription and lotteries, was over-

taken by the rise in the 1850s of commercial dealing, spearheaded by Flatow and GAMBART, who vastly increased the wealth and reputation of the mostly Academy artists they exhibited.

Controversy continued with broadsides from artists like Edward Edwards (1839), John Pye (1845) and John Partridge (1864). The Royal Commission in 1863 aired many of the disputes and recommended improvements, the most important of which was the move, under Sir Francis Grant (PRA 1866–78), to Burlington House (*see* ★GRIMSHAW) in 1868. In the same year the Academy tried to defuse charges of insularity by appointing Honorary Foreign Academicians. Prejudice against women artists, however, remained. Though women students entered the RA Schools (with restrictions) from 1860, Elizabeth Thompson (later Lady Butler, 1846–1933) narrowly missed her ARA in 1879 despite her 1874 triumph with *The Roll Call* (Royal Coll.). The first woman ARA was not elected until 1922.

LEIGHTON presided 1878–96 over an Academy still at the centre of established art and society but whose dominance was being eroded by radical change. There were now a dozen different exhibiting societies for every category

of artist, while French radicalism inspired the founding of the NEW ENGLISH ART CLUB in 1886. Dealers, led by Agnew and the Fine Art Society, vigorously promoted successful RA exhibitors, selling to wealthy collectors. Even the RA's teaching role was supplanted. Earlier, Sass's, Leigh's and Heatherley's had been the only apprenticeship for the RA Schools; the 1890s saw the development of municipal art schools, while every second house in St John's Wood was, it seemed, a private academy of art. RT

In the 20c. the Academy, caught in the widening gap between popular and avant-garde taste, soon ceased to be representative of its profession. 'Advanced' artists chose to exhibit elsewhere; its Schools yielded in prestige to the SLADE and ROYAL COLLEGE; it dwindled to a kind of rump, identified with such diehards as Sir Alfred Munnings (1878–1959) and Sir William Russell Flint (1880–1969), indifferent or violently hostile to contemporary developments. At the same time, it has retained much of its traditional upper-middle-class and business patronage, while the enormous growth of amateur activity assures a flourishing provincial constituency, less informed than the old salon public but no less numerous.

With its sequence of splendid rooms in the heart of London, the Academy still mounts major loan exhibitions and retrospectives; yet the deterioration of the Annual Summer Exhibition has become increasingly marked. In its present form, fixed in the 1930s, it presents upward of 1,000 works hung higgledy-piggledy, of which as many as 75 per cent may be sold, often, no doubt, because of the spurious authority conferred upon them by the setting. In defence, the Academy's rejection of the modernist consensus allowed it to show rewarding mavericks like William ROBERTS, Carel Weight (b.1908) and Jeffery Camp (b.1923) in an epoch when such art has been unfashionable. TH

□ Hutchison (1968); A. Brighton and L. Morris, *Towards another picture* (1978)

Royal College of Art An institution in London that can trace its descent back to the School of Design which followed from the SELECT COMMITTEE ON ARTS AND MANUFACTURES of 1835–6 and its successor, Henry Cole's College of Applied Art founded in 1851. The art departments have had many distinguished

students in the 20c., including Henry MOORE; the College perhaps achieved its artistic high point in the late 1950s and early 1960s when HOCKNEY, KITAJ and others studied there (*see* POP ART).

See also FIGURATIVE PAINTING. DB

□ Q. Bell, *The schools of design* (1963)

Royal Society of . . . *see* SOCIETY OF . . .

Rubens, Sir Peter Paul (1577–1640) Rubens's contacts with England began more than a decade before his visit in 1629–30. In 1618 he wrote 2 celebrated letters to Sir Dudley Carleton, listing the paintings – both autograph and studio pieces – which he proposed to offer in exchange for Carleton's collection of antiquities. In 1620 he painted the Countess of Arundel and her entourage (Munich) on their passage through Antwerp; and his admiration for ARUNDEL himself is voiced on a number of occasions in the correspondence. By 1621 he had painted a *Hunt* for CHARLES as Prince of Wales. In that year he indicated his interest in the decoration of the Banqueting House in Whitehall by Inigo JONES, then under construction (the most original building of its time in London); negotiations may have been taken further when he met Buckingham in Paris in 1625. Soon thereafter he painted the ceiling of the Duke's house in the Strand and an equestrian portrait (only sketches survive: NG and Fort Worth, Tex.). Also in 1625 Charles I asked for a *Self-Portrait* (Royal Coll.).

Rubens arrived in England in 1629, as an emissary of the Habsburgs, to open negotiations for peace with Spain, and left again, with a knighthood, in March 1630. It must have been in the course of this year that Rubens's most important English commission, for the ceiling of the Banqueting House, was finally settled. (The canvases were to be painted by him in Antwerp and dispatched to London.) While still in England, Rubens painted the *Thames Landscape with St George and the Dragon* (Royal Coll.) for the King, as well as a number of portraits, including those of Arundel and the King's physician, Turquet de Mayerne. He expressed his hopes for peace in the so-called *War and Peace* (NG), in which he allegorically represented the cessation of war and the fruits of peace, a theme which was to be expanded in the Whitehall ceiling.

In addition to the Whitehall paintings

Rubens, *Thames Landscape with St George and the Dragon*, 1629–30 (Royal Coll.). St George is Charles I, the Princess Henrietta Maria.

themselves, still *in situ*, 15 sketches survive, of which the most important is the monochrome modello now at Glynde Place (Sussex). The almost wholly allegorical iconography of the ceiling is not entirely clear. The square panel over the entrance represents the Union of the Crowns (in 1604), while that over the throne shows James I turning from war towards peace, who embraces plenty. In the centre is an oval panel representing the Apotheosis of James, while the 4 smaller ovals in the corners each have 2 large allegorical figures symbolizing triumphs over intemperance, avarice, ignorance and envy (or rebellion). The long panels at the sides show putti playing with garlands and animals, emphasizing the benefits of peace. The canvases were installed in 1635–6, Rubens received £3000 and a gold chain, and the performance of masques in the hall ceased almost immediately, in order to protect the paintings from the effects of smoke.

At the end of the 1630s there was talk of commissioning Rubens to decorate the Queen's House in Greenwich with a *History of Psyche*, but with his death the commission went to the cheaper and still vigorous Jordaens. DF

□ W. N. Sainsbury, *Original papers illustrative of the life of Rubens* (1859); O. Millar, *Rubens, the Whitehall ceiling* (1958); J. Held in *Burl. Mag.* (1970), 277–81; *The age of Charles I* (1972)

Runciman, Alexander (1736–85) and **John** (1744–68), Scottish brothers, went to Rome in 1766/7. Alexander stayed until 1770, but John died young in Naples. He is best known for *King Lear in the Storm* (1767; Edinburgh, NGS), an imaginative interpretation of Shakespeare's text. He destroyed much of his work before his death.

Alexander had begun as an apprentice to the Edinburgh decorative firm of Robert Norie, and first exhibited landscapes. In Rome he met FUSELI and BARRY, and decided to become a HISTORY painter. His decorative paintings in Penicuik House (1771–3) for Sir James Clerk of Penicuik, consisting of a scheme based on Ossian (chosen in preference to Homer), and scenes from the life of St Margaret in the staircase cupolas, were in the Romantic SUBLIME style associated with British artists in Rome in the 1770s (*see* NEOCLASSICISM *and* SCOTTISH PAINTING). As monumental as Barry's *Progress*

Runciman, *Blind Ossian singing*, sketch for a ceiling in Penicuik House, *c*.1771 (Edinburgh, NGS).

of Human Culture in the Society of Arts (1777–83), they were destroyed by fire in 1899. Relatively few of his easel paintings survive, apart from *The Origin of Painting* (1771; Penicuik), but his many drawings show a harshly energetic pen-and-ink style and considerable power of conception. He was Master of the Trustees' Academy in Edinburgh 1772–85. JS

□ W. M. Merchant in *Journ. Warburg and Courtauld Inst.*, XVII (1954), 385–6; S. Booth in *Journ. Warburg and Courtauld Inst.*, XXXII (1969), 332–43; J. D. Macmillan in *Burl. Mag.*, CXII (Jan. 1970), 23–30; Irwin (1975)

Ruralists, Brotherhood of An association of painters formed in 1975, on 19c. models, to work together in the countryside. Their ideals have been rustic and their approach a kind of fey realism. Among the original members were Peter BLAKE, Jann Haworth, Graham Arnold, David Inshaw (b.1943) and Graham Ovenden (b.1943). DB

□ N. Usherwood, *The Ruralists* (exh., Bristol, Arnolfini, 1981)

Ruskin, John (1819–1900), critic and social thinker, possessed the most brilliant mind ever brought to bear by an Englishman on the visual arts. His intellectual energy, range of response, profundity of insight and literary powers were prodigious. To find his equal it is necessary to turn to the great novelists and historians of the 19c., not to other art critics. Yet with it all, Ruskin was self-absorbed, prejudiced, utopian and domineering. Working as he did against the grain of society and expecting more of his

fellow men than they were able to give, he remained to some extent an isolated figure. He was, of course, far more than an art critic. However, he was a critic first and foremost, of nature, society and economic arrangements just as he was of painting, sculpture and architecture.

His father was a sherry merchant and Tory, his mother a strict Evangelical Christian, who together gave their gifted only son a cosseted, disciplined childhood in the then new South London suburb of Herne Hill. The Bible was the basis of Ruskin's education and he learnt large parts of it by heart. His other early influences were, first, nature, which he absorbed on tours of the countryside round Britain and abroad with his parents, and, secondly, art, which reached him chiefly in the form of drawn and engraved picturesque views by and after TURNER and other early 19c. British landscapists; although he visited the nearby Dulwich Gallery, he responded to the old master paintings there only superficially. Educated at home until the age of 18, Ruskin took a degree at Oxford in 1841. Long before this, however, he had begun writing poetry, studying drawing, sending communications to learned journals on geological and meteorological subjects, and had published his first book, *The Poetry of Architecture* (which is mainly about cottages). Still more, he had been unconsciously preparing himself to write an impassioned defence of Turner (*see* BRISTOL SCHOOL), *Modern Painters*, vol. 1 (1843). This book is a hymn of praise to both Turner and nature and to the one as the supreme pictorial interpreter of the other. The key aesthetic doctrine expressed in it is that truth to nature is the single most important quality of a work of art, above beauty, harmony, expressive power or anything else. Truth, moreover, is to be distinguished from imitation, which is mere deception of the eyes and can 'only be of something material', whereas 'truth has reference to statements both of the qualities of material things, and of emotions, impressions and thoughts'.

During the next dozen years, moral values, already implicit in Ruskin's choice of the word 'truth', came to dominate his art criticism and served as a link with his later social criticism. Before writing *Modern Painters*, vol. II (1846), he studied painting in Florence intensively for the first time and decided that the Italian masters of the 14c. and 15c. were superior to

Ruskin, *Study of Gneiss Rock at Glenfinlas*, watercolour, 1853 (Oxford, Ashmolean).

those of later periods because their treatment of religious subject-matter was more honest. By the same token, as he argued in *The Seven Lamps of Architecture* (1849), Gothic architecture was more admirable than classical architecture and its later derivatives because it was more spiritually orientated and because, in its forms and its use of materials, it does not tell lies. In *The Stones of Venice* (1851–3), Ruskin used the same process in reverse in order to write the spiritual and moral history of an entire city. Each stone is not only a material object but evidence both of the state of mind of the workman who carved it and of the temper of Venetian society at the time. Like most people in the 19c., Ruskin believed that Venice declined and fell, not because of economic factors or the actions of external enemies, but through pride and the love of luxury; for him, the substitution of the 'pagan' Renaissance style for the 'Christian' Gothic bore witness to this fact.

After completing *The Stones of Venice*, Ruskin returned to the subject of painting. He sorted through the Turner Bequest (the artist having died in 1851) and wrote several more books wholly or partly concerned with Turner, including the last 3 volumes of *Modern Painters* (1856–60). During the 1850s he also championed the PRE-RAPHAELITES (*see also* BRETT *and* BURNE-JONES) and influenced Holman HUNT. In 1858, however, in Turin, Ruskin experienced what has been called his de-conversion. Comparing the meanness of the Waldensian church service with the sensuous magnificence of Veronese's *Last Supper* in the Turin Gallery, he found that he could no longer remain convinced that Protestantism was always right and Roman Catholicism always wrong, or that to be a great artist it was necessary to be a morally good man. He also abandoned his belief in truth to nature as the primary artistic quality, and, although he continued to write movingly about art almost to the end of his life, the urgency had gone out of his message. He now concentrated mainly on social questions.

Taking up the theme first developed in the central chapter of *The Stones of Venice*, 'The Nature of Gothic' – that the modern factory system, by substituting mass-production by machine for individual craft skills, destroyed the humanity of those who worked under it – Ruskin launched a massive attack on *laissez-faire* capitalism. From 1855, when he began teaching at the Working Men's College in London, until the 1870s, when he founded the Guild of St George in Sheffield, he was ceaselessly engaged in persuading his countrymen to change their values: to prefer co-operation to competition, beauty to ugliness and the pursuit of goodness to the making of money. He taught drawing to carpenters, not to turn them into artists, but to make them more contented carpenters. His scheme for the Guild of St George, an idealistic community based on shared wealth, included a museum. As these examples show, Ruskin aimed to reform society by changing men's hearts and minds, not by getting Parliament to pass laws or by advocating the overthrow of the class structure; thus, while he became a communist in economic matters he remained politically a Tory.

Ruskin's private life was punctuated by a series of intense but unconsummated love affairs, one of which led him in 1848 into a disastrous marriage, annulled after 6 years, with the future Effie Millais. In the 1870s he began to suffer bouts of acute depression and from 1890 until his death was incurably insane. MK
□ *The works of John Ruskin*, ed. E. T. Cook and

A. Wedderburn (1903–12); K. Clark, ed., *Ruskin today* (1964); J. Dixon Hunt, *The wider sea: a life of John Ruskin* (1982); *John Ruskin* (exh., Arts Council, 1983)

As a watercolourist and draughtsman Ruskin was active throughout his life. He was given instruction in a picturesque approach by Copley FIELDING and later J. D. Harding (1798–1863), but in his mature work the main influences were his idol Turner and his own geological and scientific interests. Though his views of mountains can be broad and atmospheric, his most characteristic work is intensely observed and imbued with great knowledge of the structure of natural forms and architecture. The reverence towards nature which the watercolours reveal allies them to Pre-Raphaelite attitudes. DB

□ P. Walton, *The watercolours of John Ruskin* (1972); *John Ruskin* (exh., Manchester, Whitworth, 1982)

Rysbrack, detail of the monument to Sir Isaac Newton in Westminster Abbey (designed by Kent), 1731.

Rysbrack, John Michael (1694–1770) was the most outstanding of the Flemish sculptors working in England from about 1720, a view reflected in the detailed notes by VERTUE who evidently knew him well. The son of a landscape painter, he was born in Antwerp where he trained under Michel van der Voort, through whom he acquired an understanding of the rich tradition of Netherlandish Baroque sculpture based on the work of Duquesnoy, Faydherbe and Quellin. His extensive collection of PLASTER casts, models and prints showed that he was also well acquainted with antique and contemporary Roman sculpture, though he apparently never visited Italy.

Rysbrack came to England with an introduction to the architect James Gibbs. By 1723 Vertue was able to list a number of substantial works, including a classical relief of *The Roman Marriage* (London, Kensington Pal.) and a bust of Daniel Finch, Earl of Nottingham (priv. coll.: *see* ★SCULPTURE: EARLY 18C.). The Finch portrait is a remarkable combination of idealized nobility and precise observation, as well as being the first English bust to follow the Roman Republican pattern. By contrast, his bust of Gibbs (1726; London, St Martin's in-the-Fields) is a grand late Baroque image in which the full wig and the broad diagonals of the drapery reveal the sculptor's Antwerp background. Rysbrack's sculptural style may

be characterized as a blend of classical and Baroque elements.

In 1721 Rysbrack was employed by Gibbs to execute the figures on the Matthew Prior monument (London, Westminster Abbey) and continued to collaborate with him during the 1720s. By 1730 he was working with KENT, most notably on the monuments to Sir Isaac Newton (completed 1731; Westminster Abbey) and the Duke of Marlborough (1732; Blenheim). The Newton, with its strength of portraiture and accomplished handling of Baroque drapery, is among the most distinguished of 18c. English monuments. Rysbrack was now much patronized by the Earl of Burlington, who turned to him from the less talented GUELFI. The figures of Inigo Jones and Palladio at Chiswick House are the most important of many historicizing figures and busts – including the busts of British 'worthies' for the garden buildings at Stowe – executed during the 1730s.

Rysbrack also made chimneypieces and reliefs for Palladian interiors. Sometimes, as at Clandon Park, these compositions were based directly on engravings of antique sculpture; in other cases (London, East India Office) he drew on a variety of Baroque sources to create original compositions in the tradition of Flemish relief sculpture. His originality as an artist appears clearly here and in the many

drawings of Biblical and classical subjects executed apparently for his own amusement.

During the 1730s his fame was at its height and he received many commissions for both monuments and busts, produced with the support of a number of assistants, among whom was VAN DER HAGEN. In 1732/3, in preference to SCHEEMAKERS, he was awarded the commission for the splendid bronze equestrian *William III* in Bristol. However, with the success of Scheemakers' Shakespeare monument (1740; Westminster Abbey) Rysbrack's commissions diminished. During the 1740s he worked on a group of virtuoso marble busts and terracotta figures of Rubens and Van Dyck and a statue of Hercules for Stourhead. His later monuments, such as that to Admiral Vernon (erected 1763; Westminster Abbey) show him responding to contemporary Rococo taste (*see* SCULPTURE: ROCOCO) and to ROUBILIAC's handling of drapery.

Rysbrack appears to have been a genial, realistic and hard-working man who was much liked by his fellow artists.

See *HAMILTON, GAWEN; TERRACOTTA. MB
□ Whinney (1964); M. Webb, *Michael Rysbrack* (1954); K. Eustace, *Michael Rysbrack* (exh., Bristol, 1982)

Rysbrack, Pieter *see* LANDSCAPE PAINTING: 18C.

S

St Albans Psalter (Hildesheim, St Godehard) One of the most splendid and influential manuscripts of the English 12c., with 40 full-page miniatures, mostly of the New Testament, preceding the text, 5 tinted drawings, and 211 historiated initials. Assembled by Abbot Geoffrey for Christina, anchoress of Markyate, and dateable *c.*1120–30, this PSALTER is the first extant English manuscript with a cycle of full-page miniatures (as opposed to

tinted drawings) since the early WINCHESTER SCHOOL in the 10c. The style is characterized by symmetrical compositions, solemn, hieratic, elongated figures set against different coloured background panels to render space, and an extensive use of purple, which betrays a considerable debt to Ottonian art. St Albans Abbey remained an important centre of illumination throughout the 12c. *See* *ILLUMINATED MANUSCRIPTS: ROMANESQUE *and also* BIBLICAL ILLUSTRATION. CMK
□ O. Pächt, C. R. Dodwell and F. Wormald, *The St Albans Psalter* (1960); Kauffmann (1975); Thomson (1982)

St Albans School The Benedictine abbey of St Albans (Herts.) was an important centre of book illumination in the 12c. The ST ALBANS PSALTER was produced there in the 1120s, and particularly under Abbot Simon (1167–83) the abbey patronized luxury book production. It is very likely that increasingly lay scribes and illuminators were employed to assist the monks. In the 13c. both illustrated manuscripts by the monk Matthew *PARIS and the WALL-PAINTINGS still extant in the nave of the abbey church indicate a continuing activity as a centre of painting. The goldsmith Walter of Colchester was a St Albans monk who, as well as executing many works for the abbey, collaborated with Elias of Dereham on the major commission of the shrine of St Thomas at Canterbury completed in 1220.

Many 13c. illuminated manuscripts, particularly a series of illustrated APOCALYPSES, were once attributed to a School of St Albans under the direction of Matthew Paris, on the grounds of the use of a similar tinted DRAWING technique. It is now generally considered that Matthew had no school and that the Apocalypse manuscripts were produced in other centres. After his death in 1259 there is little evidence for continuing artistic activity within the abbey itself, and subsequent occasional commissions involved artists from outside. *See also* IVORY CARVING; LAMBETH BIBLE. NM
□ C. Oman in *Trans. St Albans Archit. and Archaeol. Soc.* (1930–32), 215–36; Kauffmann (1975); Morgan (1982); Thomson (1982)

St Ives School A somewhat ill-defined group of 20c. artists named from a fishing port on the north coast of Cornwall which has provided motifs for painters for more than a hundred years; WHISTLER and SICKERT spent several

St Ives School: Lanyon, *Porthleven*, 1951 (Tate).

weeks there in 1883–4 and others followed, attracted by cheap living, a mild climate and the unusual clarity of light.

In 1939 Ben NICHOLSON and Barbara HEPWORTH moved to St Ives to stay with Adrian STOKES and his wife Margaret Mellis; they were followed by Naum GABO. All remained for the duration of the war, Gabo leaving for America in 1946 and Nicholson for Switzerland in 1958; Hepworth stayed for the rest of her life. In the later 1930s Nicholson's painting had been purely abstract, but within a year of settling in St Ives, partly under the influence of Alfred WALLIS, West Penwith (the area southwest of St Ives) began to appear in the imagery of his paintings. Somewhat later Hepworth's sculpture began to reflect the shape of the coastline, sea-worn rocks and menhirs of the area.

During and after the war other painters settled in the area, including W. Barns Graham (b.1912), John Wells (b.1907), Bryan Wynter (1915–75), Terry FROST, Patrick Heron and Roger HILTON; Peter LANYON was born in St Ives and lived there almost all his life. The work of these painters up to 1950 or so was figurative and frequently included the landscape, the sea and boats. Thereafter it became increasingly abstract, often suggesting rather than depicting specific motifs. Denis Mitchell (b.1912), who worked as an assistant to Hepworth from 1949 to 1960, often has references to landscape in his sculpture. Also associated with the St Ives School is the potter Bernard Leach, who lived there from 1920. DBr
□ *Cornwall 1945–1955* (exh., London, New Art Centre, 1977)

St Martin's Lane Academy is the name given to 2 successive and related organizations in St Martin's Lane, London, each basically a drawing and painting class run on democratic lines rather than an academy in the European sense, which between 1720 and the establishment of the ROYAL ACADEMY Schools in 1768 formed the prime training ground for English artists.

Its genesis lay in London's first academy, established in Great Queen Street in 1711 with KNELLER at its head. Internal bickerings led to THORNHILL replacing Kneller in 1716. In 1720 Thornhill in turn was deposed, by CHÉRON and John Vanderbank (1694–1739), and the academy moved to a room in St Martin's Lane. Within a few years it was apparently defunct. In the winter of 1734 it was reconstituted by HOGARTH in Peter Court, St Martin's Lane, using furniture inherited from Thornhill (his father-in-law). The engraver GRAVELOT was an influential master before his return to France in 1745; in 1746 the principal teachers were the painters Hogarth and HAYMAN, the chaser George Michael Moser (1706–83), and the sculptor ROUBILIAC. Under Hogarth's regime the academy was the centre of ROCOCO in English painting and sculpture. *See also* DASSIER; GAINSBOROUGH. BA
□ Hutchison (1968); *Rococo* (1984)

St Paul's Cathedral, London: monuments to commemorate national heroes of the Napoleonic wars (1792–1815) began to be erected after a parliamentary decision in 1796. Those executed by leading English sculptors of

the day, notably BACON, BANKS, CHANTREY, FLAXMAN, J. C. F. Rossi (1762–1839) and WESTMACOTT, have a consistent style representative of a new national school of sculpture. After the poor reception of the first monuments unveiled in 1802, control passed from the ROYAL ACADEMY to the COMMITTEE OF TASTE, which, with the idea of creating a hall of fame similar to the French Panthéon, authorized expenditure of £40,000 during 1802–12, after which interest in the project waned. AY
□ Whinney (1964)

Sandby, Paul (1730–1809) was the most versatile of the generation of topographical watercolourists flourishing in London in the 1770s and 1780s. Like his brother **Thomas** (1723–98) he trained as an Ordnance draughtsman, and worked on the survey of Scotland 1747–51. His early work, which includes lively etchings, is often satirical, though with figures, and sometimes whole landscapes, which reflect the French ROCOCO. Thomas became Deputy Ranger to the Duke of Cumberland at Windsor Great Park, and Paul also went to Windsor in 1751. From 1760 Paul lived in London, where he was closely involved with the successive plans for an academy of artists; he was a founder member of the ROYAL ACADEMY of which Thomas was first Professor of Architecture.

Throughout his career Paul Sandby used both WATERCOLOUR and bodycolour, and later in life he also worked in oil, though with less success. A series of large views of Windsor Castle and its surroundings, in watercolour and in bodycolour (1770s), illustrates his manner at its most impressive and charming. He was the

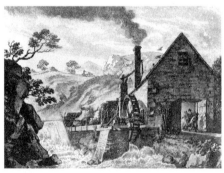

Paul **Sandby**, 'The Iron Forge between Dolgelli and Barmouth in Merioneth Shire', aquatint from *Welch Views*, 1776.

first professional artist in England to publish work in AQUATINT: *Twelve Views in Aquatinta from Drawings taken on the Spot in South Wales* (1775) was followed by North Welsh subjects which are among the first serious attempts to depict British mountain scenery. He was Chief DRAWING MASTER at Woolwich Military Academy 1768–96, and had numerous AMATEUR pupils and imitators. *See also* CLERK OF ELDIN. AW
□ W. Sandby, *Paul and Thomas Sandby* (1892); A. P. Oppé, *The drawings of Paul and Thomas Sandby . . . at Windsor* (1947); Williams (1952); Hardie, 1 (1966)

Sandys, Frederick (1829–1904) was a member of the circle around ROSSETTI and Swinburne. His paintings and drawings – portraits and Rossettian studies of women with legendary and mythological references – are mannered, highly finished, and deeply sensual in line, colour and content. *See also* WOOD-ENGRAVING. RT
□ B. O'Looney, *Frederick Sandys* (exh., Brighton, 1974)

Sargent, John Singer (1856–1925), the most fashionable ★PORTRAIT painter since LAWRENCE, was born in Florence of American parents and studied in Paris in 1874 with Carolus-Duran, whose academic realism he adopted. Studies of Velázquez, Hals and advanced French painting led him to work directly from nature, and he early showed striking virtuosity. Until 1884 he worked in France, but after a failure at the Salon came to England, eventually settling in London. Paradoxically, his early English years represent the flowering of his Impressionist style, in which he emulated the *plein air* method, immediacy of touch, thick impasto and high key of Monet in such paintings as *Carnation, Lily, Lily, Rose* (1885–6; Tate), which nevertheless remain essentially academic.

His reputation as a portrait painter began to grow and from the late 1880s onwards he accumulated a wealthy clientèle. His success was due to the fluency and vividness of his portrayal and his acute sense of social distinction, capturing the aspirations of plutocrat and aristocrat alike. Though superficiality was always his enemy, at his best he could suggest humanity and character behind the façade. After 1900 his portraits tend to carry less conviction (as he himself was aware), and

his slick recreations of the 18c. grand manner portrait can prove tiresome.

By the end of 1906 he could afford to release himself from the chore of commercial portrait painting, and confined himself to landscape, charcoal sketches, and the monumental projects he had undertaken for Boston, especially the murals for the Boston Public Library (1889–c.1915). In 1918 he had a brief period as a war artist, producing the monumental *Gassed* (London, Imperial War Mus.).

Camille Pissarro summed him up as 'an adroit performer', and he was despised by the avant-garde, yet at all periods there are paintings which show what he might have been if he had possessed more artistic stamina.　DB
□ R. Ormond, *Sargent* (1970); J. Lomax and R. Ormond, *J. S. Sargent and the Edwardian age* (exh., Leeds/NPG/Detroit, 1979)

Sartorius, John Nost (1759–1828) was the most productive member of a family of SPORTING artists. He and his grandfather **John** (1700–1780), father **Francis** (1734–1804), and son **John Francis** (1775–1831) responded competently to the steady demand for unadventurous sporting pictures.　SD
□ Waterhouse (1978)

Sarum Illuminator or **Sarum Master** A manuscript painter working in the mid 13c. in Salisbury, then an important centre of both painting and sculpture. He was the leading exponent of the mature Early Gothic style before it was transformed by influences from France in the 1260s.

His main works are 2 PSALTERS for the nearby nunneries of Wilton and Amesbury (London, Roy. College of Physicians; Oxford, All Souls College), a Missal for Henry of Chichester, precentor of Crediton (Manchester, Rylands Lib.: *see* *ILLUMINATED MANUSCRIPTS: GOTHIC), a Bible for Thomas de la Wile, the Master of the Salisbury schools (1254; BL), and probably an APOCALYPSE (Paris, BN). He favoured dramatic, monumental compositions, suggesting connections with wall-painting. He worked in full painting and, if the Apocalypse can definitely be attributed to his hand, also practised tinted DRAWING.　NM
□ A. Hollaender in *Wilts. Archaeol. and Nat. Hist. Mag.*, 50 (1943), 230–62; Marks and Morgan (1981), 14, 54–61

Saunders, Helen *see* VORTICISM

Sayers, James (1748–1825) is notable for his caricatures of the Fox-North coalition in 1783–4, for which Pitt rewarded him with a sinecure position. Composed with a profusion of wiry etched lines, his work influenced GILLRAY and heralded the great age of the English caricature.　RG
□ M. D. George, *English political caricature* (1959)

Scarfe, Gerald (b.1936) is a CARICATURIST whose virtuoso penwork can stretch the depiction of a well known face to the limits of grotesque distortion. His work has disgust and despair as its guiding force. In his early career his drawings were published by *Punch* and *Private Eye*; since 1967 he has been the regular cartoonist of the *Sunday Times*.　RG
□ G. Scarfe, *Gerald Scarfe* (1982)

Scheemakers, Henry *see* CHEERE

Scheemakers, Peter (1691–1781) was the son of an Antwerp sculptor in whose studio he was apprenticed. He probably worked later in Copenhagen and Rome, and arrived in England about 1720, perhaps as an assistant of

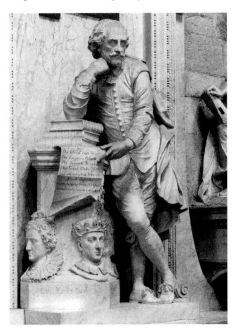

Scheemakers, monument to Shakespeare in Westminster Abbey, 1740.

PLUMIER. Following the latter's design he executed, together with DELVAUX, the monument to the Duke of Buckingham in Westminster Abbey, London (1721). Both Scheemakers and Delvaux worked for a time with BIRD, but by 1725 they were working as an independent partnership on the monument to the Earl of Rockingham (Rockingham, Northants.). In 1728 they left for Italy. Scheemakers returned c.1730 with models after the antique from which he supplied PLASTER CASTS. His familiarity with Roman portrait sculpture is evident in the busts for Lord Cobham at Stowe, with their close-cropped hair and classical armour and drapery. In the 1730s he and Rysbrack worked as rivals, competing directly for the equestrian statue of William III at Bristol. Scheemakers' unsuccessful design was executed in LEAD and erected at Hull in 1734. His celebrated monument to Shakespeare (1740; Westminster Abbey) ensured a steady stream of commissions for monuments, mostly executed by his large studio. MB
□ Whinney (1964)

Scheerre, Herman was the most influential illuminator active in London in the early 15c. His name, which occurs in full in a manuscript in the BL (Add. 16998), is Netherlandish, and his stylistic affinities are chiefly with Flemish miniaturists. His habit of incorporating his name or motto in the background decoration of his miniatures helps identify his work, though the motto was also used by other members of his atelier. There is no certain documentary reference to him: he may be the 'Herman lymnour' mentioned in 2 wills of 1407.

His most important works are the dedication page of the Beaufort Hours (c.1404–7; BL), additions to a BOOK OF HOURS imported from Flanders (after c.1410; Oxford, Bodleian, MS Lat. liturg.f.2), and some of the initials in the Bedford Psalter and Hours (c.1414–23; BL). His work is marked by a delicate refinement and sense of harmony, especially in his choice of colours, which would have been attractive to his aristocratic clientèle. In the hands of his many imitators his style easily became coarse or vapid. See *ILLUMINATED MANUSCRIPTS: GOTHIC *and also* INTERNATIONAL GOTHIC. NR
□ C. L. Kuhn in *Art Bull.*, XXII (1940), 138–56; Rickert (1965); Marks and Morgan (1981)

Scott, David (1806–49), son of an engraver in Edinburgh and brother of W. B. SCOTT, trained at the Trustees' Academy. Like HAYDON he devoted his life to the cause of HISTORY painting, but though he earned the admiration of the younger generation for his single-mindedness, he was disappointed by the world's reluctance to recognize his talents. DM
□ W. B. Scott, *Memoirs of David Scott* (1850); J. M. Gray, *David Scott* (1884); Caw (1908); Irwin (1975); Hardie (1976)

Scott, Samuel (1702–72) played an important part in the development of MARINE PAINTING in England. His early sea pieces were closely based

Samuel **Scott**, *A Morning, with a View of Cuckold's Point*, c.1760 (Tate).

on VAN DE VELDE compositions, but when he turned to depicting the Thames he developed a characteristic style inspired by CANALETTO's views. Scott's pictures of London's bridges and waterfront are notable for their keen and often humorous observation of human activity, their meticulous architectural detail, and their sensitive portrayal of light and atmosphere. *A Morning, with a View of Cuckold's Point* (Tate) is typical. *See also* *LANDSCAPE: 18C. DC
□ R. Kingzett in *Walpole Soc.*, XLVIII (1982)

Scott, Tim *see* NEW GENERATION SCULPTURE

Scott, William Bell (1811–90) was, like his brother David SCOTT, a HISTORY painter. An associate of the PRE-RAPHAELITES, he taught in Newcastle and produced a series of murals at Wallington (Northumb.) *c.*1855–60. WV
□ W. Scott, *Autobiographical notes*, ed. W. Minto (1892)

Scottish Colourists is the name given, retrospectively, to the 4 Scottish artists J. D. Fergusson (1874–1961), S. J. Peploe (1871–1935), Leslie Hunter (1877–1931) and F. C. B. Cadell (1883–1937) who, particularly in the years before 1914, produced painting remarkable for its freedom and richness of colour. All had close links with French painting, but their approach was conditioned by the bold handling and colour of Scottish artists of the late 19c., e.g. Arthur Melville (1855–1904) and MCTAGGART. This background attracted them to Fauvism, whose influence is apparent in such paintings as Fergusson's *The Blue Hat* (1919; Edinburgh, City AG) and Peploe's *Boats at Royan* (1910; Edinburgh, NGS). They continued to work in an idiom close to Fauvism, though Fergusson, inspired by the Russian Ballet, evolved a more modernistic style (e.g. *Les Eus*, 1910–11; Glasgow, Hunterian). DM
□ T. J. Honeyman, *Three Scottish Colourists* (1950); M. Morris, *The art of J. D. Fergusson* (1974); Hardie (1976)

Scottish medieval art In the early Middle Ages what is now Scotland was occupied by culturally distinct peoples: Picts, Britons, Scots (Gaelic-speakers, originally from Ireland), Angles and, from the 9c., Vikings. PICTISH art and the CROSSES of the Irish monastery on Iona show the 'Hiberno-Saxon' mingling of Celtic and Anglo-Saxon influences that can be seen

elsewhere in Britain and Ireland (see ANGLO-SAXON ART: EARLY). Pictish artistic traditions seem to have been submerged fairly quickly after the Scots established political control over most of Scotland in the mid 9c. The art of the following 2 centuries is largely obscure, but earlier conventions survive in sculpture of declining quality. Irish influences were also important, and can be seen e.g. in the 10c. Book of Deer (Cambridge Univ. Lib.) or the sculpture on the round tower at Brechin.

During the 11c. and 12c. wider contacts were established, especially after Malcolm III married the Anglo-Saxon princess St Margaret, *c.*1070. The royal family, and outstandingly Margaret's son David I, who lived until 1153, encouraged the modernization of the Scottish church and opened Scotland to the reformed monasticism of England and France. During the 12c. and 13c. many major churches were built, decorated and equipped, largely in the current English ROMANESQUE and then GOTHIC styles, to judge from the relatively meagre survivals, which are often of high quality (e.g. the 12c. sculpture of Jedburgh Abbey, or the illuminated charter of 1159 from Kelso (Duke of Roxburghe, deposited in Edinburgh, Nat. Lib. of Scotland). Decorated books and metalwork were also often imported from France and England. Native Hiberno-Scottish styles enjoyed little favour during these centuries.

The dynastic crisis and subsequent Wars of Independence which followed the death of Alexander III in 1286 help to explain the sparse evidence of artistic activity during much of the 14c. Improved conditions led to a revival of artistic patronage in the 15c. and 16c. Collegiate churches, parish churches, chapels, universities and secular buildings now attracted more patronage than monasteries. In addition a greater number of privately owned books, especially BOOKS OF HOURS, survive from this time. Artistic styles owed much less to England and more to the Low Countries and to France. A distinct Scottish style, which tended to be rather heavy and often included marked archaisms, can be seen in much architecture and sculpture. Sculpture ranges from the sophistication of Melrose (rebuilt after 1385), where a statue of the Virgin and Child is reminiscent of the elegant work of 14c. France, to the almost barbaric profusion of heavy-handed but lively carving at Roslin, *c.*1450. As before, many works of art, some specially commissioned,

Carvings in Roslin Chapel (Lothian), c.1450, a late example of **Scottish medieval art**.

Scottish painting The existence of distinct literary and intellectual traditions in Scotland is generally acknowledged, but a Scottish tradition in the visual arts is less frequently recognized. Sir James Caw (1908) was the last writer seriously to attempt to identify its characteristics, but he did so in the light of the achievement of the painters of the preceding generation and of Raeburn, and so missed the close association of painting with other aspects of Scottish intellectual and imaginative life.

In the late 15c. and 16c. Scotland's natural alignment was with her closest trading partners across the North Sea. This resulted in such commissions as the Trinity College altarpiece by Hugo van der Goes (Edinburgh, NGS), painted for an Edinburgh church in the 1470s. The political alliance with France against England was reflected in the French Renaissance character of Falkland Palace and other buildings erected by James V from c.1540. After the abdication of Mary, Queen of Scots in 1567 this French connection was broken and Scotland was firmly associated with the north European Reformation. The vernacular art and architecture of the reign of James VI (1567–1603), as seen in the painted ceilings of Pinkie House and Crathes Castle as well as the townscapes of Fife, clearly show these links. The court painters of the time, like Arnold Bronckhorst (fl. 1565–83) and Adrian Vanson (fl. 1581–1602), were of Netherlandish origin. William Gouw FERGUSON, a Scot, worked in Holland, while the leading painter in Scotland after the Reformation was Jacob de Wet (1640–97), a Dutchman. Throughout the 17c.,

were imported from abroad. From Flanders came most notably panels by Hugo van der Goes (Edinburgh, NGS) and the Hours of James IV and Margaret Tudor (Vienna, Österr. Nationalbib.); and from France 2 magnificent university maces at St Andrews and many books. Surviving Scottish work often imitates the imports and includes illumination (often rather naïve), woodwork (with paintings at Foulis Easter and Guthrie) and metalwork.

The new Renaissance styles began to be preferred to the Gothic from around 1540, when they appeared in the decoration of the palaces of James V. The Reformation ended the conditions in which Scottish medieval art had been patronized and Reformation iconoclasm and numerous earlier sackings have left us with a misleadingly impoverished view of the art of medieval Scotland.

In the culturally distinct Gaelic west of Scotland, an area whose affinities were more with Ireland than with the rest of Scotland, a largely independent style preserving many archaisms, some even originating in the Hiberno–Saxon style, appears in the later Middle Ages, principally in sculpture and metalwork. JH

□ J. R. Allen and J. Anderson, *The Early Christian monuments of Scotland* (1903); W. N. Robertson, 'Late 15c. church paintings from Guthrie and Foulis Easter', in *Proc. of the Soc. of Antiquaries of Scotland*, 95 (1961–2), 262–79; J. S. Richardson, *The medieval stone carver in Scotland* (1964); K. A. Steer and J. W. M. Bannerman, *Late medieval monumental sculpture in the West Highlands* (1977); *Angels, nobles and unicorns* (exh., Edinburgh, Nat. Mus. Antiquities of Scotland, 1982)

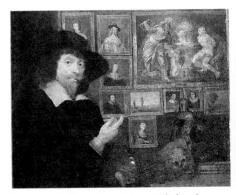

Jamesone, *Self-portrait*, c.1637–40 (Edinburgh, Scottish NPG).

in keeping with the values of the Reformation, there was no painting that could be called Baroque, though the success of the most important native-born painter of the century, George JAMESONE, is evidence that the arts were not undervalued.

The single most important legacy of the Reformation, iconoclasm and the destruction of Scotland's medieval heritage, might seem to suggest that Protestant fanaticism found an ally in some deep-seated philistinism. In fact, however, more than a century of sporadic civil war, and social, political and economic changes all contributed to the loss over a long period of both ecclesiastical and secular art and architecture. The removal of the crown in 1603 left little motive for royal investment, and the Act of Union in 1707 completed the drift of political influence south. In place of the structures of full political statehood, Scotland developed a bourgeois society based on the personal and intellectual values of Protestantism. The consequences are apparent in the development of a distinctive Scottish portraiture, first in the austere painting of William Aikman (1682–1731) and later in that of *RAMSAY.

Ramsay's background in Edinburgh was the same as that of the architect Robert Adam. The fathers of both men were involved in the attempt to establish the first Scottish art institution (St Luke's Academy, 1729), and the status of the visual arts in post-Union Scotland was very much an issue in their circle. Though Ramsay made his career mostly in England in the 1740s–60s, he kept very close links with Scotland, and the values inherent in his painting, which closely match the humane empiricism of the philosophy of his friend David Hume, clearly belong to the Scottish Enlightenment.

Ramsay's contemporary, Gavin HAMILTON, was likewise part of the Scottish intellectual tradition. Hamilton's approach to painting, as shown in his pictures from *The Iliad*, was shaped by Thomas Blackwell's writings on Homer in which he pioneered the ideas of Scottish primitivism (the conception of the superiority of art at the earliest stage of the development of human society), and the writings on antique painting of Blackwell's associate, George Turnbull. Hamilton became the pioneer of a primitivist interpretation of painting which profoundly influenced the younger generation, especially Alexander and

Gavin Hamilton, *Achilles lamenting the Death of Patroclus*, 1763 (Edinburgh, NGS).

John *RUNCIMAN. Ossian's Hall of 1772 at Penicuik (destroyed) by Alexander Runciman was the earliest expression in painting of a number of important Romantic ideas, in particular spontaneity and the imaginative identification of poetry and landscape. Runciman's links are not only with Hamilton, but also with the younger generation in literature, typified by the vernacular poet Robert Fergusson, and their new ideas about the importance of the national tradition of poetry and of song.

It was another associate of Hamilton in Rome, David ALLAN, who first interpreted these ideas through the medium of genre. Significantly, towards the end of his life he cooperated with Robert Burns, producing illustrations to his Scots songs.

The successors to Runciman and Allan were the pioneers of a national school of landscape painting – Alexander *NASMYTH, for a short period Jacob MORE, and in the younger generation John THOMSON – and the artists who developed mature Scottish genre, notably Alexander Carse (d.c.1838), Walter Geikie (1795–1837) and above all WILKIE. Their connections with contemporary literature, especially with Walter Scott, were close.

The heir to Ramsay in portraiture was *RAEBURN. Though his methods were different, from the 1780s to 1820 he developed Ramsay's essential qualities of honesty and directness in a way that marked him too not only as a painter of Enlightenment figures but as an equal member of that movement. Raeburn in turn passed those values on to the next generation of portraitists, e.g. John Watson Gordon (1788–1864), and also to painters in other modes. Both the strength of Wilkie's naturalism and the freedom of Thomson's

Wilkie, *The Letter of Introduction*, 1813 (Edinburgh, NGS).

painting are inconceivable without the force of Raeburn's example.

Wilkie acknowledged his debt to Raeburn quite unambiguously in his youthful *Self-Portrait* (Edinburgh, NGS), but he asserted his independence at an early date. His naturalism was far more analytical than Raeburn's and seems technically closer to Ramsay – perhaps through Alexander Nasmyth, who had been Ramsay's assistant. It left a profound mark on Scottish painting, passing down to *ORCHARD-SON, John Pettie (1839–93) and other members of their generation through the teaching tradition of the Trustees' Academy in Edinburgh (Scotland's first permanent art institution, founded in 1760), and in particular Robert Scott LAUDER, who was appointed in 1852.

Wilkie's technical influence was matched by that of his subject-matter. His genre idiom was continued (though in a trivialized form) by such mid 19c. painters as Sir George Harvey (1806–76), Erskine NICOL and the FAED brothers and younger men like G. P. Chalmers (1833–78). His idea of a national historical style, endorsed by the example of Walter Scott, inspired a number of painters including Sir William Allan (1782–1850), Thomas Duncan (1807–45) and James Drummond (1816–77).

Like Scottish literature, Scottish painting reveals a deep preoccupation with the question of national identity. This is clearly evident in history and genre, but it also played a part in the development of landscape painting. The historical and poetic associations of landscape were an essential part of the art of Alexander Nasmyth, and the basis of Thomson's expressive style. The distinctive character of Scottish scenery was explored too by the generation of painters born after 1800, inspired by Thomson as well as by Scott. Horatio MCCULLOCH had by his death in 1867 created the essential iconography of the Highlands. William *MCTAGGART, 30 years younger, was devoted to portraying only Scotland, but in a quite new way, expressing his subjective experience of the light and life of its scenery. His approach to landscape, with its freedom of colour and handling, continued to inspire painters, including S. J. Peploe (1871–1935), Sir William Gillies (1898–1973), and his own grandson, Sir William McTaggart (1903–80), well into the 20c., and finds close analogies in the novels of Neil Gunn.

Not all Scottish painters were concerned only with Scotland, however. A number were travellers: David *ROBERTS and Hugh William Williams (1773–1829) successfully adapted the historical landscape idiom to record exotic places, and John PHILLIP followed Wilkie to seek new subjects in Spain. The internationalism characteristic of Scottish art in all periods was maintained. Rome throughout the 18c. and early 19c. had a lively Scottish artistic colony. David SCOTT and William *DYCE, who were in different ways concerned with the spiritual significance of painting, both came into contact with the German Nazarenes there in the early 19c. In the 1860s Holland became an important source of influence.

McCulloch, *Glencoe*, 1864 (Glasgow).

Henry, *A Galloway Landscape*, 1889 (Glasgow).

George Reid (1841–1913) studied there, and the example of Joseph Israels was crucial for several of Scott Lauder's pupils, especially Chalmers.

If contemporary Dutch art was an important stimulus for the sudden and dramatic flowering of painting in Glasgow in the later 19c., another vital influence was France. Many Glasgow painters studied in Paris, and the GLASGOW SCHOOL was consciously international in outlook. This internationalism, building on a strong native tradition, resulted in one of the most brilliant episodes in British 19c. painting. The achievement of the Glasgow artists in the last 2 decades of the century, ranging from the forceful Impressionism of Sir James Guthrie (1859–1930) and W. Y. MacGregor (1855–1923) to the precocious Post-Impressionism of George HENRY and Arthur Melville (1855–1904), was a formative influence on the SCOTTISH COLOURISTS, who continued the close connection with French painting to create a kind of Scottish Fauvism.

Internationalism was hard to sustain in the economic depression that hit Scotland so severely after 1918. The subjective colourism that marks the painting of a number of artists of the post-war generation, such as Anne Redpath (1895–1965), reflects insecurity in their relationship to wider modernism. On the other hand, William Johnstone (1898–1981) and James Cowie (1886–1956) both showed themselves able to forge a distinctive kind of painting out of a dialogue between modernism and the native tradition. Johnstone was a close friend of the poet Hugh MacDiarmid, and so the long association of Scottish poetry and painting was continued – not only in his major paintings of the inter-war years but also in his later abstract landscape style. Like Johnstone, Joan Eardley (1921–1963) created a wholly modern idiom that has deep affinities with older traditions in Scottish painting, and so it is possible to talk of the continuing vitality of a Scottish tradition right down to the present day. DM
□ Caw (1908); Irwin (1975); Hardie (1976)

screenprinting was well established as a commercial printing process before it became popular with English artists in the 1960s. It is a species of stencil printing, the ink being forced onto the paper through a silk screen that has been partially masked with stencils or treated in other ways with liquid or photo-stencils. Its ability to print sharply defined edges and incorporate photographic imagery recommended it to POP artists and hard-edge abstractionists in the 1960s. It was given great impetus by the virtuoso printing skills of Chris Prater at Kelpra Studio, who formed fruitful partnerships with KITAJ and PAOLOZZI amongst others. *See also* PRINTMAKING. RG
□ Griffiths (1980)

screens of wood or stone were used in medieval churches to separate various liturgical areas. While their form might be similar, the decoration of stone screens was chiefly sculptural, while wooden screens were often enriched with PANEL PAINTINGS.

Wooden screens comprise parclose screens, enclosing chapels, and the more important rood screens, which formed the division between nave and chancel and bore the rood – Christ on the cross, usually flanked by the Virgin and St John (*see* SCULPTURE: GOTHIC, WOOD). Their traceried forms followed the development of architectural styles throughout the medieval period. No paintings are preserved on surviving 13c. or 14c. screens, but a number of 15c. and 16c. screens with dados adorned with paintings escaped iconoclasm and neglect, especially in East Anglia and the West Country. Their workmanship is often crude, but they can frequently be dated from inscriptions or documentary evidence, and they provide a valuable illustration of the devotional interests of late medieval England, usually featuring the Apostles and other popular saints, including local and unofficial ones.

The most important of the Norfolk screens is that at Ranworth, which extends across nave and aisles. It is also the most problematic, and has been variously dated between the 1430s and the end of the 15c.; an early dating is to be preferred. Close in date (1440s), and of equally high quality, is the main screen at Barton Turf. Of the later Norfolk screens those at Ludham (1493) and Cawston are outstanding. Many of the Suffolk screens, most notably the mid 15c. one at Southwold, can be assigned to the Bury St Edmunds School of artists, who preferred soft, modelled forms to the linear style favoured in Norfolk. Devon screens, largely 16c., are of poor artistic quality and primarily of iconographical interest. *See also* ★WELSH MEDIEVAL ART. NR

□ F. Bond, *Screens and galleries in English churches* (1908); W. G. Constable in *Connoisseur*, 84 (1929) (good for illustrations only); Rickert (1965), 186–9

Stone screens were used to separate the nave from the choir in cathedrals and abbey churches and occasionally also in parish churches. Unlike rood screens, in large churches choir screens or pulpitums did not always bear the rood, and were usually solid rather than transparent structures, allowing more room for sculpture.

The best surviving examples are of the 15c., at Canterbury (c.1411–30) and York (c.1480–1500). The earlier screens, e.g. Salisbury, only exist in fragments. These 3 all had standing statues of the kings of England, an English equivalent of the 'kings' gallery' on the

Wooden **screen** in Ranworth church, c.1430–50?

façades of 13c. French cathedrals, in marked contrast to the series of Apostles and saints painted on timber rood screens.

Smaller stone screens in parish churches (e.g. Stebbing, Essex, c.1340) seem mostly to have served as an architectural framework in which the Crucifix could be placed. NM

□ A. Vallance, *Greater English church screens* (1947); Stone (1972), 204, 220

Scrots, Guillim (fl. 1537–53) was painter to the Regent of the Netherlands from 1537 and a salaried painter to HENRY VIII and Edward VI 1546–53. His portrait of Edward VI in profile (NPG) is painted using deliberately distorted perspective (anamorphosis) and must be viewed at right angles (almost parallel to the picture plane) through a hole cut into the frame for a recognizable image to emerge. Several versions of full-length portraits of Edward VI and the Earl of Surrey associable with payments to Scrots survive, and show formats related to Habsburg court portraiture, but are not necessarily autograph works. SF

□ Strong (1969)

sculpture *Anglo-Saxon sculpture*: see ANGLO-SAXON ART.

Romanesque sculpture began in England in a modest way amid intense building activity in the years following the Conquest. Like the early Anglo-Norman buildings, it followed contemporary practice in Normandy: it was in a restrained low relief, largely confined to

Stone **screen** in Canterbury Cathedral, c.1411–30.

geometric patterns and simple animal and figure subjects.

The closing years of the 11c. and the early decades of the 12c. saw a considerable advance in the attention given to sculptural decoration in England as on the Continent. The interest in narrative manifest in the *BAYEUX TAPESTRY is expressed in the surviving capitals from Westminster Hall and the cloisters of Westminster Abbey, London (Dept. of the Environment and Westminster Abbey Mus.). There is also clear evidence of a revival of pre-Conquest and Viking motifs, in particular the foliate ornaments of the WINCHESTER SCHOOL (e.g. in the crossing capitals at Milborne Port). It is the increase in the amount of sculpture, in addition to the growing complexity of the decoration, which characterizes early 12c. church building. That sculptors were aware of contemporary developments in WALL-PAINTING and ILLUMINATED MANUSCRIPTS throughout the Romanesque period cannot be doubted. The capitals of the crypt of Canterbury Cathedral, recently re-dated to c.1100, show in their decoration close connections with the products of the local scriptoria. The similarity between slightly later work at Durham and these capitals must be attributable to the acquisition by the northern monastery of Canterbury books.

It is undoubtedly because doorways represent a focal point in a building that they received increasingly lavish attention. Tympana especially offered a large field for both didactic and decorative designs, and they were enhanced by ornaments applied to the arches, the capitals and the jambs of the doorways themselves. (Examples include Dymock (Glos.), the Prior's Door at Ely, and Southwell.)

In conjunction with the elaboration of arch mouldings and stringcourses and the introduction of carved corbel tables, 2 decorative elements were of particular significance for the succeeding years of the Romanesque period in England. The first is the chevron, mainly applied to arches with varying degrees of relief and complexity and first used in Anglo-Norman architecture at Durham Cathedral c.1110–20. Unlike the zigzag, chevron ornament is essentially 3-dimensional even in its simplest form, and its occurrence at Cérisy-la-Forêt c.1090–1100 suggests that it was introduced into England from Normandy. The second feature is the use of animal-, human- and 'beak'-head motifs radially placed on the moulded orders of arches, introduced during the period c.1125–50 most probably from western France. While the chevron gained widespread popularity, examples of beak-head are less evenly distributed, being particularly favoured by sculptors in Oxfordshire and Yorkshire.

Although much sculpture has been lost, it is evident from what survives that demand in the 12c. led to the formation of workshops or (more rarely) schools of sculptors. One such school has been identified in Herefordshire, where the introduction of unusual iconographic and sculptural elements into the Anglo-Norman repertoire may be attributed to a pilgrimage c.1135 by Oliver de Merlemond, founder of the church at Shobdon, who crossed France on his way to Santiago de Compostela. The placing of figures on columns, enmeshed in foliate scrolls or interlace, as at Shobdon or the south door at Kilpeck is not known in earlier English stone sculpture. Those arranged one above the other on the chancel arch at Kilpeck (c.1150) have been compared with figures on the Puerta de las Platerías at Santiago, but the feature is also found in western France (e.g. at Maillezais). The Herefordshire style is also seen in *FONTS.

Capital in the crypt of Canterbury Cathedral, c.1100.

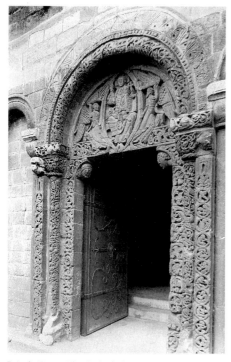

Prior's Door, Ely Cathedral, c.1130.

The contribution of Italy to the development of English Romanesque sculpture has long been recognized. Works executed by a school of sculptors in and around Northampton reveal a number of Italian elements. The doorways at Ely Cathedral, with their alternately square and round orders, closely resemble doorways in Pavia, and the use of lion and figure supports for the columns of the Prior's Door is also Italian. Such designs and motifs were absorbed into a local ornamental repertoire.

Unrelated to this group, but based at least in part on an Italian model, is the narrative frieze of Old and New Testament scenes on the west front of Lincoln Cathedral (c.1145). In execution and in certain iconographic details it recalls the frieze at Modena Cathedral (before 1120). Stylistically, however, Lincoln suggests other influences, especially the narthex at St Denis (1137–40) – an influence even more apparent in the 3 Romanesque west doorways, the date of which is still a matter of debate. It is clear they had neither the tympana nor the

array of column figures of the 'royal portals' of the Ile-de-France. English sculptors were slow to adopt the column figure: examples at Rochester Cathedral and elsewhere are no earlier than the 1160s. Those at Rochester are modelled on prototypes in the Ile-de-France and incorporated into an ensemble which includes decorative elements ultimately derived from Poitou.

The influence of western France and especially Poitou in the second half of the 12c. owes much to the uniting with England of the French lands of Henry Plantagenet. In south-eastern England these influences persisted into the last quarter of the century. In Yorkshire an important group of sculptors adopted not only the radial form of voussoir decoration but also a particular kind of corbel table where human heads are set in the arches above the corbels, a feature modelled on Notre-Dame-la-Grande at Poitiers (seen, e.g., at Barton-le-Street). From the Charente region English sculptors derived the practice of decorating an arch with figural and ornamental compositions disposed tangentially rather than radially, and enclosed in roundels, as at Barfreston (Kent) and the south porch door of Malmesbury (Wilts.). At Malmesbury (c.1160) the elongated figures in the medallions, with drapery in the form of incised band folds, and some of the ornamental details, originate in the Saintonge region of France. The iconography of the medallions, on the other hand, is strongly influenced by Anglo-Saxon manuscripts.

The draperies of the seated figures of Apostles on the side walls of the Malmesbury porch recall the strained folds of the Lincoln frieze. A different approach to the carving of draperies appears in 2 small sandstone panels at Durham (c.1160), which show perhaps the most sensitive translation into stone of the 'damp fold' style of the *BURY BIBLE and its derivatives.

Sculptors in the late Romanesque period were interested in producing compositions with a more complicated iconography, and through deeper undercutting and attention to surface detail they were able to execute refined carvings on a small scale (e.g. the BESTIARY scheme at Alne (Yorks.), c.1160).

There is no clear division between the end of the Romanesque period and the beginning of the Gothic, but new attitudes towards sculpture are evident in works executed in the last quarter of the 12c. Two main sources influenced this

Detail of the south porch door of Malmesbury Abbey, c.1160.

Figure of St John (?) from the chapter house of St Mary's Abbey, York, c.1180–90 (York, Yorkshire Mus.).

change: the manuscripts, metalwork and sculptures of northern France and the Mosan area, and contemporary manuscripts in England. Both figures and draperies are represented more naturalistically (e.g. in the doorways of the Lady Chapel at Glastonbury, c.1185), and this naturalism is reinforced by a predilection for more rounded, 3-dimensional forms (seen in fragments of the choir screen at Canterbury and the Much Wenlock lavatorium panels).

Similar trends appear in the north of England. The draperies of a fragmentary figure from Bridlington (c.1170; V&A) recall classicizing elements in such late 12c. manuscripts as the Copenhagen Psalter (Copenhagen, Royal Lib.). The further refinement of draperies and more naturalistic rendering of both form and detail in reliefs at York Minster (c.1180) reveal a debt to stylistic developments in northern France. The voussoirs and standing figures from St Mary's Abbey in York (c.1180–90; York, Yorkshire Mus.) show the influence of northern French and Mosan art at its clearest, and have much in common stylistically with the recently discovered cloister sculpture of Notre-Dame-en-Vaux at Chalons-sur-Marne (c.1180). JW

□ G. Zarnecki, *English Romanesque sculpture 1066–1140* (1951); id., *English Romanesque sculpture 1140–1210* (1953); id., *Studies in Romanesque sculpture* (1979); *1066: English Romanesque art* (exh., Arts Council, 1984)

Gothic stone sculpture in the 13c. and early 14c., although greatly indebted to French inspiration, is characterized by the individual manner in which French styles were interpreted and transformed by English sculptors. Court patronage was an important factor in the introduction of Continental influence and the spread of the traditions it generated, producing a complex pattern of inter-regional developments.

The years around 1200, often referred to as the Transitional period, are marked by a classicizing style which, in its more naturalistic treatment of figure and drapery, departed from the abstract conventions of Romanesque.

The 13c. saw a great increase in the use of sculpture, even though certain Romanesque features, like historiated capitals and figure-decorated FONTS, were largely abandoned. *ROOF BOSSES were developed as a field for figure and foliage sculpture and much use was made of figure heads for corbels and moulding

Figure of a king on the west front of Wells Cathedral, *c*.1225–50.

stops. Purbeck marble, a dark shell-limestone which could be worked to a high finish, was employed extensively for effigies and architectural details. Interiors were further enriched by the use of relief sculpture to fill the spandrels of triforia and wall arcades. Cathedral façades were designed to display large programmes of sculpture. Niche statuary was used to decorate choir SCREENS; and *TOMBS with carved effigies, which had been rare in the 12c., increased greatly in number and importance in the 13c. and early 14c. Sculpture was often richly painted and gilded throughout the whole of the Gothic period and, although most of the colour has been lost due to the combined effects of weathering and restoration, a certain amount of original polychromy survives, such as that on the Salisbury pulpitum and on some tombs.

The west front of Wells Cathedral, dating from the second quarter of the 13c., is an early example of the English preference for decorating façades with a screen of statuary. This arrangement, which may have had a forerunner in the late 12c. west front of York

Minster, is an implicit rejection of the French High Gothic layout in which sculpture was concentrated around the doorways. (Portals in the French manner were provided for the north transept at Westminster and the Angel Choir at Lincoln, but remained exceptional.) Wells has the most ambitious surviving programme of Gothic façade sculpture in England, including over two-thirds of its original complement of 176 life-size statues, a cycle of the Resurrection, and scenes from the Old and New Testaments. The sculpture shows a knowledge of developments in the Ile-de-France and has been related to a group of military effigies, of which the best known is that of William Longespee at Salisbury.

A new influence, from the atelier working at Reims *c*.1220–40, began to be felt in the 1230s. The connection is especially evident in the south transept angels at Westminster Abbey, executed early in the campaign of reconstruction begun by HENRY III in 1245, in which French artists are known to have participated. The fashion for heads with lifelike facial types and expressions, seen at Westminster in the triforium corbels, was a notable feature of the Court School, finding one of its best known examples in a head from Clarendon Palace (Salisbury and S. Wilts. Mus.).

Court sculpture of the 1260s, such as the effigy of Bishop Giles of Bridport (d.1262) at Salisbury, shows that English sculptors had adopted a version of the heavy, angular drapery style which first appeared in French sculpture *c*.1240. This development is reflected in the Angel Choir at Lincoln (*c*.1270), where the style was reinterpreted in a way which looks forward to the softer, billowy treatment seen in later sculpture in the north.

Stiff-leaf, a type of stylized foliage decoration developed in the Transitional period, was used widely throughout most of the 13c. and to a lesser extent in the early 14c. Foliage based on natural leaf forms, found at Reims before 1241, appeared at Windsor and Westminster in the 1240s; the classic examples, in the chapter houses at Southwell and York, date from *c*.1270–90. After *c*.1300 naturalistic foliage gave way to an undulating type of leaf decoration, seen at Exeter in corbels carved in 1303–4.

From the late 13c. a further expansion in the use of sculpture took place, to the point where, in small-scale works like screens, shrine bases and *EASTER SEPULCHRES, one of the main aims

of architecture was to present an elaborate sculptural display. In the DECORATED style corbel figures, caryatids and headstops became features of interest in their own right, often assuming a humorous or GROTESQUE character, and new ways of using sculpture were evolved, such as the figures in the choir triforium at Selby, represented as if actually seated on the parapet. Cathedral façades continued to be emphasized by screens of statuary, now combined with large traceried windows; and lesser churches were at times scarcely less lavish. At St Mary Redcliffe, Bristol, the polygonal north porch was given a continuous screen of statues under crocketted gables. Sculpture also became more common on external walls other than façades: St Andrew's, Heckington, is ringed with statues in buttress niches and further enriched with large projecting corbel figures. Of particular importance was the proliferation of statuary inside buildings, often in association with large displays of STAINED GLASS. In London at St Etheldreda's and at St Stephen's Chapel, Westminster, statues were placed between the windows in an arrangement recalling that of the Ste Chapelle in Paris. This trend was developed further at the Ely Lady Chapel (1321–49), where tiers of statuary filled all the available wall space above dado level. The highly imaginative use of interior sculpture at this period is exemplified by the presbytery of Wells, where the arcade spandrels

Detail of the Lady Chapel, Ely Cathedral, 1321–49.

and triforium were merged into a single zone of screenwork and statuary.

In addition to a greater profusion of sculpture, the late 13c. saw the advent of a new style. In contrast to the angularity seen in the Angel Choir sculpture, figures adopt more graceful, swaying poses accentuated by softer, more flowing draperies. The new manner, whose origins have not yet been fully explained, made an early appearance in the 1290s in the statues of the *ELEANOR CROSSES and flourished in the first half of the 14c.

The pattern of stylistic development in the early 14c. is complicated by a proliferation of local schools, notably in the midlands, Yorkshire and the south-west. Their sources, and the degree to which they may properly be termed 'regional', are problems which remain to be solved; but the existence of so many different workshops producing sculpture of the highest quality testifies to the great increase in demand for architectural sculpture and sepulchral effigies.

*ALABASTER, suitable for detailed carving, became popular from the second quarter of the 14c. for *TOMBS and retables. One of the earliest examples, a *Crucifixion* panel (V&A), has been compared stylistically to the alabaster weepers on the tomb of John of Eltham (d.1334) at Westminster, probably dating from the 1340s. The elegant drapery style and pronounced

Detail of the Angel Choir, Lincoln Cathedral, c.1270.

233

contrapposto stances, which may reflect the influence of Parisian art *c.*1330, are paralleled in works in other media, such as the GRISAILLE glass at York Minster and the BRASS of Sir Hugh Hastings (d.1347) at Elsing (Norf.).

The middle years of the 14c. witnessed a change in the relationship between sculpture and architecture. The rich ornament of the Decorated period was sacrificed in favour of a different kind of effect: instead of a generalized use of sculpture for architectural details and spandrel reliefs, carving (especially niche statuary) tended to be concentrated in well defined areas, such as screens and CHANTRY chapels. The Beauchamp Chapel at Warwick and the choir ★SCREENS at Canterbury and York are amongst the most lavish examples. Exterior sculpture also tended to be localized, on show fronts, the tradition of the screen of statuary persisting into the 15c. with the completion of the west porch at Exeter. The alabaster-carving industry flourished throughout the rest of the Middle Ages, producing a vast quantity of ALTARPIECES, many of which were exported.

French influence, which had been predominant, declined after the mid 14c. Flemish

Detail of Henry V's Chantry in Westminster Abbey, *c.*1422–50.

influence has been seen in the heavy, crumpled drapery style and realistic treatment of the statues of the reredos of Henry V's Chantry at Westminster (*c.*1422–50), and documents attest the employment of German and Flemish sculptors by the crown in the late 15c. and early 16c., but the precise relationship between English and Continental sculpture in the Late Gothic period remains to be established.

HENRY VII's Chapel at Westminster, erected 1503–*c.*1512 as an affirmation of the legitimacy of the Tudor dynasty, contains the most extensive programme of interior sculpture in England to survive from the Middle Ages. The statues, distinguished by their realism of dress, attitude and facial characterization, well illustrate the early Tudor Court Style in the years before the hostile attitude to religious imagery engendered by the Reformation effectively put an end to architectural sculpture as it had been known in the Gothic period. *See also* ★MASSINGHAM; TOREL. ND

□ E. S. Prior and A. Gardner, *An account of medieval figure-sculpture in England* (1912); S. Gardner, *English Gothic foliage sculpture* (1927); A. Gardner, *English medieval sculpture* (1951); G. Zarnecki, 'The transition from Romanesque to Gothic in English sculpture', in *Studies in Western art: acts of the 20th International Congress of the History of Art*, I (1963); Stone (1972); F. H. Thompson, ed., *Studies in medieval sculpture*, Soc. of Antiquaries of London, Occasional Papers, n.s., III (1983)

Gothic wood sculpture was destroyed with such ease at the Reformation that little survives of this major form of English medieval art. Nearly every church in the land had a crucifix (rood) set up above the ★SCREEN, almost always of wood, dividing the nave from the chancel. Of these figures there only remain a 12c. head of Christ at South Cerney (Glos.), a torso at Cartmel Fell (Lancs.) and a whole figure of Christ from the church of Kemeys in South Wales (Cardiff). Some figures of Christ and the saints were exported to Norway and still survive in Norwegian churches. An Annunciation group of *c.*1350 is preserved in the hall of the Vicars Choral of Wells Cathedral.

In TOMB sculpture more survives: e.g. the effigies of Robert of Normandy (Gloucester Cathedral), Hugh Helyon (Much Marcle, Here.) and Archbishop John Peckham (Canterbury Cathedral). The high rank and wealth of some of the patrons contradicts the view that a

Wooden misericord in Wells Cathedral, showing the miraculous flight of Alexander, c.1340.

wooden tomb was a cheap equivalent of a stone tomb.

The use of wooden vaults or roofs rather than stone vaulting was common, particularly in parish churches, and these often have carved wooden figure ROOF BOSSES: good quality examples are at Salle (Norf.), Winchester Cathedral, and the Fitzalan Chapel at Arundel (Sussex). Wooden beam roofs, capable of spanning wide spaces, incorporated large figures of angels at the terminals of the hammerbeams (see *DOOM PAINTINGS).

MISERICORDS, choir stalls, screens, chests, corbels, pulpits and bench ends form the largest category of wood sculpture. Much of this carving is purely ornamental (using architectural forms, GROTESQUES, etc.), although figure scenes do occur, particularly on misericords.

The scant survival of wood sculpture does not allow a proper assessment of its stylistic differences from contemporary stone sculpture. See also *WELSH MEDIEVAL ART. NM
□ A. Bond, *Wood carvings in English churches* (1910); A. C. Fryer, *Wooden monumental effigies in England and Wales* (1924); F. E. Howard and F. H. Crossley, *English church woodwork* (1933); A. Andersson, *English influence in Norwegian and Swedish figure sculpture in wood 1220–70* (1950)

Sculpture in the 16c. was largely determined by social and religious upheavals. The dissolution of the monasteries in 1538 meant that cathedral workshops closed, and no religious sculpture was produced after 1540. Tomb sculpture became the sole visual expression of Protestant ideology and, without direct religious imagery, the tomb evolved as a statement of the commemorated man's social position and lineage. The family tomb became especially important as a means of establishing the

standing of the new landed gentry who had been granted the monastic estates.

At the beginning of the century the development of sculpture was open to Continental influences, especially from France and Italy. A major example of Italian Renaissance sculpture was provided by TORRIGIANO in the tomb of Henry VII (1512–18; Westminster Abbey). Although the format of recumbent effigies on a rectangular tomb chest is Gothic, the decoration – particularly the 4 child angels at the corners – is Italian and the use of black and white marbles with gilt BRONZE was new. However, Torrigiano's work had little immediate stylistic effect upon the vast quantity of tomb sculpture produced in the provinces by local mason-sculptors. Not until the 1530s did Renaissance ornament become evident in many tombs. The most novel were those at Layer Marney and elsewhere in East Anglia (1530s): made of TERRACOTTA, they are wholehearted examples of Franco-Italian Renaissance form and decoration, and were probably made by French or English craftsmen who had worked with Italian sculptors in France.

Torrigiano, monument to Henry VII and Elizabeth of York in Westminster Abbey, gilt bronze, 1512–18.

Tombs of the Earls of Rutland in Bottesford church: in the foreground, the 1st Earl (d.1543), by Richard Parker; behind on the left, the 2nd Earl (d.1563); behind on the right, the 4th Earl, by Nicholas Johnson, 1591.

The majority of English tombs were produced by native craftsmen, the most important grouping being the midlands-based ALABASTER workshops whose headquarters were in Burton-upon-Trent (Staffs.). One of the most impressive tombs from there is that of the 1st Earl of Rutland (1543) at Bottesford (Leics.), made by Richard Parker (d.c.1571) – a hybrid, Gothic in form but with Renaissance decoration.

During the 1530s Italian, French and German sculptors were employed on decorative details in the Fontainebleau style at Nonsuch, HENRY VIII's magnificent new palace begun in 1538. There is little evidence that these artists had any direct influence upon English sculpture, although the decoration of the sarcophagus in the monument to Sir Robert Dormer (d.1552) at Wing (Bucks.) is perhaps linked with Nonsuch. However, French influence continued 1540–65 in decorative work on predominantly Gothic tombs.

The production of sculpture was disturbed by the iconoclasm of the mid century, and the midlands alabaster workshops never recovered

their prestige. In the reign of Elizabeth their place was taken by Protestant refugees from the Low Countries. Mostly arriving c.1567, they established workshops in Southwark (just outside the City of London) which soon flourished. Although a vast quantity of smaller monuments were still executed by local craftsmen, the Southwark workshops became the focus of tomb production. The refugee sculptors introduced Flemish Renaissance forms and ended the dominance of the Franco-Italian style. Typical of their productions were vast architectural tombs including figures of the deceased and his family, with great heraldic display, all richly coloured and gilded. Distinctive ornamental features include strapwork, crinkled ribbons and obelisks. In the treatment of the effigy a new naturalism of pose and surface detail is evident. By the end of the century the tomb as a family commemoration of death rather than a purely genealogical record had emerged, as can be seen in the monument to Sir Anthony Cooke (d.1576) in Romford (Essex), where lifesize figures of the children kneel in prayer behind their recumbent parents. Also characteristic of the Southwark style are the products of the large Johnson or Jansen family workshop, e.g. the tombs of the 3rd and 4th Earls of Rutland (1591) at Bottesford. AY
□ Esdaile (1927 and 1946); Mercer (1962), 217, 222; Whinney (1964); B. Kemp, *English church monuments* (1980), 58, 67

Sculpture in the 17c. continued to be dominated by the demand for tombs, which initially followed the Southwark workshop patterns, but gradually became more varied in composition and more restrained in decoration. The transition is apparent in the work of Maximilian COLT.

A change in the use of materials is a distinctive feature of 17c. sculpture. Links were established by the foreign sculptors at court with the Italian BRONZE tradition; alabaster declined in popularity for tombs, and black, white and grey MARBLE took its place. Painting and gilding of tombs ceased, apart from heraldic elements. Decorative motifs became more classical, with garlands and swags of leaves, fruit and flowers. Angels were reintroduced after 1610.

The most important development in tomb sculpture was the increasing freedom in the treatment of the effigy. No longer recumbent

Colt, monument to the 1st Earl of Salisbury (d.1612) in Hatfield church.

Le Sueur, *Charles I*, bronze, c.1635 (NPG).

in prayer, or depicted in niches kneeling or stiffly propped on one elbow, figures fully in the round reclined, knelt, stood or slept. The depiction of grief and restrained emotionalism found its most individual early expression in the work of Epiphanius *EVESHAM. After 1630 the use of portrait busts became particularly popular in church monuments. The increasing classicism of English sculpture is most apparent in the works carved after 1630 by Nicholas *STONE, the leading mason-sculptor of the first half of the century, which were influential in the restrained treatment of figures and drapery and the use of different coloured marbles.

Interest in the antique and in Italianate art was already apparent in the reign of James I, and blossomed under CHARLES I's patronage. His collection of copies and PLASTER CASTS after the antique (including a number made by LE SUEUR, who was sent to Rome in 1631 for the purpose) contributed to a better understanding of classicism amongst sculptors. Le Sueur and FANELLI, another foreign sculptor working at the court of Charles I, also introduced the portrait bust as an independent art form. There was little demand for decorative sculpture until the rise of English Baroque after 1660.

Stylistic advances were temporarily halted by the Civil War and Interregnum (1642–60), although there was a continuing demand for tomb sculpture. After the Restoration patronage largely passed from the crown to private individuals. Returning from exile on the Continent, they were aware of new

developments, particularly in France and the Low Countries, and their tastes initiated a new phase in English sculpture, a modified Baroque translated through Northern Europe, which lasted until c.1720. In tomb sculpture this was most evident in the use of richly coloured imported marbles and a wealth of carved detail. Some of the most striking of these displays of earthly pride came from the studio of Grinling GIBBONS.

New opportunities for major architectural sculpture were provided by the Great Fire of London (1666), notably a series of statues for the Royal Exchange and an extensive programme for Wren's St Paul's, carried out by

South transept front of St Paul's Cathedral, with the phoenix by Cibber, 1698–9

237

CIBBER and BIRD. John Bushnell (*c*.1630–74) came nearest to a form of Berninesque Baroque in his statues for the Royal Exchange; but generally the most widespread influence on late 17c. sculpture in England was Dutch, specifically the Baroque classicism of Artus Quellin's Amsterdam studio, introduced by his son Arnold (1653–86), who worked with Gibbons. Another sculptor in their circle was NOST, and he, Gibbons and Cibber produced some of the best examples of the garden statuary that was popular throughout the century.

By the late 17c. it was not unusual for an English sculptor to train on the Continent, and while much sculpture still came from masons' yards, leading artists began to call themselves 'statuaries'. AY
□ Esdaile (1927); Gunnis (1953); Whinney and Millar (1954), 104, 134; Whinney (1964), 23; B. Kemp, *English church monuments* (1980), 89

Early 18c. Around 1720 the arrival of several exceptionally talented immigrant sculptors – especially the Flemings DELVAUX, *RYSBRACK and *SCHEEMAKERS – meant that English sculpture was no longer dominated by the tradition of native mason-sculptors current since the 16c. For the first time since the Middle Ages sculpture in England could stand comparison with that of the Continent. English patrons showed a new interest in sculpture, particularly in portrait busts and funerary monuments, the 2 predominant genres in this period.

Portrait busts sometimes followed a late Baroque type showing the sitter formally dressed in a wig and broad folds of drapery, but increasingly subjects chose to be portrayed in a more relaxed manner, wearing a loose cap and open shirt. By 1730 the Roman Republican convention of close-cropped hair and classical drapery was gaining popularity. This proto-NEOCLASSICAL form appeared first in England and may perhaps be associated with the admiration of the Whig aristocracy for the values of Republican Rome. Also popular were historicizing busts of British 'worthies' such as Milton, Shakespeare and Newton, whose posthumous portraits are often surprisingly vivid.

Tomb monuments became more frequently the joint production of sculptor and architect, in accord with Continental practice. Particularly influential were the monuments illustrated in James Gibbs's *Book of Architecture* (1728). English monuments often combined Flemish conventions – especially the reclining figure – with features from Roman late Baroque sculpture, such as allegorical figures flanking the sarcophagus. In style too they drew on both Flemish and Roman sources, modified to suit native taste. The result was a distinctively English mode of late Baroque sculpture, seen at its best in the work of Rysbrack.

By the mid 18c. sculpture also played a significant role in interiors by architects like Gibbs, Lord Burlington and KENT. Busts were placed in halls and libraries, and richly decorated chimneypieces and relief sculpture began to form an integral part of Palladian rooms. For garden sculpture it was normal to use LEAD copies after the antique, and only rarely works by contemporary sculptors.

Another important aspect of early 18c. sculpture is represented by the activities of English collectors, whose acquisitions included not only celebrated and influential examples of antique statuary but also work by Italian late Baroque sculptors such as Foggini, Rusconi and MONNOT. *See also* BIRD; GUELFI; NOST. MB
□ Whinney (1964), 67–73; F. Haskell and N. Penny, *Taste and the antique* (1981)

Rysbrack, *Daniel Finch, Earl of Nottingham*, before 1723 (priv. coll.).

Rococo was the predominant style in English sculpture between *c.*1730 and 1760, and is manifest in the work of various leading artists, notably ROUBILIAC and ★CHEERE. Its ornamental characteristics, seen most clearly in the work of Cheere, are freely flowing s-scroll and shell and *rocaille* (rockery-like) motifs, all usually arranged with a striking asymmetry. Rococo in England found its boldest expression in interior decoration, and some of the most exuberantly Rococo sculpture took the form of marble chimneypieces and plasterwork on ceilings.

The emergence of the style in England was closely associated with the ST MARTIN'S LANE ACADEMY, particularly Roubiliac, DASSIER, HOGARTH and GRAVELOT. The latter's prints provided an important source of ornamental motifs used on both monuments and chimneypieces. It is likely, however, that Cheere and Sir Robert TAYLOR also had first-hand knowledge of French decorative sources and of the work of French sculptors such as Pigalle.

The distinguishing features of a Rococo figure style, best exemplified in Roubiliac's *Handel* (V&A), are an informal pose and an apparently casual arrangement of drapery which is broken into small folds suggesting changing, glancing light. The sculptor's concern is with transitory details of face and gesture rather than an idealized form, and the overall effect is distinguished from that of the late Baroque by its essential lightness and movement.

Some sculptors worked only occasionally in a Rococo idiom (notably RYSBRACK later in his career, and WILTON), and others never adopted it. *See also* CARTER. MB

□ Whinney (1964); M. Girouard in *Country Life,* CXXXIX (1966), 58, 188, 224; *Rococo* (1984)

Neoclassical is the term used to describe a taste in sculpture which developed *c.*1780 and petered out *c.*1860, and was dominant in the first third of the 19c. It is misleading because it suggests a new closeness to ancient Greek and Roman models, but it does correctly imply a novel preference for some of the severer forms of ancient art such as painted Greek vases and Greek reliefs (known at first from Roman neo-attic work but by 1820 from originals: *see* ★ELGIN MARBLES), and also a decisive reaction away from the Baroque style which had often accompanied, and sometimes activated, the Roman attitudes and ornaments adopted by such sculptors as SCHEEMAKERS, RYSBRACK, ROUBILIAC and WILTON.

Classical personifications remained popular on top of sarcophagi and in pediments, but ceased to enact complicated and dramatic allegories; urns continued to be favoured both for cooling wine and marking graves but were more rarely executed on a giant scale and no longer with opulent swelling forms; the neat aedicule was less commonly employed to frame memorial tablets (which architects were also less likely to design), but accurate Greek ornament came into fashion (at first employed with exquisite taste, but after 1810 often pedantically and mechanically); bust portraits with classical drapery continued to be as popular as those with modern dress, but Roman armour was now rejected both for this purpose and for most heroic effigies, in which Greek nudity, or something near it, was more common.

Neoclassicism also implied a rejection of features common in 17c. and 18c. sculpture and considered proper to the art of painting, such as aerial and linear perspective in relief sculpture, and dramatic facial expression, fluttering drapery and flying hair. FLAXMAN was especially influential in popularizing a style of relief with figures arranged in clear profile on a

Roubiliac, *Handel,* for Vauxhall Gardens, 1738 (V&A).

Flaxman, monument to George Steevens, the Shakespeare scholar, 1800 (London, St Matthias, Poplar, on loan to Cambridge, Fitzwilliam).

single plane. The unadorned flat surface was enjoyed as never before in British sculpture, as it was also, perhaps for economic reasons, in furniture and architecture.

Copies and casts of the antique which had been popular for gardens during the period 1750–1800 declined from favour, and whereas NOLLEKENS and Flaxman made copies of the antique, younger sculptors – whether distrustful of the antique (CHANTREY) or worshipping it (★GIBSON) – did not. After c.1820, on the other hand, there was an unprecedented demand for original gallery sculpture, especially from British sculptors resident in Rome. The most common subject was a naked or near-naked female, of obviously pure if often feeble mind, with a classical name.

See also BACON, J.; ★BANKS; COADE; ★DEARE.

NP

□ Whinney (1964); Irwin (1966)

In the early 19c. Rome remained the goal for the aspiring sculptor. However, greater naturalism developed in the work of the second generation of Neoclassicists, most obviously in the work of ★CHANTREY, partly as a result of study of the ★ELGIN MARBLES. Monumental sculpture increased its status in the period partly because of the great demand for public monuments to national heroes of the French Wars. In the opening years of the century the government invested large amounts of public money to create a sculptural hall of fame within ST PAUL'S

CATHEDRAL. The fierce competition for the commissions indicates the prestige attached to them, and their stylistic coherence confirms the existence of a national school.

A developing interest in public sculpture in the industrial cities, eager to express civic as well as national pride, added a new element of patronage which was to reach its zenith in the Victorian era. The success of provincial monuments contrasts with the many unrealized London projects. For example, FLAXMAN, BAILY, Chantrey, WESTMACOTT and J. C. F. Rossi (1762–1839) all created sculpture 1825–30 for Nash's Marble Arch in London. This naval and military monument was left incomplete because of lack of financial support. Against this failure of state patronage can be set the increasing demand for portrait busts and modest church monuments. *See also* GARRARD; JOSEPH.

AY

□ Gunnis (1953); Whinney (1964); N. Penny, *Church monuments in Romantic England* (1977)

In the Victorian period (1837–1901) sculptors initially continued to satisfy the steady demand for funerary monuments, portrait busts and statues and, occasionally, 'Ideal' works repre-

Westmacott, detail of monument to Charles James Fox in Westminster Abbey, 1810–23.

senting subjects from literature, mythology, etc. Funerary monuments became less frequent after *c.*1850 with the development of STAINED GLASS windows as a more immediately obvious and possibly cheaper means of commemoration in churches. Ideal works, being physically complex, aesthetically demanding and expensive, though they were thought to represent the sculptor's highest artistic achievement, rarely caught on except with a few rich patrons. Portraiture reigned supreme: busts provided a sculptor's main livelihood, while public commemorative statuary assumed an overwhelming position. What was a trickle in the 1830s became, with the deaths of Peel, Wellington and Prince Albert between 1850 and 1861, a torrent. The proliferation of public statuary between 1850 and 1900 was the most important new feature of Victorian sculpture.

A structured career framework and the apparent stranglehold of NEOCLASSICISM and the influence of CHANTREY stultified stylistic expression. *GIBSON still imbued Neoclassicism with vitality, and FOLEY and *WOOLNER achieved some naturalism, but for the rest it was largely a matter of how intricately one manipulated the fripperies of dress. William Theed (1804–91) and Henry Weekes (1807–77), prominent professionals, were only really happy with historic costume.

Major changes came through painter-sculptors like STEVENS, WATTS and LEIGHTON. They prefigured the NEW SCULPTURE movement of the end of the century, in which new

Frampton, *Mysteriarch*, polychrome plaster, 1892 (Liverpool, Sudley).

attitudes to modelling, technique and materials saw conceptual moulds breaking and new areas being explored. *GILBERT's *Eros* (1886–93) is a public monument in aluminium, while *The Mower* (1884), an Ideal work by Hamo THORNYCROFT, shows a fusion of classicism, idealism and naturalism, particularly in its detailed modelling.

Another feature of Victorian sculpture was the use of polychromy. Statues were occasionally painted – Gibson's *Tinted Venus* (1851–6; Liverpool, Sudley) ostensibly in imitation of the Greeks (*see* *ALMA-TADEMA), MAROCHETTI's *Princess Gouramma* (*c.*1856; Osborne) for the sake of increased naturalism. At the end of the century quite different aesthetic ideals were reflected in sculptures whose polychromy comes from the materials themselves – diverse metals and ivory – e.g. Gilbert's Clarence monument (1892–9; Windsor) and George Frampton's *Alice Owen* (1897; Potter's Bar).

See also LOUGH; MUNRO. BR

□ M. H. Spielmann, *British sculpture and sculptors of to-day* (1901); Gunnis (1953); Read (1982); S. Beattie, *The New Sculpture* (1983)

British sculpture in the 20c. should not be studied in isolation: for almost every generation experience of foreign art, whether in Paris, Florence or New York, has proved crucial.

*EPSTEIN set the precedent with his early trips to Paris, where he encountered not only

Detail of the Albert Memorial, 1863–76. In the foreground is *Asia*, by Foley; behind, *Manufactures*, by Weekes

Cubism and its offshoots but, more importantly, primitive art. The latter fundamentally changed prevailing conceptions of sculpture: carving, and in particular direct carving, became preferred to modelling. The sculptor now approached his block of material without the aid of preliminary drawings or maquettes. The final image was the outcome of a dialogue between artist and material. A rougher finish and a greater emphasis on the density, colour and texture of the material predominated over its illusionistic potential. Certain new subjects also entered the sculptor's repertoire (in Epstein's case, fertility images); but it was not until the 1930s, with the influence of SUR-REALISM and CONSTRUCTIVISM, that the subject-matter of sculpture changed radically.

The pattern of Epstein's career was archetypal. He largely avoided showing through establishment channels, and the few public commissions he secured were not sufficient to ensure him a livelihood; indeed they generally brought him bitter controversy. Consequently, much of his oeuvre is domestic sculpture, especially portraiture commissioned by private clients. In his case, however, this work is generally less innovative than his monumental sculpture, though often of a remarkably high standard.

The next generation, of which MOORE and *HEPWORTH are the most important figures, made major changes in the approach to subject-

Moore, *Four-Piece Composition: Reclining Figure*, 1934 (Tate).

matter. Though both experimented with pure abstraction, they preferred an informal abstraction in which the forms convey metaphorical associations, typically linked with landscape and the organic world. The traditional language of sculpture was revitalized by the introduction of cavities or holes, so that space became almost as important as solid matter. Sculpture was also made by assembling a number of separate elements, as in Moore's *Four Piece Composition: Reclining Figure* (1934; Tate), but it was not until the 1960s that constructed or assembled sculpture entered its most fertile period.

During the 1950s many new modes were explored, including the expressionist hybrids of animal/insect genus found in the work of CHADWICK and Bernard Meadows (b.1915), closely related in spirit to the *angst*-ridden mood dominating much sculpture abroad. These were joined by an interest in totemic forms and mythic subjects which, it was felt, conveyed universal truths. In contrast to these works which directly addressed themselves to the state of society, many genre subjects were also attempted. Affectionate if whimsical observation engaged *ARMITAGE, George Fullard (1923–73) and *CARO. *CONSTRUCTIVIST sculpture, dominated by Kenneth and Mary MARTIN, Anthony HILL and others, formed a separate stream, closer to its European heritage than to local trends.

In the 1960s abstract constructed sculpture began to dominate, stimulated largely by Caro, the major figure in this mode. A concern with a Cubist-derived sculpture of welded sheet metal was, for long, concentrated around St Martin's School of Art in London, though a preference for brutalist raw metal offcuts has replaced the brightly painted pristine forms used in the 1960s, and a turgid academicism gradually

Epstein, *Night*, on London Transport headquarters, 1929.

overtook the earlier mood of exuberant experiment and inquiry. For a time the best sculptors once associated with this milieu, KING and TUCKER, became increasingly isolated. They interpreted a sculpture as a solid 3-dimensional entity standing in space, a definition whose ubiquity was undermined in the late 1960s by the advent of conceptual, *PERFORMANCE, installation and environmental sculpture. Sculpture became for a time the most lively art form, though as a category it risked annihilation by being stretched to cover a variety of very loosely connected activities. While some of these modes continue to be vital, as in the work of Stuart BRISLEY, Tim HEAD and GILBERT AND GEORGE, the past few years have witnessed a return to the sculptural object. However, the idea, rather than issues of form or craftsmanship, now predominates, as Tony CRAGG's work attests. Others, like Carl Plackman (b.1943) and Michael Kenny (b.1941), create tableaux to explore issues that originate in the realm of linguistics, anthropology or sociology. Figurative sculpture has also taken new directions, particularly with the work of John Davies (b.1946), who places naturalistic figures, often with strange props, in situations intended to bear more on life than on art.

Attempts to characterize certain traits found in many of these artists as peculiarly British are doomed to failure, for the greatest sculptors of the century have been far more influenced by foreign ideas and art than by local stimuli. This is as true of FLANAGAN and King as it is of Caro, Moore and Epstein. Those who did not escape local traditions have often produced provincial work.

See also ATKINSON, L.; BUTLER; DOBSON, F.; GABO; GILL; JONES, A.; LATHAM; MCLEAN; MCWILLIAM; NEW GENERATION SCULPTURE; *PAOLOZZI; POPE; ST IVES SCHOOL; TURNBULL.

LC

☐ *British sculpture in the 20c.* (exh., London, Whitechapel, 1981)

Cragg, *Britain seen from the North*, plastic and mixed media, 1981 (Tate).

Seddon, Thomas (1821–56) was a landscape painter who was with Holman HUNT in the Near East in 1854, and painted vivid, detailed views showing the influence of PRE-RAPHAELITISM. WV
☐ Staley (1973)

Segar, William *see* PORTRAIT PAINTING: 16C.

Select Committee on Arts and Manufactures A parliamentary body in 1835–6 which led to the setting up of the first English schools of design, in London and in those manufacturing centres prepared to contribute to their establishment and upkeep. It is significant for its attempt to make British luxury goods more 'artistic', for its role in the development of copyright law, and as a battlefield in the long war over the privileges and power of the ROYAL ACADEMY. TG
☐ Q. Bell, *The schools of design* (1963)

Serres, Dominic (1722–93) was born in France, but after several years at sea he settled in England and became a highly successful MARINE artist. He was a founder member of the ROYAL ACADEMY and became marine painter to GEORGE III. DC
☐ D. and J. T. Serres, *Liber nauticus and instructor in the art of marine drawing* (1805, repr. 1979)

7 and 5 Society A group intended notionally to consist of 7 painters and 5 sculptors, founded in 1919 and disbanded in 1935. Members included Edward Bawden (b.1903), HEPWORTH, HITCHENS, Francis Hodgkins (1869–1947), Evie Hone (1894–1955), David JONES, MOORE, Ben NICHOLSON, Winifred Nicholson, PIPER and WOOD. Ben Nicholson, elected in 1924, engineered an increasing emphasis on abstract art. AG
☐ Harrison (1981)

Seymour, James (*c.*1702–52) was one of the first British artists to specialize exclusively in SPORTING subjects. Though probably self-taught through studying his father's collection, he allegedly received further instruction in drawing horses through correspondence with

Francis PLACE. Like his rival WOOTTON, Seymour later worked frequently at Newmarket and found abundant patronage there. By 1739 he was apparently 'reckoned the finest Draughtsman in his Way (of Horses, Hounds &c) in the whole World' (*Universal Spectator*) – despite VERTUE's assertion that he 'lived gay high and loosely' and 'never studied enough to colour or paint well'. While his vigorous drawings may accord with his supposed lifestyle, his works in oil are painstakingly constructed and eerily immaculate in detail, composition, and mood. SD
□ *James Seymour* (exh., London, Covent Garden Gall., 1978)

Shaftesbury, Anthony Ashley Cooper, 3rd Earl of (1671–1713), moral philosopher, developed the ideal of 'the Well-Bred Man' for whom artistic taste was an essential attribute, not as an innate quality but to be learned by 'Pains and Industry'. The gentleman should be concerned not with art which 'immediately strikes the Sense, but what consequentially and by reflection pleases the Mind, and satisfies the Thought and Reason'; this implied a taste for Italian art, which was to be developed on the GRAND TOUR, and the growth of an aristocratic class which would encourage HISTORY painting in Britain. DB
□ E. Wind in *Journ. Warburg and Courtauld Inst.*, II (1938), 185–8; Dobai, I (1974)

Shannon, Charles *see* RICKETTS

Sharples, James (1825–92), a Yorkshire ironworker and self-taught painter and engraver, is known for one work, *The Forge* (Blackburn), which he engraved on steel 1849–59. The print succeeded, and brought profits to its publishers and fame to Sharples. The image is striking, and lovingly created, but it was surely Sharples' unusual career and its celebration of manual labour which gave it such success. As one might expect from an artist who was made an exemplar of self-help by Samuel Smiles, it perfectly represents mid-Victorian hopes for a 'respectable' working class. TG
□ Klingender (1968)

Sharples, Rolinda *see* BRISTOL SCHOOL

Shee, Sir Martin Archer *see* ROYAL ACADEMY: 19C.

Sheepshanks, John (1787–1863) was a Yorkshire industrialist who bequeathed his collection of contemporary British artists to the nation. Now in the V&A, it provides an invaluable image of the genre and landscape painting popular in early Victorian England (*see* ★LANDSEER, ★MULREADY). WV
□ Boase (1959)

Sheppard, William *see* BARLOW

Sherborne Missal (Alnwick Castle, Northumb., on loan to BL) A richly decorated Missal commissioned for the Benedictine abbey of Sherborne (Dor.) between 1396 and 1407, written by the monk John Whas, and illuminated by John SIFERWAS and assistants. Siferwas here displays remarkable compositional inventiveness, especially in the construction of borders, and an awareness of the innovations of Flemish miniaturists, such as the Master of the Beaufort Saints, in modelling and the treatment of architecture (see INTERNATIONAL GOTHIC). NR
□ J. A. Herbert, *The Sherborne Missal* (1920); Marks and Morgan (1981), 25, 94–9

Sherborne Missal, *c.*1400–1406: the Mass for Trinity Sunday (The Duke of Northumberland, on loan to BL).

Shipley's School *see* COSWAY; SMART; SOCIETY OF ARTS; WHEATLEY.

Shoreham, a small village in Kent, gave its name to the Shoreham painters, sometimes known as the 'Ancients', who spent time there in the late 1820s and early 1830s. The main figure was Samuel *PALMER who owned a house in the village, and he was frequently joined by John LINNELL, George RICHMOND, Edward CALVERT and other sympathizers. Though of different political and religious persuasions, they were united by a pantheistic attitude towards nature and a desire to paint landscape with religious overtones, revering BLAKE who was an occasional visitor. They were the first in England of the many groups of artists to withdraw from the city to pursue common ideals, and their sense of community can be found also in the German Nazarenes in Rome and 'Les Primitifs' in Paris. DB
□ G. Grigson, *Palmer* (1947); H. Meltzer, *The Ancients* (PhD, New York, Columbia Univ., 1975)

Short, Sir Frank (1857–1945) is principally remembered as a great teacher and technical authority, with a practical mastery of all the printmaking media. He was head of the engraving school at the ROYAL COLLEGE 1891–1924 and President of the Royal Society of Painter-Etchers and Engravers 1910–39. He revived the use of MEZZOTINT and AQUATINT, and produced low-key ETCHINGS, modest landscapes and shorescapes, working directly on the plate with a delicate economy of line. CF
□ M. Hardie, *Etchings, drypoints, lithographs by Sir Frank Short* (1940)

Siberechts, Jan (1627–1703), the son of a Flemish sculptor, was brought to England in 1674 by the 2nd Duke of Buckingham who had admired his landscape paintings in Antwerp. For English patrons he chiefly did house portraits (e.g. *Longleat* – *see* *LANDSCAPE PAINTING* – and *Wollaton Hall*) with a frontal, raised viewpoint, an extensive span of surrounding gardens and countryside, extremely fine detailing, and foreground groupings of figures, carriages and horses. DD
□ Waterhouse (1978); Harris (1979)

Sickert, Walter Richard (1860–1942) became the outstanding British painter of his generation. The son of Oswald Sickert, an artist of Danish descent, and an Anglo-Irish mother, he was born in Munich; the family moved to England, via Dieppe, in 1868. He was to remain cosmopolitan.

After studying at King's College, London, Sickert had an abortive career as an actor before briefly attending the SLADE in 1881. The following year he met WHISTLER, who persuaded him to become a sort of apprentice in his studio. There he learned etching, and the subtly toned, low-keyed painting then characteristic of his master. In 1883 he took Whistler's *Mother* to the Paris Salon, and first met Degas, whose method of building up paintings from drawings Sickert came to prefer to the *alla prima* effect of pictorial unity sought by Whistler.

Sickert went through a number of phases during his long working life. The earlier Whistlerian period merged into an association with Wilson STEER and the NEW ENGLISH ART CLUB, *c.*1888–95, when he became interested in urban subjects, especially music-halls: both the stage acts and the audience were noted in little sketchbooks, and composed into paintings from memory.

From 1895 he began to winter in Venice, and he lived in Dieppe 1899–1905. After a transitional stage, in which his style varied between 'impressionist' broken brush-strokes for *plein-air* paintings and more tightly formed designs executed over a grid of lines on his canvas made from transferred squared-up drawings, Sickert found his mature style shortly after 1900. Architectural subjects abound, although his compositions are as much about the surrounding spaces as about the buildings themselves, and he produced innumerable versions of favourite scenes (e.g. *The Façade of St Jacques, Dieppe* and *Piazza S. Marco*). In Venice *c.*1903–4 he painted some very fine informal studies of Venetian women.

When he returned to London late in 1905 he began to work on a new class of subject-matter (although he continued painting music-halls), representing working-class models in 'real' surroundings. These include nudes in claustrophobic bedrooms with iron bedsteads, and a series of groups – usually a man and a woman – in bedrooms or little front parlours. Some psychological relationship between them is always implied, but the story line often remains oblique. This work spans his 'Camden Town period', *c.*1907–13, and includes many of his best paintings, dark but richly coloured.

Sickert, *Ennui*, c.1914 (Tate).

Comparisons have been made with Bonnard and Matisse, but Sickert's vision has a more dour *timbre* as he addressed himself to a particular aspect of the English character. He wrote that there should be no antithesis between subject and treatment: the real subject of a picture or drawing is the plastic facts expressed.

Between c.1906 and 1918 he developed his 'final solution' for producing the plastic qualities he wanted in painting. He would apply his basic design to the canvas in 2 colours only, red and blue, mixed with white, and leave this to dry hard before applying luminous colours on top. As perfected, this manner led to some powerful, high-keyed paintings in his second Dieppe period, c.1919–26 – though not all the surviving canvases are finished.

The work of his last period, when he finally settled in England after his third marriage in 1926, often used photographs, engravings or prints as starting points, and although attempts have been made to claim him as a proto-POP artist, its merit remains disputable (*see* PORTRAIT PAINTING: 20C.)

Sickert was a stimulating talker and writer, and as an art critic he was a maverick of the highest intelligence. His rational approach to drawing had a great effect on the CAMDEN TOWN GROUP and the EUSTON ROAD SCHOOL. *See also* ETCHING REVIVAL. BL

□ W. Baron, *Sickert* (1973); D. Sutton, *Sickert* (1976)

Siddal, Elizabeth (1834–62) was a shop girl whose fragile beauty led to her 'discovery' by the PRE-RAPHAELITES in 1850. She was frequently used as a model. She was herself artistically gifted and was encouraged by RUSKIN. In 1860 she married *ROSSETTI; 2 years later she died of an overdose of laudanum.
 WV

□ Ironside and Gere (1949)

Siferwas, John (fl. 1380–1421), Dominican friar and illuminator, probably of Dorset origin, is first recorded at Guildford Priory (Surrey), but had moved to London by 1392. His most important works are the *SHERBORNE MISSAL and a Lectionary (BL, MS Harl. 7026) commissioned by John, Lord Lovell (d.1408) for Salisbury Cathedral, in both of which he incorporates self-portraits. He had a talent for natural observation, and for adapting ideas derived from a wide variety of sources. *See also* INTERNATIONAL GOTHIC; PEPYSIAN SKETCHBOOK. NR

□ Rickert (1965); Marks and Morgan (1981)

Sittow, Michiel *see* HENRY VII

Situation was the name given to an exhibition at the Royal Society of British Artists in September 1960. The organizing committee included several young artists and critics who brought together 20 painters to exhibit abstract pictures not less than 30 sq. ft (2.8 m²) in area. That this was not an arbitrary requirement was made clear in the introduction to the catalogue by Roger Coleman. It was essentially a reaction to the scale of the American abstract paintings that had been shown at the Tate in 1956 and 1960.

Such pictures, having no perspectival space, could expand into the real space till they occupied the whole visual field of experience of the viewer. They would also be the record of the sequence of actions performed by the artist while creating them. Finally the pictures would assert that they were objects – that they existed in their own right, not as imitations. Among

the exhibitors were Bernard COHEN, Harold COHEN, Robyn DENNY, John HOYLAND, and Richard SMITH.　　　　　　　　　　　MC
□ *Situation* (exh., Arts Council, 1962)

Skelton, Jonathan (*c*.1730–59) seems to have been a member of the circle of George LAMBERT and Samuel SCOTT. His work *c*.1754, in the neighbourhood of Croydon and elsewhere in Surrey and Kent, reflects their WATERCOLOUR style and is notable for its subtle deployment of tone and informal subject-matter. In 1757 he travelled to Italy, where he produced drawings more classical in inspiration before his early death in Rome. *See also* OUTDOOR PAINTING.　　　　　　　　　　　　　AW
□ Williams (1952); B. Ford in *Walpole Soc.*, XXXVI (1956–8); Hardie, I (1966)

sketching clubs The development of the romantic WATERCOLOUR school in the 1790s was accompanied by a flowering of small societies dedicated to drawing and mutual criticism. The 'Society for Epic and Pastoral Design' grew out of Dr MONRO's 'Academy', initially under the leadership of GIRTIN and COTMAN and later under that of A. E. CHALON. A literary topic was set at each session; an early preference for landscape subjects gradually gave way around the 1820s to HISTORY and genre. Among later clubs the Clipstone Street Artists' Society 'for the Study of Historie, Poetry, and Rustic Figures' became the Langham Sketch Club, which survives today.　　　　　　　　　　　　　AW
□ Hardie, III (1968), 59; J. Hamilton, *The Sketching Society 1799–1851* (exh., V&A, 1971)

Slade School of Fine Art An institution founded in 1871 with the connoisseur and collector Felix Slade's endowments for a London University Chair in Fine Art and 6 student scholarships, and money from University College. The first Professor, POYNTER, brought a bias towards the French academic system, with its emphasis on drawing and painting from the living model, the exercise of a critical intelligence, and an awareness of art history. He was succeeded in 1876 by the Realist LEGROS, who taught mainly by demonstration. Among Legros' pupils were TUKE, W. Y. MacGregor (a founder of the GLASGOW SCHOOL), and ROTHENSTEIN.

The next Slade Professor was Fred Brown, under whose long tenure (1892–1918) the

School produced some of its most eminent pupils. He and his appointees STEER and TONKS taught successive generations of changing character. That of the 1890s showed the stylish brio of MCEVOY, Augustus JOHN and ORPEN, as well as the quieter tonal painting of GILMAN and Gwen JOHN. The latter was one of the many gifted women students whose presence has been a distinguishing feature of the Slade. More surprising to find as a Slade student, perhaps, was Wyndham LEWIS. Of the Summer Prize Competition paintings (preserved at University College) some have survived as major works, e.g. Augustus John's *Moses and the Brazen Serpent* (1898) and Stanley SPENCER's *Nativity* (1912). David BOMBERG painted his *Vision of Ezekiel* (1912; Tate) as a student.

Tonks was Professor 1918–30, and his exacting standards produced a number of gifted artists, including Thomas Monnington (1902–76), Rodney Burn (b.1899), Helen Lessore (née Brook, b.1907), Claude ROGERS and COLDSTREAM. The School had a quieter period through World War II under Randolph Schwabe and George Charlton, but when Coldstream returned as Professor in 1949 a new era of prominence began, and a significant number of avant-garde artists emerged from the Slade. He was succeeded in 1975 by Sir Lawrence GOWING, who still holds the chair. *See also* ANDREWS; GORE; HILTON; NASH; NEW ENGLISH ART CLUB; NICHOLSON, B.; ROBERTS, W.; SMITH, M.; WOOD-ENGRAVING.　　　　BL
□ A. Forge, *The Slade* (repr. from *Motif*, 1960); W. Coldstream and B. Laughton, *The Slade* (exh., RA, 1971)

Small, William *see* GRAPHIC

Smart, John (1742/3–1811), one of the best and most successful miniaturists of the second half of the 18c., trained at Shipley's Academy (*see* SOCIETY OF ARTS) before turning to miniature painting in 1760. He was active in the SOCIETY OF ARTISTS, then practised in Madras 1785–95. His meticulous naturalism offered a decorous alternative to the bravura painting style of COSWAY.　　　　　　　　　　　PN
□ Murdoch, Murrell, Noon and Strong (1981)

Smetham, James (1821–89) was a disciple of RUSKIN's naturalism for a brief but ecstatic period in the 1850s, then turned to PALMER whose influence deeply underlay all the rest of

his work, which ended with a final breakdown in 1877. RT
□ Staley (1973); M. Bishop and E. Malins, *James Smetham and Francis Danby* (1974)

Smith, George, 'of Chichester' *see* LANDSCAPE PAINTING: 18C.

Smith, John 'Warwick' (1749–1831) produced his best work in WATERCOLOUR in Italy where he stayed 1776–81. He returned to England with Francis TOWNE, whose style he influenced, notably through his early experiments with directly applied local colour, without underpainting. He gained fame for these, and became very prolific, but his later work is somewhat monotonous. AW
□ Williams (1952); Hardie, I (1966)

Smith, Sir Matthew (1874–1959) was already 30 when Paris hit him with the force of a conversion; he renounced the SLADE, attended Matisse's short-lived school, and did his best to identify with French tradition. His early work, with its simplified areas of strong flat colour, is Fauvist in inspiration; a certain rigidity in drawing becomes an asset, protecting him against mere decorativeness, and yielding powerful and rugged images. Painting in the south of France after the First World War, he discovered a new luminosity and fluency. The cursive rhythms and hot tonality of his nudes of the 1920s recall Delacroix. Limited and even conventional in its Mediterranean genre, Smith's best work has great formal authority. His painterliness, the identity of the painted mark with the subject depicted, has been

Richard **Smith**, *Threesquare 2*, acrylic, 1975 (British Council).

admired by several subsequent artists, notably BACON, HODGKIN and AUERBACH. TH
□ P. Hendy, *Matthew Smith* (1944); *Matthew Smith* (exh., London, Barbican, 1983)

Smith, Richard (b.1931) is an abstract painter who has worked for long periods in America as well as England. His early work, while abstract and freely painted, contained allusions to visual characteristics of packaging and advertising (*see* POP ART). He was a pioneer of the shaped canvas, which he curved in 3 dimensions. More recently he has constructed a long series of kite-like paintings in which the canvas is stretched on rods which are a visually active part of the composition. He has often made series of paintings by systematically varying the elements of colour, proportion, orientation, etc. *See also* SITUATION. MC
□ B. Rose, *Richard Smith* (exh., Tate, 1975)

Society of Artists An association in London, effectively the forerunner of the ROYAL ACADEMY, that emerged from the agitation by artists in the 1750s for the establishment of a state-run academy to include a public exhibition of contemporary art, administered on more formal lines than the ST MARTIN'S LANE ACADEMY. Several proposals were published but none came to fruition until it was decided in

Matthew **Smith**, *Model Turning*, c.1924 (Tate).

1759 to establish a public exhibition (the first of its kind), which was held in spring 1760. Disagreement with the patron-dominated SOCIETY OF ARTS (in whose rooms in the Strand it was held) over admission charges and the choice of exhibits resulted in a split. Those who remained at the Strand (inferior artists on the whole) formed themselves into the Free Society in 1762, while the Society of Artists, as they now called themselves, led by HAYMAN and LAMBERT and including most of the major artists, established annual exhibitions at Spring Gardens. They became incorporated by Royal Charter in 1765 and survived until 1791. *See also* COZENS, J. R.; MORLAND; MORTIMER; WILSON; ZOFFANY. BA
□ Hutchinson (1968)

Society of Arts (properly Society for the Encouragement of Arts, Manufactures and Commerce) An association founded in London in 1754 by William Shipley to encourage inventions and improvements in 'Arts and Sciences' by offering premiums and other forms of aid. It included originally an art school, known as 'Shipley's School'. In 1774 the Society moved from the Strand to a building in the Adelphi nearby, and the Great Room was decorated by ★BARRY. Now the Royal Society of Arts, it continues to this day to carry out its original purposes in the same building. DB
□ H. T. Wood, *History of the Royal Society of Arts* (1913); D. G. C. Allan, *William Shipley* (1968)

Society of British Artists *see* ROYAL ACADEMY: 19C.; SITUATION

Society of Painters in Water-Colours (later Old Water-Colour Society) *see* ROYAL ACADEMY; WATERCOLOUR

Soest, Gerard *see* RILEY, J.

Soldi, Andrea *see* RAMSAY

Spencer, Stanley (1891–1959), painter, grew up in the Berkshire village of Cookham. His attachment to it resembled Samuel PALMER's to Shoreham and his art was similarly based upon personal, mystical experience. Spencer attended classes at the SLADE 1908–12, where his painting *The Nativity* (London, University College) won him the Composition Prize (1912). The picture summarizes a range of

influences, from early Italian art and its revival by the PRE-RAPHAELITES to the Post-Impressionism of Gauguin which Spencer saw for the first time in Roger FRY's 2 exhibitions in 1910 and 1912. His painting of *John Donne arriving in Heaven* (priv. coll.) was included in the second of these. Characteristically, he identified Heaven as part of Widbrook Common.

During the First World War, Spencer served in a military hospital and saw action on the Macedonian front. His experiences informed his designs for the Sandham Memorial Chapel at Burghclere (Hants), which he decorated as a modern parallel to Giotto's Arena Chapel, Padua. The cycle of scenes from everyday military life culminates in a visionary *Resurrection of the Soldiers* on the east wall. In a revealing passage from his copious autobiographical notes, he explained that 'during the war . . . I felt that the only way to end the ghastly experience would be if everyone suddenly decided to indulge in every degree and form of sexual love'. Both the erotic element and the anatomical distortions of his subject pictures of the 1930s alienated him from

Spencer, detail of *The Wedding at Cana*, 1953 (Fredericton, N.B., Beaverbrook AG).

a public which continued to admire his landscapes and portraits. In reaction to criticism, his personal mythology intensified and he dreamed of building a second chapel to house his pictorial sermons.

In 1940, Spencer became an official war artist for the second time. He painted the war effort in the Scottish shipyards and proceeded to visualize the Last Judgment in his Port Glasgow *Resurrection* series (*c.*1940–50; Tate, etc.). Spencer reserved his final visions for his birthplace. In the *Regatta* paintings (1952–9, unfinished; Tate, etc.) he arranged for Christ to preach from a river boat to demonstrate his belief in Cookham as the earthly paradise. *See also* FIGURATIVE PAINTING. DR

□ D. Robinson, *Stanley Spencer* (1979)

sporting painting, normally defined as the depiction of rural sports such as hunting or horse racing, has existed as a distinct genre within British art since the early 18c.

A demand for the painting of contemporary sporting scenes first emerged after the Restoration, and coincided with a growth in the popularity of sport among the landed classes. Drawing on 17c. precedents in the Low Countries and BARLOW's book illustrations, WOOTTON, TILLEMANS and SEYMOUR became prominent among the early practitioners. They provided either ostensibly factual records of the exploits and animals of their patrons or, alternatively, more idealized representations which paralleled sporting literature in seeking to associate sport with virtues such as health, the experience of nature, and nobility. The latter kind, which emphasized the relationship between sportsman and landscape or presented sport as an heroic activity, gradually became less popular than the straightforward documentary type.

This lucrative profession tended to attract painters with more interest in sport than in art, an approach encouraged by the patrons' increasing concern with accuracy. The poor reputation of the genre outside sporting circles contributed to the underestimation of *STUBBS, whose extraordinary abilities were not recognized until the present century. (*See also* *AGASSE; GILPIN, S.)

Sport itself, subject to mounting criticism for the reckless behaviour of some sportsmen, had a similarly tainted reputation by the end of the 18c., and sporting society thereafter cultivated a clannish spirit which was reflected in much 19c. painting. The private humour of sportsmen (expressed in the vigorous drawings of ROWLANDSON with a wit accessible to the layman) became a popular subject for specialist artists such as Henry ALKEN, often in prints accompanied by sporting jargon and verse. The approach of Ben MARSHALL, J. F. HERRING and J. N. SARTORIUS was more consistently serious, but their commitment to portraying the intricacies of technique, custom or dress, or the precise appearance of famous animals, steered sporting painting further towards a position of isolation in British art.

Sporting subjects were also treated by non-specialist painters in the 19c. James WARD's fondness for the dramatic landscapes of Rubens, revealed even in his horse portraits, and LANDSEER's early essays in the bestial vein of Snyders may be seen as symptoms of Romanticism. Landseer's later moves towards sentimentality in animal painting accorded closely with one aspect of Victorian taste.

The invention of photography briefly threatened a genre whose essence had become record rather than interpretation. In response, Joseph Crawhall (1861–1913) and Sir Alfred Munnings (1878–1959) looked to late 19c. French art. An alternative was the more topographical approach of Lionel Edwards (1878–1966). Sporting painting today, practised with few pretensions to greatness, retains its traditionally insular character. SD

□ S. Walker, *Sporting art* (1972); *British sporting*

Wootton, *Preparing for the Hunt*, *c.*1735–45 (Yale BAC).

Marshall, *Diamond with Dennis Fitzpatrick up*, 1799 (Yale BAC).

and animal paintings 1655–1867 (Mellon Coll. cat., 1978); *Noble exercise* (exh., Yale BAC, 1982)

stained glass *Up to 1550* stained glass is a major aspect of English art, although it has not received the attention it merits, largely because most of it survives in fragmentary condition. Contrary to accepted belief the finest examples of the craft, at least from the mid 14c. onwards, are frequently to be found in parish churches and not in the great cathedral and monastic establishments. No medieval stained glass survives in Scotland, apart from excavated fragments, owing to the severity of the Reformation north of the border.

Window glass was known in the British Isles during Roman times, but the art of glazing came to an end with the collapse of Roman civilization during the 5c. It revived in the late 7c. when Benedict Biscop, Abbot of Monkwearmouth, sent to Gaul for glaziers to fill the monastery windows. At about the same time St Wilfrid, Bishop of York, glazed the windows of the Minster. Recent archaeological discoveries at Monkwearmouth and its associated establishment of Jarrow, and at several other sites, have enabled the general arrangement of these early windows to be reconstructed, although a more precise dating than late 7c.–mid 9c. has not proved possible. They appear to have consisted of small pieces of white and coloured glass set in lead to give a decorative effect akin to mosaic; a reconstruction of a figural window at Jarrow from excavated fragments is unconvincing, not least because of the absence of paint on the glass.

Not until the late 12c. and early 13c. does English stained glass survive in any quantities. In addition to the chief monument, Canterbury Cathedral (c.1175–1220), there are remains of early glazing at York Minster (c.1170–80 and later), Lincoln (c.1200–1230), Salisbury (c.1225–66), and Westminster Abbey in London. Isolated survivals in parish churches such as Dalbury (Derbys.) and a group of churches in Kent and Oxfordshire show that by c.1220 figural glazing was not confined to the greater ecclesiastical edifices. In window design, colour and figure style English glass of this period has many affinities with France; indeed glaziers from Sens were almost certainly involved in the Canterbury glazing. Canterbury exhibits the 'classic' French late 12c.–early 13c. system of medallions containing historiated subjects set against foliage backgrounds in the lower windows, and large figures in the clerestory. The predominant colours are blue, red, yellow and purple, and the figure style belongs to that phase known as 'Transitional', with classicizing overtones. The glass at York, Lincoln, Salisbury and Westminster Abbey, produced by various individual workshops, shows the same characteristics; but GRISAILLE plays a much

Medallion in Canterbury Cathedral showing a maniac cured by St Thomas Becket, c.1175–1220.

larger part than at Canterbury and most French cathedrals. This may be due to the English taste for elaborate internal sculptural decoration. There is a similar emphasis in parish church glazing, although there *grisaille* was almost certainly dictated by economy.

Several changes in glass design occurred in the last quarter of the 13c., associated with the proliferation of bar tracery and the opening of larger areas for glazing. The 'medallion' scheme was superseded by the 'band' window, comprising a horizontal band of coloured glass with figures or scenes under elaborate canopies across the middle of the window and *grisaille* above and below (a good example is Merton College Chapel, Oxford, *c*.1289–1300). The stylized foliage designs hitherto found on

Glass in York Minster in the style of Jean Pucelle, showing the Annunciation to Joachim, *c*.1340.

Detail of a 'band' window in Merton College Chapel, Oxford: a donor, set in *grisaille*, *c*.1289–1300.

grisaille are replaced by naturalistic leaf forms. Heraldry plays a large part in glazing decoration, as in the east window of Selling (Kent). Drolleries and GROTESQUES, apparently borrowed from the repertoire of the manuscript illuminator, are also common (e.g. in the nave of York Minster and Stanford on Avon, Northants.). Figures, too, underwent a transformation, with the introduction of the French-derived broad-fold drapery style and elegant, swaying posture. The range of colours also expanded, with brown, green and paler yellow and blue to the fore. The general tone is much lighter than previously, a trend which was boosted by the introduction in *c*.1310–20 of silver staining (a technique for producing yellow stain on white glass).

In addition to the works already mentioned, important glazing of the period *c*.1280–1330 survives in York Minster Chapter House, the Lady Chapel and choir aisles at Wells, and numerous parish churches of which Lowick (Northants.), Checkley (Staffs.) and North Moreton (Berks.) are particularly noteworthy.

During the second decade of the 14c. an interest in 3-dimensionality, inspired ultimately from Italy, began to manifest itself in sculptural modelling of figures with shading and in the use of perspective in canopies. A

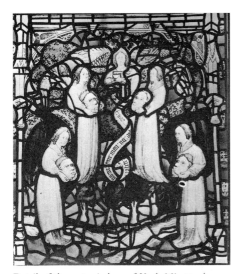

Detail of the east window of York Minster, by John Thornton, showing the Angels with the Four Winds, 1405–8.

workshop active in York in the 1330s and 1340s produced glass exhibiting these features which is very close to glass in Normandy inspired by the painter Jean Pucelle and may have been directed by a French glazier. The exaggerated postures and elongation of figures in the Wells and Tewkesbury choir clerestories and Gloucester east window (c.1348–9) are common traits in glass of the 1340s, and for the next 2 or 3 decades an element of near-caricature is often apparent. At the same time canopies became more elaborate: those at Christ Church, Oxford, and Moccas (Here.) have affinities with manuscript illuminations such as the Fitzwarin Psalter (Paris, BN) and Zouche Hours (Oxford, Bodleian). The 'band' window disappeared in the third quarter of the century with the introduction of transoms in Perpendicular tracery.

Around 1370–80 a new complexity is apparent in figure styles, some of which are related to manuscripts associated with the Lytlington Missal (London, Westminster Abbey) and the BOHUN FAMILY. Out of this diversity there emerged a version of the INTERNATIONAL GOTHIC style which was to dominate English glass-painting for more than 30 years. Important early works are the Jesse Tree for New College, Oxford, and the Win-

chester College Chapel glazing, executed by THOMAS OF OXFORD in the 1390s. This International Gothic style, which is characterized by graceful figures swathed in soft drapery, was quickly diffused throughout England and can be seen in churches as far apart as Tong (Salop), Drayton Beauchamp (Bucks.), Winchester Cathedral, Wrangle (Lincs.) and Great Malvern (Worcs.). York contains some of the finest International Gothic glass, and the style seems to have been introduced there by John THORNTON. Such is the homogeneity of the glass of the period c.1400–1435 that it is virtually impossible to identify individual workshops.

The uniformity of International Gothic breaks up in the 1430s and the remainder of the century saw wide variations in both style and quality of glazing; the more coloured glass used the greater the cost. The most expensive project was PRUDDE's glazing of the Beauchamp Chapel, Warwick (c.1447–50), and his lavish used of 'jewelled' inserts was widely imitated. The YORK SCHOOL remained active into the early 16c., and in East Anglia the NORWICH SCHOOL glaziers had their own distinctive traits. The widely scattered commissions of TWYGGE and POWER suggest that elsewhere regional variations were less clearly defined.

The quality of English glass-painting by the end of the 15c. was not high and had lost touch with Continental developments. In these circumstances it is hardly surprising that foreign glaziers, imbued with Renaissance ideas, such as FLOWER and HONE, who settled in Southwark in the early 16c., quickly found royal favour and obtained all the major

'Jewelled' glass in the Beauchamp Chapel, Warwick, by John Prudde, c.1447–50.

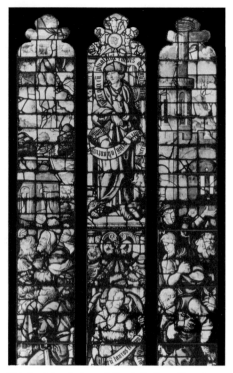

Detail of the glazing of King's College Chapel, Cambridge, 1515–31.

commissions. King's College Chapel in Cambridge, The Vyne (Hants) and Withcote (Leics.) are testimony to the quality of the work of the foreign craftsmen and demonstrate that Renaissance glass and Perpendicular architecture were by no means incompatible. RM

□ P. Nelson, *Ancient painted glass in England* (1913); J. D. le Couteur, *English mediaeval painted glass* (1926, repr. 1978)

In the 16–18c. stained glass, strictly speaking, was largely replaced by painted glass. Coloured glass had been made in Lorraine, but the destruction of the furnaces by Louis XIII in the war of 1633–6 meant that glaziers had to use white glass and apply colour by enamelling. Designers, no longer restrained by the need to lead together irregularly shaped pieces of variously coloured glass, felt themselves free to imitate pictorial styles current in contemporary easel painting. These new conventions were foreshadowed in the windows of Fairford

(Glos.; begun c.1500), and of King's College Chapel, Cambridge (1515–31), where the 100 scenes are an anthology of contemporary north European styles, late Gothic and Renaissance. The names of many glaziers working at King's are recorded, supporting visual evidence of an invasion from the Low Countries.

The chapel window at Hatfield House (Herts.) with 12 Old Testament scenes, made in 1609 by Richard Butler of Southwark, the Frenchman Louis Dauphin and the Fleming Martin Bentham, demonstrates bolder, more pictorial designs for traditional subjects, such as Jonah. The several schemes executed by the Flemings Bernard and Abraham van Linge can be studied in the well documented chapels of such Oxford colleges as Wadham (1622), Lincoln (1629–30) and University (1641). The Jonah window from a cycle in Christ Church (Oxford Cathedral; c.1635) is a justly famous example of Abraham's pictorial style, but the way in which Jonah prefigures Christ is still medieval.

Much more significant for the post-Restoration period are Abraham van Linge's

Window in Lydiard Tregoze church by Abraham van Linge, 1630s.

windows at Lydiard Tregoze (Wilts.); the window in the house is entirely secular, while heraldry predominates in the window in the church. Heraldic elements had been strong in the windows of King's, and heraldic windows are a feature in such houses as Montacute (Som.; 1598). Most of the 20 surviving windows by the major figure of the Restoration period, Henry Gyles of York, are heraldic; his Nativity window for University College, Oxford (1682-92) was replaced in the 19c.

Windows painted by William Price Sen. for Merton Chapel (1711-12) and Christ Church, Oxford, have also been replaced; but his son William Jun.'s windows in New College Chapel (1735-40) survive to amaze us: densely painted, blatantly Baroque saints with Georgian faces bulge in the openings of 14c. windows. Two complete ensembles by Joshua Price, William Sen.'s younger brother, survive, at The Queen's College, Oxford, and at Great Witley (Worcs.); the latter were painted in 1719 for Canons (Middx.). Joshua also did the north rose of Westminster Abbey, to designs by THORNHILL, and the west window, with its bold heraldry.

Most of the major works by William Peckitt of York (1731-c.1795), as at Exeter, Lincoln and Ripon Cathedrals, have been cast out, but a pompous 'Alma Mater presenting Sir Isaac Newton to George III' (1775), designed by Cipriani, adorns the library of Trinity College, Cambridge. The rediscovery at this time of the techniques of making coloured glass (especially for drinking glasses) was of great use to Peckitt, as can be seen in the 4 windows he did for the choir of New College, Oxford (1764-74) and in the bright borders and tracery lights of medieval windows he restored in York Minster.

Whether the conventions suitable for oil painting are appropriate for a window can be judged by considering the west window of New College Chapel, Oxford (1783), executed by Thomas Jervais after paintings made by REYNOLDS: it is a transparency, not a stained-glass window. Similarly, 'Moses and the Brazen Serpent' in Salisbury Cathedral (1781), made by James Pearson to a design by MORTIMER, must always, it seems, be at risk whilst the Dean and Chapter remain doubtful of its considerable merits, not the least of which is legibility. MS

□ C. Woodforde, *English stained and painted glass* (1954)

Virtues in New College Chapel, Oxford, designed by Reynolds, 1782.

19-20c. The Victorian period saw an enormous increase in the amount of stained glass produced, chiefly because a religious revival led to a great increase in church-building, but also because a renewed interest in the Middle Ages extended to medieval art forms, and because stained glass windows became a popular substitute for sculptured funeral monuments.

The glass-painters of the Regency period continued to work in the pictorial manner of the previous century, painting in enamels on large areas of glass with minimal use of leading. Coloured glass (pot metal) was more extensively employed, but it was not until the blossoming of the Gothic Revival in architecture that serious attempts were made to reintroduce the medieval 'mosaic' technique of stained glass, whereby the leads separating areas of different-coloured glass also provide the main lines of the drawing.

The fruits of detailed research into surviving medieval glass appear from the 1830s onwards, in work by Thomas Willement (1786-1871), such as the east window of Wells Cathedral Lady Chapel (1843), which incorporates fragments of ancient glass, and by the architect A. W. N. Pugin (1812-52). Pugin brought to stained glass a vast knowledge of medieval styles and iconography and outstanding abil-

Window designed by Pugin in West Haddon church (Northants.), 1850.

Helen's, Darley Dale (Derbys.), with its dense colours, clustered figure panels and profusion of inscriptions, is characteristically PRE-RAPHAELITE. By contrast, his windows in St Philip's Cathedral, Birmingham (1885–97), have large-scale, monumental figures in swirling drapery, and brilliant, sumptuous colours; they represent the summit of his achievement in stained glass. Pre-Raphaelite painting, and the glass of Morris & Co., had a considerable influence on Late Victorian stained glass design, notably that of Henry Holiday.

In the 1880s Christopher Whall (1849–1924) and other adherents of the Arts and Crafts Movement reacted against the division of labour that had become common in the large commercial studios, and advocated that artists should be familiar with and at least supervise, if not carry out, all the craft processes entailed in the execution of their designs. Whall's windows in the Lady Chapel of Gloucester Cathedral (1897–1910), full of the intricate

ities as a designer. His east window in Jesus College Chapel, Cambridge (1850) evokes the spirit as well as the formal characteristics of medieval work. Pugin's influence dominated British stained glass until the 1860s, by which time it had become a sizeable industry with a number of specialized firms (Hardman, Clayton and Bell, Lavers and Barraud, etc.) attracting established artists as designers, or working under close supervision from architects like Burges, Butterfield and Street.

With the formation of Morris & Co. in 1861 the Victorian revival of stained glass, hitherto substantially imitative, entered a new phase. Designs were provided by MORRIS himself, occasionally ROSSETTI, Madox BROWN and others, and after 1875 exclusively by BURNE-JONES. Historical precedents were abandoned in favour of compositions of figures standing against unified backgrounds of foliage or quarries. Burne-Jones became increasingly free and pictorial in his designs, while retaining the mosaic technique with a bold use of leads. His early Song of Solomon window (1863) in St

Panel designed by Morris and made by Morris & Co., in Middleton Cheney church (Northants.), 1864.

Detail of glass by Whall in the Lady Chapel of
Gloucester Cathedral, 1897–1910.

Baptistery window of Coventry Cathedral,
designed by Piper, 1959–62.

detail and rich colouring typical of Arts and
Crafts glass, illustrate his principal contribution
to the medium, the recognition that glass-
painting is a means of manipulating light and
colour rather than an extension of conventional
easel painting. His widespread influence led to
high standards of craftsmanship, but in its
design British stained glass remained tradi-
tional. The very prolific C. E. Kempe worked
in a delicate late Gothic/Renaissance mode. An
isolated exception is the abstract west window
of St Mary's, Slough (1915) by Alfred
Wolmark (1877–1961).

Evie Hone (1894–1955), influenced by
Cubism in Paris and associated with the
innovative Dublin glass studio An Túr Gloine,
produced non-historicist glass in the years
around World War II, and in the 1950s a
recognizably modern – i.e. abstract – style
began to emerge, seen at its best in Coventry
Cathedral, in the nave windows (1953–6) by
Lawrence Lee and in the baptistery window
(1959–62) by John PIPER. These windows,
which form an integral part of the building's
effect, were the foundation of an architectonic
tradition which has inspired most subsequent
stained glass. PC
□ C. W. Whall, *Stained glass work* (1905); J.
Piper, *Stained glass: art or anti-art?* (1968); M.
Harrison, *Victorian stained glass* (1980)

Stanfield, Clarkson (1793–1867) served a
decade in the navy and another as a highly
successful scenery and diorama artist before he
became a professional topographer and painter
of easel pictures. Frequent tours of the
Continent after 1830 provided ample material
for his oils and book illustrations, but his
repertoire also embraced MARINE subjects
which, in style, owed much to TURNER and
were admired by RUSKIN. PN
□ P. van der Merwe, *Clarkson Stanfield* (1979)

Stannard, Alfred and Joseph *see* NORWICH
SCHOOL

Steer, *Boulogne Sands*, 1888–91 (Tate).

Stark, James *see* NORWICH SCHOOL

Steele, Jeffrey *see* CONSTRUCTIVISM

Steer, Philip Wilson (1860–1942) was an intuitive, naturally gifted painter who enjoyed a high reputation throughout his career with hardly any recourse to the ROYAL ACADEMY. His allegiance remained with the NEW ENGLISH ART CLUB, and he taught exclusively at the SLADE.

His father, Philip Steer, was a portrait painter in Birkenhead, and his initial training was a conventional one at Gloucester School of Art. In 1882, however, he went to Paris, to study at the Académie Julian under Bouguereau and at the Ecole des Beaux-Arts under Cabanel. Then after a short period of Whistlerian influence he emerged, *c.*1887–94, as England's best Impressionist landscape painter in an international context (e.g. his beach scenes at Walberswick (Suff.) and at Boulogne). His large canvas *Three Bathers on the Sands* (priv. coll.) was exhibited at Brussels in 1889, in the company of French Post-Impressionists. Later, *c.*1895–1900, he made some surprising reversions in style, going back to Manet in figure paintings and nudes, and then to his own variations on the paint handling of GAINSBOROUGH and Fragonard. After 1900 he turned to landscape again, but of a more English variety reminiscent of CONSTABLE. An exception was a short period *c.*1907–10 when his thickly painted, expressive canvases, which show some rapport with early Cézannes, also anticipate the later work of BOMBERG. His works of the 1920s and 1930s, especially his watercolours, are less strident and

show an acute sensitivity to tone and light. BL
□ D. S. MacColl, *Philip Wilson Steer* (1945); B. Laughton, *Philip Wilson Steer* (1971)

Stevens, Alfred (1817–75) is best known for 2 exceptional works of sculpture: the decorative ensemble for the dining room at Dorchester House, London (*c.*1856) and the Wellington monument in St Paul's (1856–1912). After study in Italy 1835–44 he worked on paintings (*see* e.g. PORTRAIT PAINTING: 19C.), ceramics and industrial art, also designing bronze doors for the Geological Museum (1848, unexecuted) and a Mannerist memorial to the 1851 Exhibition (1857; model in V&A). For Dorchester House he designed not only the fireplace with Michelangelesque caryatids (now V&A) but in varying degrees all the other elements of the room. The Wellington monument is undoubtedly his masterpiece,

Stevens, monument to Wellington in St Paul's, London, 1856–1912.

though it was not finished until many years after his death, because of government delays and misunderstandings and the sculptor's own chronic procrastination. It absorbs and blends elements from English and Italian Renaissance sources to produce the most dramatic and imposing sculpture of its century in England.

BR

☐ *Alfred Stevens* (exh., V&A, 1975); Read (1982)

Stevenson, R. M. *see* GLASGOW SCHOOL

stipple engraving is a method of ENGRAVING to produce tone rather than line. The image is formed from innumerable dots and other marks punched into the plate by various specialized tools. Introduced to England in the early 1760s by W. W. Ryland, it soon rivalled MEZZOTINT and line engraving as a reproductive process, particularly of works of a soft and decorative character. Its popularity was enhanced by its comparative ease of execution and its suitability for printing in colours. *See* BARTOLOZZI.

RG

☐ Griffiths (1980)

Stokes, Adrian (1902–1972), one of the most original English writers on art and architecture since RUSKIN, is not easily summarized. Italian architecture and stone sculpture stimulated his first major books, *The Quattro Cento* (1932) and *Stones of Rimini* (1934). He began to paint in 1936. His book *Colour and Form*, written the same year, significantly affected the EUSTON ROAD SCHOOL where he became a student in 1937. A knowledge of psychoanalysis informs his many later writings on art, although they are much concerned with the corporeality of the works under discussion. His unpretentious, diaphanous paintings of landscapes, nudes and still-lifes increased in subtlety throughout his career. *See also* ST IVES SCHOOL.

BL

☐ *Critical writings of Adrian Stokes*, ed. L. Gowing (1978); *Adrian Stokes* (exh., Arts Council, 1982)

Stone, John *see* CIBBER

Stone, Nicholas (1583–1647) was the leading mason-sculptor of the early 17c. in England, whose original and vital sculpture was highly influential. Trained in the Southwark workshop of Isaac James, he went to Hendrick de Keyser's Amsterdam studio as a journeyman

Stone, monument to Francis Holles (d.1622) in Westminster Abbey.

1609–13, before establishing his London practice. His Dutch training is evident in the naturalism of his figure sculpture and the contrasting black and white marbles of the monument to Lady Carey (1617) at Stowe-Nine-Churches (Northants.). His innovatory style developed further during the 1620s when the most remarkable monuments were those to the Holles brothers (d.1622 and 1626) in Westminster Abbey, London. Here for the first time Stone made direct reference to Michelangelo's work and Roman armour.

The monument to John and Thomas Lyttleton (1634) in Magdalen College, Oxford, is typical of the radical change in Stone's style after 1630, when he predominantly used classicizing figures and drapery and relinquished rich colour effects. This development probably resulted from his study of the antique through Charles I's collections. Contact with the Italian influence of Inigo JONES, first as

Master Mason to the Banqueting House (1619–22) and then to the Crown (1632) may also have been a factor. AY
□ Stone's Notebook and Account Book, *Walpole Soc.*, VII (1919); Whinney (1964)

Stothard, Thomas (1755–1834) was a notably accomplished painter of literary subjects who left behind an enormous number of small paintings and drawings, usually for book illustrations. Though his youthful friendship with FLAXMAN and BLAKE prompted ambitions as a HISTORY painter, his leaning was more towards the ROCOCO tradition. His work is invariably charming and sometimes brilliant without even a shadow of profundity. *See also* POLYAUTOGRAPH. DB
□ Mrs Bray, *Life of Thomas Stothard* (1851); S. Bennett, *Thomas Stothard* (PhD, UCLA, 1977)

Stott, Edward *see* NEW ENGLISH ART CLUB

Streeter, Robert (1624–79), Pepys's 'famous history painter – a very civil man . . . who lives handsomely', was also praised for his 'most exact and rare landskips in Oyl'. He travelled in Italy during the Commonwealth and became Charles II's Serjeant Painter in 1660. The most important of his few surviving decorative works, the ceiling of Oxford's Sheldonian Theatre, shows Italian influences and a skill at perspective and foreshortening. DD
□ W. Sanderson, *Graphice* (1658); Croft-Murray (1960)

Stuart, James 'Athenian' *see* WATERCOLOUR

Stubbs, George (1724–1806), animal painter, portraitist, anatomist, draughtsman and engraver, is now recognized as one of the greatest and most original artists of his age. His work is distinguished by a profound understanding of anatomy and an ability to translate subjects studied from nature into fastidiously balanced compositions. His most frequent commissions were for paintings of horses, dogs and wild animals; awareness that such subjects were rated low in the artistic hierarchy did not deter him, throughout a resolute and hard-working career, from producing images which invariably arrest attention and frequently strike a deeply poetic note.

Much of Stubbs's professional and private life remains obscure. He was born in Liverpool, the son of a currier. At 14 he worked briefly under Hamlet Winstanley copying old masters at Knowsley Hall. Otherwise he was self-taught as both painter and engraver; though

Stubbs, *Hambletonian*, 1800 (National Trust, Mountstuart).

more susceptible to outside influences than he was perhaps willing to admit, he had the scientist's instinct for knowledge gained through practical experiment rather than received tradition. Apart from a brief visit to Rome in 1754, Stubbs remained for most of the 1740s and 1750s in the north of England, reputedly supporting himself as a portraitist (but few works of these decades are known) while studying anatomy. At York c.1745–51 he studied human anatomy and illustrated, from his own dissections, Dr John Burton's *Midwifery* (1751); its 18 plates are Stubbs's first essays in engraving. In Lincolnshire c.1756–8 he devoted 18 arduous months to intensive study of equine anatomy, tirelessly dissecting and delineating every stage of his dissections; 42 meticulously observed drawings survive (RA), from which Stubbs engraved a series of masterly plates published in 1766 as *The Anatomy of the Horse*, acclaimed by contemporary anatomists as an advancement of science.

Stubbs did not fully emerge as a painter until he was nearly 35 and had moved (in 1758?) to London, his home for the rest of his life. In the 1760s his genius flowered astonishingly, prolifically and diversely. From 1761 to 1774 he exhibited annually with the SOCIETY OF ARTISTS, later moving (less happily, it proved) to the ROYAL ACADEMY. His reputation was first established among noblemen devoted to racing and breeding horses: he painted their racehorses and jockeys, their hunters, hounds and grooms and, in an extraordinarily subtle series of variations, their mares and foals. In outdoor groups such as *Going out from Southill* (c.1763–8; priv. coll.) and *The Melbourne and Milbanke Families* (c.1770; NG) he steadily and uningratiatingly celebrates English sporting and country life and reveals himself, as in his 'incidental' portraits of jockeys and grooms, a most perceptive observer of different levels of social behaviour.

Stubbs also painted wild animals, including the first zebra seen in England, depicting some species dispassionately, to satisfy the scientific curiosity of patrons such as John and William Hunter and Sir Joseph Banks, and others in heroic compositions such as *Cheetah with Two Indian Attendants* (c.1764–5; Manchester); and he repeatedly returned to the highly Romantic theme (originally inspired by an antique sculpture) of a wild horse imagined in a state of nature as the prey of a lion.

Stubbs constantly experimented with technique. In the late 1760s he began chemical experiments with painting in enamels, first on copper and later on earthenware 'tablets' manufactured for him in Wedgwood's potteries. Over the next decades he translated many of his favourite subjects from oils into enamels, and also into engravings, where he perfected a very individual, mixed-method technique which is one of the greatest achievements of English printmaking; but in neither medium did he find public favour.

From the 1780s Stubbs's popularity declined. Fresh subject-matter such as farming scenes produced lyrical images like the *Haymakers* and *Reapers* (1785; Tate), yet these seemed too unsentimental for contemporary taste. A *Turf Review* project initiated c.1790 to publish 145 engravings of his racehorse portraits foundered after only 16 had been issued. Undaunted, though by now in his 70s and evidently in financial difficulties, Stubbs began work on *A Comparative Anatomical Exposition of the Structure of the Human Body with that of a Tiger and a Common Fowl*, uncompleted at his death; 125 drawings survive (Yale BAC). Like some of his last great paintings, notably the monumental *Hambletonian* (1800; Mountstewart, N. Ireland), these show that Stubbs's powers remained undiminished to the end of his long career. *See also* SPORTING PAINTING. JE
□ B. Taylor, *Stubbs* (1971); J. Egerton, *George Stubbs* (exh., Tate, 1976); *George Stubbs* (exh., Tate, 1984–5)

Sturt, John *see* AMATEUR ARTISTS

Sublime A concept dating back to classical times, which in the earlier 18c. was often associated with Longinus's writings on rhetoric. It also had literary and religious connotations. Its meaning was varied and difficult to define briefly, but it could signify the boundless and immeasurable, and also that injection of divine fire that could raise a speech or a work of art into a work of genius. It was already a well known term by 1712 when Joseph Addison wrote his *Spectator* essay 'On the Pleasures of the Imagination'.

But it was Edmund BURKE who aimed to define it most completely, in his *Philosophical Enquiry into the Origin of our Ideas of the Sublime and Beautiful* (1757), and he gives the word its full 18c. meaning. Burke's Sublime helped to confirm the use of the word in relation to

descriptions of landscape. Harsh and mountainous scenery, uncultivated and wild, frequently Alpine, was currently described as 'Sublime'. Salvator Rosa's landscapes in particular were given this epithet – not entirely correctly. As with the PICTURESQUE, Nature was seen through the medium of Art. Burke sought, using the philosophical approach of Locke, to give the Sublime a fully substantive meaning. Sublime objects, such as those showing immense size, darkness and obscurity, caused pain and terror. Seen through the medium of art, rather than in reality, they induced a sublime sensation. Burke distinguished the Sublime from the Beautiful, which was characterized by smallness and smoothness and produced a sensation of quiet happiness. Although the logical basis of his argument, far more complex than is here described, was somewhat insecure, his ideas were eagerly accepted. The Sublime became particularly associated with wild and savage landscape, though Burke himself had not so restricted it.

Burke's ideas about the Sublime are visually expressed in paintings of literary subjects by FUSELI and others and in late 18c. landscape painting, e.g. LOUTHERBOURG's *Avalanche in the Alps* (1803; Tate). At the beginning of the 19c. TURNER produced some 'Sublime Historical' landscapes such as *The Fifth Plague of Egypt* (1800; Tate), and the vastness, horror and immensity apparent in them were further exploited in the paintings of John *MARTIN and Francis DANBY, often showing epic Biblical cataclysms. JS

□ S. H. Monk, *The Sublime: a study of critical theories in 18c. England* (1960); Hipple (1957); A. Wilton, *Turner and the Sublime* (1980)

supports *see* PAINTING

Surrealism arrived comparatively late in England. Although individual artists had already come under Surrealist influence (e.g. HAYTER, Henry MOORE and Paul NASH), it was not until 1936, with the International Surrealist Exhibition, that a group was officially formed. The exhibition, held in June at the New Burlington Galleries in London, provoked enormous, largely hostile, public reaction. Roland PENROSE and Herbert READ selected the English contributions, André Breton and Paul Eluard the European. It showed paintings, sculptures, objects, and primitive art, including works by SUTHERLAND, Picasso, Dalí, Miró,

Ernst and Giacometti. The first publication of the English group was 'read and approved by', among others, Eileen Agar (b.1904), BURRA, Humphrey Jennings (1907–50), Len Lye (b.1901), E. L. T. MESENS, Moore, Nash, Penrose, Man Ray (1898–1967), Read, and Julian Trevelyan (b.1910).

While artists, writers and intellectuals were attracted to the revolutionary ideas of Surrealism, it was in England perceived primarily as an art movement (and often confused by the public with modern art in general). The broad field of action Surrealism had proposed did find echoes in England (e.g. Grace Pailthorpe and Rueben Mednikoff's work on painting and psychoanalysis), but on the whole the division between theory and practice increased.

Surrealism's 'foreignness' caused considerable public and internal debate. Herbert Read proposed a base for it within an English literary tradition, while David Gascoyne stressed its international character.

Exhibitions were held at the LONDON GALLERY and at Zwemmers, as well as under the auspices of the Artists' International Association. The *London Bulletin* (1938–40) was the main Surrealist mouthpiece; the group continued to publish tracts during the war. Its membership changed frequently, and, since the war, with the exception of a joint 'Statement' in the Paris catalogue *Le Surréalisme en 1947*, Surrealism in England has been a matter of individual commitment.

See also LANDSCAPE: 20C.; MCWILLIAM; MADDOX; TUNNARD. DA

□ D. Gascoyne, *A short survey of Surrealism* (1935); A. Breton, *What is Surrealism?* (1936); H. Read, *Surrealism* (1936)

Sutherland, Graham (1903–80), painter, abandoned his training as a railways engineer to study printmaking, 1920–25. His admiration for BLAKE, Samuel PALMER and the other SHOREHAM painters shows in his early work which, for that reason, has affinities with the drawings of Paul NASH. He taught engraving at the Chelsea School of Art from 1926. He began to paint in 1931 and exhibited 2 oils in the International SURREALIST Exhibition (1936). *Welsh Landscape with Roads* (1936; Tate) demonstrates the similarities between his response to nature and Henry MOORE's use of natural and organic forms (*see also* NEO-ROMANTICISM). Like John PIPER, Sutherland painted scenes of urban devastation as an official

Sutherland, *Welsh Landscape with Roads*, 1936 (Tate).

war artist, 1941–4. From 1947 he lived for much of each year on the French Riviera. He continued to paint landscapes and, after the *Crucifixion* which he completed for St Matthew's, Northampton in 1946, imaginative compositions, often with explicit religious imagery. The commission to design the altar tapestry for Coventry Cathedral, 1954–7, resulted in *Christ in Glory in the Tetramorph*. *Somerset Maugham* (1949; Tate) established Sutherland as a portrait painter – a reputation which did not suffer as a result of the controversy which surrounded his portrait of Sir Winston Churchill (1954; destroyed). DR
□ J. Hayes, *Graham Sutherland* (1980)

Sutton Hoo is an early *ANGLO-SAXON burial ground on the Suffolk coast. One of the barrows has been excavated to reveal a ship containing an immensely rich assemblage of grave-goods (BM) intended in the pagan manner for use in the after-life. This burial, or perhaps cenotaph, must have been that of a member of the East Anglian royal family, most probably King Raedwald, who died *c*.625. The objects give a vivid glimpse of a pagan Germanic court, much as described in the Anglo-Saxon epic *Beowulf*, coming into contact with the Christian culture of the Celts, the Franks and the Mediterranean world. The deceased was provided with probably royal insignia, jewellery, helmet, shield and weapons, with table-ware including silver from the eastern Mediterranean and a bronze bowl from Egypt, drinking vessels and utensils, and with Frankish coins, a lyre and gaming pieces; 2 silver spoons with Christian inscriptions may indicate a flirtation with Christianity.

The decoration of the jewellery, weapons and some other objects uses techniques and styles of Dark Age Germanic metalwork. A few items seem to be Swedish in origin and others to show Swedish influence, but a number of pieces of astonishingly high quality were almost certainly made in East Anglia. The main technique, gold with *cloisonné* settings of garnets and glass, was widely used in Germanic polychrome jewellery. Abstract ornament and the stylized and rhythmically interlacing animals of 'Style II' of Dark Age Germanic art are used to superb effect on the purse-lid, the great gold buckle and the shoulder clasps. The treasure also includes 3 bronze 'hanging bowls' made by Celtic (Irish or more probably British) craftsmen. These bear plaques of Celtic curvilinear ornament executed in *champlevé* ENAMEL. Significantly, some of the Anglo-Saxon metalwork shows Celtic influence, in its use of *millefiori* glass.

Some motifs in the highly sophisticated Anglo-Saxon and Celtic metalwork of the early 7c. found at Sutton Hoo compare very closely with some of the ornament in the later 7c. Book of Durrow (Dublin, Trinity College), and thus demonstrate the adoption into Insular book decoration of native metalworking traditions. JH
□ R. Bruce-Mitford, *The Sutton Hoo ship burial* (3rd ed. 1979); id. *et al.*, *The Sutton Hoo ship burial* (1975–84)

Systems *see* CONSTRUCTIVISM

T

Taverner, William (1703–72), a lawyer by training, practised in both oil and WATER-COLOUR, though no oils have been identified. He specialized in classicizing LANDSCAPES inspired by Marco RICCI and the 17c. Italianate Dutch painters. AW
□ Williams (1952); Hardie, I (1966)

Taylor, A. C. *see* NEWLYN SCHOOL

Taylor, Sir Robert (1714–88) was apprenticed as a sculptor to CHEERE and then travelled in Italy. In 1744 he was chosen to execute the pediment of the Mansion House, London, and

in 1747 commissioned for the Cornewall monument in Westminster Abbey (completed 1755). The former is dully conceived and clumsily executed; but in some monuments and smaller works combining *putti* and scrollwork he developed features derived from Cheere into an attractively individual Rococo style (*see* SCULPTURE: ROCOCO). He is more celebrated for his architecture, to which he devoted his energies from the mid 1750s. MB
□ Whinney (1964); H. Colvin, *Biographical dictionary of British architects* (1978); *Rococo* (1984)

Teerlinc, Lavinia *see* HILLIARD

tempera is a painting medium in which the binding agent is egg. It dries to a brittle film, and so is best suited for work on rigid supports such as PANELS or walls. It was gradually replaced as the principal medium by the more flexible OIL. CH
□ D. V. Thompson, *The practice of tempera painting* (1962)

Tenniel, Sir John *see* CARICATURE

terracotta is clay fired to 600–1200°C. The sculptor models the raw clay by using spatulae, styli (for the incision of details) and wire loops, and by adding pellets of clay. After cutting out any unnecessary clay from the core or back of

Terracotta bust of Hogarth by Roubiliac, *c.*1741 (NPG).

the sculpture he leaves it to dry to a 'leather-hard' state and then adds any final details, finishing the surface with a rag or sponge before firing.

Terracotta was introduced into England from Italy in the early 16c. (*see* SCULPTURE: 16C.). It has chiefly been used for preliminary models, particularly in the 18c., when the models of RYSBRACK and ROUBILIAC often equal, or even surpass, their larger finished sculptures in marble. The directness with which effects of modelling could be achieved gives such works an immediacy rivalled only in wax.

From TORRIGIANO's portrait busts onwards, the material has also been used for finished works, which were usually painted and gilded. By the mid 18c. terracotta busts were produced as cheaper alternatives to marble; any firing cracks would be filled and the surface painted, sometimes in white imitating marble (a pigmentation often mistakenly removed by later restorers).

See also DOBSON, F.; NOLLEKENS. MB
□ J. Larson in *The Conservator*, 4 (1980); M. Greenacre in K. Eustace, *Michael Rysbrack* (exh., Bristol, 1982)

theatrical painting really begins with HOGARTH's paintings of *The Beggar's Opera*, *c.*1728. The genre had a particular appeal in the 18c. because it could be harnessed to the theory of HISTORY painting, allowing the artist to explore serious subjects as well as rhetorical gesture. A number of distinguished artists in the mid 18c. worked as scene painters (including HAYMAN and LAMBERT), but the revival of interest in Shakespeare and the advent of Garrick in 1741 were the most important catalysts. Hayman, Benjamin Wilson (1721–88) and Hogarth all produced portraits of Garrick *en rôle*, the finest being the latter's *Garrick as Richard III* (1745; Liverpool). Several of Hayman's VAUXHALL GARDENS supper-box pictures of early 1740s were theatrical in content. The partnership between ★ZOFFANY and Garrick from 1762, resulting in a number of splendid paintings and large MEZZOTINTS, revitalized the genre.

In the late 18c. and early 19c. the tradition was maintained by Samuel de Wilde (1748–1832), George Clint (1770–1854), LAWRENCE, and his pupil George Henry Harlow (1787–1819). BA
□ I. Mackintosh and G. Ashton, *The Georgian playhouse* (exh., Arts Council, 1975)

Theed, William, the Elder *see* ELGIN MARBLES

Theed, William, the Younger (1804–91) *see* ALBERT MEMORIAL; SCULPTURE: VICTORIAN

Thirtle, John *see* NORWICH SCHOOL

Thomas, Grosvenor *see* GLASGOW SCHOOL

Thomas of Oxford was a glazier who executed windows for William of WYKEHAM in the chapels at New College, Oxford (*c.*1380–86 and possibly later) and Winchester College (1393–4). The early 15c. glass in the nave clerestory of Winchester Cathedral and east window of Merton College Chapel, Oxford, is also probably by him. The Winchester College glass and the Jesse window from New College (now in York Minster) are amongst the earliest examples of the INTERNATIONAL GOTHIC style in English art. RM
□ C. Woodforde, *The stained glass of New College, Oxford* (1951); J. H. Harvey and D. G. King in *Archaeologia*, CIII (1971), 149–77

Thomson, John (1778–1840) – usually known by his ecclesiastical title, the Rev. John Thomson of Duddingston – was an amateur, but one of the most original painters of his time in Scotland. He studied briefly with Alexander NASMYTH while a student at Edinburgh University, and was friendly with RAEBURN, whose landscape backgrounds were the starting point for the characteristic freedom of Thomson's landscapes. He was also a lifelong friend of Sir Walter Scott, and for both men landscape was a subject rich in historical associations.

The freedom and expressive quality of his painting is remarkable. He used strong chiaroscuro and rich paint surfaces, often applied with the palette knife in order to express the feeling appropriate to a landscape. *Martyrs' Tombs, Lockinkett, Galloway* (1826/7; priv. coll.) represents a group of Covenanters' tombs in a wild and desolate setting, the mood of the scene providing a comment on its historical associations. Thomson was an important influence on MCCULLOCH and perhaps also on MCTAGGART. DM
□ W. Baird, *John Thomson of Duddingston* (1895); Caw (1908); Irwin (1975)

Thornhill, Sir James (1675–1734) was the first painter of English birth to compete with foreign artists for major wall-painting commissions in the early 18c. He learned the methods of DECORATIVE painting from VERRIO or

Thornhill, detail of the ceiling of the Painted Hall at Greenwich Hospital, 1707–27.

LAGUERRE and by adroit manoeuvring and painterly competence rather than genius was able to wrest from his foreign rivals 2 of the greatest commissions of the day. The first was the Painted Hall at Greenwich Hospital (1707–27), an allegory of the Protestant Succession showing the constructive achievements of the Protestant monarchs since 1688, which was the largest scheme of decorative painting to be carried out by a single artist in the 18c. The second was the Life of St Paul in the cupola of St Paul's Cathedral, London (1716–19). His success, culminating in his knighthood in 1720, was important for the morale of English painters, especially his son-in-law HOGARTH.

Because he rose by politics as much as talent, he was vulnerable to the machinations of the Earl of Burlington and his protégé William KENT, who took from him a commission for decorative paintings at Kensington Palace in 1723. Thornhill was unable to complete any other major commissions, not only because of Kent but because taste had begun to move away from massive wall-painting schemes. He spent his last years in virtual retirement copying the Raphael Cartoons.

While best known for his decorative work, he made some good portraits (Cambridge, Trinity College), and there are indications of a genial, clubbable personality which regrettably does not come through in his large-scale work. See also ST MARTIN'S LANE ACADEMY; STAINED GLASS: 16–18C. DB
□ W. R. Osmun, *A study of the work of Sir James Thornhill* (PhD, London, Courtauld, 1950); Croft-Murray, I (1962); Waterhouse (1978)

Thornton, John (active 1405–33) was the leading glazier of the YORK SCHOOL. He retained properties in York and in Coventry, his place of origin, which may explain the close affinities that exist between glass in and around both cities. Thornton's only documented undertaking is the glazing of the York Minster east window (1405–8), which is an important monument of the English INTERNATIONAL GOTHIC style (*see* *STAINED GLASS: TO 1550). It is likely that he was responsible for glazing the entire Minster choir west of and including the choir transepts. RM
□ D. E. O'Connor and J. Haselock in *A history of York Minster*, ed. G. E. Aylmer and R. Cant (1977)

Thornycroft, Thomas (1816–85) trained with John Francis (1780–1861) and married his sculptor daughter, **Mary** (1809–95). Both specialized in portrait sculpture, Mary especially of the royal family (1845–60; Osborne). Thomas is best known for *Boadicea* (1856–97; London, Embankment) and also contributed to the ALBERT MEMORIAL. Their son, **Hamo** (1850–1925), was prominent in the NEW SCULPTURE movement (e.g. *The Mower*, 1884; Liverpool). BR
□ E. Manning, *Marble and bronze* (1982); Read (1982)

Tillemans, Peter (1684–1734) was born in Antwerp and trained there as a landscape painter. In 1704 he arrived in England, and was initially employed to copy old masters. He is best known for panoramic landscapes with sporting activities in the foreground and for country house views which frequently include a portrait of the owner. DD
□ Harris (1979)

Tilson, Joe (b.1928) was trained both as a joiner and as a painter, and is exceptionally well-read. He works often in wooden relief but has experimented widely with different media, especially prints. The content and imagery, while personal, refer to universal human preoccupations: games, rituals and associated objects ancient and modern. MC
□ A. Quintavalle, *Tilson* (1977)

Tissot, James Jacques Joseph (1836–1902), painter and illustrator, is now best known for his scenes of sophisticated and leisured life, often infused with tension and ambiguity in psychologically and compositionally enclosed settings. French, trained in Paris and first

Tissot, *The Captain's Daughter*, 1873 (Southampton).

influenced by Baron Leys' medievalizing, he shifted to modern life subjects c.1864. He was a friend of Degas (who invited him to show with the Impressionists), Manet and WHISTLER. Success as a caricaturist for *Vanity Fair* from 1869 attracted him to London, where he showed at the GROSVENOR GALLERY and linked the London and Parisian avant-gardes. The death of his mistress and model Kathleen Newton in 1882 radically changed his life: he returned to France in 1883 and, from 1886, visited Palestine 3 times, producing hundreds of lithographs and engravings for his hugely popular *Life of Christ* (1896–7) and *Old Testament* (1904). *See also* PORTRAIT PAINTING: 19C. RT

□ *Tissot* (exh., Rhode Island, 1968)

tombs (medieval) Tombs with effigies, having escaped the wholesale iconoclasm which so severely affected religious sculpture in the 16c. and 17c., now constitute a large part of surviving English medieval figure sculpture.

Slabs carved with effigies came into use during the 12c., being initially reserved for bishops, abbots, founders and royalty. Some of the earliest extant examples, such as that of Bishop Roger (d.1139) at Salisbury, are of black Tournai marble and were carved in Flanders. Inspired by these imported works, an English tradition of tomb sculpture in dark Purbeck marble developed, early evidence of which is the fragment of the effigy of Abbot Clement (d.1163) at Sherborne (Dor.). Purbeck marble, worked both in London and near the quarry at Corfe (Dor.), remained the standard material for effigies until c.1300.

The most prestigious bishops' tombs of the 13c. were provided with imposing canopies, often imitating the forms of shrines. The resemblance to a shrine of the tomb of Bishop Giles of Bridport (d.1262) at Salisbury was strengthened by the use of relief sculpture between the gables. Effigies of bishops usually held a crozier in the left hand and blessed with the right; not until the 14c. did they adopt a praying attitude.

Carved effigies commemorating members of the lay nobility were introduced in the first half of the 13c. An early group of freestone knights in the south-west, stylistically related to the statues of the west front of Wells Cathedral (*see* SCULPTURE: GOTHIC, STONE), already shows the cross-legged attitude expressing recumbancy which was adopted for almost all military effigies in the late 13c. and early 14c. The sword-handling pose, which became popular in the second half of the 13c., combined well with crossed legs to convey an impression of vigour and alertness.

Freestone, already used for the effigy of Bishop Peter of Aquablanca (d.1268) at Hereford, replaced Purbeck marble as the principal material for tomb sculpture in the late 13c. Often enriched with applied detail in moulded gesso, and then painted, freestone effigies accorded well with the taste for colourful ornament which prevailed in the years around 1300. Much of the original decoration survives on the tomb of Edmund Crouchback, Earl of Lancaster (d.1296) in Westminster Abbey, London. This period also saw the production of a number of wooden effigies (*see* SCULPTURE: GOTHIC, WOOD), including a group which appears to have been carved by the workshop responsible for the Crouchback effigy. BRONZE was reserved for the most costly and prestigious monuments, such as the series of tombs commemorating the monarchy at Westminster, which began c.1291 with

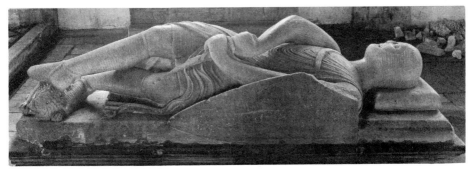

Tomb effigy of a sword-handling knight in Dorchester Abbey (Oxon.), c.1280.

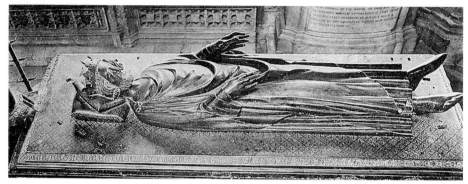

Bronze effigy of Henry III (d.1272) by **Torel** in Westminster Abbey.

TOREL's effigies of HENRY III and Eleanor of Castile.

The production of secular effigies grew rapidly between *c.*1270 and 1300. (The same period is marked by the sudden rise in popularity of monumental BRASSES.) The increase in demand encouraged a proliferation of local workshops, resulting in a great variety of style and attitude. The greatest diversity and inventiveness is shown by effigies of knights, such as that at Aldworth (Berks.) commemorating a member of the de la Beche family, who is depicted lying on his side in a twisted position and raised on one elbow. Some groups of tombs may represent the growth of specialization, although a number of workshops appear to have produced both effigies and architectural sculpture.

The royal tombs erected around Edward the Confessor's shrine at Westminster in the late 13c. and early 14c. were influential in 2 ways. As a group they inspired other families to found their own mausolea (as the Despencers did at Tewkesbury); and stylistically they helped introduce to England a number of French motifs, including 'weepers' representing the relatives of the deceased, and angels supporting the cushions beneath the head of the effigy. Heraldry was used extensively to display family connections.

The attitude of the hands joined in prayer, standard in France by the mid-13c., became current in England after *c.*1280 for the growing number of effigies of ladies and civilians (male figures of diverse social status, dressed in civil costume rather than in armour). Effigies of praying knights did not become widespread until after *c.*1300. The praying attitude became

standard for all types of effigy except those of monarchs from *c.*1350 until the end of the medieval period. (*See also* INTERNATIONAL GOTHIC.)

The use of ALABASTER for tomb sculpture was developed in the second quarter of the 14c., the first major example being the effigy of Edward II (d.1327) at Gloucester. From *c.*1400 onwards,

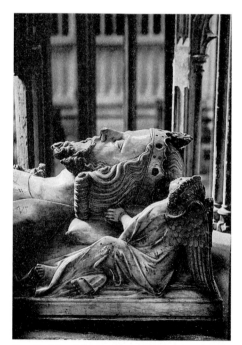

Detail of the alabaster effigy of Edward II (d.1327) in Gloucester Cathedral.

Gisant tomb of Bishop Richard Fleming (d.1431) in Lincoln Cathedral.

the tomb trade was dominated by a limited number of alabaster workshops in London, York and the midlands (*see* illustration to *★BANKS).

Military effigies adopted the straight-legged pose in the mid 14c., and from this time medieval effigies varied little in attitude. Possibly influenced by French prototypes, however, a new type of monument, the cadaver or *transi* tomb, appeared in England in the early 15c. Popular mainly with the higher clergy, it combined the traditional function of a tomb with that of a *memento mori*, comprising, besides the usual effigy, a representation of the emaciated corpse visible through the pierced sides of a tomb chest. Lavish CHANTRY chapels as a setting for tombs (e.g. the Beauchamp Chapel at Warwick of 1441–53: *see* ★MASSINGHAM) came to an end with the Reformation, but many of the traditions of medieval tomb sculpture survived until much later.

For post-medieval funerary monuments, *see* SCULPTURE: 16C.–VICTORIAN. ND
□ F. H. Crossley, *English church monuments 1150–1550* (1933); Stone (1972); B. Kemp, *English church monuments* (1980); H. A. Tummers, *Early secular effigies in England* (1980); and bibliographies in *Bull. Internat. Soc. for the Study of Church Monuments*, I (1979), IV (1981), VII (1982), IX (1983)

Tomkins, William *see* LANDSCAPE PAINTING: 18C.

Tonks, Henry (1862–1937), painter and teacher, qualified initially as a surgeon. He first exhibited at the NEW ENGLISH ART CLUB in 1891, and abandoned medicine when appointed teacher at the SLADE by Fred Brown in 1892. He was Slade Professor 1918–30. As a painter, he admired Degas; as a draughtsman, his sensitive figure studies are based on a profound knowledge of anatomy. He never accepted Post-Impressionism, and opposed the doctrines of Roger FRY. BL
□ J. Hone, *Henry Tonks* (1939); Farr (1978)

Torel, William (active 1291–3), a goldsmith of London, made the cast BRONZE effigies of HENRY III (d.1272) and Eleanor of Castile (d.1290) for Westminster Abbey, and another of Eleanor for her entrail tomb at Lincoln, which was destroyed in 1641. The 2 Westminster figures, under way in 1291, are the earliest extant bronze effigies in England and mark the beginning of the process which turned the Confessor's Chapel into a royal mausoleum along the lines of St Denis in France. ND
□ H. M. Colvin, ed., *The history of the King's Works*, I (1963); Stone (1972)

Torrigiano, Pietro (1472–1528) was a Florentine sculptor working in England 1511–*c.*1520 whose masterpiece, the tomb of Henry VII in Westminster Abbey, London (1512–18), introduced the Italian Renaissance style to English sculpture (*see* ★SCULPTURE: 16C.). He trained under Bertoldo at the Medici Academy, working in TERRACOTTA, a medium often used in his English works. According to Vasari he was exiled from Florence for breaking Michelangelo's nose and subsequently worked in the Netherlands 1509–10 before arriving in England and executing his first commission, the tomb of Lady Margaret Beaufort (1511; Westminster Abbey). He died in Spain during imprisonment by the Inquisition. AY
□ J. Pope-Hennessy, *Italian Renaissance sculpture* (1958); Whinney (1964)

Towne, Francis (1739/40–1816) was taught in London but spent most of his life as a DRAWING MASTER in Exeter. Apart from a few oil paintings, his output was entirely in WATERCOLOUR. His style is idiosyncratic, with subtly harmonized blocks of colour crisply defined with pen creating compositions untypical of his period, although he evidently influenced, and was influenced by, John 'Warwick' SMITH and William PARS, with both of whom he worked in Italy where he spent some time in 1780–81. The Alpine subjects he brought back are, if

Towne, *The Source of the Arveiron*, watercolour, 1781 (V&A).

rare, among his most powerful works. His style was imitated successfully by another Devon artist, John White Abbott (1763–1851). AW
□ A. P. Oppé in *Walpole Soc.*, VIII (1919–20), 95–126; Hardie, I (1966)

Townshend, George *see* CARICATURE

Trevelyan, Julian *see* SURREALISM

Treviso, Girolamo da *see* HENRY VIII

Tucker, William (b.1935) was one of the group of NEW GENERATION sculptors. His strongly theoretical approach initially provided him with a sort of minimal definition of a sculpture as a self-sufficient 3-dimensional object standing in space. His works, generally composed of very simple abstract forms, encouraged the spectator to scrutinize acutely the formal properties and relations of the entity in front of him. Since Tucker's move to the USA in the 1970s, his work has taken on a new monumentality, sensuousness and richness. He is also a particularly fine critic of early 20c. sculpture. LC
□ *William Tucker sculpture 1970–73* (exh., Arts Council, 1973); W. Tucker, *The language of sculpture* (1974)

Tuke, Henry Scott (1858–1929), a visitor to Newlyn in 1883 and 1884, settled at Falmouth painting zealously in the NEWLYN SCHOOL manner, until a visit to the Mediterranean in 1892 greatly brightened his palette, and the sale of *August Blue* to the nation (Tate) in 1894 encouraged his enthusiasm for the study of the open-air male nude. FG
□ *See* NEWLYN SCHOOL

Tunnard, John (1900–1971) began as a landscape painter in 1930, and in 1936 was decisively influenced by Miró, Klee, Masson, Tanguy and others, through Herbert READ's book *Surrealism*. His work is partly SURREALIST, with elements of CONSTRUCTIVISM. Many of the paintings are of fantastic constructions in deep space, betraying an interest in entomology, geology and technology. AG
□ *John Tunnard* (exh., Arts Council, 1977)

Turnbull, John *see* GROUP X

Turnbull, William (b.1922) is as well known for his abstract painting as for his sculpture. In

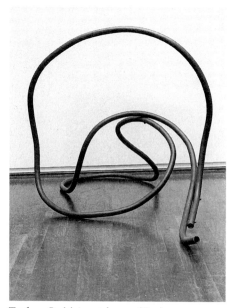

Tucker, *Beulah i*, metal, 1971 (Tate).

the early 1950s he worked in plaster, in simple forms (which reflected his profound admiration for Brancusi), to which he gave mythic or totemic titles. By the 1960s he had become rigorously abstract, often using industrial elements to make sculpture of repeating units whose minimal forms were painted in clear colours to concentrate attention on their formal qualities. More recently, he has returned to modelling, producing works which resemble ancient sculptures; once again they are basic in form (yet now resonant with associations), for Turnbull has always been concerned with sculpture as an expression of universal truths. LC

□ *W. Turnbull* (exh., Tate, 1973)

Turner, Joseph Mallord William (1775–1851) presents us with one of the many paradoxes of English Romantic art. He was essentially self-taught, but was also a fervent and lifelong supporter of the ROYAL ACADEMY; he felt instinctively drawn to classical antiquity, and yet the colouristic basis of his art tended to subvert the NEOCLASSICAL aesthetic of his day; he led an essentially solitary, misanthropic and even squalid life, and yet he was ambitious for social recognition and royal patronage; in some ways a rough-hewn cockney humorist in the tradition of English satirical art, he also brought to English painting its most sustained sense of the tragedy of landscape.

The son of a London barber, Turner passed his adolescence as the humble assistant to printsellers and architectural draughtsmen. He entered the RA Schools in 1789, began exhibiting topographical WATERCOLOURS in 1790 and his first oil, a marine, in 1796. Turner established his reputation and fortune early through topographical commissions for publishers and private patrons, was elected ARA in 1799 and, at an exceptionally young age, RA in 1802. He quickly developed a prominent position in the art life of the capital: he was Professor of Perspective at the Academy 1807–37 (although he only lectured 1811–28); from 1807 to 1819 he publicized his work in a superb series of engravings entitled *Liber Studiorum*, after both new and existing designs, and classified according to a rather spurious range of landscape and marine types. In 1804 he opened his first private gallery, and in the late 1820s, perhaps through the stimulus of his friend, the architect Sir John Soane, he conceived a plan to leave the contents of his

gallery and studio to the nation, together with almshouses for aged landscape artists. Complications in the will prevented this plan from being realized, but the opening of the Clore Gallery on Millbank should go some way towards fulfilling these intentions.

Turner was always a dedicated traveller; he visited many parts of Britain in the 1790s and in 1802 made the first of several trips to the Continent (France and Switzerland). Holland and Germany were visited in 1817 and Italy 2 years later. Towards the end of his life he made repeated excursions to Venice and to Switzerland, and his last foreign tour was in Normandy in 1845. He was always especially attracted to the sublime scenery of mountains and to those river, lake and coastal sites which would allow him to explore the broad and luminous effects of sky reflected in water.

Although he chose to make his career essentially under the aegis of the Academy (on election to full membership he changed his signature from the simple 'W. Turner' to 'J. M. W. Turner RA', to which he later added 'PP' for Professor of Perspective), Turner was also very dependent on the warm sponsorship of private patrons, who often profoundly affected the direction his art was to take. In the early 1790s he had been introduced, together with GIRTIN, to the brilliantly atmospheric watercolours of John Robert COZENS, in a sort of 'academy' run by the amateur and collector Dr MONRO. About 1800 the attentions of Sir Richard Colt Hoare of Stourhead began to interest him in classical antiquity, and at the same time he came into touch with Walter Fawkes of Farnley, probably the sponsor of his

Turner, *The Picture Gallery, Petworth*, watercolour, c.1828 (Tate). In the foreground is Flaxman's *St Michael*.

Turner, *Peace: Burial at Sea [of Sir David Wilkie]*, 1841–2 (Tate).

1802 tour, whose interest in radical politics and in modern history encouraged Turner to interpret ancient civilizations in terms of contemporary events. About this time, too, Turner met the 3rd Earl of EGREMONT, whose collection of old masters was to be a great stimulus to his art, and whose country seat, Petworth, was to become a frequent refuge for the painter from the late 1820s until Egremont's death in 1837. Towards the end of his life, Turner became a mentor to the young critic RUSKIN, and their mutual friend, the dealer Thomas Griffith, was to act as intermediary for many later watercolour commissions, notably the magnificent Swiss and Rhineland series of the early 1840s, many of which Ruskin himself acquired.

Turner never lacked for patronage, but from the 1820s he began seriously to assemble a comprehensive selection of his major works himself, sometimes buying them up in the sale-room, for preservation in what he hoped would be his Turner Gallery. This applied to oils; watercolours he took less seriously, and yet it was the procedures developed for making extensive series of watercolours after *c.*1815 – the Rhineland series for Fawkes, or *England and Wales* for the engraver Charles Heath – that shaped his whole approach to painting during the last 30 years of his life. He would lay in a large number of designs at the same time and work them up simultaneously until they were finished, abandoning many in various stages of completion along the way. Thus his bequest to the nation includes many works which were never finished, and these include many of his most popular canvases like *Yacht approaching Coast* (*c.*1840; Tate) and *Norham Castle, Sunrise* (*c.*1845; Tate). The procedures of oil and watercolour were, indeed, intimately related throughout Turner's career; and, in more general terms, the effects of the small-scale book-illustrations of the late 1820s and 1830s (such as the vignettes for Samuel Rogers' *Italy* of 1830) may be felt in many oils of the last 2 decades of Turner's life, and especially in the series of small canvases of the early 1840s, of which *Peace: Burial at Sea* (1841–2; Tate) is perhaps the best-known example.

Turner's reputation was, and is, based on his

extraordinary capacity to evoke the nuances of natural and artificial light; yet his ambitions led him constantly into the study of history, mythology and natural philosophy, and to embody these studies in his art. Only recently has attention been redirected to his subject-matter, to his extensive knowledge of the art of the past, and to the literary aspects of his mind and production, aspects to which it is fair to say we owe both his astonishing range of themes and the peculiar intensity which he brought to subjects of SUBLIME nature.

Although Turner's early mature work had a limited influence on a number of younger painters, like COTMAN, CALLCOTT, STANFIELD, PALMER and especially BONINGTON, his later style had very little effect in England despite – or perhaps because of – Ruskin's vigorous advocacy. It is in France in the years around 1900 that we must look for his successors.

See also MARINE PAINTING; MEZZOTINT; OUTDOOR PAINTING. JG
□ M. Butlin and E. Joll, *The paintings of J. M. W. Turner* (1977); A. Wilton, *The life and work of J. M. W. Turner* (1979); *Collected correspondence of J. M. W. Turner*, ed. J. Gage (1980)

Turner, William, 'of Oxford' (1789–1862) studied watercolour painting with John VARLEY. In 1811 he retired to Oxford, where he taught drawing, but he remained a member of the Old Water-Colour Society and one of its most inexhaustible exhibitors. His renderings of predominantly British scenery are often panoramic in format, elaborate in technique, and attentive to naturalistic phenomena. PN
□ Hardie, II (1967)

Twygge, Richard (fl.1476–1510) was a glass-painter who worked on several important glazing schemes. He was based in Malvern (Worcs.), and although there are a number of churches in the neighbourhood which contain glass by him he also travelled much further afield, to Tattershall (Lincs.), where he worked in 1482 with Thomas Wodshawe on several nave windows, and Westminster Abbey in London. His major surviving works are Tattershall, the Great Malvern 'Magnificat' window, and the east windows of Buckland (Glos.), Little Malvern and Oddingley (Worcs.). RM
⊓ R. Marks in *Archaeologia*, CVI (1979), 139, 148–9, 151

Uglow, Euan (b.1932) is Britain's leading exponent of systematic painting from life, in which a realist tradition deriving from the EUSTON ROAD SCHOOL is subjected to a lyrical geometry of composition: it represents the final extension of COLDSTREAM's approach, adapted and tightened (sometimes to the point of strenuousness) to achieve unequivocal statements about nature, usually in the form of a carefully posed human figure. Evasiveness in either colour or drawing is scrupulously shunned. The rigour of his method, however, does not preclude either poetry or wit, especially in some of the smaller still-life studies. TP
□ *Uglow* (exh., London, Whitechapel, 1974)

Unit One was a group of painters, sculptors and architects, brought together in 1933 by Paul NASH, which temporarily united emergent SURREALIST and abstract tendencies. In 1934 it held a touring exhibition and published a manifesto, *Unit One*, edited by Herbert READ. Before its dissolution in the winter of 1934–5 it had among its members BURRA, Tristram Hillier (1905–83), Ben NICHOLSON, WADSWORTH, HEPWORTH and MOORE. AG
□ *Unit One* (exh., Portsmouth, 1978)

Van Aken (or **Haecken**), **Joseph** (c.1699–1749) is best known as the drapery painter for leading portraitists including HUDSON and RAMSAY. He came to London from Antwerp c.1720 and before specializing c.1735 executed genre scenes and CONVERSATION PIECES. BA
□ J. Steegman in *Connoisseur*, XCVII (1936), 309–15

Vanderbank, John see ST MARTIN'S LANE ACADEMY

Van der Hagen, Gaspar(?) (d.c.1775) worked as an assistant to RYSBRACK and apparently carved some of the reliefs above the latter's chimneypieces. He is better known for his portraits in IVORY, many of which are based on marble originals by Rysbrack. MB
☐ Gunnis (1953); M. Webb, *Michael Rysbrack* (1954)

Van de Velde, Willem the Elder (1611–93), and his son **Willem the Younger** (1633–1707) came to England in the winter of 1672 and settled at Greenwich. Already established in Holland as the foremost *MARINE artists of the day, they were welcomed by Charles II. His patronage enabled them to live in some style and to achieve absolute dominance in their field.

The 2 artists had different skills but worked together as a team. The father, who was primarily a draughtsman, frequently sailed with the fleet and observed sea battles at first-hand. His son, the more gifted artist, used his father's drawings as a basis for his own paintings. Although sea battles were an important part of his work, Van de Velde the Younger also excelled at portraying storms, shipwrecks and calm scenes with anchored vessels. DC
☐ M. S. Robinson, *Van de Velde drawings in the National Maritime Museum, Greenwich* (1958, 1974); D. Cordingly and W. Percival-Prescott, *The art of the Van de Veldes* (1982)

Van Dyck, Sir Anthony (1599–1641) was born in Antwerp and trained there first by Hendrick van Balen and later as an assistant to Rubens. He came to England in 1620 to work for James I but apart from *The Continence of Scipio* (Oxford, Christ Church), painted for the Duke of Buckingham, and a half-length portrait of the Earl of ARUNDEL (priv. coll.), who may have sponsored his visit, little is known of his activity. Within a year he had departed – ostensibly for 8 months but in reality for 11 years. He travelled extensively in Italy 1621–7 and then returned home to Antwerp where he set up his studio.

With Rubens so clearly established as the dominant artistic figure in Flanders, Van Dyck was persuaded to return to England in the spring of 1632. Apart from a stay in Antwerp in 1634/5, and brief visits there and to Paris in 1640 and 1641, he remained in London. He rapidly established himself as the leading portrait painter for CHARLES I and his court, effortlessly eclipsing his rivals. Springing from a wealthy family, he was socially at ease and immensely ambitious. He had a superb facility as a painter, although the use of studio assistance necessitated by the growing number of commissions led to a noticeable unevenness in much of his later work. His speed of execution is conveyed brilliantly by his working drawings for compositions and portraits. Only in his finely executed LANDSCAPE studies does he reveal a gentler, more reflective nature. Rather than blessed with invention, he had great skill in transforming existing patterns, so as to make them appear a spontaneous expression of his own artistic personality. His style was primarily founded on that of Rubens and Titian, the work of the latter providing the major inspiration of his Italian sojourn, furthered by the esteem Titian's work evoked at the English court.

Van Dyck was remarkably adept in understanding the ethos of a particular society and projecting the image it desired of itself.

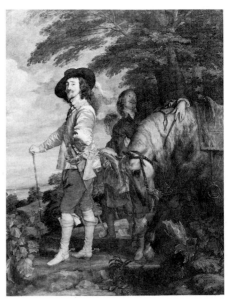

Van Dyck, *Charles I in Hunting Dress, c.* 1635 (Paris, Louvre).

Van Dyck, detail of *Portrait of The Artist [right] with Endymion Porter*, late 1630s (Madrid, Prado).

Compared with the down-to-earth renderings of MYTENS and Paul van Somer (*c.*1576–1621/2), he successfully imbued his portraits with a seemingly indigenous vitality and an atmosphere of refinement and glamour enhanced by his use of meaningful symbolism, which clearly appealed as much to his sitters as it has created an image of Caroline society for posterity. Above all he built up around the figure of Charles I an aura of romantic melancholy, which seems to express the quintessence of the Cavalier spirit.

For the King and his family he produced a series of formal and informal portraits, varying from the grandeur of the 'greate peece of o^r royall selfe, Consort and children' (Royal Coll.) and the 3 equestrian portraits of Charles (Royal Coll; NG; Paris, Louvre) to intimate studies of the Queen and her children. He also worked extensively for other court patrons, notably the 10th Earl of Northumberland and the 4th Earl of Pembroke; for the latter he produced a series of full-length family portraits culminating in the group portrait of the Earl and 9 of his family (Wilton). Although primarily associated with the Cavaliers, his work for other patrons such as Lord Wharton shows his willingness to work for those with Parliamentarian sympathies.

A projected composition of *The Garter Procession*, possibly for a tapestry to decorate the Banqueting House, never materialized. Apart from portraits, he painted a few mythologies, although only *Cupid and Psyche* (Royal Coll.), with its proto-Rococo elegance distilled from a love of Titian, survives.

His influence on English portrait painting and, to a much lesser extent, on landscape was paramount up to the end of the 18c.

See also COOPER; FAITHORNE; GAINSBOROUGH; MCARDELL; MINIATURE PAINTING; PORTRAIT PAINTING: 17C., 18C.; WATERCOLOUR. CW
□ C. Brown, *Van Dyck* (1982); O. Millar, *Van Dyck in England* (exh., NPG, 1982)

Van Loo, Jean-Baptiste (1684–1745), a French portrait painter, was in England 1737–42. His success was due to his technique for rendering facial features, which was considerably in advance of the bland mask-like manner of English painters like RICHARDSON. BA
□ Waterhouse (1978)

Van Nost *see* NOST

Van Somer, Paul *see* PORTRAIT PAINTING: 17C.

Vanson, Adrian *see* SCOTTISH PAINTING

Varley, Cornelius (1781–1873), the younger brother of John VARLEY, drew prolifically during the first half of his career. His work is usually unfinished, distinguished by refined, clear outlines often amplified with expressive washes of colour. His 'Patent Graphic Telescope' was used by COTMAN as an aid in drawing the architecture of Normandy, and was exhibited at the Great Exhibition (1851). AW
□ S. Somerville, *Cornelius Varley* (exh., London, Colnaghi, 1973)

Varley, John (1778–1842) is important as a principal disseminator of the vision and WATERCOLOUR technique of GIRTIN, especially through his work as a teacher (*see e.g.* COX, William Henry HUNT and LINNELL) and as a founder-member of the Old Water-Colour Society. He came under Girtin's influence *c.*1800 at the Sketching Society (*see* SKETCHING CLUBS), and with Dr MONRO. A tour of Wales in 1799 bore fruit in a series of fine mountain landscapes in the SUBLIME manner; later, he treated such subjects in a more formal and

John **Varley**, *Snowdon*, watercolour, 1800–1810 (Liverpool).

idealized way, widely publicized in his *Treatise on the Principles of Landscape Design* (1821) and other works. AW
□ R. Davies in *Old Water-Colour Society's Club*, II (1924–5), 9–27; A. Bury, *John Varley of the 'Old Society'* (1946); Hardie, II (1967)

Vaughan, Keith (1912–77) began as a painter in the NEO-ROMANTIC mode associated with Sutherland and Minton, but after World War II moved towards a more monumental and painterly style which echoed the late figure groups of Cézanne. He was responsive to French and later to American art; the relative abstraction of his later work reflects de Staël and also the New York Abstract Expressionists. DB
□ *Keith Vaughan retrospective* (exh., London, Whitechapel, 1962); K. Vaughan, *Journal and drawings, 1939–65* (1966)

Vauxhall Gardens, a popular London resort from the time of Charles II, were extensively redecorated between 1738 and 1751 by their proprietor, Jonathan Tyers. Apparently encouraged by HOGARTH, he commissioned works from artists of the ST MARTIN'S LANE ACADEMY, including ROUBILIAC's statue of Handel (1738; *see* *SCULPTURE: ROCOCO) and a series of over 50 large paintings for the flimsy open-air supper-boxes, designed mostly by *HAYMAN and comprising scenes from plays, popular literature, sports and pastimes, which were installed *c.*1741–2. Later, *c.*1750, Tyers reconstructed the supper-boxes in the fashionably eclectic 'Chinese-Gothick' style, creating perhaps the most exuberant expression of the ROCOCO style in England. BA
□ T. J. Edelstein and B. Allen, *Vauxhall Gardens* (exh., Yale BAC, 1983); *Rococo* (1984)

Venetian Secret A recipe supposedly revealing the secret of Venetian colour, brought by Mary Anne Provis to Benjamin WEST as President of the ROYAL ACADEMY in December 1795. West was initially taken in and he and some other painters experimented with it. A chorus of ridicule gradually built up, culminating in *GILLRAY's great satire, *Titianus Redivivus* (1797). The affair is revealing of the ignorance in late 18c. England of the properties of colour. DB
□ J. Gage in *Apollo* (July 1964), 38–41

Verrio, Antonio (1639?–1707) was the first major *DECORATIVE painter to practice in England after the Restoration, and despite his limited talent he remained in almost continuous employment in royal and other great households until his death. Italian by birth, he was brought over from France by the Duke of Montagu *c.*1671. His wall-paintings are sometimes spectacular in their illusionism but always empty of feeling. His most remarkable work is the Heaven Room at Burghley House. DB
□ Croft-Murray, I (1962)

Vertue, George (1684–1756), an engraver of portraits and antiquarian subjects (*see* ENGRAVING), is famous for the notebooks in which he recorded countless details of the art of his own and previous times. They were the basis of Horace Walpole's *Anecdotes of Painting in England* (1765–71) and are the foundation of all studies of British art of Vertue's time. *See* *HAMILTON, GAWEN. RG
□ Vertue, MS Notebooks in *Walpole Soc.*, Vertue I–VI (1930–55)

vestments although easily perishable have survived from as early as the *ANGLO-SAXON period. In particular the embroidered stole and maniple from St Cuthbert's shrine at Durham (906–16; Durham Cathedral), with stately figures on a gold ground, provide an example as accomplished as the best contemporary painting. A rare survival from the ROMANESQUE period, a set of mass vestments at Sens in France associated with Thomas Becket (d.1170), has limited geometric ornament. In the 13c. vestments were often decorated with regularly coiled scrollwork (seen e.g. on some fragments from episcopal tombs at Canterbury and Worcester cathedrals). By the mid 13c. English embroideries had become the most prestigious

Vertue, *Self-portrait*, drawing, 1741 (BM).

in Europe, and for more than 100 years *OPUS ANGLICANUM was stylistically and technically exceptionally sophisticated.

In the late 14c. the popularity of woven textiles, especially from Italy, presented a challenge to the embroiders' supremacy. Production in England became limited to increasingly stereotyped orphreys which were combined with the woven textiles, as on the Gordon-Channing Chasuble (1390–1420; V&A). In the 15c. and early 16c. identical motifs were often evenly spaced over these textile grounds, like the crowns and stars on the Chipping Campden Cope (Chipping Campden, Glos., St James). ET
□ D. King, ed., *Opus anglicanum* (exh., Arts Council, 1963)

Vincent, George *see* NORWICH SCHOOL

virtuosi Loosely, connoisseurs; according to Henry Peacham in 1634 (in *The Complete Gentleman*), the term was applied by Italians to 'such as are skilled' in distinguishing antique copies of sculpture from originals. In England it can be applied especially to the small, select group of collectors and connoisseurs around CHARLES I, and to the gentlemen, painters, sculptors and architects of the Society of Virtuosi, founded in 1689, but it was often used in the 18c. (*see* Gawen *HAMILTON). DD

Vorticism came into being in 1914–15 as a form of geometric painting based on the syntax of Cubism and Futurism and also on intricate machine drawings. It was the product of an avant-garde group of painters, sculptors and writers who formed the Rebel Art Centre in 1914, were involved in the review *Blast* (1914–15), and exhibited in the Vorticist Exhibition (1915). The group was formed out of the schism caused by a commission for the OMEGA WORKSHOPS to decorate a room at the Ideal Home Exhibition in 1913, which Wyndham LEWIS thought had been stolen by Roger FRY. Lewis and a group of artists withdrew from the Omega and set up 'The Cubist Room' at the exhibition 'Camden Town and Others' in Brighton. They included WADSWORTH, ETCHELLS, *GAUDIER-BRZESKA and Cuthbert Hamilton (1884–1959); EPSTEIN also hung drawings in the room. Lewis claimed that they formed 'a vertiginous but not exotic island in the placid archipelago of English art' and he linked their preoccupations to urban rather than rural structures.

A fully developed Vorticist style emerged in such works as Lewis's *Workshop* (1914–15; Tate), Gaudier's *Stags* (1914; Chicago), *Atlantic City* (lost) by Helen Saunders (1885–1963) and *EPSTEIN's *Rock Drill* (1913–14; Tate), but was impeded by the First World War. Clear geometric forms in sharp and often discordant tonalities characterize Vorticist work, and movement is implied through diagonal structure and asymmetric arrangement of forms. Though it works with a degree of abstraction there are always external referents. For Lewis the origin of the term Vorticism was in the vortex as 'attracting everything to itself, absorbing all that is around it into a violent whirling – a violent central engulfing'. This led to subjects drawn from ports, cities and the social life of London. For Ezra Pound, who first used the word, it was an intensive artistic practice in which colour and form in painting,

Vorticism: cover of *Blast*, No.2, 1915.

mass and plane in sculpture, and the image in poetry are the articulating mechanisms. For William ROBERTS it was little more than English Cubism. The involvement of most Vorticists in the war broke up the group and they did not re-form afterwards. *See also* ATKINSON, L. JB
□ Cork (1975–6)

Wadsworth, Edward (1889–1949) was associated with the OMEGA WORKSHOPS but left with Wyndham LEWIS to join the Rebel Art Centre and the VORTICISTS. Most of his major canvases of the period 1913–17 are lost. They were apparently influenced by Futurism, becoming increasingly abstract and geometric in 1914–15, as in his woodcut urban views like *Rotterdam* (1914). His war work on camouflage painting of ships is reflected in his pictures of

1917–19, and in the 1920s he painted maritime subjects representationally. In the 1930s he was influenced by SURREALISM, and also painted several abstract works. *See also* GROUP X. JB
□ H. Read, ed., *Unit One* (1934); Rothenstein (1952–74); *Edward Wadsworth* (exh., London, Colnaghi, 1974)

Walker, Frederick (1840–75) quickly emerged as one of the most brilliant of the 'Illustrators of the '60s' (*see* WOOD-ENGRAVING). He went on to paint an influential series of symbolist oils and watercolours on themes of youth and mortality that drew on an eclectic range of sources from the ELGIN MARBLES via Uccello to Jules Breton, but achieved a distinctively English kind of poetic realism (e.g. *The Harbour of Refuge*, 1872; Tate). A charismatic figure to his contemporaries and immortalized as Little Billee in Du Maurier's *Trilby*, he was hailed, even before his premature death, as leader of a school fit to succeed the PRE-RAPHAELITES. RT
□ J. G. Marks, *Life and letters of Frederick Walker* (1896)

Walker, John (b.1939) is an abstract painter who has, nevertheless, consistently emphasized the illusion of space in his paintings. He has used grids, collaged elements of canvas, trapezoidal stretchers, and simplified perspectives as well as a very wide range of texture, colour and media to create a body of work distinguished equally for its variety and its vitality. Its mood is often sombre or even hallucinatory. He tends to paint groups of pictures on a related theme or sharing common motifs, but also reverts to his own earlier devices in order to start something new. He is an exceptionally good draughtsman. MC
□ *Arte inglese oggi* (exh., British Council, 1976)

Walker, Robert *see* CROMWELL; PORTRAIT PAINTING: 17C.

Wallis, Alfred (1855–1942), sometimes described as a 'primitive' painter, was a rag-and-bone merchant in ST IVES, Cornwall. At the age of 70 he started to paint 'for company' after his wife's death. Using ships' or house paint handled in a direct and lively way, he painted on irregular pieces of wood and cardboard pictures of ships, remembered from his youth, in shallow pictorial space, with an instinctive feeling for abstract design. Ben NICHOLSON and Christopher WOOD discovered Wallis and his

work in 1928 on a visit to St Ives, and it was extensively collected by Nicholson and his friends. DBr

□ S. Berlin, *Alfred Wallis: primitive* (1949); E. Mullins, *Alfred Wallis* (1967)

Wallis, Henry (1830–1916) hovered briefly but significantly on the fringes of PRE-RAPHAELITISM, producing 2 of its icons, *The Death of Chatterton* (1856; Tate) and *The Stonebreaker* (1858; Birmingham) before disgracing himself by eloping with George Meredith's wife. He spent the rest of his life as traveller, watercolourist and authority on Middle Eastern ceramics. RT

□ Staley (1973)

wall-painting was one of the major art forms of the Middle Ages. In churches, walls and other available surfaces were commonly covered with paintings of a didactic or ornamental nature, and such paintings also decorated many secular buildings. They have suffered appalling destruction and damage, notably from the Victorian and later practice of stripping plaster from church walls to reveal stonework (which in the Middle Ages was not intended to be seen) and from the misguided application of 'preservatives'. Discoveries are, however, still being made, of paintings in churches limewashed over at the Reformation, and those in secular buildings covered with panelling or otherwise hidden.

Little wall-painting survives from the ANGLO-SAXON period, though in recent years

Fresco of the Deposition and Entombment in the Holy Sepulchre Chapel, Winchester Cathedral, late 12c.

fragments have been excavated at Jarrow, Colchester and Winchester. A date of *c*.1000 has only recently been suggested for a wall-painting in the church of Nether Wallop (Hants), which is perhaps the only Anglo-Saxon wall-painting *in situ*. Its figures of angels have fluttering draperies similar to those in WINCHESTER SCHOOL manuscripts.

Some of the finest surviving wall-paintings are ROMANESQUE. Notable examples in parish churches are at Hardham, Clayton, and other churches of the 'Lewes Group' in Sussex, *c*.1100; and an elaborate scheme at Copford (Essex), and a programme of APOCALYPTIC and other subject-matter at Kempley (Glos.), both *c*.1120–40. The Lewes Group paintings are particularly interesting since they were all executed by the same group of painters, perhaps working partly under the patronage of the Cluniac Priory at Lewes. These painters were almost certainly laymen, and it seems that most medieval wall-paintings were executed by travelling lay artists. The Sussex schemes show a wide variety of subjects, with, at Clayton, an impressive DOOM. Canterbury Cathedral has several paintings in the Byzantine 'damp fold' drapery style introduced in the first half of the 12c. one especially fine, *St Paul and*

Wall-painting of St Paul and the Viper in Canterbury Cathedral, *c*.1160.

St Faith (?) in the former priory at Horsham St Faith, *c*.1250–60.

the Viper in St Anselm's Chapel (*c*.1160), and others in St Gabriel's Chapel in the crypt. The blue used in the backgrounds at Canterbury was a costly mineral colour. In most parish church paintings throughout the Middle Ages inexpensive pigments such as ochres were chiefly employed.

In the 1960s some later 12c. painting of extremely high quality was uncovered in the Holy Sepulchre Chapel of Winchester Cathedral, under 13c. repainting: on the east wall is the Deposition of Christ, with the Entombment and Resurrection subjects below, and on another wall a preliminary drawing on a base layer of plaster. These Winchester paintings are in fresco (executed on the plaster before it had dried), which is now thought to have been the standard technique used in English Romanesque wall-painting, whereas most later wall-paintings are in *secco*. They are very close in style to the contemporary illumination of the later hands working on the WINCHESTER BIBLE. Also in this style were magnificent paintings in the nunnery of Sigena in Spain, executed *c*.1200 by travelling English artists. (They were

tragically damaged by fire in 1936; fragments are in Barcelona (Mus. de Arte de Cataluña).)

The new scheme painted *c*.1220 over the frescoes in the Holy Sepulchre Chapel at Winchester is Early GOTHIC in style, with figures in mannered poses, and drapery folds that are more decorative than naturalistic. On the vault, roundels enclose scenes and busts. Such roundels are also found elsewhere, and at Romsey (Hants) and Brook (Kent) are in arrangements reminiscent of contemporary STAINED GLASS. Much more wall-painting survives from the 13c. than from the 12c., with one of the most impressive ensembles in ST ALBANS Cathedral. Superb paintings of *c*.1250–60, in a style similar to that of the St Albans monk-artist Matthew PARIS, were uncovered in 1969–72 at Horsham St Faith (Norf.), in what was once the refectory of a Benedictine priory. They include a splendidly preserved figure of a saint, perhaps St Faith herself, and a unique series of scenes of the foundation of the priory. There is also much masonry pattern, simulating the joints between blocks of ashlar, which is particularly common in the 13c. and first half of the 14c.

The mid 13c. style of the Horsham St Faith paintings was soon superseded by a new style derived from contemporary French painting, with figures in angular poses and broad flat drapery folds. The Painted Chamber of the Palace of Westminster in London (destroyed by fire in 1834) was in this style. Many wall-

Wall-painting from St Stephen's Chapel, Westminster, showing the destruction of Job's children, *c*.1350–75 (BM).

Wall-painting in Eton College Chapel: the knight Amoras sells his wife, *c*.1470–90.

paintings were ordered by HENRY III for his castles and palaces, and the royal accounts for this and other periods provide valuable information on the personnel and materials employed. Royal artists also worked in Westminster Abbey, where fine paintings of the late 13c. or early 14c. survive in the south transept and St Faith's Chapel.

The period *c*.1290–1340 is the great age of EAST ANGLIAN manuscript illumination, and superb wall-paintings from this time survive in Norwich Cathedral and elsewhere in the region. Characteristic of the manuscripts is the use of GROTESQUES, birds and heraldry in the margins; and birds and shields, as well as a grotesque BESTIARY subject, also appear in the wall-paintings of *c*.1330 in Longthorpe Tower (Cambs.), the most complete secular scheme to survive.

Probably the most important painting of any type in the period *c*.1350–75 was that in St Stephen's Chapel in the Palace of Westminster. It was partly destroyed in 1834, but fragments survive (BM): they show strong Italian influences (seen also in contemporary work like the BOHUN FAMILY manuscripts), particularly evident in a sophisticated use of perspective. The Apocalypse paintings in the Chapter House of Westminster Abbey are in the INTERNATIONAL GOTHIC style of *c*.1400, and may be compared with contemporary painting in Hamburg associated with Meister Bertram. (*See also* RICHARD II.)

Many 15c. wall-paintings survive, often of rather poor quality. The finest scheme is the series of Miracles of the Virgin in Eton College Chapel, perhaps executed by Gilbert and by William BAKER in the 1470s–80s. These paintings, which are largely in *grisaille*, are very close to contemporary Flemish painting. Another fine *grisaille* scheme, in the chapel of Haddon Hall (Derbys.), includes St Christopher, one of the commonest subjects in English medieval wall-painting. This saint, patron of travellers, is normally shown as a huge figure, in a prominent position opposite the entrance door. Also particularly characteristic of later medieval wall-painting are moralizing subjects, such as the 3 Living and 3 Dead, and the 7 Deadly Sins, both of which appear in the fine 15c. paintings at Raunds (Northants.). DP

□ E. W. Tristram, *English medieval wall painting* (1944, 1950, 1955); A. Caiger-Smith, *English medieval mural paintings* (1963); O. Demus, *Romanesque mural painting* (1970), 120–25, 491–512

Walters, Samuel *see* MARINE PAINTING

Walton, E. A. *see* GLASGOW SCHOOL

Walton, Henry (1746–1813) was born in Norfolk and spent most of his life in East

Walton, *Plucking the Turkey*, exh. 1776 (Tate).

Anglia. He became a pupil of ZOFFANY *c.*1769–70 and his elegant, small-scale CONVERSATION PIECES betray his debt to that master. His pictures of domestic genre suggest a knowledge of Chardin, whose works he would have seen during excursions to Paris. After 1779 he ceased to exhibit, though he did not cease to paint (he had a private income throughout his life); he retired to his property in Suffolk, and acted as adviser to collectors of old masters. BA
□ *Henry Walton* (exh., Norwich, Castle Mus., 1963)

Ward, Edward Matthew (1816–79) was a HISTORY painter celebrated for his intimate scenes of famous characters from the past, influenced by HOGARTH. His greatest success was *The Royal Family of France in Prison* (1851; Preston). WV
□ J. Dafforne, *The life and work of Edward Matthew Ward* (1879)

Ward, James (1769–1859), painter, was born in London. From his brother **William** (1766–1826) he learned MEZZOTINT engraving, at which he excelled, but he abandoned it in the 1790s to paint animal and landscape pictures in the style of his brother-in-law George MORLAND. His later development is dominated by the influence of Rubens. He was elected RA in 1811, and his masterpiece, the sublimely immense *Gordale Scar* (Tate), was completed in 1815. Much of his later career was passed in neglect and poverty. PN
□ C. R. Grunoy, *James Ward* (1909); G. E. Fussell, *James Ward* (1974)

James **Ward**, *Gordale Scar*, 1811–15 (Tate).

watercolour as a drawing medium cannot be separated from bodycolour, or GOUACHE: both use water as a vehicle, and they have been employed by many artists interchangeably, as if one were an extension of the other. The main distinction between them is that bodycolour is opaque, watercolour transparent, relying on the white of the support (usually paper) to give highlights. The opacity of bodycolour is due to the admixture of clay or lead white with the pigment, which renders it chalky, with a brightness analogous to that of oil paint. It was first used extensively in medieval illumination. Watercolour was employed, timidly at first, from the 16c. as a means for making scientific and antiquarian records, a function it still retains as the normal medium for botanical, zoological, and some architectural drawings. An early group of such records is that made in North America by John *WHITE in the 1580s.

Apart from exceptional instances like the studies in bodycolour by Jacopo de' Barbari and Dürer in the Renaissance, watercolour was not developed significantly until its application to outline drawings in pencil or pen in 17c. Holland. VAN DYCK made a number of landscape studies in watercolour, but they are quite uncharacteristic of their time. More representative is HOLLAR, whose pale washes of red, green or blue in neat topographical views exemplify the understanding of the medium that prevailed in England until the mid 18c.

About 1750 watercolour began to be used to enhance grey wash views of buildings or towns: a pencil drawing was washed with a dead grey underpainting to indicate tone, and local colour, usually of a restricted gamut, added. Often the design was strengthened with a pen outline. Rarely, an artist such as James 'Athenian' Stuart (1713–88), trained in the Continental tradition of the fan-painters or Italian *vedutisti*, would make views in bodycolour alone. At the same time, SKELTON, TAVERNER and others experimented with more sophisticated procedures, including a wider range of colour and more informal subjects.

The flowering of the school, an important facet of European romanticism, began in the 1790s as a result of the marriage of the topographical tradition with these experiments, as well as those of men like Alexander COZENS and GAINSBOROUGH, who infused the academic idea of generalization into the formulas of antiquarian recording. They were aided in this by the theoretical writings of

William GILPIN. The stimulus of the ROYAL ACADEMY exhibitions prompted increasingly ambitious works from watercolourists, who experimented extensively with technique in these years. Paul SANDBY used bodycolour to imitate oil paint; Richard Westall (1765–1836) attempted powerful effects of rich colour and sonorous tone in watercolours of historical subjects, enhancing them with washes of gum arabic as a kind of varnish. The 'fresco' process of BLAKE must be seen as a manifestation of this movement.

The young *GIRTIN and TURNER c.1795 began to develop methods of painting in pure watercolour which obtained similar, if not grander, effects, and were widely imitated. Thanks to their success the Society of Painters in Water-Colours (later the Old Water-Colour Society) was founded in 1804 and after some vicissitudes established a regular exhibition place in London for watercolourists; it survives today. The first generation of these romantics favoured SUBLIME landscape subjects, borrowing from Turner a minute hatching technique and dexterous scratching-out and wiping-out of lights. Wove paper had by now superseded laid paper, and bodycolour was considered by many an illegitimate recourse: Turner used it sparingly. By the 1830s figure subjects shared popularity with landscapes and, especially under the influence of William Henry HUNT, elaborately applied bodycolour was widely adopted, notably by J. F. *LEWIS, Samuel PALMER and the PRE-RAPHAELITES.

After the advent of Impressionism the capacity of watercolour to express spontaneity and effects of the breezy open air (already developed in the work of *COX, BONINGTON and others) largely displaced the meticulousness of detail which, combined with breadth of vision, had contributed to the important achievements in the medium of English artists earlier in the 19c.

In the 20c. both watercolour and bodycolour have been used generally, and have played a major role in the output of e.g. Paul NASH, *BURRA, PIPER and HOCKNEY. See also *COZENS, J. R.; CRISTALL; CROME; DAYES; *DE WINT; DRAWING MASTERS; FIELDING; FOSTER; HEARNE; *MINIATURE PAINTING; *NORWICH SCHOOL; PROUT; SMITH; *TOWNE; TURNER, W.; *VARLEY, J. AW

□ J. L. Roget, *The history of the Old Water-Colour Society* (1890); Williams (1952); Hardie (1966–8); J. Bayard, *Works of splendor and imagination* (exh., Yale BAC, 1981)

Watteau, Jean Antoine (1684–1721) and his principal imitators, Lancret and Pater, influenced English art in the first half of the 18c., partly through their paintings, which were well known and sought after, but chiefly through engravings. Between 1726 and 1734 over 500 engravings after Watteau were published in the *Recueil Jullienne*, providing a vast repertoire for imitators. Watteau's style was practised in England by foreign artists like MERCIER and the Fleming J. F. Nollekens (the sculptor's father, 1702–48), the latter a pupil of Watteau, who distilled the essentials of the *fête galante* and modified it to suit the English preference for portraiture. A hint of Watteau can also be seen in native-born artists like HIGHMORE and DANDRIDGE. BA
□ P. Wescher in *Art Quarterly*, XIV (1951), 179–94

Watts, George Frederick (1817–1904), portrait and allegorical painter, won a prize in the Palace of WESTMINSTER competition (1843), then spent 3 years in Florence absorbing Titian and Michelangelo. On his return he painted 4 tragic contemporary subject pictures, including *Found Drowned* (Compton, Watts Gall.), and began the series of allegorical works which, with his portraits, made him famous. These vigorously painted canvases aspire to the grandest of the grand manner (his motto was 'The Utmost for the Highest'), but the bland universality of their themes (*Time and Oblivion*, *Love and Death*, etc.) now appears empty. He painted distinguished landscapes, and made monumental sculpture in later life (*see* SCULPTURE: VICTORIAN), but his most coherent achievement was in his *PORTRAITS of his most eminent contemporaries (NPG). DB
□ G. F. Watts (exh., London, Whitechapel, 1974); W. Blunt, '*England's Michelangelo*' (1975)

Webster, Thomas (1800–1886) was a genre painter and leader of the CRANBROOK COLONY. His robust and humorous scenes of childhood and rural life follow in the tradition of MULREADY, though they are more sober in their technique. WV
□ Reynolds (1953)

Weekes, Henry (1807–77) *see* ALBERT MEMORIAL; SCULPTURE: VICTORIAN

Weight, Carel see ROYAL ACADEMY: 20C.

Wells, John see ST IVES SCHOOL

Welsh medieval art There remains very little figure art from the Middle Ages in Wales, although in church and castle architecture there are many impressive survivals. Economically and politically throughout the period Wales was subject to English exploitation, and from the time of Edward I's conquest in 1277 came under direct English rule. As is to be expected, the art often shows dependence on England and it is difficult to define specifically Welsh characteristics.

From the 6c. to the 11c. the main monuments are a series of stone slabs and crosses. The finest are of the 9–10c., some with figure scenes, others with ornamental patterns of interlace and vine scrolls. In the art of painting only the great 8c. illuminated Gospel Book in Lichfield Cathedral has associations with Wales: it was in Welsh ownership some 50 years after its production, though its place of

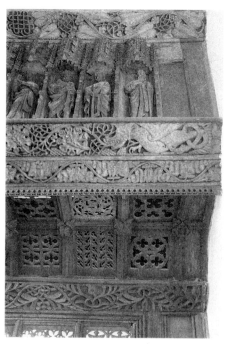

Welsh rood screen in Llananno church, Powys, c.1500.

origin is unknown. From the late Romanesque and Gothic periods are a small quantity of architectural sculpture and tombs. Llandaff Cathedral has late 12c. figure sculpture in the main portal related to West Country English work such as Glastonbury. Fine tombs of the 13c. and 14c. exist at Abergavenny, Betws-y-coed and St Asaph. Rare survivals are the 14c. stone ALTARPIECE with the Crucifixion and saints at St Davids, and a wooden figured reredos at Betws Gwerfil Goch. Many parish churches have wooden rood SCREENS with heavy parapets to the lofts of a characteristic Welsh type having rich decorative carving. The figure of Christ from the rood has survived from the church of Kemeys in South Wales (Cardiff). MISERICORDS at Beaumaris and St Davids are the most important series in Wales.

In wall and roof painting almost all is from the 15c. and 16c., e.g. Llanynys, Gyffin and Wrexham. The very few illustrated manuscripts are either of English origin, like the early 14c. Pontifical at Bangor Cathedral, or rather provincial products like the late 14c. Llanbeblig Hours (Aberystwyth, Nat. Lib. of Wales). Most of the extant stained glass is in North Wales and is of 15c. and 16c. date. The best examples are at Gresford, Llandyrnog and Llanrhaedr.

Of goldsmiths' work little survived the Reformation. A fine mid 13c. chalice engraved with a figure of Christ (Royal Coll.; on loan to Cardiff) was found at Dolgellau. NM
□ articles on rood screens in *Archaeologia Cambrensis* (1942–53); V. Nash-Williams, *Early Christian monuments of Wales* (1950); C. Gresham, *Medieval stone carving in North Wales* (1968); M. Lewis, *Stained glass in North Wales* (1970); G. Williams in *Art in Wales*, ed. E. Rowan (1978)

West, Benjamin (1738–1820), a HISTORY painter of American birth, became painter to GEORGE III and second President of the ROYAL ACADEMY in 1792. After study in Rome he came to England in 1763, and soon achieved success with paintings in a severe NEOCLASSICAL manner which seemed set to fulfil the hopes for a native HISTORY PAINTING. George III took him up and commissioned series of paintings for Windsor Castle, including St George's Chapel, which occupied him for most of the rest of his life. His dogged industriousness gave him mastery of many styles, but his overall achievement was uninspiring; there was a

West, *Agrippina landing at Brundisium with the Ashes of Germanicus,* 1768 (New Haven, Yale Univ. AG, Gift of Louis M. Rabinowitz).

growing restlessness among his contemporaries with his exalted position. He is noted particularly for his attempts to marry the conventions of history painting with subjects from contemporary life, as in *The Death of General Wolfe* (1770; Ottawa). *See also* POLYAUTOGRAPH; VENETIAN SECRET; WOOLLETT.
DB

☐ E. Wind in *Journ. Warburg and Courtauld Inst.*, II (1938), 116–27; Waterhouse (1978)

West, William *see* BRISTOL SCHOOL

Westall, Richard *see* WATERCOLOUR

Westmacott, Sir Richard (1775–1856) was a leading Neoclassical sculptor of public monuments and statues whose flourishing practice was second only to CHANTREY's. Early training with his sculptor father was followed by study in Italy 1793–7 where he worked in Canova's studio and was awarded the Academy of St Luke's gold medal (1795). After returning to London he became a favourite sculptor of the COMMITTEE OF TASTE (see also ST PAUL'S). His most accomplished monument was a public subscription commission commemorating Charles James Fox in Westminster Abbey (1810–23; see *★SCULPTURE: EARLY 19C.*). His numerous smaller monuments were sometimes inventive but rarely equalled those of FLAXMAN or Chantrey. He executed many accomplished BRONZE public monuments (like Chantrey he had his own foundry), notably the *Achilles* at Hyde Park Corner, London (1814–22). Elected RA in 1811, Westmacott succeeded Flaxman as

Professor of Sculpture in 1827 and was knighted in 1837.
AY
☐ Gunnis (1953); Whinney (1964); N. Penny, *Church monuments in Romantic England* (1977)

Westminster, Palace of: 19c. decoration
The commissions for mural paintings in the new Houses of Parliament in London (erected 1840–61) represent the most far-reaching attempt at state promotion of 'High Art' in Britain. The President of the Commission set up in 1841 was Prince ALBERT, its Secretary was EASTLAKE. Both favoured the archaizing style of the German Nazarenes, whose influence can be seen in many of the chosen designs. After competitions in 1843–6 DYCE, MACLISE, COPE and HORSLEY were selected to provide historical and allegorical frescoes for the House of Lords (1846–7). Many other rooms and corridors were then decorated, usually in the less exacting techniques of waterglass and oil. Despite much debate this venture failed to bring about the hoped-for resurrection of British HISTORY painting. *See also* HERBERT; WATTS.
WV
☐ Vaughan (1979)

Westminster Retable (London, Westminster Abbey) A large altarpiece or altar frontal datable *c.*1280 which is the most remarkable survival of 13c. *★PANEL PAINTING* in England. It was rediscovered in the 18c. in use as the lid of a chest, and its precise origin and date are still uncertain. It is divided into 5 sections and further subdivisions by a frame set with coloured glass and imitation enamel, cameos and jewels, simulating goldsmiths' work. In the centre is a standing figure of Christ blessing (instead of the more usual Crucifixion), flanked by the Virgin and St John. At the ends were standing figures of St Peter and St Paul (the latter now lost). The tall figures, placed under delicate canopies, are separated by groups of small panels in the shape of 8-pointed stars on each side; the 3 that survive are narrative scenes depicting miracles of Christ.

The figures have pear-shaped heads and mannered gestures suggesting foreshortening, both elements characteristic of works associated with the court at Westminster *c.*1260–85, especially the DOUCE APOCALYPSE. The Retable also shows bold experiments in modelling (made possible by an oil-based technique on a gesso or white lead ground) comparable with those in the work of Maître Honoré and other

Parisian illuminators of the later 13c., and suggests that there were close contacts between English and Parisian court painting at this time. MM

□ F. Wormald in *Proc. Brit. Acad.*, XXXV (1949), 166–71; E. W. Tristram, *English medieval wall painting. The 13c.* (1950), 127–48

Wet, Jacob de *see* SCOTTISH PAINTING

Wewicke, Meynnart *see* HENRY VII

Whall, Christopher *see* STAINED GLASS: 19–20C.

Wheatley, Francis (1747–1821) began as a painter of portraits and CONVERSATION PIECES in the manner of ZOFFANY, having trained at Shipley's Academy (*see* SOCIETY OF ARTS) and the ROYAL ACADEMY Schools. After a period in Dublin (1779–83) he settled in London and produced a wide variety of work, including crisp landscape watercolours, domestic genre (such as the immensely popular *Cries of London*), and sentimental literary subjects, many of which were done for ENGRAVING, the medium through which he is best known. He also executed historical pictures for the BOYDELL Gallery from the late 1780s. BA

□ M. Webster, *Francis Wheatley* (1970)

Whistler, James McNeill (1834–1903) was an expatriate American painter who made a decisive contribution to British art. In 1848–9 he first came to London, where his artistic interests were encouraged by his brother-in-law Seymour HADEN and Sir William Boxall (1800–1879). He returned to America and after study in France and a career as a painter associated with the French Realists he eventually settled in London in 1863, though he still moved easily between London and Paris. To Whistler belongs the credit of introducing 'blue and white' Japanese porcelain from Paris into the ROSSETTI circle, and his work increasingly used Oriental studio props and delicate, planar compositional devices inspired by Japanese prints. This interest in *Japonisme* in the early 1860s anticipated the AESTHETIC MOVEMENT, of which Whistler's sensibility, cosmopolitanism, dandyism (*see* ★BEARDSLEY) and wit were to make him the natural leader.

He believed that art 'should stand alone and appeal to the artistic sense of eye or ear, without confounding this with emotions entirely

Whistler, *Nocturne in Black and Gold: The Falling Rocket*, 1877 (Detroit Institute of Arts).

foreign to it, as devotion, love, patriotism and the like'. He often used titles incorporating the words 'symphony', 'nocturne', 'harmony', and 'arrangement' for his landscapes and portraits. This musical connotation is first hinted at in a portrait group, *At the Piano* (1859; Cincinnati); the spirit in which he used it later, as in *Symphony in White No. 3* (1867; Birmingham, Barber Inst.) represents a more complete fusion of line, form and colour which relates their union to the abstraction of musical sound. Similar ideas can be observed in works painted about this time by LEIGHTON and Albert MOORE.

The Thameside *Nocturnes* painted in the 1870s contain the essence of Whistler's landscape art, as the portrait of his mother, *Arrangement in Grey and Black No. 1* (1872; Paris, Louvre) does of his portraiture. In 1876–7 he painted the Peacock Room, an Oriental interior for a London house (now Washington, Freer). The decade culminated in 1878 with his libel case against RUSKIN, who had reacted to another *Nocturne*, *The Falling Rocket* (Detroit), shown at the GROSVENOR GALLERY in 1877, by describing Whistler as a 'coxcomb . . . flinging a pot of paint in the public's face'. Although

Whistler won his case the trial bankrupted him and the victory did little to promote understanding of his art.

In the 1880s and 1890s his genius flowered in a series of pastels and etchings of Venice and in a number of brilliant full-length portraits painted in Paris and London. In the etchings he emerges as one of the greatest 19c. printmakers (see ETCHING REVIVAL).

Whistler's pupils included SICKERT, Mortimer Menpes (1860–1938) and Walter Greaves (1846–1930), whose own Nocturnes of the River Thames owe a considerable debt to those by his master. Whistler found a particular following in the GLASGOW SCHOOL and the best collection of his work is at Glasgow University. RH
□ H. Taylor, J. McNeill Whistler (1978)

White, John (fl.1585–93) visited Raleigh's recently founded Virginia Colony several times between c.1585 and 1590, and also made expeditions to Greenland and Eastern Europe. His many drawings beautifully tinted with WATERCOLOUR record the exotic peoples, flora, fauna and landscapes he had seen. DD
□ P. Hulton and D. B. Quinn, The American drawings of John White (1964)

Whitehall, Banqueting House see RUBENS

Wilde, Samuel de see THEATRICAL PAINTING

Wilkie, Sir David (1785–1841) was the most important genre painter in Britain in the early

White, The towne of Pomeiock (Virginia), watercolour, c.1585 (BM).

19c. Combining a brilliant and detailed technique with narrative methods based on HOGARTH, he forged a unique style of ANECDOTAL painting that became influential throughout Europe.

Born in Fife of humble parentage, he first studied in Edinburgh, and was influenced by the work of David ALLAN. The success of Pitlessie Fair (Edinburgh, NGS) enabled him to come to London, where Village Politicians (Earl of Mansfield) became the sensation of the ROYAL ACADEMY exhibition in 1806. Over the next 2 decades he continued to paint highly successful humorous and anecdotal scenes of peasant life in a style based on Teniers and other Netherlandish artists. His patrons included the Prince Regent.

In later life Wilkie developed a growing interest in historical subjects. His Chelsea Pensioners Reading the Gazette of the Battle of Waterloo (1817–21; V&A, at Apsley House; and see ROYAL ACADEMY: 19C.) already shows this ambition, though the treatment is still highly anecdotal. After a tour of the Continent (1825–8) he painted more conventional historical pictures, showing the influence of Spanish painting and the French Romantics. In 1840 he journeyed to the Holy Land to gather material for biblical paintings, and died at sea on his way home (see *TURNER).

Despite his immense success, Wilkie retained his directness and simple manners to the end. These qualities heightened the authenticity of his peasant scenes in the eyes of his contemporaries. See also GEDDES; *SCOTTISH PAINTING. WV
□ A. Cunningham, Life of Wilkie (1843); Boase (1959)

Willats, Stephen (b.1943) is heir to the interest in cybernetics and information theory which flourished in the 1960s. He has applied it to an art of social documentation, involving his subjects directly in the creation of the work. He then forms displays comprising photographs or samples, texts, and a structure of categories devised by himself. These may be exhibited to the participants and members of their social or local group or to the art audience. MC
□ M. Compton et al., Stephen Willats (exh., London, Whitechapel, 1979)

Williams, Hugh William see SCOTTISH PAINTING

Richard **Wilson**, *The Ruined Arch at Kew*, 1760–62 (Sir Brinsley Ford).

Wilson, Benjamin *see* THEATRICAL PAINTING

Wilson, Richard (1713?–82) was the first major British artist to concentrate on LAND-SCAPE. He reconciled the ideal landscape tradition of Claude and Gaspard Poussin with the depiction of actual places in both Italy and the British Isles, creating a unified personal style; he was also influenced by the Dutch landscape tradition, particularly Cuyp.

Wilson was born at Penegoes, Montgomeryshire (Powys), the son of an Anglican clergyman who gave him a classical education and encouraged his interest in art. He went to London in 1729 and studied under the portrait painter Thomas Wright (fl.1728–37) until 1735. He seems to have started primarily as a portraitist, though his first known painting is *The Inner Temple after the Fire of 4 January 1737* (dated 1737; Tate). The first documented portraits are from the 1740s, with such works, in the style of HUDSON, as *Dr Francis Ayscough with his Pupils Princes George and Edward Augustus* (1748–9; NPG). Landscapes from the 1740s influenced by LAMBERT and Samuel SCOTT include *Westminster Bridge* (1744?; Tate) and 2

roundels for the FOUNDLING HOSPITAL (1746). These contrast with the more Dutch-inspired realism of *The Cock Tavern, Cheam, Surrey* (*c*.1746–7; Government Picture Coll. and other versions).

From 1750 to 1757 Wilson was in Italy. In Venice he got to know Zuccarelli, whose portrait he painted in 1771 (Tate) and who encouraged him to paint landscapes, as did C. J. Vernet in Rome, where he was by January 1752. Influenced by Claude, Gaspard Poussin and contemporary artists such as L'Orizzonte, he worked for visiting British patrons. For Ralph Howard in 1752 he painted several pictures, including 2 landscapes with banditti (Cardiff), and for the 2nd Earl of Dartmouth 2 large views over Rome (1753; Yale BAC and Tate) as well as nearly 70 drawings of Rome and the Campagna. He also visited Naples.

Back in London Wilson established himself as a successful landscape painter; his many pupils included Thomas JONES, William Hodges (1744–97) and Joseph FARINGTON. Despite a portrait, probably his last, of the Prince of Wales (*c*.1757) and views of the Pagoda and Grand Arch in the royal gardens at

Kew (1760–62), Wilson failed to secure royal patronage. He was a founder member of the SOCIETY OF ARTISTS in 1759 and the ROYAL ACADEMY in 1768, and tried to establish himself in the 1760s as a painter of large historical landscapes such as *Niobe* (1760; Yale BAC; *see also* WOOLLETT), but the last of these, *Cicero and his Friends* (the version in Adelaide or that in a priv. coll.), was exhibited in 1770.

Wilson continued to paint Italian landscapes, many being repetitions of compositions first painted in Rome: there are 20 versions of *The White Monk*! He also painted English and Welsh landscapes in an Italianate manner, for example *Holt Bridge on the River Dee* (*c*.1762; NG). His house portraits, such as *Croome Court* (1768; Earl of Coventry), tend to push the house into the distance. In some cases he showed instead the patron's estates or nearby landmarks, as in *Dinas Bran* and *View near Wynnstay*, painted 1770–71 for Sir Watkin Williams-Wynn (Yale BAC). About 1765–7 he painted 6 Welsh landscapes for engravings. These include *Snowdon* (versions at Liverpool and Nottingham) and *Cader Idris* (Tate).

From 1770 Wilson's affairs went into a decline and in 1776 he was given the sinecure of Librarian at the RA. In 1781 he left London broken in health and settled with cousins at Colomendy, Denbighshire (Clwyd), where he died.

See also OUTDOOR PAINTING. MRFB
□ W. G. Constable, *Richard Wilson* (1953); D. Solkin, *Richard Wilson* (exh., Tate, 1982)

Wilton Diptych (NG) A small PANEL PAINT-ING depicting RICHARD II, supported by SS. Edmund, Edward the Confessor and John the Baptist, kneeling in prayer before the Virgin and Child, who are surrounded by angels, one of whom holds a pennon. There is an amazing variety of opinion as to its date, the occasion of its execution and the nationality of its artist. This masterpiece of INTERNATIONAL GOTHIC painting has been variously dated between *c*.1377 (when Richard was crowned) and *c*.1410–20 (after his death). That it belonged to Richard himself is suggested by the presence of

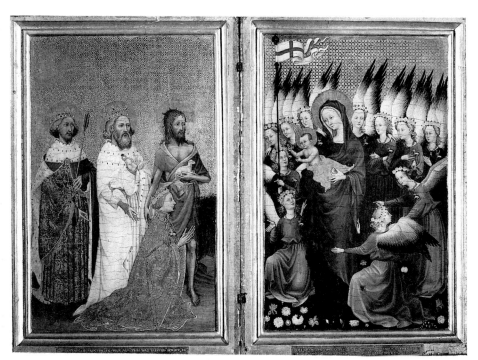

The **Wilton Diptych**, mid 1390s or later (NG).

his arms and badge of the white hart on the reverse. The form of the arms, and the broom-cod collars worn by Richard and the angels, indicate a date no earlier than the mid 1390s. Italian parallels have been cited for both the Court of Heaven and the hart, and the composition resembles the dedication pages of the Brussels Hours (executed *c*.1390–95 for Jean de Berry; Brussels, Bib. Roy., MS 11060–61). But certain of the techniques used (especially the pounced or punched gold backgrounds), and the treatment of the draperies, link the painting with contemporary English manuscripts, above all the Lapworth Missal (1398; Oxford, Corpus Christi College). *See also* CHARLES I. NR
□ F. Wormald in *Journ. Warburg and Courtauld Inst.*, XVII (1954), 191–202; J. H. Harvey in *Archaeologia*, 98 (1961), 1–28

Wilton, Joseph (1722–1803) trained under DELVAUX in Nivelles and Pigalle in Paris. From 1747 until *c*.1754 he was in Rome and Florence, and the naturalistic busts he executed on his return to England recall Roman portrait sculpture. His work is inconsistent in style, however, wavering uneasily between the ROCOCO and the NEOCLASSICAL. The influence of his friend ROUBILIAC is evident in the celebrated monument to General Wolfe (designed 1760s, erected 1772; London, West-minster Abbey). In the monument to the 2nd Duke of Buckingham (1769; Chenies) he collaborated with another friend, the architect Chambers, for whom he designed the de-corative sculpture on Somerset House, Lon-don, in the late 1770s. By then he had inherited a large fortune and left the execution of his sculpture to assistants.

In 1761 he was appointed 'Sculptor to His Majesty' by GEORGE III, and in 1768 was a founder member of the ROYAL ACADEMY. MB
□ Whinney (1964); B. Allen in *Burl. Mag.*, CXXV (1983), 195–202

Winchester Bible A 12c. Bible, one of the most celebrated of all English illuminated manuscripts, still preserved in the Cathedral Library of Winchester, the likely place of its origin. Initials containing figure subjects and some full-page frontispieces are placed at the beginning of each book of the Bible. An unusual feature is the range of styles of the artists, which has suggested to some that the illumination may have been done over a considerable period of time, perhaps with a long break. It is now thought that most of the work was done *c*.1170–80. Of the artists 4 are strongly influenced by Byzantine or Italo-Byzantine painting. Others came out of English or French ROMANESQUE traditions. One of the Byzantinizing painters was also a wall-painter, who worked in the Holy Sepulchre Chapel in Winchester Cathedral and in the convent of Sigena in North Spain (*see* WALL-PAINTING). *See also* BIBLICAL ILLUSTRATION; *ILLUMINATED MANUSCRIPTS: ROMANESQUE. NM
□ L. M. Ayres in *Art Bull.*, 56 (1974), 201–23; W. Oakeshott, *Sigena* (1972); id., *The two Winchester Bibles* (1981)

Winchester School is a term used in discussion of later ANGLO-SAXON illumination. Winchester was the principal city of Wessex, which, under Alfred (871–99) and his suc-cessors, became the focus of resistance to the Vikings and the nucleus of the unified kingdom of England. Winchester also became under Bishop Ethelwold (963–84) the key centre of the English monastic reform, which had been initiated by Dunstan at Glastonbury.

The terms 'Winchester School' or 'Winches-ter style' are derived from manuscripts thought to have been decorated in Winchester during the reform period. Best known are the New Minster Charter (966 or shortly after; BL) and the BENEDICTIONAL OF ST ETHELWOLD. Their style, decoration and iconography are based almost entirely on an eclectic use of Carolingian models, although the figure style owes something to the already Carolingian-derived manner of some southern English manuscripts of the previous decade or so. There is no continuity with pre-Viking art, except, perhaps, in the reinterpretation of classicizing models in terms of linear pattern. Rich colours and gold are used; figures are clothed in heavy draperies overlaid with a multiplicity of folds; poses and gestures are often highly expressive; and scenes are surrounded by heavy borders with gold-framed panels acting as the focus for exuberant growths of 'Winchester acanthus', which can also appear in initials. A decorative and rhythmic use of line unites picture and border.

Although the style may have originated in one of the Winchester monasteries, 'Winches-ter School' manuscripts are now known to have

Winchester School: the Maries at the Sepulchre, from the Benedictional of St Ethelwold, commissioned between 963 and 984 (BL).

been produced in other centres in southern England too. The popularity of the style can be seen in the influence that it exerted on northern French and later English manuscripts, as well as on other media such as IVORIES.

The term 'Winchester School' is normally applied only to manuscripts with painted decoration, thereby artificially distinguishing it from related styles of outline DRAWING. The basic ingredients of the 'Winchester style' continued in use in English illumination until the end of the Anglo-Saxon period, but from c.1000 they are subjected to increasingly mannered treatments. The style had moreover to compete with the influence of the impressionistic style of the Carolingian Reims School and with older traditions such as the zoomorphic decoration of initials. JH
□ Temple (1976)

Windus, William Lindsay (1822–1901) was a Liverpool painter greatly influenced by the PRE-RAPHAELITE BROTHERHOOD in the 1850s. His best-known works, such as *Too Late* (1858; Tate), depict poignant personal and social

scenes in finely painted open-air settings. WV
□ Maas (1968)

Wise-Ciobotaru, Gillian *see* CONSTRUCTIVISM

Wissing, William (1655–87) was born in Amsterdam and received his early training in The Hague. In 1676 he arrived in England and entered the studio of his countryman LELY, setting up on his own after Lely's death in 1680. His French-style portraits, with their hard, shiny paint quality and exotic vegetation, were popular with James II and leading Lincolnshire and Northamptonshire families. DD
□ Waterhouse (1978)

Wolfe, Edward *see* BLOOMSBURY

Wolmark, Alfred *see* STAINED GLASS: 19–20C.

Wood, Christopher (1901–30) began his training as a painter in Paris. He studied briefly at the Académie Julian in 1921, and made friends with Picasso, Diaghilev and Cocteau. In 1926 he met Ben NICHOLSON. Both were members of the 7 AND 5 SOCIETY and they exhibited together in London in 1927 and in Paris in 1930. In 1928 they discovered the self-taught Cornish painter Alfred WALLIS, whose unsophisticated paintings on scraps of cardboard contained the kind of naïve conviction which they admired. Wood produced his best work in Cornwall and Brittany, 1929–30. Paintings such as *Boat-builders, Tréboul* (1930; Cambridge, Kettle's Yard) reveal a wide range

Wood, *Boat-builders, Tréboul*, 1930 (Cambridge, Kettle's Yard).

of artistic sources, but they also indicate the existence of a powerful, individual talent. His life was undermined by emotional instability and drug addiction, and ended in suicide. DR
□ E. Newton, *Christopher Wood* (1959)

Woodcock, Robert see MARINE PAINTING

wood-engraving is a technique by which the engraving burin is used to incise lines in a woodblock, usually made of boxwood and cut on the cross, to produce a hard, close-grained surface capable of achieving fine effects. It was used creatively by *BEWICK in the years around 1800; then with the succeeding generation of engravers it developed into the most important method of graphic reproduction in England. Since the lines are in relief (unlike LITHO-GRAPHY, ETCHING or copper-plate ENGRAVING) woodblocks could be printed alongside let-terpress, and the engravers benefited from innovations in steam printing. This had a drawback, however, especially in the fields of illustrated news and topical humour, for to keep pace engravers had to practise division of labour: woodblocks were engraved in sections by different workers, and were as a result artistically characterless.

In the middle decades of the 19c. publishers of literary magazines and serialized fiction began to revalue the wood-engraving, and to employ a higher calibre of artist to design illustrations. The drawings of HOUGHTON, MILLAIS, SANDYS, Frederick WALKER and George Pinwell (1842–75) among others – the so-called 'Illustrators of the '60s' – were ably translated by engravers for a wider audience. In the 1870s, the artists of the GRAPHIC – notably *FILDES, HERKOMER and Houghton – made their name through applying the new standards of draughtsmanship to 'social realist' subjects. Although artists often criticized the way their work was engraved, few understood the medium. Gradually photographic processes took over the technical work, and by the end of the century the reproductive wood-engraver was all but eliminated from commercial illustration.

At the same time, a new fashion arose for wood-engravings designed and executed by the same artist, and this has remained characteristic in the 20c. William MORRIS had revived a self-consciously medieval style of woodcut, the bold, flat patterns being cut with a knife rather than the graver, usually on the coarser plank surface along the grain of a woodblock. The productions of the Kelmscott Press inspired a number of artists – RICKETTS and PISSARRO among them – to found private presses for the printing of illustrated limited editions. William NICHOLSON's woodcut books looked back in their simplicity and strength to primitive chapbooks and broadsides (see *POP-ULAR ART). Noel Rooke's book-illustration classes at the Central School in London and W. T. Smith's wood-engraving classes at the SLADE fostered a new generation of artist-engravers and in 1920 Robert Gibbings formed the Society of Wood-Engravers. The pop-ularity of the medium was in part an aspect of the strength of the whole print market in the years before the 1929 crash (see ETCHING REVIVAL), but the standard of work produced by the NASH brothers, or by Eric GILL and David JONES for the Golden Cockerel Press, was high and the demand for fine editions lasted into the 1930s. Such work tended to become increas-ingly elaborate in technique and stylistically effete, and English wood-engraving never had the innovative force so brilliantly demonstrated by the German Expressionist woodcut. CF
□ D. P. Bliss, *A history of wood-engraving* (1928); K. Lindley, *The woodblock engravers* (1970)

Woollett, William (1735–85) was the most celebrated English line ENGRAVER of his day, and did much to give the English school a European standing. His first success came with BOYDELL's publication of *The Destruction of the Children of Niobe* (1761) after WILSON, and he enlarged his range by engraving WEST's *Death of General Wolfe* (1776), one of the best selling prints of the century. Besides other plates after Wilson and West, he also engraved after STUBBS, Zuccarelli, and George Smith. His significance was marked by a monument at Westminster Abbey, London, carved by BANKS. RG
□ L. Fagan, *Cat. raisonné of the engraved works of William Woollett* (1885)

Woolner, Thomas (1825–92), sculptor, was a member of the PRE-RAPHAELITE Brotherhood, and his Wordsworth Memorial (1851; Gras-mere) is Pre-Raphaelite in its linear primitivistic refinement and in the naturalistic realism of the portraiture and the flowers. After a brief period as a gold prospector in Australia, he returned and gained acclaim for the truth of personality and likeness of his busts and statues, e.g.

Woolner, *Tennyson*, 1857 (Cambridge, Trinity College).

Tennyson (1857; Cambridge, Trinity College). The subject's friends said of *Godley* (1865; Christchurch, N.Z.) that had they only seen the legs they would have known them for Godley's. Woolner also made a few 'Ideal' works; *The Lord's Prayer* (1867; Wellington) represents the triumph of Christianity over paganism, while *The Housemaid* (1892; London, Salters' Hall) is a truthful, socially realistic portrayal. BR
□ A. Woolner, *Thomas Woolner: his life in letters* (1917); Read (1982)

Wootton, John (1682–1764) made a significant contribution to the development of both LANDSCAPE and ★SPORTING painting in England. After studying with Jan Wyck (1652–1700), he divided his long painting career between landscapes which 'approached towards Gaspar Poussin, and sometimes imitated happily the glow of Claud Lorrain' (Walpole) and sporting scenes for a succession of often aristocratic patrons. His follower George LAMBERT, and other painters such as WILSON, later exploited the taste for home-produced Italianate land-

scapes which he had helped to establish, and as a sporting artist he created formulas for the horse portrait and sporting CONVERSATION PIECE which were widely imitated. His work is well represented at Badminton, where, as at Althorp and Longleat, he painted large-scale sporting scenes for the entrance hall.

Through his high prices and through being 'in great Vogue and favour with many persons of the greatest quality' (VERTUE) he lived comfortably and sociably. He mixed – and, partly because of his deficiencies in 'face-painting', also collaborated – with many other artists; he is portrayed standing among some of them in Gawen ★HAMILTON's *A Conversation of Virtuosis* (1735, NPG). SD
□ *John Wootton* (exh., London, Kenwood, 1984)

Wright, John Michael (1617–94) was the leading native-born portraitist of post-Restoration England. After an apprenticeship with the Edinburgh artist George JAMESONE he spent 1642–56 in Rome (and briefly France), studying at the Academy of St Luke, dealing in antiquities, and forming a collection of paintings, prints and medals. Although not officially Royal Painter, he won the commission to decorate the ceiling of Charles II's

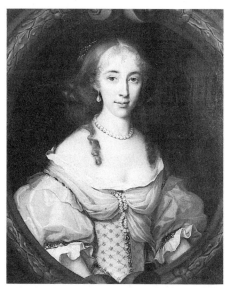

John Michael **Wright**, *Magdalen Aston*, 1669 (Nottingham).

bedroom at Whitehall and painted a vast portrait of the King (Royal Coll.). He also produced a number of more vivid smaller portraits (e.g. at Sudbury Hall, Derbys.). His Catholicism and his honest and direct style, at variance with that of LELY, cost him influential patronage and recognition, and he died in relative poverty. DD
□ Waterhouse (1978); *John Michael Wright* (exh., Scottish NPG, 1982)

Wright, Joseph, 'of Derby' (1734–97) was the first important British painter to pursue his career outside London, developing a highly personal style and pioneering the depiction of scientific and industrial subjects that reflected his close contacts with local scientists and industrialists, particularly Erasmus Darwin and Richard Arkwright.

Born of a legal family, Wright studied in London 1751–3 and 1756–7 under HUDSON and began as a portraitist in his manner, soon developing a stronger sense of character and a more fanciful elaboration of dress and ac-

cessories. He worked at Liverpool 1768–71 painting ship-owners, slave-traders and their wives in a somewhat overblown style but with a great sense of presence. His early manner parallels that of COPLEY in America. In the early 1770s he painted a few small-scale full-length portraits and CONVERSATION PIECES such as *Mr and Mrs Thomas Coltman* (priv. coll.)

Wright exhibited in Derby and Liverpool and eventually fairly regularly in London at the ROYAL ACADEMY and elsewhere; he held an exhibition of his own paintings in Covent Garden in 1785. Although elected ARA in 1781 he refused election as full RA in 1784; like STUBBS, quarrels kept him aloof from the main stream of Academy artists.

In the early 1760s Wright began to paint candlelight pictures, influenced by Thomas Frye's MEZZOTINTS and, indirectly, the Utrecht School. His first subject pictures, with tenebrist effects and actual portraits, were *Three Persons viewing the Gladiator by Candlelight* (exhibited 1765; priv. coll.), and 2 pictures popularizing scientific experiments, *The Orrery* (exh. 1766;

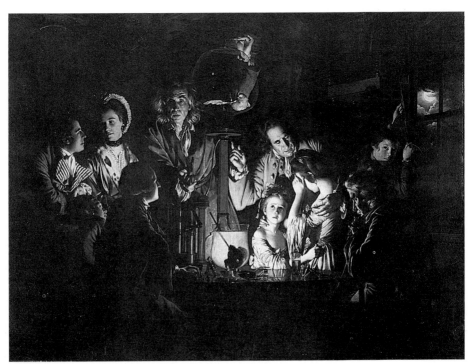

Wright of Derby, *Experiment with the Air Pump*, 1768 (Tate).

Derby) and *The Air Pump* (1768; Tate). On a smaller scale and apparently without specific portraits there followed *An Academy by Lamplight* (exh., 1769; Yale BAC), 2 versions of *A Blacksmith's Shop* (1771; Yale BAC and Derby) and Wright's first HISTORY painting, perhaps influenced by his friend MORTIMER, *Miravan opening the Tomb of his Ancestors* (1772; Derby). These show an increased interest in the setting, as does the night landscape of *An Earthstopper* (1773; Derby).

In October 1773 Wright set out for Italy where he spent most of his time in Rome (studying antique sculpture and Renaissance painting) and Naples. Pictures of Vesuvius in eruption and the Girandola, a firework display in Rome, appeared for the rest of his life, including a pair painted for Catherine II, Empress of Russia. Wright's year and a half in Italy also led to a strong NEOCLASSICAL element in his later paintings.

Back in England he settled for 2 years in Bath but failed to make a success; his candlelights were admired but not bought. In 1777 he returned to Derby and began to paint local landscapes in an increasingly mannered style, though *Landscape with Rainbow* (c.1793–5; Derby) and 2 views of Arkwright's Mills, one by night c.1783, and one by day c.1790 (priv. coll.), reflect the stimulus of new subjects. His portraits became less effortful and more generalized but remained unmatched in their sense of character, particularly those of personal friends such as the informally posed *Brooke Boothby* (1781; Tate) and *The Rev. and Mrs Thomas Gisborne* (1786; Yale BAC).

IN 1786 Wright was invited to contribute to BOYDELL's Shakespeare Gallery, completing *Ferdinand and Miranda in Prospero's Cell* (1789; untraced) and a landscape of *Antigonus in the Storm* (1789; also untraced – a second version was painted the following year); *Romeo and Juliet in the Tomb*, exhibited in 1790, was rejected (Derby). His health finally gave way in 1795. MRFB
□ B. Nicolson, *Joseph Wright of Derby* (1968)

Wright, Thomas *see* WILSON

Wyck, Jan *see* WOOTTON

Wykeham, William of, Bishop of Winchester 1367–1404, founded Winchester College in 1378 and New College, Oxford, in 1379. For his colleges he patronized the leading architects,

sculptors and glaziers of the time. The buildings are excellently well preserved, but only a small amount of the glass and sculpted and painted decoration survives. The glazier THOMAS OF OXFORD, employed at both, was a leading figure of the early years of INTERNATIONAL GOTHIC. At New College there is still original glass in the ante-chapel; the Tree of Jesse in the west window was replaced in the 18c. and is now in York Minster. A similar fate of destruction and dispersal befell the glass of Winchester College Chapel, but most of what survives has now been re-installed. Several sculpted groups of William of Wykeham kneeling before the Virgin of the Annunciation decorate the exterior of his college buildings.

At his death he bequeathed to New College his jewelled mitre and enamelled crozier, the finest of all extant English medieval episcopal insignia (*see* GOLDSMITHS' WORK). NM
□ W. Hayter, *William of Wykeham* (1970)

Wynter, Bryan *see* ST IVES SCHOOL

XY

York School of glass-painting was active in the later Middle Ages when it was dominant throughout the north. There are 2 peaks in its activity. The glazing of the Minster west window and some panels now in the choir clerestory, of the late 1330s and early 1340s, in style and certain design features reflects very strongly the influence of the French illuminator Jean Pucelle and of related windows in Normandy. Glass of the same character can be seen outside York, e.g. at Carlisle and Cartmel (Lancs.).

In the early 15c. the York workshops produced some of the most attractive glass in the country, in a version of the INTERNATIONAL GOTHIC style which seems to have been introduced by John THORNTON. The chief monuments of this phase include the Minster choir glazing, All Saints North Street and St Martin-le-Grand in York, Bolton Percy (Yorks.) and Cartmel.

The York glaziers remained active throughout the 15c. and early 16c., during which

period they tended to be organized in family firms, e.g. the Chambers and Pettys. The craft was centred in the Stonegate district.

See *STAINED GLASS: TO 1550. RM

☐ J. A. Knowles, *Essays in the history of the York School of glass-painting* (1936); D. E. O'Connor and J. Haselock in *A history of York Minster*, ed. G. E. Aylmer and R. Cant (1977)

Z

Zincke, Christian Frederick (1683/4–1767) was the pre-eminent enamel portraitist in London from 1714 to his retirement in the 1750s. Trained in Dresden as a goldsmith, he was brought to London in 1706 to assist Charles Boit in a genre which, with support from the Hanoverian court, temporarily displaced MINIATURE painting. He procured a royal appointment in 1732. Although prolific, he painted most of his enamels from life. PN

☐ Murdoch, Murrell, Noon and Strong (1981)

Zoffany, Johann (1733–1810) was born near Frankfurt and trained at Regensburg as a HISTORY painter before spending time in Rome in the early 1750s studying with the fashionable portrait painter Agostino Masucci. He probably came to London in 1760 and was soon patronized by the actor Garrick, who made his reputation. For Garrick Zoffany painted some remarkable CONVERSATION PIECES which, exhibited at the SOCIETY OF ARTISTS, were a great success and transformed the genre of THEATRICAL PAINTING. His German background doubtless appealed to GEORGE III and Queen Charlotte, for whom he produced, after 1764, a number of intimate and informal portraits plus the extraordinary *Tribuna of the Uffizi* (1772–8; Royal Coll.), painted in Florence as a sort of substitute for the GRAND TOUR the royal couple could never undertake. Zoffany remained in Florence until 1778. On his return to London he discovered that his long absence and the decline of the conversation piece had cost him his practice. He moved to India, where he lived 1783–9 and made a fortune portraying British residents and native princes.

Zoffany's remarkable talent lay in his chameleon-like ability to adapt to the local style wherever he lived. The crispness and polish of his early works gives way to a looser, more mannered style in his later years.

See *ROYAL ACADEMY. BA

☐ M. Webster, *Johan Zoffany* (exh., NPG, 1977)

Zucchi, Antonio *see* KAUFFMANN

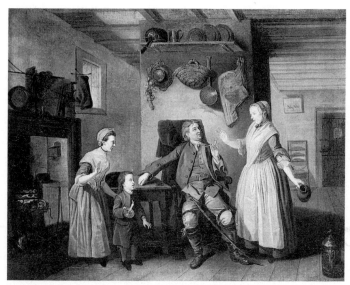

Zoffany, *David Garrick in 'The Farmer's Return'*, *c*.1762 (Yale BAC).

Bibliography

General dictionaries

ARCHIBALD, E. H. H. (1980) *Dictionary of sea painters*
BÉNÉZIT, E. (1976) *Dictionnaire des peintres, sculpteurs, dessinateurs et graveurs*, 10 vol., new edn.
FOSKETT, D. (1972) *A dictionary of British miniature painters*, 2 vol.
GRANT, M. H. (1926–61) *A chronological history of the old English landscape painters*, 8 vol.
– (1952) *A Dictionary of British landscape painters*
GUNNIS, R. (1953) *Dictionary of British sculptors, 1660–1851*, rev. edn 1968
JOHNSON, J. and GREUTZNER, A. (1976) *Dictionary of British artists 1880–1940*
MALLALIEU, H. L. (1976) *Dictionary of British watercolour artists up to 1920*
ORMOND, R. and ROGERS, M. (1979) *Dictionary of British portraiture*, 4 vol.
REDGRAVE, S. (1890) *A dictionary of artists of the English school*, rev. edn
THIEME, U. and BECKER, F., eds. (1907–50) *Allgemeines Lexikon der bildenden Künstler*, 37 vol.

General books

ALLEN, B. S. (1937) *Tides in English taste 1619–1800*
APTED, M. R. and HANNABUS, S. (1978) *Painters in Scotland, 1301–1700*
BLAND, D. (1969) *A history of book illustration*, 2nd edn
BLISS, D. P. (1928) *A history of wood engraving*
BRYDALL, R. (1889) *History of art in Scotland*
CAW, J. L. (1908) *Scottish painting 1620–1908*
CROFT-MURRAY, E. (1962, 1970) *Decorative painting in England 1537–1837*: I, *Early Tudor to Sir James Thornhill*; II, *The 18c. and early 19c.*
CUNNINGHAM, A. (1839–32) *The lives of the most eminent British painters, sculptors and architects* (many later edns)
DIXON HUNT, J. and WILLIS, P., eds (1975) *The genius of the place: The English landscape garden, 1620–1820*
EDWARDS, E. (1808) *Anecdotes of painters . . .*
EGBERT, D. D. (1970) *Social radicalism and the arts; Western Europe: a cultural history from the French Revolution to 1968*
ENGLEFIELD, W. A. D. (1923) *The history of the Painter-Stainers Company of London*
ESDAILE, K. A. (1927) *English monumental sculpture since the Renaissance*
– (1946) *English church monuments, 1510–1840*
GODFREY, R. (1978) *Printmaking in Britain: a general history from its beginnings to the present day*
GRIGSON, G. (1946) *The Harp of Aeolus and other essays in art, literature and nature*
HARDIE, W. (1976) *Scottish painting 1837–1939*
HARRIS, J. (1979) *The artist and the country house*

HIND, A. M. (1923) *A short history of engraving and etching*, 3rd edn
HUTCHISON, S. C. (1968) *The history of the Royal Academy 1768–1968*
MANDER, R. and MITCHENSON, J. (1955) *The artist and the theatre*
MERCHANT, W. M. (1959) *Shakespeare and the artist*
MURDOCH, J., MURRELL, J., NOON, P. and STRONG, R. (1981) *The English miniature*
PHYSICK, J. (1970) *Designs for English sculpture 1680–1860*
PIPER, D. (1957) *The English face*
–, ed. (1975) *The genius of British painting*
PYE, J. (1845) *Patronage of British art*
REYNOLDS, G. (1952) *English miniature painting*
– (1971) *A concise history of watercolour painting*
ROGET, J. L. (1890, 1891) *History of the Old Water-Colour Society*
ROSENTHAL, M. (1982) *British landscape painting*
SAXL, F. and WITTKOWER, R. (1948) *British art and the Mediterranean*
SHAW SPARROW, W. (1922) *British sporting painters*
– (1937) *A book of sporting painters*
SMITH, J. C. (1873–83) *British mezzotint portraits* (5 vols. and a portfolio of plates)
SUNDERLAND, J. (1976) *Painting in Britain, 1525–1975*
TODD, R. (1946) *Tracks in the snow*
VERTUE, G. (1930 etc.) MS notebooks in the BM, pub. in *Walpole Soc.* 1930, 1932, 1934, 1936, 1947, 1955
WALPOLE, H. (1762–80) *Anecdotes of painting in England* (many later edns)
WATERHOUSE, E. (1978) *Painting in Britain, 1530–1790*
WHINNEY, M. (1964) *Sculpture in Britain, 1530–1830*
WOODWARD, J. (1962) *British painting – a picture history*

Catalogues of major collections, general exhibitions and exhibiting societies

BRITISH MUSEUM, LONDON Binyon, J., *Cat. of drawings by British artists and artists of foreign origin working in Great Britain*, I (1898); II (1900); III (1902); IV (1907)
– Stephens, F. G. and George, M. D., *Cat. of political and personal satires preserved in the Department of Prints and Drawings*, 10 vol. (1870–1954)
BRITISH COUNCIL *British painting, 1600–1800*, exh., Sydney/Melbourne (1977–8)
COURTAULD COLLECTION, LONDON Cooper, D. (1954)
FITZWILLIAM MUSEUM, CAMBRIDGE Goodison, J. W., *Cat. of paintings*, III, *The British School* (1977)
FOUNDLING HOSPITAL, LONDON Nicolson, B., *The treasures of the Foundling Hospital* (1972)
GARRICK CLUB, LONDON Adams, C. K., *Cat. of pictures* (1936)
HENRY E. HUNTINGTON LIBRARY AND ART GALLERY, SAN

MARINO, CAL. Collins Baker, C. H., *Cat. of British paintings* (1936)
LOAN EXHIBITIONS (LONDON), 1813–1912: Graves, A., *A century of loan exhibitions*, 5 vol. (1905–6)
NATIONAL GALLERY, LONDON Davies, M., *Cats.: British School* (2nd edn, 1959)
NATIONAL MARITIME MUSEUM, GREENWICH *Concise cat. of paintings* (1958)
ROYAL ACADEMY OF ARTS, LONDON Graves, A., 8 vol. (1905–6)
– *British portraits* (1956)
– *Treasures of the RA* (1963)
– *Bicentenary exhibition, 1768–1968*, 2 vol. (1968)
SOCIETY OF ARTISTS OF GREAT BRITAIN (1760–91) and FREE SOCIETY OF ARTISTS (1761–83): Graves, A. (1907)
TATE GALLERY, LONDON Chamot, M., Farr, D., and Butlin, M., *Modern British paintings, drawings and sculpture*, 2 vol. (1964–5)

Periodicals specializing in British art or often containing articles on the subject

Apollo; *Art Bulletin*; *Art History*; *Art Monthly*; *Artscribe*; *Blake Quarterly*; *Burlington Magazine*; *Connoisseur*; *Country Life*; *Journal of the Warburg and Courtauld Institutes*; *Turner Studies*; *Walpole Society* (annual volumes, by subscription)

Techniques

BRUNNER, F. (1962) *A handbook of graphic reproduction processes*
DOSSIE, R. (1758) *The handmaid to the arts*
FAITHORNE, W. (1662) *The art of graveing and etching*
GETTENS, R. J. and STOUT, G. L. (1966) *Painting materials, a short encyclopaedia*
GRIFFITHS, A. (1970) *Prints and printmaking*
GROSS, A. (1970) *Etching, engraving and intaglio printing*
JACKSON, J. and CHATTO, W. A. (1928) *A treatise on wood engraving*
LAURIE, A. P. (1967) *The painter's methods and materials*
LEVIS, H. C. (1912) *A descriptive bibliography of the most important books in the English language relating to the art and history of engraving and the collecting of prints*
LUCAS, S. T. (1976) *Bibliography of watercolour painting*
MAN, F. H. (1970) *Artists' lithographs, a world history*
THOMPSON, D. V. (1936) *The materials of medieval painting*
TWYMAN, M. (1970) *Lithography 1800–1850*
WILLIAMS, I. A. (1964) *Early English watercolours*
WITTKOWER, R. (1977) *Sculpture, processes and principles*

Studies of particular periods

Medieval

ALEXANDER, J. J. G. (1978) *Insular manuscripts 6–9c.*, Survey of manuscripts illuminated in the British Isles, I
BRITISH ACADEMY (1984–) *Corpus of Anglo-Saxon stone sculpture*
GARDNER, A. (1951) *English medieval sculpture*
KAUFFMANN, C. M. (1975) *Romanesque manuscripts 1066–1190*, Survey of manuscripts illuminated in the British Isles, III
MARKS, R., and MORGAN, N. (1981) *The golden age of English manuscript painting, 1200–1500*
MORGAN, N. (1982) *Early Gothic manuscripts 1190–1250*, Survey of manuscripts illuminated in the British Isles, IV, I
PRIOR, E. S. and GARDNER, A. (1912) *An account of medieval figure-sculpture in England*
RICKERT, M. (1965) *Painting in Britain. The Middle Ages*, 2nd edn

STONE, L. (1972) *Sculpture in Britain. The Middle Ages*, 2nd edn
TEMPLE, E. (1976) *Anglo-Saxon manuscripts 900–1066*, Survey of manuscripts illuminated in the British Isles, II
1066: *English Romanesque art* (1984) exh., Arts Council
THOMPSON, D. V. (1936) *The materials of medieval painting*
THOMSON, R. M. (1982) *Manuscripts from St Albans Abbey 1066–1235*
WILSON, D. (1984) *Anglo-Saxon art*

16th and 17th centuries

The age of Charles I (1972) exh., Tate
The age of Charles II (1960–61) exh., RA
AUERBACH, E. (1954) *Tudor artists*
BAKER, C. H. COLLINS (1912) *Lely and the Stuart portrait painters*
CROFT-MURRAY, E., and HULTON, P. (1960) *Cat. of British drawings in the BM*, I, 16–17c.
English landscape 1630–1850. Drawings, prints and books from the Paul Mellon Coll. (1977) exh., Yale BAC
MERCER, E. (1962) *English art 1553–1625*
MILLAR, O. (1963) *Tudor, Stuart and early Georgian pictures in the coll. of H.M. the Queen*
OGDEN, H. V. S. and M. S. (1955) *English taste in landscape in the 17c.*
PIPER, D. (1963) *Cat. of the 17c. portraits in the NPG 1625–1714*
STRONG, R. (1969) *The English icon: Elizabethan and Jacobean portraiture*
–, ed. (1969) *NPG: Tudor and Jacobean portraits*
WHINNEY, M. D., and MILLAR, O. (1957) *English art 1625–1714*
WOODWARD, J. (1951) *Tudor and Stuart drawings*

18th and 19th centuries

The age of Neo-Classicism (1972) exh., Arts Council
ATHERTON, D. (1974) *Political prints in the age of Hogarth*
BARRELL, J. (1980) *The dark side of the landscape*
BELL, Q. (1963) *The schools of design*
BOASE, T. S. R. (1959) *English art 1800–1870*
British artists in Rome (1700–1800) (1974) exh., London, Kenwood
BURKE, J. (1976) *English art 1714–1800*
CLARKE, M. (1981) *The tempting prospect: A social history of English watercolours*
CLIFFORD, T., GRIFFITHS, A., and ROYALTON-KISCH, M. (1978) *Gainsborough and Reynolds in the BM*, exh., BM
The conversation piece in Georgian England (1965) exh., London, Kenwood
CORDINGLY, D. (1973) *Marine painting in England, 1700–1900*
CUMMINGS, F., and STALEY, A. (1968) *Romantic art in Britain*, exh., Detroit/Philadelphia
Decade 1890–1900 (1967) exh., Arts Council
DOBAI, J. (1974, 1975, 1977) *Die Kunstliteratur des Klassizismus und der Romantik in England*, I, 1700–1750; II, 1750–1790; III, 1790–1840
DRAPER, J. W. (1926) *18c. aesthetics: a bibliography*
FARR, D. (1978) *English art 1870–1940*
FARINGTON, J. (1978–) *Diary*, ed. K. Garlick et al.
The French taste in English painting during the first half of the 18c. (1968) exh., London, Kenwood
GEORGE, M. D. (1959) *English political caricature: a study of opinion and propaganda*
GREENACRE, F. (1973) *The Bristol School of artists*
HAMMELMANN, H. (1975) *Book illustrators in 18c. England*, ed. and completed by T. S. R. Boase
HARDIE, M. (1966, 1967, 1968) *Watercolour painting in Britain*: I, *The 18c.*; II, *The Romantic period*; III, *The Victorian period*

HARDIE, W. (1976) *Scottish painting 1837–1937*
HERRMANN, L. (1973) *British landscape painting of the 18c.*
HIPPLE, W. J. (1957) *The Beautiful, the Sublime and the Picturesque in 18c. British aesthetic theory*
HONOUR, H. (1968) *Neo-Classicism*
HOUFE, S. (1978) *Dictionary of British book illustrators and caricaturists 1800–1914*
HUNT, W. HOLMAN (1905) *Pre-Raphaelitism and the Pre-Raphaelite Brotherhood*
HUSSEY, C. (1927/1967) *The Picturesque: studies in a point of view*
HUTCHISON, S. C. (1960–62) 'The Royal Academy Schools, 1768–1830', in *Walpole Soc.*, XXXVIII, 123–91
IRONSIDE, R. (1948) *Pre-Raphaelite painters*, with descriptive cat. by J. Gere
IRWIN, D. (1966) *English Neoclassical art*
IRWIN, D. and F. (1975) *Scottish painters at home and abroad 1700–1900*
KERSLAKE, J. (1977) *Cat. of the 18c. portraits in the NPG*
KLINGENDER, F. D. (1968) *Art and the Industrial Revolution*, rev. A. Elton
Landscape in Britain, c.1750–1850 (1973) exh., Tate
Landscape in Britain, 1850–1950 (1983) exh., Arts Council
LIPPINCOTT, L. (1983) *Selling art in Georgian London*
LISTER, R. (1966) *Victorian narrative paintings*
– (1973) *British Romantic art*
MAAS, J. (1969) *Victorian painters*
MANWARING, E. W. (1925) *Italian landscape in 18c. England*
MILLAR, O. (1969) *The later Georgian pictures in the coll. of H.M. the Queen*
PAULSON, R. (1975) *Emblem and expression*
The Pre-Raphaelites (1984) exh., Tate
PRESSLY, N. L. (1979) *The Fuseli circle in Rome*, exh., Yale BAC
READ, B. (1982) *Victorian sculpture*
REYNOLDS, G. (1953) *Painters of the Victorian scene*
– (1966) *Victorian painting*
– (1976) *British watercolours*
Rococo: art and design in the age of Hogarth (1984), exh., V&A
ROSENBLUM, R. (1967) *Transformations in late 18c. art*
SMITH, B. (1960) *European vision and the South Pacific*
SMITH, J. T. (1828) *Nollekens and his times* (and later edns)
– (1845, 1905) *A book for a rainy day*
SPENCER, R. (1972) *The Aesthetic movement: theory and practice*
STALEY, A. (1973) *The Pre-Raphaelite landscape*

TREBLE, R. *et al.* (1978) *Great Victorian pictures: their paths to fame*, exh., Arts Council
VAUGHAN, W. (1978) *Romantic art*
– (1979) *German Romanticism and English art*
WAGNER, M. (1979) *Die Industrielandschaft in der englischen Malerei*
WATERHOUSE, E. (1965) *Three decades of British art, 1740–70* (Jayne Lectures for 1964)
– (1981) *Dictionary of British 18c. painters in oils and crayons*
WHITLEY, W. T. (1928) *Art in England 1800–1820*
– (1928) *Artists and their friends in England, 1700–1799*
– (1930) *Art in England 1821–37*
WILLIAMS, I. O. (1952/1970) *Early English watercolours*
WOOD, C. (1978) *Dictionary of Victorian painters*, 2nd edn

20th century

Abstract art in England 1913–15 (1969) exh., London, D'Offay Couper Gall.
Art in Britain 1930–40 centred round Axis, Circle, Unit One (1965) exh., Arts Council
British art and the Modern Movement, 1930–40 (1962) exh., Arts Council
British sculpture in the 20c. (1981) exh., London, Whitechapel
CHAMOT, M. (1937) *Modern painting in England*
CORK, R. (1975–6) *Vorticism and abstract art in the first machine age*: I, *Origins and development*; II, *Synthesis and decline*
Decade 1910–20 (1965) exh., Arts Council
Decade 1920–30 (1970) exh., Arts Council
FARR, D. (1978) *English art 1870–1940*
HAFTMANN, W. (1960) *Painting in the 20c.*
HAMILTON, G. H. (1967) *Painting and sculpture in Europe, 1880–1940*, rev. edn 1977
HARRISON, C. (1981) *English art and Modernism, 1900–1939*
IMPERIAL WAR MUSEUM, LONDON (1924 and 1963) *Concise Cat. of paintings, drawings and sculpture of the First World War, 1914–18*
Landscape in Britain, 1850–1950 (1983) exh., Arts Council
Painting, sculpture and drawing in Britain, 1940–49 (1972–3) exh., Arts Council
Pop art in England (1976) exh., British Council
ROTHENSTEIN, J. (1952–74) *Modern English painters*, 3 vol.
Thirties: British art and design before the war (1979) exh., Arts Council
WATERS, G. M. (1976) *Dictionary of British artists working 1900–1950*

World gazetteer of museums and galleries containing British art

BY ROSEMARY TREBLE

The listing that follows represents a selection of the holdings of British art in public museums and galleries and major libraries. It concentrates on artists and works discussed in the Encyclopaedia, but also notes some of local importance. Attributions are generally those given in the institutions' catalogues. Some collections have been described at disproportionate length, where they are less accessible (like Puerto Rico), less known (some small British provincial galleries), or where the sheer range of the collection extends even the briefest noting of each part (like the British Museum). The arrangement is alphabetical; England, Northern Ireland, Scotland and Wales appear individually in

the main sequence. The abbreviations used are those explained on p. 7, with two additions : 'beq.' means bequest, or bequeathed; 'incl.' means include, includes, including.

The preparation of this gazetteer was only possible with the generous help of a number of individuals and institutions. Thanks are due above all to Dr Catherine Gordon of the Courtauld Institute, and also to Brian Allen, Mildred Archer, the Belgian Embassy in London, John Glaves-Smith, the Lisson Gallery in London, Benedict Read, the Tate Gallery Library, Nicholas Usherwood, Malcolm Warner and Christopher Wright.

AUSTRALIA

ADELAIDE AG of S. Australia
Large Gheeraerts *Lady Aston*, and other portraits by Lely (attr.) and Reynolds; landscapes incl. Wilson *Cicero at his Villa*, 2 small Constables, and watercolours by W. Daniell, Devis, De Wint, Francia, Turner and Westall. Victorians strong, with genre incl. Faed and Hicks; Landseer animals; classicists incl. Alma-Tadema, Leighton, Poynter, Watts; many landscapes; and aesthetes Burne-Jones, Conder and Whistler. 20c. incl. most major names and especially interesting watercolours and drawings: 2 large Burra watercolours, W. Lewis *Edith Sitwell*, large Spencer *Hilda Welcomed*. Scots incl. Hornel, McTaggart, Peploe and Redpath.
BENDIGO AG A few 19c. landscape oils incl. Crome (attr.), Herring, Stanfield; later minor academics. Some watercolours, incl. Prout and Sutherland.
BRISBANE Queensland AG Paintings incl. Raeburn, Ramsay and Reynolds portraits, and small Conder landscape. Watercolours and drawings incl. 2 Bonington, Cotman, Cox, De Wint, Fuseli nude (attr.), Gainsborough pencil landscape, Lawrence, Prout, Romney *Mars and Venus*, Rowlandson, 2 Turners incl. *Temple of the Sybil at Tivoli*, Wilson, Wright of Derby; some modern drawings incl. Sickert; prints Bawden to Sutherland; Epstein bronze *Kitty*.
CANBERRA Australian NG Modern coll. incl. Bacon *Triptych*,

Moore large bronze *Hill Arches*, and 3 large Rileys. Fine print coll. with exceptional lithographs.
MELBOURNE NG of Victoria Internationally important coll. of British art with many major works 17–20c. Portraits begin with 2 16c. examples; most portraitists represented, with Mytens *Sir John Ashburnham*, Van Dyck *Countess of Southampton*, Batoni *Sir Samson Gideon and his Tutor*, Gainsborough *Speaker Cornwall* and Romney *The Leigh Family*. Sporting and animal paintings incl. Stubbs *Lion attacking a Horse*; subject paintings incl. some of Highmore *Pamela* series, Zoffany *Caritas Romana*, Haydon *Marcus Curtius*, and 39 Blake watercolours of Dante for Linnell. Range of landscapes incl. Barret, Wilson, Calvert, good Constables incl. the main oil sketch for his Diploma picture, and Stanfield's first important RA painting. Interesting early sculpture (15c. *John the Baptist*, 16c. pair of busts of men in armour), Rysbrack *Rubens*, 3 Scheemakers busts, and 2 Chantreys. Best Pre-Raphaelite coll. in the country: Millais *The Rescue*, 2 Burne-Jones, Hughes *Fair Rosamund*, Deverell, a late Biblical Holman Hunt, important F. M. Brown watercolours, plus drawings, prints and illustrations. Victorian pictures strong on Newlyn, problem and realist subjects, and classicists. Contemporary coll. incl. Hockney and Riley.
SYDNEY AG of New South Wales Religious subjects from Gavin Hamilton and West, a Reynolds male portrait, landscapes by Wilson, Wes-

tall, Turner, Constable copy of Claude, Linnell and D. Roberts, plus Etty and Danby. Important Pre-Raphaelites and High Victorians: F. M. Brown *Chaucer at the Court of Edward III* (the first picture in the coll.), Burne-Jones *St George*, Millais, 2 important Leightons (*Wedded* and *Cimon and Iphigenia*), and Poynter's huge *Queen of Sheba*. Realism of various kinds incl. widowers by Fildes and Tissot; Newlyn incl. Forbes, Tuke; other British Impressionists incl. Clausen, La Thangue, McTaggart. Many 19c. RAs and some good Victorian sculpture, especially Gibson, Gilbert and Woolner. 20c. introduced by Sickert, Steer, Gore and W. Roberts; mid century landscapes incl. P. Nash and Sutherland; important late Spencer, *Christ in Cookham*; abstract paintings and sculpture by Davie, Hepworth, Moore, Nicholson and Pasmore.

AUSTRIA

VIENNA Albertina Incl. Lely chalk *Two Heralds* (the most famous drawing in his Garter Procession series), Wheatley watercolour *Rural Repose*, and Fuseli *The Shepherd's Dream* (from *Paradise Lost*).
Kunsthistorisches Mus. The only notable holding of British painting in Austria. Good portraits: Holbein *Jane Seymour* and *John Chambers, Physician to Henry VIII*; Hilliard *Anne of Denmark, Sir Francis Drake*, and *Duc d'Alençon*; Van Dyck *Nicholas Lanier*; Wright of Derby *Rev. Basil Bury Beridge*; 4 fine Zoffanys of the family of

Empress Maria Theresa; Lawrence *Lady Milner*; Raeburn *William Law of Elvinston*; also Reynolds and attr. Kneller. Landscapes incl. Loutherbourg storm and early Gainsborough. **Mus. des 20. Jahrhunderts** Moore, Armitage, Chadwick. **Neue Gal. in der Stallburg** Lawrence *Princess Maria Theresa as a Child*. **Österreichische Gal** Kauffmann *Ferdinand and Miranda from 'The Tempest'*.

BELGIUM

ANTWERP Mus. Mayer van den Bergh Medieval coll. contains 4 14c. alabasters, a miniature from the E. Anglian Munchensey Missal (*c.*1300), and diptych portrait of man and wife probably by the Master of the Benson Portrait. Later drawings coll. incl. Wilkie. **Koninklijk Mus. voor Schone Kunsten** A few 19c. paintings and drawings incl. 2 Alma-Tademas (*Cherries* and *Mr Soons*), Tissot *Embarquement à Calais*, and 2 Burne-Jones chalk studies.

BRUGES Arentshuis Large coll. Brangwyn given by the artist (born in Bruges).

BRUSSELS Mus. Royaux des Beaux-Arts de Belgique Portraits incl. 16c. woman and man, a version or replica of Reynolds's portrait of *William Chambers*, and 2 Raeburns. Among 19c. landscapes J. B. Crome; watercolours incl. W. Daniell, Boys and Brangwyn. Some 20c.: Nicholson, Sutherland, bronzes by Armitage and Moore. **GHENT Mus. voor Schone Kunsten** Nottingham alabaster; 18c. paintings incl. 2 Hogarths (oil *Study of Hands* and female portrait), Reynolds (attr.) and Raeburn *Alexander Edgar*; modern coll. incl. Hockney and A. Jones and Conceptualists Fulton and Long.

BRAZIL

SÃO PAOLO Mus. de Arte Founded only in 1947, the coll. now has representative British pictures spanning 16–19c. Portraits incl. Holbein *Henry Howard, Earl of Surrey*; Van Dyck male half-length and *Marquise Lomellini*; Reynolds *The Children of Edward Holden Cruttenden* (painted to commemorate the heroism of the young Indian girl who had protected them in an uprising); Gainsborough *Francis Rawdon, 1st Marquis of Hastings*; and Lawrence *The Fluyder Children*. Landscapes incl. Gainsborough's largest early landscape, Turner *Caernarvon Castle*, and a version of Constable *Salisbury Cathedral from the Bishop's Garden*. A few 20c. incl. 2 interesting historical portraits: Sutherland *Nelson* and P. Blake *George Orwell*. **Mus. de Arte Contemporânea** 20c. paintings incl. Davie *Bili's Game, No. 2* and a Sutherland *Spiny Form*. Sculpture incl. bronzes by Moore, *Two Piece*

Reclining Figure: Points, and Hepworth, *Cantate Domino*, and Paolozzi in aluminium, *Hermaphroditic Idol No. 1*. Prints incl. Ayrton, Colquhoun, Hayter, K. Martin, Paolozzi, Richards and Vaughan.

CANADA

FREDERICTON Beaverbrook AG Good portraits: Hilliard *Elizabeth I*; Reynolds *Mrs Thrale and her daughter Hester* and full-length *Mrs Billington as St Cecilia*; Hoppner *Master Thomas Braddyll* (with a large dog); others by Copley, Hogarth, Gainsborough and Lawrence. Subject pictures incl. some unusual works like Hayman *The Humanity of General Amherst*, Wootton *Gen. Richard Onslow inspecting the Horse Grenadier Guards*, 2 Stubbs, and D. Allan *Penny Wedding*. 19c. coll. headed by 3 Turners (*The Fountain of Indolence*, and views of Venice and Warkworth Castle), a huge Landseer chalk drawing, *The Hunted Stag*, and Tissot *A Passing Storm*; also Etty, Faed, Foster, Frith, 2 late Herkomers, Orchardson, Rossetti, and 4 Whistler drawings done at West Point. Later 19c. well represented with 9 Sickerts (incl. *The Old Middlesex* and *Sunday Afternoon*), Steer, Conder, Tonks (*Hunt the Thimble* and watercolour of Beaverbrook with Sargent and Tonks), and Sargent. Earlier 20c. strong with Gilman, Grant, W. Nicholson, P. Nash, Armstrong, Wadsworth tempera *The Jetty, Fécamp*, Lewis *The Mud Clinic*, Gertler, Hillier, M. Smith, Wood incl. an unusual and very pretty *Nude Girl with Flowers*; also 2 important 1950s Spencers, *The Marriage at Cana* and *Resurrection: Rejoicing*. Large group Sutherland portraits incl. *Helena Rubinstein*, *Lord Beaverbrook*, studies of Churchill and Maugham; 2 Bacons incl. *Lucian Freud, Freud Hotel Room*, and B. Nicholson.

HAMILTON AG Tissot's early *Martin Luther's Doubts* and *Croquet*. **MONTREAL Mus. des Beaux-Arts/MFA** Portraits incl. Gainsborough *Mrs George Drummond*, 3 Romneys incl. *Charles Chaplin*, an early Opie, plus Lely, Beale (attr.), Hogarth, Highmore, Reynolds, Hoppner, Raeburn, Lawrence and Watts. Landscapes incl. Wilson, Gainsborough, Morland, Ibbetson, Constables, 3 Bonington oils, a Crome woodland scene, Linnell and Lavery. 19c. genre from Wilkie, an important Faed (*Sunday in the Backwoods, Canada*), and Tissot *October*, with other Victorians like Pettie and Poynter. Some watercolours and drawings, especially Rowlandson *Picture Sale at Christie's*, De Wint, Cox, 2 Ruskins, Clausen. Modern coll. incl. Sickert, Grant, W. Roberts, Bawden, early Heron; also a Moore and 2 Epstein bronzes.

OTTAWA Canadian War Mus.

Instituted by Beaverbrook in 1917, incl. specially commissioned paintings by Clausen, Nash, Roberts and Rothenstein. **NG of Canada** Largest coll. of British art in Canada begins with the remarkable Eworth *Mary Neville, Lady Dacre*, Mytens *Charles I as Prince of Wales*, Johnson *Lady Thynne*, Kneller *1st Duke of Chandos and his Family*, 3 Lelys incl. *Sir Edward Massey*. In 18c.: Gainsborough *Ignatius Sancho* (Duke of Montagu's W. Indian slave) and Romney *Joseph Brant* (leader of the Six Nations Indians who settled in Canada after the American Revolution), Zoffany family group, also portraits by Hogarth, Reynolds, Hoppner, Romney, Raeburn and Beechey; and Loutherbourg's satirical *A Midsummer Afternoon with a Methodist Preacher* and West *The Death of Wolfe*. Fine landscapes by Wilson (*A Distant View of Rome from Monte Mario*), Bonington, Constable, 4 Turners and Palmer. Victorians incl. a rare Collinson (*Childhood*), Frith's sketch for *Salon d'Or, Bad Homburg*, a Millais portrait and sketch for *Return of the Dove to the Ark*, Rossetti diptych *Salutatio Beatricis*, Holman Hunt portrait of the Canadian *Henry Wentworth Monk*, plus Egg, Etty, Greaves, W. H. Hunt, Leighton, Linnell and Watts. Later 19–20c.: Whistler, 2 Dieppe Sickerts and large version of *The Old Bedford*, 6 Steers, Brangwyn, 11 A. John (incl. *Self-portrait*), and G. John. Group of 1st World War paintings incl. Wadsworth *Dazzle-Ships in Drydock at Liverpool*, 9 P. Nash, Burra, 4 Spencers incl. extraordinary *Landscape with Magnolia, Odney Club*; plus Frost, Hillier, Hitchens, 2 Moore gouaches, Nevinson, large Nicholson still-life, an early Pasmore, and Smith. Sculptures incl. an Epstein bronze torso from *The Rock Drill*, Moore, and Long's granite *About One Hundred Stones*. **QUEBEC Mus du Québec** Turner *Near Northcourt in the Isle of Wight*. **TORONTO AG of Ontario** Sculpture dominates the British art here with the recently established Henry Moore Sculpture Centre, incl. more than 200 works given by Moore 1973–4: original plasters and models of major works like the Festival of Britain *Reclining Figure* and *Atom Piece*, bronzes incl. *Warrior with Shield* and the large *Two Forms*, and a shelter drawing. Also Hepworth bronze and Paolozzi *Ovemk*. Most important painting is Gainsborough's late *Harvest Waggon*; also Wheatley, Fuseli *Lear banishing Cordelia*, and an early Turner watercolour (*Fonthill – Morning*), plus portraits by Hogarth, Reynolds (incl. *Horace Walpole*) and Raeburn. 19c. incl. Watts *The Sower of the Systems*, 2 Tissots (*Girl in a Chair* and *The Milliner's Shop*), and Clausen. 20c. incl. A. John portrait of *Marchesa Casati* and B. Nicholson still-life.

Royal Ontario Mus. Wide-ranging coll. incl. a 14c. Nottingham alabaster *Coronation of the Virgin*, Roubiliac roundel of *Oliver Cromwell*, and Rysbrack's terracotta bust of the sculptor *Duquesnoy*.
VANCOUVER AG Most interesting earlier British painting is Fuseli *Belinda's Awakening* (from Pope's *Rape of the Lock*). Portraits incl. Hogarth *Mr Bridgeman*, Highmore *Mrs Elizabeth Harvey*, Ramsay, Gainsborough *George Montgomerie*, Beechey, Hoare and Lawrence. Landscapes by Wilson and Marlow (*Stonehenge*); 3 Morlands, 2 Westall watercolours, Wilkie *The Shadow on the Wall*, and Etty. Some Victorians incl. Burne-Jones, Frith, Leighton, Herkomer, Cox, Forbes, Hornel and McTaggart. Brangwyn, Munnings and Orpen introduce a good sampling of 20c., especially Spencer *Alpine Landscape*, a Sickert still-life, Steer, Fry *Spring in Provence*, Gilman *Halifax Harbour*, Grant flowers, Hillier, Lewis and Innes. Later 20c.: Frost, Heron, Hitchens, Nash, Nicholson, Redpath and 2 Sutherlands.
WINNIPEG AG J. Ward *The Great Bull*.

CZECHOSLOVAKIA

PRAGUE Národní Gal. (NG) Prague is the birthplace of Hollar, and the coll. of his drawings and prints is matched only by the BM.

DENMARK

COPENHAGEN Statens Mus. for Kunst Several important works: the only surviving allegorical picture by Eworth, *Allegory of the Wise and Foolish Virgins*; one of 2 versions of Mytens *Charles I as Prince of Wales*; and a large and very grand Ramsay *George III* commissioned 1765 by the King of Denmark. Also Van Dyck drawing of *Philip Porter*, an early Lely female portrait, a male portrait attr. Lely or Kneller, Romney *Portrait of the Dentist Ruspini*, and a Raeburn male portrait. Constables incl. an oil, *The Mill Stream*, 2 good drawings of Dove Dale and the important pencil *Dedham from Langham*.
FREDERICSBORG Nationalhistoriske Mus. A fine Cotes pastel of *Princess Caroline Matilda* (who married Christian VII of Denmark). Also 2 17c. miniatures: Oliver *Anne of Denmark* (James I's queen), and A. Cooper *Gen. Frederick von Arenstorff*.
HUMLEBAEK Louisiana 20c. coll. incl. British sculpture: Chadwick, Hepworth and a large Moore bronze, *Reclining Figure V: 'Seagram'*.

EIRE

CORK Crawford Municipal AG Small coll. 18–19c. incl. 2 important Barrys (*Barry and Burke in the Characters of Ulysses and a Companion fleeing from*

the *Cave of Polyphemus* and *The Prince of Wales as St George*) and Maclise *The Falconer*.
DUBLIN Hugh Lane Municipal Gall. of Modern Art Coll. begins with a popular early Barry history painting, *Venus rising from the Sea*, Mulready, and 7 Constable oil sketches. 16 Orpens (incl. *Self-portrait*), Sargent, Burne-Jones, Leighton, Stott, Watts, Lavery, McEvoy and Sickert, and most importantly Whistler *In my Studio*. In 20c. Nevinson, Nicholson, Piper, and a Moore bronze.
NG of Ireland Many interesting portraits, especially of artists and family groups: 9 Tudor portraits; Dobsons incl. large portrait group; Kneller large allegorical *William III*; Hogarth; 5 Batonis incl. 3 portraits of the Leeson family; fine large Kauffmann group of the family of the Earl of Ely with the artist; 9 Gainsboroughs incl. the actor *James Quin*; 12 Reynolds; Opie of *Barry*; important Barry *Self-portrait* and other paintings; Romney of the poet *Mary Tighe*; splendid Hoppner *Self-portrait with a Fish*; G. Barret Jun. *Self-portrait*; Lonell Mulready; Conder Orpen; and many others 17–20c. Other 18–19c. paintings: Hayman and Romney scenes from Shakespeare, Stubbs, Collins, Bonington, Etty, Constable, 31 Turner watercolours (exhibited only in January), Leech, Maclise incl. the huge *Marriage of the Princess Aoife of Leinster*, and Mulready incl. *The Toy-Seller*; further landscapes and marines from S. Scott, Brooking and Barret to Brett and Orchardson. Late 19–20c. made incl. 14 Orpen, Lavery, 2 Tissot, NEAC, Newlyn School, Fry, Grant, M. Smith and late Tonks *La Toilette*. Also fine drawings coll. with Isaac Fuller, Van de Velde, Gainsborough, Sandby, Cozens, Barry, Turner, Constable, Rossetti, Leighton, Whistler, and W. Lewis *James Joyce*.

ENGLAND

ACCRINGTON Haworth AG Some 19c. oils, watercolours (incl. Prout and Rooker) and 90 local views.
ALTRINCHAM Mus. & AG 5 portraits of the Ireland family by Gheeraerts, Hudson and Kneller amongst local coll.
BARLASTON Wedgwood Mus. Portraits of Wedgwood family and associates by Stubbs (3), Reynolds, Wright of Derby (attr.; also MS letters). Romney and Sargent; designs for ceramics incl. Hepworth.
BARNARD CASTLE Bowes Mus. Gheeraerts, Wilson, Reynolds, Gainsborough, Ramsay and 19c. coll. of NE topographical art (J. W. Carmichael and others).
BARNSLEY Cannon Hall AG & Mus. A dozen 17–19c. oils incl. Lely, Highmore, Morland and Constable.
Cooper AG Small coll. of oils and

watercolours from Towne and Cotman to P. Nash and Nevinson.
BARNSTAPLE Guildhall 30 kit-cat portraits of Barnstaple civic worthies by Hudson, who came from Devon.
BARROW-IN-FURNESS Public Lib. Sketchbooks and letters by Romney, a Furness man.
BATH Holburne of Menstrie Mus. 17–18c. portraits: Dobson *Sir Thomas Killigrew with his Pointer*, Walker, Gainsborough, Kauffmann *Self-portrait*, Raeburn, Ramsay, Stubbs *Rev. Carter Thelwell and his Daughters*, and Zoffany. Bath artists mostly 19c., headed by Thomas Barker and family, and incl. Hoare. Among other Victorians Egley, Long and Ricketts. Some landscape oils and drawings by Gainsborough, Constable and Turner. 18–19c. miniatures and series of 17c. notables by Thomas Forster in plumbago.
Victoria AG Some fine 18c. paintings incl. Farington and Hoppner *Fishing Party*, S. Scott *Lambeth Palace from the Thames*, Reynolds oil sketch for *Miss Bowles*, Loutherbourg *Storm with Smugglers landing*, and Zoffany *Charles Dumergue*. Large group of Cristall studies, Cox oil. Later 19c. more routine with Long and La Thangue, but also many Bath views and portraits, SW artists incl. Danby, Muller, and definitive coll. of Barker family of Bath. In 20c. Brangwyn and Sickert.
BATLEY see **HUDDERSFIELD**
BECKENHAM Bethlem Royal Hospital Historical Mus. Works by Dr Monro (physician to Bethlem) and Dadd, also Cibber *Raving* and *Melancholy Madness*.
BEDFORD Cecil Higgins AG Distinguished coll. 18–20c. watercolours and drawings incl. Rowlandson, Towne, F. M. Brown, Ruskin, Ginner and Spencer, with major new gift of Turner *Norham Castle: A Summer's Morn*. Oils incl. Victorians from Handley-Read coll. (Dadd, Eastlake, Lavery, Leighton, J. F. Lewis); also a Bonington, *Normandy Sands*.
BERWICK-UPON-TWEED AG Mini-Burrell Coll. presented in 1949 incl. a few 18–19c. British portraits and Glasgow School (Crawhall, Melville).
BIDEFORD Burton AG Small gall. opened 1951 houses colls. of Burton and Coop who liked English and Anglo-American Impressionists like Clausen, Fisher, Lavery; plus Opie and Reynolds.
BILSTON Public Lib., Mus. & AG Small coll. 19c. (incl. Pettie) and 20c. (Gowing, Lessore) paintings and drawings.
BIRKENHEAD Williamson AG & Mus. 40 works by Steer (Birkenhead-born), with representative Liverpool School coll. (Bond, Daniels, Huggins, A. W. Hunt, Tonge, Windus). Also 18–20c. watercolours, a few 18c. and more 19–20c. oils.

BIRMINGHAM Barber Institute Acquired only since 1932, the coll. is small but select. Landscape oils and drawings by Hollar, Van Dyck, Wilson, Gainsborough (incl. *The Harvest Waggon*), Turner, Constable and Crome; portraits by Hilliard, Lawrence, Reynolds, Romney, Orchardson and Whistler (*Symphony in White No. III*). Comic drawings incl. Rowlandson, Keene, Leech. Most recent works are a Beardsley and Sickert *Eldorado, Paris*. Sculptures: Nottingham alabaster *Coronation of the Virgin* (*c.*1400), and Nost the Elder's lifesize bronze equestrian *George I*.
Mus. & AG Nationally important British coll. incl. Dahl, Lely, Chantrey, 18–19c. watercolourists (J. Leslie Wright beq.), Cox, Alma-Tadema, A. Moore, Leader *February Fill Dyke*, Epstein (9 bronzes) and much more, crowned by famous Pre-Raphaelite coll., which incl. Brown *The Last of England*, Holman Hunt *The Finding of the Saviour in the Temple*, *May Morning* and *Two Gentlemen of Verona*, Millais *The Blind Girl*, Rossettis, and Sandys *Medea* and *Morgan-le-Fay*. Very important drawings coll., particularly for Pre-Raphaelites. Also strong local interest in Birmingham Group (Southall, the Gaskins and Geres, Payne), etc.
BLACKBURN Mus. & AG Mostly 19c., the coll. is strongest in landscapes with most watercolourists represented: Callow, Cox, De Wint, Fielding, Foster, W. H. Hunt, Prout, Turner and J. Varley. Also a range of portraits from Kneller, Reynolds and Lawrence to McEvoy and Orpen; Victorian and Edwardian subject pictures incl. Faed, Leighton and O'Neil. W. Roberts and Rothenstein in early 20c.
BLACKPOOL Grundy AG Generally conventional pictures by lesser-known 19–20c. artists with emphasis on marines, later Victorian rural subjects (e.g. Herkomer), some English Impressionists and Glasgow School (Forbes, Hornel), and 5 Grimshaw views of Liverpool.
BOLTON Mus. & AG 3 paintings for Boydell by Northcote, Opie and Romney; oils incl. Lely, Van Dyck and Wright of Derby, plus Mercier, West and Colman. Otherwise some minor Victorian subject pictures and marines, and local portraits.
BOURNEMOUTH Russell Cotes AG & Mus. Archetypal coll. of academic 19–20c. painting and sculpture centred on large group of Edwin Longs. Many exotic or dramatic subjects (Landseer), Biblical, nudes (Etty), animals and children (Mann). Henry Irving theatrical relics and associated portraits (Ricketts).
BRADFORD Cartwright Hall AG & Mus. Interesting 18–20c. coll. begins with some 18c. portraits, especially Reynolds *Thomas Lister* ('The Brown Boy') and J. Ward's oil study for

Gordale Scar. 19c. highlights: Clausen, Forbes, La Thangue; Victorian classicists; early 20c. (McEvoy); and artists with Bradford associations. Increasing contemporary coll., especially prints, associated with the Bradford Print Biennale.
BRIGHTON Brighton Mus. & AG Much of this interesting coll. has Brighton and Regency associations. Paintings incl. Wheatley *Encampment at Brighton*, B. Wilson's portrait of *Dr Richard Russell*, and others by Lawrence, Monamy, Opie, Morland, Romney and Zoffany. Blake's tempera *Adoration of the Kings* leads on to small group of Shoreham painters incl. Palmer *Dell of Comus* and 4 Linnell oils. Victorians, many from the Simpkins Bequest (1916), incl. Alma-Tadema *The Proposal* and *The Secret* and Faed. 18–19c. watercolours and drawings incl. travellers (Pars, Lear, Prout), Brighton views incl. Constable, Daniell, and 33 Royal Pavilion views by A. C. Pugin.
Preston Manor Eworth *Count de Horn* and Beale *Lady as St Agnes* are notable amongst several other early portraits attr. Hudson and Lely. Also late 18–19c. landscapes incl. Cox, Linnell, A. Nasmyth and Prout; plus Etty and Orpen portraits.
BRISTOL City Mus. & AG Hogarth *St Mary Redcliffe* altarpiece heads the earlier coll. which incl. Gainsborough portraits of *A Lady* and *A Gentleman of the Leyborne Popham Family*, Lawrence *Lady Caroline Lamb*, J. Ward and Wilson. Bristol School represented by a dozen oils by Danby, also Muller and Pyne. The good watercolours and drawings coll. also incl. much 19c. and local work. Victorian and Edwardian coll. is based on Wills tobacco family patronage: incl. an Alma-Tadema (*Unconscious Rivals*), Herkomer, Millais, O'Neil, Poole's remarkable *Visitation and Surrender of Syon Nunnery, 1539*, and D. Roberts. Good Newlyn pictures, early 20c., and growing contemporary coll., some with SW connections.
BURNLEY Towneley Hall AG & Mus. Zoffany's famous *Charles Towneley's Library* introduces 2 other pictures on the subject of connoisseurs by Cosway and Alma-Tadema, plus others with Towneley associations (incl. Turner) in a mainly 19c. coll. of pictures. Also one of only 2 pre-Reformation sets of English High Mass vestments (minus dalmatic, in Burrell Coll., Glasgow).
BURY AG A 19c. coll. founded on the bequest of Thomas Wrigley, dominated by Turner *Calais Sands* and Landseer *The Random Shot*, amongst paintings and drawings by Callcott, Clausen, W. Collins, Constable, Cox (40 works), Crome, W. H. Hunt, Linnell, Maclise, Stanfield, Turner (4 watercolours) and E. M. Ward. Also a few sculptures (Foley and Epstein).

BUXTON Buxton Mus. & AG Small coll. of 19c. landscapes, watercolours incl. Cox, and a Lowry.
CAMBRIDGE Fitzwilliam Mus. Nationally important British coll. of widest range begins with portraits by Eworth and Gheeraerts, then Van Dyck (especially drawings), Lely, and J. Richardson *Self-portrait*. 18c. incl. Hogarth portraits, *Musical Party* and *Before* and *After*, Gainsborough *Heneage Lloyd and his Sister*, Wright of Derby, Reynolds, Lawrence and Raeburn. Romneys incl. not only portraits but many designs for history paintings. Stubbs *Una and the Lion* (on Wedgwood plaque) and *Gimcrack*. Landscapes incl. distinguished groups of Turner watercolours (Ruskin gift 1861), Constable, and watercolourists especially De Wint and Linnell. Outstanding Blake coll. incl. portraits of him and MSS; also Flaxman sketchbooks and MSS. In 19c., Pre-Raphaelites and Victorians, NEAC, Sickert and Steer. 20c.: Camden Town, A. John, Ricketts and Shannon, Bloomsbury, Spencer, Sutherland and contemporaries. Portrait miniatures incl. Hilliards of *Elizabeth I* and *A Poet*, Oliver (also drawings), Hoskins, Cooper and Cosway. Manuscripts coll. rich with Peterborough Psalter, De Brailes leaves, Bird Psalter and Grey-Fitzpayn Hours. Also historical MSS, incl. Lawrence letters, Reynolds's ledgers and Romney's sitter-books. Sculpture coll. incl. Bushnell (attr.) terracotta bust of *Charles II*. Major print coll. ranges from Holbein, Van Dyck and Hollar through the 18c. mezzotinters McArdell, Green and J. R. Smith, and the Boddington coll. of colour prints (mostly 18c. genre), to Whistler and 20c.
Kettle's Yard The late Jim Ede's personal coll. of his friends and contemporaries' art in unique domestic setting. British coll. (*c.*1910–70) dominated by Nicholson, Wallis and Wood; smaller groups of work by Gaudier-Brzeska, D. Jones, Hepworth, Winifred Nicholson and others.
CANTERBURY Royal Mus. & AG Canterbury's artist, T. S. 'Cow' Cooper (1803–1902), is being actively collected, to join portraits and landscapes (especially with Kentish connections) from B. Marshall *Thomas Hilton, Esq., with his Hound 'Old Glory'*, J. Ward *Reculver*, and Stannard, to Laura Knight.
CARLISLE Mus. & AG The 1949 bequest of 600 Victorian and early 20c. works by the poet Gordon Bottomley gave Carlisle great distinction in Pre-Raphaelites and associates. The circle of George Howard (of Castle Howard, nearby) and Leighton lead on to the Victorian fin-de-siècle: Conder, Ricketts (31) and Shannon (8 oils and drawings, 61 prints). Early 20c. focuses on P. Nash (24), Camden Town, Rothenstein (9), Spencer, W. Roberts

and W. Lewis. Earlier works incl. Sandby and Palmer (3 drawings and 23 etchings); also local topography. Some sculpture.

CHELTENHAM Cheltenham AG & Mus. Some 18c. portraits (Cotes, Wheatley), local topography and portraits incl. Boys, Anthony Devis (12 works) and Farington. Coll. otherwise predominantly later 19–20c., incl. Herring (4 oils) and local connections, e.g. the Victorian animal painter Briton Riviere (1840–1920) and family (28 works) and the early 20c. Cotswold Group of C. M. and Margaret Gere and others.

CHESTER Grosvenor Mus. Local topographical coll. dominated by Moses Griffiths and Louise Rayner (1829–1924), plus Boys, Prout, and Barret. Some Civil War subjects; drawings incl. Crane.

COLCHESTER Minories AG Small group of Constable works and relics incl. his earliest dated drawing (1795). Versions of Dahl and Wright of Derby portraits, a few watercolours, several charming animals by the primitive John Vine of Colchester (c.1809–67), and an interest in early 20c. (Bevan, Fry).

COMPTON Watts Gall. Completed shortly before Watts's death, houses the artist's own coll. of his work. Nearby is Mary Watts's remarkable mortuary chapel for her husband.

CONISTON Ruskin Mus. The 800 Ruskin drawings and associated material assembled by J. H. Whitehouse previously shared between Bembridge School (I. of Wight) and Brantwood are to be concentrated here in planned major Ruskin study centre.

COOKHAM Stanley Spencer Gall. Coll. of paintings, drawings and MSS by Spencer, plus loans, in former chapel attended by the artist as a child.

COVENTRY Herbert AG & Mus. Opened 1960, coll. has grown rapidly and features many Lady Godiva subjects in various media by, amongst others, Landseer and Conder. Much local topography incl. 18c. engravings, Hollar, Callow, Cox, Fielding and Piper, plus 3 Turner watercolours and J. Varley. Main local artist is David Gee (1793–1872). Interesting 19–20c. figure drawings beginning with a Fuseli and incl. P. Blake, R. Hamilton, Hockney, A. John, W. Lewis, Orpen, Poynter, Rothenstein, Stott, Tonks and Wood. Also growing coll. of modern British painters (Nicholson, M. Smith, Bomberg, Lowry) and sculptors (Hepworth, F. Dobson).

DARLINGTON Darlington AG A generally local 19–early 20c. coll. with 19c. landscapists incl. Ibbetson and P. Nasmyth. Local school headed by John Dobbin (1815–88), painter of large watercolour *Opening of the Stockton and Darlington Railway, 1825.* A few 20c. incl. Gore, Sutherland and an Epstein drawing.

DERBY Derby AG Largest single coll. of Wright of Derby, with many major works, incl. *A Philosopher giving a Lecture on the Orrery* and *The Alchemist in Search of the Philosopher's Stone discovers Phosphorus;* Sterne subjects; Italian landscapes; portraits; and contemporary subjects, incl. *The Earthstopper.* The rest of the coll. largely 18–20c., begins with Kneller, Barret, Farington, J. Ward and West; continues in 19c. with Cox, Frith, Herkomer, Leslie, Richmond, Whistler and the local Gresley family. 20c. incl. E. Agar, Grant, A. John, Lowry, Nicholson and Pasmore.

DONCASTER Doncaster Mus. & AG Small coll. mostly 19-early 20c. but with earlier highlights. Tillemans *Thames at Twickenham;* portraits by Hoppner, Marshall and Lavery; landscapes by Cox, Prout, Pyne; caricatures by Rowlandson; a small shoal of Herrings; and, in early 20c., Hillier and Rothenstein.

DOVER Dover Mus. A few works incl. a Maclise *Paganini* and a portrait in the style of Kneller.

DUDLEY Dudley Mus. & AG Notable group of 37 Cox watercolours and drawings but coll. mainly later 19–20c. Victorian sentiment plus realism; some English Impressionists; early 20c. (Fry, Lessore); much local topography and artists (Thomas Phillips, Short); growing coll. of modern prints (Caulfield, Tilson).

EASTBOURNE Towner AG Mainly 19–20c. coll. with much local topography and marines by Devis, Callow, Prout and Martin, and drawings by locals James Owen (1847–1928) and Louisa Paris (1850s). Good earlier 20c. with Burra and Wood; active contemporary coll. incl. Davie, Heron, Lanyon, Tom Phillips, Richards, Vaughan, Weight and Wynter. Some portraits: Kneller, Mortimer (incl. *Self-portrait*). Towner's founding coll. of 22 minor Victorian academics incl. Herring and Muller. Some sculpture and prints.

EGHAM Royal Holloway College Picture Gall. Fascinating microcosm of conventional late Victorian taste: coll. bought by Thomas Holloway 1881–3 for instruction and moral improvement of students in his new university college for women. Frith *Railway Station,* Fildes *Casual Ward* and Long *Babylonian Marriage Market* star amid nearly 80 pictures, incl. landscapes by Gainsborough, Turner, D. Roberts and Stanfield; genre incl. Morland, W. Collins, Holl; history by Maclise, Millais and Pettie.

EXETER Royal Albert Memorial Mus. & AG Strongly Devonian coll. with large holdings of J. W. Abbott (31), Prout and Towne (13). Further Devon works and portraits by James and William Gandy (early 17c.), Gainsborough portrait of William Jackson playing the harp, 4 Hudson

portraits (incl. *Anne, Countess of Dumfries,* in his own opinion his best picture), Cosway, Haydon (5 oils incl. *Curtius leaping into the Gulf,* and a sketchbook), Hayman (14), and Northcote (9). Other landscapes incl. Prout, Wilson and Wright of Derby. Modern work, some with SW connections, by Frost, Heron and M. Martin. Some sculpture.

FALMOUTH AG Small coll. interesting for its English Impressionists and late Victorian academics like Burne-Jones, Fisher, Melville, Munnings, Tuke and Watts, mostly from the De Pass coll. presented in the 1930s. Other main interest is marines, incl. Hollar *The Mary Rose* and paintings and engravings by W. Daniell.

FOLKESTONE Folkestone Public Lib., Mus. & AG Nearly 200 notable late 18–early 19c. drawings and watercolours. Especially interesting are 22 figure and landscape studies by W. Collins, and Flaxman drawings for illustrations to Homer and Bunyan. Also Thornhill, Brooking, Kauffmann, Bonington, Callow, Cruikshank, Muller, Prout, Stanfield, Wilkie and others. A few minor oils incl. W. Marlow.

GATESHEAD Shipley AG Mostly 19c. but some earlier highlights, especially Roubiliac's bust of *Alexander Pope,* and marines by Scott, Monamy and Serres. Most important Victorian picture is Redgrave *The Poor Teacher* (1845 original of better-known V&A version) plus Eastlake *Ruth and Boaz,* 3 Grimshaws and a Millais. Rest of coll. mostly minor landscapes and marines incl. 7 Carmichaels.

GLOUCESTER City Mus. & AG Interesting pictures by some major artists of local subjects. Begins with a dozen 16c. portraits of Gloucester notables; other portraits incl. Lawrence. Much landscape and topography: Johannes Vorstermans (1643–99) *City of Gloucester,* 8 Wilson oils, Cristall, Farington, Fielding, Gainsborough, Grimshaw, Steer, and local artists. The Cotswold Group (*see* Cheltenham) introduce small 20c. coll. (Burra, Lessore and Rothenstein) and some sculpture (Chadwick).

GOMERSAL *see* **HUDDERSFIELD**

GREAT YARMOUTH Great Yarmouth Museums Some Norwich School works headed by Vincent *The Dutch Fair on Yarmouth Sands,* plus J. J. Cotman and J. B. Crome drawings, Bright, and Stannard family. Many coastal topographical, marine and E. Anglian wildlife paintings, drawings and prints, mostly 19–20c., incl. W. H. Hunt and local artists. Also fine group of 'Pierhead paintings' – E. Anglian ship portraits.

GRIMSBY Wellholme Galls. Some 18–19c. marines by Carmichael, Huggins and Webster, and paintings by or attr. W. Daniell, S. Scott and Wilson.

HARROGATE AG Frith *Many Happy Returns of the Day* and a version of *A Dream of the Past*, Grimshaw *A Yorkshire Home* and Fgg portrait of *Frith* are notable Victorians in a small 18–19c. coll. which incl. the Barkers of Bath, Fielding, Herring and Prout.
HARTLEPOOL Gray AG & Mus. Mostly 19c. coll. with interesting group of 21 paintings and drawings by Pre-Raphaelite follower F. J. Shields (1833–1911). Also Maclise and Forbes; watercolours by Cox; and in 20c. Auerbach, Freud, Lowry and Spencer.
HEREFORD Hereford City Mus. & AG Some 100 works by Cristall and group by John Scarlett Davis (1804–44), both from Hereford; also incl. 2 Knellers, Pettie and Steer.
HOVE Hove Mus. of Art Incl. some 17–19c. portraits: Huysmans *Charles II*, Cotes and Beechley; also landscapes and subject pictures by Gainsborough, J. Varley, Bonington, Fielding and Forbes. Now concentrating on modern coll.
HUDDERSFIELD, BATLEY and GOMERSAL (Kirklees Metropolitan Council) Small colls. of the 3 galls. mostly 19c.: Callcott, Clausen (*The High Royd* murals), Conder, 4 Grimshaws incl. *Liverpool Docks* and *Silver Moonlight*, Martin *Joshua commanding the Sun to stand still*, Nicol, Tuke, and Watts *Time, Death and Judgment*. 20c. incl. Bevan, Fry, Sickert, Steer.
HULL Ferens AG Richest in portraits and marines. Portraits begin with an Elizabethan lady by Segar, Gheeraerts, Dobson *Musician*, fine portrait by local artist J. Riley of a Whitby merchant, Hogarth, a less usual outdoor Devis (*The Strickland Family in the Grounds of Boynton Hall*), H. Walton, Cotes, Hoppner; with strong 20c. portraits incl. McEvoy and Wolmark. Landscapes by Wilson, Ibbetson, Constable (cloud study), Bonington, Callcott, Pyne, Stanfield and Bright. Genre and Victorian subjects by Hull artists T. B. Hall and Thomas Brooks (known for his scenes of wrecks and rescues), Lady Butler, Leighton, Paton, Pettie; late NEAC and Newlyn pictures, Brangwyn's large *Santa Maria della Salute* (with many prints and drawings), Conder, Steer and Sickert lead into 20c. and Camden Town incl. M. Drummond. Most British 20c. groups represented: Bloomsbury, Vorticists, Surrealists, Unit One, St Ives; also Hockney. Good range of sculpture from 1930s onwards (Moore, Hepworth, Armitage, Paolozzi, Fullard). Marine coll. begins with Isaac Sailmaker *Royal Yacht off Sheerness* (c.1680) and Van de Velde, followed by Brooking; the 18–early 19c. Hull School (Fletcher, Meggitt, Thew) culminates in Hull's greatest marine painter, John Ward (1798–1849); plus Grimshaws (of the docks) and Wadsworth.
HUNTINGDON Cromwell Mus.

Portraits of Cromwell and associated figures by or attr. Dahl, Dobson, Riley, Walker, Beale, Cooper and Lely. Also J. Ward *Battle of Marston Moor* and Wilton bust of *Cromwell*.
IPSWICH Mus. Dominated by Gainsborough and Constable, coll. is essentially Suffolk-orientated. Some 14 Gainsboroughs, especially early Suffolk period incl. *William Wollaston*; the fine Constables incl. *Golding Constable's Flower Garden* and *Kitchen Garden*. Rest of coll. begins with 2 15c. *Entombments* on panel, 16–17c. local portraits, Cleveley *View of Ipswich*, and portraits by J. Riley and Beale. Some Norwich School, especially Vincent *The Travelling Tinker*, Bright and Stark; Legros portrait of Suffolk-born sculptor *Woolner*, and 23 Steer incl. *Knucklebones, Walberswick*. Some 20c. prints and paintings incl. Hilton.
KENDAL Abbot Hall AG Opened 1962, coll. concentrates on Lake District people and places, headed by Romney *Leveson-Gower Children* and 5 other works, the newly researched 17c. portraitist John Bracken, 40 Ruskin watercolours and drawings, and many sketchbooks and portfolios of John Harden of Brathay Hall (1772–1847) and his family. Other local topography by Beaumont, Constable, Cristall, Devis, Ibbetson, Lear, Christopher Machell (1747–1827) and J. Varley. Rest of watercolour coll. contains Blake, Cotman, Rowlandson, C. Varley and Turner's 1804 *Passage of Mount St Gothard*. Active 20c. coll. incl. Frost, Heron, Hilton, M. Hughes, Nicholson, early Pasmore (*The Maid*), Redpath, Kurt Schwitters (post-war Ambleside resident), Vaughan; plus sculpture incl. Hepworth and M. Martin.
KETTERING Alfred East AG 2 late Victorians dominate: 89 works by landscapist Sir Alfred East (1849–1913) and 35 by Newlyn-turned-Symbolist T. C. Gotch (1854–1931). Otherwise some early 20c. (Bawden, Bevan, Hillier, Spencer), modern prints (Paolozzi) and paintings (P. de Francia, Hoyland), and local coll., especially young artists.
LANCASTER City Mus. Hayter *Joseph interpreting the Dream of the Chief Baker*, watercolour *Shipwreck* attr. Blake, and Fielding and Foster stand out from mostly local, mostly topographical coll. A few 20c. incl. Hitchens.
LEAMINGTON SPA AG & Mus. This mainly 19–20c. coll. begins with a Wilson, and incl. De Wint, Egg, Nicol, and large coll. Thomas Baker of Leamington and other local artists. 19c. ends with Clausen, Steer, Stott and Tuke. In the 20c. V. Bell, Bevan, Fry, Grant, Hitchens, P. Nash, Nevinson, Spencer and Sutherland.
LEEDS City AG (incl. **Lotherton Hall** and **Temple Newsam**) One of the major colls. of British art outside London, wide in scope but particularly strong in 20c., watercolours and

drawings, Victorians and sculpture. Home ground for Moore (a dozen works), in honour of whom the new Henry Moore Sculpture Study Centre has been established. Sculpture 18–19c. incl. marbles by Joseph Gott (1786–1860), R. J. Wyatt (1786–1850), Banks, Weekes, Joseph, Leighton, and recently donated group of H. Thornycroft models; 20c. incl. massive Epstein limestone *Maternity* (1910). Earliest paintings are Gheeraerts and Mercier; later in 18c. Reynolds, Gainsborough, Wheatley *Irish House of Commons*, and gems by less-known artists like H. R. Morland (*The Fair Nun Unmasked*). Lupton coll. (bequeathed 1952) is foundation of Printroom, which ranges 17–20c. with many fine 18–19c. watercolours and large group of Phil May drawings. Victorians incl. Hunt *Shadow of Death*, Tissot, Leighton, Grimshaw, Holl and many more. Good 20c. coll. incl. most well known names, especially M. Smith *Lilies*, W. Lewis *Praxitella*, and Spencer. Active contemporary coll. incl. Long.
LEICESTER Mus & AG A good coll. with special interest, appropriate to a hunting shire, in sporting paintings, especially Ferneley (b. in Leicestershire). Also portraits of county notables from 15c., incl. Hogarth *Wollaston Family* (on loan) and the splendid B. Marshall *Daniel Lambert* (the fattest man then recorded). Victorian coll. based on genre by Faed, Nicol and others, with highlights in Dyce *Meeting of Jacob and Rachel*, reduced version of Frith *Railway Station*, and Leighton's last painting, *Perseus*. Good early 20c.: Grant, Gertler, Ginner, W. Roberts, Sickert and M. Smith; plus active contemporary coll. incl. Heath and Hilton. Range of sculpture from Victorians to Gaudier-Brzeska, Moore and new work; representative watercolours and drawings.
LINCOLN Usher AG Predominantly 19c. coll. with good holdings of artists with Lincolnshire origins, especially large coll. of De Wint, plus William Hilton (1786–1839), William Logsdail (1859–1944), Bramley and Shannon (many lithographs). 4 Gibson marbles head a small sculpture coll. which incl. 2 Nollekens (*Venus chiding Cupid* and *Mercury*) and 'the Lincolnshire Grinling Gibbons', Thomas Wilkinson Wallis (1821–1903). Fine coll. of miniatures incl. Cosway, Lens and Zincke.
LIVERPOOL Sudley AG & Mus. Coll. of 19c. Liverpool merchant George Holt (bequeathed 1944) begins with group of 18c. female portraits incl. fine Gainsborough *Viscountess Folkestone*, 4 Turner oils incl. *Rosenau* and *The Wreck Buoy*, and Bonington *Fishing Boats in a Calm*. Majority Victorian incl. classicists Alma-Tadema and Leighton; landscapists

Cox, Linnell, Millais, P. Nasmyth, Pyne; subject pictures by Wilkie, Landseer, Mulready, Frith, G. B. O'Neil, Hook and Fildes. Holman Hunt *Finding of the Saviour in the Temple* (small version) heads the half-dozen Pre-Raphaelites incl. Rossetti, Millais and Burne-Jones; also Dyce *Garden of Gethsemane*.

Liverpool's notable sculpture coll. is housed here: Neoclassical pieces, group of Gibsons incl. the celebrated *Tinted Venus*, many Victorians, and New Sculpture incl. Gilbert *Mors Janua Vitae* and Frampton.

Walker AG One of the most important colls. of British art in the country with examples from most periods and fine earlier paintings like the *Pelican Portrait* of Elizabeth I by Hilliard, and Hogarth *David Garrick as Richard III*. Remarkable coll. of artists born in or associated with Liverpool and its area, most notably Stubbs, who is represented by a fine group of paintings incl. *Molly Longlegs, Horse frightened by a Lion, The Lincolnshire Ox*, and charming study of *A Monkey*. Good coll. of Landseer's rival, Liverpool-born Richard Ansdell (1815–85), incl. the large *Hunted Slaves* plus Ansdell oil studies recently acquired from Countess of Sefton's estate along with Ibbetson, Marshall, and other additions to Liverpool's coll. of hunting and sporting paintings. 18c. portraits by Cotes, Devis, Gainsborough, Highmore, Humphry (pastel *Stubbs*), Lawrence, Ramsay, Romney and Zoffany. Fine landscapes and subject pictures: Wilson *Snowdon*; Fuselis incl. the large *Oedipus and his Daughters* and 2 Milton subjects: 3 Wright of Derby incl. *Firework Display at the Castel Sant'Angelo*; and West *Death of Nelson*. Important coll. of Pre-Raphaelites and followers incl. Millais *Isabella*, Holman Hunt *Triumph of the Innocents*, Brett *The Stonebreaker*, plus F. M. Brown, Windus, Hughes, Rossetti and Burne-Jones. One of the largest colls. of Victorian academics outside the Tate incl. popular favourites like Poynter *Faithful unto Death*, Holiday *Dante and Beatrice*, Pettie *The Temple Gardens*, Herkomer *Eventide*, and Yeames *'And when did you last see your father?'*. Fine watercolours and drawings, especially Romney *Cupid and Psyche* series and other literary drawings, Turner, J. Gibson *Fall of the Rebel Angels* and Andrew Hunt (1790–1861). 20c. coll. has good Camden Town (Sickert, Ginner) and main modern artists (P. Nash, Pasmore, Hockney) regularly updated by gifts from the biennial John Moores Liverpool Exh.

LONDON BL Outstanding coll. of illuminated MSS of all periods. Anglo-Saxon incl. Lindisfarne Gospels, Vespasian Psalter, Benedictional of St Ethelwold, Aelfric's paraphrase of the Pentateuch. Romanesque incl. the Psalter of Henry of Blois and Shaftes-

bury Psalter. 13c. incl. Westminster and Evesham Psalters, De Brailes Hours, a Bestiary, MSS by Matthew Paris and an Apocalypse. 14c. incl. E. Anglian Gorleston, St Omer and Luttrell Psalters, De Lisle and Queen Mary Psalters. International Gothic: Sherborne Missal (on loan) and Bedford Psalter and Hours.

BM Unparalleled colls. of medieval art and prints and drawings. Amongst medieval: Anglo-Saxon Sutton Hoo treasure, Franks Casket and ivories incl. the Alcester tau-cross. Romanesque and Gothic enamels, jewellery, notably the Dunstable Swan brooch, Gothic ivories, liturgical and secular vessels like the 15c. Lacock Cup, and fragmentary wall-paintings from St Stephen's Chapel, Westminster.

Drawings and watercolours coll. begins with Holbein portraits incl. *Anne Boleyn*, John White's watercolours of America, and Hilliards. 17c. incl. Inigo Jones architectural subjects, Hollar, Barlow illustrations (especially for *Aesop*), Place, Van de Velde the Elder, 16 Lely Garter Procession figures, Kneller, Dahl, and some pastel portraitists and plumbago miniaturists. In 18c., Thornhill book of decoration schemes, many Hogarths incl. those for *Industry and Idleness*, large groups of Reynolds and Gainsborough heading the portraitists; Fuseli's 1770s Roman sketchbook, Flaxman, and Blake (incl. complete series for Young's *Night Thoughts*). Caricature represented by immense coll. of Rowlandsons, Gillrays, Cruikshanks, etc. Great English watercolourists – Taverner, Skelton, Pars, Towne, 'Warwick' Smith, J. R. Cozens and Girtin, and many finished Turner watercolours (others transferred to Tate). Constable coll. second only to the V&A. Norwich School headed by many Cotmans; Cox, Palmer (incl. an 1824–5 sketchbook); many Victorians incl. Pre-Raphaelites, academicians, illustrators. Modern coll. being developed on foundation of Camden Town (especially Sickert), Euston Road, sculptors' drawings incl. Moore, plus C. Richards sketchbooks and Hockney drawings.

Print coll. similarly comprehensive with Hollar, 18c. mezzotint portrait engravers, through Bewick and 1860s wood-engraving to the Etching Revival and on to present day. Also many other groups of prints, especially London topography, satire and history.

Small sculpture coll. incl. Rysbrack and fine Roubiliacs.

Thomas Coram Foundation for Children In addition to artists and works mentioned in the 'Foundling Hospital' entry (pp. 89–90), coll. incl. Hogarth *March to Finchley*, Northcote, West, 8 roundels of London hospitals by Gainsborough, Wilson *et al.*, marine battles by Brooking and Copley, portraits by Cotes, Hudson, Millais,

Nebot, Opie, Phillips, Ramsay, Reynolds and B. Wilson. 20 sculptures incl. Roubiliac, Rysbrack and Baily.
Courtauld Institute Gall. British works from 5 main benefactors. Viscount Lee coll. incl. a 14c. E. Anglian *Crucifixion* on panel, 16–18c. portraits incl. Eworth *Sir John Luttrell*, Lely *An Idyll* (Lely and his family), Beechey full-length *Queen Charlotte*, and others by Dobson, Gainsborough, Ramsay, Romney and Raeburn. Among some 1,500 drawings beq. Sir Robert Witt and the Spooners are Oliver, Barlow, 2 Lely heralds from Garter Procession, and Laroon, followed by drawings by most great English artists with particularly fine groups of Richardson portraits, Gainsborough landscapes, many Romneys incl. 3 sketchbooks, Fuseli, 10 Flaxmans, over 40 Constables, representations of Victorian academics, caricature and illustration. Samuel Courtauld coll. incl. drawings by Sickert and some sculptors (F. Dobson, Epstein, Gill). Roger Fry beq. incl. his own work, other Bloomsburys and contemporaries.
Dulwich Picture Gall. First purpose-built gall. in Britain, designed by Soane and opened 1814 to house the Desenfans-Bourgeois coll.; also earliest main coll. presented to Dulwich College 1686 by the actor William Cartwright. Among paintings, Van Dyck's poignant *Venetia Stanley, Lady Digby, on her Deathbed*; Gainsboroughs incl. early conversation piece and Linley family portraits; Hogarth *Fair Angler*; fine pair of Hudson portraits; versions of Reynolds's late *Self-portrait*, *Infant Samuel* and *Mrs Siddons as the Tragic Muse*; charming Knapton *Lucy Ebberton*; Greenhills incl. *Self-portrait* and *William Cartwright*; and Northcote *Desenfans* and *Bourgeois*. Other portraits by C. Johnson, Dahl, Lely, Kneller, Jervas, Riley, Beale, Beechey, Romney, Lawrence, West. A few landscapes incl. Canaletto's cristalline *Old Walton Bridge*, Wilson *Tivoli*, and Loutherbourg.
Fulham Public Lib. 54 19/early 20c. works beq. 1954 by Cecil French, whose taste was for English Symbolists and Classicists. 25 Burne-Jones watercolours and drawings, 2 oils and 4 drawings by Leighton, 2 Alma-Tadema oils, A. Moore *Apricots*, 4 Watts, plus Clausen, Legros, Shannon and Stott.
Geffrye Mus. Some early portraits incl. Beale *Self-portrait*, Devis and Batoni *John Monck*. Subject pictures by Wheatley, Leslie, and Hicks incl. *The General Post Office*, on loan with Redgrave *Going to Service*. Other artists incl. A. E. Chalon, Holl and a few 20c.
Guildhall AG Homeless since WW II but selections exh. in the Barbican. Many portraits of significance to the City of London incl. the first City commissions, portraits by J. M. Wright

of the 22 Fire Judges (assessors of damages claims after the Great Fire of 1666). Royalty by Kneller, Jervas, Ramsay; other portraits incl. Lely, Reynolds, Beechey, Hoppner, Lawrence, Opie and Romney. Several fine panoramas of London, especially Marlow (incl. *Blackfriar's Bridge and St Paul's*), Nebot *Covent Garden*, S. Scott, W. Daniell, 69 drawings by E. W. Cooke of the reconstruction of London Bridge, D. Roberts, and Stanfield. 127 19c. paintings presented by Charles Gassiot 1902 incl. Constable's full-size sketch for *Salisbury Cathedral from the Meadows*; genre by W. Collins, Faed, Landseer and Webster; landscapes by Linnell and Muller; Pre-Raphaelites and associated artists incl. Millais *My First* and *My Second Sermon*, 2 Dyces incl. *George Herbert at Bemerton*; and 2 fine Tissots, *Too Early* and *The Last Evening*. Other well known Victorians incl. Poynter *Israel in Egypt*, A. Moore, several Alma-Tademas, and Leighton. 20c. tends to be academic, but incl. more than 1,000 paintings, drawings and sketchbooks by M. Smith. Many London topographical prints and drawings in the associated **Guildhall Lib.**

Imperial War Mus. From WW I many large set-pieces like Clausen *In the Gun Factory at Woolwich Arsenal 1918*, Sargent *Gassed*, A. John *Fraternity*, W. Lewis *A Battery Shelled* and Spencer *Travoys arriving with Wounded*. Large colls. of Lavery (59 oils) and Orpen (138 paintings and drawings) and smaller groups by other War Artists like J. and P. Nash, Nevinson, W. Roberts, Rothenstein, Steer and Tonks; also Bomberg and Epstein. WW II dominated by Moore drawings (3 from Shelter Sketchbooks and 7 mining scenes). Some WW I artists reemployed, e.g. Spencer 12-panel *Shipbuilding on the Clyde*; plus Bawden (162 watercolours), Gross (383 drawings), Lamb, Monnington, Sutherland and Weight.

Kenwood Coll. of 1st Earl of Iveagh beq. 1927 to the then London County Council incl. celebrated 18c. pictures. Gainsboroughs incl. *Mary, Countess Howe*, large landscape *Going to Market*, and the 'fancy picture' *Two Shepherd Boys with Dogs Fighting*; 15 Reynolds incl. *Mrs Tollemache as 'Miranda'* and several child subjects; Romneys incl. a *Lady Hamilton*; other portraits by Raeburn, Lawrence and Hoppner. Also Van Dyck incl. *James Stuart, Duke of Richmond and Lennox*. Landscapes incl. Wilson *London from Highgate*, the Cromes' *Yarmouth Water Frolic*, Turner, Morland, and Landseer, and Ibbetson decorative landscapes intended for the Music Room of the house. Kauffmann and Zucchi decorative paintings form part of the house itself.

Leighton House Mus. of the artist's

life and work in his own house; contains paintings, colour studies and oil sketches for larger works, and many drawings. Also important Leightons and complementary High Victorians on long loan from Tate.

Marble Hill House 2 Thornhill classical subjects, Hogarth portrait, Vanderbank portrait and illustrations to *Don Quixote*, Gravelot *Le Lecteur*, and Mercier *The Letter-Writer*.

William Morris Gall. Morris and Co. designs and Brangwyn gift of his own works and coll. incl. F. M. Brown, Holman Hunt, Hughes, Muller, Alma-Tadema, Crane, Clausen, Lavery, Melville and Sickert.

Mus. of London Pictures of London people and topography by British and some Continental artists. Amongst earliest works are 2 15/16c. wallpaintings from London houses. Fine London townscapes by S. Scott of *Covent Garden Market and Piazza* and 2 by his pupil Marlow of *N. End of London Bridge* and *The Adelphi*. Victorian favourites feature London life, like Ritchie *A Summer Day in Hyde Park*, and G. W. Joy *The Bayswater Omnibus*. Portraits and theatrical paintings incl. Peake *Prince Henry* and Hayman *Garrick and Hannah Pritchard in 'The Suspicious Husband'*.

Nat. Army Mus. Major tableaux of battles incl. Wootton *George II at the Battle of Dettingen*; more pacific moments represented by E. Penny *Marquess of Granby aiding a Sick Soldier*. Many portraits, incl. Reynolds, Raeburn and Beechey. Also drawings and prints.

NG Masterpieces of British art. After the *Wilton Diptych*, Holbein *The Ambassadors* and Van Dyck *Equestrian Portrait of Charles I* demonstrate the skills of immigrant masters. Hogarth is first of the natives with his *Marriage-a-la-Mode* series and *The Shrimp Girl*. Gainsborough incl. 2 contrasting portraits of couples, the early *Mr and Mrs Andrews* and late *Morning Walk*, with 2 portraits of his daughters, *Mrs Siddons*, and 2 of his most famous landscapes. Similarly early and late male portraits by Reynolds and the fine *Lady Cockburn and her Sons*. Turner's will requested that his *Sun rising through Vapour* and *Dido building Carthage* should hang, as they now do, between Claude's *Seaport* and *Mill*; other famous Turners incl. *The Fighting Temeraire* and *Rain, Steam and Speed*, epitomizing the differences between Turner and Constable shown by the equally famous *The Cornfield*, *The Haywain*, *Cenotaph to Reynolds*, *Salisbury Cathedral* oil sketch and *Weymouth Bay*. A few other portraits by Stubbs, Lawrence, Linnell. Sculpture by Chantrey and Gibson, mostly of donors and administrators of the NG.

Nat. Maritime Mus., Greenwich Incl. fine marines by Van de Velde, S. Scott, Serres, Monamy, Brooking,

Cleveley, Callcott, Stanfield and Carmichael. Amongst works by artists not normally associated with marine painting like Stothard and Westall is Zoffany's *Death of Captain Cook*, his only heroic composition. Many portraits of nautical heroes incl. those by C. Johnson, Lely, Kneller, Dahl, Devis, Hudson, Hogarth, Highmore, Ramsay, Zoffany, Reynolds, Copley, Romney, Northcote, Beechey and Orpen.

NPG Many painted portraits from 15c. on, with many royal portraits by unknown artists in first 2 centuries, then Holbein life-size cartoon of *Henry VIII*, Sittow, Scrots, Lockey, Flicke, Eworth, Hilliards. Fine group of Hilliards of *Raleigh*, *Drake*, *Dudley* and *Elizabeth I* and many other Elizabethan portraits crowned by the famous Gheeraerts *Ditchley Portrait* of Elizabeth I. 17c. rich in Mytens, Peake, Oliver, Rubens, Walker (incl. *Cromwell*), Cooper, Lely and Kneller. 18c. shows some informality creeping into portraiture, e.g. in Devis *1st Marquess of Downshire and his Family*, and revealing self-portraits by amongst others Gainsborough, Hayman, Hogarth, Ramsay and Stubbs. Early 19c. dominated by Lawrence and Landseer with fine portraits by Phillips and G. Richmond's visionary *Samuel Palmer*. Victorians incl. splendid Leighton *Richard Burton* and Tissot *Capt. Frederick Burnaby*. End 19/20c. incl. Sargent *Ellen Terry as Lady Macbeth*, and other theatrical portraits, Lavery and Fildes of royalty, A. and G. John self-portraits, and Sickert *Beaverbrook* and *Churchill*.

Ranger's House, Blackheath 17–18c. portraits incl. great series of full-length portraits of 7 ladies commissioned c.1614 on the marriage of Elizabeth Cecil and Thomas Howard, 1st Earl of Berkshire, and 2 portraits of the Sackville brothers, 3rd and 4th Earls of Dorset. Also a charming *Boy aged 5* attr. Peake, Lely *Mary of Modena*, and others by C. Johnson and Hudson.

RA Holdings consist of the Diploma coll. (a representative work presented by each artist on becoming RA), with a bias towards classical subject-matter perhaps because it was thought suitably august for such a final repository, and works given by artists, their heirs and patrons. Interesting portraits: Reynolds *Hayman* and *Giuseppe Marchi*, Wilson *Self-portrait* and *J. H. Mortimer*, and, amongst Victorians, Pettie *Faed*. Early RAs incl. important Flaxmans – marble relief *Apollo and Marpessa* and c.100 drawings for illustrations to Aeschylus and Homer. Sculpture also incl. important group of 16 Gibsons, plus Theed Jun. bust of *Gibson*, Chantrey, Foley, Frampton, Leighton, Westmacott and Woolner. 18–19c. bridged by West with *Christ blessing Little Children* and drawings, Turner's early *Dolbadarn Castle*; important group of Constable landscape and sky studies (presented by

his daughter 1888), the great *Leaping Horse* and *Boat passing a Lock*. Many 19–20c. Diploma works incl. Redgrave *The Outcast*, Millais, Orpen, Lavery and Ricketts. Very important coll. artists' MSS, letters and sketchbooks.

Sir John Soane's Mus. Most important works are Hogarth *Rake's Progress* and *Election* series, and 55 plaster reliefs, models and casts by Flaxman. Portraits include *Soane* by Lawrence and Jackson. Other paintings incl. Turner *Admiral Van Tromp's Barge*, Reynolds *Love and Beauty*, Callcott, W. Daniell, Eastlake, Hilton and J. Ward. Among watercolours and drawings 28 Cozens, Westall, Barret, Cosway, Fuseli, Barry, Mortimer (also prints), Stothard and Turner. Also 2 Reynolds Roman sketchbooks. Drawings by Nollekens, Rysbrack and Scheemakers inform the sculpture coll. which incl., with the Flaxmans, terracottas by Quellin, Rysbrack and Banks, and other works, especially models, by Chantrey and Gibson.

Tate The national coll. of historic and modern British art aiming for as complete a representation as possible of easel painting, watercolours, drawings, sculpture and modern prints, with many masterpieces and large groups of individual artists' work on the way. Highlights incl. Lely *Two Ladies of the Lake Family*; in 18c. Cotes *Paul Sandby*, Wright of Derby *Experiment with the Air Pump*, Barry *Lear weeping over the Body of Cordelia*, 35 Reynolds incl. *Three Ladies adorning a Term of Hymen*, many Gainsboroughs incl. 11 original copper plates, and Stubbs *Haymakers* and *Reapers*. Loutherbourg's sea battles, J. Ward *Gordale Scar* and the important Blake coll. move into 19c., where the 275 Turner oils beq. to the nation by the artist dominate space and period. They are to be rehoused, with the thousands of watercolours formerly in the BM, in the new Clore Gallery. Constable incl. lovely portrait of *Maria Bicknell* and many famous landscapes. J. Martin great *Last Judgment* trio. The 1847 Vernon beq. laid foundation of Victorian coll. with Landseer, Leslie, Mulready and E. M. Ward; many famous pictures incl. Frith *Derby Day*, major Pre-Raphaelites like Holman Hunt *Awakening Conscience*, Millais *Ophelia* and later popular favourite *The Boyhood of Raleigh*, Rossetti, Brown, Martineau, Burne-Jones; many later Victorian favourites added with Sir Henry Tate beq. and Chantrey purchases incl. Bramley *Hopeless Dawn*, Fildes *The Doctor*; and 19c. avant-garde like Whistler *Little White Girl*, Conder, Sickert and Steer. Every 20c. group represented and many major works from Bomberg *Mud Bath* to Hockney. Post-war artists incl. Caulfield, B. and H. Cohen, Heath, Heron, Hodgkin, Art and Language, Cragg, Craig-Martin, Flanagan and Willats.

V&A The enormous extent of the British coll., from Anglo-Saxon to modern and incl. all media, defies summary. Among medieval art, illuminated MSS, stained glass (incl. some from Winchester College chapel), rubbings of brasses, sculpture incl. alabasters and notable ivories (Anglo-Saxon liturgical comb and *Adoration of the Magi*, 14c. Salting Diptych), remarkable metalwork (see the entries on enamel, pp. 80–81, and goldsmiths' work, pp. 103–5), *opus anglicanum* (the Syon Cope), and alabasters. The sculpture coll. is essentially the national coll. and aims to represent all major periods up to early 20c.; medieval sculpture is followed by Torrigiano terracotta bust of *Henry VII*; some 17c. ivories; and examples of all the best 18c. and 19c. artists incl. Rysbrack, Roubiliac, Wilton, Flaxman (with loans from University College), A. Stevens, etc. Also fine coll. of sculptors' drawings.

Miniatures incl. Holbein, Hilliard, Oliver (*Self-portrait*, etc.) and Cooper. Very large holdings of prints and drawings with special interest in sketchbooks, incl. 25 of Farington's and 45 of Steer's, many Sketching Society drawings, largest coll. Mulready and Maclise drawings anywhere, Beardsley, some 20c. Paintings coll. initiated 1857 by Sheepshanks gift of 233 early Victorian paintings, mostly literary and genre, by W. Collins, Landseer, Leslie, Maclise, Mulready, Redgrave, Webster and Wilkie. Isabel Constable's 1888 gift of 98 paintings (mostly oil sketches), 300 drawings and watercolours, and 3 sketchbooks by her father crowned coll. of British painting which ceased active purchasing in 1900 when national coll. transferred to Tate. Earlier paintings incl. fine landscapes by S. Scott, Wilson and Loutherbourg, Gainsborough's famous peepshow of 12 oils on glass, J. Ward *Bulls Fighting*, 2 notable Cromes and 8 rare De Wint oils. Portraits range from Kneller *Self-portrait* to many Victorians, especially of literary figures.

Wallace Coll. Earliest British work is 15c. alabaster; then Rysbrack and Roubiliac marble busts of royal subjects. 18c. portraits headed by 12 Reynolds incl. the famous *Nelly O'Brien*, *The Strawberry Girl*, and 1 of the 3 portraits of *Mrs Mary Robinson* 'Perdita' in the coll.; others by Gainsborough and Romney. 2 further Gainsboroughs, and other portraits by Ramsay, Lawrence and Hoppner. Bonington represented by 36 works. Watercolours by Callow, Fielding, Harding, and 4 Turners. Other paintings by Hilton, Morland, D. Roberts, Stanfield, Van de Velde, Westall and Wilkie.

Wellington Mus., Apsley House Wilkie *Chelsea Pensioners reading the Waterloo Despatch* and portraits of

George IV and *William IV*, 4 fine Lawrences, charming little Leslie *Wellington looking at a Bust of Napoleon*, and other portraits by Beechey, Copley, 5 Dawes, Hayter and Hoppner. Also W. Allan, Landseer, and E. M. Ward *Napoleon in the Prison of Nice*.

MAIDSTONE Mus. Vol.II of the Lambeth Bible; 16c. portrait of *William Wickham, Bishop of Lincoln*; marines incl. a Brooking and attr. Monamy; animals incl. a Ferneley stable and Morland pigs. Major group of drawings by James Jefferys. 19c. incl. Hazlitt *Self-portrait*, and interesting Victorian oil and watercolour landscapes and rural subject pictures with A. and H. Goodwin views of Kent and Italy, Pinwell *Hop-Pickers*, Brett *Oaks in May*, Haslemere, and W. B. Scott *Water-meadow*.

MANCHESTER City AG Major coll. 18–20c. with some earlier like Gower, J. M. Wright, and large Lely *Sir John Cotton and his Family*. Strong 18c., especially portraits by Wright of Derby, Reynolds, and others incl. Dandridge, Devis, Hudson, Kauffmann and Romney. Splendid Stubbs *Cheetah and Stag with two Indian Attendants*, early Wheatley *Twelfth Night* scene, Barry's huge *Birth of Pandora*, and important Blake series of 18 library portraits. Landscape strong in watercolours and drawings, incl. Turner *Now for the Painter*, Constable, De Wint, Cox (incl. *Rhyl Sands*) and many others 18–19c. Fine Pre-Raphaelites headed by 40 F. M. Brown (incl. *Work*), 12 Millais (incl. *Autumn Leaves*), 10 Holman Hunt (incl. *The Hireling Shepherd*), 11 Rossetti, Hughes (incl. *Ophelia*), plus Brett, 11 Burne-Jones, W. Collins, Collinson, Martineau, Sandys and Windus. Other Victorian works, many celebrated in their day, incl. Eastlake, Lady Butler and Herkomer, and High Victorians Leighton (incl. the huge *Captive Andromache*) and A. Moore. 20c. coll. covers most movements and artists, from Orpen *Homage to Manet*, through Nicholson *Au chat botté* and Riley to current developments. Important sculpture begins with 2 15c. alabasters and incl. Roubiliac, Woolner, Watts, Gilbert, Gill, Epstein and Moore.

John Rylands Lib. Missal of Henry of Chichester.

Whitworth AG Founded 1889 and now the University AG, coll. is exceptional for its watercolours, drawings, prints, 20c. paintings and sculpture, and textiles incl. 15c. English ecclesiastical vestments. Watercolours and drawings begin with Thornhill, Gainsborough, Rowlandson, Blake, several Cozens of Lakes Nemi and Albano, Girtin, many Turners, plus others incl. Alken, Hearne, Pars, Rooker, Skelton, Taverner and Towne. Later in 19c. Palmer, Lear, Pre-Raphaelites especially F. M. Brown, Holman Hunt, Rossetti, Mil-

lais, Ruskin, much Burne-Jones. Some oils incl. Wootton *Classical Landscape* and J. F. Lewis *Indoor Gossip, Cairo*. Late 19–20c. good on NEAC and Slade, especially Sickert drawings, Steer watercolours, A. John drawings; Vorticists, early 20c. landscapes (P. and J. Nash, Innes, Spencer); War Artists; works 1950 onwards incl. Auerbach, V. Bell, Butler, Chadwick, B. Cohen, Hill, Hoyland, Paolozzi, Riley and Wynter. Prints strong in Hogarth, mezzotint portraits especially late 17–early 18c. line-engraved portraits by Faithorne and Vertue, topography, 18–19c. satirical prints, lithographs by Whistler and Shannon, etchings and drypoints from Whistler onwards, modern woodcuts and wood-engravings.

MIDDLESBOROUGH Middlesborough AG Small but growing coll., opened 1958, of 20c. art with V. Bell and Grant designs for decorations, Bomberg, Minton, Nash, Wallis, Wood, then Auerbach and Herman; some abstract painting incl. Hitchens. Sculpture good, especially Gaudier-Brzeska *Wrestlers* relief (and a drawing, *Two Warriors*) and Epstein bronze *Maugham*. Drawings incl. A. John, W. Lewis *War News*; also prints.

NEWCASTLE Laing AG Fine coll., especially important for 20 works by Northumbrian John Martin, but with great scope 18–20c. Good portraits: Hudson, Batoni, 3 of the Monck family by Wright of Derby, Ramsay *James Adam*, Reynolds and Lawrence. Landscapes by Wilson, Lambert, Barret, Callcott, a Constable *Salisbury Cathedral*, Grimshaw, and great range of watercolours. History and classics incl. Maclise, Poynter, Alma-Tadema; Landseer incl. *The Otter Hunt*; later Pre-Raphaelites incl. the major Burne-Jones *Laus Veneris*. 20c. begins with good Clausen and Stott, Camden Town, Wood and Spencer; post-war art predominantly abstract (incl. Hodgkin lithographs and Hoyland), some Pop, and active current collecting. Flourishing NE School initiated by T. M. Richardson Sen. and incl. Henry Perlee ('Smuggler') Parker, Carmichael, W. B. Scott, C. Napier Hemy, H. H. Emmerson, Hedley and Jobling. Sculpture incl. Westmacott, Watts maquette for *Physical Energy*, Frampton, Epstein and Moore.

NORWICH Norwich Castle Mus. & AG Superb coll. of Norwich School paintings, watercolours and drawings with fine representations of all Norwich artists: J. and J. B. Crome, Bright, J. J. and M. E. Cotman, Dixon, the Ladbrokes, Lound, Middleton, the Stannards, Stark, Thirtle and Vincent; and perhaps most notably oils, watercolours and drawings by J. S. Cotman. Coll. also incl. earlier artists, especially with E. Anglican connections like Gainsborough, Opie (incl. *Self-portrait*) and West; watercolourists De Wint,

Sandby; some High Victorians like Burne-Jones, group of Sandys (incl. *Self-portrait*), Watts; Victorian water colours incl. Ruskin; group of Munnings.

Sainsbury Centre, University of E. Anglia A few medieval pieces, incl. mid 12c. stone head of Christ. Small but fine 20c. coll.: important Moore sculptures incl. *1929 Half-figure No.2* and drawings; a dozen Bacons; Gertler figure drawing; and sculpture by McWilliam, Chadwick and Davies.

NOTTINGHAM Nottingham Castle Mus. & AG Nottingham was Bonington's birthplace and has an important group of his work incl. oils, his supposed *Self-portrait* and his last painting, with drawings and studies. Good landscapes throughout this 17–20c. coll.: Wheatley *The Harvest Waggon*, fine Wilson *Snowdon from Llyn Nantle*, one of Cotman's first RA exh. watercolours, Sandby and Ibbetson rainbows, through many Victorians to good 20c. incl. W. Nicholson, Newton *Regent's Canal*, Spencer *Cookham Dene*, and Hillier. Also Morland *The Artist in his Studio*, some important Victorian academics, and a Dyce *Virgin and Child*. Drawings coll. incl. 2 important Fuselis, *Brunhilde watches Gunther, whom she has bound to the Ceiling* and *Women with Baskets*, Flaxman *Revenge of Orestes*, Westall, Victorian and Edwardian illustrators, Shannon, Clausen, Philpot, A. John and W. Roberts.

OLDHAM AG & Mus. Good coll. of relatively minor Victorian and Edwardian RAs, with emphasis on coastal and sea drama scenes; also oils and drawings by William Stott of Oldham. Watercolour coll. incl. the usual names with Danby *Scene from 'A Midsummer Night's Dream'*, Palmer *Herdsman* and Rossetti *The First Madness of Ophelia*. Late 19–20c. incl. NEAC, and Sickert *Barnet Fair*.

OXFORD Ashmolean Mus. Major coll. notable especially for Palmer, Pre-Raphaelites, Pissarro, and fine coll. of drawings. Portraits: 4 Gainsborough, Reynolds *James Paine the Architect and his Son*, Batoni *David Garrick*, Ramsay *Flora Macdonald*, and Gheeraerts, Johnson, Lely, J. Riley, Zoffany, Raeburn, Jackson *Beechey*, Romney, de Wilde, Dandridge, Hayter, Herkomer, A. John, and W. Roberts *T. E. Lawrence*. Landscapes incl. N. Bacon, fine Wilsons and Turner of Oxford. Other paintings incl. Hogarth, Etty, J. Martin and Watts; all the Shoreham artists, especially a large group of Palmers incl. a *Self-portrait*; Pre-Raphaelites with 7 Holman Hunt, 3 Millais (incl. *Return of the Dove*), large Rossetti drawings, 5 Hughes (incl. *Home from the Sea*), plus C. A. Collins, Deverell, Inchbold and Martineau. Late 19–20c. incl. many Pissarros, Camden Town incl. Sickert *Ennui*, and Spencer. Printroom exceptional with wide range incl. Gains-

borough, Barry, Fuseli, Cotman, Pre-Raphaelites, illustrators and landscapists. Medieval coll. incl. Anglo-Saxon jewellery, especially the 'Alfred Jewel'. Sculpture incl. fine Baroque bust of *Wren* by Edward Pearce, and Roubiliac.

Bodleian Lib. Outstanding coll. of medieval MSS, incl. Anglo-Saxon illustrated Caedmon, a famous late 12c. Bestiary, the Douce Apocalypse, Ormesby Psalter and a Bohun Psalter. Also a few later portraits, incl. a Gheeraerts.

PLYMOUTH City Mus. & AG Devon and Cornwall govern this coll. which incl. portraits by Hudson, Hayman, Reynolds, Opie, Northcote, Haydon and miniaturists. Local topography incl. Prout, Rowlandson, Towne and Turner, with other landscapes by S. Scott, Pocock, Barret and W. Daniell, and Northcote's 1778 Italian sketchbook. Victorians incl. some Pre-Raphaelites, landscapes and Newlyn. Good range early 20c. and modern especially St Ives painters. Superb Rysbrack model and drawings from coll. of his friend Charles Rogers.

PORT SUNLIGHT Lady Lever AG Lord Leverhulme formed this coll. in early 20c. 2 especially fine Reynolds full-length portraits of ladies and other portraits by Gainsborough, Hoppner, Raeburn, Romney, and later Fildes, A. John and Sargent. A version of Wilson *Diana and Callisto*; group of Turners and Constables, and many important Victorians incl. Millais *Sir Isumbras*, Rossetti, Burne-Jones *Beguiling of Merlin*, Leighton's huge *Daphnephoria* and lush *Garden of the Hesperides*, large F. Walker *The Bathers*, and favourites by Alma-Tadema and Orchardson. Some important late 18c. and 19c. sculpture incl. Flaxman *Cephalus and Aurora*; also fine miniatures.

PRESTON Harris AG Formed round 1883 beq. of Richard Newsham, local collector of mostly academic contemporary painting and sculpture many of whose artists he knew. Among rural subjects Clausen, A. Hughes, Linnell and Webster; sporting series by Alken; landscape, marine and topographical pictures by Callow, Cox (a large group), De Wint, Fielding, Foster, W. H. Hunt, Holman Hunt, Leighton, Pissarro, Prout, Pyne, D. Roberts, J. Varley (incl. many drawings), Seddon, Stanfield and Turner; genre and subject pictures incl. 3 of the best-known in the gall. – Alma-Tadema *Pastime in Ancient Egypt*, J. F. Lewis *In the Bey's Garden* and E. M. Ward *Royal Family of France in the Prison of the Temple* – plus many others (incl. W. Collins, Danby, Egg, Etty, Fildes, Frith, Grimshaw, Landseer, Leslie, Maclise, Melville, Muller (also landscapes) and Watts). Particularly good 20c. RA portraits, also Brangwyn, F. Dobson, Fry, Ginner, Gore, A. John, P. and J. Nash, Newton, Piper,

Sickert, M. Smith, Spencer, Stokes and Sutherland. Victorian sculpture incl. Gilbert, Leighton, Thornycroft and Watts.

Some earlier artists: Barlow, Farington, Highmore, Hudson *William Kent and his Wife*, Ibbetson, Romney *John Flaxman*, West, Wilson, and many by the local Devis family. Watercolours and drawings by or attr. many major 18/19c. artists.

READING Mus. & AG Earliest part of British coll. is 12c. sculpture from Reading Abbey. Picture coll. based on 19c. oils and watercolours beq. by the biscuit manufacturer W. I. Palmer. Havell family of Reading well represented; watercolours and drawings incl. Sandby, Rooker, Duncan; comprehensive coll. Baxter prints; much local topography. New policy from 1960s of collecting paintings between the wars has brought good works by Bevan, Ginner, Gore, Grant, J. Nash, Piper, Sickert and Spencer.

RUGBY Lib., Mus & AG Early 20c. paintings and drawings by Grant, Lessore, Lewis, Nevinson, Sickert and Wood; mid 20c. Bawden, Freud, Hepworth, Hodgkins, Lowry, Minton, P. Nash, Richards, Spencer and Sutherland. Recent work incl. H. Cohen, Davies, Hilton, Hoyland and Wynter.

SCUNTHORPE Borough Mus. & AG Small coll. mostly 19c. pictures by or attr. Bonington, Constable, Girtin, Herring, Rowlandson and Westall. Victorian landscapes and marines incl. Cooke and Stanfield; portraits incl. Herkomer and Horsley; some prints.

SHEFFIELD City AGs (Graves and Mappin) Major coll. especially strong in 19-20c. but with important earlier paintings incl. Barry *Jupiter and Juno*, Turner's large early Claudean *Festival upon the Opening of the Vintage at Macon*; portraits by Gainsborough, Highmore and Lawrence; and landscapes and subject pictures by Bonington, W. Collins, Constable, Etty, Morland, Wilson and Wright of Derby. The large Victorian and 19c. coll. founded on beq. of Mappin, whose taste ran to RA subject painting and landscapes incl. Poole *Solomon Eagle* and many Petties; also Collinson, Cope, Frith, Linnell, Muller, Phillip, D. Roberts, Stanfield and E. M. Ward. Later 19c. coll. incl. splendid Sargent *The three Vickers Sisters*, Conder, Sickert, Stott, Whistler; 20c. incl. Camden Town, WW I artists, portraits by Fry, A. John and W. Roberts, lovely G. John *A Corner of the Artist's Room*, Surrealists and landscapes (especially by P. Nash), Euston Road, and most recent groups with emphasis on Sheffield-born artists like Burgin, Derrick Greaves, Hoyland, Jack Smith and sculpture especially Fullard.

SHREWSBURY Mus. (Clive House) Gems of the coll. are William

Williams (fl. 1758–97) *A Morning* and *An Afternoon View of Coalbrookdale*. Otherwise some portraits by Zoffany (attr.), Linnell, Richmond; and good local topography by Boys, Cox, De Wint, Farington, Hearne, Pyne, fine Sandby incl. *The Old West Bridge*, Sayer, 'Warwick' Smith, Turner *The English Bridge*, and J. Varley.

SOUTHAMPTON Southampton AG Some 18c. portraits headed by Gainsborough *Lord Vernon*; good range of landscapes, especially Wilson, Loutherbourg *Shipwreck*, Vincent *The Yare at Norwich*, with Wheatley, Sandby, Towne, Ibbetson, Turner, De Wint and Cox. Visionary subjects by Blake and Martin. Views of Southampton area from Dayes, early Linnell and Constable to Nevinson; and artists associated with the area incl. Frederick Lee Bridell (1830–63), Herkomer and Hicks. Some good Pre-Raphaelites incl. Brown, Holman Hunt, and Burne-Jones *Perseus* series, and other Victorians incl. Tissot and 390 Keene drawings. 20c. especially good with Camden Town and London Group; interesting female portraits by Gaudier-Brzeska, A. and G. John, Lamb, M. Smith, Spencer, and Sickert self-portrait *The Juvenile Lead*. A dozen Sutherlands, and excellent contemporary collection incl. Green, Fullard, Fulton, Finlay, Hill, A. Jones and Walker.

SOUTHEND-ON-SEA Beecroft AG Small coll. of surprising quality begins with a 16c. portrait *Marchioness of Dorset*, C. Johnson portrait of a lady, Kneller and Lely School. Landscapes incl. Lambert, Loutherbourg, Morland, Barker, Constable and Cox. Early 20c. incl. Hillier, Newton, Orpen; post-war paintings mostly academic incl. J. Nash and Weight. Also watercolours and drawings incl. Devis, Rowlandson, Callow, Cox, Fielding, Foster, Lear, Loutherbourg, Rossetti *Head of Fanny Cornforth*, Turner. The Thorpe Smith coll. of local history and topography incl. W. Daniell watercolour *Southend*, Bright oil *Hadleigh Castle*, and prints.

SOUTHPORT Atkinson AG An archetypal provincial Victorian coll. with good landscapes incl. an unusual Hicks, Muller, D. Roberts, E. M. Ward and Webster; subject paintings incl. W. Collins and T. Faed; Cranbrook Colony; and in complete contrast Sickert *Sinn Feiners*. Also some portraits, mostly later 19–20c. academics but incl. Lely *Duchess of Portsmouth*, Highmore, then Watts, La Thangue portrait of his wife, McEvoy, and A. John *The Red Toque*.

SOUTH SHIELDS Mus. & AG Small marine and local coll. incl. Cleveley and Carmichael, plus a Frith.

STALYBRIDGE Astley Cheetham AG Mostly 19–20c. with a lone Gheeraerts portrait of a lady. Some interesting 19c. landscapes with Bon-

ington, W. Collins, Cox, 3 Danbys, Linnell. High Victorians represented by Burne-Jones *St Nicholas* and a drawing, and Watts *Sir Percival*. 20c.: Gertler, Grant, W. Lewis drawing.

STOKE-ON-TRENT City Mus. & AG Paintings mostly 19–20c., best on NEAC and early 20c., especially Sickert, W. Roberts, Grant, Lamb, Lessore, McEvoy, Nevinson, Orpen. Watercolours and drawings coll. incl. Barret, Beaumont, Cotman, Danby, A. John, Landseer, Lear, Romney (drawing for *The Leveson-Gower Children*), Rossetti, Turner and C. Varley. Good prints from Hollar to Legros and Whistler.

STRATFORD-UPON-AVON Royal Shakespeare Theatre Picture Gall. Paintings and sculpture of Shakespearian subjects from Van Somer/Gheeraerts *Earl of Southampton* to F. M. Brown drawings for his *Shakespeare* painting. Many scenes from the plays, most 18–19c., incl. some painted for Boydell's Shakespeare Gall., and other large paintings incl. Loutherbourg, Fuseli, Northcote, Stothard and Wheatley. Miniatures incl. A. E. Chalon. Sculpture by Foley, Frampton and Woolner.

SUNDERLAND Mus. & AG 19c. NE artists Carmichael, Hemy, A. J. Moore; other marine paintings by Brett, Stanfield; Victorians incl. T. Faed, Landseer, Legros, J. F. Lewis, Rossetti; local topographical drawings incl. 11 T. M. Richardson. Some 20c. watercolours and drawings incl. Grant and late Hornel, and good 20c. prints.

SWINDON Mus. & AG Active 20c. coll. beginning with Clausen, Orpen and Rothenstein, ranging through Camden Town, Vorticists, Bloomsbury, Bomberg, Gertler, A. and G. John, Moore, Nashes, Wood, and good selection of post-war names like Freud, Hodgkin, Long, McLean, Tom Phillips, R. Smith and Turnbull.

THETFORD Guildhall 90 portraits of Norfolk and Suffolk notables beq. by the Indian Prince Frederick Victor Duleep Singh, incl. Clint *Cotman*, H. B. Love *J. B. Crome*, Robert Cardinall (Kneller pupil) *Gainsborough's Uncle*, 16c. *Elizabeth I*, Ladbroke *Opie*, and early Gainsborough *Mrs Oliver of Sudbury*.

TRURO County Mus. & AG Interesting and little-explored coll. 18–19c. paintings and drawings incl. Hogarth *The Wedding Banquet*, Opie, Constable, and Victorian drawings.

TUNBRIDGE WELLS Municipal Mus. & AG 31 Victorian genre and landscape oils from the 1952 Ashton beq. incl. T. S. Cooper (*see* Canterbury), Linnell, J. Phillip and Stanfield.

WAKEFIELD Wakefield AG Known for its 20c. British coll. but also has earlier works. Portraits incl. attr. Soest *Sir Robert Walpole*, Kneller (attr.), Mercier and Romney; landscapes incl. Gainsborough, D. Roberts

and local topography, e.g. John Buckler (1793–1894) and Christopher Machell (fl. 1786–1816). Also Rowlandson and oil studies attr. West. Some Victorians incl. Grimshaw, Tissot. Modern coll. has Camden Town; 1930s abstractionists; landscapes by Bawden, Minton, P. Nash, Piper, Sutherland, Weight; and more recent painting and sculpture incl. Heron. Good print coll.

WALSALL Mus. & AG Garman-Ryan coll. given by Epstein's widow has wide range of British art incl. early Reynolds portrait, Blake *The Humility of the Saviour*, Cristall watercolour, Etty nude, W. M. Thackeray pencil *Self-portrait*, with some landscapes, Pre-Raphaelites, and Victorian illustrators. 20c. dominated by the 42 Epstein sculptures and drawings, plus Bevan, Freud (Epstein's son-in-law), Gaudier-Brzeska, A. John, McEvoy, Munnings, Sickert and M. Smith.

WOLVERHAMPTON Central AG 18–20c. coll. headed by important late Wilson *Niagara Falls*, Gainsborough full-length *Sir Edward Turner*, Fuseli *Apotheosis of Penelope Boothby*, and Wright of Derby *Dr Erasmus Darwin*, with other works by J. M. Wright (attr.), Zoffany, Kauffmann, Morland, Wheatley and Raeburn, and Wolverhampton genre painter Edward Bird (1772–1819). Interesting earlier Victorians, especially with royal connections, incl. W. Collins, Landseer, Leslie, Linnell, Maclise; Bristol School and Cranbrook Colony (O'Neil); and other Victorians especially T. Faed, Poole and Elizabeth Forbes. Watercolours and drawings coll. incl. W. H. Hunt. 20c. incl. W. Roberts, Caulfield and Tom Phillips.

WORCESTER City Mus. & AG Largely 19c. and local coll. incl. Victorian watercolourists, Cattermole, group of Cox, De Wint, Muller, Prout; and paintings incl. Worcester landscapist Benjamin Williams Leader (1831–1923).

WORTHING Worthing Mu. & AG A little-known coll. with a good Holman Hunt, *Bianca*, and other 19c. paintings incl. Cox, Forbes, Marshall and 40 J. Ward. Some 18–19c. drawings incl. Rowlandson, Sandby and Wheatley, and group of drawings for *Punch*. 20c. paintings mostly pre-war, incl. Gilman, Ginner, and Spencer. Many Sussex artists 19–20c. incl. landscapists G. and Vicat Cole, Bertram Nicholls and Claude Muncaster.

YORK York City AG Coll. starts with early 16c. *Leake Panels* through Dahl and Lely to Laroon and much good landscape incl. Louterbourg, Marlow, Wilson; also a Fuseli fragment of a large Boydell *Prospero* subject. 19c. coll. dominated by York-born Etty, plus Martin and many Victorians, especially from the 1882 Burton beq., incl. E. M. Ward *Hogarth's Studio in 1739* and good group

of York-born brothers Albert and Henry Moore. Whistlerian and NEAC artists Conder, Greaves, Steer, Tonks; Camden Town, especially Sickert; Spencer and other mid 20c. figurative artists. Large York topographical coll. of drawings and prints.

FRANCE

BAYONNE Mus. Bonnat Based on the coll. of the Salon painter Léon Bonnat. Some English 18–19c. portraits and landscapes incl. Lawrence *Fuseli* and (attr.) the composer *Weber*, plus Reynolds sketch for *Colonel Tarleton*, Hoppner and Lawrence; also a Constable *Hampstead Heath*. Drawings by Dobson, Lawrence and Bonington.

BESANÇON Mus. des Beaux-Arts A few 16–19c. British pictures incl. Eworth *English Gentleman*, Mercier (previosly attr. Hogarth) *Watchmaker's Shop*, 2 important Lawrence portraits (*Duc de Richelieu* and *Duchess of Sussex*), and 2 Constables (the early *Landscape with a Black Cloud* and a later *Mill*).

BORDEAUX Mus. des Beaux-Arts Incl. pair of large Zoffany 1760 Rococo *Venus* subjects and pair of Louterbourg landscapes.

CHANTILLY Mus. Condé Hilliard *Sir Walter Raleigh*, Reynolds *Countess Waldegrave and her Child*.

PARIS Mus. Cognacq-Jay The dozen British works are of fine quality and incl. Cotes *Charles Colmore*, unfinished Lawrence portrait head, Reynolds *2nd Earl of Northington*, Romney (attr.), 2 Gardners, and Morland watercolour *First Steps*.

Louvre The best Continental coll. of British art other than Leningrad, almost entirely 18–19c. with especially good groups of Lawrence and Bonington. Portraits incl. Gainsborough conversation piece of himself and his wife and 2 other portraits of ladies, Reynolds *Master Hare*, Mortimer *Portrait of a Woman holding a Work by Mortimer*, Lawrence *J. J. Angerstein and his Wife* and other portraits, with Beechey, Cosway, Cotes, Hoppner, Lely, Mercier, Opie, Raeburn *Hannah More* and *Captain Hay of Spot*, Ramsay *Queen Charlotte*, Romney *Ralph Willet*. Landscapes begin with Wright of Derby *Lake Nemi*, several Boningtons; Turner *Pont-Neuf, Thames Estuary*, and a reworking of a *Liber Studiorum* landscape admired by Edmond de Goncourt and Pissarro; Constable *Weymouth Bay*, oil sketch for *Helmingham Dell* and views of Hampstead, the Stour and Salisbury. Bonington's *Francis I* and *Anne of Austria* and Etty introduce the Victorians who incl. Alma-Tadema, F. M. Brown *Don Juan*, Burne-Jones *Princess Sabra* and a *Wheel of Fortune*, Crane *Portrait of the Artist's Wife*, Millais, Tissot, and Watts *Love and Life*. Whistler's famous *Portrait of the Artist's Mother* leads on to Lavery, McEvoy, Rothenstein, Shan-

non, Sickert, Steer, Tonks and Fry (*A Room of the 2nd Post-Impressionist Exhibition, 1912*). Much of the 19c. coll. is being transferred to the new Mus. d'Orsay. The Cabinet des Dessins British coll. has Constable drawings incl. an early sketchbook.

There are also a few British pictures in the following collections:
DIJON Mus. des Beaux-Arts (4 Tissot oils, incl. the large *Japonaise au Bain*); **LE MANS Mus. de Tesse** (Constable's 1821 *Malvern Hall*); **MONTPELLIER Mus. Fabre** (Reynolds version of *The Infant Samuel*); **NANTES Mus. des Beaux-Arts** (interesting Tissot 4-part series, *The Prodigal Son in Modern Life*, painted in England); **STRASBOURG Mus. des Beaux-Arts** (several Loutherbourgs in his birthplace, incl. *Llanberis Lake* and classical and religious subjects); **VERSAILLES Château** (2 Lawrence portraits, incl. unfinished *Baron François Gérard*).

GERMAN DEMOCRATIC REPUBLIC

BERLIN Gemäldegal. der Staatlichen Mus. Fine full-length Gainsborough *John Wilkinson*. **DRESDEN Gemäldegal.** Holbein double portrait painted in England.

GERMAN FEDERAL REPUBLIC

There is some British art in most German museums of any size. The more important holdings are:
AACHEN Neue Gal. Modern coll. incl. P. Blake *ABC-Minors*, R. Hamilton *I'm dreaming of a White Christmas* and a version of *My Marilyn*. Also Constable *After the Thunderstorm*.
BERLIN Staatliche Museen Preussischer Kulturbesitz: Gemäldegal. & Kupferstichkabinett (Dahlem) Reynolds *George Clive and his Family* and drawings. Gainsborough *Mrs Robert Hingeston* and 4 drawings, incl. study for *Hon. Richard Savage Nassau*, plus Wilson, Wright of Derby, and Lawrence *The Angerstein Children*.
– **Neue Nationalgal.** Constables incl. the early *Stour Valley from Higham* and one of 3 known versions of *The Admiral's House, Hampstead*. 20c. coll. incl. H. Moore, Butler, and Bacon *Isabel Rawsthorne* and *Three Studies in a Street in Soho*.
– **Schloss Charlottenburg** Kneller *Queen Mary*.
BONN Rheinisches Landesmus. The only notable group of Clarkson Stanfields outside Britain, incl. the large *Rhine at Cologne* and *Burg Eltz*.
COLOGNE Wallraf-Richartz-Mus. One of the largest colls. of contemporary British art on the Continent, with 5 Hamiltons incl. *My Marilyn* and *Swingeing London 67 II*. Also a Bacon (2nd version of *Painting*

1946), P. Blake *Bo Diddley*, and 2 Allen Jones, *Fig-falling* and *Perfect Match*.
DARMSTADT Hessisches Landesmus. 17–20c. British art, from Van Dyck *4th Duke of Pembroke*, Reynolds *The Architects Paine, Father and Son*, and Loutherbourg *Rendezvous*, to Brangwyn *Ship in Harbour*, Leighton *Unexpected Arrival*, and R. Hamilton *Aah!*
FRANKFURT-AM-MAIN Goethe-Mus. Largest group of Fuselis outside Switzerland and Britain: *Mad Kate* (for Cowper's *The Task*), *Woman at the Window* and *Moonlight*, *The Nightmare*, *Lear and Cordelia*, *Britomart releases Amoret*.
Städelsches Kunstinst. A Holbein, Lely *Lady Penelope Naunton*, Hopper *Girl with a Rabbit*, Lawrence *1st Marquess of Abercorn*, a Morland of *Cottagers* and a Romney male portrait. 2 interesting Leightons: oval 1852 *Self-portrait* painted while studying at the Städelsches Kunstinst., and a portrait of Frankfurt sculptor *J.G.F. Schierholz* (1856). Also Bacon oil study.
HAMBURG Kunsthalle Two separate gifts – that of G. C. Schwabe, a Hamburg businessman resident in London, who presented 148 Victorian pictures in 1886, and Baron von Schröder's coll. acquired in 1910 – combine to make this the largest coll. of British 19c. painting outside the English-speaking world. Highlights are 4 Alma-Tademas; 2 important Dyces, *Joash shooting the Arrow of Deliverance* and the RA 1853 version of *Jacob and Rachel*, plus a small landscape; 6 Herberts; Millais *Minuet*; Rossetti *Helen of Troy* and a study for *Dante's Dream*. Other Victorians incl. Callcott, Fildes, Landseer, Leighton, Leslie, Redgrave, Stanfield and E. M. Ward. Works of other periods incl. Fuseli *Creation of Eve* (from his Milton Gall.) and a drawing, *Perseus and the Graeae*; Bonington; Bacon and Moore.
HANOVER Niedersächsiches Landesmus. Kneller *George II as Prince of Wales*, Lawrence *Charles Manners-Sutton*, Hoppner *Pitt the Younger*, a Wilson landscape; in 20c. Bacon and Moore.
HEIDELBERG Kurpfälzisches Mus. Some late 18–early 19c. English paintings incl. Fuseli *Euphrosyne* (from his Milton Gall.), a Hoppner child portrait, and Lawrence *Metternich*.
MUNICH Neue Pinakothek Second largest British coll. in Germany, concentrates on 18–early 19c. with a fine Stubbs *Hound* and landscapes by Wilson (*View over the Thames from Kew Gardens*), Turner (*Ostend*) and Constable (*Stoke-by-Nayland* and 2 others); also 2 Louterbourgs, Morland of fishermen, Wilkie, and Ibbetson (*George Biggins' Ascent in Lunardi's Balloon*). Portraits by Gainsborough of *Uvedale Price*, *James 8th Earl of Abercorn* and *Mrs Thomas Hibbert*, Romney *Catherine Clements*, Raeburn *Mrs Campbell of Kilkenny*, and 3 Lawrences.

Also Fuseli *Satan and Death separated by Sin* (from *Paradise Lost*).
STUTTGART Staatsgal. The splendid set of Burne-Jones finished oils of the *Perseus* series (see Southampton), for the music room of Arthur Balfour's London house, were acquired in 1972. Also 2 English Holbeins, *Sir Anthony Denny* and *Archbishop William Warham*; Reynolds, Gainsborough, Raeburn and Constable; Bacon *Chimpanzee*.
WUPPERTAL Von der Heydt-Mus. Barker *Landscape with Cows and Fishermen*, Constable landscape; 20c. sculpture incl. Armitage and Chadwick.

In addition to the above, a few paintings or sculptures will be found in each of the following:
BOCHUM Mus. Bochum (Bacon *Reclining Figure*); **BREMEN Roseliushaus** (Kneller *John Locke*); **BRUNSWICK Herzf Anton Ulrich-Mus.** (Kneller *Thomas Parker*, *Earl of Macclesfield*, and 2 non-English Knellers); **DUISBURG Städtisches Kunstmus. & Lehmbruck-Sammlung** (Armitage, Chadwick, H. Moore); **DÜSSELDORF Kunstsammlungen Nordrhein-Westfalen** (Bacon *Reclining Figure*); **ESSEN Folkwang Mus.** (H. Moore); **Villa Hügel** (Raeburn *Alexander Mackenzie Fraser*, Constable landscape); **HANOVER Herrenhausen-Mus.** (Zoffany *George III* and *Queen Charlotte*); **Kunsthalle** (Bacon *Study for Portrait of P.L.*); **KARLSRUHE Staatliche Kunsthalle** (Louterbourg landscape, Fuseli *Celadon and Amelia*); **KASSEL Neue Gal.** (Louterbourg *Lowing Herd on a Riverbank*, Gainsborough landscape study with farm, Constable *Evening Landscape*); **Schlossmus. Wilhelmshöhe** (Ramsay *George III* and *Queen Charlotte*); **KIEL Kunsthalle** (Lawrence male portrait); **KOBLENZ Mittelrhein-Mus.** (Zoffany *Sacrifice of Iphigenia* from his 1st German period, Stanfield *Landscape with Bad Ems*); **LEVERKUSEN Städtisches Mus. Schloss Morsbroich** (contemporary British painting incl. Turnbull *Double Red*); **MANNHEIM Kunsthalle** (Bacon *Pope Screaming*); **MUNICH Alte Pinakothek** (Lely *Henrietta Maria*); **Bayerische Staatsgemäldesammlungen** (Constable *Limekiln*, Brangwyn landscape); **Münchner Stadtmus.** (Bacon *Crucifixion Triptych*, 1965); **NEUSS Clemens-Sels-Mus.** (2 1870 portraits of *Maria Zambaco* by Burne-Jones and Rossetti); **NUREMBERG Germanisches Nationalmus.** (2 Fuselis: subject from *The Heptameron* and wash drawing of his wife with a relief medallion of Medusa); **OFFENBACH-AM-MAIN Klingspor-Mus.** (20c. graphics incl. H. Moore); **OLDENBURG Landesmus.** (Louterbourg *Storm on a*

Rocky Coast, 1767); **REGENSBURG Mus. der Stadt** (a very early Zoffany, *The Three Graces*); **SAARBRÜCKEN Saarland-Mus.** (2 Louterbourg oil landscapes, Stanfield *View of Saarburg*); **TRIER Städtisches Mus.** (Zoffany *Hunting Still-life*, 1760, and Stanfield *Marketplace, Trier*); **ULM Ulmer Mus.** (R. Hamilton *Study for 'Hers is a Lush Situation'*, Allen Jones *6th Bus, Palette Bus*); **WURZBURG Mainfränkisches Mus.** (Zoffany's first known *Self-portrait* and early *Holy Family*).

HUNGARY

BUDAPEST Szépművészeti Múz. (Mus. of Fine Arts) A few British paintings incl. Constable *East Bergholt – Battle of Waterloo Celebrations* and a Morland of 3 huge pigs; plus 4 portraits: Hogarth (attr.) *Mrs Thornhill*, Reynolds *Sir Edward Hughes*, Hoppner (attr.) *Mrs Swete*, and Raeburn *Mrs Kenneth Murchison*.

INDIA

BARODA Fateh Singh Mus. Some British paintings.
Mus. & Picture Gall. Romney, Crome, Cox, Barker of Bath, Morland, Constable *View on the Stour*, and Victorians incl. early Leighton *Cimabue finding Giotto in the Fields near Florence*, Millais *Devotion*, Frith *The Race for Wealth*, J. F. Lewis, Landseer, Watts, Crane stained glass, sculpture by J. Gibson.
BOMBAY Prince of Wales Mus. Coll. incl. Lawrence, Gainsborough, Romney.
Town Hall Full-length statues by Chantrey (incl. *Elphinstone*), Foley, Woolner (*Sir Bartle Frere*).
CALCUTTA Asiatic Soc. of Bengal Paintings by British artists working in India, e.g. Robert Home.
Marble Palace Mus. Works by or attr. British artists, incl. Wilkie *Blind Fiddler*, Opie *Danae*, Gainsborough, Reynolds *Hercules and the Serpents*, W. Allan, Romney, Landseer, Westmacott.
Victoria Memorial Hall 5 important Zoffanys, incl. *Mr and Mrs Warren Hastings* and *Col. Polier with his Friends*; many T. and W. Daniells; also paintings by artists working in India, incl. Hickey, Home, Kettle and Wales; Cornwallis monument by Bacon Sen. and Jun., *Hastings* by Westmacott, and *Hastings* by Flaxman (completed by Denman).
NEW DELHI Rashtrapati Bhavan Portraits of Viceroys from 18c. onwards.
HYDERABAD Salar Jung Mus. Leighton *Paolo and Francesca* and *Ariadne abandoned by Theseus*; Watts *Orpheus and Eurydice*.
MADRAS Government Mus. Por-

traits of Governors by artists incl. F. Grant, M. A. Shee.

Fort Mus. Some British works. For India an exception might be made to record the existence of late 18–early 19c. monuments in a number of churches: **BOMBAY St Thomas's Cathedral** (Bacon Jun.); **CALCUTTA St John's** (Westmacott); **MADRAS St George's Cathedral** (Chantrey, Flaxman, Weekes), and **St Mary's** (Bacon Jun., Flaxman). Also **BARRACKPORE Police College** has in its grounds many public monuments from Calcutta.

IRELAND *see* **EIRE** *and* **NORTHERN IRELAND**

ITALY

BOLOGNA Mus. Civico Gainsborough portrait of his friend J. C. Bach.

Pinacoteca Naz. Barry *Philoctetes on the Island of Lemnos*, painted for the Accademia Clementina in Bologna when Barry was made a member.

FLORENCE Pitti 16c. English School *Elizabeth I*; amongst other Van Dycks, a fine male portrait in his English style; Lely *Cromwell*.

Uffizi Holbein *Sir Richard Southwell*. Also a number of British artists represented in the celebrated coll. of artists' portraits and self-portraits, founded by Cardinal Leopoldo de'Medici in 17c., among them several depicting Holbein (incl. a miniature from Charles I's coll. and another portrait from Lely's coll.) and Van Dyck (incl. one from Lely's coll. and another with Endymion Porter), also Moro, Lely, Kneller, Reynolds, Kauffmann, Zoffany, Holman Hunt, Millais, Leighton, Crane and Watts. The Gabinetto dei Disegni e Stampe incl. Van Dyck pencil *View of Rye*.

MILAN Brera Reynolds *Lord Donoughmore*.

Mus. Poldi Pezzoli Eworth *Portrait of a Man*, 1559.

PARMA Gall. Naz. Zoffany *The Festival of the Maize Harvest, 'La Scartocchiata'*.

POSSAGNO Gipsoteca Canoviana Lawrence portrait of *Canova*.

ROME Gall. Naz. d'Arte Moderna 2 interesting earlier works, Romney *Shipwreck Scene from 'The Tempest'* and Rossetti *Jane Morris*, plus portraits attr. Raeburn and a Sargent, preface the only coll. of modern British art in S. Europe, mostly 1950s–60s: paintings incl. R. Adams, Hayter, R. Smith and Tilson; construction by Pasmore; sculpture by Armitage, Chadwick, Moore; prints by Beardsley, Brangwyn, Hayter, Moore and Pasmore.

Mus. di Roma 3 Gavin Hamiltons of Homeric subjects from the Villa Borghese.

Pinacoteca Vaticana Lawrence *George IV*.

JAPAN

TOKYO NG of Western Art Some Victorians incl. Millais' late *Ducklings*, and 20c. British art.

THE NETHERLANDS

AMSTERDAM Rijksmus. Best Dutch coll. of earlier British art begins with a 16c. *Elizabeth I* and a painted satire on the exploitation of the Netherlands. Good portraits incl. Moro *Sir Thomas* and *Lady Gresham*, important late Van Dyck wedding portrait of the young *William and Mary*, Dobson *Prince Rupert*, J. Riley *Katherine Elliot*, and Lawrence. Also 2 W. G. Ferguson, Laroon *Merry Company*, and 3 Alma-Tademas. The Rijksprentenkabinet has fine British drawings incl. 2 Lely Garter Procession figures, 2 small circular Wilson landscapes, Gainsborough's delightful chalk *Studies of a Cat*, and late Palmer watercolours.

APELDOORN Rijksmus. Paleis Het Loo 5 copies or attr. Kneller incl. portraits of William and Mary, Copley *William II*, and 3 Hoppner portraits of Dutch royalty.

The Hague Dienst Verspreide Rijkskollekties (State-Owned Art Colls. Dept) Some British portraits incl. a 16c. *Woman with a Monkey*, Lely portrait of a woman, Dobson *Oliver Cromwell*, and a Kneller.

Mauritshuis Holbein portraits incl. *Robert Cheseman, Falconer to Henry VII*; Hilliard *Elizabeth I* and *James I*.

Rijksmus. Mesdag 3 Alma-Tademas and a Sargent.

LEEUWARDEN Fries Mus. Large coll. of Alma-Tadema – born nearby – incl. 17 paintings, especially portraits and early subject pictures.

OTTERLO Rijksmus. Kröller-Müller Incl. Legros landscape and modern British sculpture by Caro, Chadwick, Hepworth, King, Paolozzi, etc.

ROTTERDAM Mus. Boymansvan Beuningen Best Dutch coll. of modern British art: paintings by Bacon, Davie, Green, Kitaj, Nicholson, Pasmore, Riley and Tilson. Sculptures and constructions incl. a Chadwick maquette, Epstein bronze *Romilly John*, Hepworth marble, Moore bronze head of a girl, and Pasmore. A few earlier works incl. a Van Dyck *St Jerome* well known in 19c. British private colls. and Bonington *Grand Canal, Venice*. Drawings and watercolours incl. Lely study for *6th Duke of Norfolk*, Rowlandson *The Boompjes, Rotterdam*, and late Gainsborough wash landscape.

Other Dutch museums contain a few British works:

DELFT Rijkmus. Het Catharijne Convent (Gheeraerts *Dives and Lazarus*); **Stedelijk Mus. Het Prinsenhof** (Gheeraerts *Sir Philip Sidney* and 7 *Gates of Delft*); **DORDRECHT Dordrechts Mus.** T. Phillips portrait of *Ary Scheffer*, and an early Alma-Tadema); **EINDHOVEN Stedelijk van Abbemus.** (contemporary art incl. Cragg *Red Skin*); **ENSCHEDE Rijksmus. Twenthe** (Holbein *Richard Mabott*); **GRONINGEN Groninger Mus.** (Alma-Tadema *Looking at Art*); **HAARLEM Frans Halsmus.** (W. G. Ferguson (attr.), Northcote *Self-portrait*); **HEINO Kasteel Het Nijenhuis** (Hogarth *Daniel Lock*, Turner landscape); **LAREN Singer Mus.** (Bonington coast view, Alma-Tadema *Reclining Lady in a Wood*).

NEW ZEALAND

AUCKLAND City AG Best coll. 18–19c. British art in New Zealand with important group of Fuselis (incl. *Satan's First Address to Eve* and drawings), Blake *Lot and his Daughters*, Mortimer *Banditti* and Stothard *The Dance*. Other 18c. pictures incl. Sartorius *Captain O'Kelly's 'Eclipse'*, Hodges *View in Dusky Bay, New Zealand* and, with S. Gilpin, *Two Tigers in a Rocky landscape*; plus landscapes by Ibbetson, Linnell, Morland, Pyne and Wilson. Amongst the portraits are Dahl *George I*, Beale *Sir Nicholas Stuart, Bt*, Northcote *Reynolds*, fine Wright of Derby *Hon. Mrs. Boyle*, 2 Gainsborough male portraits and a Raeburn. Good 18–early 19c. watercolours and drawings incl. 34 Rowlandsons, 36 Turners, 6 J. Wards, Loutherbourg, Gainsborough and C. Fielding. Good Victorians incl. Burne-Jones *Fortitude* and 13 drawings incl. *The Car of Love*. RA pictures mostly bequeathed by Mackelvie or bought 1884–1914 with his fund: especially Maclise *Spirit of Justice* (oil related to Pal. of Westminster decorations), 3 Friths incl. *Pope makes Love to Lady Mary Wortley Montagu*, 2 Leightons, a late Millais 'dreary landscape' (*Blow, Blow thou Winter Wind*) and a portrait, Tissot *Still on Top*, 3 Alma-Tademas, plus others incl. La Thangue, Linnell and Pettie. Victorian watercolours and drawings incl. Callcott, Herkomer, Keene, Lear, Lewis, D. Roberts and Rossetti (incl. pencil study for *Beata Beatrix* predella). Some 20c.: H. Moore, 2 Epsteins incl. a bronze torso from *The Rock Drill* and R. Hamilton *Picasso's Meninas*.

CHRISTCHURCH Robert McDougall AG Raeburn portraits of *Gen.* and *Mrs Barbara Walker of Bowland*, some 18–19c. miniatures. Otherwise oils mostly Victorian, among them 3 Eastlakes incl. *Song of the Shirt* (and watercolour), Leighton *Teresina*, 3 La Thangues, and Brangwyn. A few British watercolours and drawings: 2 Rysbracks of classical

figures, Sandby, Prout, C. Fielding, Leech, Phillip and Stanfield. 20c. P. Nash watercolour *The Ghost of the Heinkel*, Sickert oil *The Shoreditch Empire*, A. John drawing, and T. Frost. Sculpture incl. Bayes.

DUNEDIN Public AG Founded 1884, the AG is the oldest, and now has the best foreign coll., in NZ. Portraits incl. Dobson *Earl of Macclesfield*, Gainsborough *William Lowndes-Stone* and, with Hoppner, *Lady Charlotte Hill*, Romney *Rev. John Romney*, Reynolds *Duchess of Gloucester*, plus Ramsay, Hoppner, Raeburn, Etty. Landscapes by Wilson (*Roman Bridge at Rimini*), the only recognized Turner oil in NZ (*Dunstanborough Castle*), and a Constable sketch of Brighton Beach, a nice link with the Victorian coll.'s Frith oil sketch for *Ramsgate Sands*. Other interesting Victorians incl. Herbert *Adoration of the Magi*, Tissot *Waiting for the Train*, Burne-Jones *Hope*, plus E. M. Ward, NEAC/Newlyn (Brangwyn, Clausen, Forbes, 3 La Thangues), Scots (Hornel, MacGregor, McTaggart), through to 20c. with Fry, A. John, McEvoy, Orpen, Sickert, M. Smith, Spencer and Steer. Watercolours and drawings 18–early 19c.: Cotman, Cox, De Wint, Gainsborough, Girtin, Rowlandson, Sandby, Turner, Varley; Victorians incl. Alma-Tadema, Sargent. Modern: drawings by Hepworth, Moore, Sutherland, D. Jones, small Nicholson oil, Tilson and Vaughan. Epstein bust of *Betty Joel*.

NELSON Bishop Suter Memorial AG Mostly 19–20c. minor Victorians and 20c. academic artists, incl. La Thangue *The Shrine – Alassio*, and, in 20c., Russell Flint, Gross, Hitchens, A. Gwynne-Jones and A. Stokes.

WANGANUI Sarjeant Gall. A few interesting High Victorians: 2 Burne-Jones, the large chalk *Fountain of Youth* and *Thisbe* oil, W. B. Richmond *Water Carrier in Egypt* (presented by Lord Leverhulme, as were many paintings in NZ colls.), and 2 J. Colliers (portrait of, and *Self-portrait* for, Alma-Tadema). Otherwise Webster *The New Recruit*, later 19c. RAs, and a lone Fry oil, *Chambéry*. Watercolours and drawings incl. Callow, Cox, Lear and McEvoy.

WELLINGTON National AG Best coll. of early 20c. British art in NZ, demonstrating the transition from 19c. with some academics and late NEAC like Brangwyn, Clausen, Orpen, Poynter (*Asterie*), Stott, and a large Tonks chalk drawing (*The Baby's Bath*). Camden Town incl. Gilman *Girl Dressing*, Ginner drawing of Leeds, Gore *Hampstead Road*, Sickert *The Blue Hat*. Also Gertler nude (*The Straw Hat*), Lamb (*Death of a Peasant*), M. Smith, Spencer (*Joachim among the Shepherds*), Wallis, and Wood (*The Jockey*). Abstracts incl. an E. Agar collage, Hepworth painting, Hitchens, Nicholson, early Pasmore (*The Win-*

dow), Piper collage, C. Richards and Sutherland. Other drawings by A. John, Lewis, P. Nash and W. Roberts. Sculpture also modern: Epstein bronze *Menuhin*, Hepworth bronze. Earlier paintings incl. a fine Copley (*Mrs Humphrey Devereux*) and a Morland. Good watercolours and drawings: Gainsborough landscape, Girtin, C. Fielding, 2 Lear views, Bonington seascape, Callow, 4 Cox, 3 Cotman watercolours, Devis, Foster, Hearne, Constable, Landseer, Prout, Palmer (*The Good Farmer*), 2 Mullers, Pyne, D. Roberts (views of Dieppe and Southampton), Rooker, 5 Rowlandsons, Ruskin, Sandby watercolour (*The Town Gate of Windsor Castle*), 2 Turner watercolours, Turner of Oxford, Varley, and 4 De Wint watercolours. Good print coll. has some 500 by British artists incl. Hogarth and Whistler.

Turnbull Lib. Best coll. 18–early 19c. NZ landscapes by English artists travelling with Capt. Cook; also a W. Blake Illuminated book.

NORTHERN IRELAND

ARMAGH County Mus. 19–20c. coll. of local topography and portraits (Molyneux family of Castledillon), with 10 C. Varleys.

BELFAST Ulster Mus. Many Irish and local paintings, plus Scottish connections, strongest in later 19–20c., especially Lavery (40 oils) and Orpen. Earlier works by Kneller, Barret and Fuseli, and growing contemporary coll.

PORTUGAL

LISBON Mus. Calouste Gulbenkian Mainly 18–19c., beginning with portraits: a Van Dyck male portrait, fine Gainsborough full-length *Mrs William Lowndes-Stone*, Hoppner *Miss Frances Beresford*, Romney *Miss Constable*, and Lawrence *Lady Elizabeth Conyngham*. 19c. distinguished with 2 stormy Turner oils (the large *Wreck of a Transport Ship* and *Mouth of the Seine, Quille-Boeuf*) and a watercolour of Plymouth; plus Burne-Jones *The Mirror of Venus* and *The Bath of Venus*.

PUERTO RICO

PONCE Mus de Arte The only notable coll. of British art in Central America, and a distinguished one. Victorians especially interesting: Pre-Raphaelites incl. Millais *Escape of a Heretic*; 2 late Holman Hunts, *Sorrow* and *The School of Nature*; Rossetti *Dis Manibus* or *The Roman Widow*; the very important Burne-Jones *The Sleep of King Arthur in Avalon* (with related drawings and large oil modello) and small *Briar Rose* series, with a *St Matthew*; Seddon *A Valley in Brittany*; Sandys *La Belle Iseult*. Leighton's

famous *Flaming June* (with chalk study) heads other Victorians like 2 Ettys incl. *The Toilet of Venus*, Tissot *In the Louvre*, and landscapes by Linnell, 2 D. Roberts and Stanfield. Earlier pictures mostly portraits, incl. a Gainsborough young lady, Reynolds *Gen. Sir Charles Vernon*, Lawrence *Frederick, Duke of York*, Raeburn and Romney. Also Kauffmann *Judgment of Paris*, J. Ward *Lioness and Heron*, West *Resurrection of Christ*, Gainsborough drawing *Mountain Landscape with Shepherd and Sheep*, Constable *In Helmingham Park*, and Bonington coastal scene.

SCOTLAND

ABERDEEN AG Broad-based coll. incl. Victorians (Rossetti, T. Faed, Clausen) and watercolourists (Blake, Bonington, Cozens, Turner) with local roots in notable 19c. Aberdeenshire artists: Dyce (*Titian's First Essay in Colour* and MSS), J. Phillip, Reid, and James McBey (Memorial Printroom). Also strong in earlier Scots and English portraits (Ramsay, Hogarth, Raeburn). Portrait coll. greatly widened by Macdonald beq. of 94 mostly British 19c. artists' portraits in 1900. The beq. incl. funds for purchase of contemporary art and Aberdeen's enterprising coll. has A. John's *Blue Pool* (1911), G. John, Sickert, Tonks, B. Nicholson, Bacon's *Pope – Study after Velasquez* (1951) and active contemporary acquisitions, especially sculpture (Paolozzi, Fullard).

ARBROATH AG (Angus District Mus. incl. Brechin, Forfar, Montrose) Numerous works by James Watterson Herald (1859–1914) and David Waterson (1870–1954), oils by Ramsay and J. Phillip, plus local portraits and lesser-known 19–20c. Scots.

AYR Carnegie Lib. Sound Scottish representation, incl. Hornel and Peploe, and W. Lewis pencil drawing of Naomi Mitchison.

BRECHIN *see* ARBROATH

BRIGHOUSE Corporation AG A very Victorian coll. with the emphasis on the pathetic, incl. Faed *The Mitherless Bairn*, small version of Egg Queen *Elizabeth discovers she is no longer young*, and other works incl. Leslie, Mulready and Grimshaw. Some watercolourists incl. De Wint, Cox and W. H. Hunt.

BROUGHTY FERRY Orchar AG Provost James Guthrie Orchar's interest in 19c. Scottish and British prints is foundation of coll. Scots incl. 29 works by McTaggart, 9 Orchardsons and 14 Petties (incl. portrait of Orchar). Some English artists incl. Hook, Leighton, J. F. Lewis and Linnell; 36 Whistler etchings and 18 by Haden. A few earlier works (Ramsay landscape, Raeburn); some 20c. (Cameron, Munnings). Some 20c. sculpture.

CAMPBELTOWN Public Lib. 7 18c. Scottish School portraits, 2 large

McTaggart oils, and some local marine pictures.

DUMFRIES Gracefield Arts Centre Mostly Scottish 19c. incl. Glasgow School (especially Peploe), Victorian academics (T. Faed, Wilkie), and some English 19–20c. like Brett, Lear, Sickert, Clausen and Gertler.

DUNDEE City AG Portraits by Allan, Ramsay, Raeburn; Scottish subjects by Nicol, Lauder, Orchardson, Paton, Pettie (8 oils), and Wilkie (5 works). Good Glasgow School and Scottish Colourists (Cadell, Crawhall, Fergusson, Hornel, Hunter, Lavery, Park, Pringle), and 15 watercolours and drawings by Dundee's own Art Nouveau artist George Dutch Davidson (1879–1901). Other 19c. artists incl. Cox (61 pencil drawings), Linnell, Holl, Rossetti (*Dante's Dream*) and Brangwyn (267 works). Developing 20c. coll. emphasizes Scots-born painters and sculptors: Paolozzi, Redpath, and Dundee-born and trained Turnbull.

EDINBURGH NGS Major national coll. of Scottish artists to 1900. In 17c. Ferguson and Jamesone. Portraits by Aikman (*Self-portrait*), C. Alexander, many Ramsays (incl. *J. J. Rousseau*), outstanding coll. of Raeburns spanning his career (incl. self-portraits and the memorable early *Rev. Robert Walker skating on Duddingston Loch*), Geddes, Gordon, W. Nicholson. History incl. Gavin Hamilton, A. and especially J. Runciman, many D. Scott, W. Allan, Drummond (*The Porteous Mob*), W. B. Scott, Dyce (incl. *Francesca da Rimini*). Genre, with strong Scottish flavour, from D. Allan (also *The Origin of Painting*), Carse, Geikie, large coll. Wilkies (incl. early *Self-portrait* and *Pitlessie Fair*), Harvey, Nicol, Faed brothers, Chalmers. Landscape and topography: A. and P. Nasmyth, More, many Thomson, D. Roberts and J. Phillip foreign subjects, McCulloch, McTaggart (many, incl. portraits). Also in 19c. Paton *Quarrel* and *Reconciliation of Oberon and Titania*, Lauder, Orchardson (incl. *Master Baby*), Pettie. Glasgow School incl. classic 'Kailyard' picture, Guthrie *A Hind's Daughter*.

Rest of coll. as distinguished. Portraits incl. Lely, Mercier, Hudson, Hogarth (the murderess *Sarah Malcolm*), Gainsborough (incl. *The Hon. Mrs Graham*), Gardner, Cotes, Opie (*Self-portrait*), Kauffmann (the architect *Novosielski*), Reynolds (incl. *The Ladies Waldegrave*), Romney, Lawrence, Hoppner, Whistler, Sargent and Clausen. Landscapes by Wilson, Gainsborough, J. Ward (Scottish scenes), Constable (incl. *Dedham Vale*), Cotman oils and Bonington, De Wint. Also Stothard illustrations to Burns, Morland, and later in 19c. Etty, Millais, A. Moore, Legros. Sculpture by A. Gilbert and Stevens.

Nat. Lib. of Scotland 12c. Scottish Kelso Charter (on loan), late 14c. Bohun Psalter.

Nat. Mus. of Antiquities of Scotland Major coll. of Scottish medieval art, incl. the Pictish St Ninian's Isle Treasure, Celtic Hunterston Brooch and Monymusk Reliquary, Viking carved stones, and the Bute Mazer.

Scottish NG of Modern Art Lively and growing coll. incl. contemporary Scots Boyle, Davie, Finlay and Turnbull. Many later 19–mid 20c. Scots like Cameron, Cowie, Gillies, Hornel and Redpath. Some English artists, especially Steer (44 works); and sculpture by Epstein and Martin. Large 20c. print coll.

Scottish NPG Large coll. of portraits of Scots by Scots and others, late medieval to contemporary. Amongst the earlier artists are Gheeraerts, Van Dyck, Lely, Wissing, Kneller and Ramsay. 18–19c. bridged by Hoppner, Nollekens and Raeburn, continuing into 19c. with Wilkie and Watson Gordon, and into 20c. with Orpen. The subjects are from Scottish history of the past 600 years: a sampling of the famous incl. Mary Queen of Scots, James VI/I, Robert Adam, Carlyle and Bonar Law; the greatest number of any one subject are of Sir Walter Scott.

University Lib. 11c. Celtic Psalter which belonged to Queen Margaret of Scotland; 15c. Book of Hours.

FORFAR see **ARBROATH**

GLASGOW AG Scottish artists naturally dominate the large British coll., with particularly fine portraits throughout, starting with one of Ramsay's finest (*3rd Duke of Argyll*), Reynolds, Zoffany, Raeburn, Lawrence and ending with Whistler's famous *Thomas Carlyle* and A. John *W. B. Yeats*. Major 19c. artists incl. Constable, Turner, Wilkie, with Faed (recently acquired *Last of the Clan*), Guthrie, McCulloch, Paton, Pettie, Phillip, and much Glasgow School (Fergusson, Henry, Hornel, Peploe). 20c. coll. growing. The building itself is adorned with New Sculpture by Frampton *et al.*

Burrell Coll. Opened in 1983 to house Sir William Burrell's celebrated coll. Medieval art incl. the possibly English bronze-gilt 12c. *Temple Pyx*, alabasters (among them a rare late 14c. *Holy Trinity*), late 14c. orphreys completing the set of vestments in Burnley, 15–16c. carved misericords, and stained glass. Paintings incl. Hilliard, Hogarth, Kneller, Gainsborough, Hudson, Reynolds and Raeburn portraits. Some Glasgow School, incl. 132 watercolours by Crawhall (who shared with Burrell Northumbrian family origins) and Whistler.

Hunterian Mus., University of Glasgow Celebrated Whistler coll., given by his sister-in-law Rosalind Birnie Philip, is a monument to Whistler's later antipathy to England and affection for the Scots and Glasgow. Second only to the Freer's (*see* USA: Washington), it now also incl. many of Whistler's friends – Sickert, Menpes, A. Moore – and Glasgow School followers (Fergusson, Henry). Also many drawings and designs by the Glasgow Art School group around Mackintosh. Small coll. of good 18c. paintings, incl. Ramsay portrait of *William Hunter*, founder of the mus. and first RA Professor of Anatomy 1768, and several Stubbs of wild animals commissioned by Hunter. Large and distinguished print coll. has rare 18–19c. prints by Barry, Blake, Fuseli, Crome and Gainsborough; also wide range of modern British prints.

Pollok House Good portraits incl. Oliver *Lady Arabella Stuart*, C. Johnson, Kneller (attr.), Dahl, Mercier and 6 Blakes, incl. *Adam naming the Beasts*, *Canterbury Pilgrims* and *The Entombment*. Also 18c. Scottish School family portraits, and Etty.

GREENOCK AG Largely Scottish coll. with emphasis on Glasgow School, Scottish Colourists (Cadell, Fergusson, Hunter, Peploe) and some academics. Also 2 earlier portraits – Raeburn *Chantrey* and a Ramsay. English artists incl. Leighton, Tuke and Munnings.

HAWICK Mus. & AG Small coll. 19–20c. local artists and topography plus McTaggarts and Redpath.

INVERNESS Mus. & AG Beale *Charles II* and *Bonnie Dundee*, Van Dyck, Lely, Batoni *Charles III* (the Old Pretender), Reynolds and Raeburn are interesting peaks in an otherwise minor Scottish and local 19–20c. coll. with groups by Gillies and Redpath and incl. McTaggart. Some English 18–19c. watercolours on long loan.

KILMARNOCK Dick Institute 2 Raeburns and a Ramsay start this basically 19–20c. Scottish coll. which incl. Lauder, Cameron and Hornel. Leighton *Greek Girls playing at Ball* is the most important of the few English works, which incl. Constable, Crome and Alma-Tadema. Some prints and sculpture.

KIRKCALDY Mus. & AG Based on the notable John W. Blyth coll. bought 1964. Largest coll. anywhere of McTaggart and Peploe, set in context of Scottish painting with 18–19c. portraits (Raeburn, Geddes), landscape (Nasmyth), genre (Wilkie, Faed) and Glasgow Boys (MacGregor, Guthrie, Lavery, Hornel, Henry). English paintings headed by the best Camden Town coll. in Scotland: 6 Sickerts (incl. a *Camden Town Murder*), Gore and Gilman; plus J. Martin *Evening in Paradise*.

KIRKCUDBRIGHT E. A. Hornel AG & Lib. Over 50 works by Hornel, many unfinished, plus Faed brothers, Henry and Munnings.

MILNGAVIE Lillie AG 19–20c. mostly Scottish, with a few landscapists, Glasgow School and Scottish Colourists; 20c. incl. Gillies.

MONTROSE see **ARBROATH**

PAISLEY Mus. & AG Basically 19-early 20c. Scottish with many landscapes and portraits of local notables. Subject pictures by Faed, Guthrie, Orchardson, 4 Patons incl. *Christ bearing His Cross*, and D. Scott historical triptych *Wallace defending Scotland*. Some progressive Scottish 19c. painting from Fergusson (*Manteau Chinois*), Hornel, 9 Lavery, McTaggart, Melville. Watercolours and drawings incl. Clausen, A. John and Tuke. Some portraits: Ramsay, Raeburn.

PERTH AG Many portraits incl. Dobson, Herkomer, Landseer, large Lavery *Portrait of a Girl in White*, Orchardson incl. 4 portrait sketches of the Cranstoun family, 3 Raeburn incl. large *Sir Alexander Mackenzie*, Ross miniature. Landscape by A. Nasmyth, Bonington, 6 Cameron Highland views, and D. O. Hill *View of Perth from the North*. Subject pictures incl. 3 Millais and MacGregor.

STROMNESS (ORKNEY) Pier Gall. 67 paintings and sculptures coll. by Margaret Gardiner since 1930s, mostly her artist friends direct, especially important for 11 Nicholsons 1929–52, 13 Hepworth sculptures and drawings, and other St Ives artists incl. Frost, Heron, Hilton, Lanyon and 7 Wallis.

SOUTH AFRICA

CAPE TOWN South African NG Best coll. of 18c. British art on the continent, especially sporting pictures bequeathed by Sir Abe Bailey: 3 Stubbs incl. *Firetail with his Trainer*, Alken, 4 Ferneleys, and many Herrings. Among portraits 3 Knellers incl. *Capt. and Mrs Temperley*, Hogarth (attr.), Lawrence of the poet *Southey*, 2 Hoppners incl. *William Pitt*, Beechey and Geddes. Subject paintings incl. Gainsborough's 'fancy picture' *The Milkmaid*, Gardner *Thalia*, Etty; landscapes mostly 19c. incl. a small Constable of Hampstead. Some good Newlyn and later 19c. incl. Bramley, Brangwyn and Conder. Some 20c. incl. Bell, Epstein, Gertler and Ginner.

DURBAN AG Interesting 19–20c. British coll. begins with the recently acquired and newly identified Constable 1817 oil of *East Bergholt Church*. Some earlier works incl. Kneller, Highmore (attr.), Hogarth (attr.) and Herring. Good Victorian subjects especially Bramley, Clausen, Dadd, Faed, Frith and Poole; landscape paintings and drawings incl. Callow, Clausen, Cox (*Rhyl Sands*), De Wint, La Thangue and Muller. Interesting 19–20c. portraits: Herkomer *Queen Victoria*, Rothenstein *Alphonse Daudet*, Hockney *Andrew*, A. John *McEvoy* and *Dorelia*, W. Lewis *T. S. Eliot*. Also Camden Town and 1st World War artists, especially P. Nash *Monster Field*.

EAST LONDON Ann Bryant AG Most interesting British painting is an unidentified classical subject by Kauffmann; also Eastlake *Colosseum, Rome*, and minor 19c. oils and prints.

JOHANNESBURG Municipal AG Fine 19-early 20c. British coll. initially advised by Sir Hugh Lane. Pre-Raphaelites and associates incl. Collinson *St Elizabeth of Hungary*, Deverell *Irish Beggars*, Holman Hunt drawings and watercolour, Brett, Houghton, Martineau, Millais and Rossetti; other Victorians incl. Alma-Tadema, Etty, Frith, many Keene drawings, Landseer, Maclise, A. Moore, Orchardson and Watts. Good NEAC and progressives like Fred Brown, Clausen, Conder, Fisher, Greaves (*Tinnie*), Legros, Steer. Some important early 20c. incl. A. John *The Childhood of Pyramus*, Sickert *The Pork Pie Hat*, early Epstein marble *Mrs McEvoy*, Fry *V. Bell*, with Camden Town, portraits by McEvoy and Nicholson, and other paintings incl. Lavery, Pissarro, Rothenstein, Shannon and Tonks. Later 20c. incl. Moore, Pasmore, Piper and Sutherland; good modern prints. A few earlier works incl. Raeburn portrait, and landscapes by Wootton, Wilson (*Villa Madama*) and Bonington.

KIMBERLEY William Humphreys AG Especially interesting are a rare W. G. Ferguson still-life and Kauffmann *Achilles discovered by Ulysses*. Portraits by Lely, Hogarth (attr.), Raeburn, Geddes, Wilkie and A. John; still-lifes by McTaggart and Sickert; and nudes by Etty and Orpen.

PIETERMARITZBURG Tatham AG Good NEAC, Camden Town and earlier 20c. especially 3 Gertler, Sickert, Steer (*The Sofa*), also Brangwyn, Clausen, Fisher, Gilman, 4 Ginner drawings, Gore, Newton and Tonks. Some Victorians too, especially landscapes, and Whitwell coll. of Victorian and 20c. prints. A few earlier British works incl. an early Opie *Self-portrait* and Cotman drawing *View over the Humber*.

PRETORIA Pretoria Art Mus. 2 portraits attr. Lely, *Nell Gwynne* and *Duchess of Cleveland*, and minor Victorian landscapists.

SPAIN

MADRID Mus. del Prado Most important of the pictures of English subjects by Continental artists are Moro's great *Mary I* (painted for her future husband Pilip II of Spain). As well as many Continental Van Dycks, coll. incl. his *Portrait of the Artist with Endymion Porter*, an equestrian *Charles I*, court flautist *Jacob Gaultier*, and *Diana Cecil, Countess of Oxford*. Later portraits incl. Gainsborough *Dr Isaac Henrique Seguiera*, fine full-length Lawrence *10th Earl of Westmorland*, a Reynolds man and a Hoppner lady.

SWEDEN

STOCKHOLM Nationalmus. Painting coll. wide-ranging, with portraits by Hilliard (*Frances Howard, Duchess of Richmond and Lennox*), J. Riley (*George Legge, Baron Dartmouth*), Reynolds (*Sir Thomas Mills*, also an allegorical figure), Gainsborough (*Thomas Haviland*), Opie, Beechey (*K. Q. Svinhufvud*), Hoppner, Orpen, A. John; also 2 18c. English School (incl. *?Mrs Garrick*). Marines by Van de Velde the Younger. Landscapes by the Griffiers, Crome and Constable (study); historical landscape by Wilson (*Death of the Children of Niobe*). Also Morland, 3 Boningtons (incl. *Tintoretto painting his Dead Daughter*) and Poole. Sculpture: 3 15c. and 16c. alabaster reliefs.

SWITZERLAND

AARAU Aargauer Kunsthaus Fuseli *Odysseus between Scylla and Charybdis* (from his Milton Gall.).

BASEL Kunstmus. One of the 2 main Swiss colls. of Fuseli: paintings incl. Undine and Titania subjects, drawings incl. a powerful *Prometheus*, Shakespeare, Dante and classical subjects, figure studies and a rare pencil landscape. 20c. sculpture incl. Moore.

GENEVA Mus. d'Art & d'Histoire Hogarth *Mrs Catherine Edwards* and relics of Danby's Swiss exile in *The Baptism of Christ, Lake at Sunset*, and *Baptism of Clorinda*.

LOCARNO Mus. d'Arte Contemporanea Incl. work by B. Nicholson, a Swiss resident in his later years.

WINTERTHUR Kunstmus. Paintings by Fuseli: *Titania's Awakening* (version painted for Boydell's Shakespeare Gall.), *The Vision of the Deluge* (2nd version of No. 25 of the Milton Gall.) and a Venus and Cupid subject.

ZURICH Kunsthaus Zurich, Fuseli's birthplace, has a large coll. of his work, with paintings incl. Theseus, Macbeth, Titania and 2 Achilles subjects, and many drawings. Also Kauffmann portrait of *Winckelmann*.

USA

Almost every American museum of any size has some British art. The following list incl. the principal colls. and a selection of other museums whose holdings are of interest.

BALTIMORE Walters AG 14c. East Anglian Botiler Hours.

BOSTON MFA Especially interesting group of 18–19c. landscapes and subject pictures incl. the important late Gainsborough 'fancy picture' *Haymaker and Sleeping Girl*, and 8 other works; Turner *The Slave Ship*; 2 Constables, *View of Dedham* and *Osmington and Weymouth Bays*; Martin *The Seventh Plague of Egypt*; and Whistler *The Last of Old Westminster*, a

Venice *Nocturne* and 2 other oils. Also good portraits with many Copleys, mostly American but incl. *George IV as Prince of Wales*; 3 Lawrences incl. *John Philip Kemble* and *Sir Uvedale Price*; pair of Cotes oils and a fragment of a double portrait; Romney *Mrs Billington as St Cecilia*; plus Van Dyck, Hogarth, 7 Reynolds and Leslie. A fine group of Blakes, incl. illustrations to *Comus* and *Paradise Lost*, head the watercolours and drawings coll. which incl. Rossetti *Before the Battle* and Whistler's delicate pen and wash drawing of his mother-in-law. Victorians incl. 3 Alma-Tademas, Burne-Jones, Leighton and Tissot *L'Acrobate*.

BUFFALO Albright-Knox AG The most important British painting here is Hogarth's last comic-moral picture, *The Lady's Last Stake*. Also Reynolds *Cupid as a Link-Boy*, Gainsborough *Miss Evans*, and other 18c. portraits incl. Lawrence, and landscapes incl. Wilson. In 19c., Tissot *L'Ambitieuse*.

CAMBRIDGE Fogg Art Mus. Particularly important British works in the drawings coll.: *Two Poor Knights* from Lely's Garter Procession series, Reynolds, Gainsborough, important Blakes incl. the Linnell set of illustrations to Job and a group of Dante watercolours, and a strange Dadd watercolour *Landscape with Bull Calf*. Paintings incl. good Copleys, *Portrait of Benjamin West* and *Monmouth before James I*; 2 small Reynolds ladies; a late Gainsborough; and 5 Lawrences incl. small *Mrs Siddons*. 19c. strong with fine group of Whistlers incl. *Maud Franklin*, nocturnes, *Mrs Walter Sickert* and *Lillie in our Alley*; also Alma-Tadema *Tragedy of an Honest Wife*, Burne-Jones *Self-portrait*, Millais *The Proscribed Royalist*, F. M. Brown, Holman Hunt, a group of Rossettis and Watts *Sir Galahad*. Some contemporary art.

CHICAGO Art Institute of Chicago After a Eworth portrait of a lady of the Wentworth family, the good 18-19c. coll. is headed by Reynolds *Lady Sarah Bunbury sacrificing to the Graces*, with *Master Worsley ('The Boy in Red')* and other portraits, and incl. works by Copley, Gainsborough, Hoppner, Lawrence, Leslie, Raeburn, Reynolds, Romney and West. Landscapes incl. Constable *Stoke-by-Nayland*, and 2 Turners (incl. *Snow-Storm, Avalanche and Inundation*), Wright of Derby and Bonington. Drawings coll. incl. 2 important Wilsons; Fuseli *Milton dictating to his Daughters* and Homer, Dante and Spenser subjects; Hockney pencil portrait (*Ronni*). Victorians: 8 Whistlers incl. *Battersea Reach* and study for *Thomas Carlyle*; Rossetti version of *Beata Beatrix*; and Faed, Brangwyn, Orpen and Watts.

CINCINNATI Cincinnati Art Mus. Distinguished group of Gainsboroughs incl. *Mrs Philip Thicknesse*, an early landscape, and the late *Cottage Door with Children Playing*. Also fine Constable *The Thames and Waterloo Bridge*. Portraits incl. 6 Reynolds (mostly small), Raeburn's delightful *The Elphinstone Children* and other portraits, plus Hoppner, Lawrence, West, 3 Alma-Tademas and Whistler.

CLEVELAND Cleveland Mus. of Art Turner's RA exh. version of *The Burning of the Houses of Parliament* and Constable *Branch Hill Pond*; plus portraits by Hilliard (*Sir Anthony Mildmay*), Reynolds (*The Ladies Amabel and Mary Jemima Yorke*), Gainsborough (*George Pitt, 1st Lord Rivers*), Cotes (pastel *Lady Mary Redcliffe*), and Lawrence; also West portrait of *Mrs West and her Son*, *Raphael* and the allegorical *Etruria – Manufacture supporting Industry*.

DETROIT Detroit Institute of Arts 2 night scenes are the major British works here: one of Fuseli's most important versions of *The Nightmare*, and Whistler's *Nocturne in Black and Gold: The Falling Rocket*. Other works incl. Holbein miniature of *Sir Henry Guildford*, Wheatley *The Wilkinson Family*, Hogarth *Lady in Yellow*; 10 Gainsborough portraits and landscapes incl. 2 large portraits of *Lady Anne Hamilton* and *Hon. Richard Savage Nassau*, and *The Market Cart*; portraits by Van Dyck, Reynolds, Raeburn; and a Landseer Highland deer-hunting scene.

FARMINGTON Lewis Walpole Lib. Coll. devoted to Horace Walpole with some important Hogarths and caricatures.

FORT WORTH Kimbell Art Mus. Good 17–19c.: Lely portrait of the dwarf couple *Richard and Anne Gibson*, grand full-length Reynolds *Miss Warren* and 2 other portraits of young women, delicate early Gainsborough *Miss Lloyd* plus other portraits and a landscape, Zoffany *Sayer Family*, Romney and Leighton. Unusual Hoppner *Romantic Landscape*, Turner *Glaucus and Scylla* and interesting moral narratives by J. Ward, *Disobedience in Danger* and *Disobedience Detected*.

HARTFORD Wadsworth Athenaeum Fine landscapes: Wright of Derby *Matlock Tor, Moonlight*, Turner *Van Tromp's Shallop at the entrance of the Scheldt*, a small Constable *Osmington Bay*, Landseer version of *The Otter Hunt*, and Whistler *Alone with the Tide, the Coast of Brittany*. Portraits incl. Van Dyck *Robert Rich, 2nd Earl of Warwick*, and works by Copley, Reynolds, Gainsborough, Lawrence, Romney and West. Unusual genre piece by Wright of Derby, *The Old Man and Death*. Some Pre-Raphaelites incl. Holman Hunt version of *The Lady of Shalott* and Burne-Jones *St George*.

KANSAS CITY Nelson Gall.-Atkins Mus. Again good landscapes, with Gainsborough *Repose* (one of his

own favourite works), Constable *Helmingham Dell*, and Turner *Hastings, Fishmarket on the Sands*. Also Hilliard *George Clifford, 3rd Earl of Cumberland*, West *Venus comforting Cupid*, Barry pen drawing of *The Detection of Satan by Ithuriel* (from *Paradise Lost*), and works by Hogarth, Hoppner, Lawrence, Reynolds and Wright of Derby.

LOS ANGELES Los Angeles County Mus. of Art Important Turner *Lake of Geneva from Montreux* and 18c. paintings; also Deare relief, *The Judgment of Jupiter*.

UCLA Art Galls. Gainsborough *Peasant smoking at a Cottage Door*.

See also **MALIBU, SAN MARINO**

MALIBU J. Paul Getty Mus. Fast-growing coll. incl. Lely *Louise de Kéroualle*, late Gainsboroughs of *James Christie* the auctioneer, *Anne, Countess of Chesterfield* and *The Earl of Essex presenting a Cup to Thomas Clutterbuck*; and one of the 2 sets of Hogarth *Before* and *After*. Most important Victorian pictures are Alma-Tadema's great processional *Spring* and Millais' *The Ransom*.

MINNEAPOLIS Minneapolis Institute of Arts This 18–19c. coll. begins with Hogarth *The Sleeping Congregation*, and contains 2 important religious works, a Reynolds version of *The Infant St John in the Wilderness* and Blake *Nebuchadnezzar*. Early Gainsborough landscape (the Claudean *Wooded Slope with Cattle and felled Timber*) and large portrait of *John Langston*; Wright of Derby *Mrs Beridge*; and other portraits by Ramsay, Raeburn and Lawrence. Some 19c. paintings: Dyce *Eliezer of Damascus*, Leighton *Jonathan's Token to David*, Millais *Peace Concluded* and Tissot *The Journey of the Magi*.

NEW HAVEN Yale Center for British Art One of the finest colls. of British art in the world, concentrating on the period up to 1850 with a dazzling array of major works. Fine group of Stubbs incl. *Two Gentlemen out Shooting* series and largest *Lion Attacking a Horse*, many Wright of Derby incl. *The Blacksmith's Shop*, Hogarths incl. versions of *A Midnight Modern Conversation* and *The Beggar's Opera*. Landscapes 18–19c.: Canaletto *Walton Bridge* (large extended version of Dulwich picture); Wilson *Rome from the Villa Madama* and other important paintings and drawings; Gainsboroughs; Turners incl. the great *Dort Packet-Boat becalmed*; Constables incl. the finished *Hadleigh Castle* and sketch for *The Young Waltonians*. Many fine portraits from Van Dyck *Earl of Newport*, Barlow, Reynolds *3rd Earl of Harrington*, many Gainsboroughs incl. the early *Gravenor Family*, Romneys incl. Flaxman modelling the Bust of *William Hayley*. History and literary painting are represented by an early Barry (*The Education of Achilles*), fine group of Blakes, and Martin *Cruci-*

fixion and versions of *The Bard* and *Belshazzar's Feast*. Extraordinary coll. of *c.*10,000 drawings and watercolours founded on several major British colls. (Iolo Williams, Martin Hardie, Tom Girtin), and rare topographical art from Abbey coll., with works by all major and many minor artists. Sculpture incl. especially Roubiliac and Rysbrack. Increasingly important 19–early 20c. section: J. F. Lewis *The Frank Encampment*, Landseer version of *Van Ambrugh and his Lions*, Walker *Strange Faces*; plus Burne-Jones, Collins, Dadd, Eastlake, Egg, Leighton, A. Moore, Palmer, Redgrave, Wallis and Webster; some Camden Town.

Yale University AG Ranges from West *Agrippina landing with the Ashes of Germanicus* to Alma-Tadema *A Roman Art Lover*, with works by Devis, Highmore, Reynolds, Gainsborough (a drawing), Wright of Derby (a pair of portraits), Copley, Blake and Stanfield.

NEW YORK Brooklyn Mus. 18–19c. paintings incl. Reynolds portraits; Blake watercolour *The Great Red Dragon and the Woman Clothed with Sun*; and the complete set of Tissot's late New Testament illustrations.

Frick Coll. Important early portraits begin with 2 Holbeins, the best version of *Sir Thomas More* and *Thomas Cromwell*; fine Van Dyck *Anne, Countess of Clanbrassil* and *James, 7th Earl of Derby, his Lady and Child*; outstanding Hogarth *Mary Edwards*; Gainsborough portraits incl. full-length *Hon. Frances Duncombe* set in an Arcadian landscape; Lawrence *Lady Peel*, and others by Reynolds, Hoppner, Raeburn and Cotes. Landscapes: Gainsborough late Watteauesque *The Mall in St James's Park*; group of important Turners incl. *Harbour at Dieppe* and *Cologne*; and Constable's famous *The White Horse* with a *Salisbury Cathedral*. Also Blake watercolours for *Pilgrim's Progress*; and 5 important Whistlers: portraits of *Mrs Frances Leyland*, *Rosa Corder* and *Lady Meux*, and *Symphony in Green and Grey: the Ocean*.

Jewish Mus. Complete set of Tissot's Old Testament illustrations.

Metropolitan Mus. of Art Fine coll. begins with group of Holbein portraits incl. several English sitters, a Hilliard, the most important of Peake's portraits of *Henry, Prince of Wales in the Hunting-Field*, a Van Dyck *Self-portrait* and 4 English portraits amongst a good many others, and a fine Lely of *The Capel Sisters*. 18c. portraits: 15 Reynolds, incl. the large *Hon. Henry Fane and his Guardians* and *George, Viscount Malden and his Sister Lady Elizabeth Capel*; 9 Gainsboroughs incl. fulllength *Grace Dalrymple*; a dozen Raeburn incl. *The Drummond Children* and *Mrs Harvey and her Daughter*; superb Lawrence *Elizabeth Farren*; Cotes oil *6th Duke of Bolton*; plus Romney and Hoppner. Other impor-

tant 18–19c. pictures: early Hogarth conversation piece *The Wedding of Stephen Beckingham and Mary Cox*; Wilson oil *Capuchins at Genzano*; Blake watercolours and drawings incl. *The Angel of the Divine Presence bringing Eve to Adam*, *The Parable of the Wise and Foolish Virgins* and *The Angel of Revelation*; and 2 Kauffmann Calypso and Telemachus subjects. In 19c., Wilkie *Return of a Highland Warrior*, Constable *Salisbury Cathedral* and *Mrs Pulham*, Burne-Jones *Le Chant d'Amour*, and 4 important Whistlers incl. *Theodore Duret* and *Connie Gilchrist*.

MoMA Outstanding coll. of 20c. art incl. one or more works by each of the following. Paintings and drawings by Bacon, Burra, B. Cohen, Colquhoun, Davie, Denny, Freud, G. John, McKnight Kauffer, Kitaj, W. Lewis, Lowry, MacBryde, Pasmore, Piper, Riley, Sickert, Spencer, Sutherland, Tunnard, Wallis and Wynter. Sculpture by Armitage, Butler, Caro, Chadwick, Epstein (a representative coll., incl. plaster studies given by his widow), Flanagan, Gabo (a 1941 *Spiral Theme*), Gaudier-Brzeska, Hayter, Hepworth, P. King, Moore (incl. drawings for sculpture), Paolozzi (sculpture, drawings and studies for silk-screen series), and T. Scott. Assemblages, conceptual and mixed media works by Gilbert and George, Latham, Long, Nicholson, R. Smith, Tucker.

Pierpont Morgan Lib. Wideranging coll. of medieval MSS incl. Romanesque Life of St Edmund from Bury, an important page associated with the Winchester Psalter (the 'Morgan Leaf'), and the East Anglian Windmill and Tickhill Psalters. Romanesque enamelled ciborium. Later drawings and watercolours, especially Hogarth and large group of Blake incl. the important Thomas Butts sets of watercolour illustrations to Job and to Milton's *L'Allegro* and *Il Penseroso*. Also Lely, Wilson and others.

New York Public Library Important Blakes and largest coll. of Gillray drawings (over 100).

NORTHAMPTON Smith College Mus. of Art Interesting coll. of which the highlights incl. one of Wright of Derby's grottoes, a Wilson *White Monk*, 2 Hogarths incl. an unfinished but lively portrait of *James Caulfield, 1st Earl of Charlemont*; Reynolds *Mrs Nesbitt as Circe*; Gainsborough drawing for *The Market Cart*; Fuseli subject from *King John*; and Tissot *Young Lady in a Rocking Chair*.

PHILADELPHIA Pennsylvania Academy of the Fine Arts 2 important Wests, the huge *Death on a Pale Horse* and *Penn's Treaty with the Indians*, plus Leslie *The Murder of Rutland by Lord Clifford*.

Philadelphia Mus. of Art Fine 18c. pictures: 2 Hogarths, *Assembly at Wanstead House* and *The Fountaine*

Family; 3 important Gainsborough landscapes; fine Sandby oil of *N. Terrace at Windsor*; Wheatley *The Fisherman's Return*; good group of Blakes; Palmer *Tivoli*; Bonington; and one of 2 versions of Turner's *Burning of the Houses of Parliament*. Later 19c. incl. Alma-Tadema, Tissot, and the important Whistler *The Lange Lijzen*, as well as his *Lady Archibald Campbell* and a nocturne.

Rosenbach Coll. Important Blakes, incl. *The Number of the Beast is 666*.

PROVIDENCE Mus. of Art, Rhode Island School of Design Good drawings incl. Wilson's airy *Capuchins at Genzano*, 2 Gainsborough landscapes, and Constable pencil and watercolour *The Thames from Windsor Castle*. Among the paintings, Reynolds *Caricature Group of Musicians*; and good group of Tissots, his early Salon painting *The Dance of Death*, *Ces Dames des Chars* (Paris Series), and study for *In the Louvre*, plus 2 drawings.

RALEIGH Mus. of Art Mainly portraits, incl. 2 English Van Dycks, *Mary Villiers, Duchess of Richmond and Lennox* and *Henry, Prince of Wales*; large Cotes oil *James Duff, 2nd Earl of Fife*; 4 Raeburn male portraits; plus Reynolds, Gainsborough, Hoppner and Lawrence. Also Fuseli *Three Witches* and Wilkie *Columbus at the Convent of La Rabida*.

ST LOUIS St Louis Art Mus. Some good 17–18c., especially portraits: Holbein *Lady Guildford*; 3 Wright of Derby; 3 Reynolds male portraits incl. *J. J. Angerstein*; and 2 Gainsboroughs incl. his copy of Van Dyck *Lord John and Bernard Stuart*.

Washington University Gall. of Art Hogarth *Lord Grey and Lady Mary West as Children*.

SAN FRANCISCO Achenbach Foundation for Graphic Arts, California Pal. of the Legion of Honor Major coll. of prints, with some drawings, incl. Blake.

M.H. de Young Memorial Mus. Gainsborough landscape and 18c. English portraits.

SAN MARINO Huntington Lib. and AG Distinguished coll. of 18–early 19c. portraits, starring Gainsborough's *Jonathan Buttall* ('The Blue Boy') – the most famous British painting in America – with *The Cottage Door*, a pair of grand full-length portraits, *Viscount* and *Viscountess Ligonier*, Gainsborough's friend *Carl Friedrich Abel*, and other portraits. Equally important for Reynolds with the original *Mrs Siddons as the Tragic Muse*, plus *Diana, Viscountess Crosbie* and *Countess of Harrington* amongst a dozen works. Also the famous Lawrence *Miss Sarah Moulton* ('Pinkie') – by Cotes a large Van Dyckian oil of *Thomas and Isabel Crathorne*; Romney *The Beckford Children*; and other works incl. Hogarth, Highmore, Hayman, Wright of Der-

by, Raeburn, Copley, Hoppner, Wheatley and a Morland *Farmyard*. 19c. incl. 2 Constables, Turner and Stanfield. Amongst an extensive coll. of British drawings and prints (probably the best in the USA outside Yale) are an unusual late Gainsborough aquatint landscape, Cotes pastels and a drawing, Dadd, and Holman Hunt.

SARASOTA John and Mable Ringling Mus. A large and important Gainsborough portrait of *Lt-Gen. Philip Honywood* and a Reynolds, nearly as large, *The Marquis of Granby*. Some classical works incl. Kauffmann *Sappho*, West *Agrippina and her Children mourning over the Ashes of Germanicus*, and Etty *The Combat, Woman pleading for the Vanquished, an Ideale Groupe*.

TOLEDO Mus. of Art Important 18–19c. landscapes: Gainsborough *Peasants returning from Market through a Wood* (almost certainly the picture commissioned by Lord Shelburne for Bowood, intended, along with a Wilson and a Barret, to lay the foundation for a school of British landscape painting; probably the earliest version of Wilson's *White Monk*; the painting Constable was working on at his death, *Arundel Mill and Castle*; rounded off with Turner, and a fine Whistler, *Crepuscule in Opal: Trouville*. Portraits incl. Reynolds *Master Henry Hoare as a Gardener* and 3 others; also Holbein, Hogarth, Lawrence and Wilkie. 19c. subject pictures incl. Martin *The Destruction of Tyre*, Hughes *Ophelia*, a Rossetti *Salutation of Beatrice*, and Tissot *London Visitors*.

WASHINGTON Folger Shakespeare Lib. Remarkable coll. of paintings, prints and drawings of Shakespearean subjects.

Freer Gall. The Whistler coll. here surpasses that at Glasgow, with not only a large and representative coll. of fine paintings, drawings and prints, but also *Harmony in Blue and Gold: the Peacock Room* – the entire room and its decorations, complete with the painting *Rose and Silver: La Princesse du Pays de la Porcelaine*, from the house of his patron F. R. Leyland.

Lib. of Congress Bought in 1920 almost the whole of the Royal Coll. of satirical prints.

NGA Another fine coll. of 16–early 19c. portraits: 2 English Holbeins, *Edward VI as a Child* and *Sir Brian Tuke*; one of Van Dyck's best English portraits, *Philip, Lord Wharton*, also *Lady d'Aubigny*; Stubbs *Col. Pocklington and his Sisters*; Wright of Derby *Richard, Earl Howe*; Reynolds *Lady Elizabeth Delmé and her Children*; and among a dozen Gainsboroughs *Mrs Richard Brinsley Sheridan* and *Georgiana, Duchess of Devonshire* (by Cotes, Raeburn and West (*Self-portrait*). Major subject pictures: Copley *Brook Watson and the Shark* and West *The Battle of la Hogue*. Also Blake

watercolours and drawings incl. *The Ghost of Samuel appearing to Saul* and 2 *Great Red Dragon* watercolours; Constable *Wivenhoe Park* and a *Salisbury Cathedral*; and the important Turner *Keelmen heaving in Coals by Night*, as well as late Venetian views.

WILMINGTON Delaware Art Mus. Major coll. of Pre-Raphaelites: the most important picture is Rossetti *Found*, with a number of other works; 4 Millais paintings; Holman Hunt version of *Isabella and the Pot of Basil*; F. M. Brown *Hampstead Heath from the Artist's Window*, *Romeo and Juliet* and *The Corsair's Return*; plus Burne-Jones, A. Moore, Poynter and Watts.

WORCESTER Worcester Art Mus. A Gainsborough landscape, probably the first he exhibited, complements a portrait of *The Artist's Daughters*; plus Hogarth pair *Mr and Mrs William James*, a fine Cotes oil *6th Baron Craven*, and other portraits by Raeburn and Reynolds. 19c. incl. Etty *The Wrestler*, Tissot *Gentleman in a Railway Carriage*, and 2 Whistlers, the oil sketch for *La Princesse du Pays de la Porcelaine* and *Arrangement in Black and Brown: the Fur Jacket*.

USSR

LENINGRAD Hermitage The greatest coll. of British art outside the English-speaking world (formed round the coll. of Sir Robert Walpole, bought by Catherine the Great in 1779), spanning 16–19c. with many fine works. The most important pre-18c. portrait is Kneller *Grinling Gibbons*. Other portraits incl. Eworth (attr.), Gheeraerts, Dobson *Abraham van der Doort* and Walker (attr.) *Cromwell*. Lely drawings incl. 2 for Garter Procession and *Catherine of Braganza*. 18c. coll. dominated by 2 Wright of Derby, *An Iron Forge* and *Firework Display at the Castel Sant'Angelo*, with 3 Reynolds classical and mythological subjects incl. *The Continence of Scipio* and *The Infant Hercules strangling the Serpents*. Also fine portraits by West of *George, Prince of Wales* and his brother *Henry Frederick*; female portraits by Gainsborough, Romney; also Raeburn, Opie, and Hoppner *Sheridan*. Rural scenes and landscapes incl. Wootton *Hounds and a Magpie*, T. Jones *Landscape with Dido and Aeneas*, 6 Morlands, and W. Marlow *Seaside View*. Print coll. rich in 18c. with mezzotints, Hogarth, Bartolozzi, and over 5,000 satirical prints. 19c. begins with group of Lawrence portraits, and George Dawe's 332 half-length portraits of Russian generals victorious against Napoleon (1819–29). Landscapes incl. Bonington, W. Allan, P. Nasmyth, Walton and Crane. Coll. concludes with a Burne-Jones/Morris tapestry *Adoration of the Magi* and Brangwyn *Charity*. Watercolours and drawings incl. Row-

landson, Lawrence and A. Cozens. Sculpture: Nollekens marble bust of Fox and a *Laughing Child*; Gibson full-length marbles of *Psyche carried by the Zephyrs* and *Cupid as a Shepherd*.

MOSCOW Pushkin Mus. Wright of Derby *Vesuvius with the Procession of St Januarius's Head*; Kauffmann *Morning Amusement*, *Lady embroidering a Turkish Costume*.

WALES

ABERYSTWYTH Nat. Lib. of Wales Major coll. of Welsh topography 18–20c., especially Wilson and Reynolds, plus Welsh portraits, Sandby's Scottish drawings, and some early illuminated MSS.

University Arts Centre Small coll. of small-scale 18–19c. oils (Wright of Derby, Crome, Etty, Leighton), 19c. watercolours and drawings (Turner, Leech, Rossetti, Poynter) and miniatures.

CARDIFF Nat. Mus. of Wales Definitive coll. of Welsh art headed by large holdings of Wilson (20 oils, drawings) and his followers, Innes, A. and G. John, and C. Richards. Many portraits of Welsh notables from C. Johnson and Mytens onwards. Important 19c. sculpture coll.: Armstead, Chantrey, Frampton, Gibson (6 marbles), A. Gilbert, Sir William Goscombe John (1860–1952; 72 works), Leighton; plus in 20c. Chadwick, Epstein. Also good basic 18–20c. coll. with Victorian academics, Newlyn, Bath and St Ives artists, Camden Town and Welsh topography.

HAVERFORDWEST Graham Sutherland Gall. Large coll. of paintings, drawings and prints by Sutherland.

NEWPORT Mus. & AG Landscapes from Barret, Loutherbourg and Barker of Bath, through Cox and Forbes, to A. John. Some Victorian subject pictures (Poynter, E. M. Ward). In 20c. Gowing, Minton, Munnings, W. Roberts, Spencer *The Sausage Shop*.

SWANSEA Glynn Vivian AG Now the national coll. of modern art for Wales, incl. Camden Town and other early 20c., Innes, A. and G. John, Alan Gwynne Jones and C. Richards. Also some earlier pictures: landscape paintings and drawings by Wilson (especially the important moral landscape *Solitude*), Gainsborough, Turner, and most late 18–19c. topographical artists; some portraits incl. Lawrence, Barker of Bath, Leslie.

ZIMBABWE

HARARE NG a few British works, incl. Gainsborough (attr.) *Francis John Browne*, Reynolds (attr.) *Lady Elizabeth Lyttelton*, a large Barker of Bath *Landscape near Bath*, Morland coast scene, Rowlandson (attr.) watercolour *Return of the Husband*, and Pissarro *Le Lavandou*.

Acknowledgments for illustrations

The owners of works reproduced have been identified in abbreviated form in the captions: we are pleased to acknowledge them fully here, and also to thank private collectors who have remained anonymous. Works in the Royal Collection are reproduced by gracious permission of Her Majesty the Queen (Crown Copyright). Other works are reproduced by courtesy and by permission of the Marquess of Bath, Longleat House, Warminster, Wiltshire, England – Musée de la Tapisserie, Bayeux – Bethlem Royal Hospital, Beckenham – Ulster Museum, Belfast – Birmingham Museums and Art Gallery – Peter Blake – City Museum and Art Gallery, Bristol – the Duke of Buccleuch and Queensberry K.T. – in Cambridge: the Master and Fellows of Corpus Christi College; the Syndics of the Fitzwilliam Museum; Kettle's Yard, University of Cambridge; the Master and Fellows of Magdalene College; the Master and Fellows of Trinity College; the Syndics of Cambridge University Library – National Museum of Wales, Cardiff – Sir Frank Cooper, Bt – The Detroit Institute of Arts – the Board of Trinity College, Dublin – the Dean and Chapter of Durham Cathedral – National Galleries of Scotland, Edinburgh – Royal Holloway College, Egham – Sir Brinsley Ford – Beaverbrook Art Gallery, Fredericton, New Brunswick – Glasgow Art Gallery and Museum – the Trustees of the National Maritime Museum, Greenwich – St Godehard, Hildesheim – Indiana University – Edwin Janss Jr – Art Gallery and the Museum of Lakeland Life and Industry, Abbot Hall, Kendal – King's Lynn and West Norfolk Borough Council – in Liverpool: Merseyside County Museums; Sudley Art Gallery and Museum; Walker Art Gallery – in London: the British Library Board; the Trustees of the British Museum; Thomas Coram Foundation for Children; the Greater London Council as Trustee of the Iveagh Bequest, Kenwood; Guildhall Library, City of London; Imperial War Museum; Lambeth Palace Library; The Museum of London; the Trustees of the National Gallery; the Trustees of the National Portrait Gallery; Royal Academy of Arts; Royal Society of Arts; Science Museum; Tate Gallery; Victoria and Albert Museum (Crown copyright); the Trustees of the Wallace Collection; the Dean and Chapter of Westminster Abbey – Los Angeles County Museum of Art – Museo del Prado, Madrid – in Manchester: John Rylands Library; City of Manchester Art Galleries – Mr and Mrs Paul Mellon, Upperville, Va. – The National Trust (Petworth and Mountstewart) – The National Trust for Scotland (Fyvie Castle) – in New Haven, Conn.: Yale Center for British Art, Paul Mellon Collection; Yale Medical Library; Yale University Art Gallery; Yale University Library – in New York: The Frick Collection (Copyright); The Metropolitan Museum of Art – the Duke of Northumberland – Nottingham Castle Museum – in Oxford: the Visitors of the Ashmolean Museum; the Curators of the Bodleian Library; Campion Hall and the Trustees for Roman Catholic Purposes; the Rector and Fellows of Exeter College – Musée du Louvre, Paris – the Earl of Pembroke, Wilton House, near Salisbury, Wiltshire – Museo Capitolare, Pienza – the Trustees of the Lady Lever Art Gallery, Port Sunlight – City Museum and Art Gallery, Plymouth – Southampton Art Gallery and Museums – the Governors of the Royal Shakespeare Theatre, Stratford-upon-Avon – Peter Stuyvesant Foundation.

For photographs other than those supplied by owners, our thanks go to the following individuals and institutions. (Illustrations are identified by page number and, where necessary, A = above, B = below, L = left, R = right.) Christie's Ltd, London 73, 109; Courtauld Institute of Art, University of London 56B, 99A, 99B, 140B, 158A, 228B, 229, 230, 241B, 247AL, 269, 293A; F. H. Crossley 78, 235A; Crown Copyright, Reproduced with permission of the Controller of Her Majesty's Stationery Office 71, 265; N. E. Dawton 79B; Express Newspapers 52B; E. C. le Grice 181; Sonia Halliday and Laura Lushington 252B, 255; Hirmer 279A, 279B; Martin Hürlimann 232; Juda Rowan Gallery, London 136A, 204A; F. L. Kenett 164; A. F. Kersting 233A, 235B, 258B, 259; Laing Art Gallery, Newcastle-upon-Tyne 146A; Alfred Lammer 251B; Emily Lane 207, 256A, 256B; The Leger Galleries Ltd, London 102, 206; the Trustees of the Lord Leighton Collection 146B; London Transport 242B; Richard Marks 253B; Marlborough Fine Art, London 27, 137, 195; R. Brian Marsh 185; Mendelssohn 236; Paul Mellon Centre for Studies in British Art, London 120, 140A; National Portrait Gallery, London 191B; S. Newbery 142B; Anthony d'Offay Gallery, London 91, 150; Perth Art Gallery and Museum 142AR; Ramsay and Muspratt, Cambridge 254L; Royal Academy of Arts 84B; Royal Commission on Historical Monuments (England) 84A, 268A, 280A, 281A; Edwin Smith 28, 74, 89, 98, 228A, 231L, 233B, 234, 267, 268B; Henk Snoek 257R; Eileen Tweedy 221; Warburg Institute, University of London 56A, 68A, 217, 231R, 240B; University of Warwick 93; John Webb for Rickmansworth Council 18; Christopher Wilson 180, 224A, 284; Christopher Wood Gallery, London 197; the Dean and Chapter of York Minster 252A, 253A.

Finally, we thank contemporary artists and their copyright holders who have allowed works to be published, and note that *The City of the Circle and the Square* is reproduced by kind permission of the artist, Eduardo Paolozzi.